# JEWISH LIFE
# IN THE MIDDLE AGES

Thérèse and Mendel Metzger

# JEWISH LIFE IN THE MIDDLE AGES

Illuminated Hebrew Manuscripts
of the Thirteenth to the Sixteenth Centuries

ALPINE
FINE ARTS
COLLECTION LTD

PUBLISHERS OF FINE ART BOOKS, NEW YORK

© 1982 by Office du Livre, Fribourg, Switzerland
Published in 1982 by Alpine Fine Arts Collection, Ltd.
164 Madison Avenue, New York, New York 10016

English translation © 1982 by Office du Livre, Fribourg,
Switzerland

ISBN: 0-933516-57-6

This book was produced in Switzerland

# Contents

*To our daughter, Deborah*

# Preface

This work is based entirely on the study of primary sources collected during more than twenty-five years' research on Jewish illumination.

This research has had constant support from the *Centre National de la Recherche Scientifique*, of which one of us has been a research fellow since 1959 and from which the other has received help on many occasions.

Over the years, our research on original manuscripts has led us to all the great libraries and collections in western and eastern Europe and in Israel; we have also studied material from the United States in the form of microfilms and photographs. Our research in these libraries was greatly aided by the welcome we received and the excellent facilities available to study the Hebrew manuscript collections and to trace the stylistic parallels in Western manuscripts. It is thus our pleasant duty to thank all those keepers of manuscripts and librarians, too numerous to mention here, employed in the libraries we have been visiting since 1954, as well as the owners of collections who made their manuscripts available to us. The names of these libraries and collections can be found in our catalogue.

We are particularly grateful to these custodians of manuscripts for having provided our publishers with the photographs we had chosen, * for having allowed photographers on our behalf to have access to material in their care, or in certain cases for having permitted us to use photographs we had received on a personal basis or which we had taken ourselves. †

As in all our previous works, we were fortunate to have had from the outset the warm encouragement of Professor André Grabar, to whose teaching and friendship we owe so much and to whom we offer our gratitude and respect.

Finally we would like to thank Jean Hirschen, Director of Office du Livre, Fribourg, Switzerland, who enabled us to produce this book and saw it through to publication.

---

* We regret that the library of the Hungarian Academy of Sciences was unable to give us permission to reproduce more than 6 of the 40 to 50 pictures we had chosen from manuscripts in the Kaufmann collection, because of a projected publication by the library itself. On two occasions we have been obliged to use a sketch to replace a particularly important illustration that proved unattainable.

† *See* Iconographic sources.

# Introduction

Was Jewish illumination sufficiently rich and diversified to afford a picture of Jewish life in the Middle Ages? When our publisher put this question to us in November 1976, we decided to resume work on a project that for some years had been lying dormant in our files. His initiative stimulated us to formulate the project more precisely, to give it shape, and to try to clear a path through the thicket of problems that lay in our way.

One of our problems arose from certain traits well known in medieval art and especially in book illustration—conventions in representing figures and rendering their expressions, the simplification and decorative stylization of architectural and rural settings, the influence of more ancient models that were copied or amalgamated. What documentary value could be derived from works so subservient to influences and traditions?

We also had to come to terms with the fact that the most profusely decorated and illuminated Jewish books, contrary to traditional views on the subject, were not secular but religious, excepting of course the liturgical scroll of the *Tora*. On the whole, Jewish pictures took their subject matter from the stories of the Bible, from liturgical texts and from Jewish ritual. What can they show us of the life of the medieval Jew, its daily routine and its historical setting?

There are thus many barriers to a direct reading of our pictures. But we do know that only at a very late date did medieval art begin to portray the past with 'historical' as well as 'local' colour. Jewish pictures, like their Christian counterparts, allow us to discover aspects and scenes of medieval Jewish life through the biblical 'stories' they portray; the appearance and everyday dress of medieval Jews, through the biblical heroes at the time of the patriarchs. We can do this all the more easily in that Jewish iconography was not bound by the conventions and strict codifications of Christian iconography: no physical type, no particular mode of dress, no symbolic colour was ever established to represent the appearance and costume of the partriarchs and heroes of the Jewish people's ancient history, as was the case for Christian saints.

We also had at our disposal the decoration found in our manuscripts, which is more abundant than illustration and, despite the dominance of stylized forms, has a greater range in its inspiration. Taking its models from the world of flora and fauna, from a repertory of everyday objects, and even often from architectural settings, this decoration enabled us to reconstruct and resuscitate the surroundings of everyday Jewish life.

The frequent occurrence of ritual images provided us with a fairly complete picture and, hence, a more specific interpretation of the religious aspects of medieval Jewish life.

Finally, a last problem in interpreting our sources had to be overcome: some of our manuscripts were decorated and illustrated by non-Jewish illuminators. Their images had, of course, to be read with care. But insofar as they were clearly ordered by Jews and found acceptable, there was no reason to challenge the evidence they offer without good reason.

With these considerations in mind, we invite the reader to grasp, first of all, how the universe and nature were perceived by the medieval Jew; what the life of man might have been within that context; then to follow us into the city and the teeming quarter to which the Jews were relegated. There the reader will be introduced to the synagogue and communal buildings before entering the home and seeing the range of Jewish domestic furnishings. Then he will meet the inhabitants of the Jewish quarter themselves: the first encounter will be only with their outward appearance and the diversity of their dress; but then he will follow them as they go about their professional activities and into the intimate surroundings of their family life. Finally, he will see this life in the setting which, for the Jews, gave it all its meanings—that of prayer and observance of the Law.

However, there remain some insurmountable limitations to our enterprise: those imposed by the state of our documentation, the very limited number of illuminated manuscripts that have come down to us—the survival rate varying according to region and period—and uncertainty about where the documents were produced.

Our picture cannot, therefore, be complete either in time or space. The only regions we can treat are northern and eastern France, although in a limited fashion; the German Holy Roman Empire, rather more amply; and most completely the Rhineland, Italy and non-Muslim Spain. In terms of time, we are restricted to the last centuries of the Middle Ages, the thirteenth to the early sixteenth centuries. The French contribution is limited to a few scattered manuscripts dating from the second

quarter of the thirteenth century to the early fourteenth century, when Jews were expelled from the kingdom. The Germanic lands and the territories of the Empire provide us with the longest sequence of pictures, from the second third of the thirteenth century to the late fifteenth century. In Italy our documentation stretches from the late thirteenth to the early sixteenth century. In Spain, the flowering of illustration between 1300 and the late fourteenth century was succeeded early in the fifteenth by the decorative style, which was adhered to without exception until the disappearance of the Jewish book in the chaotic expulsion of the Jews from Spain and Portugal.

The reader should not, then, expect in these pages and accompanying pictures an exhaustive description of all aspects of medieval Jewish life as we know it from textual sources and tradition. Following the example of restorers of ancient frescoes who refrain from completing pictures damaged by the hand of man and time, we have deliberately accepted, and even emphasized, the 'blank' areas of the picture we have tried to reconstitute.

Finally, in choosing our illustrations to accompany the written text, we were guided by significance of image or detail rather than by beauty. Also, despite the risk of alienating the reader's attention with *déjà vu*, we have been unable to avoid reproducing pictures already well-known. The reason is simply that many scenes and motifs appear no more than once or twice in the whole of Jewish illumination, and when one or another of them was necessary as evidence, we were obliged to include it.

1   Castile, in 1300: town gateway with the three heraldic towers. Lisbon, Biblioteca Nacional, Ms. Il. 72, folio 445 recto.

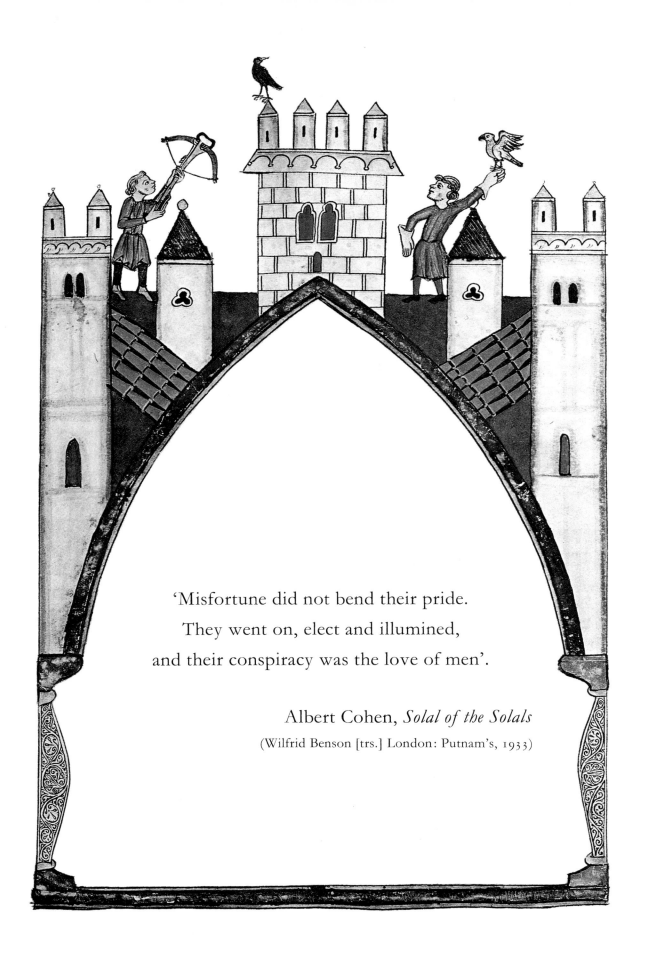

'Misfortune did not bend their pride.
They went on, elect and illumined,
and their conspiracy was the love of men'.

Albert Cohen, *Solal of the Solals*
(Wilfrid Benson [trs.] London: Putnam's, 1933)

*Transliteration of the Hebrew*

Hebrew words have been transliterated rather than given in Hebrew letters. The rules of transliteration followed are those recommended by the Israel Academy of Sciences and Humanities:

## CONSONANTS

| | | | | | | | | | |
|---|---|---|---|---|---|---|---|---|---|
| ʾ | א | w | ו | kh | ך, כ | p | פ | s | שׂ |
| b | ב | z | ז | l | ל | f | ף, פ | t | ת |
| v | ב | ḥ | ח | m | ם, מ | ẓ | ץ, צ | t | ת |
| g | ג | ṭ | ט | n | ן, נ | q | ק | | |
| d | ד | y | י | s | ס | r | ר | | |
| h | ה | k | כ | ʿ | ע | sh | שׁ | | |

## VOWELS

| | | | | | | | | | |
|---|---|---|---|---|---|---|---|---|---|
| a | ◌ָ | e | ◌ֱ | ey | ◌ֵי | o | ◌ֹ, ו | u | ◌ּו |
| a | ◌ַ | e | ◌ֶ | i | ◌ִ | o | ◌ָ | u | ◌ֻ |
| a | ◌ֲ | e | ◌ֵ | | | | | | |
| | | e | ◌ְ | | | | | | |

N.B.   Neither the *alef* nor the *ayin* have been transliterated when they occur at the beginning of words. Consonants with a *dagesh* (point placed within a Hebrew letter) have been doubled except where a modification of the pronunciation is involved, i.e., *vet/bet, khaf/kaf, fe/pe.*

   Anglicized spelling of the words 'Ashkenazi' (Jew of northern Europe) and 'Sephardi' (Jew of the Iberian peninsula) has been used throughout.

*Concerning a Glossary*

Since each Hebrew word used in transcription is followed immediately, or at least at its first occurrence in the text, by a translation or explanation, we have not included a glossary.

# I  The Medieval Jew and the Universe

'In the beginning God created the heavens and the earth'.

The book of the Law opens with these words, the account of the creation of the world, the first manifestation of divine Will before which all is mystery. This account, affirming the all-powerful nature of God, which was an article of faith for the medieval Jew,[1] was at the same time a stumbling block for medieval Jewish philosophy that always tried to reconcile the concept of creation *ex nihilo* with contradictory ideas inherited from Greek philosophy—the Aristotelian eternity of matter and the theories of emanation of Neoplatonism. For mystics— utilizing the vision of Ezekiel (the story of the chariot)—the account of the creation proved to be a unique means of approaching questions about God, man and the world. Every day the hymns, psalms and initial benedictions of morning prayers and of the *aleynu le-shabeah* prayer glorified 'the Eternal One who created the universe through His word... who created the world from nothingness' *(barukh she'amar...)*, who 'made heaven and earth, the sea' (Ps. CXLVI:6), who alone 'made heaven, the heaven of heavens, with all their host, the earth... the seas' (Nehemiah IX:6), 'author of light and creator of darkness' *(yozer or)*, 'Creator of the world ... who spread out the vault of the heavens and established the earth' *(aleynu)*. Every year, after the feasts of autumn, the cyclical reading of the *Tora*, the Law, begins with the grandiose account of the first mysterious days of the world.

Despite the familiarity of all Jews with this evocative concept —so many works of art, both painting and sculpture, by medieval Christian artists were inspired by it—the biblical account of the origin of the world, a fundamental belief for Jews, was only very rarely the subject of illustrations in medieval Jewish books. This fact may be less surprising than it appears at first sight: the exceptional position in religious thought of the account of creation, the limitations and barriers surrounding its study, and the formidable mystical experience to which it could provide a path may well have made it a forbidden subject for pictures. It confronted the artist with a crucial problem: what was he to portray if not God Himself engaged in His acts of creation? Medieval Jews were strictly forbidden to portray God. How was an artist to show an action without the Being responsible for it? It seemed impossible as well as forbidden. Indeed, it is astonishing that even under these conditions there were Jewish illuminators who tried pictorially to rival the immensely evocative power of the Word.

## Pictures of the Creation of the World

In the Sarajevo Haggada,[2] a Spanish illuminator of the second half of the fourteenth century has made an ambitious attempt to represent the six days of creation. He portrayed the primeval darkness and waters; the dramatic appearance of light and its separation from the original darkness; then, on the surface of the earth, a sphere suspended under the celestial vault, the separation of the land from the sea; the advent of grasses and trees; the illumination of the firmament by the sun, moon and stars, the peopling of the three elements—water, air and land —by aquatic animals, winged creatures, quadrupeds, reptiles and finally man.

Although the painter followed the iconographic model of creation as it appears in the Latin Bibles of the thirteenth century, he solved the problem of representing the Divinity in quite an original manner, both aesthetically satisfying and religiously acceptable. He did not fall back on the easiest way of resolving the problem: the complete suppression of all representation of divine intervention and the use of the ancient anthropomorphic symbol, the hand of God. These devices were, used in early fourteenth-century Italy,[3] by the painters of the only two other series of illustrations of the creation in medieval Jewish manuscripts. Without portraying the Divinity, the Spanish painter has managed to represent His action with an austere grandeur. The artist depicted golden beams, symbolic of the spirit of God, undulating above the primeval waters. These are then bundled together and focused upon the creation of each day. Their repetition in every picture highlights the miracle of the successive creative acts.

One of the Italian painters included the human figure in his pictures but avoided illustrating the creation of man by substituting a decorative motif. The suppression of this scene in the second series prevents us from seeing how the second painter approached the problem. However, both Italian painters avoided illustrating the seventh day, the day of divine rest: the first substituted an ornament; the second finished the series on the sixth day. The Spanish illuminator, on the other hand, managed to show the seventh day in a picture whose subject has a simplicity investing it with the fullness of meaning that Jewish tradition gave to the creation of the world and of man. In a situation where Christian artists show God in majesty reigning over His creation, the Jewish painter portrayed an ordinary Jew of his time, wrapped in the long cloak worn to the synagogue on

the *shabat* and resting with his head supported on his hand. This signifies that in observing the *shabat*, the day blessed and sanctified by God (Genesis II:3), man participates in the holiness which his Creator had assigned to him as his destiny and to which he is led by the study and observance of the *Tora*; the picture also shows that man was already experiencing, on that day, the eternity that was to be his lot.

## The Universe

Pictures of the universe in which the medieval Jew lived are rare and fragmentary; however, the few Sephardi, Ashkenazi and Italian Jewish manuscripts that have survived do illustrate the general outlines and essential characteristics of the world of medieval Jews.

### *The Celestial Vault*

For western Jews, as for Christians and Muslims in the last two centuries of the Middle Ages, the earth was round and positioned at the centre of the universe.[4] The stars were fixed on the blue celestial vault that set the limits of the universe.[5] Every day, the course of the 'two great lights' (Genesis I:16) could be observed on the celestial vault: the sun, the larger, during the day and the moon, the smaller, at night.[6] Every month, the latter went through the phases of its cycle. Its weaker light made it seem a silver star next to the larger golden one,[7] but it was the moon that 'aroused, month after month, the changes and events in the world, good and bad' (Solomon Ibn Gabirol, *Keter malkhut* ['The Royal Crown']) and that served as a guide for establishing the calendar and feasts. The waxing new moon marked the first day of the month.[8]

During the year, the sun crossed the vault of the heavens and passed through the twelve constellations of the Zodiac. The twelve full moons appeared in an annual cycle in the same constellations, while the planets revolved within them. The course of the sun along the Zodiac marked the years and the seasons of the year. In the Middle Ages, as in late Antiquity, the familiarity of the Jews with the Zodiac differed little from that of their Christian or Muslim contemporaries and was the fruit of astrological interests rather than of the practical use recognized

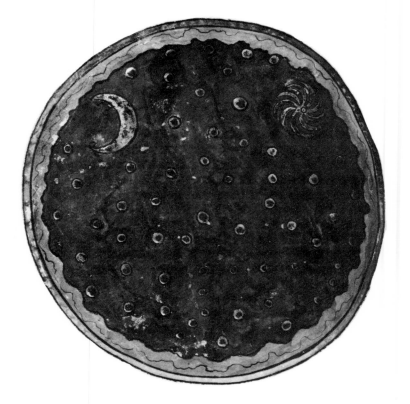

and exploited by compilers of calendars. One tradition dating from Talmudic times held that 'there are no planets for Israel, but only for all nations in common,' a tradition which Maimonides was almost alone in following in the Middle Ages. Despite this, the belief that the constellations governed the months, and the planets the days and hours of life, was common both to the greatest philosophers and to the superstitious populace. The twelve signs of the Zodiac had already been associated with the twelve tribes of Israel, even though the names of the signs were translated into Hebrew from those that the Babylonians had transmitted to Greek and Roman Antiquity, and an effort had been made to relate the signs to biblical figures and episodes. Thus Aries was linked with Abraham sacrificing Isaac; Taurus recalled the calf Abraham offered to the divine messengers, and Gemini, Jacob and Esau. The introduction of the liturgical hymns of Eleazar Kalir (ninth century?) into the services of the holidays of *pesah* (Passover) in the spring, and of *sukot* (the feast of Booths or Tabernacles) in

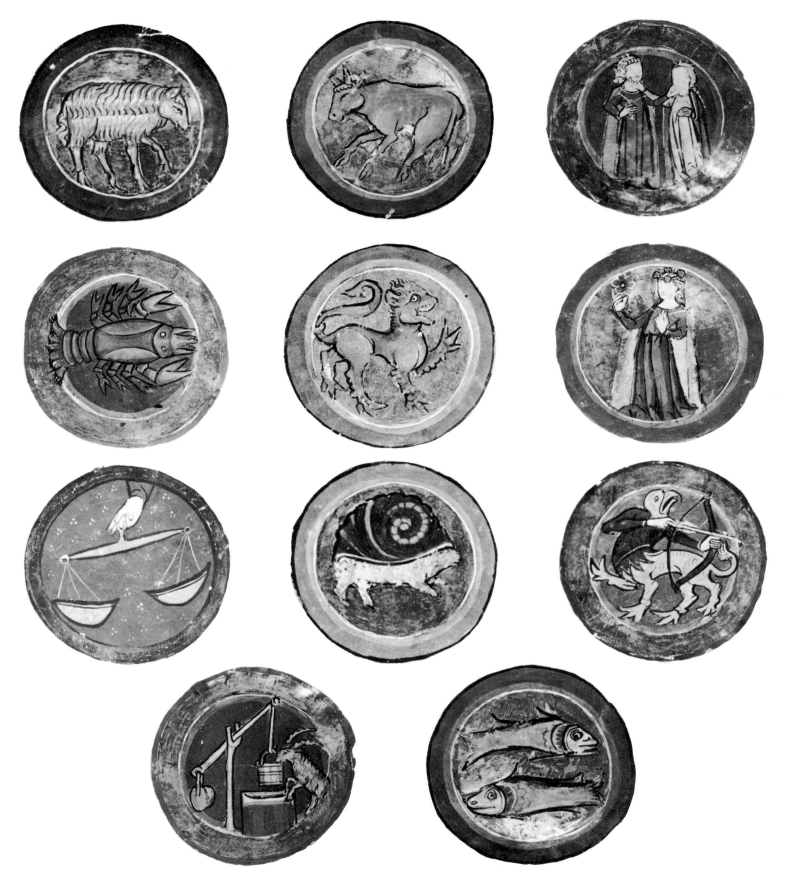

4 '... And a wind from God sweeping over the waters... and God separated the light from the darkness' (Genesis I: 2 and 4) (Spain, Aragon, 1350–60). Sarajevo, National Museum, Haggada, folio 1 verso (upper register).

5 'And God called the dry land Earth, and the gathering together of the waters He called Seas... And the earth brought forth vegetation: seed-bearing plants... and trees...' (Genesis I: 10 and 12) (Spain, Aragon, 1350–60). Sarajevo, National Museum, Haggada, folio 1 verso (lower register).

6 'And God made... the lesser light to dominate the night: he made the stars also' (Genesis I: 16) (Spain, Soria?, 1300). Lisbon, Biblioteca Nacional, Ms. Il. 72, folio 239 verso.

the autumn, gave the signs of the Zodiac what was virtually a religious sanction, since the verses of these hymns developed the agricultural and historical allusions, both allegoric and symbolic, of the theme of the twelve months and the signs that presided over them. In fact, it is the illustrations of these hymns in holiday rituals that show us the Zodiac as conceived by medieval Jews.

In spite of the adoption of Greco-Latin names for the signs of the Zodiac, the designs were no longer those of classical Antiquity, seen until the sixth century in the pavement mosaics of Palestinian synagogues. Some signs, it is true, are easily recognized among the animals, Aries, Taurus, Leo, Pisces, and, among the figures, Virgo (a girl in long clothes) and the double figures of Gemini—but they have a medieval aspect, and more particularly, a Jewish medieval aspect. The signs of the Zodiac appear in a series of manuscripts, all German, that covers almost a century, from 1258 to 1340. During this period in Germany, Jewish iconography presents distinct characteristics. By the addition of beaks, the heads of human figures are made to look animal-like or the figures may have complete animal heads.[9] On faces, the eyes, nose or mouth can be totally or partially lacking.[10] Gemini is usually depicted as a pair of figures, but it can also be shown as a courtly couple.[11] Hybrid animals are sometimes substituted for this sign[12] or it can also appear as a single human figure with two birds' heads.[13] Sagittarius is no longer the classical centaur, but rather a human archer with an animal's head[14] or a hybrid animal composed of a lion's body, a human bust and a bird's head.[15] Usually, however, only arms holding a bow and arrow[16] are portrayed and sometimes just a bent bow.[17] Cancer is never represented as the crab of Antiquity but as a crayfish, the same sign used by Christians; the Hebrew word for this sign, *sartan*, is the term for both crab and crayfish. Occasionally Cancer is portrayed as a monster—a hybrid animal with four legs, boar's tusks, a carapace and a fish-like tail,[18] or as a kind of mermaid with a human head and the body of a fish.[19] As for Capricorn, a real caprid with four feet replaces the hybrid animal with goat's torso of classical iconography. Only by accident does this sign sometimes resemble a sheep[20] or a calf.[21] It appears that Jewish illuminators of this period were not acquainted with pictures of Scorpio, an animal unknown in the regions from which our manuscripts derive. Scorpio is usually shown as a tortoise with a tail of varying length and depicted from above or in profile; its carapace can take the form of a shell coiled like a snail's.[22] Scorpio can also be an animal with

four feet and a long tail[23] or a hybrid animal with a serpentine body, a bird's head and a long beak.[24] Such a hybrid could also have a flat head, wings and four feet.[25]

Jewish signs of the Zodiac in the Middle Ages are distinguished by the originality of the motif adopted for Aquarius: instead of a man emptying the contents of one or two vessels, Aquarius is a well with a hanging bucket[26] or just the bucket alone.[27] This change derived from the Hebrew word for the constellation, *deli*, which means bucket. The final distinctive feature of these Jewish signs of the Zodiac in Germany can be seen in the margin of the *pesaḥ* hymn. The signs of Capricorn and Aquarius are portrayed together in the same picture; a caprid is drinking from the bucket of the well—in the text the two signs are associated in the same verse.[28]

Only once, in the fourteenth century, are the signs of the Zodiac shown in a circle divided into twelve parts.[29] Hebrew manuscripts of the thirteenth and fourteenth centuries usually show these signs in a series of medallions, a type of presentation borrowed from contemporary Christian art, though Jewish artists are known to have used the twin series of the labour and occupations of the months, so often associated with this form of presentation, on two occasions.[30]

This is how the signs of the Zodiac are shown over a century later, in the margins of a German *maḥzor* of the 1460s.[31] They are still very medieval in character. Virgo and Sagittarius are dressed according to contemporary fashions; Cancer is a crayfish,[32] and Capricorn a he-goat.[33] Scorpio is slightly more convincing this time, despite its six feet, fish-like body and head, badly articulated claws and small tail.[34] But these signs of the Zodiac are not properly Jewish. Aquarius is a man pouring out two small buckets, and Gemini is portrayed as two small, naked children. This and other evidence point to the conclusion that, for the decoration of this manuscript, recourse was had to a non-Jewish illuminator, who was influenced by Christian models.

A few Italian pictures of the Zodiac survive; the oldest date from the end of the fourteenth century and the first half of the fifteenth. They are not designed to illustrate the cycle of the seasons, but rather have a medical association and testify to the belief—discussed in another chapter—that each of the twelve signs of the Zodiac is related to an organ of the body, whose health they influenced. The first series, painted on a *homo signorum*, includes a real scorpion, even if Cancer is shown as a tortoise and Capricorn as a unicorn, but all the pictures were copied from a non-Jewish model that contained no trace of what

4

5

6

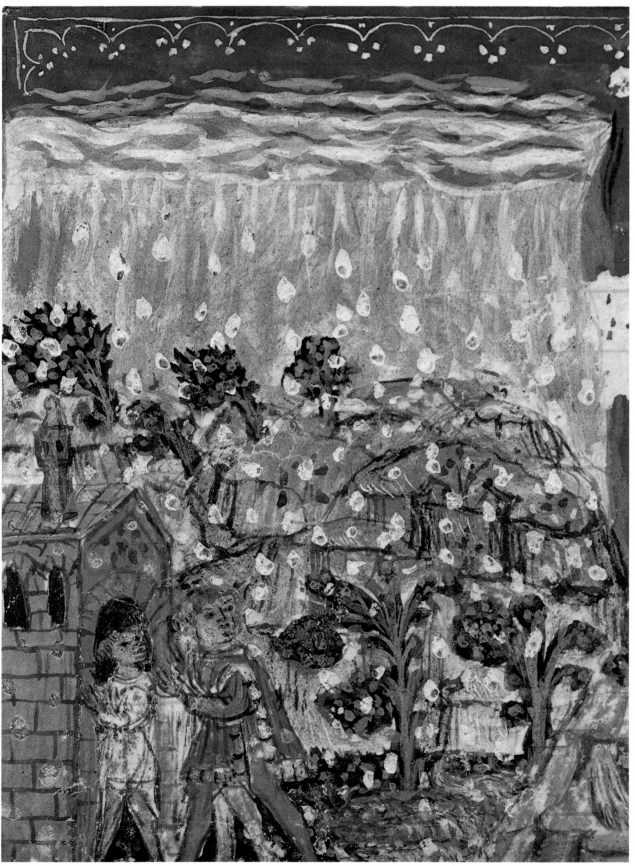

7

7  Hail damaging trees (Italy, Emilia, 1470–5).
London, British Library, MS. Harley 5686, folio 60 recto (detail).

was characteristic of the Jewish Zodiac: Gemini is represented as a naked couple, Aquarius as a vessel full of water.[35] The second series, found in a copy of Avicenna's *Canon*,[36] also illustrates the influence of the seasons on the human body, although the signs of the Zodiac are accompanied by pictures of the labour and occupation appropriate to each month. This series has an irreproachable Scorpio beside a medieval crayfish for Cancer, a goat for Capricorn and a Sagittarius wearing a tunic on his chest. Its interest lies in the fact that, although it is taken from a non-Jewish model—a naked couple is used to signify Gemini—Aquarius is represented by the medieval Jewish motif of the well. The non-Jewish origin of the series is confirmed by the painter's oversight in depicting a pig in the slaughter-house scene for the sign of Sagittarius[37] rather than the ox used by German Jewish painters of the thirteenth and fourteenth centuries.[38]

The most recent picture of the Zodiac can be found at the beginning of an Italian *maḥzor* of the late fifteenth century.[39] It precedes the text of the *Keter malkhut* by Solomon Ibn Gabirol (*c.* 1020–58) with which the *maḥzor* begins, as do many Sephardi and Italian prayer books of the late fourteenth and fifteenth centuries. This cosmic picture of the 'twelve princes' among the stars symbolizes all creation, the work of divine Will. Its source appears to be verse XXII of this sublime poem, celebrating the attributes of the One God and the marvels of His creation, before which man can only take stock of his own frailty and offer prayers of supplication and worship. However, the series of constellations, apparently bearing the mark of contemporary humanist culture, evidences no Jewish characteristics: even the names of the constellations, written in Latin characters, are half Latin, half Italian.

## Atmospheric Phenomena

While the stars moved about the heavens and one season was followed by another, the rains, gift of divine Mercy, nourished the earth. The fury of the elements—air, water and fire, ministers of God's judgement—was responsible for tempests, storms, hail and snow. But Jewish illuminators were not overly concerned with such subjects. All we have at our disposal illustrating the great forces of nature are two modest pictures of a sky with heavy rain,[40] a view of the ruins and bodies left by a flood,[41] a schematic rainbow with or without colours,[42] a few storm clouds with lightning,[43] and some pictures of hail-storms[7]—a catastrophe widely feared in the Middle Ages, when the loss of a harvest could mean ruin and famine. Hail struck both man and beast, flattened the crops in the fields and splintered trees.[44]

We probably would not have as many illuminations as these had forty days of rain not been responsible for the Flood (Genesis VII:4), had the rainbow not been the sign of God's covenant with Noah (Genesis IX:13), had the Law not been given on Sinai amidst claps of thunder, lightning and thick storm-clouds (Exodus XIX:16), and had hail not been one of the plagues of Egypt (Exodus IX:22-5). The fifteenth century only provides one picture of a hail-storm that was not biblical, an illustration to a fable,[45] and only a single landscape under snow.[46]

## The Animal Kingdom

The medieval Jew, and indeed all his contemporaries, accepted that at the creation of the world, the elements had been peopled with all kinds of animals: wild, tame, real and fabulous—including giraffes, lions, elephants, panthers, camels, bears, foxes, oxen, birds, fish, snakes and dragons.[47] Once saved from the Flood, the four-footed and winged creatures and the reptiles continued unchangingly to reproduce and multiply after leaving Noah's ark.[48] It was thought that Adam had seen all these creatures on the sixth day, when God asked him to name those he subjected to his power: beasts of the forests, fields, rivers and seas; of lands near and far-away; those that flew as well as those remembered only in stories.[49]

Medieval Jewish literature included no work comparable to the *Etymologiae* of Isidore of Seville, the *De Universo* of Raban Maur, the *De Imagine Mundi* of Honorius of Autun, or above all the *Physiologus* or *Bestiary* in which all familiar, exotic and monstrous fauna were listed and described; its traditional illustration constituted a pictorial encyclopedia of the animal kingdom. Beasts figured only by chance in the illustration and decoration of Jewish books. However, such decoration was so profuse that it is not difficult, in going through Hebrew manuscripts from the thirteenth to fifteenth century, to gain a fairly complete idea of the creatures in the bestiary of the medieval Jew.

8

9

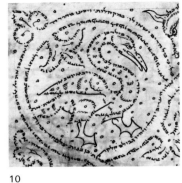

10

## Insects and Arachnids

Insects are not seen frequently, though illuminations of Jewish books from Spain commonly include pictures of vermin associated with men and animals: ticks and lice, as well as locusts devouring vegetation[50]—this can be explained by biblical references to such creatures (Exodus VIII:14; X:13-15). Butterflies, in flight or alighting, can be seen occasionally in the margins of Jewish manuscripts decorated in Spain, Portugal and Italy. They are generally small, grey or a velvety beige in colour; a few speckled in pink, blue or in the colours of fire, gold, and dark blue.[51] One has big golden wings ocellated with scarlet.[52] Very small bees can be identified by the beehive around which they fly in Italian coats of arms[53]—in German pictures of the second half of the fifteenth century bees are scarcely more recognizable.[54] A large green fly painted in trompe-l'œil by a French artist in a fifteenth-century manuscript is so real that the reader is liable to try to brush it away.[55] Scorpions were only illustrated in Spain[56] and in Italy.[57]

## Birds

Birds of every kind are found on the decorated pages of our manuscripts; they are depicted in flight, perched on some support, walking, singing, pecking and foraging in a natural, stylized or heraldic manner. Leaving aside the merely conventional decorative devices, frequent at all periods, we shall only comment on the birds with specific characteristics, those portrayed in a position or movement that evidences observation and knowledge of real members of the feathered tribe, even though the artist may have been following a model.

In court-yards everywhere, hens surrounded by their chicks can be seen pecking,[58] while the cocks perch to crow.[59] Sometimes a bird of prey, buzzard or sparrow-hawk swoops with open wings on a chicken or chick, creating havoc in the farm-yard[60] and around the house. Among all the birds that nest in the trees at dusk,[61] the bull-finch with his flame-coloured breast is particularly striking, as is the gold-finch streaked with fire and sulphur.[62] Two birds on a bush sing with open beaks; another bird walks along on stiff legs, anxiously looking behind with a sudden movement of its long neck.[63] Jays with blue highlights on their coats[64] are nearby, as well as crows greedily

8 Singing birds confronting each other (Germany, end of the thirteenth century).
London, British Library, MS. Or. 2091, folio 338 recto (lower margin).

9 A bird walking (Germany, end of the thirteenth century).
London, British Library, MS. Or. 2091, folio 338 recto (in the form of an initial).

10 The swan (Germany, c. 1300).
Oxford, Bodleian Library, MS Can. Or. 137, folio 220 verso.

devouring grain, crumbs and scraps of food.[65] Pigeons[66] and doves[67] are common, as are the loquacious magpies.[68]

Geese waddle through the fields;[69] ducks search out their fodder[70] and can be seen swimming on a pond or river,[71] sometimes together with swans.[72] The latter step out of the water on large, webbed feet, with their throats blown out, necks bent back and aggressive beaks ready to strike.[73] In the marshes, cranes, herons and storks, perched on long legs, seize their prey: fish, turtles, snakes or frogs.[74] Red partridges run over the furrows.[75] Hunters let fly falcons[76] that capture their prey on the wing.[77] An eagle bears its victim away in its claws.[78] A vulture looks for carrion with piercing eyes.[79] At night, screech-owls and owls cry.[80] Green parrots or parakeets from Asia,[81] imported into Italy in the late thirteenth century,[82] had become common, as they had in Spain and Portugal by the fifteenth century.[83] They can be seen in German pictures of the fourteenth century.[84] Peacocks display the oriental fantasy of their marvellous decoration.[85]

## Batrachians, Reptiles, Molluscs, Shellfish and Fish

There are other frogs than those fabled creatures that invaded Egypt (Exodus VIII:2).[86] As early as 1340, a German illuminator tried to sketch some, crouched with gathered forces, before they leapt and in the process of jumping,[87] and frogs are also shown caught by waders, like turtles and other reptiles. The snake, a descendant of the one that tempted Eve (Genesis III:1-6),[88] crawls along the ground and threatens men with its mortal bite,[89] though the latter are always fascinated by its twisting, knotted body.[90] Turtles were also familiar,[91] but lizards were rare.[92] Snails too can be seen sometimes.[93] Among crustaceans, crabs were rare and hardly appeared outside Italy;[94] the crayfish, on the other hand, was more common in the north.[95] Fish abounded in rivers and streams and in the sea,[96] although particular species cannot be distinguished. Most fish were

11 | 12 | 13

11 The tortoise (Italy, Forli, 1383).
London, British Library, MS. Add. 26968, folio 323 recto.

12 The snail (northern France, *c.* 1280–5).
London, British Library, MS. Add. 11639, folio 243 recto.

13 The crayfish (northern France, *c.* 1280–5).
London, British Library, MS. Add. 11639, folio 162 recto.

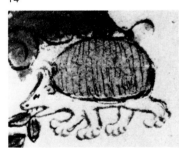

14 | 15

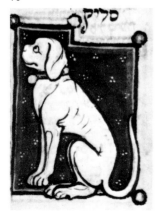

16 | 17

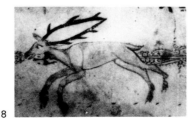

18

spindle-shaped and had gills; fins and scales were clearly 284, 285
shown.[97] A shorter fish that was fatter and wider appears in 285
Spanish manuscripts.[98]

### Small Mammals

Hedgehogs are scarcely seen in the vegetation of illuminated 14
borders except in Italian manuscripts from the fourteenth
century.[99] The same can be said for the mole.[100] But mice are 287-8
everywhere, being devoured by cats [101] or caught in traps.[102] 27
Squirrels were a popular subject because of the elegance of their
seated posture.[103] Rabbits and hares were innumerable in
northern and in southern countries—they frolic, graze, and lie
in the grass.[104] But it was the hare's lot to be dug out from his 320
lair,[105] chased by dogs,[106] caught [107] or captured in his form.[108] 15

### Wild and Domestic Animals

Dogs are pictured everywhere as the faithful servant of man,
guarding his house.[109] They were used not only in hunting for 16
game such as hare, but also for deer and boar. Hunting, a 17
frequent spectacle for non-participants, was a common subject
in the decorative margins and panels of our manuscripts.[110] 34, 320, 329

Hart and hind were carefully portrayed, the elegance of their
shape and poses nicely observed. Even before the appearance of
the charming ornamental borders with standing or seated stags

14 The hedgehog (Italy, Forli, 1383).
London, British Library, MS. Add. 26968, folio 322 verso.

15 The hare is caught squatting down (northern France, *c.* 1280–5).
London, British Library, MS. Add. 11639, folio 281 recto.

16 A faithful dog (northern France, *c.* 1280–5).
London, British Library, MS. Add. 11639, folio 338 verso.

17 The wild boar (northern France, *c.* 1280–5).
London, British Library, MS. Add. 11639, folio 166 recto.

18 A deer running (Italy, Rome?, end of the thirteenth century).
Rome, Biblioteca Casanatense, Ms. 2898, folio 55 recto.

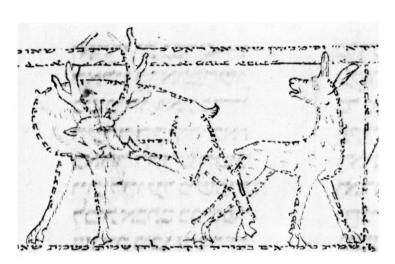

19  Hart and hind (Germany, 1294).
Vatican, Biblioteca Apostolica, Cod. Urbin. ebr. 1, folio 146 recto.

## Exotic Fauna

Medieval Jews were aware of the existence of a large number of African and Asian animals through pictures, stories, travellers' tales and, when they were imported into Europe, through seeing them.

Monkeys were the most familiar. They were from small species, e.g. cercopitheci, then known as guenons, but rhesus, macaque and magot monkeys were also shown; these could be easily trained and acclimatized in Germany,[128] in Italy [129] or in Spain.[130] From the early fourteenth century monkeys were found in the houses of the rich,[131] where they wore clothes,[132] and in the streets, where their trainers made them fight, play an instrument [133] or dance.[134]

The lion was the most frequently illustrated big game. It was known first as a heraldic animal and thus appears *rampant, contourné, affronté, passant,* and addorsed in the decoration of our manuscripts.[135] But those we are concerned with here are the more realistic lions seen in illuminations using a Bestiary for models [136] or those drawn and painted, from the late thirteenth century and throughout the fourteenth, by Italian and Spanish illuminators.[137] These lions are shown in a greater variety of postures and with more realism: stalking their prey, sitting, lying or crouched with claws bared ready to spring on their prey.

By the thirteenth century the kings of Aragon kept lions from North Africa in their menageries—in this they were the precursors of Italian princes and cities. The Jewish community of Barcelona was responsible for the upkeep and training of these animals up to the end of the fourteenth century. This royal animal was thus much more familiar to medieval Jews.
Among the felines well known in the West in the Middle Ages were panthers, leopards and cheetahs. For a long time in the

and hinds that appear in the marginal decoration of fifteenth-century Italian manuscripts, the sketch by a German artist of the late thirteenth century captured a couple of deer in familiar postures,[111] as did an Italian illuminator's of the same period.[112] The forest housed the fox, who visited the farm-yard,[113] and wolves, dangerous to both man and beast,[114] as well as the wild brown bear shown clambering down the mountainside,[115] although the bears usually depicted were tame.[116] Dogs are seen again with men, guarding the flocks of sheep and goats,[117] bullocks, cows and calves.[118]

It is noteworthy that the pig, the very symbol of an impure animal for Jews, never appeared in scenes of everyday life, apart from the one instance cited above in the series of pictures illustrating the occupations of each month in the Canon of Avicenna from Bologna.[119] However, a pig is seen in a picture of the animals leaving Noah's ark.[120] Noah must have embarked small numbers of impure animals along with the pure ones (Genesis VII:2). The pig is also illustrated in a series of pictures designed to show these two categories of animals (Deuteronomy XIV:7 ff.).[121]

Man also has in his service oxen who pull the plough,[122] asses and mules for carrying loads [123] or for riding,[124] as well as various horses—cart horses,[125] saddle horses [126] and war horses.[127]

20  The magpie (Spain, Soria?, 1300).
Lisbon, Biblioteca Nacional, Ms. Il. 72, folio 437 verso (detail).

21  The crane has caught a tortoise... (Spain, Soria?, 1300).
Lisbon, Biblioteca Nacional, Ms. Il. 72, folio 147 recto (detail).

22  ... and the heron a tench (Spain, Soria?, 1300).
Lisbon, Biblioteca Nacional, Ms. Il. 72, folio 31 verso (detail).

23  The peacock, who combines the colours of all the birds (*Berensh raba* ['Great *midrash* for the book of Genesis'], VII: 4) and whose 'plumes have as many colours as there are days in the year' (*Midrash Tanḥuma B* for the book of Leviticus XXXIII) (Spain, Soria?, 1300).
Lisbon, Biblioteca Nacional, Ms. Il. 72, folio 436 verso (detail).

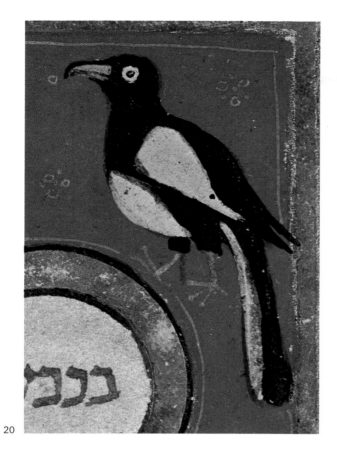

20

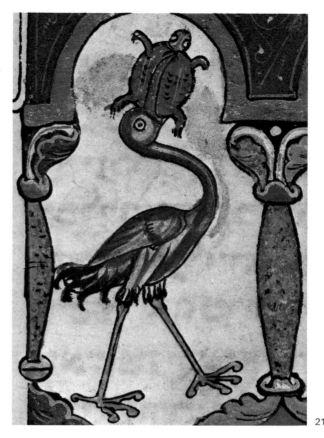

21

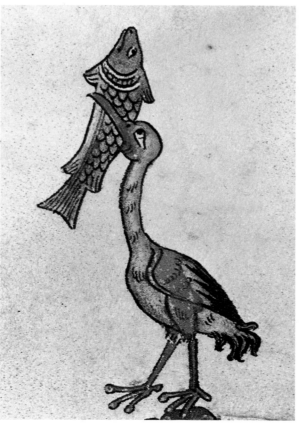

22

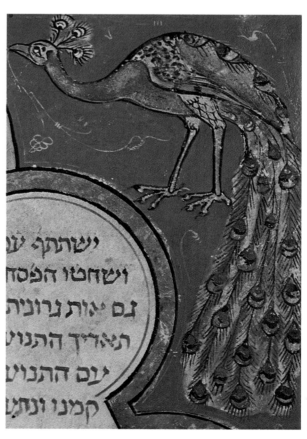

23

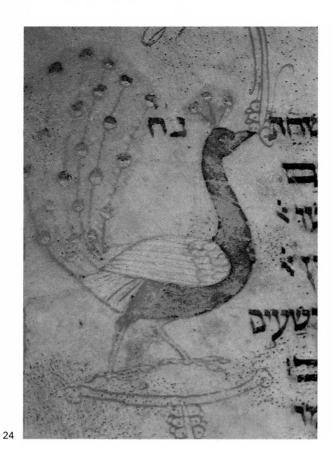

24

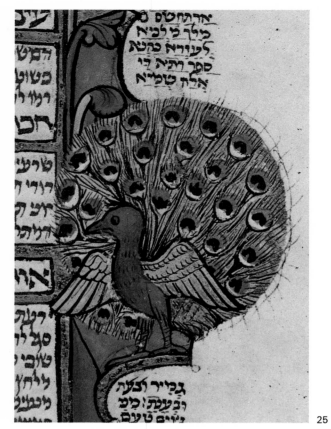

25

26

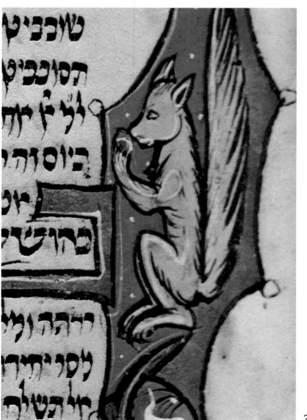

27

north, these beasts were only known through the pictures of Bestiaries from which they were copied [138] and from pictures deriving from Italy.[139] But in Mediterranean lands such animals could survive the climate. Princes kept them in menageries and trained cheetahs for hunting. Cheetahs with spotted coats are difficult to distinguish in our pictures; however, they can be identified by their non-retractible claws. If the illuminator was not just trying to show the innate ferocity of these animals by depicting their claws even when they were walking, we owe to his powers of observation (or to those of the artists responsible for the models he followed) some pictures from the late thirteenth century [140] of cheetahs shown among leopards and panthers later in the same century.[141] In fifteenth-century Italy, the distinction between these animals is easier to observe: the cheetah is leaner, higher on its legs and wears a collar like a tamed animal,[142] while the panther has heavier withers and legs that are thicker and shorter.[143]

The medieval Jew also knew of exotic animals that were peaceful. Ostriches were illustrated in France in the late thirteenth century,[144] whereas the conventional picture of the voracious ostrich with a horse-shoe in its mouth is found only in Germany in the second half of the thirteenth century[144a] and into the fourteenth,[144b] and in Spain in 1300.[145] There are a few sketches there of the gazelle,[146] preceding the Italian pictures of ostriches, which only date from about 1470.[147]

The silhouette of the camel was more widely known. Whereas German pictures of 1236 to 1238 [148] very carefully depict the characteristics of the dromedary—the hump, the curve of the neck—pictures from France of about the same date (around 1239 [149]) show the camel as a horse with a long neck and a hump (sometimes omitted) that is small, pointed and very clumsily drawn. In the latter instance, it is not clear whether the rounded protuberance of the shoulder represents a first hump. In a micrographic sketch from the second half of the thirteenth century,[149a] the two small protuberances on the back of a long-necked animal may indicate that it is a camel with two humps. In an illustration of circa 1300, the bale attached to the camel's back prevents us from determining whether it has one hump or two.[149b] The same ambiguity is found somewhat later in a German picture of 1331.[150] In France, of course, it was not until between 1260 and 1266 that Brunetto Latini (*c.* 1220–94?), the master of Dante, writing in *langue d'oïl*, described the camel with one or two humps in his *Livre du Trésor*. However, it was possible to meet them in the more complete Latin Bestiaries,

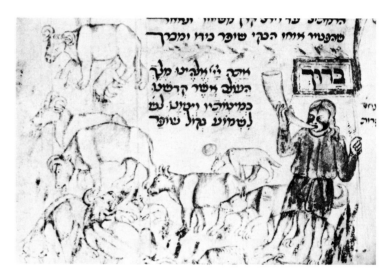

28    A cowherd with his drove (Italy, Forli, 1383).
London, British Library, MS. Add. 26968, folio 238 recto.

although northern illuminators often seem to have considered the existence of camels as dubious.

More than once, even in fourteenth-century Spain,[151] only the camel's cloven hoofs and rather longer neck distinguish it from the mule; both animals have long ears. Other pictures portray the camel carefully: with a longer, more flexible neck and an upper lip and nostrils that are better characterized.[152] Nevertheless, the ears remain too long and the hump is only suggested by the height of the bundles on the animal's back or, rather naïvely and quite falsely, by a slight rise in the withers just in front of the load. The most realistic dromedaries, despite the excessive length of their neck, are those found in a copy of the Atlas of Abraham Cresques [153] dated 1375: singly or in a caravan these stride through Africa and Asia. The artist was unaware that he should have shown camels with two humps in the latter continent.

The evidence of merchants and pilgrims who had seen camels during their travels in the Middle East and North Africa appears to have been used very unevenly to improve traditional models. Not until 1392 could the inhabitants of Barcelona examine camels at first hand when ambassadors from Grenada brought some to King John I as a present from the sultan.

29 An ostrich with powerful feet and a horseshoe in its beak (Spain, Soria?, 1300).
Lisbon, Biblioteca Nacional, Ms. Il. 72, folio 436 verso (detail).

In fifteenth-century Germany, an illuminator active between 1460 and 1470 seems not to have known what camels looked like, to judge from the way he painted them,[154] though other illuminators earlier in the century had obviously at least seen pictures of these animals.[155] Exact illustrations of dromedary or one-humped camels can finally be found in Italy around 1470.[156]

62

In Ashkenazi countries in the thirteenth century, the giraffe too was known only as a picture from a Bestiary, though it was portrayed with remarkable accuracy: careful attention was given to the stance of the animal deriving from the difference in height between its withers and rump.[157] The giraffe's coat, however, was not spotted but plain, although its markings are one of the most notable characteristics of this animal.[157a] The giraffes with plain coats painted a little later in about 1300 in Hebrew manuscripts from Old Castile[158] were probably also copied from a Bestiary. Lack of direct acquaintance with the giraffe led to its being painted a reddish brown with white spots in another Castilian Bible of the same date.[159] However, in fifteenth-century Italy, Jewish illuminators would have been able to see giraffes, since they were among the exotic animals imported for menageries, but none were portrayed.

33

360

The elephant that Frederick II brought to Cremona and the one given by St Louis to Henry III of England in 1255 were the last seen in the West until the early sixteenth century, when the king of Portugal, Manuel the Great, sent one to Pope Leo X. Therefore, in spite of the hold that this giant of the animal kingdom had on the imagination, it was usually shown in a fantastic or bizarre manner, although the trunk, the tusks and the bulk of the animal—its three distinguishing characteristics —were always included. Thus from 1300 to 1320 in German lands, a model also used by Christian artists was followed: the elephant's pleated ears opened like a fan towards the rear, covered the top of the head and met in front to form the trunk; the tusks, almost vertical, came out of the lower jaw, like those of a boar, and the feet were cloven or had several toes.[160] Illustrations of elephants can be found in the following decades with more accurate details—the shape of the foot, the relation of the trunk to the body, the position of the tusks—but they are exceptional, and in general, fantastic versions flourished.[161] The same holds true in the second half of the fifteenth century.[162]

37

In Spain in 1300 the elephant's silhouette is more life-like: the size of the legs and feet are emphasized: the trunk is correctly positioned, but the nostrils are put near the root of the trunk, and the tusks come out of the lower jaw.[163] The elephants in the

Atlas by Abraham Cresques (painted around 1375[164]) are rather too tall, and their legs are overly thin, but they appear to have their tusks correctly positioned in the upper jawbone.

59

In the Middle Ages the elephant was thought to be a war-like animal. The Alexander legend, so popular in those times, described the elephants of King Porus that fought the Macedonian troops in India. One of the pieces in the original game of chess, later to become the bishop, was a war elephant. This is how it was usually portrayed in the Middle Ages. But the palanquin—a light tower full of armed soldiers—became a city tower made of masonry or, as in late thirteenth-century Hebrew manuscripts from France, a crenelated tower with defenders[165] or, as in Germany in about 1300, the cornice of a crenelated tower, sometimes surmounted by a dome.[166] In a Castilian Bible, the palanquin takes the form of a castle with three heraldic towers,[167] while in the Atlas by Abraham Cresques, it becomes an oriental town with ramparts, towers and bulbous domes.[168]

77

59

Fabulous Beasts

Medieval Jews were familiar with the same fabulous creatures as their Christian contemporaries. For Jew and Christian alike, these animals had the same kind of reality as exotic fauna— which were usually only known from stories or pictures—and indeed as the more familiar animals. In their eyes, a hare chewing the leaves of a bush at the edge of the forest, the bird of prey that threatened it, the bear that could be tamed and given a collar and chain, the exotic monkey that became a household pet, the eagle, king of the birds and symbol of power, whose head might wear a crown, were all just as legitimate inhabitants of the earth as the winged dragon, the mermaid with a double tail or the monster composed of a human head carried on two legs.[169] In Europe a hunter chasing deer and boar could imagine that his hounds, led into the depths of some oriental forest, might meet a fabled unicorn.[170]

30

34

Unicorns were especially popular in Ashkenazi Bestiaries. In the late thirteenth and early fourteenth century, unicorns took on the traditional aspect of a horse with a long horn protruding from its forehead, but they were original in two respects. The unicorn's horn was only exceptionally in a spiral;[171] usually it

was thick and ringed like those of the goats and rams shown in our manuscripts. Secondly, its feet did not have hoofs like a horse but rather were cloven like those of sheep or deer. The unicorn was usually shown in a defensive posture: rearing up, head lowered, with horn pointing directly forward.[172] In the middle of the fifteenth century it was still like a horse with cloven feet, but its horn was a spiral;[173] later in the century its feet were cloven, but its horn was straight and smooth and flared at the extremity like an elephant's trunk.[174]

In Spain, on the other hand, the unicorn was portrayed very much like a giraffe. Although the unicorn's rump was at its shoulders, and its ears and tail were shorter, it did have the long flexible neck of the giraffe and cloven feet. The unicorn was shown galloping, its long horn held horizontally,[175] or with its front feet planted apart and its neck bent down to the ground, it stood defiantly with its horn pointing slightly upwards.[176]

For Italian Jews in the late thirteenth century, the unicorn had the body of a horse, though with a longer neck and ears and a bigger head. Its rear hoofs were cloven and its front hoofs became paws similar to the lion's. Its horn, thin and slightly curved, rose almost vertically.[177] An illustration from the first half of the fourteenth century shows a unicorn with a large brown body, big feet and a head with short ears. The mane and long tail make it possible that the artist intended to portray a horse; however, the animal has the long spiral horn of the classical unicorn.[178] The classical model appears with all its characteristics from the late fourteenth century: a horse with a white coat and a straight spiraling horn in the centre of its forehead, shown in a defiant posture, rearing to combat an imaginary enemy.[179] The unicorn is found again in the 1470s,[180] and the decoration of one Bible[181] even includes the picture of a unicorn resting in a maiden's lap, an echo of the *Physiologus* legend and the Alexander Romance.

French Jews were alone in having another fabulous horse, the *fauvel*, which was quite different from the unicorn. The impetuous *fauvel*, red as fire and with flaming eyes, had escaped from hell. Its name suggested not only its colour but also a number of sins indicated by the letters of its name: flattery, avarice, villany, variety (probably meaning inconstancy), envy and laziness. In all, the *fauvel* was a symbol of bad fortune.[182]

The phoenix, the fabulous bird that was born again from the ashes of its funeral pyre, was not unknown to medieval Jews. It can be seen in a late thirteenth-century illumination[183] on its pyre of sandalwood.

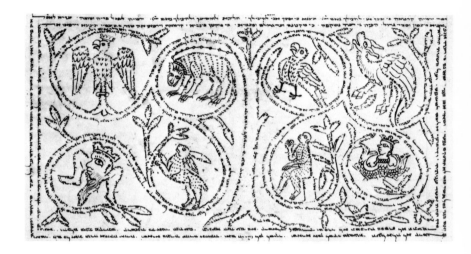

The thirteenth-century painter from France who portrayed a pelican took his model from a Bestiary that made the bird look very like a falcon:[184] the pelican is standing on its nest and opening its breast as it was reputed to do to feed its starving offspring.

Jewish imagination also peopled the world with a huge number of hybrid animals. Among these the basilisk and the griffin were the most remarkable of the traditional hybrids.

In Italy, Spain and Germany, Jewish illuminations show griffins of a classical type: hind-quarters like those of a lion; wings, head, strong beak, front feet with powerful claws like those of an eagle, and the pointed ears of a dog.[185]

The basilisk, whose glance and breath were fatal, is sometimes seen in late thirteenth-century manuscripts from France and Italy. The basilisk conforms to the most widely accepted idea of its shape in only one picture—from Italy—where it is shown as a cock with a serpent's tail, though with the feet of a quadruped.[186] In another Italian illumination[187] and yet another from France,[188] the basilisk is a more complex hybrid and almost certainly derives from Brunetto Latini's description of the basilisk in his *Livre du Trésor*, where it was said to have six feet. The French illuminator went on to make up a most bizarre basilisk with the body of a quadruped carried by eight feet, six of them like those of a lion or a dog—it is impossible to tell which—preceded by a pair of bird's feet. The head is rather high, with the drooping ears of a dog and the beak of a bird of

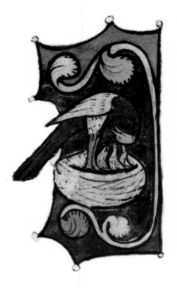

32   The pelican (northern France, *c.* 1280–5). This image was borrowed from the Christian Bestiary and was not based on actual observation. It illustrates the traditional legend of the sacrifice made by the pelican for its young. It was only at a later date, in the eighteenth and nineteenth centuries, that Jewish iconography occasionally made use of the theme, on the curtains of the *Tora* ark or on tombstones of Jewish women, of the pelican tearing open its breast as a symbol of divine or maternal love. London, British Library, MS. Add. 11639, folio 325 recto.

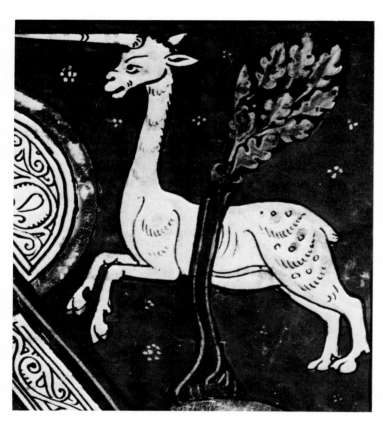

31   Unicorn (Spain, Soria?, 1300).
Lisbon, Biblioteca Nacional, Ms. Il. 72, folio 441 recto (detail).

Curious though they are, the basilisk and the griffin lose their identity among the crowd of hybrid animals produced by the fertile imaginations of Jewish illuminators. Quadruped, reptiles and winged creatures were dismembered and reassembled in the most astonishing combinations, giving birth to a fauna of such surprising vitality that its unreal quality is quite forgotten. The fish with the bird's head [191] appears quite normal, as does the lion with the wader's neck and large beak,[192] the lion and the dog whose tail is that of a fish,[193] the dog that is half serpent [194] and the bird with a dog's head.[195]

45

364

If the thirteenth century was the century of the dragon in Western art, nowhere did this monster dominate the world of the fantastic more powerfully than in medieval Jewish illumination, where its influence lasted into the fourteenth century. It was the most common kind of dragon—with the feet of a lion, eagle or ox; the body of a serpent; an eagle's or bat's wings and a tongue of fire that shot out from its dog-like jaws—portrayed on innumerable pages in Italy,[196] Spain [197] and especially in Germany.[198]

360, 74

364

Jewish imagination added several variations of this already complex dragon. Sometimes it had two heads on as many

prey; one of the two tails has long flowing hair, the other positioned above it, is a cock's tail. No part of this basilisk takes the form of a serpent, although Brunetto Latini had described it as the king of serpents. The same can be said for the Italian illustration, in which this monster has the body of a lean quadruped, a short tail and only four feet: a pair of cloven hoofs behind a pair of bird's claws. Whereas, in the former illumination, the basilisk had lost the crest that ought to have been worn as a crown by this 'little king'—a title indicated by its name—in the latter it has the head, beak and crest of a cock. Jews in Germany became aware of the basilisk in about 1310 [189] and then around 1340,[190] as the cockatrice.

33   The giraffe (Spain, Soria?, 1300).
Lisbon, Biblioteca Nacional, Ms. Il. 72, folio 436 verso (detail).

34   From reality to fantasy: hunting a deer, wild boar, and a unicorn (Brabant, Brussels, 1310).
Hamburg, Staats- und Universitätsbibliothek, Cod. Levy 19, folio 97 recto (detail).

35   The cheetah (Spain, Soria?, 1300).
Lisbon, Biblioteca Nacional, Ms. Il. 72, folio 443 recto (detail).

36   The lion, feared by the fabulous *re'em* itself despite its monstrous size and gigantic horns (Spain, Aragon, *c.* 1350-60).
London, British Library, MS. Add. 14761, folio 26 recto (detail).

37   The elephant, who inspired the blessing to 'him who made all strange creatures' (Spain, Soria?, 1300).
Lisbon, Biblioteca Nacional, Ms. Il. 72, folio 112 verso (detail).

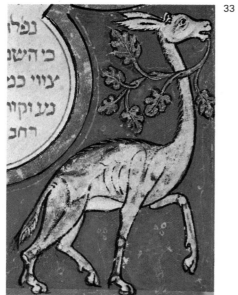

33

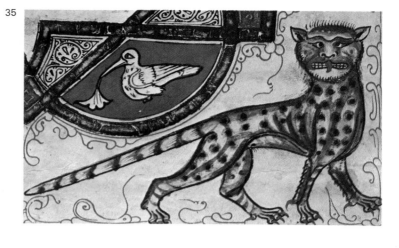

35

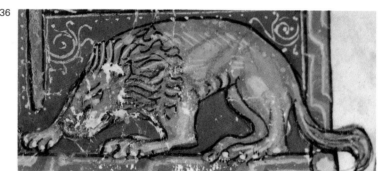

36

34

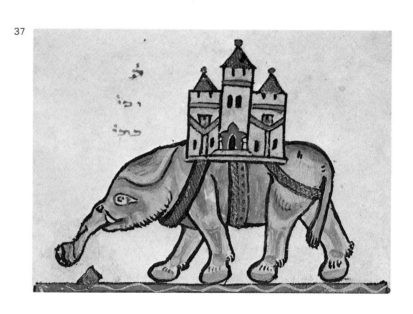

37

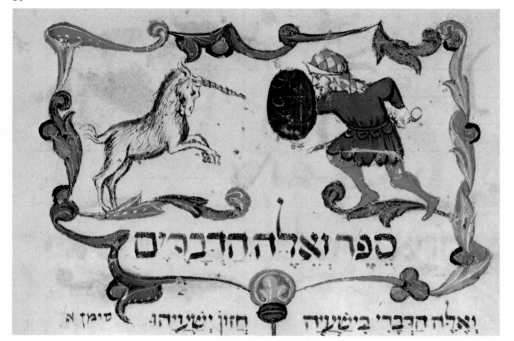

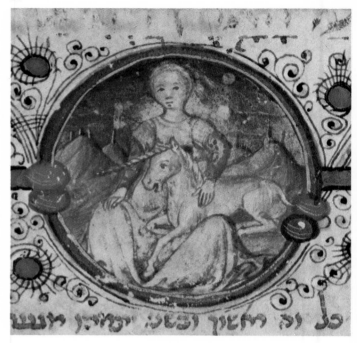

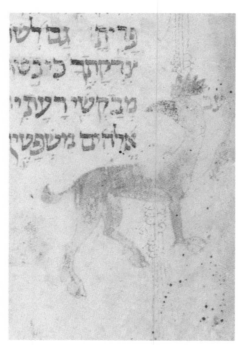

necks.[199] Whether it had one or two heads, the dragon could have another at the end of its tail.[200] Another specimen had three necks with three different heads: a dog's, a monkey's and a bird's.[201] Not content to associate various kinds of animal with the dragon, the medieval Jew also made it part of the vegetal kingdom by depicting its tail as branches or foliated leaves,[202] which sometimes spread out over margins and panels with an astonishing exuberance.[203]

The tail and wings of dragons are sometimes put on familiar animals, giving rise to the lion-dragon,[204] the ox-dragon,[205] the deer-dragon,[206] the cat-dragon[207] and various bird-dragons.[208]

In addition, dragons were endowed with parts of the human anatomy: arms instead of paws[209] or, more commonly, a human head on their neck or tail.[210]

Dragons were not the only creatures turned into hybrids with human anatomy. The introduction of the human element multiplied the number of fabulous creatures that could be produced. These monsters are impossible to classify since they are always different,[211] but among them can be found some well-known types: the sphinx, the winged lion with a human head,[212] birds with human heads, cloven hoofs and a serpent-like tail, possibly the descendants of the antique lamiae, which devoured children;[213] the centaur, half man, half horse,[214] and sirens with fish tails, who seduced sailors,[215] seen combing their long blond

45 Hybrid: a fish with a bird's head (Germany, end of the thirteenth century).
London, British Library, MS. Or. 2091, folio 251 recto.

hair while looking at themselves in a small round mirror[216] or playing the tambourine.[217] Male sirens, companions of the females, were sometimes depicted too.[218]

In addition to putting human faces on animals, medieval Jewish artists sometimes saw fit to put animal faces on human bodies when constructing monsters. Medieval Jews, like their Christian contemporaries, probably believed that evil spells could change a man into an animal—wolf, cat or ass—and accepted that men with dogs' heads (the cynocephalus) and men with horns or birds' heads also existed. It is wrong, however, to assume that it was these strange men that the artists wanted to portray in illuminations where human beings with animal heads appear. Such figures are in fact the protagonists of biblical or ritual scenes: patriarchs, Hebrews or ordinary believing Jews of the Middle Ages. They were shown with animals' heads because of the reluctance to portray the human face in the Rhineland from the thirteenth to the mid-fourteenth century, an attitude revealing the influence of pietism that derived from twelfth-century Hasidism. Substituting an animal's face was one way, among others, of resolving the problem; other devices were to show figures from the back or with a headdress that hid the face.[219]

### The Symbolic Significance of the Animal World for Medieval Jews

The Bestiary was not only—and not even primarily—an encyclopedia of the animal kingdom, but also a book on

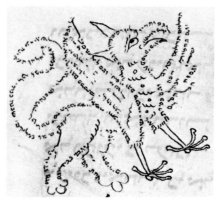

43 Griffin (Germany, end of the thirteenth century).
London, British Library, MS. Or. 2091, folio 268 recto.

44 Basilisk (northern France, *c.* 1280–5).
London, British Library, MS. Add. 11639, folio 295 verso.

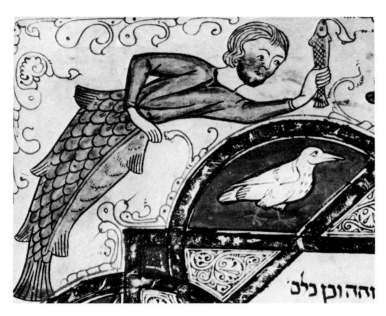

46 A merman (Spain, Soria?, 1300).
Lisbon, Biblioteca Nacional, Ms. Il. 72, folio 443 recto (detail).

Christian morals. The animals included in it were those whose characteristics best mirrored the virtues and vices of men—vices to shun and virtues to emulate. All the animals symbolized the good and evil that clashed in the world. For Christians, this struggle was explained in terms of Original Sin and Redemption, the latter based on the Incarnation and Resurrection of Christ. Thus, the animal kingdom became a mine of Christological symbols.

It might be expected that the Christian symbolism pervading the Bestiary would have prevented pictures in it from being transferred to Jewish books. In fact, leaving aside isolated cases of borrowing, important series of pictures from Bestiaries can be found in various Hebrew manuscripts of the thirteenth and fourteenth centuries from France,[220] Germany,[221] Spain [222] and Italy.[223] In reality, Christian and Christological symbolism was something imposed on these collections of pictures of animals. It was the text of the Bestiary, sometimes with a parallel series of pictures taken from the Gospels or the lives of the saints, that made this symbolism explicit. Whereas Christian readers would

see Christ Incarnate, Christ Crucified and Christ Resurrected in the unicorn, pelican, lion or phoenix of the Bestiary, Jews were free to interpret these creatures as they wished or to endow the real animals and fabulous creatures with their own symbolism. Thus, they could accept an illustration of a screech-owl surrounded by sparrows,[224] without seeing the anti-Semitic symbolism read into it by Christians.

It would be wrong to assume that pictures of familiar fauna and captivating monsters taken from the Bestiary, and depicted with such naturalness and vivacity, were intended solely to represent the marvels of creation. Rabbinical tradition did not create a symbolism of the animal world as detailed and organized as that elaborated by Christian theology; nevertheless, Jewish religious thinkers were accustomed to taking animals as the subjects for metaphors and allegories of a moralizing and didactic nature, a practice inherited from the Bible. However, there was no classification of animals as symbols of good or evil comparable to the rigid and all-embracing distinction between pure and impure animals (Leviticus XI:2-46; Deuteronomy XIV:3-20).[225] This distinction related only to sacrifices and the eating of animals' flesh. These notions of purity and impurity were ritual and not moral. Impure animals such as the lion, the eagle or the leopard could be taken as symbols of virtuous qualities. Although a certain number of animals—dove, swan, gazelle, sheep, lamb, young goat or ox—were regularly understood to represent meekness, purity, fidelity and good in general, most animals that were symbols of evil had an ambivalent nature. The guile of the serpent (Genesis III:1), instigator of the Temptation and Fall, was generally considered evil, and rabbin did not consider changing this interpretation, although Jesus suggested to his disciples that they be wise like serpents (Matthew X:16). The curse laid on the serpent by God (Genesis III:14) ensured that it became the major symbol of evil. And yet it had positive connotations when used as the emblem of the tribe of Dan (Genesis XLIX:17).[226]

Other wild beasts were in a similar position. The lion and the bear against which the shepherd David had to defend his father's flocks (I Samuel XLIX:34-7) [227] were evidently symbols of evil, enemies of God and God's people. The lion, leopard, bear and wolf incarnate the forces of evil that attack the forces of good (represented by the kid-goat, ram, sheep, lamb, calf and ox). In Messianic times, the former will be abolished and the original peace of the world, destroyed by the sin of Adam, will be restored (Isaiah XI:6-8; LXV:25).[228] Jewish tradition recog-

50

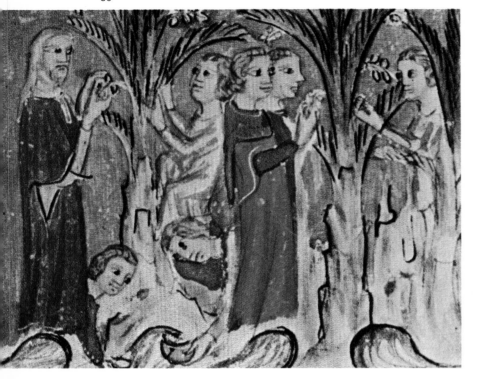

51

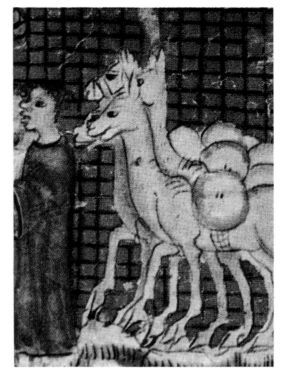

52

53

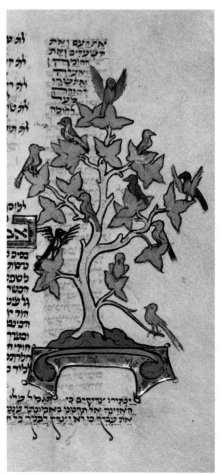

54

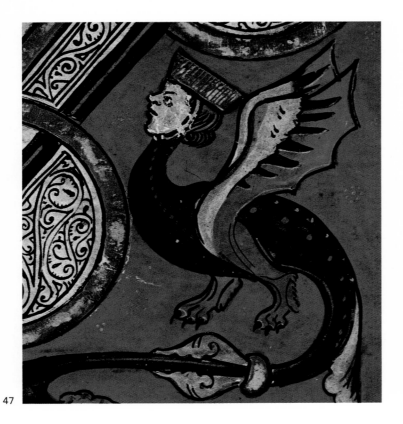

47

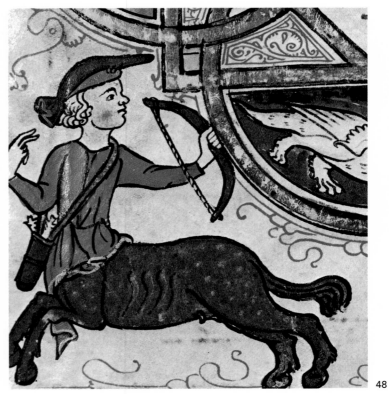

48

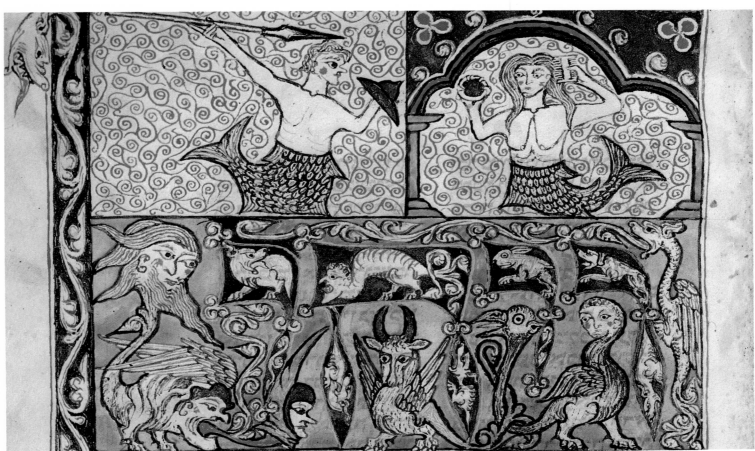

49

expulsion from Paradise, and another can be seen on the standard of Manasseh. As seen above, the unicorn in Jewish illustrations was not entirely like a horse. The aspects of its shape that distinguish it from a horse are related to characteristics of a deer or, less frequently, to a giraffe, but not to an ox.

The phoenix was depicted as a bird with brilliant plumage. Jewish legend, however, maintains that this creature, a symbol and testimony to the resurrection of the dead, enjoyed eternal life because it was the only animal that refused to taste the fruit of the tree of knowledge when Eve offered it. That phoenix was described as a purple monster with the paws and tail of a lion, a crocodile's head and six pairs of wings; it accompanied the sun as it crossed the heavens.

Bestiary of Providential and Eschatological Creatures

According to Jewish tradition, some animals played a particular role in the history of humanity and of Israel, a role attributed to them in some cases by divine providence at the time of creation. Such animals are scattered rather unevenly through our illuminated manuscripts.

First, there is the serpent that deceived Eve. It appears in pictures of the Fall or alone in the margin beside the biblical text (Genesis III:1). It is sometimes shown as a hybrid with a human head—a formula borrowed from Christian art—in order to stress its similarity to man, in particular in its intelligence and its gift of speech, a point upon which Jewish legend insisted.[240] Usually, however, it was depicted as an ordinary snake.[241]

More rare are contrasting pictures of the crow, a symbol of egotism and vice—the first animal to leave the ark and never to return (Genesis VIII:7)[242]—and the dove, symbol of fidelity—it brought the olive branch back to the ark (Genesis VIII:11)—and of the peace which the Creator made with His creatures.[243]

The ass of Balaam, which had been miraculously endowed with the gift of speech (Numbers XXII:28), was created at dusk on the sixth day and Balaam received it from Jacob. It appears only exceptionally in our illuminations.[244]

Illustrations of the lions that spared Daniel to make his innocence manifest (Daniel VI:23) are equally rare.[245]

On the other hand, there are many pictures of the huge fish in whose stomach Jonah spent some time (Jonah II:1-2), which

was also brought into being at the creation of the world.[246] Medieval Jews saw in this fish a symbol of the power of penitence, which redeemed mankind lost in the depths of sin. Jonah was also a symbol of death and resurrection; furthermore he became a Messianic figure.

For analogue reasons, depictions of Samson tearing apart the lion (Judges XIV:5-6) occur fairly frequently in our illuminations. The lion symbolizes evil, from which Israel is protected by the prodigious strength of Samson, another prefiguration of the Messiah.[247]

The ram is surely the animal most frequently encountered in this Bestiary of providential animals. It too was created at dusk on the sixth day and reserved for the trial of Abraham and Isaac (Genesis XXII:13). The Middle Ages was a time of persecution for the Jews, and the immediacy of martyrdom helped to redirect the thoughts of the religiously minded to the sacrifice of Abraham. The significance of the story, already powerfully symbolic, became more poignant, whether the whole scene was shown (as in Spain[248] and much more frequently in Ashkenazi countries[249]) or only part of it: the ram on its own (found almost exclusively in Ashkenazi countries,[250] though occasionally in Italy[251] and in Spain[251a]). [364]

This Bestiary of providential animals included a few more mysterious creatures, created and kept in reserve, as legend had it, for a particular and unique task. One was the *taḥash*, whose skin was used for covering the desert Tabernacle, another the tiny *shamir*, with whose help the precious stones on the pectoral of the high priest were said to have been cut and the stones of Solomon's temple dressed. These animals caught the imagination of commentators, but there is no trace of them in our illuminations.

This is not the case with three incredible monsters of gigantesque proportions, each of which represented a branch of the animal kingdom: Leviathan (Job XL:25-32) for aquatic animals, the *ziz, ḥol,* or *bar-yokhani* for birds and the Behemoth [55-7]

47   A dragon with a woman's head (Spain, Soria?, 1300).
Lisbon, Biblioteca Nacional, Ms. Il. 72, folio 441 recto (detail).

48   A centaur archer (Spain, Soria?, 1300).
Lisbon, Biblioteca Nacional, Ms. Il. 72, folio 442 verso (detail).

49   A mermaid, merman and various hybrids (Brabant, Brussels, 1310).
Hamburg, Staats- und Universitätsbibliothek, Cod. Levy 19, folio 549 recto (detail).

nized the same symbols of good and evil in two series of illustrations of opposing animals—completed respectively by the eagle, falcon and sparrow-hawk, peacock, cock and dove —that decorated the legendary throne of Solomon.[229] But animals symbolizing evil could also change their roles. The lion was not always the 'lion in his den' who 'croucheth and humbleth himself' (Psalms X:9-10); as the guardian of justice it was the young lion of Judas (Genesis XLIX:9), symbol of the tribe [230] and later of the kingdom of Judah [231] and then of the Jewish people, whose bravery it exemplified (*Mishna, Pirqey avot*, 'Ethics of the Fathers' V:23). The same applies to the strength of the leopard and the swiftness of the eagle *(ibid.)*. According to popular legend, that bird of prey committed the first murder on leaving the ark and represented the enemies of God and His people, all the destructive forces that aroused God's anger (Jeremiah XII:9; Deuteronomy XXVIII:49; Isaiah XLVI:11). But hovering above its nest, the eagle was also the symbol of the divine protection of the people of Israel (Deuteronomy XXXII:10-11). The wolf was the symbol of the tribe of Benjamin (Genesis XLIX:27).

Recourse to metaphor, allegory and symbolism based on animal subjects was rarely systematic. Animal symbols were attached to only seven of the twelve tribes of Israel: the lion for Judah (Genesis XLIX:9), the ass for Issachar *(ibid.:* 14), the serpent for Dan *(ibid.:* 16), the gazelle for Nephtali *(ibid.:* 21), the wolf for Benjamin *(ibid.:* 27), the bull with two horns or with one, for Ephraim and Manasseh (Deuteronomy XXXIII:17 and *Midrash*) and the leopard for Gad *(ibid.:* 20). This series of animal emblems occurs only very rarely in Jewish medieval illumination.[232]

Medieval Jews inherited the spirit of the author of the Proverbs, who advised following the example of certain animals (Proverbs VI:6), a spirit also found in fables with animals as protagonists. Like their Christian contemporaries, medieval Jews thought that God taught man through the example of the beasts of the earth and imparted wisdom through the birds of the air—had the *Tora* not been revealed, observation of the conduct of various animals would have enabled man to discover the laws of ethics. The same spirit lies behind the dictum of *Juda ben Tema (Mishna, Pirqey avot* V:23), where the moral exhortations rest on four metaphors associated with animals: 'Be as courageous as the leopard, swift as the eagle, agile as the deer and as strong as the lion in carrying out the wishes of your Father who is in heaven.' Although this text is very rarely illustrated by

pictures of the four animals,[233] this precept was among the most familiar of Jewish moral teaching and was learnt in childhood; it could hardly fail to endow the animals that it mentioned with its moral symbolism. It may be that on occasion pictures of one or other of these animals, shown individually or in a series as decorative motifs, had moralistic overtones. However, it is not certain that the elephant found in medieval illuminations already symbolized steadfastness and perseverance in submission to the Law, as it did in the paintings in the synagogues of central Europe in the seventeenth and eighteenth centuries.

Whether or not this was the case, the lion and hart or hind certainly had a rich symbolical value, which accounts for their frequent appearance in the decoration of our manuscripts. Deer represented piety and submission to divine Will. When shown pursued by hunters with their dogs, they became the symbol of the precarious situation that was the lot of the people of God in medieval times.[234] The lion, on the other hand, symbolized triumph and was the emblem of the kingdom of Judah; it evoked Israel's past with nostalgia and expressed hope for its restoration.[235]

The most mysterious of all the symbolical animals are the fiery creatures on the chariot of divine glory in the vision of Ezekiel (Ezekiel I:10; X:14); three have animal faces; the face of the fourth creature is that of a man, though Ashkenazi iconography sometimes replaced it with that of another animal.[236] These animals are rarely found in Italian illuminations [237] or in those from Spain.[238] In those countries they appear to be directly derived from iconography for the Christian symbols of the four Evangelists. The 'faces' appear more frequently—and with more originality—in Ashkenazi illuminations.[239]

## Jewish Legend and the Illustrations of the Bestiary

Jewish tradition endowed some of the fabulous animals from the Bestiary with particular characteristics that have hardly left a trace in illustrations of them. The illuminations in Jewish manuscripts do not differ essentially from illustrations in the Christian Bestiary.

According to Jewish legend, the unicorn is an ox or bull with a single horn. Adam sacrificed an animal of this kind after his

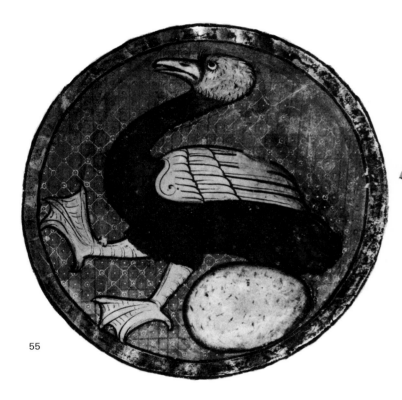

55

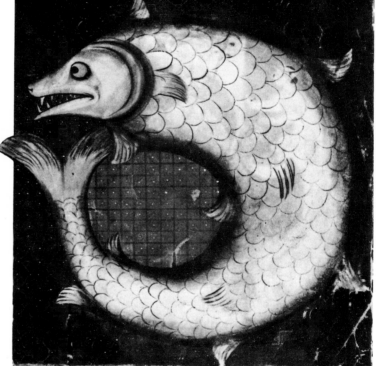

56

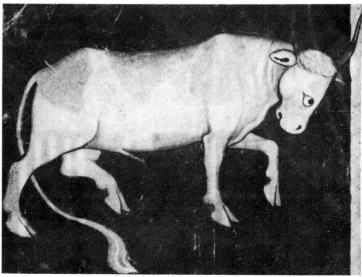

57

(Job XL:15-24) for quadrupeds. The first two monsters were created on the fifth day, the third on the sixth. They are said to play an essential role in the harmony of the world: without their intervention, huge fish, birds of prey and fierce beasts would consume the three elements, and in all, life would cease. But every year, at the summer solstice, autumn equinox and winter solstice respectively, Behemoth roars, *bar-yokhani* shrieks and beats its wings and Leviathan agitates the sea. This inspires such fear in the fiercest quadrupeds, winged creatures and aquatic animals that they restrain their greed and give other species a chance to live.

These monsters were primarily created to feed the just at the mystic banquet that awaited them in the world to come. This eschatological role helped to transform these three legendary creatures into Messianic symbols. It was in this specific capacity that a gigantesque bird was depicted in medieval Ashkenazi manuscripts,[252] where it sometimes appeared with a griffin,[253] a huge fish and a wild ox.[254]

58  A young oak with an owl and two other birds sitting in it (northern France, *c.* 1280–5). London, British Library, MS. Add. 11639, folio 352 verso.

## The Vegetable Kingdom

Attention given to plants in Jewish illuminations cannot rival that given to animals. Moreover, in the thirteenth century, and even in the fourteenth, the shapes of trees and their leaves were drawn in such a stylized fashion that individual species cannot usually be identified. Fruit is generally depicted by no more than spots of colour. Flowers were either rosettes, heraldic fleurs-de-lis or various kinds of fleuron. The foliage of trees and grass was usually green when used in rural or forest scenes, but separate leaves, flowers and fruit incorporated into decoration of title pages and margins were liable to be in quite fantastic colours.

However, illuminators of this period did not entirely ignore the flora of the countries in which they lived. French artists of the late thirteenth century, like their German colleagues of the fourteenth century, took the trees, plants and flowers of their surroundings in the temperate zone as models for elements of their decorative schemes. The elongated and denticulated leaves
58  of the oak [255] can be identified, with acorns ripening among
261  them.[256] More rarely the pointed lobes of maple leaves [257] and the shoots and branches of the willow,[258] with its narrow leaves neatly arranged, are visible. Vines—either the whole plant or a branch on its own—spread out their large leaves and bunches of grapes.[259] Scarlet roses abound on rose bushes,[260] and
218  ripe corn is harvested.[261]

Mediterranean vegetation can be seen in the work of Spanish illuminators: olive trees with knotty trunks, fruit and scanty
211, 213  foliage;[262] vines,[263] as one might expect, and fig trees with figs.[264]
298  Occasionally there are pomegranates [265] and palm trees with
50  bunches of dates.[266]

Hebrew manuscripts of the same period from Italy are no more helpful in providing illustrations of specific varieties of plant, though a late thirteenth-century Psalter does have a willow with long narrow leaves beside a river.[267]

Even in the fifteenth century, despite their general verisimilitude, the landscape background copied by Jewish and non-Jewish illuminators from contemporary art did not depict details of vegetation in a more realistic style. This was the case in Germany [268] as well as in Italy, where strict stylistic
62  conventions ensured that trees were shown either as fruit trees, round trees, tall thin trees or trees in the form of superposed
343  umbrellas.[269] However, bunches of white or red grapes hanging on the vine,[270] climbing round a tree trunk in the usual Italian
300  manner,[270a] and those picked to be eaten immediately [271] appear

quite realistic, as do the grapes placed on a table with split 367
pomegranates.[272] No less real are the clusters of dates that burden a palm tree.[272a]

It was during the fifteenth century that familiar flora began to make an appearance in the marginal decoration of Hebrew manuscripts, following a fashion common to all Western countries. Realistic depiction of flora was carried to its naturalistic limit in Flanders and France. Since, with certain exceptions, there were no Jewish communities established in these countries at that time, our manuscripts contain only isolated instances of such work: one in a manuscript from France [273] and the other from Spain but showing Flemish influence.[274] The field flowers and wood strawberries in these manuscripts were evidently copied from a repertory of decorative motifs.

A climbing rose with spiky stem and delicate flowers and the blue columbines with which a German illuminator decorated a page from a Haggada evidence a desire to depict flowers realistically.[275] In Italy, where floral decoration remained very stylized in the fifteenth century, columbines and violets enliven the conventional corallas and fleurons with which they are interspersed.[276]

A late fifteenth-century Italian manuscript, however, does provide the only important piece of evidence about medicinal plants, used so much in everyday life.[277] Sixty-five such plants 244-6 are depicted in it in coloured sketches.

Pictures of fruit are rare, as we have said; those of common vegetables are even more so. But one kind of fruit and one vegetable that were used for ritual purposes led to the frequent illustration of the *etrog* (citron), one of the *arba'a minim* or 'four 370 species' of which the Law enjoined the faithful to partake at the time of the *sukot* holiday, and the lettuce or cos lettuce that was 297 eaten as *maror* (a bitter herb) during the ritual *seder* meal at the Passover. Both are usually shown in a very stylized manner, though occasionally with enough realism to depict the grainy skin of the citron as well as its shape and colour,[278] and the root of the lettuce plant under its leaves.[279]

## The Symbolism of Plants

Very few Jewish symbols were based on plants. Grapes, figs and pomegranates always had a special significance, since they were associated with the Holy Land (Deuteronomy VIII:8),[280] but strictly speaking they cannot be called symbols.

In Antiquity, the palm tree and palm branch had been emblems of Judea. The palm and *etrog*, with the *shofar* (ram's horn), were the oldest symbols of the liturgy of feasts in the ancient Temple. In the Middle Ages, the iconography became crystalized in pictures of the 'four species' of plants used in the *sukot* ritual, and these plants acquired essentially moral overtones as symbols: playing on the symbolic relationships between knowledge of the Law and taste, good deeds and smell; each of the four plants represented a category of the children of Israel according to which of the qualities they possessed— wisdom and justice, wisdom alone, justice alone, or neither one.

The olive tree, symbol of the tribe of Asher (Deuteronomy XXXII:24), the tree that gave its name to the Mount of Olives, appears primarily in scenes commemorating the destroyed Temple[281] or in connection with representations of the vision of Zachariah (IV:3).[282]

390 A tree laden with fruits, representing the tree of life (Genesis II:9 and III:22),[282a] sometimes symbolizes the *Tora*,[283] as in a verse from Proverbs (III:18), recited on every *shabat*, on Mondays, Thursdays and holidays, along with other verses glorifying the Law, after the readings as the *Tora* scroll was put back in the Holy Ark.

Usually it is the tree of knowledge of good and evil (Genesis II:9 and III:*passim*), depicted with the tempting serpent coiled in its crown.[283a]

58 The 'tree with birds' painted by a French illuminator in the late thirteenth century was certainly copied from a picture of the *peridexion* tree, an image of Christ in whom souls took refuge from evil, which was personified by a dragon hidden under the tree in a cave. The painter has suppressed any hint of Christian symbolism by leaving out the cave and the dragon, thus allowing the tree to be interpreted as the tree of life despite the absence of any fruit on it.

The frequent appearance of vines in the decoration of our manuscripts can probably be ascribed to the fact that they were a symbol of Israel (Psalms LXXX:8-10); Isaiah V:7; Ezekiel XVII:6-10; XIX:10-14; Hosea IX:10). The golden vine decorating the porch of Herod's temple had already been endowed with this symbolic message.[284]

# The Land of Men

Medieval illustrations pay little attention to the earth itself, to mountains and valleys, rivers and seas. Sea and mountain were represented merely by an ideogram until the fifteenth century,[285] or as background and decorative motifs that contributed to the understanding of certain 'stories' such as the crossing of the Red Sea,[286] the adventure of Jonah[287] or the revelation on Sinai.[288]

The countryside, its highways, whether secure or perilous, the sea and its storms were probably more familiar to many Jews than to most of their Christian contemporaries. This familiarity can be ascribed to a number of very diverse factors: the harassed flight of Jews escaping from massacres or being driven from one region, one country or one continent to another; the risky but potentially lucrative expeditions of Jewish merchant travellers; the comings and goings of messengers from one community to another; the intellectual and spiritual quests of masters and students; the enthusiastic journeys of Jewish pilgrims to the land of their fathers and to their holy city, Jerusalem. Wherever he lived, the humblest medieval Jew was aware of a vast and variegated world throughout which his brothers were dispersed, but like all men of his time, he was only marginally interested in the route itself. It was regarded merely as the means of passing from one city to another. Benjamin of Tudela, who lived in the second half of the twelfth century and was a precursor of the great medieval travellers, noted down above all what related to towns and the activities of town life, in addition to details of the life of the Jewish communities within them.

### The Atlas of Abraham Cresques

A stunning testimony to this over-riding interest in man, the map of the world by the Jew Abraham Cresques[289] was the first 59 to show all of the world known at that time. It included China, accessible to Westerners after the Mongols established peace throughout the East from 1280 to 1338. The Atlas was described by its author as 'a picture of the world and the diverse customs

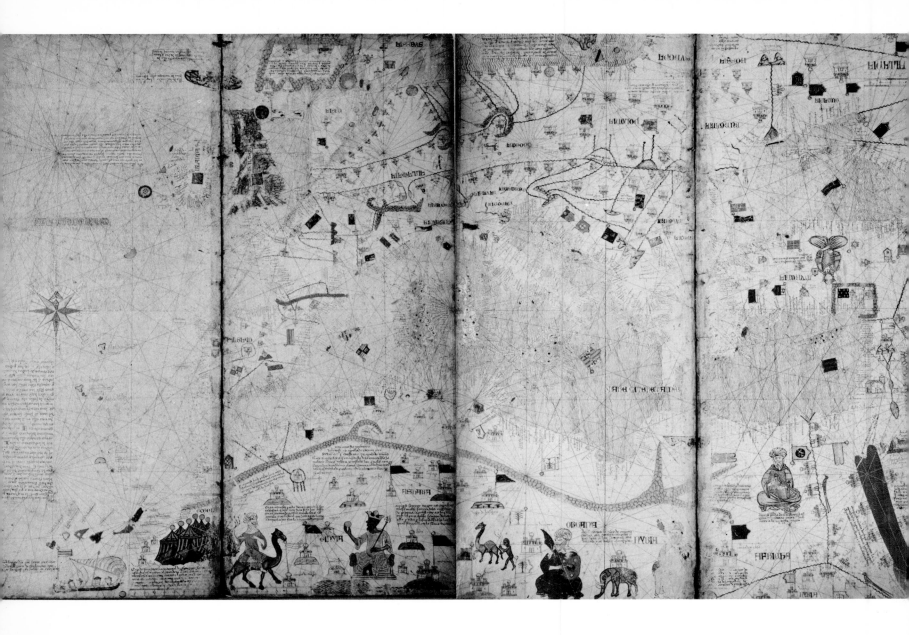

59 'World Map' from the Catalan Atlas, dated 1375. Although anonymous, it is probably the work of the 'master of maps and compasses', Abraham Cresques the Jew, the only well documented Majorcan cartographer of this period. From 1368 until his death in 1387, he enjoyed the favour and patronage of the king of Aragon, Pedro IV 'the Ceremonious', and of the Infante Don Juan, the future Juan I of Aragon. Cresques was heir to a tradition of Majorcan cartography that developed in the first half of the fourteenth century and is represented by the map of Angeli Dulcert dated 1339. The present map is the most complete 'picture' of the known world at that time. It was a luxury object, not intended to direct a ship but to satisfy the curiosity of a rich connoisseur who wanted to know all there was to know about the inhabited world from north to south and east to west. Cresques followed the contours, explanatory notes and some of the motifs in Dulcert's map closely, but he added the Canary Islands (discovered in the 1340s) and took into account the expedition of Jaime Ferrer who left for the 'Rio del Oro' in 1346. He also added to the description of Asia the first map of China known to us, largely inspired by the account of Marco Polo.

Though this map borrowed from portulan maps the abundant nomenclature of the ports edging its coasts, and from nautical maps the close network of rhumb lines, its illustrations and written notes make it a map of physical, economic, political, historical, religious and mythological geography. As a religious map, it gives prominence to the centres of the three great monotheistic religions, with the strange exception—constant in Catalan maps until the sixteenth century—of Rome, capital of Christendom.

The astronomical, cosmographical and astrological data assembled on the introductory pages (not illustrated) of the map show no more than what is supposed to have been the general level of knowledge among maritime circles of the time and prevent us from considering Cresques as a specialist in these fields. The quality of the paintings, however, makes his map a real work of art and a worthy gift for a king. It is in all probability the map presented by Don Juan to Charles VI, the new king of France, in 1381.

Another surviving manuscript may possibly be attributed to Abraham Cresques, the author of the finest Catalan world map known: intriguing coincidences of names and dates have led some scholars to affirm that he was the copyist and illuminator of one of the most sumptuous Hebrew Bibles, the Farḥi Bible from the Sassoon Collection. The question deserves re-examination. Paris, Bibliothèque Nationale, ms. esp. 30, fol. 2 verso–6 recto.

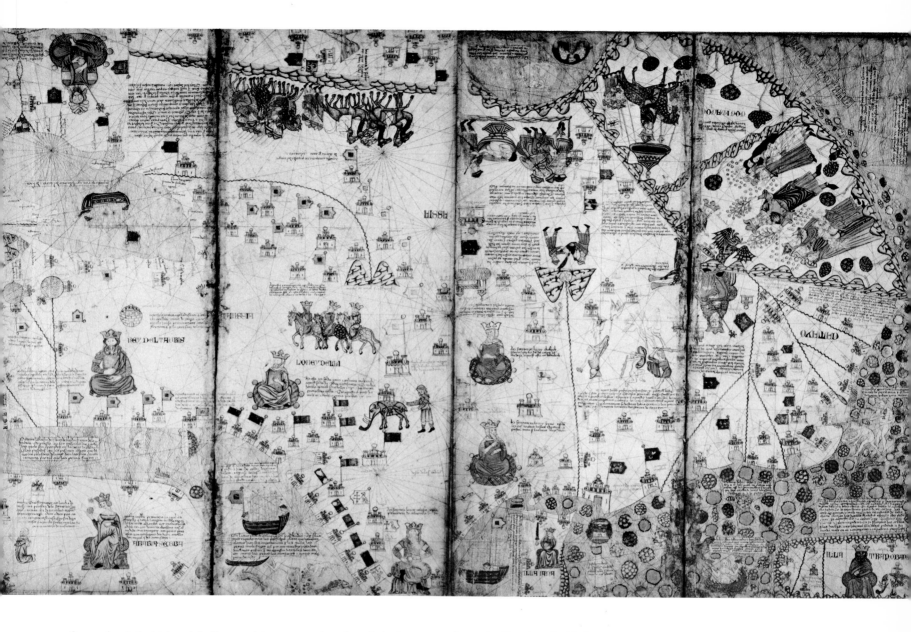

of peoples inhabiting it'. Seas, with conventional undulations for waves and very stylized formations of rock for the principal mountain ranges are portrayed, as well as the course of rivers. That is the entire extent of the representation of the earth's surface, whereas indications of human settlements and human domination over the land are innumerable. The Atlas is a portulan in its western part; the coastlines are bristling with names of ports, while the interior is filled with cities, each with a tall standard flying above it, bearing its arms. As the eye moves eastwards, it passes from cities familiar to the author, or those known from reliable sources, to cities about which only hearsay and legends give evidence.

Also depicted are the emblems of the kingdoms in which most of these cities were found, and for Africa and Asia, pictures of contemporary or legendary sovereigns wearing crowns or turbans. These ports and towns stud the commercial routes that lead over land or sea to coveted riches: gold from Guinea, pearls from the Persian Gulf, diamonds from India, various spices and silk from China.

The painter of the Atlas paid little attention to legends and fabulous creatures, portraying only pygmies and a siren. Only one human race, African negroes, are depicted distinctively. The illuminator of the Sarajevo Haggada had already shown the dark skin, the broad, flattened nose and projecting lips of 'Moorish' merchants and a Moorish maid in two scenes.[290] Of the exotic fauna discussed above, Abraham Cresques elected to portray only beasts used by man for work or pleasure: the dromedary of the caravan; the elephant, tamed and set to work by inhabitants of Asia and valued as a source of ivory; the falcon, used for hunting, and the parrot, kept as a domestic pet.

Apart from showing political geography, land and sea routes, economic activities and, to a lesser extent, ethnography, Abraham Cresques' work was also a map of religious geography. Medieval man was unable to conceive the world

other than in its religious dimension, and it is the complexity of its religious perspective that constitutes the particular interest of this Atlas. Since it was made for a Christian prince, Don Juan of Aragon, it could not avoid illustrating the birth of Christianity, with a picture of the Three Kings journeying towards Bethlehem, nor fail to indicate the holy centres of Christianity and important pilgrimage churches—the Holy Sepulchre, the Convent of St Catherine at Sinai and St James of Compostella —all surmounted by crosses. But the painter accords these places no more prominence than Mecca, the religious centre of Islam. Indeed, the representation of Mecca is emphasized by the picture of a Muslim at prayer, a discreet but intentional reminder that the prayers of Muslims were also addressed to the One True God. Abraham Cresques also ensured that his Jewishness was evident: the auspicious and inauspicious days on the first leaf on the Atlas are all defined exclusively by reference to events in the Old Testament. Beyond this, the only remains of past history indicated in the East are Noah's ark, shown high and dry on Mount Ararat, and the Tower of Babel near the Persian Gulf. There are also further indications. The caption for Mount Sinai 'on which God gave the Law to Moses' is written in red ink. It has been wrongly asserted in recent studies of this Atlas that, among the several hundred captions to be found on it, this is the only one in red. In fact the caption for the town of Moltas, built by Alexander, is also in that colour. This reinforces rather than undermines the notion that the other caption in red constituted a profession of faith, while the second red caption was only there to dissemble, in some small degree, the painter's boldness in singling out Mount Sinai. Lastly, our painter included an eschatological picture of the anti-Christ to the north of China, or Cathay as it was called by Marco Polo: the caption to this picture is completely anti-Christian, describing its subject in terms which make it clear that he is to be identified with Jesus.

### The World Picture of the Fifteenth Century

The fifteenth century had a different view of life on earth and developed pictorial conventions to express it. Representations of skies with graduated colours, banks of clouds, receding planes and blue horizons draw attention to ambient space and distances. This new vision of the earth has left traces in some of our Hebrew manuscripts. A few Italian pictures provide a scenic background that shows more than just the immediate area in which an event took place. The viewer can disregard the subject of an illumination and, for example, contemplate the sea lapping around the bottom of a mountain range in the distance.[291] With his eyes he can follow roads and paths up from the plain to a crag overlooking a river whose meandering course disappears in the far-away hills towards the rays of the setting sun.[292] Such panoramas were intended to depict land which was there to be inhabited by men—their presence, toils and the days of their lives are always in evidence. Land in the plain around villages was cultivated, men looked after their animals and went fishing and hunting.[293] War and merchant ships travelled from one port to another.[294] On the hills and crags, towns and castles were built by men.[295] In an allegorical picture filled with pessimism very close to that in the book of Ecclesiastes,[296] the earth and its landscapes, the scene in which man's destiny unfolds, became symbols of the tragic contradictions inherent in life. Like the contrast between the stars of night and day, the steep bare rocks and the fertile countryside echo the contrast between the security and pleasures of peace and their loss through the struggles and dangers of war; just as youth, whose standard floats over the former, gives way to old age, whose emblem marks the relentless passage of time before the final struggle dominated by the image of death.

53 62 66

## The Historical Framework of Medieval Jewish Life

The illuminations in medieval Hebrew manuscripts have enabled us to reconstitute the vision of the universe which Jews of the period formed on the basis of their beliefs, knowledge, experience and legends. It now remains to be seen whether these manuscripts are a useful source for establishing where and at what period Jewish communities were active in the medieval West.

### Heraldry

Heraldic decoration was exceedingly popular among Ashkenazi and Sephardi Jews, as is evidenced by the place accorded to it in

60  Heraldic eagle with a single head (Germany, 1294).
Vatican, Biblioteca Apostolica, Cod. Urbin. ebr. 1, folio 269 verso (detail).

61  Heraldic eagle with a single head (Spain, Soria?, 1300).
Lisbon, Biblioteca Nacional, Ms. Il. 72, folio 178 recto.

the decorative schemes of manuscripts made for them. But heraldic devices cannot be expected to provide much precise information concerning the date and localization of any manuscript, since the Jews held no official station in feudal society and thus had no recognized coats of arms. Those found so frequently in the decoration of their manuscripts were not even the coats of arms of the towns where they resided, but those of the kings and princes under whose rule they led their lives.

<span>60</span> Many German manuscripts made *circa* 1300 and in the first decades of the fourteenth century contain a great number of heraldic eagles, either with or without crowns.[297] The castle of

<span>64, 67</span> Castile and the lion of Leon [298] or the 'pale gules' on a gold field

<span>65</span> (the arms of Aragon [299]) appear in the panels and margins of numerous Spanish manuscripts. The same is true of the few known examples of fifteenth-century Spanish armorial bearings: the arms of Aragon and Naples can be seen in a *Haggada* from

Spain [300] and those of the united kingdoms of Castile and Aragon in a Bible from the same country.[301]

Their evidence, however, is rather ambiguous and does not allow the place where the manuscripts were written to be identified with any precision. A manuscript of the late fourteenth century, almost certainly from Aragon, contains the arms of both Castile and Aragon at a time when the two kingdoms were quite independent of each other.[302] Two other manuscripts, one written in Barcelona in 1348, and both decorated in Barcelona in the second half of the fourteenth century, contain images of the lion of Leon.[303] It is possible, though, that the lion was meant to be the lion of Judah and not the one in the arms of Leon. Indeed, it is probable that these two emblems—the lion of Leon and the castle of Castile—owed their popularity to their Jewish associations: the first being identified with the tribe of Judah and the second with the symbol

of divine protection according to a verse from the Proverbs: 'the name of the Lord is a strong tower: the righteous runneth into it and is safe' (XVIII:10). This verse and the castle of Castile were in fact juxtaposed on the same page in one manuscript.[304] The heraldic lion frequently appears in Ashkenazi illuminations as the emblem of Judah and not as part of an armorial bearing.[305] It has been thought that other coats of arms could be identified, for instance those of Aragonese families in the Sarajevo Haggada;[306] however, even if many heraldic devices in our manuscripts were originally intended to portray personal arms, the impossibility of identification has reduced them to a purely decorative role now. This is the case of the eagle and fleur-de-lis in a Castilian Bible of 1300,[307] of a shield 'azur, three pales or' in a *Haggada* of the third quarter of the fourteenth century,[308] of an eagle and three bezants in a late thirteenth-century French manuscript,[309] and of a series of shields—checky, with addorsed fish, an eagle, a lion, a lily, or three roses, etc.—in an Ashkenazi manuscript of about 1300.[310]

In Italy, on the other hand, the coats of arms that Jews had painted in their manuscripts from the late fourteenth to the late fifteenth century were personal arms. Most were very simple and consisted only of 'figures'—lion, cock, sun, moon, star—on a plain shield or one divided into compartments. Elaborate coats of arms, constructed according to the rules of heraldry, were rare. An example is that of Daniel, son of Samuel the physician: a shield 'party per fess; argent (or azure), a demi-lion rampant or; barry wavy of six argent (or azure) and or; crest: a helmet on a circlet of piping gules, surmounted by a lion's head, with mantling' that is found, with variations indicated, between 1383 and 1405.[311] Another example is the arms of the Norsa family in 1492:[312] 'or, a fess azure charged with a crescent accosted by two stars, with the busts of two men affronted issuant in chief and a third at the base'. This coat of arms is well known from later examples.

Most heraldic arms found in our manuscripts lack any individuality and must have been used by several families at various periods and in different places. They are therefore of little use when trying to date or localize the Jewish communities for which the manuscripts were made. Individualized arms can only provide a means of dating, since the individual or family that used them did not necessarily reside continually in the same place, but carried the arms around with them, like Daniel, son of Samuel, mentioned above, who went from Forli to Bertinoro, and from there to Pisa and Perugia.

Arms very similar to those of the condottieri Gattamelata were associated in two very closely related manuscripts, one of them dated 1438.[313] If these were indeed the Gattamelata arms —doubt arises from the nature of the animal coming out of the hive: in one case it appears to be a cat *(gatta)*, but in the other it is more like a lion—we would have a much more secure criterion for localization. It is regrettable that the practice of associating their personal arms with those of the towns where they resided, or of the princes under whose authority they lived, was not more widespread among Italian Jews.

The Architectural Setting

Coats of arms allow us to do no more than give a geographical and chronological sketch of the places inhabited by Jews. Since most Jews in the period which concerns us lived in towns and were confronted by the buildings in them every day, it was natural that architectural settings should play a large part in the decoration of Jewish manuscripts. The style of the buildings that were used as models in the illuminations provides much surer criteria for identifying the places where Jews lived.

62   In the countryside: plain, hills and river. The fact that dromedaries mingle with sheep, oxen and donkies in this European landscape is a reference to Job I:3. (northern Italy, Ferrara?, *c.* 1470).
Jerusalem, Israel Museum, Ms. Rothschild 24, folio 65 recto.

63   The arms of Castile (Spain, Soria?, 1300).   ▷
Lisbon, Biblioteca Nacional, Ms. Il. 72, folio 7 verso (detail).

64   The arms of the united kingdoms of Castile and Leon (Spain, Soria?, 1300).   ▷
Lisbon, Biblioteca Nacional, Ms. Il. 72, folio 448 verso (detail).

65   The coat of arms of Aragon: Or, four pallets gules (Spain, *c.* 1350).   ▷
London, British Library, MS. Or. 2884, folio 27 verso (detail).

66   Human activities beneath the heavens, on land and sea: war and peace   ▷▷
(northern Italy, Lombardy?, Veneto?, *c.* 1440).
Bologna, Biblioteca Universitaria, Ms. 2197, folio 2 recto.

67   The three-towered castles of Castile (Spain, Soria?, *c.* 1306).   ▷▷
Oxford, Bodleian Library, MS. Kennicott 2, folio 15 recto.

68   The armorial bearings of Daniel, son of Samuel the physician (northern   ▷▷
Italy, Forli, 1383): shield parted fess-wise, argent and argent, in chief a lion issuant or, langued gules, and in base bars wavy or, surmounted by a helmet with a crest repeating the charge, on a cushion gules, and mantling lined with ermine.
London, British Library, MS. Add. 26968, folio 340 verso.

44

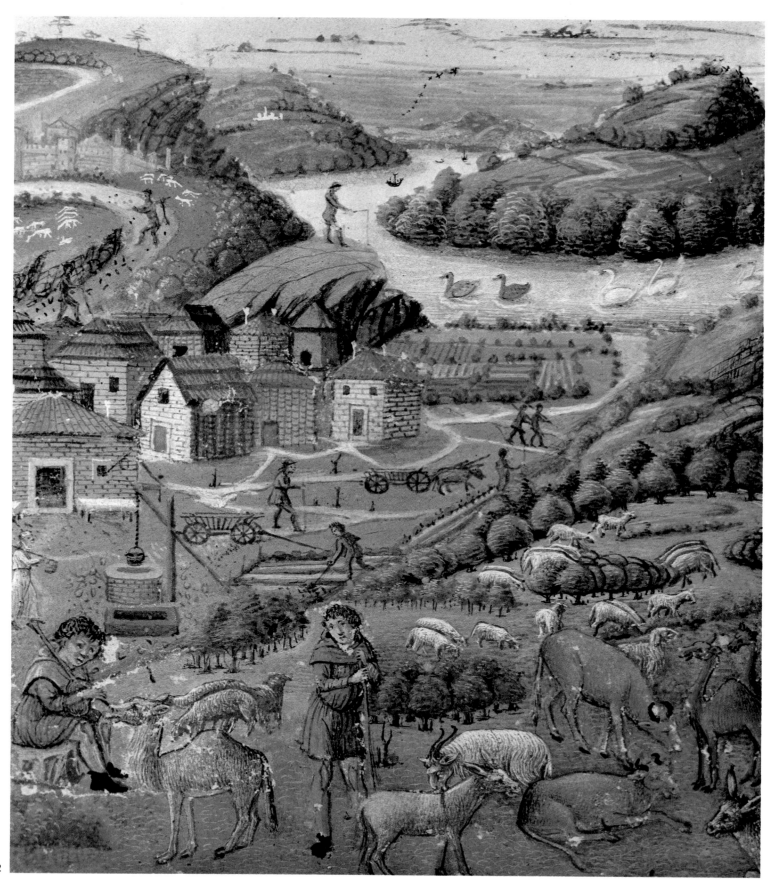

63

64

65

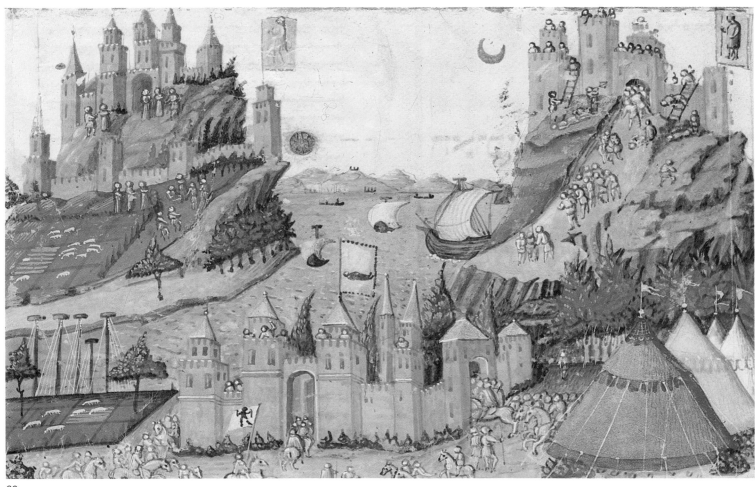

66

67

68

69

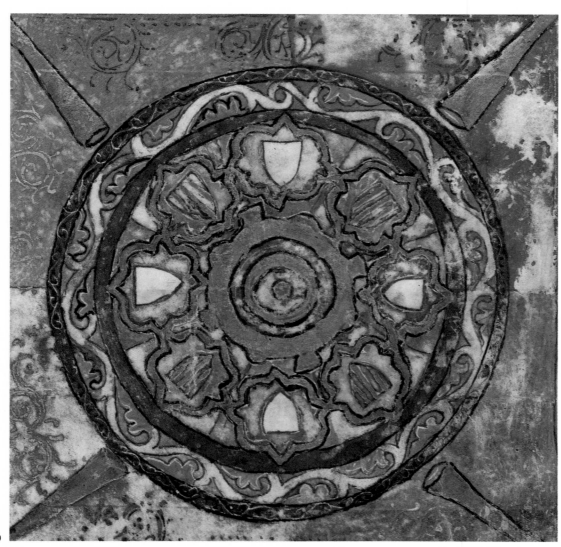

70

69 Three shields from northern Italy (Lombardy?, Venezia?), 1438, bearing a peacock, hive and dove as arms. All are indented on the 'dexter' side. The shield on the left is 'azure, a peacock in his pride vert, azure and orange, within a bordure or', that on the right 'gules, a dove rising, within a bordure or', the dove holding in its claws a branch 'vert' above a 'terras' of the same colour. The central shield is 'azure, a hive with lion issuant, within a bordure or', surmounted by a crested helmet reproducing the charges on the shield (hive and lion), with matching mantling 'gules and vert'. The shields on the left and right may be those of the 'Pavone' or 'Colombo' families; were the lion in the central shield replaced by a cat, the arms would be those of Gattamelata, the *condottiere* of Venice, which appear elsewhere in a manuscript of the same style and date (Bologna, Bibl. Univ., Ms. 2197). Who can say whether the change was made intentionally or not?
Oxford, Bodleian Library, MS. Can. Or. 79, folio 2 verso (detail).

70 From Aragon: plain shields and shields emblazoned azure, three pallets or (Spain, *c.* 1350–60).
London, British Library, MS. Add. 14761, folio 61 recto (detail).

71

71 Castile: Gothic bay and horseshoe arches (Spain, first quarter of the fourteenth century).
London, British Library, MS. Or. 2737, folio 86 verso (detail).

72

72 In the kingdom of Aragon: crenellated towers and a Gothic gable (Spain, *c.* 1350).
Jerusalem, Israel Museum, Ms. Sassoon 514, folio 70 recto (detail).

71 Early fourteenth-century Jewish manuscripts from Castile introduce the complex world of Hispano-Moresque architecture, with Gothic bays and small domes of glazed tiles above horse-shoe arches;[314] the pointed arch of the gates of one town is surmounted by the merlons typical of Muslim ramparts.[315]

Jews in Roussillon and Catalonia around 1300 and the following decades have left us pictures of the long galleries of thin columns popular in that region, with one or two registers of capitals surmounted by trilobed or pointed arcades.[316]

The outline of buildings with tall windows, towers, steeples and roofs seen in views of towns from mid fourteenth-century Aragon[317] show that Gothic styles had been adopted,[318] though semicircular openings remained common.[319] The latter were popular even in the late fourteenth century, when the flattened arch was becoming fashionable.[320]

Architectural styles were very different in the towns inhabited by German Jews. Semicircular arches with massive pillars and cubic capitals, covered with the vegetal and monstrous geometric designs of Romanesque buildings, could still be seen in Rhineland towns in the last decades of the thirteenth century.[321] From 1300 onwards, a different style emerges, based on high, austere Gothic façades and storeys of bays having lancet windows and trilobed or starred windows beneath gables with crockets.[322]

73   In the Rhineland: Romanesque pillars (illustration from the first years of the last third of the thirteenth century).
Jerusalem, Jewish National and University Library, Worms Maḥzor/I, folio 39 verso (detail).

Ashkenazi Jews apparently paid some attention to the stone buildings being constructed around them. Illuminations in their manuscripts illustrate, albeit in a haphazard manner, the transformations in Gothic architectural styles from the fourteenth to the fifteenth century in so careful a way that the presence of Jews can be deduced, if not in particular towns, at least in the Rhineland and the provinces of southern Germany. Jews were there to witness the growing use of pinnacles and turrets from the mid-fourteenth century.[323] And throughout the fifteenth century they saw the flattening of arches to make them look like basket handles or ogee arches and also partitioned vaults, multiple ribbing, the introduction of very slender supporting columns, the use of overhanging and recessed

75   Spain, c. 1350: roofs, crenellated tower, spires and a dome.
Jerusalem, Israel Museum, Ms. Sassoon 514, folio 42 verso.

76   Romanesque architecture in the Rhineland: arched bays and doors, galleries with arched and trilobed arcades (illustration from the last quarter of the thirteenth century).
Jerusalem, Jewish National and University Library, Worms Maḥzor/II, folio 73 recto (detail).

77   Flamboyant Gothic architecture in the Rhineland: gables with crockets, ▷ pinnacles and turrets, lancet windows and a rose window (illustration from the 1300s).
London, British Library, MS. Add. 15282, folio 238 recto (detail).

78   Rhineland, c. 1427–8: a *Burg* on its rocky peak.   ▷▷
Hamburg, Staats- und Universitätsbibliothek, Cod. hebr. 37, folio 154 recto (detail).

79   Germany, c. 1430: a castle defended by an outer wall in the middle of the ▷▷ forest.
Manchester, John Rylands University Library, MS. Ryl. Hebr. 7, folio 33 recto (detail).

80   Gothic Italy, end of the thirteenth century: crenellated *palazzo* with wide ▷▷▷ arched doors and tall windows; high fourcornered towers.
Parma, Biblioteca Palatina, Ms. Parm. 1870–De Rossi 510, folio 119 verso (details).

81   Gothic Italy, in 1304: towers of patricians rising above the town walls.   ▷▷▷
Parma, Biblioteca Palatina, Ms. Parm. 2153–De Rossi 3, folio 145 recto (detail).

82   Northern Italy in the fifteenth century: round towers with crenellated ▷▷▷ galleries above medieval ramparts.
Florence, Biblioteca Medicea Laurenziana, Ms. Plut. 3.10, folio 176 recto (detail).

83   Grecian lands under Italian influence, at the beginning of the sixteenth ▷▷▷ century: a crenellated tower, dome and campanile.
Chantilly, Musée Condé, ms. 732, folio 13 verso (detail).

74   Flamboyant Gothic architecture in the Rhineland: bays with rose and lancet windows, gables, pinnacles, crockets and fleurons (c. 1300).
London, British Library, MS. Add. 15282, folio 1 verso (detail).

75

76

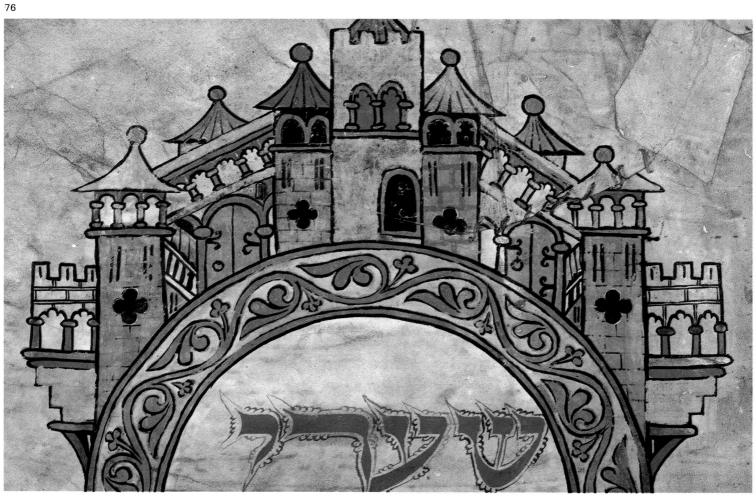

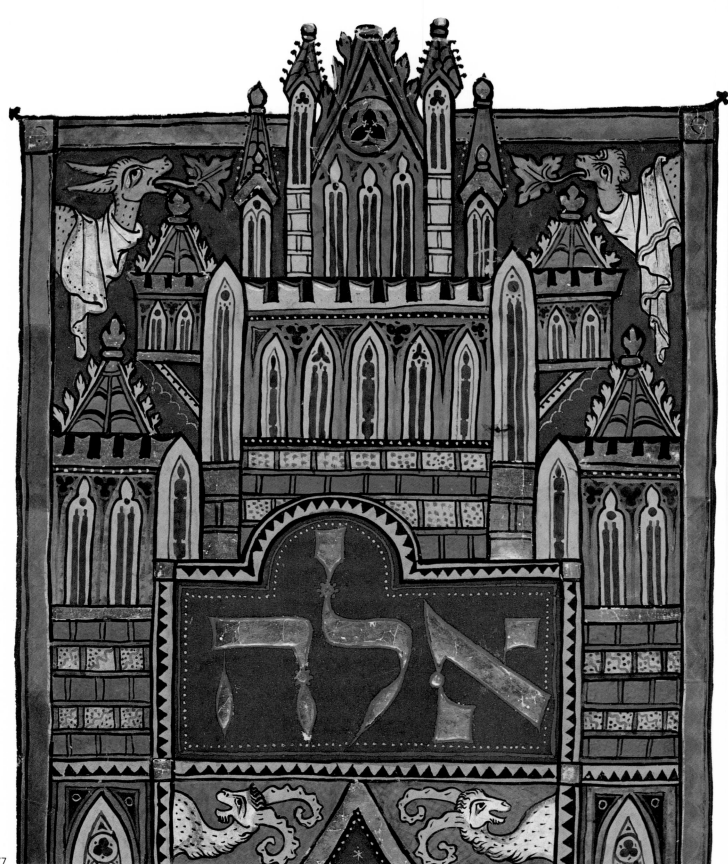

77

78

79

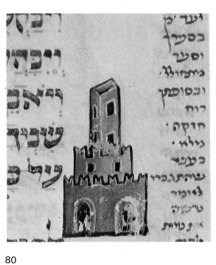

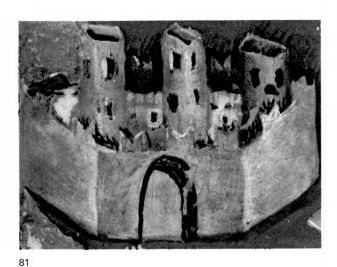

80

80

81

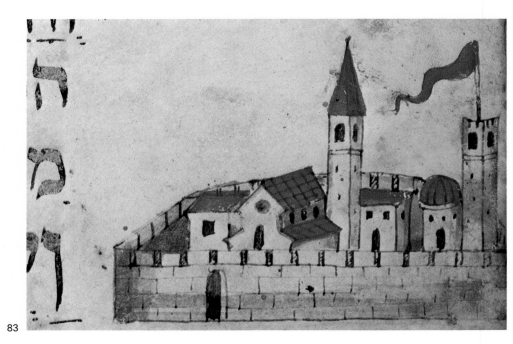

82

83

84

לכבות ענותר אניהני

85     86

84 Gothic architecture in fifteenth-century Germany (illustration from 1427–8).
Hamburg, Staats- und Universitätsbibliothek, Cod. hebr. 37, folio 73 recto.

85 Fifteenth-century Germany, about 1430: a Gothic bay with a flamboyant rose window.
Manchester, John Rylands University Library, MS. Ryl. Hebr. 7, folio 5 verso (detail).

86 The gateway of a German fortified town, with a drawbridge (about 1460–70).
Jerusalem, Schocken Institute, 2nd Nuremberg Haggada, folio 11 recto (detail).

decoration to delimit surfaces and pierced parapets.[324] They could admire the development of more delicate tracery decorating bays with patterns of curves and counter-curves, and rose windows arranged in spirals[325]—in fact, all the elements that make the lacework of the flamboyant Gothic style so fascinating.

The beauty of large ecclesiastical and secular buildings in the towns where they lived did not make the Jews forget the hardship and precariousness of their own lives. With their ramparts, moats and gates fortified with draw-bridges, such places might offer security for a time, but Jews were always 86 likely to be expelled from one day to another.[326] And then, the sight of closed town gates only signified hostility and exile.[327] From the early fifteenth century, German cities were increasing-

ly liable to expel their Jewish communities either temporarily or definitively, Jews were thus obliged to lead a life of wandering as they travelled from one city to another, and were even forced to settle in villages and hamlets. Such wanderings ensured that the Jews became familiar with the fortified castles that were so typical of the German—and especially the Rhineland—countryside, set on every hill-top with their strong walls and tall 78-9 towers.[328] Our pictures show that the picturesque quality of these scenes was appreciated, though they must have had a deeper significance in the eyes of refugee Jews, representing 271 potential security to those shut out of towns and threatened by violence.

Italian illuminations of the late thirteenth and early fourteenth centuries provide a more tranquil picture of Jewish life. Jewish

87　Northern Italy in the fifteenth century (*c.* 1470): town walls with large round towers, a palace and several campaniles.
Jerusalem, Israel Museum, Ms. Rothschild 24, folio 165 recto (detail).

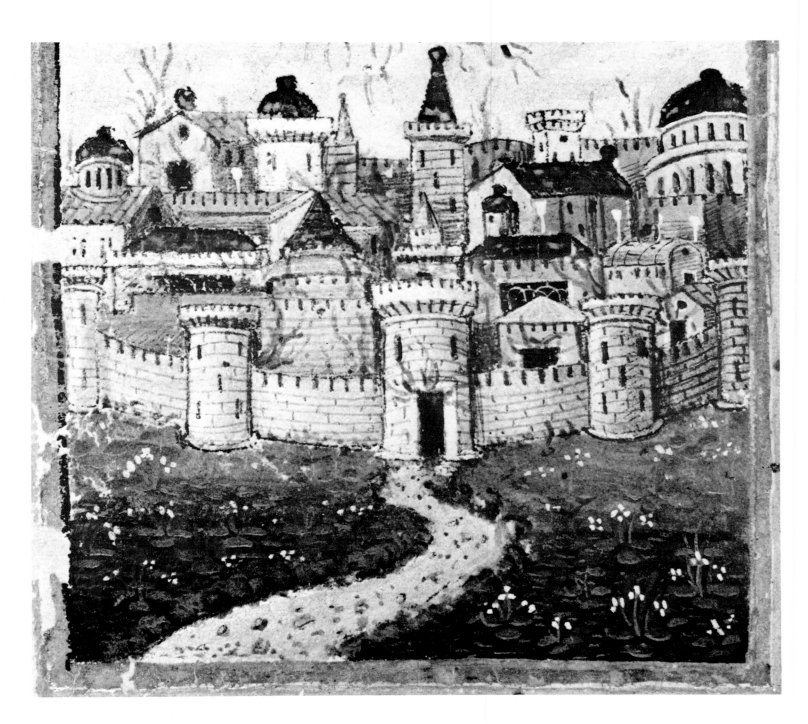

communities were tragically suppressed in the kingdom of Naples at the advent of the new Angevin dynasty and were active for only a little while in Rome before the popes deserted the city, but they flourished in the cities of central and northern Italy. Refugees travelling up from the south or coming down from Germany found shelter within the crenelated walls of these cities, in the shadow of Gothic *palazzi* and the proud towers of patrician families.[329]

80-1

The old Gothic ramparts or the mighty city walls of the Renaissance period are evidence of the incessant rivalries between northern Italian towns in the fifteenth century. On the other hand, the sumptuous palaces, towers, bell-towers and cathedrals reflect the commercial success of these city dwellers and their enthusiasm in beautifying their towns.[330] Jews played their part both in the economic and in the cultural life that flourished there.

82

87

Still much later, illuminations in sixteenth-century manuscripts from a Jewish community of Greek rite show us high four-cornered towers, tall campaniles and buildings with three aisles,[331] all evidence of Italian or even Venetian influence. The likely provenance of these manuscripts is a town such as Corfu or the Island of Crete at Candi, where Jewish life prospered under the rule of the Most Serene Republic of Venice.

From the revolutions of the heavenly vault to the grass in the fields, from familiar animals and the exotic animals of foreign lands to even stranger imaginary beasts, the illustrations and decorations in these manuscripts have led us to explore the universe as seen and conceived of by medieval Jews. These illuminations reveal close observation of nature and the evocation of spell-binding fantasy. When contrasted with the astonishingly diverse and beautiful 'mirror of the world' produced by Christian art in the West during the same centuries, these illustrations may seem no more than a mere handful of unrelated and mutilated impressions. However, as the brilliant or faded remains of a much larger corpus mercilessly destroyed by enemies of the Jews, they nevertheless show how medieval Jews viewed the marvels of creation and enable us to decipher in their symbols the secret of Jewish beliefs and hopes. These illuminations allow us to perceive medieval man's view of the place he held in the universe and the place he had made for himself on earth—a place he was enlarging towards the south and east by the progressive discovery of Africa and Asia. Finally, the heraldic emblems and architectural backgrounds, without providing much more information than the placards of the Elizabethan theatre, enable us to reconstitute the historical setting of the kingdoms and medieval cities where Jewish life established itself, prospered and was destroyed.

# II  The Jewish Quarter

As a spiritual being, the medieval Jew enjoyed freedom in his relations with creation and put his trust in the privileged role that God had assigned him in the organization of the Universe. In his life on earth, on the other hand, he experienced only servitude and humiliation. Jews were cruelly deprived of rights and liberty wherever they lived, whether this was in a street of their own choice, as was the case in Italian towns until the sixteenth century, when Jews were confined to a ghetto, whether they lived of their own accord in streets next to each other or whether they were forced into a restricted quarter of the town, isolated from the rest of society by walls, with all access closed at night—this became the rule very early on in Spain and was adopted bit by bit throughout German lands. The mark of their servitude and humiliation was the cross, for it was the Church that imposed on Jews their lowly status. It is remarkable that in no illumination from a Jewish manuscript of our period can any cross be seen on the steeples, towers or tops of buildings, even when their silhouette makes their function plain. Admittedly, most pictures of towns related to scenes from the Old Testament. Might the absence of crosses be a result of a scrupulous respect for 'local colour'? We think not. But Jews customarily avoided any sign, shape or combination that recalled the cross, the source of so much suffering for them: it was a kind of revenge which led them to omit from the views of cities in their manuscripts any representation of the symbol signifying persecution. However, medieval Hebrew manuscripts do reveal some aspects of this Jewish quarter—*aljama, juderia, Judengasse, Judendorf, Judenstadt*—where medieval Jews had to lead their lives, for most significant to them was the house of prayer, the synagogue.

## The Synagogue

It was prescribed in the Talmud that the synagogue *(beyt ha-knesset)*, the focal point in the life of the Jewish community, should be the highest building of the town. Texts frequently mention the tall and imposing proportions of many medieval synagogues; those of Toledo bear witness to them even today. The Jews were evidently zealous in complying with this precept, for they were reprimanded in frequent decrees issued by royal and ecclesiastical authorities. In 1205 Pope Innocent III deplored the fact that the Jews of Sens had built a synagogue higher than the church, while Pope Innocent IV referred, in a bull of 1250, to the scandal caused to the Christian faithful by the excessive height of the new synagogue built by the Jews of Cordoba. As a consequence, in 1261 Alfonso X, king of Castile, issued a decree: 'The Jews shall not enlarge, nor heighten, nor embellish their synagogues'.

Another general practice was to pierce windows in the walls of the synagogue. It derived from the example of Daniel, venerated by tradition as the model of the faithful Jew in exile, who remained true to his faith and its observances. According to the Bible (Daniel VI:11), 'he went into his house, and his windows being open toward Jerusalem, he kneeled upon his knees three times a day, and prayed, and gave thanks before his God...'

But as their situation deteriorated and their ancient synagogues were confiscated or destroyed in different European countries, the Jews were obliged to content themselves with more modest buildings that offered no insult to churches, the sanctuaries of the dominant religion. The continual impoverishment of the Jewish community, ground down by taxation and decimated by massacres and deportations, is another reason why Jewish places of worship were so small and insignificant of aspect.

From the outside they looked more like secular buildings than like the Christian churches, close to which they often stood in the cramped conditions of medieval towns.

## The Architecture of the Synagogue

Very few pictures of synagogues are available to us today. In the second half of the fourteenth century, the faithful are portrayed coming out of a synagogue in Aragon.[1] The only notable feature of the façade would be the height of the semicircular arch over the door with its carefully laid voussoirs, were it not that it is most probably enlarged to this extent by the artist as a conventional method of showing the interior of the building more clearly. The two storeys of arched windows—little more than loopholes on the lower floor, taller and with pierced grilles on the upper one—would hardly serve to designate the function of the building or distinguish it from the surrounding houses.

59

89    Only the entrance of another, slightly earlier synagogue, which may also be Aragonese, is depicted.[2] Two stone steps lead up to it; the door is open to welcome the faithful. Beneath the rounded arcade the two leaves of the door are panelled, and nails are visible along the mouldings. Above the doorway, underlined by a cornice as on the preceding building, rises a storey with tall windows. The little flattened tile dome is probably only a fanciful interpretation of the roof.

104    An almost contemporary but less complete illustration[3] just suggests arched doors at the top of a flight of stairs and the crenelated coping of the building. Again in this case the angle turrets are perhaps purely decorative.

Another miniature of this date,[4] singularly unskilful in its perspective and details, provides a new aspect of the building. In a façade with a steep gable, severely reduced and shortened to make room for details of the interior, a rounded door with moulded panels can be seen at the top of three steps; right against the frame at the top of the illumination a roof of blue-glazed tiles appears.

For synagogues in Germanic lands and in eastern Europe, 103  miniatures have little to add to the rare architectural remains that have survived the ravages of time and demolition such as the synagogues of Worms (rebuilt in its original form) and the Altneuschul of Prague or to those known from recent drawings or photographs such as the synagogues of Regensburg and Cracow. We are free to imagine them with high ridge roofs and rows of tall windows, Romanesque or Gothic doors, pointed or stepped gables.

91    Perhaps the imposing building with double stepped gables —a profile that conforms to what is known of other such buildings—seen behind three round towers in the background of a miniature painted at Coburg in upper Bavaria in the late fourteenth century[5] is also a synagogue.

There are no representations of the exteriors of medieval Italian synagogues. The small house with a tile roof, arched door and small windows, which must represent a place of worship in a manuscript illuminated at the beginning of the fifteenth century,[6] looks just like an ordinary house. The undifferentiated aedicules that form the background to certain rites at particular moments of the service in Ms. Rothschild 24[7] shed no light on this matter. The most ancient buildings still standing and intact, for example at Trani and Pesaro, either date from the thirteenth or from the sixteenth century. Thus they cannot provide comparisons enabling us to ascertain whether the decoration of pierced Gothic cupolas of silver and gables which surmount the illustration of a prayer hall in Manua dated 1435,[8] reflects an  92 actual architectural tradition.

Once inside the doors, the wealth and variety of illuminations compensate for the initial disappointments: however, they too have their limitations.

Literary texts and documents provide the sole source of information on the plans and typical internal structure of German synagogues: an oblong hall divided into two groin-vaulted naves—the three-aisle plan of churches with its Trinitarian symbolism was avoided—by a central row of columns or a hall with a single vault and no central division. Paintings of such synagogues consist merely of schematic representations of ritual furnishings.

It is not our intention to ignore them, but Spanish pictures of the fourteenth century give only an imperfect idea of the interior elevations of buildings. The structures are schematic with simple or polylobed arcades carried on slender columns, revealing a system of naves separated by columns, the number and height of which cannot be distinguished. In the absence of contemporary monuments with which to compare these Aragonese representations,[9] no further conjectures are possible.

The oldest and largest synagogues in Castile were divided into an uneven number of aisles—the scrupulous avoidance of the number three is not in evidence in Spain. The great synagogue in Toledo had five aisles, while the one in Seville had three. The experience of wandering in Santa-Maria-la-Blanca among its mysterious forest of columns exercises a spell barely suggested by the comparatively uninformative allusions found in the illuminations mentioned above.

88  A synagogue in Aragon, after 1350: the *Tora* scrolls, with all their ornaments, displayed in a ark-niche that is about to be closed; in front of the ark is the high *bima*; the eternal lights are seen alight; the faithful, wearing the *houce* or cloak and *chaperon* or hood, begin to leave.
Sarajevo, National Museum, Haggada, folio 34 recto.

89  A synagogue in Aragon, *c.* 1350: the eternal light.   ▷
Jerusalem, Israel Museum, Ms. Sassoon 514, folio 32 verso.

90  The interior of an Ashkenazi synagogue, early fourteenth century: on the  ▷ left, a closed ark-chest, the eternal light, a stand for candles and the officiant at his desk; on the right, the *bima*.
Milan, Biblioteca Ambrosiana, Ms. Fragm. S.P.II. 252.

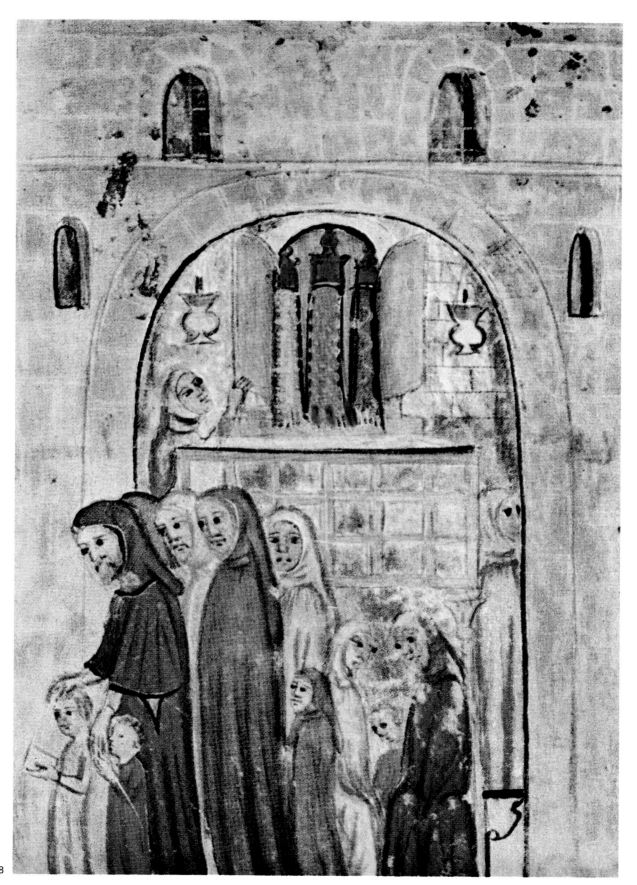

88

89

90

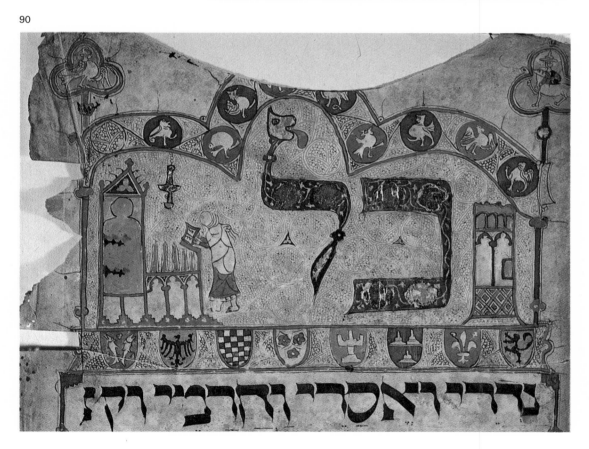

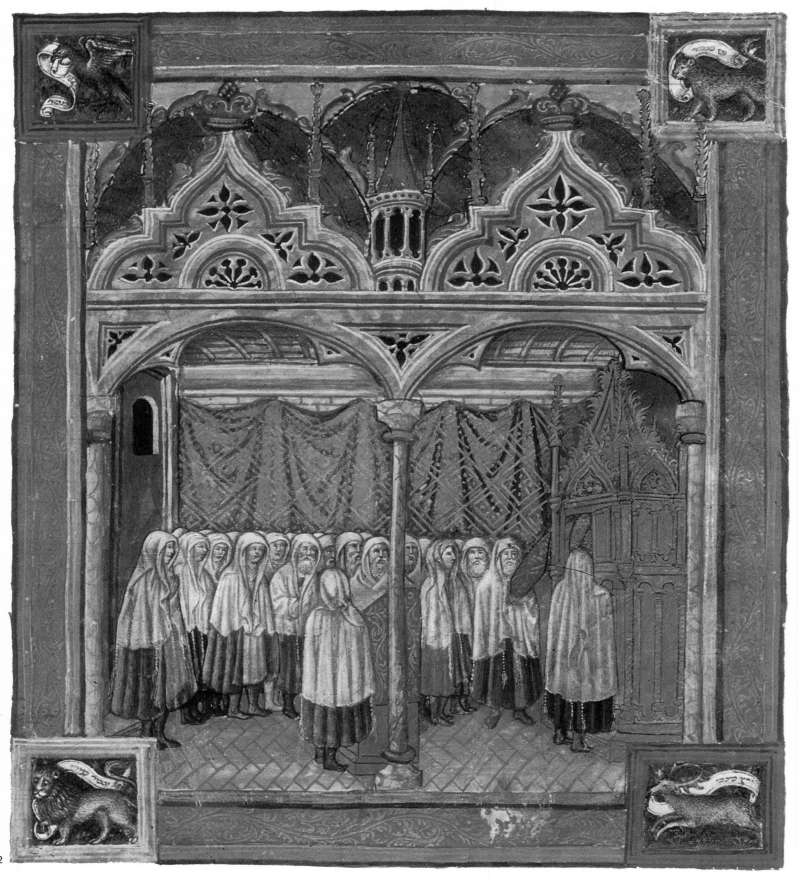

92

The sexes were always separated during prayer; however, since the participation of women in the services was not required by divine commandment, architects did not consistently reserve any particular area for women, either in the plans or the elevations. When such a reserved area occurred, Spaniards preferred a high gallery (e.g., at Toledo and Cordoba), in accordance with the traditions of ancient synagogues. The Ashkenazim, on the other hand, chose to put the women in an annex, usually added to the synagogue at a later date, for instance at Worms and Prague. The most common solution was to use a light manoeuvrable screen, the *meḥizah*. This was a wooden lattice or grille with a curtain that allowed an area to be marked off for women at the back of the communal prayer hall.

The only synagogue illustrated [10] where women are shown present at the service comes from late fourteenth-century Aragon and seems to reflect this custom. On the same level as the men, but behind them, are a row of three women beneath the last three arcades. Although a screen is not shown, it can only have been of the type just described.

The interiors of Italian synagogues of the following century are shown in illuminations painted in extremely elementary perspective, but are nonetheless much more informative. The prayer halls are very simple, without any central division, and differ very little from the large halls of private houses. They are characterized by tiled floors, walls with the fabric either left exposed or simply rendered, single- or double-arched windows, coffered ceilings or low barrel vaults made of carved wood.[11]

◁ 91   Late fourteenth-century Germany: possibly a synagogue or a school, near the towers of the ramparts.
London, British Library, MS. Add. 19976, folio 72 verso (detail).

92   Mantua, Italy, 1435: the interior of a synagogue. After the reading of the *Tora*, the scroll in its wrapping is about to be put back in the ark; the officiant stands at his desk in the centre of the hall; the faithful are all clothed in the *ṭallit*, to which the *ẓiẓiyyot* are attached. The leopard, eagle, deer and lion of the precept of the *Judah ben Tema* (*Pirqey avot* V:23) can be seen in the four vignettes in the corners.
Vatican, Biblioteca Apostolica, Cod. Rossian. 555, folio 12 verso.

## Furnishings

These illuminations contain few representations of architecture, but they are invaluable for the information they provide about ritual objects that have totally disappeared today. Made of fragile or precious materials, of wood (encrusted with gems or not), of metals, glass or rich fabrics, they have not survived fire, pillage or greed.

The Holy Ark

The focal point of any synagogue is the receptacle for the *Tora* scrolls, containing the divine law. This was a chest of varying size installed in a niche in the wall facing Jerusalem or placed against this wall. The sanctity of its contents led to its being called *aron ha-qodesh* (holy ark).

Two Ashkenazi illuminations, one dated 1304,[12] the other of about the same date,[13] tell us something of portable arks, though without indicating where they were placed. These arks are rather narrow chests, with Gothic doors and pierced gables decorated with crockets on the slopes, the whole standing on high legs, for the faithful had to be able to see the scrolls within the ark when its doors were opened at certain moments during the service.

A third, more decorative ark is found in an illumination dating from after 1450.[14] Though its position is not clear, it appears to be a wall niche. The two wooden doors open under a richly carved ogival arch that has flamboyant crockets and is flanked by tiered pinnacles.

At almost the same date, a holy ark is depicted twice in another Ashkenazi manuscript.[15] One of the two is obviously a chest-ark in flamboyant Gothic style with carved gables, pinnacles and turrets.[16] The other could be either a chest-ark or a niche-ark; only the façade, with two steps leading up to it, is shown. This ark has a semicircular opening with a folding door.[17]

There is an niche-ark shown in Spain in the second half of the fourteenth century in one of our Aragonese synagogues.[18] The wooden doors are encased in a semicircular arch rising from a plinth. In spite of the lack of perspective, the miniature manages to indicate the actual position of the ark, in the centre of the end wall opposite the entrance.

From Italy, on the other hand, only portable arks have come down to us. The earliest is seen in an illumination from Perugia dated 1391. It is a Gothic chest decorated with trilobed arcading

93 An Ashkenazi country, probably France, in about 1300: the officiant at his desk in front of a ark-chest; the *ẓiẓiyyot* are attached to the corners of his *tallit*, which is decorated with stripes and, on the upper edge, with the embroidered band, the *aṭara*.
Parma, Biblioteca Palatina, Ms. Parm. 3006–De Rossi 654, folio 99 verso.

roof and a façade decorated with small square moulded panels. Although it is painted in a very schematic fashion, and apart from the crowning, this ark appears to resemble the ark from Modena (now in the Musée de Cluny, Paris) which, at a little later date, 1472, is still decorated in purely Gothic style, with spirals and flamboyant quatrefoils on slender arcades in the square panels of the façade and sides.

The popularity of Gothic taste is also evident in the simpler arks of this period from the same region.[23] They are in the form 96 of large chests with a straight cornice and plinth, and doors decorated with iron fittings and arcades. A small dome with lantern and pinnacles reflects the same style on another ark [24] that shows the influence of classical architecture in its architrave as well as in its tall moulded plinth. 97

This style has triumphed completely in the arks that can be perceived beneath fanciful baldachins in three Italian illuminations from between 1480 and 1500.[25]

One important accessory of the holy ark is a curtain, made of the richest cloths, that was suspended in front of the doors of the ark. The traditional name of this hanging, *parokhet*, recalls the name of the veil that separated the Holy of Holies, where the Ark of the Covenant was kept, from the forward part of the Sanctuary.

The only picture of a fourteenth-century Spanish ark does not include the *parokhet*, nor does it appear on the earliest Ashkenazi chests, though there is one on a niche-ark of the fifteenth century.[26] Drawn open to the left, its scarlet folds fall behind the 98 opened door. The curtain hanging on a rod in front of a movable ark falls in long straight folds.[27] Most Italian arks also lack this 355 feature. A single specimen among those dating from the second half of the fifteenth century has its façade covered from cornice 97 to plinth by a curtain with gold brocading on a red ground.[28]

The Scrolls of the Law

The sacred scrolls of the Law, the most treasured possession of every Jewish community, were kept in the holy ark and were as lavishly decorated as resources allowed.

In a fourteenth-century Spanish ark and in the Italian and German arks of the fifteenth century, the scrolls stand upright and side by side, but they are decorated differently.

In Spain, as in the East, the scrolls were kept in metal cases decorated with engraving and embossed work. These caskets

and topped by a small pyramidal dome. The doors are adorned with iron fittings.[19]

From the same town comes a Gothic ark of similar shape, in an illumination of about the same date as the one just mentioned. The sculptural decoration on it is much richer, however.[20]

92    The ark in a painting of a synagogue done in Mantua in 1435 is again a magnificent Gothic chest.[21] A tall structure resting on a plinth with two storeys of blind arcading on colonnettes; the chest is crowned by a flamboyant dome; the slopes of the gables flanking it are covered with exuberant crockets and framed by pinnacled turrets. The door to the container for the scrolls opens in the upper storey.

Three decades later, in 1465–66, in a synagogue in Reggio nell'Emilia,[22] we find another Gothic chest with a pyramidal

94 Late fourteenth-century Germany: the *Tora* scroll, placed on the desk with its mantle removed; its *aẓey ḥayyim* can be seen, as well as the *mappa* with which it is bound.
Vatican, Biblioteca Apostolica, Cod. Vat. ebr. 324, folio 80 verso.

were in turn covered with costly fabrics. Ashkenazi and Italian scrolls had coverings of cloth known as *me'il* (the mantle of the *Tora*). Under the mantle a length of embroidered cloth, the *mappa*, was wrapped round the scroll to keep it firmly closed.

The beginning and end of each scroll were attached to staves, at the lower end of which were knobs so that the scroll could be easily handled, lifted and unrolled. Literary sources relate that the rounded tops of these staves were decorated from at least the eleventh century with a covering of precious metal, silver or even gold, called *tapuḥim* (apples) in Spain, while in Ashkenazi countries the staves with their knobs were known as *aẓey ḥayyim* (trees of life) by extension of the symbolism applied to the Law itself. In the East the term used was *rimmonim* (pomegranates), a term borrowed from Moses Maimonides, and this is what they are generally called today. The cathedral treasury of Palma de Majorca contains unique examples of these *rimmonim* dating from the late fifteenth century that derive from a Jewish community in Sicily. On them the decoration of the upper finials had developed into a series of towers with turrets at the angles from which rows of small bells were suspended. In this developed form such ornaments became detachable and only covered the tips of the staves.

The scrolls were also adorned with a crown of precious metal, the *aṭara*, symbolizing the dignity of the Law. Some Jewish communities in the south of France or Spain had such crowns as early as the beginning of the thirteenth century. In 1366 the *aljama* or Jewish community of Burgos had to sell the silver crowns of its scrolls in order to pay a heavy royal tax. Detailed orders for such crowns were received by goldsmiths in Avignon in the fifteenth century.

Medieval illustrations do not portray any of the other metal ornaments that become common during the following centuries, in particular the Tora shield 'breast piece' and the *yad* or pointer used to follow the text.

No Spanish miniature shows the scrolls without their mantles, so that the *tapuḥim* are never visible.

94, 105 A few German pictures of the late fourteenth and first half of the fifteenth century do show the *aẓey ḥayyim*, but by a strange coincidence they are all pen drawings and scarcely if at all coloured, so that the precious metals decorating the finials on the staves never appear.[29]

99 In an Italian miniature from Perugia,[30] the only stave visible is painted brown—its extremity is of turned wood but not decorated with precious metal. The absence of a second stave in

this miniature is not a chance result of the perspective. The illuminator was perfectly competent but has clearly portrayed a single stave. This is to be explained by a mistake on the part of the illuminator rather than by a special type of roll with only one stave. The illuminator was probably not Jewish and thus not intimately acquainted with the objects he was asked to illustrate. Indeed, the style of decoration in this manuscript has been identified as that of Matteo di Ser Cambio, an artist well known in Perugia.

The *mappa* seems to be represented in two German illustrations, one dating from the first decades of the fourteenth century,[31] the other from the late fourteenth century.[32] The first 94 is painted and shows a strip of blue cloth bordered with red, wrapped in a spiral around the scroll, covering it from top to bottom. The other has merely a pen drawing of a strip bound around the scroll. In both cases the *aẓey ḥayyim* are left completely uncovered. The scroll in the Vatican drawing might have been portrayed when it was about to be read and thus without its mantle; in the Budapest painting, however, the scroll is shown in a small niche and should normally be carrying all its ornaments. It would seem therefore, that at least in the early fourteenth century, if not still at its end, the mantle was not in general use in Germanic lands.

Two Aragonese miniatures[33] from the mid- and late 95 fourteenth century respectively show the officiant raising in his arms the case containing the *Tora*. The cloth mantle, the colour of which has peeled off in one of the miniatures, can be seen under the small gilt onion-top domes of oriental type.

The scrolls kept in an ark of the mid-fourteenth century[34] are 88 also draped in richly coloured brocaded or embroidered cloths with fringes. The domes of the cases, made of precious metal, appear to support crowns.

On the other hand, the Ashkenazi scrolls that can be seen in arks of the second half of the fifteenth century[35] have covers of 93, 356 precious cloth but no metal ornaments. The covers are closed at the top and completely conceal the tops of the staves, which are perhaps decorated, while the parchment scrolls and their handles can be seen through the slits at the bottom.

In Italy in an early fifteenth-century miniature from Perugia,[36] 99 the scroll is loosely clad in a precious cloth so that both ends of the staves can be seen. Is this because at this time the mantle did not cover the scroll and staves completely as it did in examples shown in later illustrations? Or is this again a case of carelessness by a Christian illuminator unfamiliar with his subject?

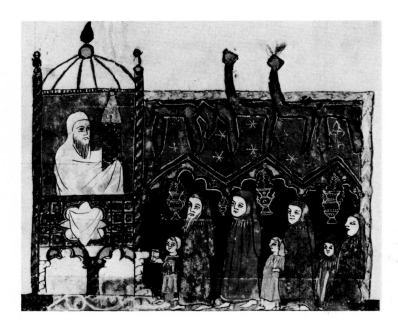

name of *shabat* lamp. The wicks, each with its own arm attached to the oil reservoir, create a little ring of light. Below the lamp hangs a little cup to collect the oil that exudes from the wicks and drips off the arms.

In Spain quite different lamps were used in the synagogues in the mid and second half of the fourteenth century. They were made of glass or metal and followed Islamic models: the oil that feeds the wick is held in a spherical bowl with a widely flaring rim, narrow foot and lateral rings for the chains on which the lamp was hung. The light diffused through the flared rim.

Rather than a single lamp,[40a] the Sarajevo Haggada[41] shows    89
two small lamps flanking the ark.                                  88

These perpetual lamps were not the sole source of light in the synagogue, however, nor indeed was lighting their function. Other lamps of the same kind were used for this, hanging in the   95
aisles either directly from the vaults or from transverse beams at the level of the capitals. A system of pullies and cords attached  103
to the traverses was no doubt used to lower the lamps so that they could be filled, extinguished, cleaned and their height adjusted.[42]

In pictures of Italian synagogues from the second half of the fifteenth century, there are three kinds of *ner tamid*. Two are oil lamps. One, the most common kind in the West during the Middle Ages, had a conical glass flaring out into a cup;[43] the other, rather similar in shape to the Hispano-Moresque glass lamps, is in glass or gilt metal.[44] The third type has branches with  96
candles.[45]

In the synagogues where this last kind of lamp hangs, the faithful use candles in candlesticks, placed on each prayer desk,  96
to follow the morning prayer in the dim light of dawn.[45a]

92   In the Mantua synagogue of 1435,[37] scrolls in covers, brocaded with gold and without metal ornaments, can be seen in the open ark and in the arms of one of the faithful.

Very similar again is the cover of gold and green brocade seen
97 on the scroll carried by an officiant in Ferrara in a miniature of 1470.[38] It is shown very clearly and appears to be completely closed at the top and held tight at the bottom, perhaps by a string, leaving the handles of the scroll projecting.

Towards the end of the century in northern Italy the scroll still had a brocaded cover, closed at the top but slit on the sides so it hangs freely.[39]

### The Perpetual Lamp and Lighting

In front of the ark a lamp *(ner tamid)* burned perpetually, symbolizing the divine light dispensed by the Law.

The earliest evidence for this lamp comes from an Ashkenazi illumination of the early fourteenth century.[40] It is shown hanging in front of the ark and can be recognized as the kind of
90 star-shaped metal lamp that was to become so popular under the

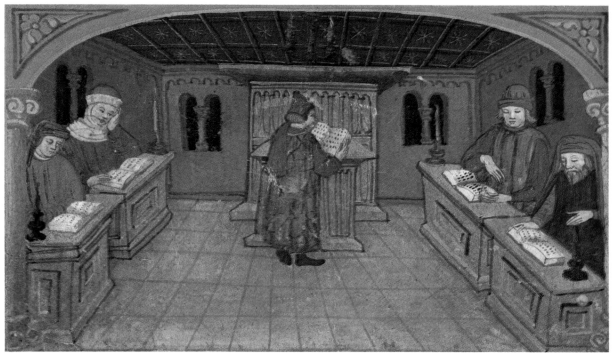

96

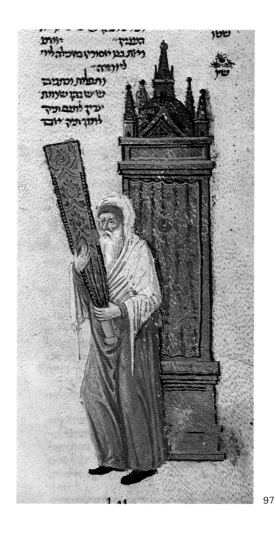

97

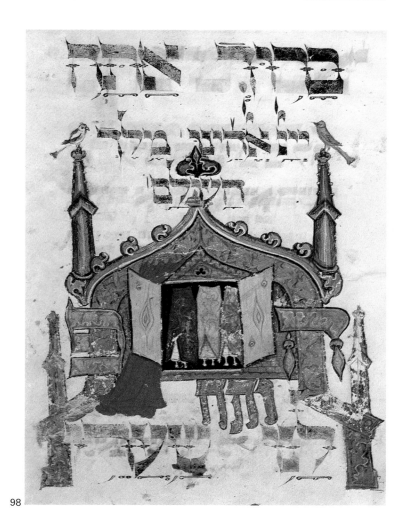

98

99

100

א להמא וחלת לתקת קאלמו לסיבה עשירית האנפה דמולי לה וינקל שהא עשירית האיפה דכתי ביה
וינ שיעור עשירית אל היא אם לא תשין ידו לשתי תרומ אושע בליות

שטנין כסא ומוזנין חמרא ומם כינרכת היין

101

*102* Lombardy, *c.* 1450: richly carved candelabrum and prayer stand. Vatican, Biblioteca Apostolica, Cod. Rossian. 498, folio 117 verso (detail).

102    In addition to that kind of candlestick,[46] candelabra were also placed beside the reading stands; these resembled the one shown by a Lombard illuminator in about the mid-fifteenth century, standing on three eagle claws and worked in bronze or gilded wood.[47]

## The *Bima* and the Officiant's Desk

The interior organization of medieval synagogues was based on two liturgical components of synagogue worship: the holy ark with its *Tora* faced, along the axis of the building, the tribune from which the officiant read the sacred text in the midst of the assembly. The tribune *(bima)* was called *almemor* in Spain from the twelfth century onwards, a name derived from the Arabic *al-minbar* (pulpit), which it closely resembled in form and function. On the tribune stood a desk *(ammud, teyva* or *shulḥan)* for the reading of the *Tora*. This desk was covered with a precious cloth and the scroll of the Law laid upon it.

How near the *bima* should stand to the ark is an old controversy, revived on several occasions by the rabbin. In Europe, the view of Maimonides seems to have prevailed from the twelfth to the fifteenth century. He considered that the centre of the synagogue was the place for the *bima* and its desk.

The position of the *bima* cannot be gauged from the miniatures, on account of their rudimentary perspective, but they do give an idea of what the *almemor* looked like at this period. It was usually made of wood, to recall the platform known as the 'wooden tower' (Authorized Version, 'wooden pulpit') (Nehemiah VIII:4) from which Ezra, on the return from Babylon, read the *Tora* to the people who had forgotten it during

their exile. It was thought that the *bima* should have at least six steps, by association with the throne of Solomon, with a seventh step used to support the scroll while it was being read. The structure was thus fairly tall, flanked by a small staircase that terminated in a screen onto whose struts was attached the desk. Thus the *bima* had become more like a pulpit than a tribune.

This is in fact what it looks like in Aragonese miniatures of synagogues from the mid- and second half of the fourteenth century: a four-cornered box raised on colonnettes with capitals, open on one side and reached by a small staircase. In three of the illustrations [48] the *bima* is depicted clearly, and in one of them the required six steps of the staircase are visible. The sides of the box are of carved wood and covered by square or lozenge-shaped moulded panels. The Mudéjar style of woodworking can be perceived despite the schematic representation.                                              88, 103

In two illuminations the *almemor* consists of no more than these elements. In two other cases [49] the superstructure is more developed. At the corners of the box are colonnettes with decorated tops. In one case they support a light gallery, in the other a small openwork dome. These examples are the most deserving of the biblical appelation 'wooden tower'.                                              95, 103

Another Spanish miniature [50] shows a structure more difficult to explain, largely because of the unskilled work of the artist and the poor condition of the miniature.                                              104

The colonnettes support a broad desk rather than a pulpit. It is raised at some height above the faithful seated around it, but no platform can be seen for the officiant. Two colonnettes extend the supports and flank the front corners of the desk, while at the back is a panel surmounted by a gable, decorated either with niches or small rounded doors. This structure may represent an *almemor* in the form of a raised desk placed in front of an ark, at a distance that the absence of perspective prevents us from estimating. Or it may represent a single structure comprising both desk and ark. If this is the case, the illumination would provide an exception to the rule generally followed in the

99    Italy, perhaps at Perugia, *c.* 1400: the officiant, wearing the *ṭallit*, holds the *Tora* scroll, covered in a precious cloth, in his arms. Jerusalem, Jewish National and University Library, Ms. Heb. 4° 1193, folio 32 recto.

100    Italy, possibly at Ferrara, *c.* 1470: lighting the *ḥanuka* lamp in the synagogue. Jerusalem, Israel Museum, Ms. Rothschild 24, folio 113 verso.

101    Spain, *c.* 1330: slaughter-house, kitchen and communal hall. London, British Library, MS. Or. 1404, folio 8 recto.

103 Spain, *c.* 1350: the interior of a Gothic synagogue, with hanging Moorish lamps, and a high *bima* on thin columns with stairs leading up to it. The faithful sitting below listen to the officiant reading; they are wearing cloaks with long hoods.
London, British Library, MS. Or. 2884, folio 17 verso.

104 Spain, third quarter of the fourteenth century: the faithful sit at the foot of the *bima*, in front of the ark.
Oxford, Bodleian Library, MS. Opp. Add. 8° 14, folio 242 recto.

West, which dictated that the *almemor* should be placed, as we have seen, not close to the ark but in the centre of the synagogue.

The only Ashkenazi representation of the *bima* is earlier than the Spanish illuminations, though it only dates from the beginning of the fourteenth century.[51] It reveals a rather different structure.

The notion of a tower is equally evident. The box is decorated with a network of quatrefoil lozenges; slender colonnettes at the corners and in the centre of each side support trilobed arcades having a coping decorated with arcading. Against the right-hand column is the surface of the desk, set on edge so as to be visible. But instead of being raised up like a pulpit, this *bima*

stands on low feet. It looks very similar to the attempted reconstruction of the original *bima* in the Worms Synagogue, which also had simple feet, although the former structure is two centuries later and has much more elaborate decoration. Our picture does not show it, but we have to imagine the *bima* raised on a podium as it was at Worms. The colonnettes and trilobed arcades are otherwise remarkably similar to those of the *bima* made at Worms after the destruction of the twelfth-century synagogue by fire in 1349. This *bima* was destroyed in its turn in 1615 during a pogrom but was rebuilt in 1620 in the Gothic style and shape of the original. It was demolished again in 1841 or 1842 and is known only from a lithograph of 1843.

90

The similarities between the Worms *bima* and the one in our illumination seem to indicate that this kind of design was fairly common in the fourteenth century.

There is nothing like either the Spanish *almemor* or the Ashkenazi *bima* in fifteenth-century representations of Italian synagogues.

92 In the Mantua manuscript of 1435,[52] the cantor stands in front of a high wooden desk draped with a precious cloth. It is placed in the middle of the prayer hall and is turned towards the ark, but it rests directly on the tiled floor and not on a platform.

On the other hand, the desk in a synagogue in Reggio nell' Emilia[53] of 1465 is stationed at quite a distance from the ark on a broad platform only two steps high, with a candelabrum at each corner. The desk consists of a table on four colonnettes, under which the screw for regulating the height and degree of inclination can be seen.

Another synagogue in the same region and of the same period[54] has, in contrast, a massive desk with a fixed inclined surface on a broad pedestal. It too stands on a very low wooden platform.

Thus in both pictures the *bima* is reduced to a low platform without any kind of superstructure, not even a screen. There was nothing to detract from the importance of the desk.

96 Finally, in another exactly contemporary illumination[55] from Emilia, there is nothing but a desk standing directly on the floor, decorated with the same arcades on colonnettes as the holy ark before which it is placed. The desk forms an ensemble with the ark, just like the holy ark and desk of 1472 from the Modena synagogue, now in the Musée de Cluny in Paris.

On the basis of two of our illuminations we can conclude that, although the *bima* existed in Italy, it was very different from those in Spanish and Ashkenazi synagogues.

Indeed, the Mantua illumination leads us to think that some synagogues had no *bima* at all. Even if so inexpert an artist as that of the Ashkenazi illumination could leave out the platform of the *bima*, it seems unlikely that an accomplished artist like the Mantua illuminator could have omitted it if it was before his eyes, given his attention to detail depicting the holy ark, the scrolls, the desk and, as we shall see, the costumes.

One of the illuminations mentioned[56] raises another problem. In the pictures referred to previously, the desk, or *bima*, was stationed some distance from the ark and, in the Mantua miniature, in the centre of the prayer hall. In this illumination, however, the desk is clearly next to the ark. This need not

indicate a different tradition. The miniature in question is in the same manuscript as one that shows the desk on a *bima* at some distance from the ark. While the latter miniature shows the blowing of the *shofar* for *rosh ha-shana* (this was done from the *bima*), the former illustrates morning penitential prayers on the days preceding the holiday. Thus the illustration might be taken to show that these prayers were not recited from the *bima*, but near the ark. The officiant stands at a desk, but it need not be the one on the *bima*, which would not be depicted if only a restricted part of the hall were represented here.

Two illustrations of this desk are known in the two Ashkenazi 90, 93 illuminations of the early fourteenth century.[57] The construction of one desk is not very clear, but the other is a light portable structure standing on a single foot.

There is also a drawing[58] of an officiant's desk done in 105 Germany in the first half of the fifteenth century. More important, the drawing shows the pedestal decorated with Gothic arcading and on a moulded base. At the four corners of the inclined surface rise pillars carved with fleurons. However, the desk's position in relation to the holy ark is not indicated.

The cloth on which the scroll is laid is folded back and spread over the unopened parts of the scroll.

The praying figure seen in several of the miniatures of MS. Rothschild 24 [59] is shown in front of a desk; however, since the ark is not depicted, it is not always clear whether the officiant or merely one of the faithful was portrayed.

In any case it is surprising that representations of fifteenth-century Italian synagogues accord such small importance to the *bima*, for in the synagogues that survive today, it was precisely in Italy that the most monumental type of *bima* developed in the sixteenth and seventeenth centuries. Built at the back of the hall on the wall opposite the ark, and as high or even higher than it, the *bima* is embellished with decoration similar to the ark's that extended along the ceiling and its cornices to link together those two components of the building: the *bima* had become an element of the internal architectural scheme rather than a piece of furniture.

## Seats and Individual Desks

Rabbinical exegesis of the words of Genesis XIX:27 ('And Abraham got up early in the morning to *the place where he stood before the Lord*') established the principle that all should have a fixed place for prayer. Thus everyone had his own seat in the synagogue; the notables were placed to the left and right of the ark, while the rest of the congregation sat facing it.

There is no illustration of this arrangement, which is enjoined by the Talmud. In Spanish miniatures of the fourteenth century, the faithful are aligned in the aisle [60] or grouped around the *almemor*.[61] In fifteenth-century Italian synagogues they stand in rows along the walls.[62] The Mantuan miniature tells us nothing on this point, because it represents that moment in the service, after the reading from the scroll, when the faithful accompany the scroll back to the holy ark.[63] The placing of the worshippers is more evident where seats and individual desks were used.

In most Spanish illuminations we are just able to divine the seats, stools and benches, often suggested by the seated posture of the figures, whose clothes cover them. In only one case [64] is an armchair with a low back visible through the opening of the door, near the *bima*.

In Italian miniatures, on the other hand, each of the faithful is shown seated on a bench—which cannot be seen—before a lectern that holds his prayer book.[65]

## The *ḥanuka* Lamp

Medieval synagogues also had a special lamp that was lit for the holiday of *ḥanuka*, which commemorates the rededication of the Temple in 165 B.C.E. and the miraculous illumination of the *menora* (the seven-branched lampstand) that burned for eight days. This lamp therefore had to have eight lights. It was placed to the right of the holy ark in commemoration of the position of the *menora* in the Temple.

The use of the *ḥanuka* lamp at home was known from the Talmudic period, but its presence in the synagogues is not mentioned before the twelfth century. It became customary to have such lamps there in the fourteenth century, although the earliest specimens to survive date from the sixteenth.

The adoption of a design with the branches stemming from a single foot has been assumed to be natural enough for this commemorative lamp, but there is no proof for it. Pictures of lamps with seven branches are common in Hebrew manuscripts from the late thirteenth to the late fifteenth century: the illuminators, it is argued, took as their model the *ḥanuka* lamps they knew in the synagogue. This argument is not convincing; the sources used by these illuminators were primarily literary texts.

It is certain that neither of the two synagogal *ḥanuka* lamps portrayed in Jewish illuminations have branches. Both are to be found in Italian manuscripts, it is true, so the evidence applies only to Italy. One dates from the first half and the other from the second half of the fifteenth century. Although it is not absolutely certain that the lamps are in a synagogue, they are too large to be intended for domestic use.

In the earlier of the two pictures, unfortunately in poor condition, the lamp, fixed to the wall at eye-level, is composed of a horizontal cross-bar to which eight oil lamps are attached.[66]

The lamp in the second picture is also very high. Its Renaissance-style foot is in the form of a pillar with the bell of a large capital at the top and a moulded base at the bottom. The cornice that surmounts it holds eight candles stuck in a series of sockets,[67] and not oil lamps.

## Candle Grills

The last ritual object to be noted in our medieval illuminations is the candle grill. Many candles were lit in synagogues: in memory of the dead and on the anniversaries of the date when

someone had died, or simply as a pious gesture of the faithful to embellish the synagogue before prayers, at the start of the *shabat* and at the beginning of every feast.

A pricket grill of this kind can be seen in an Ashkenazi illumination of the fourteenth century.[68] It is shown in frontal perspective, like the ark next to which it stands. The grill could also be placed directly in front of the ark. In this picture, the desk of the officiant appears to be joined onto the grill, but this is due to lack of skill on the part of the artist. The grill is in the same Gothic style as the *bima* shown on the right-hand side of the picture. In Ms. Sassoon 511,[69] the candles are set on a Gothic console-table to the right of the ark. In Ms. Rothschild 24,[70] the candle grill appears to be fixed in the opening of a piece of Gothic furniture, but the position of the grill within the synagogue is not indicated.

### Decoration

There is scarcely any trace in the illuminations of the beautiful decorations with which the faithful bedecked the interior of the synagogues to make them fitting places for the crucial moments in the life of pious Jews—the confrontation with God in prayer and the reading of the Law. A similar reticence in supplying information has already been noted in discussing architecture.

Only literary texts give us some idea of the Ashkenazi synagogues with their stained-glass windows and mural paintings with animal and floral motifs. Synagogues still standing in Toledo and Cordoba testify to the splendour of the carved stucco decorating the walls.

One of the illuminations from 1435,[71] however, shows a fifteenth-century Italian synagogue with sumptuous but unfortunately ephemeral decoration: a heavy cloth of green and gold brocade is suspended from the bare wall, which the artist has made a point of showing behind it.

'How goodly are thy tents, O Jacob, and thy tabernacles, O Israel' (Numbers XXIV:5) were the words uttered by every worshipper as he entered the synagogue. The interpretation of these words was, of course, primarily spiritual. However, as the royal decree of 1261, cited above, that forbade such embellishment proves, medieval Jews, like their ancestors before them and their descendants after them, sought to make their synagogues as beautiful as their means allowed, to create an atmosphere that spoke to the soul through the eyes.

106 Somewhere in Germany, *c.* 1428: a woman taking the ritual bath in the *miqwe*.
Hamburg, Staats- und Universitätsbibliothek, Cod. hebr. 37, folio 79 verso (detail).

## Community Buildings

The synagogue was the most important building of the Jewish quarter, and there might be several when the population was large, apart from the private synagogues of rich families in Spain and Italy and of the Jewish guilds in Spain. But the leaders of the community were responsible for providing other indispensable facilities as well.

## *The Ritual Bath*

One of these was the *miqwe*, the ritual bath necessary to fulfil the laws of purity. Married women underwent their menstrual purification there. The immersion of proselytes also took place there during the ceremony of conversion, and particularly pious individuals practised immersion there before each *shabat* and on the eve of every holiday. It was required, too, for the purification of new metal and glass utensils before they were used to prepare food.

There is only one Jewish illumination that shows the rite of immersion, and it comes from the Rhineland in the first half of the fifteenth century.[72] The characteristic details are all depicted: complete nudity of the body, vertical immersion, the arms out-stretched to avoid touching the body. The only detail which does not strictly follow the accepted rite is that of the heads, with hair untied, shown only partially, not totally immersed.

The immersion of *kelim* (vases and vessels) is likewise rarely portrayed and is visible only in an illumination from Spain of the first half of the fourteenth century.[73] Bowls and long-necked vases are being brought by men and plunged into the ritual water.

The German illuminator has provided no clue to the structure of the bath, but the Spanish miniature shows a pool that can be reached by a number of steps. It may be that these steps were indeed supported on vaults and columns such as those seen descending to the floor of the pool. There is no known Spanish *miqwe* to which we can refer for confirmation. It may, however, be no more than an architectural fantasy on the part of the artist, who also depicts a vault covering the pool. Ritual baths were always covered. The earliest ritual baths known in Germany (at Speyer and Worms) are underground, excavated and lined with masonry to quite a depth; access is again by steps. Care was taken to build them as near as possible to the source of water.

## Public Baths

Immersion in the *miqwe* was only valid if the body was perfectly clean. For this ritual reason, as well as in the interests of general hygiene, the community provided public baths for its members. Such baths were all the more necessary since the Jews were excluded almost everywhere from the rivers, where Christians had the exclusive right of bathing.

There are no pictures of Jewish public baths. The bath shown in the allegory of the Fountain of Youth at the end of an early fifteenth-century German *Haggada*[74] is purely imaginary and does not correspond to any kind of bath used by the Jews. It is shown as a fountain of conventional Gothic design and has nothing in common with public baths of this date. The fact that men and women are shown together in it rules out any association with Jewish baths.

## Wells and Fountains

All medieval towns suffered from pollution of their rivers. Tanners, dyers and butchers were primarily responsible; rubbish was also thrown into them, and they were used as sewers. Ritual and hygienic preoccupations led the Jews to be very careful about the quality of the water they drank or used for washing their hands. It has even been suggested, and it seems likely, that it was the Jewish habit of avoiding certain wells that gave rise to the notion, with all its sorry consequences, that Jews

poisoned wells. To make sure of a supply of pure water, whenever possible, the Jewish community had its own well or fountain, as shown in German illuminations of the fourteenth and fifteenth centuries.[75] These fountains were guarded, especially at the Passover, when the use of water for making unleavened bread had to be carefully supervised.[76]

107

## Ritual Slaughtering

The community also saw that the laws regarding food were respected, especially those concerning meat. As soon as the size of the Jewish population warranted it, a *shoḥet* was appointed by the community to take charge of ritual slaughtering. Many communities ran both slaughter-house and butcher shop.

Four illuminations depict such medieval Jewish slaughter-houses: two Spanish vignettes from between 1320 and 1330[77] and two Italian miniatures, one from 1435 and the other later.[78] They are no different in elevation and openings from other contemporary interiors. The only piece of specialized equipment, shown in two of the illuminations, is the joist with hooks for hanging the slaughtered beasts.

101, 112

252

## Communal Ovens

Communal ovens were more frequently depicted and appear in most representations of the Passover rituals (the *haggadot*). Whether or not Jewish communities had their own bakers or used bread made by Christian bakers, as they did in France, a communal oven was indispensable for preparations for the Passover: the *mazzot* (biscuits made from dough without yeast and eaten throughout the eight days of the holiday) were baked there. The *mazzot* could be made only by Jewish hands, and the manufacture had to be supervised.

These ovens appear in Ashkenazi miniatures of the thirteenth to the fifteenth century from Spain and Italy. The design differs from country to country.

In Germany throughout the Middle Ages, the oven was built of masonry, a rounded vault with a doorway half-way up the side. The fire was at the bottom. The earliest examples have a simple circular hole at the back to create a draught. This kind of

quadrangular furnace and above it a vaulted oven within a quadrangular body, surmounted by a crenelated cornice. In the second half of the fifteenth century, the square oven is built of small red bricks with a little dome on top.[85]

The communal oven had different functions at other times of the year. It was lit every Friday, on the eve of the *shabat*, so that families who had no ovens could leave in it food prepared for the following day's meal to keep hot.

## Community Kitchens

The Jewish community also provided its members with the means to roast meat and cook soups for marriage feasts and other banquets. German communities nearly all had 'soup kitchens'. They provided hearths with andirons, stoves, spits for meat and an enormous copper cauldron for soups.

The same cauldron—for it is unlikely that any community had more than one—once cleaned out with boiling water, was used before the feast of the Passover with more boiling water to purify the metal utensils necessary for preparing food. The utensils had to be cleansed of any trace of yeast that the use of flour and contact with bread might have left on them. All housewives brought their utensils for this obligatory purification, which might take place in public, as at Worms in front of the women's bath.

This is shown in a German illumination of the early fourteenth century.[86] A huge cauldron is suspended above an open wood fire. The artist depicted on the side the utensils— knives and boards—contained within it, so as to leave no doubt about the cauldron's function. A woman at the left of the cauldron is bringing more things to put in it, while one on the right brings more water in a bucket. The boards for slicing and chopping are an unexpected item: wooden objects cannot be rendered *kasher* (ritually pure). Were these boards supposed to be wooden tables which, once thoroughly scoured, could be purified by pouring boiling water over the surface? Or was the artist, elsewhere quite accurate in depicting Jewish traditions, misled in his choice of household utensils?

A Spanish illumination of the same date[87] shows the scene rather differently. Two men are carrying out the purification, plunging various utensils, including a number of bowls brought to them by a woman, into the boiling water and retrieving them

oven changed hardly at all from the late thirteenth[79] and early fourteenth centuries[80] to the second half of the fifteenth century.[81]

The Spanish ovens were quite different. Illuminations in an archaizing style, dating from the first quarter of the fourteenth century, show a side view of them. The furnace at the bottom is a square of masonry; the oven above it is hemispherical and surmounted by a conical hood.[82] By about the mid-fourteenth century, the construction seems to become more complicated. Above the door is a second draught hole, and this is capped with a narrower conical hood.[83]

Italian ovens have a more architectural aspect. An illumination of the late fourteenth century[84] shows a massive

108 Germany, *c.* 1320–5: a communal cauldron and the purification in boiling
water of cooking utensils.
Leipzig, Universitätsbibliothek, Ms. V 1102/I, folio 68 verso.

with a carefully drawn pair of tongs—an indispensable tool.
Under the cauldron, in the centre of the picture, is a huge fire to
keep the water boiling.

A second Spanish miniature, rather later in date, again shows
a man carrying out this task over a large fire. The objects being
plunged in the frothing water are, however, difficult to
identify.[88]

## Community Halls

In the same building as the community oven and kitchen, or at
least close by, Jewish communities in France and Germany had
rooms where marriages were celebrated and where the balls that
were so popular in medieval Jewish society were held, as we
shall see. There was also an inn for travellers. The Spanish
communities apparently did not have such extensive facilities,
though they had enough housing and other facilities to arrange
a *seder* (the ceremony and evening meal of the Passover) for the
poor.

A very lively miniature, in spite of its elementary perspective,
shows the whole range of communal amenities in Spain in the
101 second quarter of the fourteenth century:[89] a large hall in the
centre where the feast is celebrated, a slaughter-house and
butcher's shop to the right and a kitchen to the left.

The large vaulted halls that rise above each other in tiers in
German miniatures of the early fifteenth century possibly depict
the rooms where German communities held marriages and balls, 169
though they may be purely architectural fantasies.[89a]         170

## Schools

Adults were accustomed to pursue religious studies in the
synagogues, but schools were provided for children and
adolescents starting very early in the Middle Ages. These
schools either occupied buildings annexed to the synagogue or,
very often, were in large independent houses. After the Jews
were driven out of the kingdom of France in 1306, their schools
were seized by the royal treasury and were sold at twenty to
thirty times the price of Jewish private houses, a sufficient
indication of their size and spaciousness.

Scenes of school or study in Jewish illuminations are so
reticent in depicting the background that there is very little to
learn about their exterior aspect or about how they were
organized internally. School rooms can only be identified by the
furniture seen in them, notably the master's chair and the
benches and desks of the pupils.

## Health Care

When it could afford it, each Jewish community saw to the
health of its members by employing a doctor to visit the sick.

There are illuminations with very detailed scenes of the care of the sick, but none depicting a medieval Jewish hospital. Only literary sources make references to them: in Cologne in the eleventh century and in Munich in the early fourteenth. At Trapani in Sicily there is a thirteenth-century building which is thought to have been a Jewish hospital.

## The Cemetery

A major obligation of the Jewish community was to acquire and maintain a cemetery, the *beyt-'olam* (house of eternity). This responsibility took precedence even over that of building a synagogue, since the living could use an ordinary room for prayer, whereas the dead were obliged to remain in one place.

The cemetery was sometimes situated outside the town walls, as at Barcelona and Gerona in Spain, where it was sited on a neighbouring hill. It was more usual for the cemetery to be at the edge of the Jewish quarter, at least fifty paces from the nearest house. It was surrounded by a high wall to protect the tombstones against desecration. The bodies of the dead were laid out in a special building, the *beyt-ṭahara*. All Jewish cemeteries were planted with trees and bushes.

There is no representation in German Jewish illumination of an Ashkenazi cemetery with upright tombstones some of which still survive in Europe. Nor is there any Spanish picture showing the tombstones laid flat on the ground, as is characteristic of Sephardi cemeteries. Some miniatures, however, do show these cemeteries planted with trees.[89b]

In illuminations of the first half of the fourteenth century, from Aragon for instance, mourners are seen leading the funeral procession round a coffin that has just been set down under the trees.[90] Another Aragonese manuscript of the late fourteenth century shows a grave being dug in the shade of a tree.[91]

Two illuminations from northern Italy at the end of the fifteenth century depict funeral processions arriving at the cemetery. In one the cemetery is enclosed by a high stone wall, above which various trees, including cypress, are visible.[92] The other shows the last prayers being said before the corpse is lowered into the grave.[93] The grave in this case is lined with stone, which was contrary to Jewish practice.

But before coming to rest in 'the house assigned to all the living' (Job XXX:23)—a rest often disturbed, since persecutions affected the dead as well as the living—the

medieval Jew had to acquire or rent a house for himself and his family in those places where, like Jacob in his tribulations, he 'stayed'.

# Dwelling Houses

## France

Rabbinical French texts of the twelfth and thirteenth centuries give many details about the kinds of houses inhabited by Jews north of the Loire: built in stone when possible, rather than the more usual wood, with sloping roofs and overhanging eaves, a cellar, an upper storey reached by an outside ladder and a porch giving onto a courtyard that was often shared by several houses.

Such houses are not shown in the illuminations of the very few medieval Hebrew manuscripts of this date from France to have survived. The few round or trefoil arches on columns, signifying doors, that can be seen in the Pentateuch copied at Rouen in 1239[94] give us no impression of them, any more than do the architectural frames of little 'views' with crenelated walls,

110   Germany, *c.* 1460: a house in the Judengasse.
Jerusalem, Schocken Institute, 2nd Nuremberg Haggada, folio 32 verso (detail).

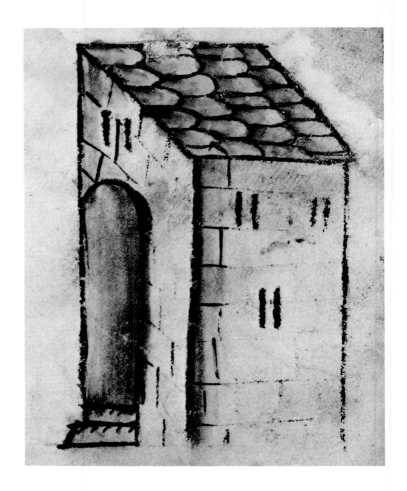

high rounded doors, small domes and pinnacles shown in the illuminations of MS. Add. 11639 [95] of the late thirteenth century.

There is not a single Jewish representation of the external appearance or internal organization of these houses from the following century either. We need look no further, since the Jews were totally expelled from the French kingdom at the end of the fourteenth century.

## Germany

Miniatures are no more useful a source in forming an idea of Jewish dwelling houses in the Rhineland or central and southern Germany. No illuminated manuscript deriving from Jewish communities there contains either paintings or drawings of such houses. Literary sources tell us that they were spacious, surrounded by courtyards big enough to plant kitchen gardens and put up lightly built annexes for studying and taking meals during the hot season. The *sukkot* for Tabernacles could also be set up there at the appropriate time.

The scenes shown in illuminations from the lavishly decorated manuscripts of the second quarter of the thirteenth century—the Munich *Rashi*,[96] the Milan Bible[97] and the Wrocław Bible[98]—only rarely include any indication of the physical environment in which they were produced. As in French illuminations, there is little more than an architectural feature to signify the separation of the outside from the inside of the house in the miniature from Cod. hebr. 5/I in Munich.[99] In the same manuscript, two tall houses with roofs of large tiles and narrow rounded windows can be seen rising above the walls of a town. The solid Jewish houses that sheltered several families and often aroused the envy of their neighbours perhaps looked no different.

As we have seen, German illuminators of the late thirteenth and fourteenth centuries were lavish in their use of architectural decoration for the frames of initial pages of text. Dwelling houses were too modest to be portrayed among such structures of pierced arcades, bristling with crenelated towers, crowned with domes, gables and pinnacles.

Not until the fifteenth century do simple dwelling houses begin to find a place in the illuminations decorating the books of German Jews. Houses crowded behind town walls can be seen in pictures of towns done in a more realistic manner than

the decorative and imaginary schemes of earlier centuries. Stone walls pierced by tall doorways and many narrow windows on several storeys, plain triangular gables or prouder stepped ones, sloping roofs covered with slates—judging by their uniform blue colouring—are the characteristics of the houses of the lower parts of Rhenish towns in about 1427 or 1428,[100] which were dominated by the upper town with its fortified castle. And

111   Spain, first quarter of the fourteenth century: the *miqwe*, with the faithful purifying cups and decanters.
London, British Library, MS. Or. 2737, folio 90 recto.

112   Spain, *c.* 1320–30: communal slaughter-house: ritual slaughtering and scrutiny of the carcases.
London, British Library, MS. Add. 27210, folio 15 recto (detail).

113   Spain, first quarter of the fourteenth century: a Jewish bakery.
London, British Library, MS. Or. 2737, folio 88 recto.

114   Spain, first quarter of the fourteenth century: the communal cauldron, where utensils and metal receptacles are purified in boiling water.
London, British Library, MS. Or. 2737, folio 87 recto.

115   Spain, *c.* 1350: mourning over a coffin placed under trees in a cemetery.  ▷
London, British Library, MS. Or. 2884, folio 11 verso (upper register).

116   Late fourteenth-century Spain: a grave being dug in a cemetery beneath  ▷
a tree; the body, wrapped in a shroud, is being carried on a bier.
Budapest, Hungarian Academy of Sciences, Ms. A. 422, folio 1 verso (lower register).

111

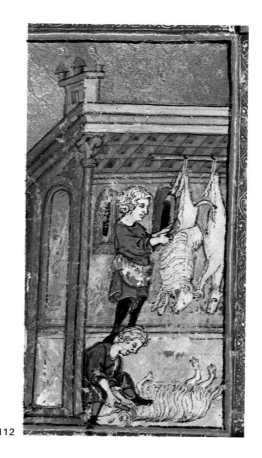

112

113

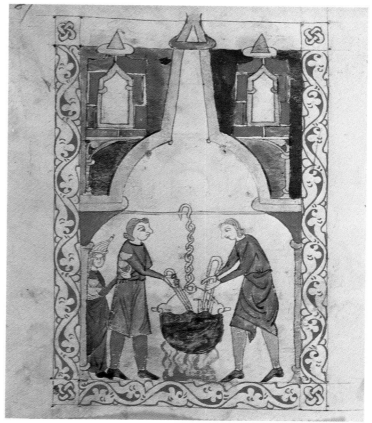

114

115

116

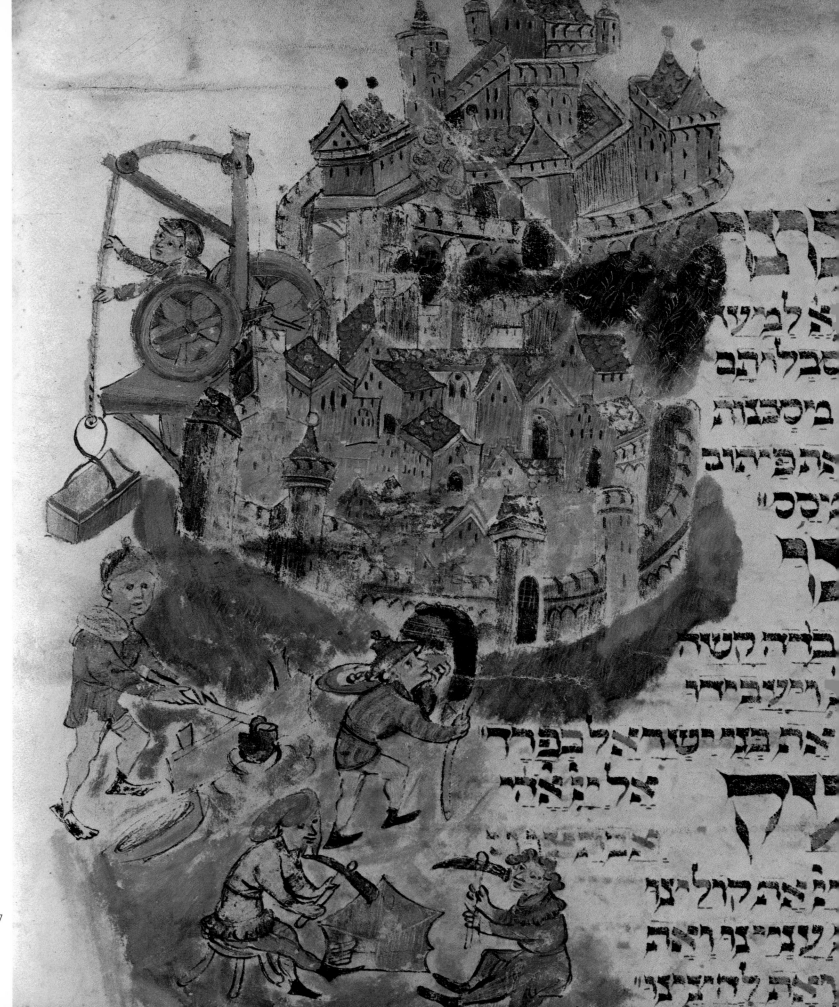

בלמי

שכליהם

מסבות

מפיהם

מכס

בזה לשה

ויעבירו

יתבני ישראל לבד

אל זאה

ומקולצר

ועניתיות וראה

אתלחצ

117

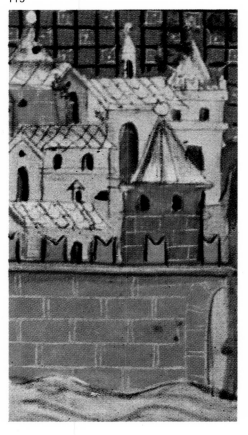

ודקין את
הסדקין ובכל
שים בר...ז
ל...
יפה לבדיקה.

השבת שתים

השבת שותם שה... יורע ע..

these must have been the houses occupied by the Jews at the time, for Jews were often relegated to the quarter nestling in the shadow of the ramparts.

110    Other, later pages (*c.* 1460 to 1470) depict single houses or streets of houses, always of stone with tile or slate roofs, large doors and narrow windows.[101]

In the same manuscript, one illumination[102] gives further 118 details. Opening onto a courtyard with a garden, the tall narrow house has a vaulted cellar, several storeys and a steep roof with pink tiles. The building was lit by loop-holes and windows with leaded panes, as well as by rounded bays, probably closed from the inside with wooden shutters; some of these bays have supports made of planks, which could also be folded down in front of the window.

The right of Jews to construct, lease and acquire buildings was subject to strict limitations almost everywhere from early in the Middle Ages. However large and solid, these houses could usually only have provided cramped homes for the numerous families they sheltered. Literary texts alone give some idea of what their modest rooms looked like, since nothing very clear can be seen through the doors and windows that appear in our illuminations. There are a few pages from an early fifteenth-century manuscript that have pictures of beautiful halls with 169-70 ribbed vaults.[103] These may represent the halls of the most opulent houses, whose modest exteriors, literary texts assure us, disguised a luxury within that rivalled that of the most sumptuous Christian dwellings.

◁ 117    Germany, *c.* 1428: houses of the Jewish quarter, crowded together in the lower part of the town near the ramparts.
Hamburg, Staats- und Universitätsbibliothek, Cod. hebr. 37, folio 27 verso.

118    Germany, *c.* 1460–70: a house several storeys high, in the Jewish quarter.
Jerusalem, Schocken Institute, 2nd Nuremberg Haggada, folio 3 recto (detail).

119    Aragon, after 1350: houses near the ramparts, an area to which the Jewish quarter was often confined.
Sarajevo, National Museum, Haggada, folio 20 recto (detail).

120    Aragon, after 1350: a house with a covered terrace.
Sarajevo, National Museum, Haggada, folio 26 recto (detail).

121    An Italian city in Lombardy, *c.* 1460–5: the palace of a rich Jew.
Parma, Biblioteca Palatina, Ms. Parm. 3273–De Rossi 134, folio 1 verso (detail).

## Spain

Illuminations tell us nothing about the private houses of Spanish Jews before the fourteenth century, and what evidence there is relates entirely to that century.

One such house, isolated and clearly defined, first appears between 1320 and 1336.[104] It is a modest dwelling house, with a ridge roof covered with large scale-shaped tiles and terra-cotta ornaments along the ridge. The door and twin windows are rounded. Thin colonnettes with capitals support the angles of the roof. One of these houses has an upper storey that provides an additional room.

At the same period there were also houses in stone or brick of several storeys, with roofs made of flat tiles and windows and doors set in deep recesses.[105] The blind arcading that decorates the top of the walls under the cornices supporting the roofs and marks each floor-level is reminiscent of the earliest Romanesque decoration in Catalonia. But it probably reflects the influence of Italian painting, then very powerful in the region, in which architectural decoration of this kind was common.

The Aragonese houses illustrated a little after the middle of the fourteenth century in the Sarajevo Haggada[106] seem to be 119 more typical. Of one or more storeys, they are roofed with broad flat tiles, with rounded tiles to cover the joints. One of them[107] has a truly meridional feature: a top storey in the form of a covered terrace with a balcony. The balcony—probably of 120 wood—rests on beams that project from the wall, and light wooden stays support the tiled roof. The windows and door are still rounded. The two leaves of the door are made up of a number of panels. The door has a cross-bar and lock; there is a knocker in the form of a ring on the right-hand leaf.

In late fourteenth-century Aragon, houses are again found that have a terrace as top storey; the ridge or pyramidal roof is tiled and sometimes surmounted by a lantern.[108] Other pages of this manuscript depict simpler houses of a single storey;[109] one has walls faced with glazed faience tiles, whose bright alternating colours make a very decorative and characteristic mosaic.

Spanish illuminators sometimes show us the interiors of houses. In an illumination dating after 1320[110] is a Catalan bedroom, the most frugal of rooms, with a twin window and a wooden ceiling supported at the corners by brackets. More luxurious but probably less evocative of real life are the halls with tiled floor and coffered ceilings seen in several illuminations

143 of the same period.[111] In fact, the depiction of coffered ceilings or arcades was a convention of Catalan illuminators following Italianate models. In Aragonese and Catalan houses of the time, ceilings had parallel beams, the richest with the star-shaped lattice compartments known as *artesonado*. But even had they wanted, the illuminators' modest talents did not rise to showing such ceilings, even in simplified perspective.

Towards the end of the century, from the Barcelona region, there is a picture of a bedroom with the same kind of coffered ceiling; it is painted and the walls appear to be made of enamelled bricks.[112]

## *Italy*

Only crenelated towers, campaniles and *palazzi* can be seen above the walls of Italian towns that obscure the lower dwelling houses, which are rarely portrayed separately.

In the late thirteenth century, dwelling houses are shown with walls of large stones and pitched roofs covered with tiles and 240 rounded openings.[113] By the late fifteenth century, this basic 255 design had changed only in details: roofs are of gutter tiles, and the chimneys are either square with pyramid-shaped crowns or round with crenelations. High up in the walls are small twin or rectangular windows, sometimes with bars or solid wooden shutters.[114]

But at this time there were Jewish families sufficiently 121 prosperous to live in veritable *palazzi*, red brick palaces of the Mantuan or Veronese style. These had rather feudal ground floors without windows. The first floor, however, was adorned with twin windows below rounded arches divided in the middle by a marble colonnette.[115] The doorways to the courtyards are no longer merely rounded at the top or Gothic, but decorated 122 with Renaissance cornices and ornamental pediments.[116] The building is organized around an interior courtyard. Above the arcades of the portico that surround it are the balconies of the 194 upper storeys.[117] The rounded windows are glazed with bottle glass.[118] The inner courtyard leads to a garden surrounded by 266 high walls, which sometimes has pierced arcades.[119]

Vestibules with coffered vaults leading to tiled halls open onto the porticoes.[120] Since opulence, as we shall see, mainly took the form of rich furniture, the walls are bare; sometimes even the stone-work is left uncovered. The ceilings are usually of uncovered wooden beams and joists, making coffers that are often painted and decorated.

These interiors differ little, whether the houses portrayed are in Ferrara, Mantua or Lombardy. Slightly earlier pictures prove that they had not changed significantly since the first half of the fifteenth century.

Our illuminations allow only a very incomplete view of the Jewish quarter in medieval towns. We can glimpse a few façades, the odd wall or roof, behind which we have to imagine the interiors, of which we know only a few details, very scattered chronologically and geographically. In the schematic elevations and structures impressionistically portrayed, only furniture, accessories and the actions associated with them—the ceremonies, rites and practices—reveal the function of synagogues and communal buildings, since the architecture is not particularized. The periods from which the miniatures derive and the areas—ranging from the kingdom of Aragon to German towns and Italian principalities—in which they were produced have inevitably influenced the designs of synagogues and ritual furniture with the particular styles of decorating and building dominant in those regions. But the specific functions for which ritual furniture was made ensured that it kept its identity in spite of changes in shape and style. The evidence of miniatures, though it may be imprecise and difficult to interpret on occasion, allows us to fill in some gaps in our knowledge of the history and evolution of certain pieces of ritual furniture. Private dwelling houses, of which our knowledge is no less incomplete, also bear the marks of the influence of the regional traditions and stylistic conventions of illumination, as is only to be expected. The houses do not seem to differ essentially from standard houses of the same time and place. What made them Jewish homes were the customs, the joys and sorrows, the hopes and tragedies of the Jewish families who lived in them.

# III  The House

## Acquisition

The Jewish marriage contract, the *ketuba*, obliges a husband to provide his wife with a dwelling and to furnish it according to his means and the customs of the place where he lives. To acquire or rent a house or apartment, he had to apply to either a Jew or a Christian. Many houses in the Jewish quarter in fact belonged to Christians, and if such a one was involved, the formalities of buying or renting it were those that obtained generally in the town in question. But when the owner of a house was Jewish, the transaction was governed by Jewish laws concerning the transfer of real estate.

It is obviously not easy to represent a legal transaction in a picture. The only representation of the purchase of a house to be found in Jewish illumination—at the beginning of book XII of the code of Maimonides relating to various means of acquiring property—shows none of the details of the judicial formalities of the sale that the illuminator chose to portray, such as the delivery of money or the written deed. All that is visible is two men engaging in conversation beside a house to which they are pointing.[1]

240

## *The* Mezuza

Whether it was bought or rented, the dwelling of a Jew had the *mezuza* on its principal entrance and on the door-posts of its rooms. The *mezuza* is a piece of parchment; on it, in a square Hebrew script, two passages from Deuteronomy (VI:4-9; XI:13-21) are copied on the recto, twenty-two lines in all, and the word *shadday* (Almighty) on the verso. The parchment is rolled up, with the text on the inside, and kept in a long narrow case, either semi-cylindrical or flat and made from wood or metal, which has an opening so that the word *shadday* can be seen on the outside of the roll. The *mezuza* was hung on the top third of the right-hand door-post so that it inclined towards the interior. The verses inscribed on the *mezuza* proclaim the unity of the God of Israel, enjoin observance of His commandments and exalt His power and providence.

As we have seen, Jewish illumination provides few pictures of houses, and only one among them depicts a *mezuza*. It is attached to the jamb of a door in a rich house of the Italian Renaissance.[2] Since the artist has shown the *mezuza* in gold, it

122

must have been made of metal; it is fixed to the exterior rather than the interior of the jamb in a vertical rather than in a slanting position. It seems unlikely that this picture depicts a local variant of a tradition that is known from other sources—precepts, descriptions and more modern practices—to be constant and universal. This depiction is a mistake and can be linked with other evidence—discussed elsewhere—which suggests that the illuminators of this manuscript were not Jewish, despite the detailed representation of Jewish rites and practices it contains. The person coming out of the house is touching the *mezuza* with his right hand. This is a very exact portrayal of a custom observed by pious Jews who, as they left or entered a building, accompanied this gesture with a prayer for divine protection.

## Furniture

Placed under the sign of his faith and the protection of his God, the house of the medieval Jew had to be furnished. Like his contemporaries, he acquired only what was vital for the essential activities of life: sleeping, preparing and eating meals, that is to say beds, tables, chairs, benches, stools and kitchen utensils, to which were added chests and boxes or bins for storing things.

## *The Bedroom*

From the thirteenth century to the fifteenth, and from one country to another, the furnishing of bedrooms changed in style and accessories. Bedding is an example. Fundamentally it consisted of two essential elements, a bed and a chest. The latter had a lock and key and contained the family's most treasured possessions: gold or silver money, other valuables, clothes, various deeds. Therefore it was logical to keep it in the remotest part of the house, the bedroom, where it was inaccessible to casual visitors and would be near the owners at night.

Literary sources tell us that in France, Jewish houses had beds made simply of a frame resting on two supports, around which was stretched a piece of leather fixed to the frame with rings, as well as more imposing beds. In the latter, a base of planks was fixed between four posts that served as legs at the bottom and bedposts at the top, so that the bed looked the same when turned

122 A Jew, *c.* 1470, piously touching the *mezuza* on the door jamb as he leaves a house in Ferrara(?).
Jerusalem, Israel Museum, Ms. Rothschild 24, folio 126 verso.

upside down. One such high bed on legs is visible in a miniature of the last quarter of the thirteenth century.[3] The sheets fall over the top of the posts at the foot of the bed; between the posts at the head of the bed are cushions that supported the sleeper's torso. The bottom sheet trails down over the cushions and posts. In Germanic countries in the second quarter of the thirteenth century,[4] there were beds of the same type, with legs and posts. The head of this bed is raised considerably, and the person asleep, supported by a cushion with a chequered cover, is almost in a sitting position. Two centuries later,[5] the bed is a more elaborate piece of furniture. It has four posts with terminal knobs, but a rather high bedstead makes a frame around the head of the bed. Cushions with chequered coverings are under the sleeper's head, but his position is nearly horizontal.

In the second half of the fifteenth century, the usual type of bed was made of a frame between four solid posts; those at the head of the bed were higher and decorated with knobs at the top. A square pillow was used. Bedding had a border and did not fall outside the bed frame.[6] This type of bed was sometimes placed beneath a tester and surrounded by curtains.[7] There were also beds on a wide framework in Gothic style. A bench placed along 124 the bedstead enabled it to be entered easily.[8]

Miniatures from Spain dating from the first quarter of the fourteenth century—the precise place of origin is not known but they may be from Castile[9]—depict beds with very high 290 legs but quite low bedsteads. Sheets and blankets fall over the posts. There are no cushions to be seen, and the top sheet is folded back over the blankets.

Beds illustrated a little later, in about 1330, in Aragon are still rather high. Only the legs can be seen under the sheet that falls down to the ground over the bed-posts. The head of the bed is very high, and square cushions of embroidered cloth or cloth with woven designs and large pompons at the corners lie on the sheet, under the head of the sleeper, who is lying under a blanket without any visible top sheet.[10]

Shortly afterwards, in about the middle of the fourteenth century and still in Aragon, the beds are slightly different. Legs and bed-posts are no longer visible. The bed appears to be on a platform supported by a rectangular structure. The bedstead is raised up high once again, but there is no pillow under the sleeper's head. The sheets are not tucked in and fall freely around the rectangular structure. The top sheet is folded back over the blanket, which is of squirrel fur or ermine lined with cloth.[11] A 123 wooden chest with a lock stands next to the bed;[12] a hanging

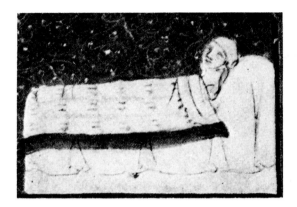

suspended by rings from a horizontal bar allows the bed to be enclosed.[13]

In Spanish bedrooms of the late fourteenth century,[14] the bed no longer has a raised head. A bolster and small elongated pillow support the sleeper's head. The top sheet is folded back over the blanket. The bed has neither legs nor posts; it is the rectangular structure itself that provides a support over which the sheets and blanket fall. The chest with its lock and strap hinges is placed against the bed.[15] The lid of the chest is convex, and the fact that it has been coloured red indicates that it was covered with hide or coloured canvas.

131   At about the same time, an Italian bedroom[16] was depicted with a bed on a platform; the raised head-board supports a canopy. Fitted tightly over the bed and its bolsters is a bedspread. Along the foot of the bed stand not one but three chests with locks—an obvious sign of wealth—these also served as benches. Behind the bed, a brocaded hanging covers the bare walls and enlivens the decor of the room.

242   Some decades later,[17] the bed, mounted on a wider platform, had a wooden head-board that was either rounded into a canopy or surmounted by a tester with curtains. The sheets and blankets fall to the platform. On the bolster, a small pillow cushioned the sleeper's head.

In the latter bedrooms, which were for the sick, tables covered with table-cloths can be seen and on them the glasses, carafes and boxes necessary for nursing patients. These tables were not part of the permanent furnishings of the bedrooms and were only put there when the need arose. This is also true of the chair with four slanting legs and a large inclined back, on which the doctor could sit while he wrote out his prescriptions.[18]

In the second half of the fifteenth century, beds in Italy had 294 scarcely changed. The characteristic elements—head-board supporting a small canopy, platform, bolster—remain the same.[19]

There was usually a bathroom next to the bedroom, a retreat which the rich had installed for washing, but it is not shown in any illumination. However, pictures of the large wooden tub widely used in the Middle Ages are to be found in several German manuscripts of the fifteenth century.[20]

## The Hall

Tables were used along with chests, benches, chairs and stools to furnish medieval halls. They were of two varieties. Some were permanent structures, small and manœuvrable, made up of a surface supported by legs; these were used for various purposes.

Others were temporary and only erected for meals—the surface of joined planks was laid on trestles, and this improvised structure was hidden by a table-cloth that often reached down to the ground. Benches and various seats, usually kept along the walls, were then placed at the table as required.

Furniture of this kind was depicted fairly often in Jewish illuminations. Apart from its incidental appearance in a number of scenes, it necessarily figured in the numerous illustrations of the *seder* (the ritual meal on the eve of the Passover). Only a few examples need be selected from these illuminations characteristic of various countries and successive periods.

132  In the north of France in the last quarter of the thirteenth century, long tables on trestles are portrayed without table-cloths in illuminations.[21] The seats on which the guests were sitting behind the table are not visible, but the master of the house[22] and people in other illuminations sit in large, lightly constructed arm-chairs of an elegant shape. Backs and arms were either solid or, more frequently, had cross-bars holding the posts together, with bars in the form of spindles supporting the arm-rests.[23]

125  The earliest picture of a Spanish table, of 1299 to 1300, shows
101  one on trestles, also without a table-cloth.[24] But in Aragon about 1330, the table, which is evidently on trestles, is completely hidden under a table-cloth. This hangs in a series of curving folds with a vertical line of straight folds at regular intervals, proving that this table-cloth is made up of two parts: one is

draped around the table and hangs vertically to the edges to which it is attached, while the other, a rectangular piece of linen, covers the surface of the table top.[25]

The most common form of seating was a bench, or possibly a bench incorporating a chest; cushions were put on them when needed.[26] A kind of horseshoe-shaped arm-chair[27] can also be found (it had a back with enveloping arm-rests), as well as a solid wooden chair with a high back.[28]

Valuable cups and caskets were kept in a cupboard with a single-leaved door and tall solid legs.[29]

In about the middle of the fourteenth century, tables around which guests were shown still had movable trestles and were covered by table-cloths with gathered side-hangings.[30] But table-cloths made of a single piece of cloth that hung down freely  133 over the sides of the table could also be seen. Whereas cloths of the earlier period were white, with at most one or two coloured stripes at the border,[31] they now usually had wide decorative strips embroidered or woven along the weft, either at the ends or at regular intervals along the entire length of the table-cloth.[32] The light chequered pattern in two tones on one of these table-  378 cloths,[33] which we have already noted in the first quarter of the  144 century,[34] probably indicates that they were damask table-cloths.

While the guests were seated at table on benches or stools, the master of the house presided at the head of the table seated in an arm-chair with a low back;[35] a favoured visitor might also have such a chair.[36]

Beside this arm-chair, which was also used for purposes other than eating at table, small benches were still used for seating.[37]

The tradition of table-cloths with embroidered or woven decoration in wide bands continued to flourish in Aragon  134 towards the end of the fourteenth century. The side-hangings on table-cloths had quite disappeared, and the table-cloths now fell straight over the four sides of the table.[38]

In Germanic countries, the earliest tables found arranged for meals date from the second quarter of the thirteenth century.[39] Their dimensions and the table-cloths that cover them show that they belong to the type of table with movable trestles. The way the table-cloth in the second illustration hangs is interesting: there appears to be no separate hanging fixed to the table, but straight folds seem to form at the ends of the projecting trestles, and the table-cloth loops down between them.

Seating was provided by benches or arm-chairs of as light a structure as those found in France half a century later.[40]

126 A heavy key for a door or a chest, of the late thirteenth or early fourteenth century.
Parma, Biblioteca Palatina, Ms. Parm. 3286–De Rossi 440, folio 96 recto.

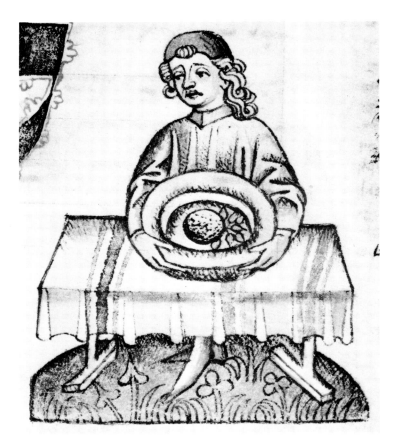

127 Germany, about 1450: a large metal bowl on a table with a single leg at each end rising from transverse bases; the table-cloth has a decoration of wide blue stripes.
Parma, Biblioteca Palatina, Ms. Parm. 2895–De Rossi 653, p. 236.

128 About 1450, cupboard with a single leafed door and a base with moulding; the chest shown near it has a strong lock and a flat lid.
Munich, Bayerische Staatsbibliothek, Cod. Hebr. 107, folio 23 verso (details).

Towards the end of the thirteenth century, the chairs are still of the same type, with posts of turned wood, light traverses and rails.[41] The tables on trestles are covered by table-cloths with draped hangings.[42] On smaller four-legged tables, however, the table-cloth falls freely over the edges of the table.[43]

There are no pictures of German round-topped chests from this period, but the large keys depicted in the margins of monumental Bibles of the fourteenth century were probably designed for the solid locks on them as well as for locks on house doors.[44]

In the first quarter of the fifteenth century, stools— rectangular or circular—are often encountered.[45] At least in the richest houses, the tops of the tables were no longer borne by trestles but by legs on a base, placed at regular intervals. The table-cloths, without hangings, fall freely and are decorated with dark blue lines forming cheques.[46]

A little later, we see a smaller table supported by two legs, with feet joined by a cross-piece. It is covered by a fringed damask cloth with blue stripes.[47] In the middle of the fifteenth century, rectangular tables still have legs with feet. Along with them are small round tables with three legs. The table-cloths are plain or have blue stripes.[48]

Chairs are solid and low, without backs,[49] or they have arms and are a lighter type of construction with posts and legs joined by cross-bars. These derive from the type already seen, which date from the thirteenth century.[50] For storing things, there were cupboards standing on a base with mouldings, having single-leaved doors and shelves on the inside,[51] as well as plain or carved round-topped chests with locks mounted on a base.[52]

129 A German table of about 1460–70, with a carved transverse brace and legs. Jerusalem, Schocken Institute, 2nd Nuremberg Haggada, folio 4 recto (detail).

130 A German chest of about 1460–70 used for storing precious vases. Jerusalem, Schocken Institute, 2nd Nuremberg Haggada, folio 18 verso (detail).

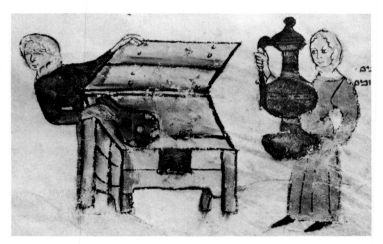

various chairs usually with backs that were not too high.[58] Cups, goblets and pitchers were kept in chests with rather low legs and flat or convex lids: the chests were rustic in appearance being made from bare planks without any carving but with a strong lock.[59]

130

At the end of the fifteenth century,[60] table legs still have large feet, but they are joined with a brace. Goblets and pots are kept on the shelves of a cupboard with two compartments and a

In the following decades, the furnishings of a room in a rich dwelling at Ulm or Augsburg consist of a large round table with a single central leg resting on a foot in the shape of lion claws that can be seen under the table-cloth. The guests are seated on benches with carved panels.[53] The master of the house sits on a tall carved chair on a platform that is surmounted by a Gothic canopy with pinnacles.[54] His most valuable plate was kept in a handsome piece of furniture of the same style: one overhanging compartment with a single-leaved door and projecting facets.[55] Although it is less rich, this appears to illustrate quite well the sumptuous description given by the chronicler, Anselm of Parengar, of the furniture of Samuel Belassar of Regensburg.[55a]

Tables on trestles and stools remained the usual furnishings in rooms of more modest dwellings.[56]

In the interior of richer houses, almost all large and small tables are supported on legs with wide feet.[57] The more elaborate shapes are distinguished by their carving and were designed for display. The seats are still of well-known types: stools, benches,

136

137

129

131 An Italian bedroom of about 1400: a tapestry hanging from a rail covers the wall; the headboard of the bed rises to form an overhanging canopy; around the bed are three chests, used both as benches and for storing prized possessions. Jerusalem, Jewish National and University Library, Ms. Heb. 4° 1193, folio 32 recto (lower margin).

132 A scene from late thirteenth-century France, with an arm chair, trestle table, stem cup, bowl and knives. London, British Library, MS. Add. 11639, folio 205 recto.

133 Aragon, after 1350: a table-cloth with a hanging border draped over a long trestle table; on it are a knife, stem cups, goblets, a metal bowl and a glass decanter; there are two hanging lamps, one Hispano-Mauresque of glass, the other of metal with a number of branches or spouts. Sarajevo, National Museum, Haggada, folio 31 verso of the text.

134 Late fourteenth-century Aragon, a kitchen and hall: meat is being roasted on the hearth, while other food is cooked in a cauldron; knives, bowls and glass drinking vessels can be seen on a table-cloth decorated with woven or embroidered stripes; large towels, also with a decoration of stripes, are thrown over a high beam. Budapest, Hungarian Academy of Sciences, Ms. A 422, folio 2 recto (detail).

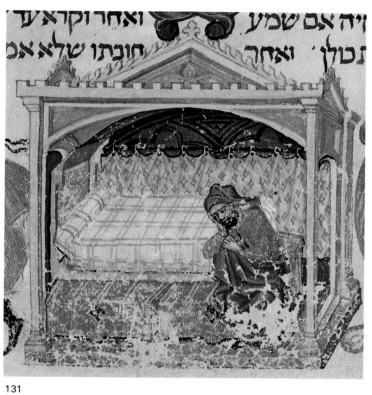

זה אם שמע וקרא ע
תטלן · ואחר חובתו שלא אם

131

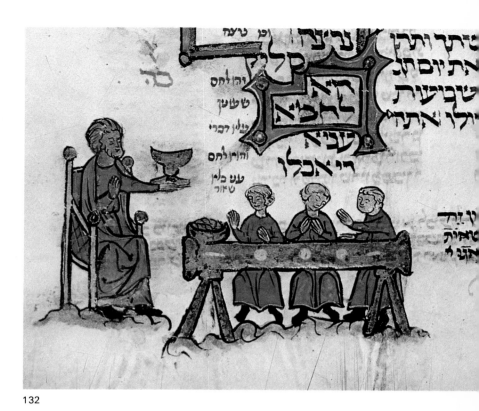

132

133

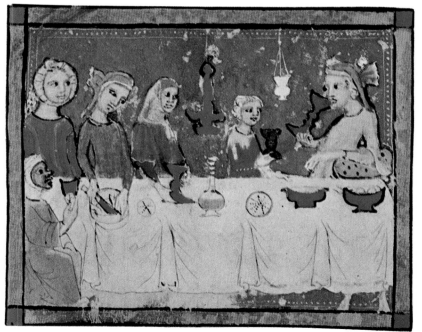

134

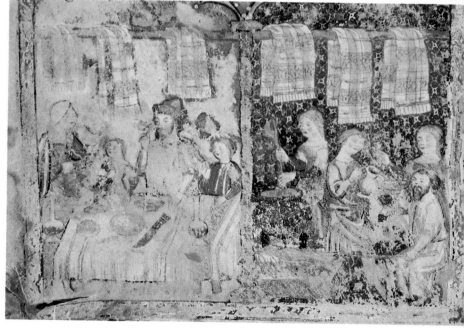

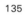

135

136          137

heavy crenelated cornice, the whole resting on a solid base. The decoration is of arcading and painted in bright colours. The door has two leaves and is on hinges; it is ornamented with fittings and rings in the centre of the panels.[61]

In Italy, the earliest pictures of furniture date from the second half of the fifteenth century. A document from the north depicts 151 tables with four straight legs.[62] On the smaller end of the table, 257 some have a wide skirting panel, which is pierced with Gothic trefoils and a trilobed arch.[63]

Almost a century later in the south, between 1460 and 1480 in the kingdom of Naples, very simple tables without table-cloths rest on trestles[64] or on four straight legs.[65] Seats are small benches or chairs with rather low backs and curved arms. Side 333 panels, cut out to form trilobed arches, reveal the four legs.[66]

Around 1450 in the north, one finds table-cloths decorated 372 with stripes and with patterns woven or embroidered in blue.[67] 334, 347 About 1470 there are tables with four legs, covered with damask cloths that hang down near the ground.[68] The inept perspective of the illuminations puts the four posts all in the foreground, but the fact that they are vertical rules out any possibility that they were trestles.

193 In the same period, about 1465 to 1470, tables with oblique legs joined by a rail occur.[69] Towards the end of the century, 150 other tables are supported on trestles; these legs are more elaborate and held together at each side with panels cut out to form trilobed arches.[70]

There are also smaller round tables, on three legs,[71] and other rectangular ones on a central spiral.[72] In a particularly rich dwelling, there is a round table whose central leg is supported by three carved dolphins with interlaced tails that are lying on a base.[73]

135 A German table, of about 1430, supported at each end by a single leg rising from a horizontal base on the floor; on the blue-striped damask table-cloth we can see knives, goblets, cups with lids, a galette cake, (on the left) a metal fountain above a large basin and a long damask towel decorated with blue stripes and a fringe.
Manchester, John Rylands University Library, MS. Ryl. Hebr. 7, folio 5 recto (detail).

136 About 1460, a Gothic German chair with a canopy, on a rostrum, and a large goblet of precious metal with a lid.
London, British Library, MS. Add. 14762, folio 2 verso.

137 About 1460, a piece of Gothic furniture with a projecting cabinet.
London, British Library, MS. Add. 14762, folio 1 verso.

Seats are the same types as found in other countries: round stools,[74] rectangular stools,[75] chairs that are to a greater or lesser extent monumental. Some have solid inclined backs and arms bent round into a hook;[76] others have straight backs simply 150 made from a few traverses slung between two back posts.[77] They 338 may also have arms;[78] some even have a step and canopy.[79]

In the north of Italy in the second half of the fifteenth century, cupboards with two compartments were used for storage. They have crenelated cornices on arcades, doors with two leaves and rich fittings.[80] In the region of Ferrara, a two-compartment 138 cupboard of this kind may have a door of only a single leaf and, in contrast to the base, cornice and panels that are moulded, a rich Gothic coping of gables and pinnacles with turrets.[81]

## The Study

Interest in books was general throughout medieval Jewish society. In spite of the high price, it was not rare for men of modest means to have at least a few books in their homes. Educated people collected them. This is made clear by the terms of legacies, deeds of sale and purchase, and inventories of books found in manuscripts that have survived until today. Physicians and astronomers needed them, as did translators and copyists. Teachers of the *Tora* and the Talmud used them constantly for teaching and research, since it was specified that all teaching should be done from a book and not from memory. Apart from schools, then, a number of private houses included one or more pieces of furniture for storing books, reading them and writing them—shelves, racks, *lectrin, scriptionale*.

This furniture was the same as that found in schools. Almost all the illustrations where it appears show teaching being done, a subject discussed in another chapter. The particularities of school furniture will be noted there, but a piece of furniture like that around which a group of *talmidey-ḥakhamin* (students of the sacred text) is shown in Germany in about 1460 or 1470,[82] both 175 desk and rack, skilfully carved, certainly had its place in the rich dwelling whose furniture we have already had occasion to admire.

It is in Italy in the second half of the fifteenth century that the exegetist, the philosopher, the moralist or the copyist is most frequently seen working in the intimacy of his *studiolo* (study).

He can be seen seated in a chair with a high back in front of a desk supported by lateral posts or walls that completely hide 264

138 An Italian cupboard of the 1470s. The sumptuousness of the Gothic coping with its pinnacles and turrets contrasts with the austerity of the moulding seen on the base, cornice and pannelling.
Jerusalem, Israel Museum, Ms. Rothschild 24, folio 155 verso.

the legs. On the inclined top of his desk is a book or a leaf of parchment. On a level upper surface are an inkstand, scraper and reference books.[83] During fine weather, desk and chair could be
266 put in the garden.[84] Sometimes, however, a scholar is shown sitting on a simple stool at an ordinary table,[85] or on a small bench in front of a round table with a central leg.[86]

Towards the end of the fifteenth century, in a more
147 completely furnished *studiolo*, a *lectrin* with two inclined surfaces is fixed to the desk, so that it can be rotated and two books consulted easily. Along the wall on a shelf, a sloping board allows books to be stored next to each other. The books are laid flat with the spines facing to the right and the edge with the clasp to the left—the usual position, for books in Hebrew are read from right to left. This provides a clear indication that it was a Jewish library.[87]

Another man shown studying between 1460 and 1465 sits on
146 a tall, wide, deep chair surmounted by a canopy, which is in itself a self-contained study. The *scriptionale* on which he rests to read or write is fixed to two arm-rests above his knees, while shelves on the side walls contain books, ink-pots, etc.[88]

## The Kitchen and Domestic Utensils

The other essential room of Jewish houses represented in illuminations is the kitchen. There, utensils can be seen whose

regional and chronological differences are minimal when compared to their similarities, be they fire-places, , bellows, fire-dogs, spits, pot-hangers, hooks, cauldrons, tripods, cooking-pots or saucepans.

An illumination from the north of France dating from the last quarter of the thirteenth century[89] shows a spit held at one end by a ring on an upright and at the other by a fork on which its point rests.

Ashkenazi manuscripts include two other early pictures of spits, dating from around 1300.[90] Both are very rudimentary and show a whole animal being roasted on a spit. In both cases, the spit seems to rest only on a fork or a single support; the other end is held by a scullion who turns the spit. The illumination from Parma also shows cooking being done in the fire-place. Under its hood hangs a pot-hook supporting the handle of a three-legged kettle in the hearth above the fire.

When kitchen scenes start to reappear in Jewish illuminations from Germanic lands (after the mid-fifteenth century), they are more detailed. The spit has undergone improvements that were quite old by then. It lies on two supports: one of them a fire-dog, the other a tripod with a ring on top through which the spit passes.[91] Cooking was also done in the hearth in saucepans or kettles with feet that were hung on hooks above the fire-place after scouring.[92]

In Spain in the early fourteenth century, the spit is as rudimentary as that seen in Ashkenazi pictures of the same date. It has only one support,[93] but from the first quarter of the
139 fourteenth century[94] it rests on two fire-dogs. The fire was stoked with hand bellows, an implement already seen earlier in the century, while the scattered embers that fell under the roasting meat were swept up with a broom. Cooking was also
134, 140 done in large bulbous cauldrons resting on tripods.[95]

Representation of spits of a slightly later date[96] do not reveal how they were constructed. Their supports are not visible. All that is clear is that the cooking was done in the front of the fire-place before a roaring fire.

After the middle of the fourteenth century, the spit was turned on two high supports of worked iron above a hearth.[97] But it might also be fixed on two supports above a brazier with pierced
134 iron sides. Towards the end of the century, a similar brazier was put under the spit that was supported by fire-dogs.[98]

As for all other kinds of furniture—with one exception dating from the late fourteenth century—it is only in the fifteenth century, and mostly in the second half, that

139 Cooking on a spit in Spain, first quarter of the fourteenth century; the fire is kept up with a large pair of hand bellows.
London, British Library, MS. Or. 2737, folio 91 verso (detail).

140 A cauldron, first quarter of the fourteenth century, from Spain: it has two handles, a flaring rim and a deep, rounded bowl, and sits on a tripod.
London, British Library, MS. Or. 2737, folio 90 verso (detail).

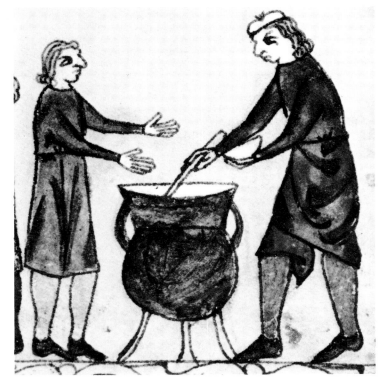

illuminations provide scenes of kitchen fittings in Jewish houses in Italy.

The single fourteenth-century picture shows only a large cauldron suspended on a hook.[99]

At the end of the fifteenth century, in the house of a wealthy family with its coat of arms—the escutcheon of which has only been roughly sketched, without charges or quarters, on the mantelpiece—we can identify traditional utensils in illuminations that are among the most realistic and expressive known, despite the sketchiness of their execution.

149   In the monumental fire-place hang two hooks: one empty, the other bearing a cauldron above a flaming fire. On either side of the fire stand a pair of tall fire-dogs with hooks for a spit, though one is not shown here. In front of this are secondary hearths on which sit two large kettles; one is closed with a lid.[100] A second picture shows cooking being done on a spit:[101] in a lower fire-place, whose mantelpiece is decorated with a *tabula ansata* that provides a measure of the luxury of the place, a whole animal is being roasted on a spit in front of a big fire. The spit rests on the hooks of two fire-dogs.

Two other illustrations from between 1470 and 1478, show very clearly and with considerable precision another kind of

spit. As in one of the Ashkenazi miniatures of the same period, the spit is held at one end in the ring fixed on top of a three- or four-legged support and rests on one of the hooks of a second three-legged support at the other end.[102] In the first illustration, a long low basin with ring handles has been placed under the meat to gather the juice. In the second, cooking is being done in a saucepan with a long handle, which is suspended from a tall tripod standing above the flames of the fire.

A few other utensils complete the repertory of equipment found in the kitchen. The fact that their function did not change ensured that their shape changed little. Since on the whole, they were plainly made and of small size, our illuminations often represent them only in a schematic fashion. It would not be worthwhile to try to trace the almost imperceptible changes of detail in their shape and style during the period covered by our miniatures.

Ladles or large spoons are necessary accessories for stirring and serving when cooking in cauldrons, kettles and saucepans.[103] Mortars and pestles were also used,[104] together 141 with knives, chopping boards and buckets.[105] Illuminations from Spain[106] and Italy[107] prove that baskets were used for 142, 298 carrying fruit, vegetables or biscuits.

Water was fetched from wells or fountains in large cauldrons carried by two people, suspended by a handle from a rod carried 148 on their shoulders, or in smaller cauldrons carried by hand.[108]

Finally, in a corner of the kitchen or in a neighbouring store-room, the mistress of the house or her servants kept brooms made of rushes or twigs, according to the regional tradition.

In an Aragonese house of the first half of the fourteenth century, the tiled floor was cleaned with a brush having such a

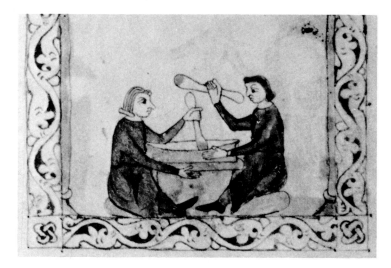

141  Spain in the first quarter of the fourteenth century: dried fruit being ground in an enormous mortar by women seated on cushions.
London, British Library, MS. Or. 2737, folio 88 verso (detail).

142  Spanish basket, first quarter of the fourteenth century, with a flat base and a single rounded handle over the top, made of flexible strips of wood woven together. Here it is shown used for carrying galette cakes.
London, British Library, MS. Or. 2737, folio 89 verso (detail).

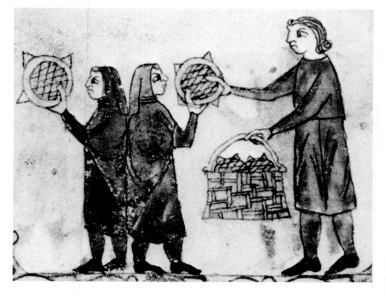

short handle that its user had to work bent double and almost on his knees, while a Turk's-head brush on a long handle was used 143 to clean the spiders' webs from the coffered ceiling.[109] The fact that such a brush, which is especially suited for cleaning carved ceilings, was used appears to indicate that, although the illuminator was following an Italianate model, he intended to portray a ceiling of worked wood, as we have suggested. The same utensils are found in another illumination from the middle of the century.[110]

In the second half of the following century, German 118 housewives are shown shaking much more convenient brooms out of the window: a much thicker bundle of twigs with a longer handle.[111]

For a preliminary rite of the Passover, the *bediqat ḥameẓ* (searching for leaven), at least the Ashkenazi Jews in Germany 138 and Italy used bunches of feathers or the wing of a goose or chicken in their houses in the Middle Ages. This rite is often depicted in *haggadot*,[112] but we have no illumination showing the daily use of this rudimentary feather duster.

## The Cellar

There are no representations of cellars in Jewish houses in Spain where vats of wine and jars of oil were kept, and the same can be said for Italy. But a few German illuminations of the second half of the fifteenth century take us down under their vaults, 118 where barrels were kept in rows on their side.[113] These were broached with a strong metal spike to draw the wine from the casks.[114]

## The Tableware

Laid tables give us specimens of tableware used over the two and a half centuries during which medieval Jewish illuminations were produced. As a general rule, ordinary people had tableware of wood or earthenware, but as they rose in the social hierarchy, they used tableware made of ever more precious metal: pewter or silver, silver-gilt or even gold. The tables of the rich, and those of the less rich during feasts, were laid with metal plate only. Glass, in the form of drinking vessels or jugs, was introduced at varying dates in different countries.

In thirteenth-century manuscripts, basins, cups, goblets and bowls, ewers, jugs and pitchers are shown in gold or silver,[115] as 132 befitted representations of objects in precious metal, though there were exceptions where the artist's fantasy led him to colour the objects with various opaque colours.

In early fourteenth-century Spain, cups and vases can be seen with long necks barely coloured with touches of ochre,[116] which 144 could be taken at first sight for glass. In fact, they can only have been made of metal, since in none are the contents visible as they would be if the objects were transparent. It is worth noting that no metallic paint or gold leaf was used in the series in which this miniature appears. There is no doubt when the objects laid on 165 the tables are shown in gold or silver.[117] The varied colours, vermilion or brown, still given to some of the pieces at this 101 period can only have been intended to indicate metal.[118]

Towards the middle of the fourteenth century, glass began to appear on Jewish tables in Spain. On two occasions, among the

143   A thorough spring cleaning in Spain, *c.* 1320–30. Dust is being cleared from the corners with a rod and from the coffered ceiling with a Turk's head brush; a hand brush is used for sweeping the floor.
London, British Library, MS. Add. 27210, folio 15 recto (lower register).

cups, goblets and bowls of gold or silver, there are decanters with a short flared foot, spherical body and long narrow neck.[119] The second decanter is half full of wine. The same decanters are found on a table at the end of the century.[120]

At the same date, Jews in Italy were using not only decanters of the same type, but also stem glasses and elegant glass ewers.[121] Glass decanters for wine or water and glass goblets were rarely absent from tables throughout the fifteenth century, in either the first half,[122] the second half[123] or the end of the century.[124] They predominate on a table of the early sixteenth century.[125]

In Germanic countries up to the late fifteenth century, the pieces most commonly used—cups, goblets, ewers and pitchers—were of metal. The material from which they were made was indicated by opaque colours—red, blue or yellow—in the early fourteenth century, by an illuminator who does not use gold.[126] In miniatures from the middle of the century,[127] when no gold or silver was used, the use of metal is indicated by a lack of transparency and by the fact that the objects are barely coloured. On the whole, gold and silver, which were painted or burnished and are now more or less tarnished or blackened, fills in the shape of these objects.[128]

From the middle of the fifteenth century, thick greenish or bluish glass goblets covered with knobs were used. These are typically German goblets known as *Warzenbecher*.[129] Transparent decanters and glasses also appear on tables towards the last quarter of the century.[130]

The commonest pieces of tableware are found in every region: bowls, basins, cups with or without a stem or lid, goblets, jugs, pitchers, ewers and bottles. To these must be added knives. Regional traditions and fashions inevitably influenced the shapes. We have already referred to that of the most remarkable pieces of glass. Certain shapes of metal were also characteristic of specific countries at various times.

In Spain, from the the first quarter to the end of the fourteenth century, cups are flared and on a tall stem often decorated with a knob; the vases have spherical bodies and long narrow necks that are straight or slightly flared.[131] This shape (also found in glass decanters) is that of Syrian bottles, common throughout the Islamic world, and from Islamic Spain it spread to the northern provinces. A curious metal vase is also depicted: its narrow neck widens near the top into a bulb of equal size to the spherical body.[132]

In late fourteenth-century Italy, good examples of *Pokal* (goblets) in gilded metal can be found.[133]

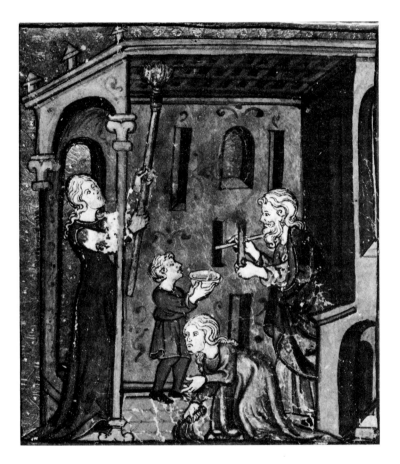

However, it is in fifteenth-century Germany that the most varied shapes of cup are encountered. Particularly imposing are the ones whose lids are like a second stem-cup placed upside down on the first.[134] When the mouth is turned in, the cups look like two spherical bodies on top of each other.[135]

At the end of the thirteenth century in France and in the first half of the fourteenth in Germany, miniatures portray the small kegs used on trips for water or wine; these had straps so they could be carried over the shoulder.[135a]

German pictures from the second half of the fifteenth century also depict metal gourds with a flattened body.[136]

On all tables, both early and late, the only cutlery consists of knives. This was the case on all medieval tables. However,

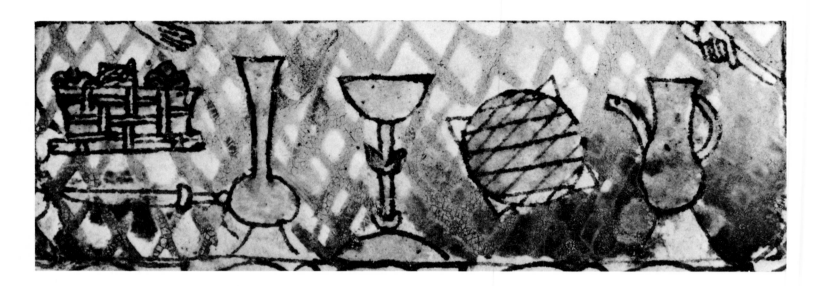

334 although they were rare and considered 'non-Jewish', silver spoons were not unknown in France in the thirteenth century. There is a single illumination that shows them being used in Germany in the second half of the fifteenth century. In the Second Nuremberg Haggada and its twin, the Yahuda Haggada, both rich in scenes of everyday life, guests are not only seen meeting for the *seder*, as in other *haggadot*, but also eating the meal that follows, taking their soup. In one of the pictures, a figure drinks from a bowl, while the two others take the liquid from plates with long spoons and carry it to their mouths.[137] A man and woman are also seen using spoons in the corresponding picture in the Second Nuremberg Haggada.[138] As a general rule, spoons were not used until the sixteenth century; soup was drunk directly from a bowl or plate that was used by the whole company and not just by an individual. Similarly, several guests drank from the same glass at the tables of the rich as well as at those of the poor. Spoons were apparently not brought to the guests before the soup, since they are not shown on tables laid ready for meals. Spoons did not even appear on the tables of the wealthiest lords until the early sixteenth century, as can be seen before 1426 at the table of Duke Jean de Berry in the *Très Riches Heures*, and, a century later, on the princely table in the Grimani Breviary.

Forks are likewise not visible on the tables, but this is to be expected: it is not until the late fifteenth century that they appear

in Italy, and they were adopted slowly and without enthusiasm in northern Europe during the following centuries. People helped themselves and ate with fingers and a knife.

The same can be said of metal plates, which are rarely met with in the fifteenth century and were used communally. Meat was served on slices of bread called *quadrae*.

The presence on Jewish tables of metal tableware—usually gold or silver—and delicate pieces of glass is not surprising. The tables are almost always shown laid for feasts, when the best pieces in any household were brought out. Meals on these occasions began with the blessing of the wine pronounced by the head of the house. To fulfil religious rites, Jews used the most beautiful and precious objects they could obtain; therefore, it was natural for the wine to be poured into a precious cup— one made of precious metal was indispensable for the *qiddush* (the inaugural blessing of the *shabat* and holidays) and was an essential item among the utensils of Jewish households. These cups are seen in this rôle on tables throughout the period, in shapes dictated by prevailing fashions, the most noteworthy of which were discussed above. Other cups and goblets were also necessary for the ritual meal of the Passover, the *seder*, during which each guest had to drink four cups of wine. A wide range of such cups can be seen in the many illustrations in *haggadot* of tables set for the *seder*, particularly those from Germanic countries in the second half of the fifteenth century.[139]

145 About 1450, in Germany: a *Warzenbecher* of thick glass decorated with small hemispheres in relief, shown on a table-cloth with blue stripes draped over a small round table.
Parma, Biblioteca Palatina, Ms. Parm. 2895–De Rossi 653, p. 236.

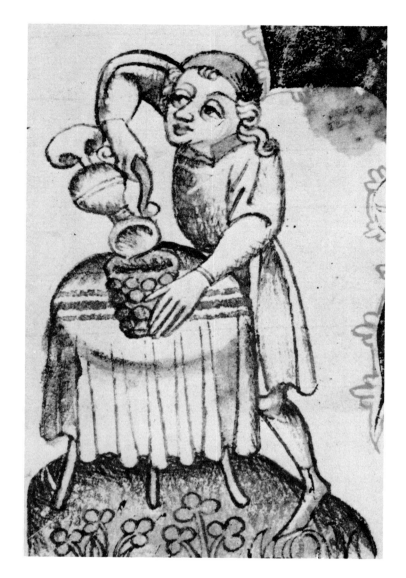

Another indispensable item, at least in Ashkenazi houses, was the basin or large platter on which the ritual food for the *seder* was brought to the table (Sephardi and Italian Jews used a basket instead, as we shall see when describing rites associated with holidays). Such dishes can be seen in illuminations dating from the thirteenth to the fifteenth century, for example in late thirteenth-century France,[140] and especially in Germanic countries in the second half of the fifteenth century,[141] as well as in the houses of immigrant Jews of German origin in Italy.[142]

Another notable object, a receptacle for spices, gave a distinctive touch to the group of precious vessels found in Jewish houses. It appears in the twelfth century, when, at least with Ashkenazi Jews, spices began to replace fragrant herbs in the concluding ceremony of the *shabat*. Rabbi Ephraim of Regensburg tells us that he kept them in a special glass vessel. There is no known example of such a vessel dated prior to the mid-sixteenth century, when they were of worked metal in the shape of a belfry. It has been thought that such vessels could be identified in certain illuminations, but close examination of the miniatures and their relation with the text shows that the objects in question could only be drinking vessels. What these receptacles for spices looked like or what they were made of between the thirteenth and sixteenth centuries remains a mystery.

## Implements for Washing Hands

The medieval Jew needed to wash his hands not only when at table, where eating was done with the fingers, but also throughout the day to fulfil the precepts of ritual purity, as we shall see. Every Jewish house, therefore, had a supply of water and appropriate recipients for religious as well as hygienic purposes.

Pots or ewers and basins were commonly used at all periods for the performance of this rite. Water was poured from a pot or ewer over the hands stretched out above a basin. This can be seen in Spain after 1350,[143] in Italy throughout the second half of the fifteenth century[144] and in Germany from the early fourteenth to the late fifteenth century.[145]

Fountains were also used in various countries. These were wide-bellied and of metal, with or without a pair of spouts, and suspended above a large basin on a movable handle that allowed the fountain to be tilted to pour the water. This kind of fountain appears in Spanish pictures of the second half of the fourteenth century.[146] In Ashkenazi countries, in the early fourteenth century, fountains had no spouts;[147] in the middle of the same century, water was taken from them with a bowl.[148] In the early fifteenth century, fountains assume the most functional shape—with two spouts.[149] This is the shape they took in Italy in the second half of the fifteenth century.[150] In the houses of the wealthy in late fifteenth-century Italy, hands could be washed in jets of water that fell into the stone or marble basins of the elegant fountains that adorned the inner courtyard or the vestibule.[151]

## Household Linen

Long towels were used for drying hands. Usually these towels had fringes and, like the table-cloths, were decorated with stripes. In almost all the preceding illuminations, it is apparent

that when not in use the towel was suspended from a bar near the fountain.

Those shown hanging in the kitchen and a room of a house 134 in Aragon in the late fourteenth century [152] are very beautiful, decorated with bands of embroidered or woven designs. Not all may have been intended for ablutions. Some were possibly spare table-cloths—fingers were wiped on table-cloths during meals: communal use of a single dish, the eating of meat without individual plates and wine spilt on the table must have made the table-cloth dirty and rather unappetizing in a fairly short time. However, napkins might also be used to protect clothing while handling food.[153] The person serving wrapped up the hot plates 368 with napkins so that they could be carried.[154] But no guest is shown at any of our tables, even in the late fifteenth century, wearing a napkin at table; the habit was not generally adopted even by the late sixteenth century. Some pieces of linen also served as dish-cloths, but there is only one German picture from the second half of the fifteenth century that shows one being used by a young woman wiping out pots.[155] Together with bedding and table-cloths, which we have already described, and bath towels (of which we have found no trace) napkins and dish-cloths constituted the bulk of the household linen in a medieval house.

## Lamps and Candlesticks

Lighting in houses was provided throughout the period covered by our sources by candles or oil lamps. The lamps our miniatures show suspended in rooms above tables and, more rarely, in bedrooms, evidence the same diversity of types in various countries as the lamps found in synagogues.

In Spain, from the first quarter to the end of the fourteenth 133 century, these were lamps of Moorish type, made of glass or metal.[156]

But towards the middle of the fourteenth century, two other 378 kinds of metal lamp began to appear: one is boat-shaped with a 156 bowl hung beneath it;[157] the other, a *velón*, is in the shape of a stem-cup and has a lid surmounted by a stem that is attached to the chain, while the wicks burn in two lateral spouts.[158] It is difficult to decide whether the lamp painted in gold shown next 133 to a Moorish lamp in a miniature of the Sarajevo Haggada [159] is of the same type, or whether it is the lamp with branches and thus of a third type. The number of branches cannot be

determined, nor can one tell whether this lamp—unique in Jewish illumination in Spain—reflects a regional tradition or was merely borrowed from the customs of northern Jews with whom such lamps were common. A borrowing of this kind might have been facilitated by the fact that star-shaped lamps were already known before this time in the south of France, as we shall see.

Ashkenazi Jews usually used a particular type of lamp from the early fourteenth century [160] right up to the late fifteenth century—examples can be found in the first half of the century [161] and in the second half.[162] This lamp had branches 152 arranged in the shape of a star and under them hung a bowl— a shape already encountered in synagogues of the early fourteenth century. The number of branches seems to vary and is often difficult to determine, since it depends on the illuminator's skill in drawing them in perspective. However, the illuminator of the London Haggada has clearly painted six branches, while no more than four can be seen on the lamps in the Yahuda Haggada and, sometimes, in the Paris Haggada. In bedrooms, on the other hand, a lamp with one wick was used.[163] 124

In late fifteenth-century Italy, hanging in the fire-place of a kitchen, a simple oil lamp with a single wick of a kind widely used since antiquity can be seen; it might be made of either earthenware or metal.[164] But from the mid-fifteenth to the early 149 sixteenth century, lamps shown suspended above tables in living rooms have branches and are star-shaped.[165] These lamps had four or six branches, with a bowl suspended underneath and 368

146 A monumental arm-chair from Italy incorporating shelves and a *scriptionale* (1455–65).
Parma, Biblioteca Palatina, Ms. Parm. 3596, folio 3 verso.

147 A late fifteenth-century Italian study, showing a desk with a revolving ▷ stand capable of supporting two books; an inclined shelf on the wall is used for storing books flat.
Parma, Biblioteca Palatina, Ms. Parm. 3143–De Rossi 958, folio 10 recto.

148 Germany, *c.* 1460–70: water for the kitchen being carried in a big metal ▷ cauldron.
Jerusalem, Israel Museum, Yahuda Haggada, folio 1 verso (detail).

149 The monumental fireplace of a late fifteenth-century Italian kitchen: under ▷ the wide hood are hooks, oil lamps, what appears to be an hour-glass, andirons, and cauldrons on the fire itself. In the foreground, a pauper seeking alms is given a bowl of soup.
Parma, Biblioteca Palatina, Ms. Parm. 3143–De Rossi 958, folio 10 verso.

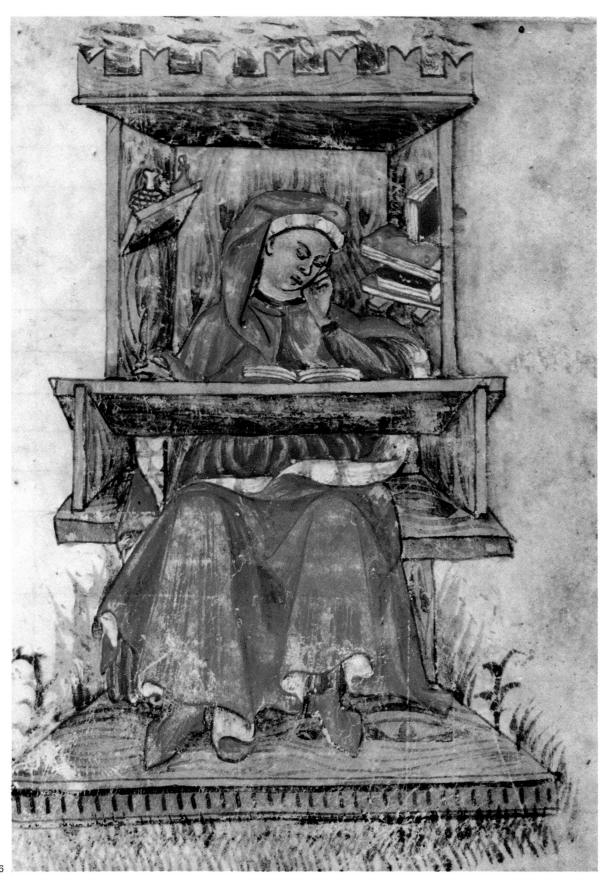

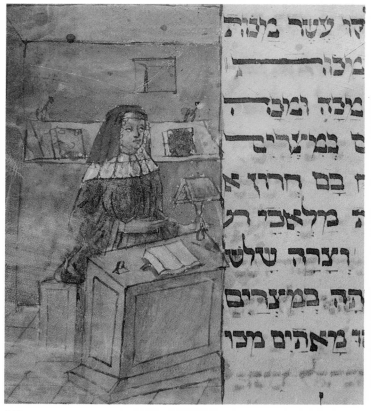

קו אשר מצוה

מצוה ת

מצה ומר

ס במצרים

ח בם חרוז א

ה מלאכד ת

וצרה טלש

תה במצרים

וד מאהים מכו

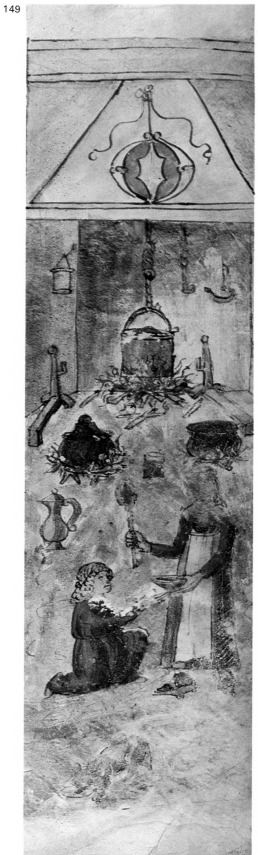

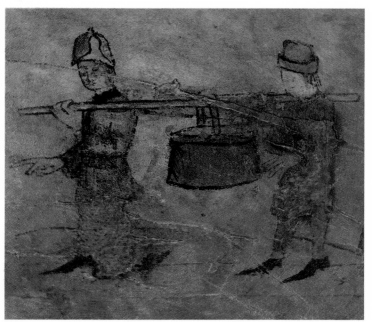

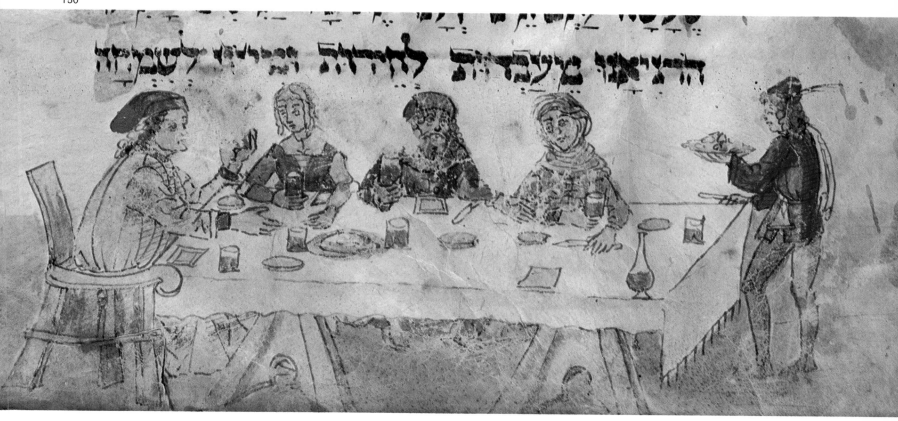

הוציאו מעבדות לחירות ומיגון לשמחה

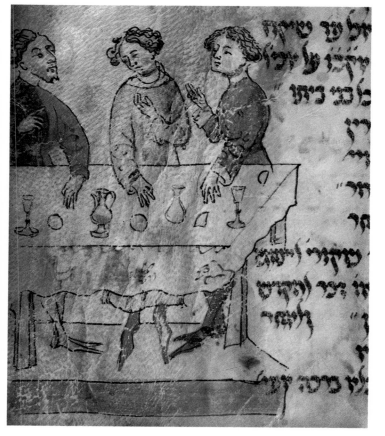

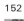

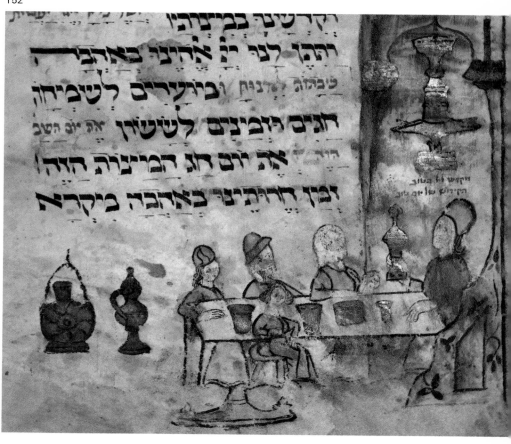

ותרשנו במצותיו
ותתן לנו יי אלהינו באהבה
שבתות למנוחה ומועדים לשמחה
חגים וזמנים לששון את יום הזה
את יום חג המצות הזה
זמן חרותנו באהבה מקרא

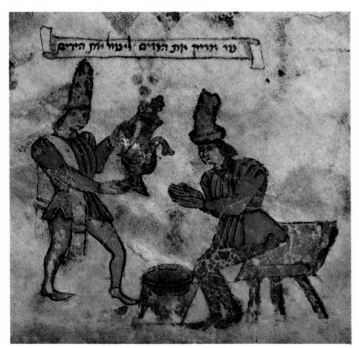

153

154

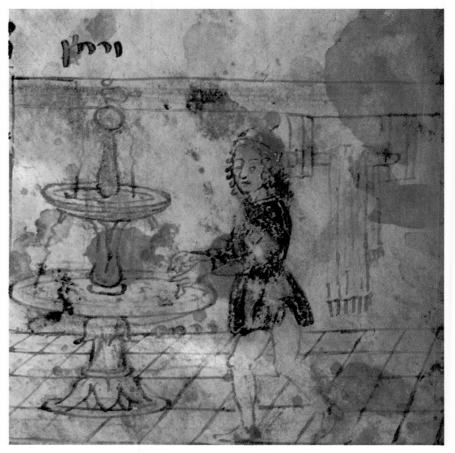

155

156  A Spanish oil lamp of about 1350: made of metal and with a sealed oil reservoir, it belongs to the *velón* type which has a foot allowing it to be stood upright; here, however, it is shown suspended from a vault by a ring. London, British Library, MS. Or. 2884, folio 18 recto (detail).

157  An Italian candlestick of the 1470s: its two arms are attached to a shaft rising from a large circular base which itself rests on three short legs. Jerusalem, Israel Museum, Ms. Rothschild 24, folio 156 verso (detail).

were thus similar to the Ashkenazi lamp, a type which they certainly copied and which was imported to Italy by the many German Jews who were driven from their country of origin by persecutions at this time.

Candles were used in Italy after 1450 for lighting synagogues, but there is no indication that they were used in private houses. Only in Ms. Rothschild 24 (1460–70) are lighted candles seen on 157, 337 a number of tables in two-branched candlesticks.[166]

Lights played a central rôle, both symbolic and ritual, in the life of pious Jews. They are the symbol of the soul and of life. The *shabat* and holidays begin with a blessing over the lights, lit before nightfall, while another such blessing concludes the rites on these days.

It happens that in almost all our pictures of the star-shaped lamp (certainly in all German and Italian representations) it is shown burning above the *seder* table, especially for the ceremony that concludes the *shabat*, which coincides with the beginning of the holiday.[167] The lamp cannot therefore be considered simply as a household accessory, because its ritual function made it mandatory for Jewish home ceremonies. The lamp may not have been lit during the week: most probably only candles or more simple lamps were used then.

156                157

◁ 150  Northern Italy in the late fifteenth century: decanters and goblets of glass on a table with carved trestles, and a light movable arm-chair. Parma, Biblioteca Palatina, Ms. Parm. 3143–De Rossi 958, folio 12 verso.

◁ 151  Delicate glass decanters and elegant stemware on an Italian table of the late fourteenth century. Jerusalem, Schocken Institute, Ms. 24085, folio 29 recto.

◁ 152  Germany, *c.* 1460–70: an oil lamp of metal with branches arranged like a star, and a bowl suspended underneath it; the table is supported on two legs, each with a wide transverse base; also seen are cups with lids and metal goblets, gourd flasks and ewers with lids. Jerusalem, Schocken Institute, 2nd Nuremberg Haggada, folio 4 verso (detail).

153  Germany, 1460–70: a ewer, basin and towel being used for the ritual ablution of the hands. Paris, Bibliothèque Nationale, ms. hébr. 1333, folio 5 recto.

154  Italy, first half of the fifteenth century: a vase of metal for flowers. Florence, Biblioteca Medicea Laurenziana, Ms. Plut. 3.10, folio 178 verso (detail).

155  Late fifteenth-century Italy: hands being washed at a jet of water from a fountain of tiered basins; hanging on the wall is a fringed towel. Parma, Biblioteca Palatina, Ms. Parm. 3143–De Rossi 958, folio 3 verso.

However wealthily furnished, Jewish houses had to have a store of wax candles, since these were used for ritual as well as secular purposes. The candles in candlesticks shown in Ms. Rothschild 24 are, therefore, those lit before holidays, and the candlesticks were also objects used in the cult at home. Wax candles were required for the rite of *bediqat-ḥamez* (the search for   138, 143 leaven) before Passover.[168]

In Spain, by the second half of the fourteenth century, the *havdala* blessing was recited not over lamplight but over candlelight;[169] moreover it was said over a plaited candle with several   366 wicks, as the rite prescribed.[170]

There was yet another oil lamp in the Jewish house, the one lit for the feast of *ḥanuka* (the feast of the Temple dedication, also called Feast of Lights). This lamp, which according to Meir ben Baruch of Rothenburg (*c.* 1215–93) should preferably be of metal, was usually suspended on the opposite door-jamb from the *mezuza*, that is to say to the left of the door, for the eight evenings of the feast. Because of persecutions, however, the rabbin allowed it to be suspended inside the house near the door

in case of danger. We know too that Menahem ben Solomon Meiri (1249–1316), an influential rabbi from the south of France, accepted the use of the lamp with star-shaped branches, though the lamp had to have eight branches.

The only illustrations of the domestic *ḥanuka* lamp to be found in our manuscripts are Italian and show lamps of the first type: a mural lamp with eight bowls in a row. One of these lamps, 371 depicted in a manuscript of 1374, is made from a long narrow sheet of metal, with typically Italian crenelations on the upper part, in front of which are fixed a line of eight bowls with spouts.[171] Another, from the last quarter of the fifteenth century, is made up of eight metal lamps with a single wick suspended from small arms attached to a horizontal bar.[172]

In an Italian manuscript of 1397 there are separate Moorish-type lamps for the *ḥanuka*.[173] It must not have been forbidden to use separate lamps, placed side by side, up to the number of eight on the last day.

Hardly any medieval *ḥanuka* lamps have come down to us: four or five, probably from the fourteenth century, and scarcely more from the fifteenth. The earliest lamps must have been Ashkenazi. They were wall lamps decorated with Gothic arcades and openwork rose-windows on the triangular pediment below which the bowls were attached, or with monsters and beasts in relief that closely resemble those found in various Hebrew Ashkenazi manuscripts from the fourteenth century. Fifteenth-century lamps come chiefly from Italy and Sicily; however, none of them are like those in our Italian manuscripts. Not until the sixteenth century do crenelations reappear on the upper part.

## Comfort and Decoration

Only written sources refer to wall paintings with biblical subjects, such as the sacrifice of Isaac or the combat between David and Goliath, which decorated the interiors of the houses of rich medieval Jews. Those who had the means adorned their houses with hangings, curtains, cushions and carpets for preference, to make them more comfortable and attractive. In bedrooms we have already met hangings on the wall and curtains screening off the beds. Walls in other rooms, such as the 378 main hall in Spain shortly after 1350, also had hangings.[174] The position of the chair of the head of the house, in Italy as in Spain, 188 was emphasized by hanging fabrics on the wall behind it,[175] by

draping them over it as a canopy[176] or by using them to cover the back, arms and seat of his chair.[177]

Cushions were used on beds, to make them more comfortable, as well as on seats, but the flowing clothes of the people sitting on them usually prevent them from being seen clearly. Those that are visible (usually in Italian illuminations) show that cushions were used for a variety of purposes. A domestic pet —a tame squirrel—is seen on one.[178] Mourners put them on 347 the ground to sit on,[179] or the *seder* basket might be placed on one.[180]

Cushions also had a ritual function at the time of the *Pesah* feast. The master of the house leaned his elbows on them as he 133 presided over the *seder*.[181]

Another particularly luxurious item was an oriental carpet, spread out over the floor tiles. Examples are only seen in Italian manuscripts of the second half of the fifteenth century.[182]

The wealthy of fifteenth-century Italy also sought to decorate 194, 381 their homes with vases of wrought metal for keeping cut 154, 158 flowers.[183] Shrubs planted in pottery bowls were kept on window ledges or in the bays of the galleries of each floor.[184] In 194 the late fifteenth century, on the holiday eve, a rare refinement was to place a sheet of polished metal, elegantly shaped according to the classical tastes of the period, as a *tabula ansata* behind a star-shaped lamp so as to reflect more light.[185]

At first sight, it might appear that the furnishings and decoration of Jewish houses was little different from that of the neighbouring Christian houses. However, let us suppose that

some natural catastrophe had preserved a medieval 'Pompeii' and left intact Jewish houses and possessions, disregarding the fact that pillage, dispersion, confiscation and destruction had wiped out almost any trace of them before this. In examining the furniture, tableware and everyday utensils, which barely allow one to do more than distinguish between different social levels, what would serve to identify the Jewish houses? Very little, it is true. On the negative side, there is the absence of any pious image, relic or devotional book associated with Christian practices. On the positive side, one might be struck—perhaps to a greater degree in the houses of the more wealthy—by the tendency of Jewish households to have so many precious cups and basins for washing. Apart from a few books in Hebrew, one would also have come across peculiarly Jewish objects that for the most part have not survived in the original and are all too rarely seen in our miniatures: the *mezuza*, the *ḥanuka* lamp, sometimes a star-shaped oil lamp, perhaps even a receptacle for spices or a plaited candle, discrete but irrefutable evidence of the customs, religious rites, faith and cultures of the Jews who lived in these houses.

# IV   Costume

Because the Jews formed a distinct community within the society in which they lived, it is interesting to speculate about the clothing they wore in the West, particularly between the second third of the thirteenth century and the early sixteenth century, the only period in the Middle Ages for which Jewish illumination provides evidence. Did the Jews show any preference for certain kinds of clothing that would distinguish them from their Christian neighbours? Did they preserve, after their dispersion and exile, traditional forms of dress perpetuated over the centuries and maintained in the various places where they lived? And finally can our illuminations provide a primary source for ascertaining information about the 'marks' which, on many occasions and almost everywhere in the Middle Ages, Christian society obliged the Jews to display on their clothes? For the history of costume our sources are more than abundant, since every picture in which people appear shows details of dress. In order to answer the preceding questions, rather than analyze all the documentation available, we shall select a choice of the most characteristic illuminations that are dated or datable and whose geographic origin is more or less established.

## Jewish Costume in Spain in the Fourteenth Century

In the first quarter of the fourteenth century, probably in Castile, the illustrations of MS. Or. 2737,[1] show us that men wore clothes that differed according to their rank or occupation.

113-14
140, 214
Labourers, craftsmen and servants, and the more humble folk generally, wear a short tunic or *cote* that scarcely reaches down beyond the knee and is held in at the waist by a cord or thong hidden in the folds of the garment. The sleeves are narrow at the forearm and wide at the arm-holes. Brightly coloured *hose* cover their legs. On their feet are soft black shoes that rise above the ankle. Hair was worn short, but it covered the ears and was curled with an iron at the level of the neck; long wavy hair is rarely seen.[2] Usually a short curl of hair falls onto the forehead, beards are not common.[3] Most people are bare-headed,[4] but 159 some wear a coif or *cale*, a piece of white linen that covers the 140 head and is fastened under the chin.[5] Others wear a flat toque[6] 113 or a short hood called a *chaperon*, the peal of which is held up by a stay and falls forwards.[7] The *chaperon* can also be draped over 139 the top of the head where it forms a kind of crest.[8] There is also

a cloak with a peaked hood, the short peak falling backwards. 111, 142 This cloak is short in the front and comes to a point behind.[9]

At a higher social level (that of notables, students and teachers), the tunic or *cote* becomes longer and may be covered by a long cloak draped over the shoulders.[10] These people also 331 wear a *garde-corps* with a hood hanging back over the shoulders; this is a garment with long wide sleeves having holes for the arms halfway down so that part of the sleeves are behind the arms; vertical stitching beneath the shoulders keeps the sleeves at the proper height as they drape down in folds.[11] A master teaching and a notable are wearing a *houce*, a garment that is very wide at the shoulders with arm-holes open to the elbows; it forms a cloak over the arms and has a hood.[12] Hair, worn either short and curled or long and wavy, is sometimes covered by a flat toque with a small turn-up.[13] Beards, worn rather short, seem to be an attribute of age and dignity.[14]

All women and girls wear a floor-length tunic or *cote* with long 160, 253 sleeves; it is loose over the top of the body and held in at the waist with a cord. Girls' long wavy hair falls freely, held in place only with a thin diadem.[15] Married women cover their hair with a short shoulder-length veil.[16] Some women wear a tall hat of pleated cloth with a gorget,[17] and sometimes they have a long cloak on their shoulders.[18]

No great changes were made in the clothing of the Jews of Aragon as late as around 1330. The illustrations in MS. Add. 27210 show merely a greater variety of forms of dress.[19]

For the men, the tunic or *cote*—both long and short—is again a mark of social rank. The short version, sometimes worn under an apron, is particularly suited to the work of craftsmen[20] 112 and servants.[21] Boys also wear this kind of tunic.[22] Under it, 318 coloured hose with black shoes or the more fashionable black hose with soles can be seen. A short hooded cloak was worn over the tunic.[23]

The long tunic *(cote)* had tight sleeves when worn as an under-garment and wide sleeves when worn over the other 143 clothes.[24] Over the *cote* men often wore a long cloak attached at the shoulders[25] and fastened with a fibula[26] or knot, usually on the right shoulder.[27] A kind of dalmatic is also found: a garment without sleeves that is open at the side.[28] Some men wore a large hooded cloak that is draped over the arms, there being no arm-holes,[29] or a *gonelle*, a hooded cloak open at the front.[30]

Whatever their social rank, all men wore their hair similarly: more or less short and wavy but with the ears covered and short curls on the forehead. Beards varied in length and were a mark

of age or dignity.[31] If not bare-headed, men wore a coif or *cale* alone,[32] sometimes with a flat toque in a variety of colours on top of it,[33] or the flat toque alone was worn.[34] The short hood or *chaperon* was also encountered; its peak was brought round and fixed at the front,[35] or it was draped from the peak of the coif or *cale*.[36] There were also hats with brims that came to a point over the eyes[37] or at the neck.[38]

A few pictures illustrate something of men's underwear: a white linen shirt reaching down almost to the knee[39] and breeches or *braies*, a type of underpants, also of linen, that cover the thighs and are held at the waist by a belt called the *braiel*.[40]

Besides long tunics or *cotes*, which were loose above the waist and sometimes held in with a belt,[41] women also wore close-fitting tunics with laces at the sides and full, trailing skirts.[42] Through the lacing, a tunic of a different colour, worn as an undergarment, was visible. The tunic with laces, the *saya encordata*, was typically Spanish. Over the tunic a surcoat could be worn; it was very long, without sleeves and also close-fitting.[43] Girls went bare-headed, their hair falling to their shoulders.[44] Married women wore a short white veil,[45] and the older ones a wimple.[46] Occasionally women might wear a long cloak on their shoulders.[47]

New-born babies were entirely covered from head to foot in swaddling-clothes.[48]

At about the same date, MS. Ryl. Hebr. 6[49] and MS. Or. 1404[50] depict clothing that is still very similar to what we have described. Black hose with soles are now worn generally; the short hood is perhaps found more frequently, usually worn as a cowl or, more rarely, draped over the head.[51] A new kind of head-dress for women appears: a small round hat made up of

cloth twisted into two fillets of piping, one on top of the other, sits right above the forehead, on the linen head-dress or *couvre-chef* that passes under the neck to form a chin-piece or *mentonnière*.[52] This head-dress may be made up entirely from the same cloth, in red for instance.[53] A variant shows the chin-piece or *mentonnière* twisted into piping too.[54] Women wear their hair hanging down their backs, but it is kept in place by a hair-net over the ears.

The lines of small buttons that fasten the very tight sleeves of both men's and women's tunics can be seen very clearly.[55] The surcoats of men and women are fairly loose, with sleeves that flare out as they fall behind the elbow.[56] Men still often wear a *houce* with short sleeves.[57] A detail, which was to become characteristic, is the tabs in the slits of the neck-lines.[58] Women's surcoats with high waists and low necks are decorated around the neck and the middle of the bust with a rich ribbon[59] or large buttons of precious metal—the most luxurious ornaments of the time.[60]

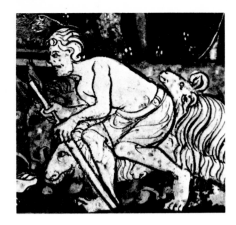

161 Aragon, *c.* 1320–30: men's underwear, *braies* or underpants secured by the *braiel*.
London, British Library, MS. Add. 27210, folio 13 recto (detail).

162 Aragon, *c.* 1350: Jews on a journey wearing the cloak or the *surcot* with sleeves flaring from the elbow, and hats with brims and crowns of varying size. London, British Library, MS. Or. 2884, folio 10 verso (lower register).

Clothing in the 1350s and in the third quarter of the fourteenth century can be seen in a group of manuscripts, probably from Aragon, of this date: MS. Or. 2884,[61] the Sarajevo Haggada,[62] Ms. Bologna 2559,[63] the Haggada Ms. Sassoon 514,[64] and MS. Add. 14761.[65] We shall only refer to the new types of dress shown there.

Men's outer garments are of three types. The *garde-corps* with folded sleeves that hangs behind the arms was now rare,[66] and gave way to two new shapes for this piece of clothing. The first one varies in length and consists of two flaps with bands fixed to the shoulders.[67] The other one, the more common form, was rather like a surcoat, with sleeves flaring behind the elbow; generally, there were two slits in the front (the fitchets) which allow the wearer's hands to be slipped under the garment.[68] This piece of clothing was often worn with the short hood *(chaperon)*, its cape covering the shoulders.[69]

The *houce* in its usual form was also worn, making a cape over the shoulders and having wide slits under the arms.[70] However, the most popular shape for this garment was the one described about 1330: lined with another material or with fur, its funnel-shaped sleeves reaching down to the elbow, its arm-holes long enough to permit the arms to be kept inside. Decoration on the front sometimes consisted of two small lapels,[71] or more usually of two flaps, rounded at the end, that are turned back to display the cloth or fur of the lining.[72] The *houce* was usually worn with the short hood, and the cape of the latter was then tucked under the *houce*.[73]

Men wear long capes, usually without openings, but sometimes with a slit in the front. They are gathered at the neck and have a short hood joined to a long peak. These capes are even worn by small boys.[74]

The flat skull-cap [75] was still worn as well as the short hood *(chaperon)*, worn over the head or draped about it to make a crest, while the liripipe fell over the shoulder.[76] Nevertheless, these were often abandoned on journeys in favour of a whole range of hats of various heights with turned-up brims.[77] A white nightcap was worn to bed.[77a] Beards, when worn, were pointed and sometimes quite long,[78] though usually short.[79]

The only underwear depicted was knee-length breeches or *braies*.[79a] Shoes that cover the ankle seem to be most popular, and they were worn over coloured hose.[79b]

There were new items, too, in women's clothing. Over the long tunic *(cote)*, women and girls wear a surcoat with elbow-length sleeves,[80] though there are some extended by long narrow

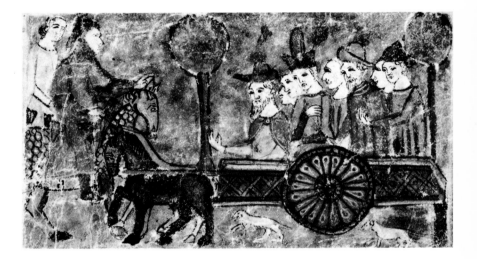

cuffs, mostly lined with fur, that fall down freely and thus lengthen the sleeves.[81] The open surcoat, that was evolved in Spain in the preceding century and was to cross the Pyrenees and become a style adopted at the court of France, is only seen in a single illumination.[82] The wide openings down its sides, reaching below the hips, were usually bordered with fur. The openings on the side, around the neck, and in the middle of the chest in our illumination are deocrated with gold ribbon. Women wore a long cloak over their shoulders that fastened round the neck.[83]

Married women had a number of head-dresses. Following contemporary Spanish fashions, the chin-piece *(mentonnière)*, twisted into piping, encircled the temples and was attached above the forehead with a buckle or a piece of jewellery, thus making a frame all around the face.[84] Hair was gathered behind the head. But it is also common to see a head-dress *(couvre-chef)* of fine linen covering a woman's neck and head, held in place by a head-band of the same material.[85] Long-tasselled ribbons with fringes were sometimes attached to the backs of these head-dresses.[86]

In a picture of a mother giving birth to a child, we see the long undershirt of white linen and knee-length stockings [87] which were both common feminine attire.

Fur, known to have been frequently used and to have lined most outer garments, is rarely worn by the Jews of our Spanish illuminations. However, there are men wearing formal cloaks

113

one case, long narrow valances *(pentes)* are attached to these cuffs.[99]

Young men, too, wear a tunic *(cote)* that fits tightly around the waist and is padded over the chest; these tunics are either knee-length or much shorter, not reaching below mid-thigh. The tunics are buttoned down the front and have a belt, worn low; the most elegant belts are in two colours.[100] These clothes belong to the tradition of jerkins *(jaques)* and *cote-hardies* so fashionable from the 1340s in Western Europe, though they lack the exaggerated narrowness and excessively short skirt. In this version the skirt is flared and even seems to be pleated.

The most notable change occurred in hair styles. Girls still have long uncovered hair, but it is often parted in the middle to form plaits and attached behind the neck. Men part their hair and do not let it grow below their ears. Beards are short and forked, moustaches narrow and drooping.[101]

Shoes, following prevailing fashions, are longer and more pointed. The top of the foot is often left bare, and the shoe is done up with a strap.[102]

## The Attire of Jews in France in the Thirteenth and Fourteenth Centuries

The illustrations of Cod. Vat. ebr. 14,[103] dated 1239, are much too rough and schematic to allow us to identify particular types of dress. All that can be clearly recognized is the conical cap worn by men with its peak bent backwards slightly.[104]

The only source of information on the clothing worn by Jews in northern France dates from the late thirteenth or early fourteenth century and comes from MS. Add. 11639 in London.[105]

In the late thirteenth and early fourteenth centuries, differences in dress between men and women were not great. Both wore the tunic *(cote)*, though the man's might be either long or short, while the woman's was always long. The tunic was quite a loose-fitting garment, sometimes held in at the waist by a belt below which it hung in loose folds. The sleeves were tight at the forearm but loose over the rest of the arm and at the arm-holes.[106] Over this garment, men sometimes wore a second tunic *(cote)* with wide sleeves that might or might not be drawn in around the waist.[107] This last type of tunic might also be worn

lined with fur and having a fur cape or *camail*[88] or short hoods *(chaperons)* lined with fur; when these are raised and pushed back on the forehead, the face is framed in fur;[89] thrown back over the shoulders, they make a kind of collar around the neck.[90]

134, 163    In the last quarter of the fourteenth century, the Kaufmann Haggada[91] shows that the same kind of clothes and head-gear were still being worn. Men are seen in tunics *(cotes)*, in *houces* with tabs at the neck-lines and funnel-shaped sleeves,[92] in long capes with hoods,[93] and in cloaks.[94] Still recognizable are draped short hoods and tall hats with brims.[95]

Shirts are thigh-length and slit at the sides with long sleeves.[95a] Hair is still covered with a nightcap during sleep.[95b]

163    Married women also wore a wide cloak over their long tunics *(cote)* that hid much of the neck,[96] and their heads and necks were covered by a head-dress *(couvre-chef)* of white linen. Some women wore a chin-piece *(mentonnière)* of piping as well, fastened in the middle of the forehead.[97] For journeys a hat with a peak that fell forward and a brim was put over the head-dress *(couvre-chef)*.[98]

Girls, however, wear surcoats that are cut lower around the shoulder, close fitting at the bust and waist, and that flare out in a skirt with many pleats. There are no side-openings, but there are slits in front for the hands. Some surcoats are slit to show the entire skirt; others have a row of small buttons in front from top to bottom. All have very tight sleeves ending in wide cuffs. In

without a belt and without the inner tunic with tight sleeves underneath.[108] Women wore a sleeveless surcoat over their tunic.[109] Men and women both wore a big round cloak, attached around the neck with a clasp or *fermail*,[110] or a rectangular cloak draped over the shoulders; its gathered folds were held in place over the chest by the forearm.[111]

Women's head-dress varies according to the series of miniatures studied. In the earliest, women wear the head-dress *(couvre-chef)* directly on their hair[112] or draped as a chin-piece *(mentonnière)*, covering the ears and attached at the top of the head with a head-band or circlet of the same material. Hair was swept back and enclosed in a hair-net, the *crépine* ('fringe').[113] In a later miniature, under a head-dress made up of a chin-piece and a head-band (both much narrower than those mentioned hitherto), the hair was gathered under the hair-net into two bunches at either side of the head, in imitation of a fashion that spread from England in the years around 1300.[114] In the latest illustrations from the first quarter of the fourteenth century, girls are bare-headed as always, and married women wear a head-dress *(couvre-chef)* draped over their heads and under their chins so as to cover neck and head completely—an ancient practice that remained popular for quite some time.[115]

Throughout the period, men mostly went bare-headed. If they wore head-gear at all, besides a coif *(cale)*[116] or the occasional short hood *(chaperon)*,[117] they preferred a hat with a conical crown which, judging by its drooping peak, was made of soft cloth.[118] Hair was short, curled around the ears, and the forehead was bare.[119] Around 1300 and later, men's hair was often curlier, their beards longer and fuller.[120] But it is difficult to determine whether these differences correspond to a change in fashion or merely to a new style of illumination.

The evidence regarding the clothing of Jews in southern France is problematic. Although the Wolf Haggada[121] was probably copied in Avignon in the last decades of the fourteenth century, it is not certain that the illuminations, all of which are in the margins, were also done there. However, the figures shown in it—all men—have full beards and wear a *houce* with long arm-holes that forms a cape over their arms. Through the arm-holes, the tunic *(cote)* can be seen, fastened around the waist with a belt.[122] The short hood is still worn and can sometimes be seen hanging outside other clothing, but usually it is tucked inside,[123] leaving visible the rounded tabs at the neck-line which are well-known from Aragonese illuminations of the second half of the fourteenth century.

# Jewish Clothing in Germanic Lands, from the Thirteenth to the Late Fifteenth Century

The earliest manuscripts, Munich Cod. hebr. 5,[124] and Ms. Milan B. 30-32. Inf.,[125] dated 1232 and 1238 respectively, are illuminated in rather different styles: one is angular, and the other is done with sinuous lines; however, both show the same kind of clothes—those commonly worn at this date and throughout the thirteenth century.

In the first manuscript, the men wear tunics *(cotes)*—short, medium-length or long—spilling over a narrow belt at the waist and a cloak attached at the right shoulder with a clasp *(fermail)*.[126] Women wear a long tunic, a cloak over both shoulders, and a head-dress *(couvre-chef)* covering head and neck.[127] Coloured hose are worn, as well as delicate shoes, open at the top of the foot and fastened at the ankle.

Men's hair is rarely shoulder-length, and beards are short. Hats have a wide flat brim and a very narrow crown, thus resembling an upside-down funnel.[128]

In the second manuscript, surcoats with flowing sleeves[129] join the long, wide tunics.[130] A large lined cloak was worn over the shoulders,[131] or a rectangular cloak could be wrapped around the body and the left shoulder.[132] Only black hose with soles are in evidence.

Women wear a head-dress *(couvre-chef)* draped so as to form a chin-piece *(mentonnière)*.[133] Men have a skull-cap with piping round the edge.[134]

Surviving miniatures show that, in the last decades of the thirteenth century and in the early fourteenth century, costume was still essentially unchanged from what it had been in the first half of the thirteenth century: tunics of variable length, coloured or black hose, surcoats and cloaks. If we were to try to arrange chronologically the costume of a Jew portrayed in 1272,[135] that of a Jew in the years around 1300[136] and that seen in an illumination from around 1320,[137] not knowing those dates, we would only be able to do so by noting the stylistic differences in the treatment of almost identical subjects.

However, the head-gear of both men and women merits closer examination. The figures just mentioned all have inverted funnel-shaped hats, as do people shown in other manuscripts, for example in the Schocken Bible,[138] the Birds' Head Haggada[139] and the two Budapest *Mishne Tora*.[140] Whereas, in

200

336

339, 168, 306

164 Burgundy under the Holy Roman Empire, *c*. 1300: the *chaperon* worn right over the head, its skirting covering neck and shoulders to leave only the face exposed. The specimen shown here has a rather short *cornette*, or liripipe, pointing forwards, and is worn over a coif.
Parma, Biblioteca Palatina, Ms. Parm. 3191–De Rossi 264, folio 159 recto.

some manuscripts, such as the Birds' Head Haggada and the Regensburg Bible, this kind of hat appears to be what Jews wore all the time, in other manuscripts it only seems to be the most popular among a number of hats—this is the case in the London *mahzor*, MS. Add. 22413 [141] and in the Budapest *mahzor* [142]—two parts of the same manuscript. In yet other manuscripts, such as the Schocken Bible mentioned above,[143] this hat appears only occasionally. In the latter manuscript, the hat most favoured has a brim that comes to a point in front,[144] a type also seen occasionally in the two preceding manuscripts alongside the inverted-funnel hat.[145]

On the other hand, in the illuminations in a manuscript of 1310 [146] no Jews wear this inverted-funnel hat; they only wear a short hood (*chaperon*), a piece of head-gear that appears rarely in the manuscripts of this date but does still appear, for example, in the Parma Bible.[147] The short hood was worn right on the head, its liripipe (*cornette*) falling freely in back [148] or hanging forward supported by a stay.[149] The short hood was also placed on the head with the liripipe at a peak hanging forward and the rest draped behind as a crest.[150]

There are only a few pictures of the head-dress worn by women, some of a popular type, others more uncommon. In about 1300, Jewish women wore chin-pieces (*mentonnières*) and a head-band with a fluted top edge, both very narrow as prescribed by contemporary fashions. Hair was divided into two masses, one on either side of the head, and kept in a hair-net. This hair style was adorned with a jewel fixed at the front.[151] There is often no more than the hair-net [152] or a head-scarf covering the hair and knotted in the middle of the forehead.[153]

In the Regensburg Bible, also datable to about 1300, women wear a head-dress (*couvre-chef*) draped around the neck and head or circlet (*touret*) of embroidered material; from it hangs a cape that falls past the women's cheeks and covers their shoulders.[154]

Around 1320 there is little change: women's hair was worn in two masses, one over each ear, and covered by a hair-net;[155] the plain head-dress worn directly on the head was still in style.[156] Instead of falling freely, the flaps of the *couvre-chef* were held in by a cloak fastened around the neck by one, two or three buttons. Head-gear in the 1340s was the same: hair-net and *couvre-chef*.[157] But in 1348, a head-dress that encased the head was common, and its very short pleated flaps framed the hair plaited over the ears.[158]

In the 1340s, there were some innovations in men's fashions. Men wore short tunics (*cotes*) with hanging sleeves that flaired

towards the bottom,[159] but a loose robe with full funnel-shaped sleeves, rather like the *houce*,[160] was also encountered. The accompanying head-gear was the short hood (*chaperon*), worn with the cape tucked under the robe or draped around the head.[161] A garment of the same type in the Dresden *mahzor* [162] is more luxurious; it is lined with fur and slit down the sides to show the lining that also appears on the hood folded back to make a collar. Other head-gear includes the coif (*cale*), the toque with a brim, the peaked hat and the funnel-shaped hat.[163]

There are almost no illuminated manuscripts of Germanic origin capable of giving us information about the dress of German Jews in the second half of the fourteenth century.

A miniature of the late fourteenth century [164] only shows us a child in a loose, short tunic and short black half-boots. His master is dressed in a long robe with full sleeves reinforced with ribbon around the arm-holes and wears a flat toque with a small brim. His short hair covers his ears, and his beard is pointed. In a drawing of the same period,[165] there is a Jew dressed more traditionally: a robe with wide elbow-length sleeves worn over a tunic, the sleeves of which are buttoned tight over the forearms. This man is wearing a short hood and has a forked beard.

165 Costume of Spanish Jews in the 1330s: *cottes* with tight sleeves fastened by small buttons, and *surcots* with flaring sleeves barely reaching beyond the elbow; the woman's *surcot* has large decorative buttons of precious metal down the front; a *chaperon* is draped over the man's head; the woman's head-dress consists of a hairnet, a *couvre-chef* fastened under the chin like a *mentonnière*, and a very small bonnet with two layers of piping; black hose with soles are also worn.
Manchester, John Rylands University Library, MS. Ryl. Hebr. 6, folio 19 verso (detail: lower register, on the left).

166 Costume of Jews from Aragon, third quarter of the fourteenth century: ▷ *cotte* with sleeves tight over the forearm and fastened with small buttons; *houce* with flaring sleeves, low-cut arm holes split under the arms, and a pair of tabs on the neckline. The latter garment is worn over the *chape* of the *chaperon*.
Bologna, Biblioteca Universitaria, Ms. 2559, folio 5 recto (detail).

167 Costume worn by Jews from northern France, early fourteenth century: ▷ *cotte* with sleeves tight over the forearm for both men and women; men have an outer *cotte* with sleeves, while women are seen in a sleeveless *cotte*; for head wear, married women have a *couvre-chef* draped over head and neck, and men a soft pointed hat; on feet and legs are black hose with soles.
London, British Library, MS. Add. 11639, folio 741 recto.

168 A German Jew, *c*. 1320–5, wearing a *cotte*, cloak, coloured hose, dark ▷ shoes, and the inverted funnel hat commonly worn by Jews in German lands.
London, British Library, MS. Add. 22413, folio 148 recto (detail).

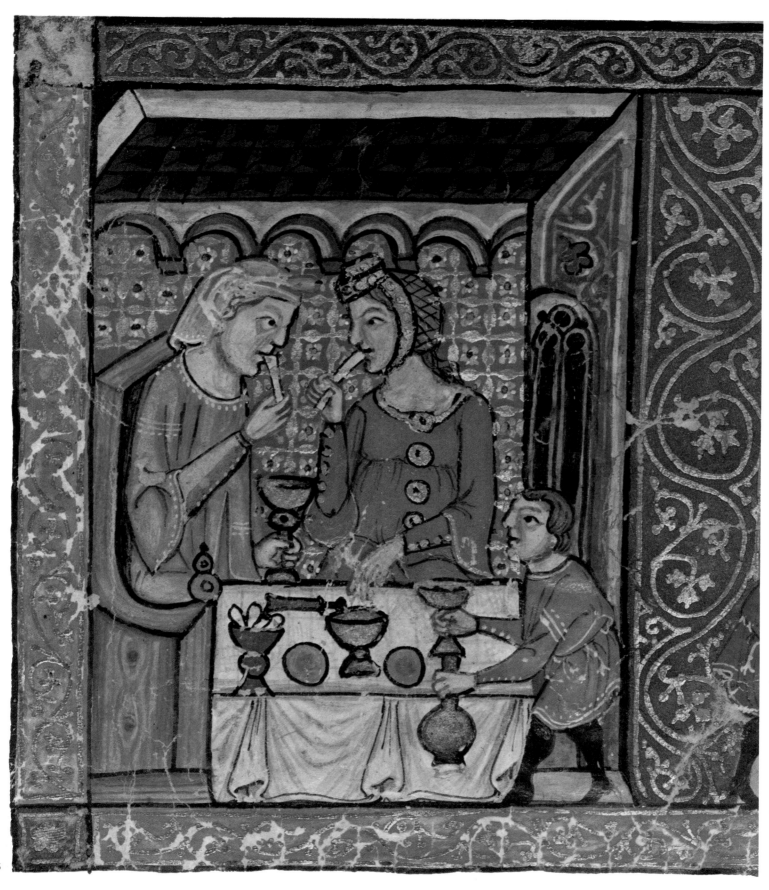

166

167

168

169

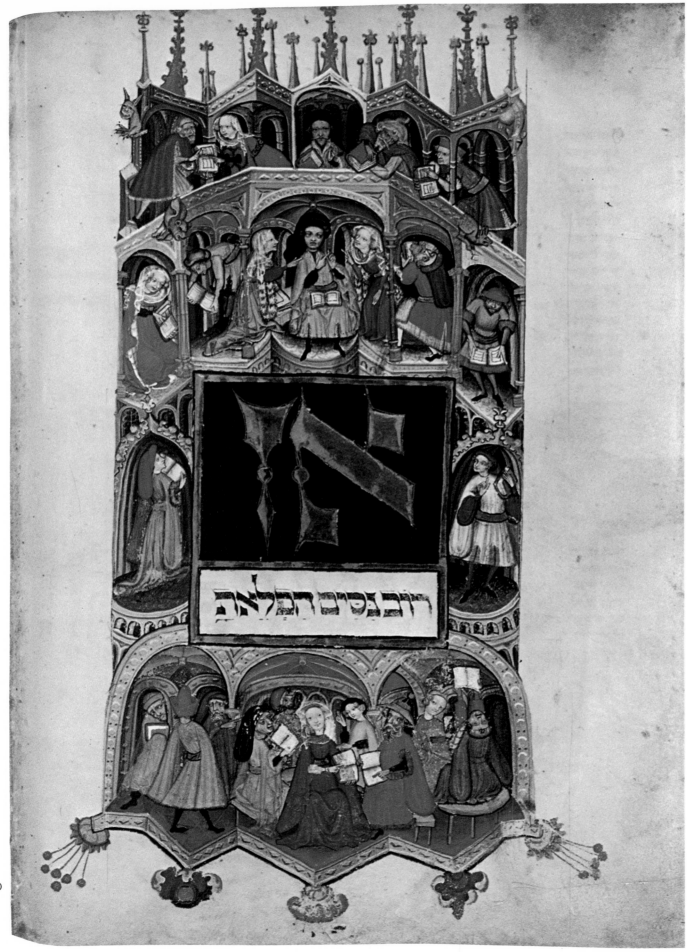

There is more information about the dress of German Jews in the fifteenth century. For the early part of the century, the most remarkable manuscript—the Darmstadt Haggada,[166] which must date from the second decade of the century at the latest —depicts people wearing extremely refined contemporary clothing as well as people in more ordinary dress.

Men might wear only a long robe with wide sleeves, tight-fitting at the wrist and having a belt around the waist. They also wore over it a flowing gown with round bag-shaped sleeves and a hood.[167] More luxurious robes, coming right up to the neck and without a hood, had the same long and round bag-shaped sleeves, but the openings for the arms in the upper part of the sleeves were lined with fur,[168] as was the whole garment in all probability. These robes were very loose, trailed on the ground and were held in at the waist by a goldwork belt. The same kind of robe can also be encountered in a shorter form, no more than knee-length. These were held in at the waist by a belt of precious metal, below which were slits in front and behind the knees.

The sleeves were long and bag-shaped, or short and tight-fitting. The bag-shaped sleeves had fur borders at the slits and the openings for the arms. The wide cuffs on the short sleeves were also of fur, as was the decorative band of varying width at the bottom of the garment.[169] Some gowns, slit at the neck to make a small V-neck with lapels, had long, trailing sleeves that were open.[170] Another version had long sleeves hanging behind the arms with the same 'organ-pipe' folds as those in the skirts of the garment. These sleeves reached to the hem of the garment. Such garments are termed *Tapperten*; their shape derives from

the late-fourteenth and early-fifteenth-century French over-gowns called *houppelandes*.

The head-gear worn with these garments is extremely varied: caps with soft peaks, skull-caps, toques with a brim, a hat with a high turned-up brim and a crown either like a sugar-loaf or tapered and bent, hoods *(chaperon)*, and funnel-shaped hats.[171] At this period it is worth noticing that the shape of the hood was modified: a long narrow liripipe was not usual; the hood was shaped like a long soft cap, its bottom, wide and rounded, rolled up round the opening for the head and falling over the shoulders or down the back. Though this is not shown in our miniatures, the hood was also often folded back over the head instead of being left hanging down. The funnel-shaped hat continued the change it had begun in the first half of the fourteenth century: above a flat brim, the crown, which is wide at the bottom, tapered towards the top and was surmounted by a ball, giving it an even stranger appearance.[172]

According to their age, men were either beardless, clean-shaven or had a short beard and tapering moustache. Hair was worn short and curling over the ears, or longer and rolled around the head.[173]

Shoes and hose with soles are in the *poulaine* style, with pointed but hardly elongated toes.[174]

Women also wore long tunics *(cotes)* with sleeves that were tight at the wrist, and long, flowing overgowns called *houppelandes*. Sleeves were varied: either full, open down their length and bordered with fur, or long and bag-shaped with round openings towards the top, sometimes bordered with fur.[175] Women also used a large fur-lined cloak.[176] The designs on the square or circular plates of belts prove that they were sometimes worked of gold or silver,[177] but when detail is lacking on the burnished gold it is impossible to decide whether the belt was made of metal or of golden cloth. The head-gear of most married women consisted of a veil, fine enough to be transparent. It is either laid over their hair, or draped over their heads and thrown back on a shoulder.[178] The veils may be fluted around the edges and tied more tightly to make a wimple *(guimpe)*.[179] Some women, who wear a *houppelande* that has a high collar, preferred turbans on their heads, flat fur hats or cloth hats that rest on the masses of hair on either side of their heads.[180] The transparent veil can even be seen on top of such a turban. Hair, whether plaited or not, was always gathered around the ears.

A manuscript that must be almost contemporary with the Darmstadt one, the first Nuremberg Haggada,[181] has rather

◁ 169  Jewish costume in the Rhineland, first quarter of the fifteenth century: for the men, long robes and cloaks, soft hats, skull caps, toques, *chaperons*, the inverted funnel hat; for the women, *cottes*, with tight sleeves, *houppelandes* with long bag-shaped sleeves and belts of precious material, *couvre-chef* loosely draped or carefully arranged, flat hats, plaited hair gathered in bunches over the ears. Darmstadt, Hessische Landes- und Hochschulbibliothek, Cod. or. 8, folio 37 verso.

170  Jewish costume in the Rhineland, first quarter of the fifteenth century: for women, luxurious *houppelandes* lined with fur, with long sleeves either slit or bag-shaped, and loosely draped *couvre-chef*; for men, long or short *houppelandes* with short, long or bag-shaped sleeves, or sleeves slit to hang down behind the arm, toques, skull caps, hats with tall crowns, inverted-funnel hats, hose and shoes in the *poulaine* style. Darmstadt, Hessische Landes- und Hochschulbibliothek, Cod. or. 8, folio 48 verso.

clumsy but nevertheless precise illustrations of similar over-
gowns *(houppelandes)* with bag-shaped sleeves. Only one is
completely visible: a very long *houppelande,* held in by a low belt
of goldwork plates and buttoned down the front. There is also
another figure wearing a padded doublet with buttons all the
way down his chest;[182] the fact that he is shown seated prevents
the rest of his costume from being seen. His outfit is completed
by gloves of pliant leather and a pouch-purse attached to his belt
by its string.[183]

171

Despite their undeniable sense of movement and the intensity
of their expression, the illustrations of Hamburg, Cod. hebr.
37 [184] are often too defaced and indistinct to allow us to see more
than the outlines of Jewish clothing worn around 1430.

117, 271

The sleeves of the long and short robes worn by men are often
full and drawn in around the wrists, but they are no longer bag-
shaped as before. The robes of labourers, servants and
children [185] were short, in keeping with tradition. The wide
robes formed folds under the belt and were buttoned down the
front. As an outer garment, men wore very large cloaks with
luxuriant folds,[186] or sometimes a *houppelande* [187] with a collar and
wide *barbele* sleeves. On their heads they wore caps with soft
crowns, draped hoods *(chaperons),* and other hats of various
shapes, among them the inverted funnel-shaped hat with a ball
on top.[188] Men's hair was short or of medium length; cheeks
were shaved; beards clipped. The youngest men were clean-
shaven.

Women had cloaks, under which they wore full-skirted robes,
drawn in at the waist by a belt; the bodice was tightly fitted and
cut low around the neck to emphasize the bust.[189] Women's
heads and necks were covered by a head-dress *(couvre-chef)* with
a fluted edge.[190]

Illuminations from the middle of the century [191] give much
more precise details.

172
173, 222

Young people normally wore a short robe with a small
straight collar; the skirt of the robe formed folds that were
bordered with slashed *barbelures* [192] or a band of fur.[193] These
robes were embellished with goldwork belts worn very low
about the hips.[194] The gilded youth of bourgeois society wore a
kind of dalmatic of the same length as the robe over it; this was
bordered with fur around the neck, at the bottom and along the
slits on the sides.[195] The belt encircling it might be made of a
folded piece of material.[196] Scholars, masters and their pupils
wore a long robe, often lined with fur, and sometimes buttoned
down the front.[197] The soft shoes are still in the *poulaine* style,
with raised tips.

260

Sometimes hair was shoulder-length,[198] but the young also
wore it curly and swept up around the head,[199] or occasionally
quite short.[200] Young men were beardless, while elder men had
beards.[201] Men's hats were extremely varied: some were elegant
with a wide, low crown and fur brim; others were more practical
with the brim split at the sides so that it could be turned down
to cover the neck.[202] The hood *(chaperon)* had become quite
rare.[203] It is seen occasionally, flung over the shoulder, with the
liripipe *(cornette)* falling forward. This head-gear was pre-
shaped, its rolled brim and loose drapery held in a fixed place;
thus it was worn as a hat.[204] The most usual head covering,
especially for scholars, was a round skull-cap, with or without
a button at the top.[205]

Women still were wearing fur-lined overgowns *(houp-
pelandes).*[206] Their long robes, trailing on the ground, had sleeves
that were narrow at the forearm and a round neck-line cut quite
close to the neck; this wide robe, held in small oblique folds
under the bust by a belt, fell freely into a full skirt. Silhouettes
had a certain curvaciousness, a distant echo of the fashion of the
first decades of the century, when the line of the hips and the
swell of the belly were emphasized.[207]

173

Women's hair, either gathered above each ear [208] or plaited
and wound around the head or temples, was covered with a
white veil that passed under the chin and was thrown back on a
shoulder.[209]

122

צורת האדם אוכל ומשתכר יהעני בבושתי מתנבר

only the bottom of the torso.[224] Jackets and gowns have wide arm-holes, and the sleeves, full at the arm-holes, are spread out in a shape characteristic of this period.[225]

The most common outer garment was sleeveless and slit right down the sides. It was pulled on over the head, and its two flaps —one in front, the other behind—fell in straight folds.[226] Men were bearded, clean-shaven, or still beardless depending on their age. Their hair was worn fairly short. Limp hoods were common: the long liripipe either hung down or was worn round the neck like a scarf.[227] For travelling, a hood without a liripipe was worn over the head or folded down around the neck to cover the bottom of the face, and a hat was worn as well.[228] There was a wide choice of hats: small round hats with a brim or a flat beret,[229] hats whose crowns were wide and flat or cylindrical, flared or conical, with or without a brim.[230] There were also hats with very tall narrow crowns.[231] The only type that was no longer in evidence after the middle of the fifteenth century was the inverted-funnel hat.

The upper part of women's robes had the same cut as men's jackets. Sleeves, cut very wide, are attached to the robes high up on the shoulder in the same way as men's.[232] A more detailed picture even shows the sleeves gathered at the shoulder and the fullness caught up tightly at the wrist.[233] The bodice was close-fitting over a prominent bust and drawn in around a well-defined waist. From the waist, and sometimes from just below the bust, a set of pleats adorns the front of the skirt. Belts were usually worn low, about the hips.[234] Cloaks could be either long or short.[235] If they were married, women wore their hair, plaited over the ears, covered with a veil of white linen, which usually had a fluted edge and was draped over both the head and neck.[236] Only men's undergarments are portrayed: between 1460 and 1470 very scanty underpants, which were common then, and covered the lower body only,[236a] and a short undershirt with long sleeves.[236b]

Children's clothes reflect those of adults on a small scale.[237] Men, women and children all wear shoes of the *poulaine* type, with turned-up tips.[238]

Some illustrations from nearer the end of the fifteenth century show that dress, as we have described it, had not really changed by then. Women wore gowns with a close-fitting bodice and full skirt; a rather stiffer veil was draped around their heads and necks.[239] Long wide robes, often lined with fur, were always put on for ceremonies and usually worn by men once they reached a certain age.[240] Shorter robes or jackets were worn by the

Illustrations of the clothes usually worn by German Jews in the second half of the fifteenth century are fairly numerous.

The London Haggada, MS. Add. 14762 [210] depicts wealthy bourgeois Jews from about 1460, who are dressed in robes and cloaks made from rich fabrics—crimson velvet, gold and blue brocade—with fur trimmings. The robes are long and loose; the folds either fall straight down or are held in at the waist by a belt.[211] Over the robe, some people wore a second sleeveless gown, edged in fur around the neck, hem and deeply slit arm-holes.[212] Other people were wrapped in cloaks fastened at the chest with a jewel.[213] On their heads they wore hoods,[214] or hats with wide low crowns, that were either rounded or soft, and had a brim of fur.[215] However, the most common hat was a toque with a tall conical crown that was flat on top and dressed with all kinds of cloth—either of the same rich fabric as the robes and cloaks or of plainer cloth in a single colour: crimson, grey or black.[216] Hair either came down to the ears or was shoulder-length; beards seem to have been worn by older men.[217] Shoes were barely pointed.[218]

The clothes of the people shown in the margins of Paris, ms. hébr. 1333,[219] the Second Nuremberg Haggada or Nuremberg Haggada II,[220] and the Yahuda Haggada [221] belong to the same type. Again we find long gowns with fur trimmings,[222] together with shorter robes.[223] Nor were the young afraid to show off their legs in tight hose. Indeed, following the fashion of the time, skirts with *Schecke* folds and jackets, slit down the sides or in the middle of the back, were so short that they sometimes covered

younger men.[241] Head-gear was of all kinds: flat and high toques or hoods *(chaperons)*.[242] But the inverted funnel-shaped hat only reappeared among these types in one series of pictures: Munich, Cod. hebr. 200.[243]

## The Costume of Jews in Italy from the Late Fourteenth to the Early Sixteenth Century

We do have an illuminated psalter in the late thirteenth century,[244] but it only allows us to identify a few items of men's 311 dress: the tunic *(cote)* with long sleeves buttoned down the forearm,[245] an outer garment, perhaps a cape,[246] a hooded robe,[247] a short hood draped over the head,[248] and a hat with a brim.[249] Men were usually bare-headed.[250] Hair was worn rather short and cut into bangs on the forehead. Beards were rare.[251]

Apart from what we can glean from these illuminations, we are dependent on illustrations from the last quarter of the fourteenth century in Hebrew manuscripts of Italian origin for an almost complete picture of the tastes and habits of dress of the Jews in the cities and principalities of Italy.

A Haggada from the north of Italy[252] shows that although 176 scholars wore long clothes—full gowns and the *houce*—in the last decades of the fourteenth century, much as their colleagues in Spain and in Germanic lands are known to have done,[253] some men had adopted much more fashionable clothes, such as the 177 very elegant, padded *cote-hardie* that fit tightly over the chest and reached down to mid-thigh; it was worn with very tapering, tight hose in the *poulaine* style. *Cote* and hose were of two colours, here red and green. Heavy goldwork belts were worn 370 very low.[254] Tight at the waist but with wider, longer skirts (down to the knee), a discreet version of the *houppelande*[255] is encountered; its lining, visible at the lapels and the wide draped collar, was in a contrasting colour.

Most men, whatever their occupation, went bare-headed, although the hood *(chaperon)* with a long liripipe wound round the neck like a scarf was not unknown.[256] Men's hair was kept short, but slightly wavy; it stood out above the ears and the nape of the neck on either side of a central part.[257] The beard, which was an attribute of age, was forked.[258]

178, 257  Young women wore tunics *(cotes)* with long narrow sleeves, and very tight-fitting bodices, sometimes buttoned down the

front, and having wide skirts. These tunics were plain or of two colours. The neck-line was low enough to reveal the shoulders.[259] Women's wavy hair was parted in the middle and hung down the back;[260] or it could also be worn in two plaits attached at the top of the temples to fall down along the cheeks.[261] Married women had a veil over their hair and wrapped themselves in cloaks.[262]

In the years 1430 to 1440 we see men and women dressed in the same fashions that are represented in sumptuous detail in the works of Pisanello. These clothes are illustrated in a number of manuscripts from northern Italy: a copy of the *Arba'a ṭuṛim* ('The Four Orders')[263] of Jacob ben Asher (1270?-1340), done in Mantua in 1435; a copy of parts III and IV of the same work,[264] dated 1438; a *siddur* copied at Forli in 1383 but illustrated in part around 1430 to 1440;[265] a copy of Avicenna's *Canon*[266] done before 1450.

The normal costume for women was a jacket *(veste)*, a cloth garment, usually of a single colour, with long sleeves, a tight-fitting bodice and a round or square neck-line depending on the region or the town: square in Venice and Genoa, round in Milan and Mantua. The skirt was full and pleated at the waistband. This costume was worn without any over-garment in the house, and is not peculiar to any particular occupation.[267]

Completely attired women wore a very full, long gown over the *veste* that trailed on the ground. This was the Italian version 335

173  Costume worn in Germany, *c.* 1450: for women, a full pleated dress with a high belt and *couvre-chef* draped over the head and passing round the neck to fall over a shoulder; for men, a short robe with a straight collar, tight around the waist, its fur-lined skirts pleated and held by a goldwork belt slung very low. Oxford, Bodleian Library, MS. Opp. 154, folio 12 recto.

174  German Jews on a journey, *c.* 1460–70: the jackets of the men and dresses of the women have sleeves that come high up the shoulder; the jackets are very short, and tight over the top half of the body, while the dresses are close fitting over the bust and waist, with pleats in front falling from a low belt; the *couvre-chefs* have goffered hems; hats are small, with narrow turn-ups and crowns of varying height; the *chaperon* is worn right over the head like a balaclava; shoes are in the *poulaine* style.
Jerusalem, Schocken Institute, 2nd Nuremberg Haggada, folio 20 recto (detail).

175  German Jews, *c.* 1460, wearing full robes made from a cloth of some ▷ weight, velvet or brocade, sometimes lined with fur; cloaks of the same materials might be fastened over the chest with a jewel; for the head, cylindrical toques, rigid or with a soft crown, wide and flattened, with the fur lining turned up as a brim.
London, British Library, MS. Add. 14762, folio 7 verso.

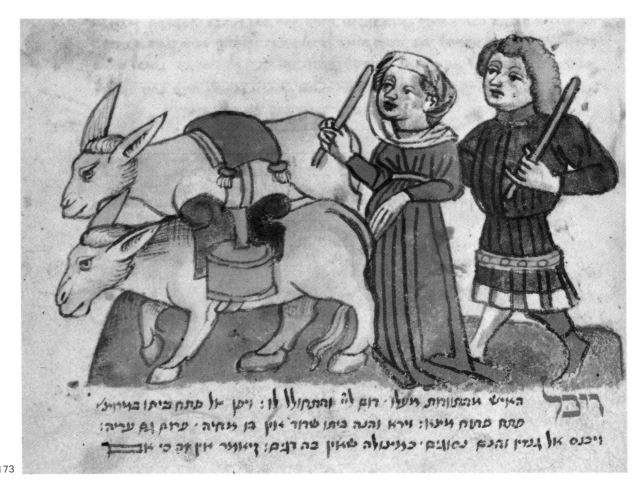

**רבל**
האיש מתגודרת משבו רום לה: והתחולל לו: ויקן אל פתח ביתו בעריו:
פתח פתח מיעו: וירא והנה ביתו שרוד דין בן מחיה: ערום נס עריו:
ויכנס אל נמין ונבם נשונם: כעישוה שאין בה רנבם: ויאומר אין אה כי אובד

173

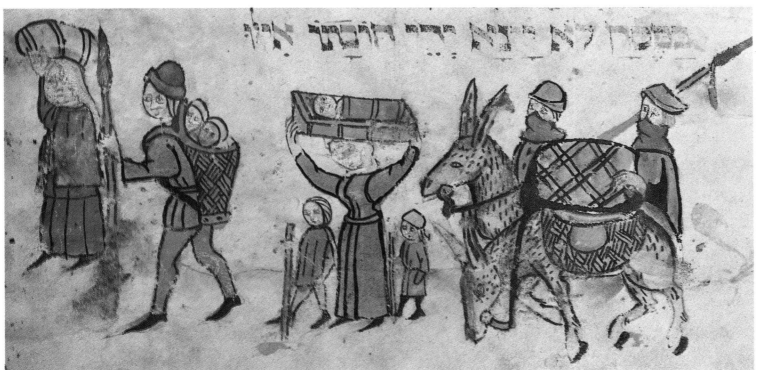

174

175

177

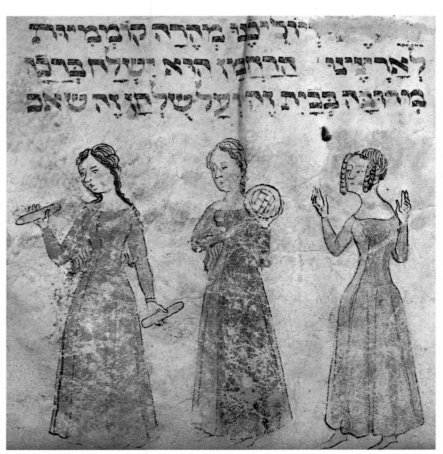

178

of the French *houppelande*. The fullness was caught in under the bust by a high belt, and the enormous sleeves hung right down to the ground. Some of these sleeves covered the arm up to the hand and were open down their entire length; the soft folds revealed the rich fur lining of the garment.[268] Other sleeves were long and bag-shaped,[269] with two openings: a long slit from the shoulder that allowed them to hang behind the arm, and a round hole at the end through which the hand could pass. There were also sleeves, slit from the shoulder, that hung behind the arm in 183 straight folds, merging with those of the back of the gown.[270]

However, the most characteristic trait of this attire was the head-gear. Women's hair was hidden; above the uncovered 3, 252, 335 forehead, temples, ears and nape of the neck, the enormous *balzo* was worn. This is a balloon-shaped hat whose frame was covered with a fine veil and an interlacing of precious ribbons, or, as in our pictures, with fabrics of a colour that either matched or contrasted with the gown.[271]

Men wore clothes of different lengths and of varying types according to their age, occupation, or as circumstances demanded. A full knee-length tunic, loose above the belt, was 252 worn with hose[272] by humble folk and by those working as 184 craftsmen. The wealthier wore a robe edged with fur, with loose rounded sleeves held in at the wrist. The regular rounded folds were caught in a belt and descended to the calves or to the ankle.[273] Such people also wore cloaks of medium length.[274] Judges wore a fur-lined cloak over the long robe or a furred robe with hanging, slit sleeves.[275] These clothes all continue the traditions of earlier times, but among them appears something

new: an over-garment known in its various forms as the *giornea*, which is the elegant male's counterpart of the new female fashions.

Throughout this period the *giornea* is influenced by the overgown *(houppelande)* worn by men in France and Burgundy, and its cut is influenced by the German *Tapperten*, which are themselves an adaptation of the *houppelande*. Underneath the *giornea* a jerkin *(justaucorps)* was worn, of which only the high neck-line and tight sleeves are visible. The essential characteristic of the *giornea* is the regular folds flowing down from the shoulders in front and back. These folds might be drawn in at the waist by a belt, below which they flared out again;[276] in the more 184 daring version, the folds hang straight down from the shoulders and are scarcely disturbed by the low, loosely worn belt.[277] 252 Sleeves were very short and only reached down to the forearm,[278] or they were long and slit from the shoulders. They match the line and style of the garment and might fall in straight folds, flare out, or hang like large bags bulging behind the arm.[279] Wide fur trimmings edge the bottom of the garment, the slits, and the cuffs of the sleeves.

Hose were worn under this short garment: plain hose with ordinary clothes, two-colour and embroidered hose or hose trimmed with lace with more elegant attire.[280] Although these hose were pointed, they did not rival the extravagancies of the French, Burgundian and German *poulaines*.

People often went bare-headed. Hair was 'basin-cut', a fashion that had come from the north.[281] Older men wore beards.[282] Hoods *(chaperons)* were among the favoured head-dresses, sometimes fur-lined like those of magistrates; they were worn about the shoulders when heads were bared.[283] Among the various head-gear were hats composed of two or three circles of piping, one on top of the other; enormous turbans of fur or 184, 252 feathers;[284] and above all, the even more gigantic *mazzochio a* 335 *ciambella*, a similar turban surmounted by a tall crown, that was wide and limp, and expertly draped on top.[285]

The illustrations in the copy of Avicenna's *Canon* now in Bologna,[286] probably done in the north, perhaps in Venetia, towards the end of the first half of the fifteenth century, show costume styles a little less influenced by these fashions. What is portrayed are scenes representing physicians, surgeons, apothecaries and their bourgeois clientele.

Women are usually shown inside their houses, and thus wear very simple clothes: plain gowns with long sleeves, a round 242 neck-line, a skirt, gathered or in folds, with a veil over their

◁ 176  A Jewish master and his pupils, northern Italy, late fourteenth century: robes are long, reaching down to the ground or halfway down the calf; the master wears the *houce*; shoes are in the *poulaine* style; hair is short and brushed over the ears from a central parting. Note the articulated and revolving lectern, and the hanging oil lamp, adjustable by means of a pulley.
Jerusalem, Schocken Institute, Ms. 24085, folio 23 verso.

177  Late fourteenth-century Italian costume: *cotte-hardie*, and parti-coloured hose in the *poulaine* style. The man represented is carrying the *pokal*, a cup on a tall stem.
Jerusalem, Schocken Institute, Ms. 24085, folio 3 recto.

178  Costume worn by Italian maidens, late fourteenth century: the *cotte*, parti-coloured or in a single colour, has a low neck-line, tight sleeves, and is close-fitting over the bust; hair falls over the shoulders or is bunched in plaits over the temples.
Jerusalem, Schocken Institute, Ms. 24085, folio 32 recto.

holes, the hem of the skirt and the cuffs of the sleeves might be edged with fur.[291] The extravagance of earlier times was confined to hats, which are sometimes made up of a number of [238] fillets of piping, one on top of the other, and had strange crowns with draped crests.[292] Hair was sometimes curly and usually [242] longer, and hats were placed directly on top of it.

Illustrations depicting Jews for all ages and of both sexes in their day-to-day dress abound from the second half of the fifteenth century. These allow us to follow the major variations in style from the middle of the century, particularly in northern Italy whence the majority of these manuscripts derive. The most important of these are the New York–Rome *Mishne Tora*,[293] probably copied and decorated in Lombardy about 1450, a group of manuscripts dating from the years 1465 to 1470 from Emilia or Romagna: MS. Harl. 5686,[294] Ms. Heb. 8° 4450,[295] and the Weill *Mahzor* [296] as well as the MS. Add. 26957,[297] dated 1469, and Ms. Parm. 3596,[298] which must have been illuminated between 1455 and 1465 in the region of Mantua.

Cloaks and long robes scarcely changed at all; nor did the robe [146] without sleeves worn as an outer garment. These were, as always, the usual clothing of judges, scholars, masters and their [185] pupils, and of older men for important occasions and religious ceremonies.[299] Hoods *(chaperon)* too remain the same, though they have a tendency to be more faithful to traditional models [179] and to avoid the wide fillet of piping.[300]

Many of the *giornee* also followed well-known styles. Some were tight-fitting above the waist; others were looser, held in at the waist and had a skirt of variable length that flared out in round folds. Sleeves were long.[301] There is also a fuller version [186, 368] of the *giornea*: the folds started at the shoulders, and the wide sleeves, slit vertically, were thrown back. *Giornee* were [187] sometimes lined and edged with fur. A belt was worn either high [193] or low.[302] *Giornee* without sleeves became more and more common: some were still quite long [303] and sumptuously lined and edged with fur.[304] However, a short version gained [188] increasingly in favour; it consisted of two lengths of pleated cloth, one covering the chest and the other the back; these were drawn in by a low belt.[305] [180]

Under this short *giornea* with open sides, the jerkin *(justaucorps)* and the hose attached to it by laces are visible.[306] Sleeves were usually gathered from shoulder to elbow and tight over the forearm.[307]

Young men often took off their *giornee* and went about in jerkins and hose only [308] when they took part in some physical

head, covering much of the forehead and falling over the shoulders without being tied, so that the hair is invisible. One woman, however, seems to be wearing a tall pink head-dress under a transparent veil.[287] A woman arriving for a consulta-
[238] tion [288] with one of the people mentioned above wears only a veil on her head and wraps herself up in a wide cloak.

Men's clothing, excesses in the width of the sleeves or the skirts of the *giornea* apart, could be put into specific categories
[242-3] between 1430 and 1440. Physicians usually wore loose-fitting robes, sometimes fur-lined, with a hood *(chaperon)*. The latter was mostly of the kind known in Italy as '*cappuccio a foggia*': constructed around a wide fillet with a liripipe that fell over one shoulder.[289] It could also be worn around the shoulders.[290] However, the *giornea* was the most popular garment: with folds, a marked waist and with or without sleeves; sometimes they were completely open down the sides and were not held in at the waist. In both kinds of *giornea*, the borders or slits of the arm-

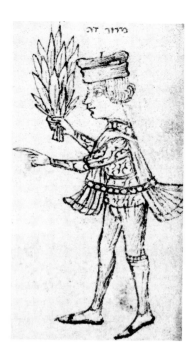

180 Costume worn by an Italian Jew, 1469: *justaucorps* with tight sleeves and hose attached to it with laces; slippers are worn over the hose on the feet; a gold-work belt, worn low down, keeps in the folded skirts of a very short *giornea*; the *berretta* has a high turn-up; hair is short and curled. London, British Library, MS. Add. 26957, folio 45 verso.

181 An Italian Jew, 1469, wearing a toque with ear-flaps over his short hair; his beard is cut very close. London, British Library, MS. Add. 26957, folio 43 verso.

182 An Italian Jew, 1469, wearing a hat with a pointed crown and a turned-up brim that reaches forward in a peak; hair and beard are worn long. London, British Library, MS. Add. 26957, folio 43 verso.

toques and caps with or without brims and with flat, conical or pointed crowns.[312] The most popular came from Lombardy and were particularly fashionable in Mantua; these *berrette 'a cannelatto'* were brimless and had a flared crown with felt piping 187, 294 round the flat bottom edge.[313]

Pictures in the Vatican *Mishne Tora*[314] show that the dress of women around 1450 in Lombardy had changed little from that of the preceding decades. For a ball, women wore trailing robes, 372 still rather like the *houppelande*, with a high belt under the bust and long sleeves of contrasting colours hanging down behind their arms.[315] The *escoffion* head-dress can be seen too; in Italy, the inverted saddle shape of its piping led to its being called *a sella*.[316] This kind of head-dress was invented in northern Europe and was very popular there. In Italy, however, its popularity was of short duration, and it always remained foreign to indigenous fashions, as can be deduced from the fact that it was said to be *alla fiamminga, alla francese,* or *alla di là* (in Flemish, French or foreign style).

, 368, 372 activity such as dancing, participating in nuptial processions or setting up the *sukka* tents for the Festival of the Tabernacles, all of which are depicted in our Jewish illuminations. Hose are still stitched only between the legs and attached to the sides of the jerkin; at the top a bit of white linen belonging to the breeches is visible in front, or sometimes a gusset of the same material.[309]

180 Pattens might be worn over hose.[310]

Young men dressed in this way often went bare-headed,[311] 181-2 though all kinds of head-gear could be worn: birettas *(berrettes)*

After 1460, the commonest kind of gown fit the top half of the body tightly; it was laced in front, had a fairly high waist and gathered or pleated skirt. The neck-line was lower, allowing necklaces with pendants—now fashionable—to 'adorn' the neck and bust.[317] Sleeves were often of a different material, so that on plain-coloured robes they might be made of brocade— a fashion that originated in Ferrara. Sleeves were usually gathered and puffed on the arm, like those on men's jerkins (*justaucorps*).[318] A robe with a slit on both sides was worn, occasionally over the jacket or *veste*; sleeves lined with a different colour material hung down behind the arms.[319]

Women's head-dresses still included the so-called *atours*, but ones which were rather smaller than the *escoffion*. The commonest variety of head-dress had horns; it was covered by a small veil held in place with jewelled pins; the veil was often made of precious cloth, and its folds hung down to the level of the neck.[320] Another popular head-dress conformed to the shape of the head and consisted of plaited hair, entwined with ribbons and decorated with jewels, framing the face.[321] Unmarried women who were betrothed went bare-headed. Some fiancées wore their hair short, slightly rolled on the sides and curled around the neck,[322] while others left it in one long braid hanging down their backs. In the latter case, the braid was wound in cloth in a colour that matched the gown, but this habit did not spread.[323]

The dress of little boys and girls followed the same styles as adult clothes.[324] Babies were still wrapped in swaddling-clothes.[325]

The Washington Haggada and MS. Rothschild II in New York,[326] dated 1478 and 1492, show a series of costumes and head-dresses identical to those just described. Since these two manuscripts, curiously enough, belong to a group where the same kind of figures were recopied unchanged for several decades, they cannot be taken to prove that Jews remained faithful to fashions that had been superseded by others in the rest of the population.

In the 1470s a wave of austerity seems to have influenced the dress of Jews who followed the fashions of Ferrara, depicted in Ms. Rothschild 24.[327]

We see young and old men wearing long robes and cloaks, with a *cappuccio a foggia* on their heads or a toque with brim, or a round skull-cape.[328] Adolescents wear a *giornea*, closed at the sides, with long sleeves and skirts of a decent length.[329] Only adolescents and children go bare-headed.[330] Married women

cover their head, neck and bust with a white veil, tied up as a coif or wimple.[331] Their robes have long sleeves gathered at the shoulder, a high waist and often a high round neck-line. The bodice of some gowns is typical of Ferrara fashions at that time: a V-shaped neck-line, open to the waist; the V was filled in with a kerchief of a contrasting colour, a white 'modesty'[332] or a triangle of black velvet.[333] Women held these robes up in the front when walking or dancing, revealing an underskirt of another colour.[334] Girls wore their hair in the Ferrara style: plaited or in small buns wrapped with, or covered by, fine white veils.[335] Another kind of head-dress had an *atour* that rose up in a cone and was covered by a white veil;[336] although not very high, it looks very like what was commonly called a *hennin* or steeple head-dress. This head-dress was never adopted by Italian women and was only worn in Italy by foreigners. But, on the evidence of the rites in its liturgical texts, Ms. Rothschild 24 is known to have been copied for an Ashkenazi Jew, more precisely for one from a German country. This detail of dress may have had nostalgic associations recalling the place of origin of the manuscript owner's family. It may also explain the less fashionable look of the rest of the clothes in the illustrations.

183   A Jewish marriage, Italy, 1438: men and boys wear flowing fur-lined robes with bag-shaped sleeves; the high-waisted *houppelandes* worn by the women have sleeves that are bag-shaped or slit down their length to hang behind the arm; women's hair is covered by a fine veil or the then fashionable *balzo*. The *ṭallit* is placed over the heads of those being wed.
Oxford, Bodleian Library, MS. Can. Or. 79, folio 2 verso (detail).

184   A Jewish tribunal, Italy, 1435: the magistrates are in robes, cloaks and *chaperons*, all lined with fur; the barristers have long cloaks and *chaperons* on their shoulders; the litigants are in robes and short cloaks or in the *giornea* with short sleeves or long sleeves that are slit, and have belts slung either high or low; hair is in the 'pudding basin' cut.
Vatican, Biblioteca Apostolica, Ms. Rossian. 555, folio 292 *bis* verso.

185   Magisterial lectures, northern Italy, about 1450: both teacher and students ▷ wear a long robe with wide sleeves drawn in at the wrist, and an outer robe without sleeves; as for the head, the toques have turn-ups and crowns of varying heights.
Vatican, Biblioteca Apostolica, Ms. Rossian. 498, folio 2 verso (detail).

186   A crowd of Italian Jews, *c.* 1460–70: men and boys wear hose and the ▷ *justaucorps*, over which is the *giornea*, with or without sleeves, sometimes drawn in at the waist, and on occasion with a low slung belt of some precious material; women have high-waisted, full dresses with long sleeves tight over the forearm, like those of the *justaucorps*, and a round, low neck-line; the hair, in nets, is bunched over the ears and covered with a veil, which might also cover the *atours*.
London, British Library, MS. Add. 14762, folio 15 recto (detail).

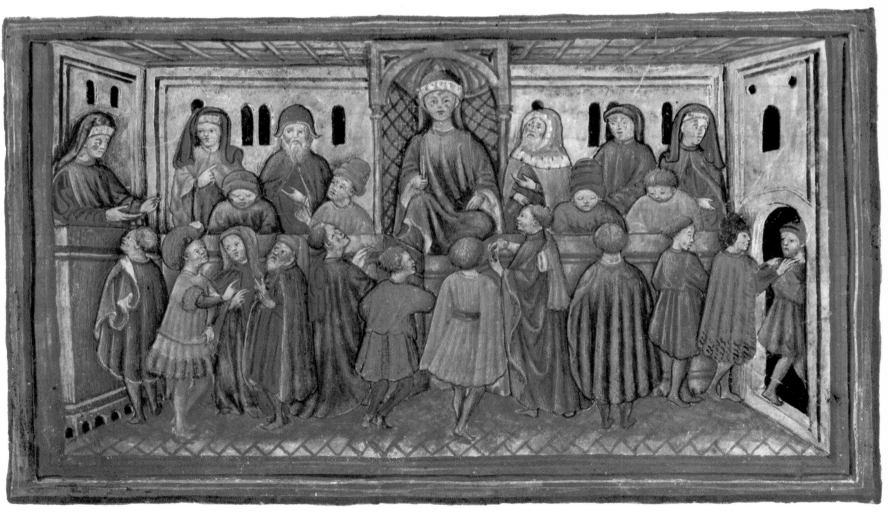

185

ויושב ד׳ בהם והגון לא ישׁיר מיד מצרים וכו׳

186

◁ 187 A Jewish marriage in about 1455–65: the overgarment of the woman and the *justaucorps* of her fiancé and the witness all have sleeves that are tight on the forearm but full and gathered on the upper arm; the outer robe, loose and sleeveless, is worn without a belt; the *giornea* with its pleating and low belt, has sleeves slit to hang behind the arm; the woman's hair is bound into a single plait hanging down her back and sheathed in cloth; the *berretta* is in the 'cannelato' style.
Parma, Biblioteca Palatina, Ms. Parm. 3596, folio 275 recto.

188   Italy, *c.* 1455–65, two kinds of *giornea*: one is long and with a fur lining visible at the neck-line and the wide armholes; the other is shorter and lighter, pleated, with a low slung goldwork belt.
Parma, Biblioteca Palatina, Ms. Parm. 3596, folio 156 verso.

189

190

Another group of illuminations [337] reveals the influence of fashions from Lombardy and Venice at the end of the fifteenth century. The *giornea* worn by young men is not like the garments with pleated skirts described previously, but rather like short cassocks, open at the side and held in by a belt.[338] Other *giornee* are no more than short waistcoats, with or without sleeves, very tight-fitting and with V-shaped slashes over the hips.[339] A new piece of clothing, the result of German influence, is the *saioni*. It is a knee-length garment open all down the front, with sleeves that can be quite loose at the wrist. The most typical *saioni* had sleeves with cuffs and was held in with a sash around the waist; there are two wide lapels on the front of the *saioni* between which the lacing of the jerkin *(justaucorps)* worn underneath can be seen.[340] The jerkin was a characteristic Venetian garment of the period. Apart from the usual robe, there are also long robes known as *zimarre*; these are open at the front and have lapels over the chest.[341] Hair was worn long and wavy. The *cappuccio* was still worn but without a liripipe.[342] Toques were popular and were sometimes decorated with plumes, another mark of

189   The costume of a Jewish woman, Italy, 1469: a brocaded dress with sleeves full to the elbow and tight on the forearm; the bodice is close fitting with a low neck-line; around the neck is a necklace; the horned head-dress leaves the forehead bare, and the hair, wrapped tightly in a net, is covered by a light veil hanging down the neck and supported by an *atour*.
London, British Library, MS. Add. 26957, folio 39 recto.

190   Another hair style fashionable in Italy, 1469: the hair is in plaits, bound closely to the head, entwined with ribbons or threaded pearls and decorated with jewels, making a frame around the face.
London, British Library, MS. Add. 26957, folio 45 recto.

191   A Jewish baby, *c.* 1460, wrapped in the *maillot* or swaddling clothes which, as was the general custom, enclosed both arms and legs to prevent the child from making any movement.
Stuttgart, Württembergische Landesbibliothek, Cod. or. 4° 1, folio 8 recto (detail).

foreign influence.[343] Soft shoes that more or less covered the bottom of the calf were worn over hose.[344]

150   Women's clothes were also influenced by late fifteenth-century fashions, as can be seen from the low, square neck-line, the lacing of the bodice, the sleeves slashed from the elbow.[345] When women's heads and busts were not covered by a finely draped veil, curly hair framed their cheeks,[346] sometimes under a small white veil.[347]

The examination of the costume worn by Jews in illuminations in medieval Hebrew manuscripts necessarily involves investigating the whole range of medieval fashions, although, since such manuscripts do not always rival the masterpieces of medieval illuminated manuscripts or contemporary medieval painting, their evidence may not be quite as impressive. Contrary to what might be expected, there was no tradition of clothing peculiar to Jews. From one country,

province or even town to another, the dress of Jews was as different as that of their Christian compatriots. Like them too, the Jews succumbed to the influence of changing fashions over the centuries. The archaic style of dress in some of our pictures, as we remarked previously, does not portray what people were actually wearing then—this we know from other contemporary illuminations—but was rather the result of an illuminator's using earlier models. Insofar as our manuscripts are dated or datable, it appears that all novelties of dress were adopted without an appreciable delay. Medieval Jews were alive to all changes in fashion, as we can see when considering the cut of their clothes, the neck-lines of women's garments, the shape of sleeves, the style of shoes and hair, the shape of head-gear and the way it was worn.

## The Value of Evidence from Jewish Iconography in Examining Jewish Clothes

Might this conclusion be misleading? Given the significance of differences in dress between the social classes and professions, it may seem odd that the special status of the Jews in the last centuries of the Middle Ages, together with their inferior status, their precarious economic position and general insecurity, was not reflected in the clothes they wore. Our illuminations seem to show that the Jewish community sought to dress in the same way as the wealthier classes, or even at times as the aristocracy. Might this not simply be an illusion, the outcome of a process of

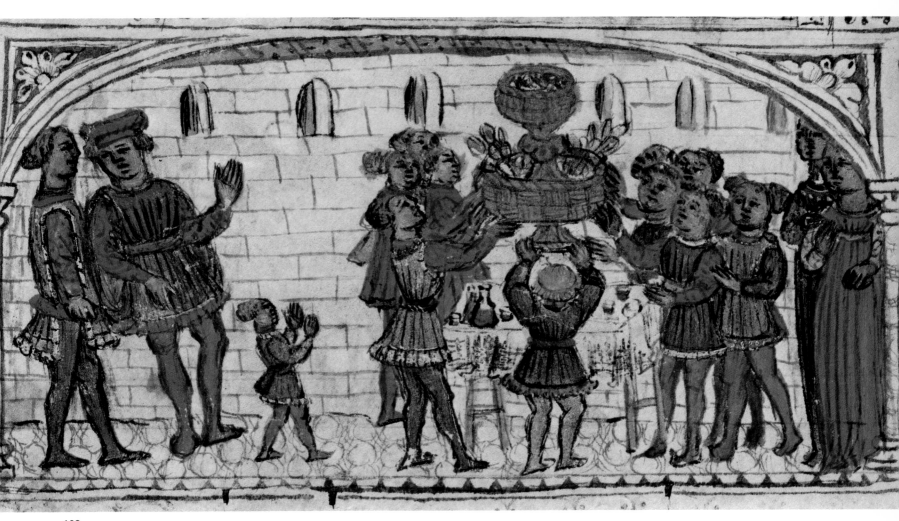

193

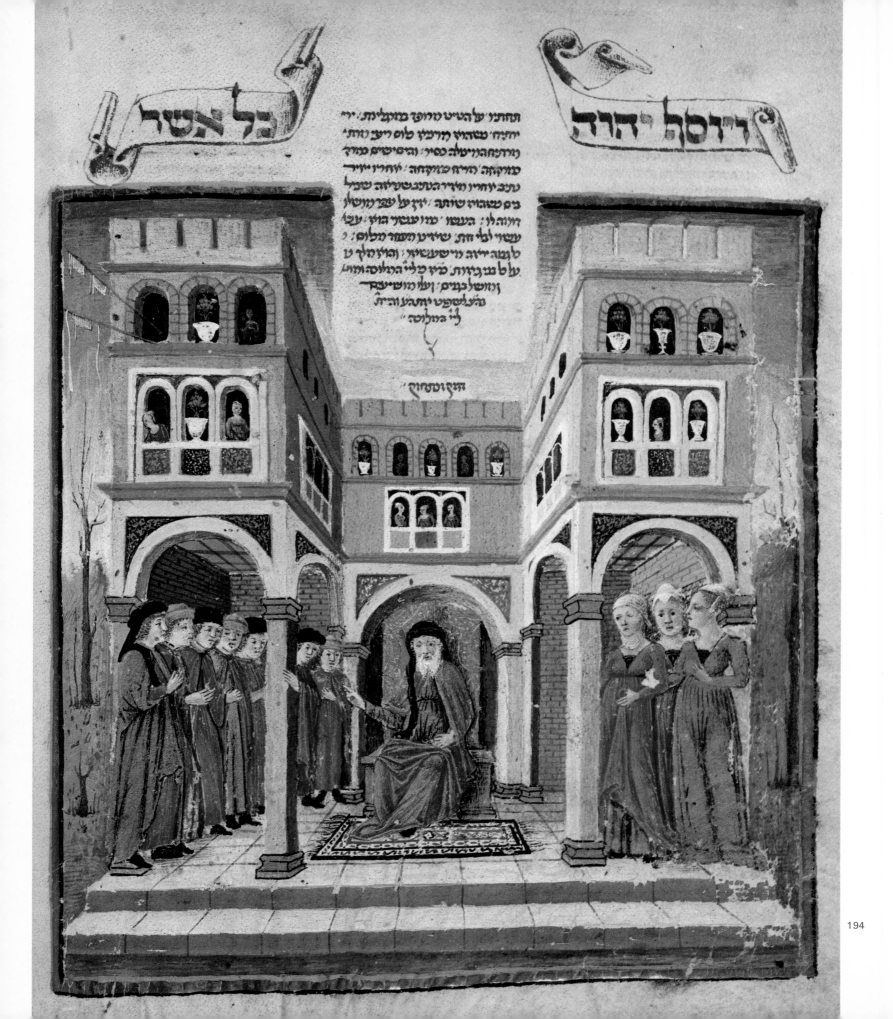

בל אשר

ריוסל יהודה

תחתיו על הטיט טרוף מזוליית ידי
יחנח טהורי מרומין לוס ריב וחתי
מרדחה הוילה כסיר והיסייים מרך
מזרקות מרח מזקחה יחרין יוייר
עתב יחרין מזיר העתנגבשטרלזה שכל
בם טבוריו שותב יין על שברמסלו
דולוה לו העטו מדו עבוסי מזיר עפי
עשוי לפני חת שידיע ומפור מלום ו
טלנגה ירוב וישעטשוזי ומריומלך ט
על ט מבגזית מזין כלי הולישה וחול
נחשל בנים ועל חושעיבר
מטבלשפט יתהגע זרזת
לזי הולוכה

חיז ומחוק

195

196

197

198

idealizing sad reality? In the books they decorated or had non-Jewish illuminators decorate for them, did the Jews portray themselves liberated from the stigma of their humiliation?

## Measures Regulating Jewish Dress and Badges of Infamy

Beginning with the Lateran Councils that took the first discriminatory measures against all Jews living within Christian territory, a vast series of papal bulls, conciliar canons, royal ordinances and municipal statutes were issued, imposing on the Jews every kind of humiliation in the matter of dress. More than once, Jews were prohibited from wearing certain types of clothing. In 1254, for example, the Council of Albi prohibited the *chape*, a wide circular cloak, because a Jew wearing it might be mistaken for a member of the clergy. Nearly two centuries later, in 1413, it was forbidden for the Jews of Majorca to wear the mantle worn by the nobility and the rich.

Severe restrictions were imposed on the richness of Jewish garments. In 1412 laws in Valladolid fixed a maximum value for a Jew's complete outfit; at Cologne, in 1404, permitted clothing was itemized in detail: the material, length of the garment, width of the sleeves, nature of the trimmings, and the number and value of the jewels.

Special garments were also decreed. In 1268 in Aragon, an earlier order was renewed obliging Jews to wear a *capa rotunda*. At the end of the fourteenth century in Aragon, several royal decrees and, in 1412 in Castile, the laws of Valladolid required that Jews wear a long robe reaching the ground over their other clothes. In 1413 this obligation was adopted by the king of Aragon for the Jews of Majorca, together with another concerning the shape of their hood (*chaperon*). Across the Mediterranean Sea in Rome, in 1360 Jews had to wear a *tabard*, a kind of short dalmatic in red, and their wives a red skirt.

But the more generalized obligation to wear special badges was the most oppressive. The most widespread of the duties imposed was a wheel-shaped badge, intended to draw the attention and the hostility of the Christian crowd to the wearer. It appears to have started in France in the early thirteenth century; after the Lateran Councils it was adopted one by one by the majority of kingdoms and cities as the distinguishing mark for the Jews. Only in German towns was it rare until the fifteenth century: the most usual distinctive mark there until that date was a special hat known as the Jew's hat (*Judenhut*).

It is difficult to decide for certain what traces were left by these restrictions, obligations and badges of infamy on clothing that formed a part of the daily reality for the medieval Jew. Small format pictures of mediocre quality cannot as a rule show precisely what the differences were between garments of the same cut but of a different quality and with less luxurious trimmings. Nor were the mandatory garments—mantles, robes or hoods (*chaperons*)— radically different from the clothes then worn by Christians. They were not degrading in themselves; for example, the round cape was obligatory at one time and then forbidden at another, because it remained a source of confusion unless marked by the wheel-shaped badge. At first the long Spanish robe, the *gramalle*, was essentially a garment worn by nobles; then it became more generalized as an overgarment worn by Jews as well as by others. The *gramalle* became discriminatory only when Jews were prohibited from wearing anything else or from going without it. In any case, we cannot accuse Jewish illustrators of not being faithful to reality for failure to depict the uniformity of clothing imposed by the early fifteenth-century Spanish laws resulting from the anti-Jewish preaching of St Vincent Ferrer—all the illustrations were drawn earlier. The same is true of the clothes imposed on the Jews of Rome in 1360: no illustrated Hebrew manuscript from Rome survives from that period.

◁ 195  A German Jew, *c.* 1460, wearing the *rouelle*, a yellow wheel-shaped badge on the right-hand side of his chest.
London, British Library, MS. Add. 14762, folio 45 recto (detail).

◁ 196  German Jews praying, in 1471: over their shoulders is draped the *tallit*.
Oxford, Bodleian Library, MS. Opp. 776, folio 20 verso (detail).

197  Late fifteenth-century Italian Jew carrying the *Tora* scroll with its covering of brocade; his head and shoulders are covered by the *tallit*, decorated with an embroidered *atara* and with a *ziziyyot* at each of its four corners.
New York, Jewish Theological Seminary of America, MS. Acc. No. 03225, called MS. Rothschild II, folio 125 verso.

198  A Jewish youth from Germany, *c.* 1460, wearing the *arba' kanfot*, a kind of scapular of white linen with the tied *ziziyyot*, hanging in front and behind, attached to its four corners; this ritual piece of clothing is worn over the robe but under the cloak, which might hide it.
London, British Library, MS. Add. 14762, folio 8 verso.

## The 'Wheel-shaped badge' *(Rouelle)*

What of the badge, the sign of the wheel, that was constantly being prescribed in France, Spain and Italy during the period covered by our documentation in these lands? It is true that it was no less rare in our Jewish pictures, both Spanish and French. The fact that, to our knowledge, there are four certain representations of it in German and Italian illuminations hardly changes the general picture.[347a] At the end of a German

Haggada of the third quarter of the fifteenth century, the wheel was painted in yellow, in the form of a circle, once on the left and once on the right of the garments worn by two bearded figures, 195 one of whom is wearing a hood *(chaperon)*, the other a toque.[348] The badge is also represented as a yellow circle on the chest of one of the people in a scene added between 1460 and 1470 to the same manuscript[348a] by an illuminator trained in Italy. The badge was drawn in the same shape, but in white, on the left of 199 the mantle worn by the bridegroom in a scene depicting a wedding in a manuscript copied at Padua in 1477.[349] In both cases, however, there are various indications that these pictures were by a non-Jewish hand, except for the Italian-style scene in the German Haggada.

It is worth noting that the German manuscript dates from the period when the badge, imposed for the first time at Augsburg in 1434, had already been adopted by a certain number of German towns, and that the Italian manuscript was illuminated during the period when the fanatical preaching of St Bernardino da Feltre was kindling popular hatred against the Jews, thus causing the reinforcement or adoption in many Italian towns of discriminatory measures—particularly the wearing of the badge. These illuminations were not, it is true, the only ones in Jewish manuscripts produced by Christians or by workshops following Christian models, but it is probable that Jewish clients gave instructions on all points connected with the realities of Jewish life. As we have already seen more than once, mistakes were inevitable, and in this particular case the lapses were perhaps not altogether involuntary. However, in the third illustration of the German manuscript, probably added in Italy by a Jewish illuminator, the presence of the badge can be explained as the influence of the two German illuminations already included in the manuscript and also, perhaps, by a desire to indicate quite clearly that the victim in the murder scene was Jewish.

The reasons why the Jews suppressed the representation of the badge[349a] are perfectly clear; they felt the outrage keenly and tried, often with success—at least in Spain and Italy—to obtain exemption, either individually or for whole communities, in return for a substantial financial indemnity. It is more difficult to explain why Christian art, in which representation of Jews abounds—especially as the tendency grew to make depictions of the Gospels more realistic by introducing figures of contemporary Jews—should show the badge so rarely. It is all the more surprising in that it would be difficult in Christian art

to find any distinction of note between the clothes worn by Jews and those worn by contemporary Christians, before the typical Jewish style became orientalized in the fifteenth century. Perhaps, in the eyes of the Christians, the badge was not sufficiently humiliating; whereas, there is no lack of representation of the distinctive 'Jewish hat'.

## The 'Jewish Hat'

This hat might have seemed and might still seem to be such more degrading and odious than a simple coloured badge that could be hidden even at the risk of a fine or corporal punishment. The Jewish hat is a much more obvious distinction, both in daily life and in illustrations.

It is therefore surprising that the Jews, far from playing down the hat, as they did the wheel-shaped badge, depicted it quite openly throughout the history of medieval miniature painting. It is the inverted-funnel hat which we noted in the earliest
200 German illuminated manuscript known—Cod. hebr. 5, Munich, dated 1233—as well as in the first half of the fifteenth
117 century in the Cod. hebr. 37, Hamburg, or in Camb. Univ. Lib.
201 MS. Add. 662 [350] and even in one of the last manuscripts to be illuminated in Germany, towards the end of the fifteenth century, Cod. hebr. 200, Munich.

Despite appearances, the significance of this hat was quite different from that of the badge. As early as the twelfth century and right through the thirteenth, Jews can be seen in Christian art, in stained glass, sculpture or manuscript illuminations, wearing different sorts of hats, with more or less conical or pointed crowns. Among these is the soft cap we noted in MS.
167 Add. 11639 in the British Library and various models of the inverted-funnel hat. Although in France, for example, in certain periods it was obligatory for Jews to wear a pointed hat, whose exact shape was not prescribed, it was a hat with which they were already familiar. This is even more true of the *Judenhut*, the funnel-shaped hat worn by German Jews by their own choice long before the Council of Vienna in 1267 that made it obligatory to the exclusion of any other headwear.

The shape, so strange to modern eyes, has led to the belief that it was specially chosen to make its wearers ridiculous. At the time it was adopted by the Jews, it apparently was not considered bizarre. In fact, it differed only slightly from the flat-

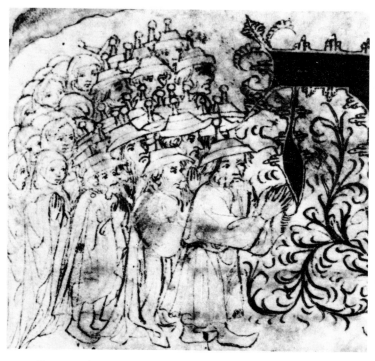

201 Germany, first half of the fifteenth century: a group of Jews wearing a version of the 'Jewish hat' often found in the fourteenth century: the crown is flattened and above it rises a long narrow cone, looking rather like a stem, surmounted by a ball.
Cambridge, University Library, MS. Add. 662, folio 53 verso (detail).

202 About 1300, Germany: a heraldic shield with arms consisting of three 'Jewish hats'.
Milan, Biblioteca Ambrosiana, Ms. Fragm. S.P. II. 252 (detail).

brimmed, pointed hat worn by horsemen and derived directly form the classical *petasus*.

The funnel-shaped hat was so much their own that Jews used it as one of their emblems, for example on fourteenth-century seals from Zurich and Überlingen. In a miniature of the early fourteenth century is an example of a coat of arms of this kind with three Jewish hats.[351] It also appears on the standards and shield of the Hebrews in the desert in an illustration to the Book of Numbers from the early fifteenth century.[352] This hat served as a decorative motif too, skilfully combined with interlace, in the micrographic panel of the initial word of the Book of Proverbs in a late thirteenth-century Bible.[353] Lastly, in a *maḥzor* decorated between 1320 and 1325, a painter proudly superscribed his name, Joseph, with a drawing of this hat.[354]

However, the funnel-shaped hat became increasingly rare in our Jewish illuminations, while different head-gear associated with changing fashions increased in numbers. This gradual disappearance in manuscripts reflected what was happening in reality. In fact, it was probably the abandoning of the *Judenhut* by the Jews that led to the imposition of the badge in the German towns. From the moment their funnel-shaped hat ceased to be a voluntary distinction—at a time when such differences between groups of people were sought for and accepted—and became instead a method of discrimination, Jews gradually developed a negative attitude towards it.

Special Badges for Women

The *rouelle* had to be worn by every Jew whether man, woman or even child from various ages: seven, twelve or thirteen. Special robes seem to have been specified for men and mantles for both men and women. There were also certain distinctive signs for women. One we have already met, the red skirt in Rome. A more widespread one was a veil marked with two blue stripes, decreed by a papal bull of 1257. After the Council of Avignon of 1326, this *oralia* or *orales* must have become a horned head-dress, for it is then called *cornalia*. In 1434 it is prescribed under that name at the same time as the badge at Augsburg. Veils, which were universally worn by Jewish women in the illustrations in our manuscripts, were, however, never in this shape, nor were they decorated with blue stripes.

## The Jewish 'Ethos' of Dress

The suppression of the badges of infamy is understandable enough. It need not completely invalidate our confidence in the evidence of our illuminations, nor cast doubt on the authenticity of the bourgeois and often even aristocratic style of dress shown there, if we bear in mind the attitude of Jews to clothes from Talmudic times: 'The glory of God is Man, and the glory of Man is his clothes' (*Yevamot*, 63b). Thus formulated, this aphorism may seem excessive at first sight, but it demonstrates clearly the high moral plane on which the Jews put all things concerning decency of dress and bearing from early times; for them these were inseparable from personal dignity. This refinement in dress did not express a vain obsession with appearance, but rather a duty towards God's creation—Man—who is the recipient of His knowledge and the agent of His will; every Jew was expected to see to this duty both for the poor and for himself. The more a man devoted himself to study, the more he was expected to clothe himself, from head to foot, in a dignified fashion. The same attitude prevented Jews from praying in their ordinary clothes, and in particular obliged them to wear clean clothes to the synagogue. A Jew was also expected to possess, as far as his means allowed, special clothes for the *shabat*.

Furthermore, the marriage contract, the *ketuba*, laid down the exact amount the husband was supposed to spend on his wife's dress and ornaments. Medieval wills also included recommendations from fathers to sons concerning dress; in one from fourteenth-century Spain, the sons were enjoined to 'accustom yourselves, your wives and children always to wear clean and beautiful clothes so that both God and man may honour you'.

## Luxury in Clothing and Jewish Sumptuary Laws

The costumes we have described often appear in liturgical scenes or in illustrations of holidays and ceremonies such as weddings. Therefore, they might all have been dress clothes and not those worn every day. Furthermore, an illuminated manuscript would only have been commissioned by a rich man, and nothing would be more natural for the painter of the illustrations than to show the patron's style of domestic and social life in it. The clothing could then represent only the wealthiest classes.

202

These classes always formed quite a wide segment in medieval communities (except in Spain) apart from periods when they suffered extortions, spoliations and persecution, and thus luxury was frequently increasing. At every period of the Middle Ages in Germany, Spain and Italy, Jewish moralists and religious leaders exorted the members of their communities to limit the luxury of their clothes and the splendour of their wedding and circumcision celebrations, both for moral reasons and for fear of exciting the jealousy of the Christian populace, which could quickly become a menace. The most striking of such documents is the sumptuary laws promulgated at Forli in 1418 by a committee of representatives of the Italian Jewish communities.

Luxury clothing was therefore a reality of Jewish life, and a widespread one. That this taste for luxury led to the adoption of the latest fashions prevalent in the Christian society is confirmed by the complaints of moralists—who were especially critical of the fashion of short garments that left the legs uncovered. Our Italian paintings dating from after the late fourteenth century that show young men following this kind of fashion, incontestably give us a true picture of reality. The variety and vividness of the colours of clothing also added an element of luxury. Jewish moralists in Spain encouraged their brethren to wear black as a symbol of their exile among foreign nations.

In 1397 Queen Mary of Aragon also wanted to force Jews to wear black, but as a symbol of the blackness of their hardened hearts. Although it does seem that the admonitions of the moralists led some Jewish communities to dress primarily in black, at least towards the end of the fifteenth century, 109, 115 \ 46, 349-50 fourteenth-century illuminations depict dark-coloured clothing only for mourning[354a]—and even then it was not common.[354b]

## Some Typical Jewish Habits of Dress

*Leviticus* XIX:27 prescribes: 'You shall not round off the side growth of your head, or destroy the side growth of your beard'. In the sixteenth century—a time when mysticism flourished—Judaism attached great importance to wearing a long beard and side locks *(pe'ot)* hanging down from the temples past the cheeks. This fashion was finally adopted by the most orthodox Jews. Historians have therefore sought to find evidence of special hair styles corresponding to this among medieval Jews. Jews also cover their heads in the synagogue, and the most pious never go bare-headed. What was the attitude of medieval Jews in these matters, and what traces are to be found of it in medieval illumination?

## Fashions in Hair and Beards

Christian iconography has sometimes been invoked to answer these questions. The example of the *Minnesinger* Süsskind von Trimberg (first quarter of the thirteenth century) is often quoted; he is supposed to have declared that when converted to Judaism he would wear a beard, a Jewish hat and a long mantle. In fact, he was thus represented in the Manasses manuscript in Heidelberg,[355] datable to the early fourteenth century.

As a general rule, Jews are often depicted in Christian iconography with beards, at least from the thirteenth century onwards. However, this is not an absolute proof that Jews in general wore beards. At periods when beards were rarely worn, it is not surprising that Christians would distinguish Jews in their pictures by this attribute, especially as it is certain that the most pious—and therefore in Christian eyes the most typical—Jews tended to wear beards, even if they trimmed them.

However, contrary to recent claims, it is impossible to identify the presence of the *pe'ot* in Christian pictures.[355a] The beards depicted on Jews grow from the temples or from further down on the jaw, exactly like those sometimes given to Christian figures. Locks in a bun over the ears (in the thirteenth and early fourteenth centuries) and long, curled or wavy locks at various periods were an integral part of hair styles and were even identical to the fashionable hair styles observed on Christians. *Pe'ot* are also totally absent from medieval Jewish illuminations, as the reader may verify by looking through the illustrations reproduced in this book.

This absence is to be expected, since long side locks were not worn by Jews in the Middle Ages. This fashion was started in the sixteenth century by the disciples of Isaac Luria (1534–72), and was especially popular in central Europe from the seventeenth century. A special preoccupation of the Middle Ages was the rabbinical dispute on the observance of the precept of Leviticus. How much of the beards and hair at the temples could be cut or even shaved? Cutting with scissors was generally permitted,

203 Italy, *c.* 1400: a face on which are shown the five areas—two symmetrically on the temples and cheeks and one on the chin—where, according to the ordinances in Leviticus XIX: 27, the hair and beard should not be cut.
Jerusalem, Jewish National and University Library, Ms. 4° 1193, folio 27 recto (detail).

though the suitable length remained debatable. Shaving was the great problem. In principle the prohibition only referred to five points on the face, but the rabbin who interpreted the Talmud did not agree on precisely where they lay. A manuscript of the *Mishne Tora* of Maimonides (1135–1204) includes a unique illustration with a solution to the problem. It is from Italy around 1400 and shows the head of a bald man, no doubt so as to make the matter clearer, with a small beard on his chin, side whiskers cut short at the top of the jaws, and tufts of short hair above the ears.[356] It can readily be understood that the difficulties attending the solution of this problem and also the Talmudic tradition that regarded the beard as a natural attribute of the masculine sex to be respected, encouraged the most pious Jews to keep their beards, trimmed to a greater or lesser extent. Thus, beards were customary among the *talmidey ḥakhamin*, but were mandatory only for someone performing one specific communal function, that of the officiating *ḥazzan*, reader of the *Tora*. Most Jews throughout the Middle Ages adopted the fashions of beards prevalent at each period, and as this excluded a beard most of that time, Jews were frequently clean-shaven, as rabbinical writings testify. The hair of Jews too was cut, curled and rolled like that of their Christian contemporaries. That this was indeed the situation is attested by the fact that, in attempts to strengthen discriminatory measures, royal edicts ordered Jews to let their beards grow and not to cut their hair, for instance, in southern Italy in 1222 and in Spain in 1412.

In every period of the Middle Ages and in every country, as stated previously, Jewish illustrations show a good proportion of beardless or clean-shaven faces, but there is a certain consistent tendency to wear a beard among the elderly and among teachers or scholars. Illuminations also show to what extent beards were worn by the *ḥazzanim*. They are bearded in the few ritual scenes in the synagogue from the second half of the fourteenth century which come from Spain.[357] Although the officiant is often shown in Ashkenazi lands between 1300 and 1320 with his head completely wrapped in the *ṭallit* (the prayer shawl that hides the whole face or the lower face),[358] he seems to have a beard[359] at the end of the thirteenth century. He still had one at the end of the fourteenth century,[360] and in the fifteenth century.[361] The custom seems to have been followed in Italy, despite exceptions that are perhaps only due to inadvertance:[362] in about 1430 the officiant is bearded,[363] and again at the end of the century.[364]

## The Obligation to Cover One's Head

The custom of covering one's head during prayer is not derived from biblical prescription but apparently from a usage acquired during the Babylonian exile and subsequently adopted by oriental Jews. In the West in the Middle Ages, the custom was less consistent. French Jews did not cover their heads in the synagogue in the twelfth century, and in northern France and Germany young boys were still not doing so in the thirteenth.

Representations of Jews worshipping in the synagogue do not occur before the fourteenth and fifteenth centuries. To mention those we have examined, in Spain, Germany and Italy, all the faithful have their heads covered, and even children wear some head covering—a cap, coif *(cale)* or hood *(capuchon)*—which argues that the custom was widely practised.

It is more difficult to decide whether or not Jews covered their heads on principle when they were outside the synagogue. There have been many cases of bare-headed figures in our descriptions, in all situations depicted. However, there have also been figures wearing head coverings indoors, on rising, at bed time, at table and at study. It should not be forgotten that the meal represented was the ritual *seder* repast, during which many blessings are pronounced. Thus, that all the participants in a late thirteenth-century French illumination[365] or in a late fourteenth-century Italian illustration[366] were bare-headed and that, on the contrary, all the heads depicted in Spain after 1350 were covered,[367] and also in Germany and Italy in the second half of the fifteenth century,[368] may prove nothing about ordinary life but only reflect a custom relative to prayer. On the other hand, in these medieval centuries it was usual to keep one's head covered indoors with the same head-gear as was worn outside: it is likely that, even under the influence of contemporary fashions, Jews were not bare-headed more often than Christians, but rather the reverse.

Since Talmudic times and with no divergences of opinion or exceptions, Jewish married women were enjoined to cover their hair. As we have stressed, illustrations in medieval Jewish manuscripts faithfully reproduced this custom everywhere and at every period, from the thirteenth to the end of the fifteenth century. But, since Christian women adopted the same custom after the sermons of St Paul and it was to a great extent still followed in the fourteenth and fifteenth centuries, the Jewish custom did not create any specific distinction.

203

95, 103

105, 355

96

197

132

151

133, 152,

204　Late thirteenth-century Italy: a Jew at prayer wearing the *ṭallit*; two of the *ẓiẓiyyot* attached to its four corners are visible.
Parma, Biblioteca Palatina, Ms. Parm. 1870—De Rossi 510, folio 163 verso.

## Special Clothing

The Jews possessed special clothes for the *shabat* and holidays. So far we have not described them any further than to say they were more luxurious than everyday wear. This luxury became such that the authorities of Jewish communities—in Italy in 1418 and Spain in 1432—decided to put a curb on excesses and ostentation in dress. In Italy one of these measures consisted of imposing a black outer garment without slashed or floating sleeves that covered and hid the rest of the clothing. An attempt to show it has perhaps been made in a picture of 1435 from Mantua;[369] as far as can be seen under the prayer shawls, all the figures except one (for which the painter probably inadvertently reversed the colours) wear a large black or dull-coloured cloak —dark grey, blue-grey or beige—over light-coloured garments. The cloaks hang in wide round folds and open at the front.

Although the same kind of black or dark grey cloak was known in sixteenth-century Germany, there was no sign of it in any Jewish illuminations from the preceding century.

In Spain, on the other hand, though there is nothing on the subject in the texts, it is noticeable that, in the middle and the end of the fourteenth century, the faithful assembled in the synagogue (apart from some figures[370] who wore a *houce* with wide short sleeves) wore hooded capes gathered at the neck, with a long liripipe hanging down the back; there were no openings for the arms. The colour of the capes was not uniform, however, and could be either dark or light.

## Ritual Garments: *Ṭallit* and *Ẓiẓiyyot, Arba Kanfot*

A biblical injunction, repeated daily in the *shema* (the central prayer of Judaism) commands the children of Israel to 'make them *ẓiẓiyyot* (fringes) in the borders of their garments throughout their generations' (Numbers XV:38). These fringes were thus part of everyday wear. Each fringe was composed of four threads passed through a hole, then doubled, twisted and knotted at a corner of the *ṭallit*, a large rectangular shawl in which Jews wrapped themselves in ancient times. This type of shawl was abandoned during the Diaspora, and thus the habit of wearing the *ẓiẓiyyot* was lost. Despite the renaissance of

Talmudic teaching in the West from the eleventh century, the fringes were still not generally worn in the thirteenth. In a rough sketch from 1239 they were depicted at the bottom of a gown.[371] The custom of fixing them to a piece of linen or white wool, sufficiently large to wrap around the head and body, became widespread. The *ṭallit* became a purely ritual garment donned only for prayer: for daily morning prayer; the services of the *shabat* and holidays; the service on the day of *yom kipur* (the great pardon) in the case of the ordinary faithful; and for all prayers recited before the ark and for readings of the Law by the officiants.

Ashkenazi pictures of the late thirteenth and early fourteenth centuries represent the officiant wearing the *ṭallit* with its *ẓiẓiyyot*,[372] but it does not look as though the congregation wore it in the synagogue.[373]

During the marriage ceremony, the *ṭallit* placed on the heads of the bride and groom acted as the ritual canopy.[374] The custom continued but is not attested in the illuminations, except in Italy in the fifteenth century.[374a]

In Spain, the same state of affairs prevailed in the second half of the fourteenth century according to the illuminations. The officiant certainly wrapped himself in a large white shawl, but the *ẓiẓiyyot* are hidden by the parapet of the *almemor* (platform) and the faithful are not wearing shawls.[375]

In Italy the *ṭallit* and *ẓiẓiyyot* had already appeared by the end of the thirteenth century on a layman who is reciting the beginning of morning prayers on an ordinary weekday.[376] At the end of the fourteenth century and around 1400, the *ṭallit* with *ẓiẓiyyot* was worn both by worshippers at prayer and by the officiant, whether the latter was praying before the ark or holding the *Tora* scroll in his arms.[377] The *kohen* (priest) also put on the *ṭallit* to bless the people.[378]

Only in the first half of the fifteenth century in Italy and Germany do representations of the congregation of the faithful first appear, in which everyone wore the *ṭallit*. The most remarkable one is in Cod. Rossian. 555 of the Vatican,[379] with which we are already familiar. The illustration in Hamburg Cod. hebr. 37[380] is equally explicit. Other illuminations—around 1430, then between 1465 and 1470—depicted scenes in the synagogue where neither the officiant nor the worshippers wore the *ṭallit*,[381] but in Ms. Rothschild 24 it was worn habitually by everyone.[382]

The *ṭallit* was also worn for the performance of various religious rites: when blowing the ram's horn *(shofar)* during *rosh*

92

90, 93

336

183

95

204

99, 197

384

92

97

361

*ha-shana* (New Year);[382a] during *sukot* (Tabernacles), when blessing the *lulav* and the *etrog*;[383] by the child's godfather during circumcision.[384]

340

Apart from an Ashkenazi illustration of the late thirteenth century, in which the officiant is wearing the Jewish hat and is, therefore, only wrapped from the shoulders in the *tallit*,[385] everywhere throughout our period, the *tallit* covered the head and enveloped the body, while one of its flaps was often flung over one shoulder. Only in a German picture of 1471[386] were

196 Jews at prayer portrayed wearing the *tallit* draped over their shoulders like a scarf.

The central part of the upper edge of the *tallit*, which hangs over the forehead when the head is covered and is therefore called the *atara* (crown), was decorated with rich embroidery as

93 early as the beginning of the fourteenth century in Ashkenazi

197 lands.[387] It was decorated in the same way in northern Italy, but not before 1465 or 1470.[388] Sometimes the *tallit* was decorated with stripes woven across the width, near the edges.[389] The stripes were portrayed greyish brown on an Italian *tallit* of the thirteenth century.[390] In modern times these stripes are blue or black. The red stripes that appear in the Leipzig *Maḥzor* can only be due to an unexplained fantasy of the painter.

Pious Jews who wished to wear *ẓiẓiyyot* all day long created a special garment in the Middle Ages, a scapular that could easily be worn under other clothes. The *ẓiẓiyyot* were fixed at the four 198 corners; this undergarment is the so-called *arba kanfot* (four corners). It was not noted before about 1350, when it was mentioned in Jacob ben Asher's *Ṭur oraḥ ḥayyim*, and there is only a single illustration of it, from the second half of the fifteenth century, in Germany.[391]

The miniatures in Jewish manuscripts make it clear that there was no uniformity, tradition or character that could be termed national in the clothing—following prevailing fashions—worn by Jews in the later Middle Ages, in whatever country they resided. But religion and the prescriptions of the Law, those ever-living sources of the fundamental unity of Jewish groups of the Diaspora, also gave birth to original creations in the only garments common to all Jews: the *tallit* and the *arba kanfot*, to which the *ẓiẓiyyot* were attached. These garments were the reflection of the exclusively religious unity of Jews and had no more than a ritual function, but one that was invested with great spiritual meaning: they furnished a daily reminder to the scattered people who donned them that they observed a common Law, belonged to a chosen people and were privileged to maintain a special relationship of love that united them with their God.

# V  The Professional Life of the Jewish Community and Its Place in the Medieval City

Judaism has never looked upon manual labour as degrading, nor relegated manual workers to a low social status. The Bible repeatedly praises manual labour, and there is many a Talmudic adage extolling the dignity and greatness of human labour. 'Six days you shall labour' (Exodus XX:9) was as much a biblical precept as the rest required on the seventh day. Only work and the wages derived from it, said the sages, could ensure a man's independence and dignity. One of the duties of a father was, therefore, to see that his sons learned a trade. Moralists saw work as a sure way to avoid the idleness that leads to vice. However, work was not considered the purpose of human life; the meaning of life lay in the study and fulfilment of the Law. Practice of a trade was therefore to be limited to ensuring the necessary means of existence, although some sages considered working at a trade as a safeguard against mental instability and the health hazard to the soul inherent in exclusively studious pursuits. In the Middle Ages, Maimonides advised a disciple: 'Devote yourself to commerce and the study of medicine, but, do not neglect the study of the Law: therein will you find the right method.' It is well known that Maimonides's medical pursuits held a central place in the master's life.

In fact, during antiquity and the Middle Ages, whenever the civil and religious authorities of the countries where the Jews lived left them free to choose their professional activities, there is hardly an occupation to which Jews did not devote themselves, be it agriculture, crafts, commerce or the liberal professions.

But in the period with which we are concerned—from the thirteenth to the fifteenth century—the professional activities of the Jews could not develop autonomously. The extent and form of those activities were increasingly defined by the progressive segregation of Jewish communities from the Christian populations among whom they were established.

In degrees varying according to the country, two principal obstacles had discouraged Jews from embracing the rural life or engaging in large-scale agricultural enterprise: first, the determination of the Catholic Church to deprive those whom she wished to reduce to the status of pariahs of the right to employ initially any slave labour and then any Christian; second, the restrictions on the ability of Jews to acquire and possess land, consequent on the extension of the feudal system. Both causes operated in France. On the other hand, in Spain the Jews had received lands to reclaim or cultivate from the kings for their services during the Reconquista, and although the Church was

able to impose its restrictions in Aragon before the end of the thirteenth century, such restrictions were still ineffective in Castile in the early fifteenth century.

Previously the Jews had been among the pioneers of long-distance trade in western Europe, ranging from the Mediterranean to the Rhine, and via the Danube valley through Bavaria and Austria to the Crimea, the Caucasus, Baghdad and Mosul. Now, they took only a limited part in such trade, for they had been supplanted by Christians, who hampered them in numerous ways.

As the towns organized themselves and the trade guilds became consolidated, local trade and crafts were closed to the Jews. They were forbidden to practise a growing number of trades, at least among Christian clientele, or to sell an increasing number of articles of food to Christians. The many taxes imposed on them for entering and leaving markets, as well as tolls of all sorts, were calculated to discourage their activity as tradesmen.

However, the Jews were among the first people to understand the importance of credit, and as early as the eleventh century they were engaged in providing loans auxiliary to their commerce. Of course the largest transactions, necessary at that time because of the gathering momentum of economic life, were in the hands of great Christian merchants whose commercial activities allowed them to circumvent the prohibition against lending at interest which the Catholic Church maintained intransigently. Jews had a clearer field when providing loans to the local trade, at fairs and, for immediate needs, with or without pledges for security. Thus, wherever the Jews were excluded from other activities, money-lending, first carried on as a sideline to their other occupations, became their main resource. Although the Catholic Church condemned it as she did Christian usury, and had difficulty accepting the domination that she felt it allowed Jews to exercise over Christians, economic necessity made the Church not only tolerate but sometimes even solicit money-lending.

Despite being heavily taxed and controlled, money-lending had advantages over owning house or land: it provided liquid assets during persecutions, which were becoming ever more frequent, and substantial profit at a time when the fate of Jewish communities depended on how well they met the increasingly onerous taxes imposed on them by kings, princes and towns. In fact, the Jews were now hardly tolerated or they were accepted only insofar as they were able to pay taxes and ransoms and lend

205　Working in the fields, Normandy, 1239: a plough with two wheels and a
pair of handles, drawn by two horned animals.
Vatican, Biblioteca Apostolica, Cod. Vat. ebr. 14, folio 59 verso.

the necessary capital for the most diverse enterprises: fortifications, fitting out ships, military expeditions, crusades, feasts, royal receptions and so on. Sooner or later, however, one final seizure of goods followed by expulsion would put an end to the precarious protection afforded by the Jews' temporary usefulness.

The professional activity of medieval Jews became increasingly delimited. Craftsmen, those engaged in small trades and the liberal professions, saw their clientele progressively reduced to the members of the Jewish community, while in the end money-lending, which primarily fulfilled the needs of a non-Jewish clientele, became the last economic link between Jewish groups and the majority of the Christian population.

How far did these trades and occupations—better preserved in rabbinical writings than in Christian chronicles—laws and ordinances, provide subjects for medieval Jewish illustrations? What do we learn of these activities from the illuminations in Hebrew manuscripts? Is the picture complete and coherent, or fragmentary and allusive?

## Glimpses of the Economic Life of Jews in Northern France in the Thirteenth Century

### Agricultural Life

Already in the Carolingian period, the Jews were expert vintners, who even supplied Christians with wine for the Mass; this continued to the eleventh and twelfth centuries. By the thirteenth century, it was the last agricultural activity in which

Jews were still engaged, no doubt because of the need to supervise the wine used for the *qiddush* benediction. However, the vine has left no trace in our French manuscripts, apart from a decorative motif on one page of a late thirteenth-century manuscript. [1]

On the other hand, a few drawings—very unskilled but strangely lively—executed in micrography in 1239 at Rouen, in one of the two earliest illuminated Hebrew manuscripts of French origin, [2] show the fields being ploughed before sowing, [3] and both large and small cattle. [4] No doubt, these illustrations translate the biblical text literally: labouring in the fields in Egypt (Genesis XLVII:23–24), the flocks of Jacob (Genesis XXXII:6) and the beasts for sacrifices (Numbers VII:88). But the extraordinary realism of the sketches of the animals—bull, oxen, goat and ass—and the illustration of the plough with its two wheels and heavy share, reflect realities close to the draughtsman: the rural life of his time to which the Jews, according to the documentary evidence—as skilful at farming as they were at wine growing—were not yet strangers.

### Money-Lending

The other aspect of Jewish economic life—the manipulation of money and the credit required by commerce and lending at interest—was only represented by drawings of the changer's scales, twice in the same manuscript, [5] and always within a biblical context (Genesis XXIII:16 and Exodus XXV:3).

We have found no trace in this manuscript or elsewhere of other trades like that of the butcher, flour merchant, barber or doctor, which the Jews were still practising, for example, in Paris towards the end of the thirteenth century, as attested by the tax rolls of that city between 1292 and 1297.

## Trades and Occupations in Spain in the Fourteenth Century

Although for the most part Spanish illuminations once again provide information indirectly by biblical illustrations of what might be called 'obligatory' subjects, they offer a much more

varied account of Jewish professional life in the Middle Ages.

It was not until the early fifteenth century, under pressure of religious fanaticism, that the king of Castile made an attempt, by promulgating the laws of Valladolid in 1412, to eliminate Jews from the economic life of his kingdom. Until then, in spite of local controls, taxes and restrictions, Spanish Jews in Castile, Navarre, Aragon and Majorca were engaged in the most varied trades and professions, ranging from work in the chancery secretariat or the treasury and tax-collecting to agriculture, and including astronomy, medicine, commerce and crafts.

## Agriculture

In villages or on the outskirts of towns, Jews owned fields, olive groves, orchards and vineyards. The less rich worked them themselves, and sold the produce. Olive trees, fig trees and their fruit, pomegranates and vines were illustrated naturalistically. [6] Tending the vineyard, picking grapes with special pruning knives, and harvesting grapes in little baskets were illustrated about 1330, and again towards the middle of the fourteenth century. [7] A picture from after 1350 shows us a peasant hoeing: his feet and chest are bare, and he is only wearing breeches. [8]

## Building

There were many restrictions placed on the Jews with regard to building houses and synagogues. They were not even entirely free to repair or enlarge buildings of the previous century. Nevertheless, to cite only a few examples, early in the fourteenth century the synagogue of Cordoba was rebuilt; in 1321 that of Castellon de Ampurias was enlarged; before 1339 Don Yuçaf of Ecija had a synagogue built at Seville, and in Toledo in 1357, Don Samuel Halevi built his splendid private house of prayer. Other indispensable restorations and reconstructions were undertaken as well, especially after the all too frequent attacks on the *aljamas* (Jewish quarters). Nor was construction lacking outside the Jewish quarters, despite the monopoly in many areas of Muslim masons. At any rate, Jews in the various building trades must not have been idle.

A series of illustrations from the first quarter to the end of the fourteenth century [9] shows brick-makers, mortar mixers, masons and their assistants and carpenters at work at the construction sites.

The brick-makers can be seen kneading clay with their feet and shaping the bricks. [10] As the building rises, ladders allow the labourers to carry up bricks and stone on their heads or backs, while a cord and pulley facilitate the raising of bricks and mortar in baskets. [11] Then masons, sometimes perched on a precarious plank scaffolding at the top, [12] spread the mortar and lay the

those skilled at working iron, copper, gold or silver: the blacksmiths, locksmiths, turners, goldsmiths and engravers. Some of these trades were organized into guilds with their own synagogues. Unfortunately Jewish illumination has not provided us with a single illustration of this busy and picturesque world, not one drawing to transmit the special movements of one of these trades, the details of tools, or the appearance of a studio or workshop.

Equally underrepresented in Jewish illustrations are the shops in the streets of the Jewish quarters; there is no sign of the market booths or stalls in the towns where the Jews were forced to sell some of their products, such as cloth, under special controls and subject to taxes, and where everyday objects and luxury items changed hands. Nor is there any echo of the animated daily scenes of people buying their bread, fruit, vegetables, poultry and meat.

bricks or blocks, [13] fixing them solidly with hammers. [14] Despite the precision of detail and the accuracy with which certain gestures are represented, the masons depicted are lacking such essential equipment as squares, levels and plumb lines.

207   Carpenters used axes, adzes and saws to shape the pieces of wood. [15] Sawing was done with a long saw with a large-toothed blade fixed to a rectangular frame, so that the whole could be gripped with both hands. [16] A plane was perhaps also used. [17] Uprights, planks, and braces were assembled with nails that were hammered in. [18] In the same manner as for masonry work, a pulley block and tackle allowed planks and the necessary tools to be hoisted up to the carpenters. [19]

Whether in wood or stone, brick or plaster, only the roughest work is depicted; specialists in decoration—sculptors and plasterers—are not represented.

## Craftsmen and Small Shopkeepers

As far as we can glean from the texts, crafts practised by Jews were still extremely varied in the fourteenth century. In Saragossa and Barcelona, for example, the middle and lower classes in Jewish communities earned their livings as craftsmen. The Jews had for long been specialized in the manufacture of cloth: both its dyeing and weaving. There were tailors and embroiderers; others worked skins: there were tanners, saddlers, shoemakers and even expert furriers. Then there were

## Midwives and Mourners

In every human community pregnancy and birth have always been and still are attended by experienced practitioners. The Bible records the important role of Jewish midwives in Egypt (Exodus I:15–17). Rabbinical commentaries describe their profession. In this case it is not surprising to find so few illustrations, for Christian iconography included the actual birth process only exceptionally, [19a] therefore, the Jewish images or those inspired by them are all the more interesting. One miniature simply shows us the mother just after giving birth, 290 seated naked in her bed and holding her newborn baby in her arms; [20] yet another depicts the birth itself: [21] The mother fully 289 dressed and even wearing shoes, is seated on the edge of the bed with her legs hanging down and her skirts raised; a midwife is kneeling beside her grasping the children by the head—the illuminator has chosen the exceptional case of twins being born simultaneously. In the Alba Bible, [22] in which the iconography bears the imprint of the commentaries of the translator-rabbi Moses Arragel, we have the unique example of a woman—Eve—delivering her own child.

Death was the occasion not only of religious rites peculiar to the Jewish community but also of the ceremony of lamentation, the *qina*, which was both a Jewish tradition and a general custom among ancient peoples. It was still practised widely in the

208 A small popular orchestra in Spain, c. 1350–60: among the players of wind, string and percussion instruments are, from left to right, a tambourine player who simultaneously plays a flute, a rebeck player, a piper and a timpanist. London, British Library, MS. Add. 14761, folio 61 recto (detail).

209 A Spanish musical instrument, c. 1350–60, apparently related to the drum or psaltery; in spite of the curious curved shape of the sound box with its single sound hole, it has strings stretched between the longer of the curvilinear sides and the straight edge on top, where they are tensioned by pegs; the small implement shown suspended on the left may be a tool for varying the tension of the strings while playing. London, British Library, MS. Add. 14761, folio 28 verso (detail).

208

209

Middle Ages, particularly in Spain in the period we are considering. The lamentation was led by professional mourners: according to our sources Jewish and Muslim women were so employed in Seville, by both Christian and Jewish families. Some Jewish illuminations illustrate this practice during the fourteenth century: women beside the deathbed show the conventional gestures of sorrow. [23]

348

## *Entertainers and Musicians*

To add to the gaiety of celebrations (especially the feasts held at circumcisions and weddings), musicians were called in. Often there were storytellers, singers and tumblers as well. Although sometimes they were well-established in one place—Pamplona, for instance, had a famous tumbler in the fourteenth century—mostly they were itinerant, providing their services as the occasion arose. Rich households hired the services of instrumentalists and singers. At every period Jews performed their repertories along with non-Jewish minstrels, but there were some who specialized in traditional Jewish songs and tunes. Though it is impossible to judge their exact repertoire, we have an idea of it from a miniature dating from after 1350 showing a small popular orchestra with wind, string and

percussion instruments: one person plays both tambourine and flute, while a cymbalist and a piper accompany two musicians on stringed instruments, playing a lute and a rebeck, respectively. Dulcimers and psalteries might also be included. [24]

208-9

## *Money-Lending and Trade*

Both in Aragon and Castile, middle-class Jews, craftsmen and tradesmen lent at interest out of necessity, because otherwise they could not earn enough to pay the excessive taxes weighing on them, whereas members of a few rich families had lucrative positions with kings, princes or church dignitaries as treasurers, bankers, *almoxarife* (tax farmers) or customs collectors: the Ravaya family in Aragon, between 1260 and 1270; in Castile, Don Samuel and Abraham ibn Shoshan, between 1262 and 1307; later during the fourteenth century, Don Yuçaf, *almoxarife major* to Alfonso XI; Don Samuel Halevi, treasurer to Peter the Cruel; Benveniste de la Cavalleria, customs collector in Aragon. Only one allusion is made to this financial activity in our Spanish illuminations, and again—as in the French manuscript—it is through the motif of a money-changer's scales in a Castilian Bible of 1299 or 1300. [25]

215

210 An ocean-going Spanish ship, 1472: it has three masts and square sails, crow's-nests provided with bundles of arrows or bolts for use when attacked, fortified forecastle and poop, a carved dragon's head on the prow, and an axial rudder, a technical refinement that was useful when sailing on a straight course far from land, particularly along meridian lines.
Oxford, Bodleian Library, MS. Kennicott 1, folio 305 recto (detail).

Commercial activity was the subject of some more descriptive pictures. In fourteenth-century Aragon, Jews were still taking part in the local cloth, skin and grain trade. In an illustration from the middle of the century, we see sacks of grain being carried on the backs of donkeys or mules. The grain was then stored in conical silos, sometimes made of masonry. Perched on ladders, labourers emptied the sacks of grain into the silo, while a scribe noted down the figures. [26]

In the fourteenth century, Jews no longer played the part they had previously in Mediterranean trade, between the south of France and Catalonia, on the one hand, and Italy, North Africa and the Middle East, on the other. Jews were probably still travelling in the mid-fourteenth century from Barcelona to Alexandria, Cyprus, Damascus and the Holy Land, but as time went on restrictions were imposed on their participation in commercial operations and companies. In 1381, for instance, the Catalan consul in Alexandria was not permitted to rent rooms or shops in the *fondaco* to Jews or Muslims.

Although it seems that the Jews of Barcelona, Valencia and Majorca did not own ships in the fourteenth century, or travel in great numbers, they still participated in the sea trade through the 'command' system, which was then a common practice. They played the role of the 'stable partner', who stayed ashore

and provided cash and goods to travelling merchants, in exchange for assuming all the risks in case of shipwreck, or the major share of profits after a successful voyage. During this period Jews were therefore among those waiting anxiously at the ports for the return of the heavily laden merchant ships that plied the inland sea.

Stocky, broad-beamed vessels with high sides, these ships, also known as *coques* ('hulls'), can be seen in some illustrations of the early fourteenth century. The smallest had a single mast with a square sail and a forecastle; two oars at the poop served as a rudder. [27] Larger ships had castles both fore and aft, a double 216 rudder at the stern, and two masts. [28] In case of attack, the castles and tops were armed with arrows and missiles for archers and crossbowmen to fire at the enemy. In 1375, on the world map attributed to Abraham Cresques, [29] a very different, low-draught 59 ship was portrayed: a long slender galley sailing towards the African coast, its lateen sail filled and its flag with the red and gold stripes of the arms of Aragon floating in the wind. Since it was equipped with oars, this sloop only needed to use its sails, as in our picture, with a favorable wind. A much larger high-draught ship, with three masts, tops fitted with arrows, square 210 sails, two castles and a carved figurehead, was depicted a century later, in 1472, with an axial rudder. [30]

## Cartographers, Compass and Astrolabe Makers

Abraham Cresques, the probable painter of the world map described at the beginning of this book and mentioned just above, painted other maps for the infante Don Juan of Aragon; his son Jafuda, whom Abraham Cresques trained in the same profession, finished the map on which his father was working when he died in 1387. Both father and son were also *brujuleros*, to distinguish them as painters, rather than makers, of compasses. On the bottom of the circular receptacle in which the magnetic needle floated, they used indelible colours to paint the compass card just like the one opposite Portugal on the world 59 map dating from 1375. [31] The Cresques family were not the only Jews to practise this craft. Hayyim ibn Rich is also known; like Jafuda Cresques, he was converted to Christianity in 1391, and his son, Gabriel de Valseca, painted a famous map that was

bought by Amerigo Vespucci in 1439. Not all maps were as *de luxe* as these. Much more modest nautical maps were used by sailors as navigation aids.

Spanish Jews were also skilled in making and perfecting scientific instruments that enabled navigation to become more exact: for example, David Bonjorn of Perpignan, Isaac Nafuci of Majorca (who worked for Peter IV and John I) and Abraham Zacuto in Portugal at the end of the fifteenth century. Of those instruments made for calculating the height of the stars over the horizon, time and latitude, the most appreciated by navigators were the simplest, planispherical astrolabes called 'nautical astrolabes'. They were more easily transported than armillary astrolabes, more accurate than the arbalest and easier to use than quadrants.

## Astrologers and Astronomers

Among both Jews and Christians, it was rare for an astronomer in the Middle Ages not to be an astrologer as well. From Talmudic times the majority of sages had accepted the idea that every person was born, lived and died under the influence of a particular heavenly body, his *mazzal*. Maimonides alone among the medieval Jewish philosophers saw only self-deception and chicanery in astrology. Therefore, it is not surprising to find Jewish astrologers attached to the kings of Spain throughout the Middle Ages: Yahuda ben Moshe ha-kohen at the court of Castile in the thirteenth century; Cresques de Vivers in Aragon in the fourteenth century; Abraham Zacuto attached to John II and Manuel I of Portugal in the fifteenth century.

Observations and calculations were the foundation of astrologers' predictions and horoscopes. If the former were as accurate as possible, the chances were greater that the latter could pierce the secrets of the future. Belief in astrology was a much more potent force in the progress of astronomy than any purely scientific interest. The instruments for observing and calculating, and the astronomical tables that benefited science were usually perfected in the interests of the pseudo-science. Thus, the scientific activity of Abraham Zacuto, who taught astronomy and astrology at the University of Salamanca, and contributed to the success of the Portuguese voyages of discovery—his astronomical tables were also used by Christopher Columbus—was indissolubly linked with his work as an astrologer. In 1496, before the departure of Vasco da

Gama, the king of Portugal asked Zacuto not only to instruct the sailors in the use of his new astrolabe, astronomical tables and maps, but also to predict the fate of the expedition.

Whether of astronomers or astrologers, or both at once, there was hardly a team engaged in astronomical research in medieval Spain in which Jews did not play an important if not a decisive role. They were involved in the compilation of most of the astronomical tables (the 'Tables of Toledo', in the twelfth century, and the Alphonsine Tables in 1272), and often they set up their own personal tables, such as Abraham ibn Ezra did in the twelfth century, Jacob ben David Bonjorn in 1361 or Abraham Zacuto in the fifteenth century. Jews had a strong religious motive to establish as accurate a calendar as possible: they wanted to harmonize the solar and lunar calendars so that they could observe their holidays on exact dates. During their work, some Jews were led to make observations or propose methods of calculation that were in turn fruitful for the later development of astronomy. Isaac ben Joseph Israeli in his *Yesod olam* ('Foundation of the Universe') in 1310 did just that.

However diverse and enthusiastic the interest among Spanish Jews in the Middle Ages for astronomical research, it did not occupy a large place in their illuminations. There are, of course, many astrological and astronomical manuscripts rich in diagrams and figures, as, for example, a copy of the *Almageste*,[32] probably dating from the fourteenth century but not decorated until the fifteenth. Others contain illustrations of the constellations.[33] However, astrologers and astronomers themselves only appear very rarely. One rather summary picture from 1472[34] depicts an astrologer holding up his astrolabe, but the instrument, painted in red and blue, is more decorative than scientific. In the second half of the fourteenth century, a skilful miniaturist, who was probably not a Jew, depicted an astronomer observing a starry sky in which both a golden sun 217 and a silver moon are shining; the astronomer is using an astrolabe, on which the alidade can be seen, and he is consulting a book of astronomical tables which lies on his lap.[35]

## Physicians

If there is one profession practised by Jews more often than astronomy, it is medicine. In times when the field of human knowledge was limited, it was still possible for a single mind to

embrace all of it; therefore, it was not rare for a doctor also to work at astronomy. Among the Spanish Jews alone there are numerous examples: in the twelfth century, the master Talmudist and philosopher Maimonides; in the fourteenth, Don Samuel ibn Wakar of Toledo; in the fifteenth, Joseph Vecinho. Despite the number of papal bulls and royal ordinances aimed at limiting the access of Jews to the instruction and study of medicine, as well as limiting their practices to the Jewish community, their skill was such that popes and kings, bishops and monks in their monasteries, nobles and humble folk alike had recourse to the experience, devotion and care of Jewish doctors. In Spain, Jewish doctors were no exception: however, since there are no Spanish illuminated Hebrew manuscripts containing illustrations either of their teaching or of their consultations, we shall not dwell upon them.

## Royal Service

Spanish miniatures offer no evidence of those individuals who officially or unofficially (depending on the success of the Catholic Church in exerting pressure on sovereigns to exclude Jews from all posts of authority) had the confidence of the kings of Aragon or Castile. Such was the case of Don Samuel Halevi of Toledo, who, under the title of 'Treasurer', was actually a minister of Peter the Cruel. Perhaps, though, their careers and the roles they played, the details of their functions, are alluded to in the story cycles of Joseph that were treated in several manuscripts; [36] for it was said of Don Yuçaf of Ecija, who sat in the Privy Council of Alfonso XI: 'He was a veritable Joseph ... there was no one greater than he in the kingdom of Castile.... He was close to the king and great among the Jews.' In this case, the comparison must have been easy to make because his first name, Yuçaf (which means Joseph), was the same as the biblical Pharaoh's minister.

## Economic Life and the Occupations of Jews in the German States

By the end of the thirteenth century Jewish miniatures serve as a reflection of the economic and professional life of Jews in Germany; this had, by then, deteriorated so far that the paucity of available documentation is hardly a surprise.

## Rural Life

Harvesters, both men and women, cut wheat with sickles and bound the sheaves, while a labourer followed them with a rake. The gleaners hastened to gather the fallen ears into baskets. The sheaves were threshed with hinged flails, and the grain was 218 winnowed. [37] As the months went by and the sun traversed the zodiac, work in fields and gardens went on: hoeing, pruning and grafting trees and vines; harvesting hay and wheat; threshing, winnowing; harvesting and pressing grapes; autumn ploughing 219 and sowing. [38] Those scenes in a few *mahzorim* of the late thirteenth, early fourteenth, and early fifteenth centuries illustrated the story of Ruth or accompanied the *piyyuṭ* of Eleazar Qalir, which was included in the prayer for rain on the first day of *pesaḥ*, the Passover holiday. But during our period in the Rhineland and southern Germany, whence these pictures come,

211    Castile, *c.* 1300: olive trees tended by Jews. The produce was destined for their own needs, though any surplus could be sold.
Lisbon, Biblioteca Nacional, Ms. Il. 72, folio 316 verso (detail).

212    Working the earth with a pick in Aragon, after 1300.
Sarajevo, National Museum, Haggada, folio 3 verso (lower register, left, detail).

213    Vines in Aragon, *c.* 1350–60. Jews in Spain, as elsewhere in western Europe, grew vines with care, the wine being needed as an everyday drink and for ritual purposes on the *shabat* and holidays.
Sarajevo, National Museum, Haggada, folio 31 recto of the text.

214    On a building site in Castile, first quarter of the fourteenth century: a ▷ mason and his assistant at work supervised by a foreman.
London, British Library, MS. Or. 2737, folio 62 verso.

215    The scales of a money-changer in Castile, 1300s: the hemispherical trays ▷ are suspended by cords from the serpent-head ornament at each end of the oscillating bar.
Lisbon, Biblioteca Nacional, Ms. Il. 72, folio 206 recto.

216    A Spanish ship of the 1300s: rigging consists of a single mast and a square ▷ sail; there are two tillers; the forecastle is fortified, and the ship's 'standard' projects from the bow prow.
Lisbon, Biblioteca Nacional, Ms. Il. 72, folio 304 recto (detail).

217    Second half of the fourteenth century: a Spanish astronomer looks at the ▷ stars with an astrolabe and makes his calculations with the help of astronomical tables.
Copenhagen, Royal Library, Cod. Hebr. XXXVII, folio 114 recto (detail).

211

212

213

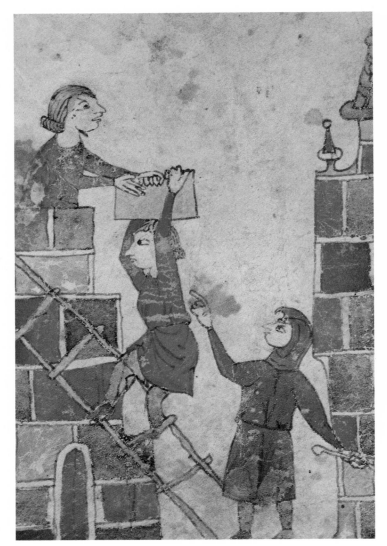

214

215

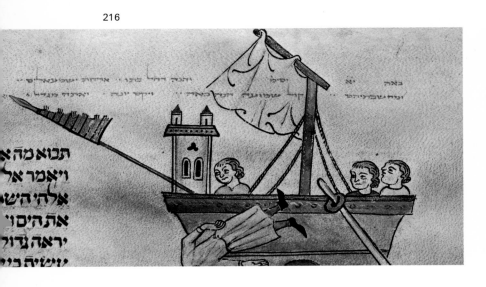

216

217

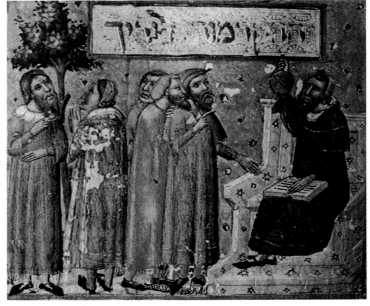

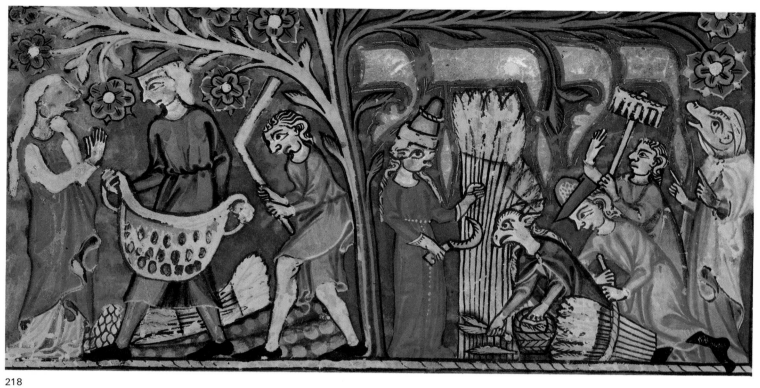

218

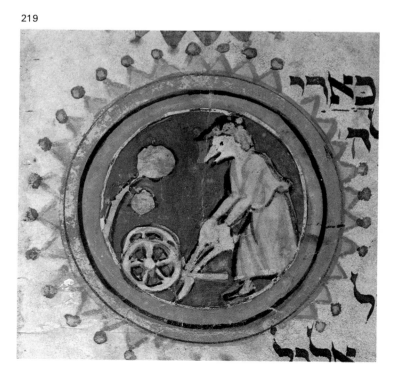

219

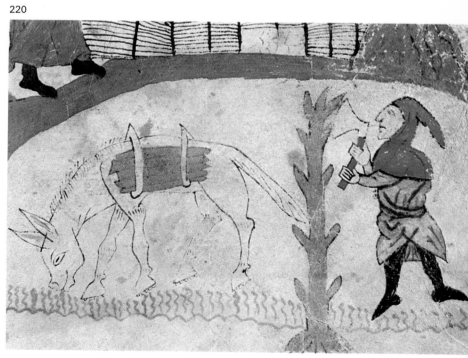

220

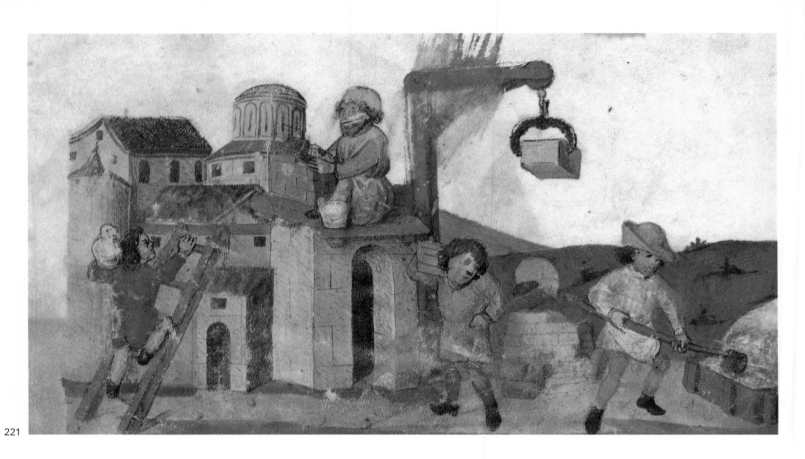

221

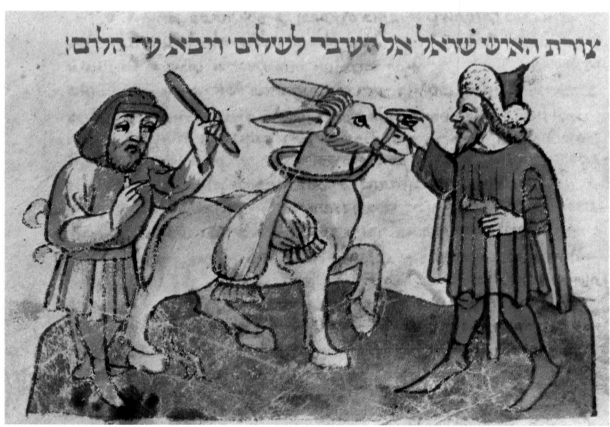

צורת האיש שׁואל אל העבר לשלום · ויבא עי הלום:

222

and where the Jews had lost the right to own or cultivate land, rural occupations (with the exception of viticulture which is still attested in a few rare places in the fourteenth century) were only a memory for Jews, something they saw during their peregrinations.

It is not unlikely that Jews were sometimes still able to practise the humblest rural trades, such as woodcutting. A plain
223 or reinforced bill-hook with a straight blade is not rare among the tools decorating the margins of certain large Ashkenazi Bibles of about 1300. [39] On one page of a *maḥzor* from 1348 a
220 woodcutter is cutting off tree branches with an axe and loading them on his donkey's pack-saddle. [40] Was it not to the level of 'hewers of wood and drawers of water', of foreigners, the lowest of the low, in the words of the Bible itself (Deuteronomy XXIX:10), that the Catholic Church was bent on bringing the Jews?

## Crafts

Excluded from the crafts, Jews struggled to maintain the right to practise a few trades indispensable to their community: manufacturing clothing for example. It was important that they made sure to avoid the forbidden mixture of wool and linen, *sha' aṭnez* (Deuteronomy XXII:11). For cutting-out material, Jewish
224 tailors around 1300 used the type of scissors that were then current with large thick blades but without loops for the fingers. [41]

Although hardly allusive, the sole of a shoe was a motif repeated quite often in the marginal decoration in micrography of the Bibles already mentioned. [42] They demonstrate a familiarity at least with shoe repair, if not with shoe making. Even though there is no visible evidence, not even anything as fragmentary as the preceding case, it is obvious that the need to mend utensils and objects of all sorts forced the Jews to pursue other craft activities, though it may have been on a very small scale and at a low level of specialization.

Forced to live within the narrow limits of the quarter reserved for them, deprived of the right to build or enlarge their synagogues and only allowed to repair them, Jews had little occasion to take up building as a trade.

It is not clear from the textual sources whether the Jews employed Jews or Christians when they needed construction workers. Despite the rich and realistic detail used in a scene from
117 1427 [43]—active and energetic figures are shown carefully sorting out stones, mixing plaster or mortar, hoisting stones with a metal grab operated by a system of pulleys—we still do
221 not know if the craftsmen were Jewish or not. Nor are we sure about those portrayed in a fine illumination from the 1460s. [44]

◁ 218   Germany, *c.* 1320–5: harvest time. On the right, a couple are cutting the corn with a sickle, their hands protected by gloves (an unusual practice); others tie up the sheaves; another person is gleaning, gathering the fallen heads of corn and putting them in a basket; on the left, the corn is being beaten with an articulated stick on a paved surface, and the grain winnowed in a large wicker winnowing basket.
London, British Library, MS. Add. 22413, folio 71 recto.

◁ 219   Germany, after 1272: ploughing. The plough is of a type, used at least since the tenth century, with two wheels, a pair of handles, coulter and ploughshare (not clearly visible).
Jerusalem, Jewish National and University Library, Worms/I Maḥzor, folio 96 verso.

◁ 220   A Jewish woodcutter in Germany, *c.* 1348, cutting branches off a tree with an axe; the bundles of wood are put onto the pack-saddle of his donkey that grazes while waiting to be loaded.
Darmstadt, Hessische Landes- und Hochschulbibliothek, Cod. or. 13, folio 202 verso (lower register).

221   A building site in Germany, *c.* 1460: plaster or mortar is being mixed; building materials—cut stone, bricks and mortar—are being carried up a ladder or hoisted by a crane to the mason working on the scaffolding.
London, British Library, MS. Add. 14762, folio 7 recto.

222   A Jewish merchant from Germany in the 1450s leading his donkey loaded with bags.
Oxford, Bodleian Library, MS. Opp. 154, folio 24 recto.

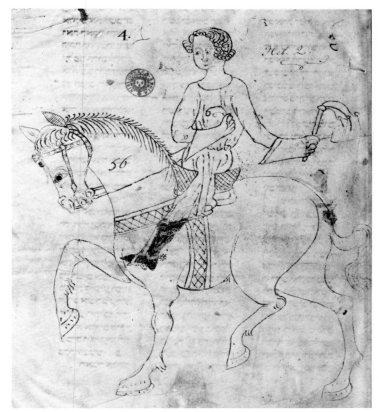

## Commerce and Money-Lending

Until the early fourteenth century, Jews in many places were under an obligation to raise horses at their own expense and to supply them to the city where they dwelt in time of war. At times they were even allowed to trade them, provided they were either draught- or saddle-horses. [45] In fact, in some areas, for example in Bavaria and Franconia from the thirteenth to the fifteenth century, horse-trading was the only commerce Jews were permitted.

225-6

Excluded from large-scale commerce and from retail trade in towns, Jews could still, during those two centuries illustrated by our illuminations, continue to buy agricultural products locally in the countryside to resell to the town shopkeepers.

In the fifteenth century, such modest Jewish merchants could be seen on the roads of southern Germany pushing their donkeys laden with bags. [46] Humbler, but even more numerous, were the pedlars who carried their wares themselves from village to village, throughout the countryside. Not so much as their silhouette has been preserved in the iconography of the period, however.

222

227-8

Nor can the rare pictures of fishing scenes and cargo boats in manuscripts of the second half of the fifteenth century [47] provide an adequate account of all the river traffic, or the fish trade in particular, in which Jews of the German lands were active until the thirteenth century. Drawn from a reality outside the daily life of the Jews of that time, the illuminations do no more than illustrate the texts they accompany.

Though not integrated into general commerce, the Jews were inevitably drawn into various types of trade because they lent money at interest. Objects made of precious metal, valuable jewels, ordinary household utensils, clothes of every quality,

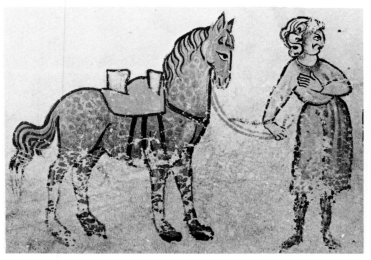

227 Fishermen catching fish with rod and line from a boat, Germany, *c.* 1450. Munich, Bayerische Staatsbibliothek, Cod. hebr. 107, folio 60 verso.

228 A large single-masted boat on a river, Germany, *c.* 1460-70; the pilot points out the route from the crow's-nest.
Jerusalem, Schocken Institute, 2nd Nuremberg Haggada, folio 41 recto (detail).

grain and horses all became the property of the money-lender if he was not reimbursed within the stipulated period, after which he had the authority to sell them. Although sales must have been as colourful and picturesque as modern second-hand markets, not a single illuminator found or sought a pretext to portray them.

Actually, this should not be too surprising. The Jews of Germany turned to lending money at interest as a result of the economic and social discrimination directed against them. It became their only occupation and was not only authorized but sometimes even imposed on them by civil law; therefore of vital importance, the iconography it produced was nonetheless very sketchy and unspecific.

The manipulation of money, the weighing of coins, and the exchange of currency are represented in the late thirteenth and early fourteenth centuries in the same way as in France and Spain: solely by the motif of scales. [48] Once, however, we see the subject in the scene: the money changer has put a handful of coins on the scales, and the balance is tipped. [49]

A second motif, the purse, which was often attributed to Jews in Christian iconography as a stigma of the infamy of criminal usury, may well indicate in a picture of about 1340, [50] that the Jews who wear it are money-lenders. The purse was a motif sufficiently familiar to be introduced into the marginal decoration of an early fifteenth-century prayer book, [51] and to be seen hanging at the belt of one of the Jews whose furniture and

clothing we have already admired—such riches which at that period only money-lending could have provided. [52] About 1450 the purse motif appears again in some scenes in which one person hands money to another, but with no indication of the context of the transaction. [53]

## Minstrels and Musicians

At family feasts, which run like a shining thread through the all too often dark fabric of Jewish daily life, the *Spielmänner* (Jewish minstrels) performed the usual tricks, sometimes in the street or on the square, such as juggling with goblets, [54] or showing

dancing bears and trained dogs. [55] For their Jewish audiences in the fourteenth century, in addition to the German epics and the King Arthur cycle, they sang songs inspired by the Bible and by Jewish legend glorifying such heroes as Moses, Abraham and Joseph, and later the great fifteenth-century Yiddish epic, *Shmuel*

344   *Bukh*. At weddings musicians gladdened the hearts of the newly married couple. [56] The usual orchestra of strings, lute, viol and

231   harp, accompanied by wind and percussion instruments, flute, bagpipes, portable organ and trumpet, [57] played for the assembly's dances in the community's *Tanzhaus*.

## Doctors and Astrologers

In Germany too, Jews were doctors and their patients were not restricted to their co-religionists; even princes had Jewish doctors. Nevertheless there is no trace of their activity in our illuminations.

In addition, there were astronomer-astrologers, whose obligatory astrolabe made a fleeting appearance, in a lovely sketch, corresponding absolutely to the traditional schema. [57a]

# The Professional Life of the Jews in Italy

Only a few illustrations from the late fourteenth and the fifteenth centuries give a glimpse of trades and professions in Italy. Nothing in our manuscripts directly evokes the intense activity in commerce and crafts of Southern Italian Jewish communities before the end of the thirteenth century, when they were annihilated by forced conversions and emigration. The documents of the later centuries are, without exception, so limited in content and so few in number that it is impossible to give a more living or complete picture of the daily activities of a Jewish community established to the north of Rome than we have of those in other areas.

## Small Trades, Crafts and Commerce

The life of already existing Jewish communities in the north of Italy revived, and new ones arose from the end of the thirteenth to the fifteenth century, when cities appealed to the Jews to found lending establishments. The impoverishment of craftsmen and small tradespeople was increasing, and the poorest

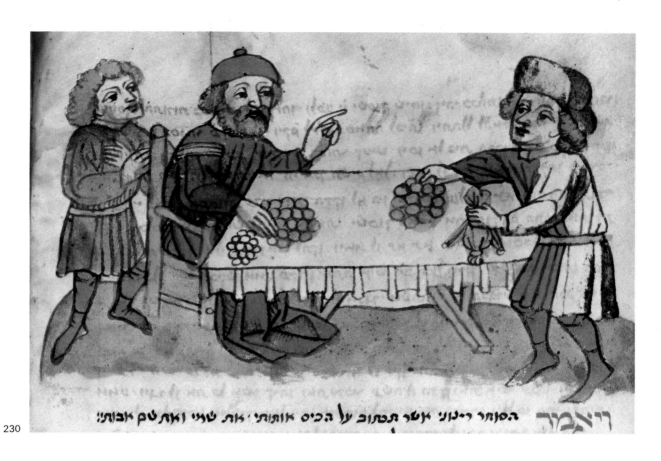

230 ויאמר הסוחר ריגוני אשר תכתוב על הכיס אותותי אות שמי ואת שם אבותי

231

232

233

234

עלי זכו בו או בקטין או בחזקה · את הספינה הרי זה מכר את התורן

ספרי ואלה שמות

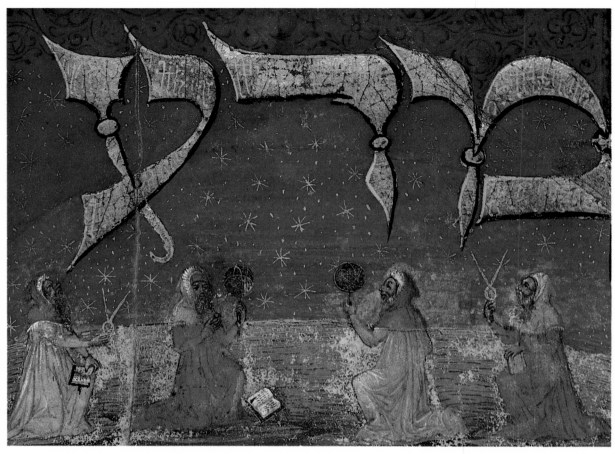

237

238

classes were growing in number. Christian usurers practised illegally, and since their operating risks mounted with the rigid application of Canon Law, they had to raise their rates of interest. The only solution was to have recourse to Jewish money-lenders, with whom the authorities drew up precise agreements, recorded in a *condotta*. The *condotta* was generally limited to the establishment of a lending bank, but sometimes it also authorized commerce. However, in the Jewish communities that created their religious and social structures around such foundations, commerce and crafts soon started up.

The main branches of Jewish activity were trading in, and even the manufacture of cloth, particularly of silk; when the guilds created too many obstacles there, Jews turned to trading in second-hand articles—especially clothes—and peddling, as well as trafficking in precious stones that they themselves imported from Egypt and Palestine. Our illuminations are extremely disappointing in their account of the functioning of the lending houses, on which the whole edifice of Jewish economic life was founded, nor are the lives either of hardworking craftsmen or enterprising businessmen better portrayed.

Money is almost entirely absent from the world of these illustrations. Only exceptionally does the well-known motif of the money-changer's scale appear:[58] as will be discussed later, its symbolic significance came to eclipse its real importance in the everyday life of this time. There are only two scenes in which an

376

◁ 235 Italy, *c.* 1374: the sale of a high prowed ship with its iron anchor, steering oars at the stern, rigging with pulleys and a large square sail; the purchaser has a purse in his left hand and counts out money from it with his right.
London, British Library, MS. Or. 5024, folio 225 verso.

◁ 236 An Italian merchant, late fourteenth or early fifteenth century, selling oil; he drives his donkey along in front of him loaded with a tub and a small barrel with a tap.
Venice, Museo Ebraico, Bible, folio 19 verso (detail).

237 Jewish astronomers, Italy, about 1450: they are shown using armillary astrolabes, compasses and astronomical tables for their observations and calculations.
Vatican, Biblioteca Apostolica, Cod. Rossian. 498, folio 13 verso (details).

238 A doctor seeing patients, northern Italy, *c.* 1438–40: he examines specimens of urine—the first step in establishing any diagnosis—brought to him by his patients in glass jars protected in wicker baskets.
Bologna, Biblioteca Universitaria, Ms. 2197, folio 7 recto (detail).

actual payment is being made: for a purchase and as a fine. In 235 both cases the people involved are represented either with a purse or a wallet.[58a]

As for craftsmen, we only have illustrations of some carpenters holding planes[59] and masons building a tower.[60] 239 Even then there are no texts to confirm that in the region from 232 which these illuminations come and the dates when they were drawn—1374 and in the late fifteenth century, respectively— the Jews were actually practising these trades.

The 1374 portrayal of two ship's outfitters in which one is paying the other for a cargo ship—a little single-master with a square sail and side tillers[61]—is also difficult to explain at this date. The Jews certainly participated in sea trade and possessed cargo boats in thirteenth-century southern Italy, but even if this illumination draws on contemporary reality, it does no more than translate visually a text that codifies Talmudic decisions still applicable at that date. We return to contemporary Jewish reality, somewhat after 1450, in two scenes showing the 240 purchase of a house and of a horse,[62] respectively. Finally, a few

236   street scenes transmit a faint echo of daily life: an oil merchant cheerfully pushes his donkey laden with a barrel having a tap and 233, 241   a little basin, [63] and a water carrier goes on his rounds, his buckets hanging on either end of a rod perched on his shoulders. [64]

## The Liberal Professions

234   A late thirteenth-century [65] illumination with delicately drawn and painted lutes, rebeck and psaltery provides further evidence of that already well-attested taste of the Jews for music and playing instruments; a taste which was to become ever more pronounced in the following centuries.

In the fifteenth century, music, singing and dancing were all considered an essential part of a good education and were taught equally to boys and girls. Jewish music and dancing masters also taught Christian pupils, and in Venice, for example, Jews had opened schools that the authorities attempted to close from 1443 onwards. Jewish illumination does not provide a picture of Guglielmo da Pesaro, called Guglielmo Ebreo, ballet master of Lorenzo de Medici and dancing master of Isabella d'Este, as well as the author of the remarkable *Trattato sull'arte del ballo* from around 1463. It does, however, depict the orchestras that provided music for dancing during that century, both a small 335   wind band called *capella alta* [66] and a more varied ensemble with strings and percussion, harp, lutes and tambourines. [67] Some

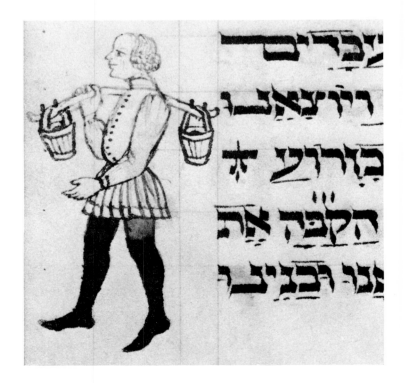

172

Jewish instrumentalists were well enough known to be employed by the Italian courts, although it was not until the following centuries that Jewish instrumentalists and composers played an appreciable role in Italian music.

## Astronomy and Astrology

Though they never achieved the reputation of the Jewish astronomers from Provence or Spain, Italian Jews were versed both in that science and in astrology. In the fifteenth century the most notable Jewish astronomer was certainly Angelo Finzi who had founded a money-lending institution at Mantua in 1435 and was the author of numerous works on mathematics and astronomy, as well as of astronomical tables. In 1498 Bonet de Lattes, an exile from Provence became doctor and astrologer to Popes Alexander VI and Leo X and continued to publish his annual astronomical and astrological calendar begun in 1493. He had invented an astrolabe that could be worn on a finger like a ring and that told the time night and day. These astronomers, like their Christian colleagues, had armillary astrolabes at their disposal. [67a] They also appear to have used a large compass, probably a very simplified form of the quadrant, to measure the angles of the stars. They were aided in their calculations by astronomical tables. [68]

237

## Medicine

By the time doctors and medical affairs first appeared in the illustrations of Hebrew manuscripts in the early fifteenth century, medical science and its practice among the Jews already had had a long and glorious history. It is enough to recall that Jewish medical science dates from the first centuries of the Christian era and that Jewish doctors achieved eminent positions throughout the Middle Ages, both in the Muslim world and in the Christian world.

At the time of our miniatures, the competence and dedication of Italian Jewish doctors was in keeping with that worthy tradition. Despite the restrictions imposed periodically by the authorities and despite jealousy and calumnies too, Jewish doctors were sought after by the great: popes, cardinals, bishops and princes took them on personally and towns appointed them as municipal doctors.

Doctors generally wore a large long gown, often lined with fur, and a hood *(chaperon)* appropriate to the dignity of their function. [69] A doctor's dwelling was spacious, and he received his patients in a large room with a coffered ceiling. From our illustrated sources we can piece together the following hypothetical day in the life of a busy doctor: his many patients, 238 both men and women, waited for a consultation. He was seated on a settle with his assistant, probably a pupil, standing behind him. The patients stood waiting their turn for the consultations which were in fact public. Each patient brought a specimen of urine in a flask protected by a little wicker basket. [70] The doctor raised the flask to examine the urine, for it was the colour, clarity, fluidity, deposits and smell of the urine that provided him with the first element of his diagnosis of the health of his patient. The doctor made his observations directly to the patient. [71] But he also had to visit patients bedridden with fever. He began the house visit by taking the patient's pulse. [72] A woman, the 242 patient's wife or mother, was present at the examination. [73] He left the room to inform the anxious family of his diagnosis and prognosis. [74] He might write out a prescription, which he explained to the person nursing the patient. [75]

A doctor might also have to consult [76] his colleagues or give 243 lectures, [77] which were usually private, for in the fifteenth century it was still very rare for Jews to be admitted as teachers in the universities.

The apothecary and surgeon-barber exercised their arts following the directives and under the supervision of the doctor. The apothecary prepared medicines, ointments, poultices. In his shop in painted faience jars and containers he kept drugs of every kind: oxides, salts, gums, resins, balms, animal substances and the plants needed for his preparations. Pot-bellied bottles enveloped in plaited straw contained liquids. The solid substances were ground or pounded in mortars with a pestle to prepare them for the complex mixtures with which most medicines were made then. [78]

Plants had been one of the great resources of the pharmacopoeia since antiquity, their properties, whether real or imagined, taught by tradition and experience. [79] Roots, bark, wood, leaves, flowers and seeds were all used as the case warranted. A modest Jewish medical herbal of the fifteenth 244-6 century, copied and illustrated in Italy, [80] preserves a series of these plants and their properties: for instance, Saint John's wort *(Hypericum perforatum)*, called the exorciser, [81] considered to be a diuretic, expectorant, vermifuge and, as an oil, a disinfectant

and healant among other things; daphne *(Daphne mezereum)* [82] whose bark is a stimulant and sudorific, while its seed is a diuretic and purgative: both are toxic; and saxifrage *(Sassafras officinale)* [83] a stimulant, depurant, aromatic, and, as an oil, an antiseptic. Surgeon-barbers, surgeons with short robes, who were not qualified with any official degrees, performed cupping and bleeding [84]—sometimes under the supervision of the doctor himself [85]—and operations, for example, for empyema in the case of pleurisy. [86]

The doctor might also prescribe cures, such as sun therapy in the mountains or baths, at spas or in the mountains. [87]

In the Middle Ages, Jewish medical science, though of course it abided by the hygiene prescribed in the Talmud, was mainly nourished by the common heritage of Hippocrates and Galen; it relied especially on the medical encyclopedia of Avicenna, the *Canon of Medicine*, which had enriched this heritage through its author's observations. Known first in the original Arabic text, then in Hebrew, during the thirteenth century, Avicenna's was the accepted authority. Avicenna himself was portrayed, in the manner of the time, as a contemporary doctor. We see him teaching from a university pulpit in a fine edition of the *Canon* that provides a unique series of medical illustrations. [88] Avicenna already appears in a full-length 'portrait' added at the beginning of the century to a Sephardi copy of Book I of the *Canon*: [89] he stands before a pyramidal lectern placed on a tall Gothic support and holds an open book on which his name, *aven sini*, is written in Hebrew. The sharp profile and almond-shaped eyes make it apparent that the painter intended to show an Oriental; Avicenna's costume is Italian, however: under a sleeveless robe with wide pleats, the neck of the shirt is visible, in Italian fashion, beneath the tunic *(cote)*, and though the turban on his head has an oriental air, it is, in fact, a *mazzochio a foggia*.

Medieval medicine had inherited from late antiquity the conviction that there was a close correlation between the universe, the macrocosm, and man, the microcosm. Both were said to be formed of the same four elements: earth, air, water and fire, and endowed with the same four qualities: heat, cold, dryness and humidity. Medieval men also believed that the external anatomy was governed by the Zodiac (the outer belt of the celestial sphere), while the internal anatomy depended on the planets that described circles within that sphere, and that the moon ordered the flux of the four humours, blood, yellow bile, phlegm and black bile. Sweats, purges and hot baths were certainly practised to restore the balance of the humours, but the

most frequent treatment—because it was thought most effective—was bleeding. One had to be careful, however, not to bleed a limb when the moon was in the zodiacal sign that controlled it. In addition there were days and months that were more or less favourable for bleeding, depending on the temperament of the patient, which was determined by the predominance of one of the four humours. Therefore surgeon-barbers had to consult special calendars that gave the necessary indications for calculating the opportune moment for bleeding a patient. Sketches of the human body showing the relation of the signs of the Zodiac to the limbs *(homo signorum)*, the positions of the veins and where to bleed *(homo venarum)* illustrated manuals of surgery and medical calendars in the thirteenth century and later. Jewish doctors conformed to these

242 An Italian doctor, *c.* 1438–40, visiting a patient: first of all he takes the patient's pulse (on the left), essential when dealing with cases of fever; the examination takes place in the presence of a woman of the household; the doctor leaves the patient in his room under supervision (on the right) and tells the patient's wife and children of his diagnosis (on the right and below); beside the patient's bed is a small covered table on which a carafe and a glass for medicines are arranged, together with a round flat box containing a preparation brought from the apothecary.
Bologna, Biblioteca Universitaria, Ms. 2197, folio 402 recto (detail).

243 An apothecary's shop in northern Italy, *c.* 1438–40. Like all medieval ▷ shops, it is open onto the street; behind the counter piled with the raw ingrediants for the apothecary's work are shelves filled with painted faience bowls, flat round boxes and bottles in straw baskets containing everything necessary for the preparation of medicines. A group of doctors converse beneath a nearby *loggia* with a colonnade (they are, in fact, shown in front of the *loggia*, either as a result of a desire to depict the scene more clearly, or of the painter's lack of skill). Another doctor arrives on horseback to join the group. In front of the shop, a patient has just managed to have a sample of urine examined. Life in the street carries on regardless: two dogs come together under the curious gaze of a child.
Bologna, Biblioteca Universitaria, Ms. 2197, folio 492 recto (detail).

244 A page from a Hebrew medical herbal, fifteenth-century Italy: St. John's ▷▷ wort *(hypericum perforatum)*, reputed to drive away the devil, as is shown by the picture of the devil on the left.
Paris, Bibliothèque Nationale, ms. hébr. 1199, folio 45 recto.

245 A page from a Hebrew medical herbal, fifteenth-century Italy: spurge ▷▷ laurel, also known as mezereon *(daphne mezereum)*.
Paris, Bibliothèque Nationale, ms. hébr. 1199, folio 58 recto.

246 A page from a Hebrew medical herbal, fifteenth-century Italy: saxifrage ▷▷ *(sassafras officinale)*. According to the inscription on the right, this herb is effective in the treatment of gallstones, its root is aromatic, it encourages the healing of wounds and stops bleeding.
Paris, Bibliothèque Nationale, ms. hébr. 1199, folio 65 verso.

244

245

246

247

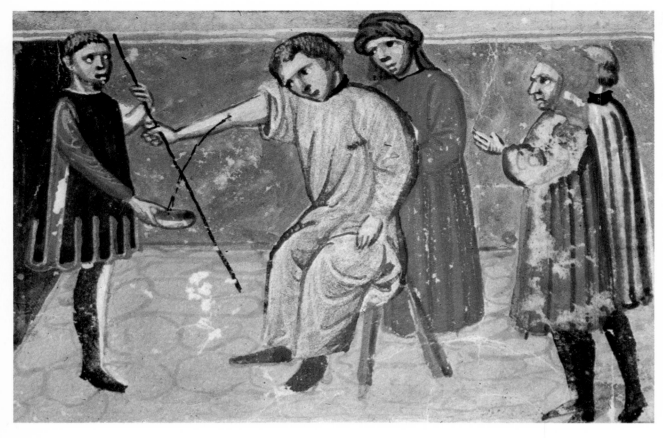

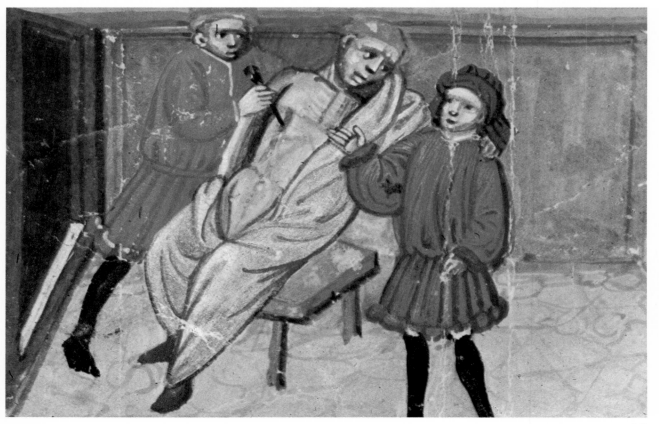

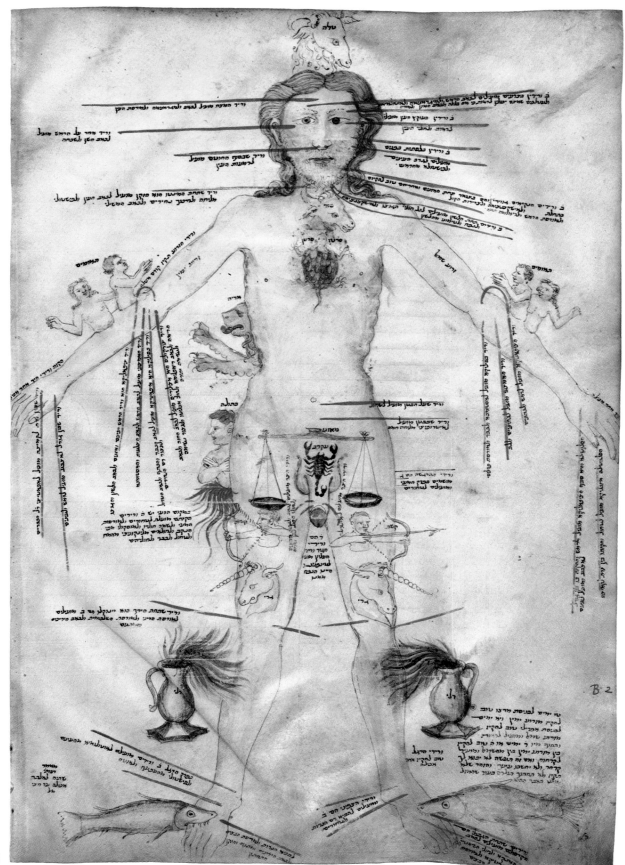

251

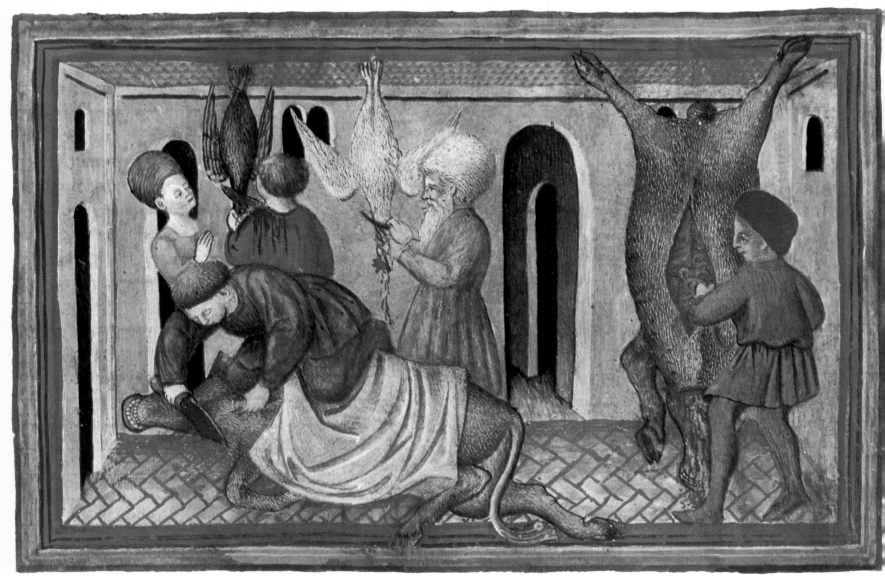

252

generalized practices of astrological medicine. We have a fine specimen of this tradition at the end of a manuscript from about 1400 copied in Italy and containing Hebrew medical texts 251. (nearly all of which are translations): a figure combining *homo signorum* with *homo venarum* accompanied by Hebrew translations of the usual inscriptions describing the veins. [90] The *homo signorum* and the corresponding feminine figure were only sketched, before 1450, in the Bologna *Canon* of Avicenna. [91]

# Community Jobs and Functions

No matter in which period or country, the very existence of a Jewish community (which was founded on the observance of the Law and its precepts in the religious, moral and social

◁◁ 247–9   Pictures illustrating the work of a surgeon (shown in a short robe), Italy, *c.* 1438–40: the application of cupping-glasses; bleeding, in this case under the supervision of the doctor himself, shown in long robes; an operation to evacuate the suppuration associated with purulent pleurisy—the incision is made high up to avoid damaging the liver.
Bologna, Biblioteca Universitaria, Ms. 2197, folio 492 (details).

◁◁ 250   Avicenna, the illustrious Arab physician, as represented in Jewish circles, Italy, early fifteenth century.
Bologna, Biblioteca Universitaria, Ms. 2297, folio 4 recto.

◁ 251   An Italian representation of the *homo signarum* combined with the *homo venarum*, dating from *c.* 1400. The signs of the zodiac are shown on the parts of the body and members they were thought to govern. Red lines, like jets of blood, indicate the different parts of the body where incisions for bleeding could be made. The names of the signs of the Zodiac, and the captions describing the veins—adapted from the Latin inscriptions normally used for this kind of picture—are in Hebrew. The absence of any specifically Jewish features in the iconography of the signs of the Zodiac indicates that this well-executed figure was copied from a non-Jewish model.
Paris, Bibliothèque Nationale, ms. hébr. 1181, folio 264 verso.

252   A Jewish butcher, Italy, 1435: on the left, the ritual slaughter of an ox *(sheḥita)*, the *shoḥet*, holding the beast on its side with his two knees and holding its head in the appropriate position with his left hand, cuts its throat with a long knife; on the right the *bodeq*, or inspector, examines the lungs of the ox, which is cut open and hung from its hind legs to facilitate the draining of the blood. In the middle ground, *sheḥita* of two fowls hanging by their feet. The woman in the background can only be a customer, although she may have been a member of the group responsible for the ritual slaughter in the butcher's shop, since in Italy, alone of all European countries even up to the sixteenth century, women could obtain the rabbinical licence necessary to engage in this activity.
Vatican, Biblioteca Apostolica, Cod. Rossian. 555, folio 127*bis* verso.

sphere) was based on the exercise, by some of its members, of a unique set of functions different from any in the Christian society surrounding the Jews.

## *The* Shoḥet

Prescriptions relative to the consumption of meat, deduced from Deuteronomy XII:21, necessitated the presence of a *shoḥet*. As early as the Middle Ages this job could not be performed without a rabbinical licence, which the candidate was awarded only after being examined on his theoretical and practical knowledge. A *shoḥet* had to have a thorough knowledge of the Talmudic requirements for ritual slaughtering *(sheḥita)* and quite a detailed knowledge of animal anatomy both in order to find the exact location for cutting the trachea, oesophagus, jugular vein and carotid arteries, and to examine the viscera, especially the lungs, to detect any malformation or disease liable to make a beast unfit for human consumption. He also had to show his skill in sharpening and handling a knife to fulfil the intention of *sheḥita*: producing instant unconsciousness and a minimum of pain, the only conditions under which man was authorized to kill an animal to nourish himself. Finally, since *sheḥita* was a ritual act, it was only valid if the man performing it was of irreproachable piety and conduct.

Obviously, pictures can only render the most external aspect of this rite—its functional gestures. These can be identified in several slaughter-house scenes, from the first half of the fourteenth century in Spain, [92] in Germany about 1300, [93] in Italy in the first half of the fifteenth century, [94] and much later, in the sixteenth century, in the part of Greece under Italian domination. [95] Contrary to what is seen in Western scenes of slaughtering, the *shoḥet* never raises a cleaver or an axe to fell a beast. In Jewish slaughtering, the animal is lying down, sometimes on its back, and the *shoḥet* holds it still with his foot or knee while he slits its throat with his long knife in one rapid continuous movement; blood can be seen spurting from the incision. In Germany small animals were placed on trestles.

Evidence from the second Nuremberg Haggada [96] and the Yahuda Haggada is aberrant: [97] although the knife has the requisite long blade and the animal is placed on a trestle, as in 1300, owing either to the illuminator's lack of skill or his ignorance, the nape of the beast's neck and not its throat was depicted being cut. Again, in Italy in 1477, [98] an illuminator who

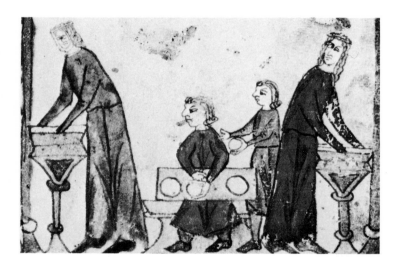

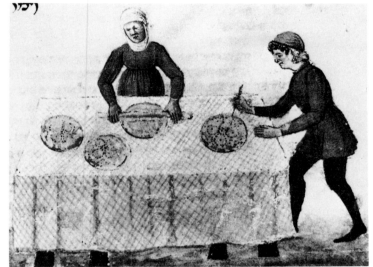

was probably not Jewish had the curious idea of depicting the *shehita* of a stag in a very good illustration; although venison is certainly a permitted food, the necessity of capturing the stag alive makes it very unlikely that it could be ritually slaughtered. The shape of the blade is correct, but the downward direction of the cut and the position of the beast rearing up on his hind legs definitely are not.

112     Sometimes a scene was more complete. In an illustration from Spain from about 1330,[98a] as a *shohet* slaughters the sheep, his assistant hangs them up by their hind legs and skins them. But 252 in an Italian manuscript from 1435, a whole ritual slaughter-house comes to life before our eyes:[99] an ox is being slaughtered, the lungs of another are being examined; two chickens are also being ritually slaughtered, while a woman, who presumably brought them, peeps in at the door to check on the progress of the operation. A bit later, two symmetrical illustrations also depict the *shehita* of an ox and the examination of its viscera.[100]

## The Baker

Anxious to prevent overly intimate relations with pagans, Talmudic rabbin had forbidden Jews to partake of their bread. Nonetheless Jews were permitted to buy bread from non-Jewish bakers, since bread did not contain any forbidden ingredients. In the Middle Ages, as long as Jewish communities contained a class of craftsmen—in Germany in the thirteenth century, in Spain and Italy throughout the entire period we are considering —they naturally had Jewish bakers. The Jewish baker's work was no different from that of his Christian counterpart: kneading and shaping round or flat loaves, loading the oven, baking and 253, 113 unloading the oven, all went on in Jewish bakeries.[101] The 257 Jewish baker had only one ritual obligation, that of setting aside from the *halla*, that portion allocated to the Levites. This dough, separated with an appropriate blessing and thrown into the furnace, symbolized that portion of bread the Levites could no longer consume after the destruction of the Temple.

    As the feast of the Passover *(pesah)* drew near, every Jewish community undertook the production of an original product: *mazza*, the flat unleavened bread essential to the celebration of this holiday. To avoid fermentation, the grain and water, which are the sole ingredients of the *mazza*, were supervised at every stage of production. The grain was checked right from harvest time, especially during milling, since at this period, there were 256 no longer any Jewish millers.[102] The purity and temperature of the water were also supervised, as was every phase of production: mixing, kneading, dividing the dough, shaping the flat biscuits, and baking. These operations were consigned to as many people or groups as was necessary to complete them with

255 Two crimes condemned by rabbinical justice: theft by burglary—the thief, perched on a ladder to reach a high window, is shown stealing clothes —and armed assault.
New York, private collection, previously Frankfurt/Main, Stadtbibliothek, Ms. Ausst. 6, folio 170 verso.

maximum speed. Many manuscripts show at least one of these operations, but it is the German illuminations after 1300 and in the second half of the fifteenth century, together with the exceptional pictures in Ms. Rothschild 24 (which is of the Ashkenazi rite and certainly done for a German Jew who had emigrated to Italy) that best depict the special features 254 distinguishing the production of *mazza* from that of ordinary bread. Among other things these illuminations are unique in showing the traditional perforation of the *mazzot* which was done to prevent them from rising during baking: with the flat or round metal combs and spikes made for this purpose, intercrossing lines or circles and dots were impressed in the dough into decorative patterns. [103]

## Courts of Law and Judges

During their long history, the people of Israel had developed their own laws and an original jurisprudence, very much imbued with the spirit of their moral and religious Law. Preserved in the Talmud and its commentaries and in the innumerable rabbinical *responsa*, these laws were continuously rethought and enriched by experience all the time. Thus Jewish communities could not enjoy real autonomy unless they also possessed judicial autonomy, which is precisely what the anti-Jewish laws, like those of 1412 in Valladolid, Spain, tried to deprive them of. Judicial autonomy had been consolidated from within by the *taqqana* of Jacob ben Meir Tam (1100–71), a ruling proclaimed at the synod of Troyes in 1150 and unanimously accepted by Jewish communities in both north and south; it excommunicated any Jew who betrayed a co-religionist before a non-Jewish tribunal.

In spite of their central importance, judicial institutions and procedure do not appear in Jewish iconography before the second half of the fourteenth century, and then only in Italy. The illuminations do not show executions. Indeed, two Talmudic punishments that antedate execution, stoning and hurling from a height (the former illustrated in 1374, [104] the latter in about 1400 [105]) were no longer practised in the Middle Ages. With the exception of Spain, capital punishment was generally only rarely applied, and in those cases the condemned was handed over to the civil authorities and excuted according to the law of the land. Specifically rabbinical punishments such as fines, flogging and

excommunication *(ḥerem)* were not illustrated in the manuscripts, except in one case where a fine is being paid for a bodily assault. [105a]

Misdemeanours and crimes, on the other hand, were the subject of some illustrations. The crime considered the gravest, because it imperiled the very existence of individual Jews or their entire community, was that of the *malshin* (the informer) who in his own interest revealed details of the internal life of Jewish communities and slandered the Jewish religion. An illustration from about 1400 shows a Jew struck with 312 astonishment as a *malshin* denounces him, and hence all of his people. [106]

In the first half of the fifteenth century and around 1450 to 1460, much more descriptive miniatures represent assault and 255 battery during a night-time brawl, theft in the form of breaking and entering, and armed assault. [107]

Tribunals in session were also portrayed *(batey-din)*. We have an illustration from 1374 of a tribunal with three judges *(dayyanim)*—the most common number—before which most civil cases were pleaded, seated on a semi-circular bench and assisted by a clerk at a little table. [108] In the first half of the fifteenth century, this court with three judges is depicted again, [108a] but in 1438 and around 1450 to 1460 we also see the witnesses bringing the accused before a tribunal, consisting of a judge surrounded by several assistants and a clerk in one case, and four judges in the other. [109] A miniature from 1435 [110] brings 184 to life the activity of a court in session. Several cases were judged in the same hall before various tribunals, seated on raised

benches of two levels before which both the plaintiff and accused stood and pleaded their cases. On the left, a judge delivers his sentence, while the plaintiffs argue in the foreground. In the centre a case between two parties assisted by lawyers is being heard. On the right a condemned man is being led off.

Because our manuscripts do not show them, we can only mention the activities of the members of the Jewish community's council, its president *(parnas)*, treasurer *(gabay)*, secretary-scribe, and the *shammash* who served many functions, including public crier and executant of the decisions of the council and the court *(beyt-din)*.

The circumcisor *(mohel)* by whom every newborn boy was marked with the seal of the covenant of Abraham, was not an employee of the Jewish community. He was just a pious member of the congregation, who had learned to perform this delicate operation sometimes with such skill that his services were employed outside his own Jewish community. Though the circumcisor does not appear in Jewish illuminations from Spain, he is a familiar figure in Germany from 1300 and in Italy throughout the fifteenth century. The actual functioning of the *mohel* will be taken up in the next chapter on family life.

## Religious and Spiritual Functions: Ḥazzan *and the Rabbi*

The qualities that every Jewish community hoped to find in the *ḥazzan* who interpreted its prayer were a knowledge of the sacred texts and the liturgy, piety and morality, combined with a fine voice and imposing presence. Some of the *ḥazzan's* duties in Spain, Germany and Italy have already been discussed: leading the prayers,[111] and reading the *Tora*.[112] He was also portrayed blowing the *shofar* (the ram's horn) for *rosh ha-shana*.

Though the *ḥazzan's* presence was not indispensable at the wedding celebration, he was customarily used to recite the seven benedictions. It is quite probable, therefore, that in those Italian wedding scenes from 1435[113] and about 1470[114] the figure in a long robe with a venerable beard before whom the bridegroom gives the ring to the bride, or the man pronouncing the blessings, was a *ḥazzan*. If we cannot, in fact, be certain as to his identity, it is because he had no distinguishing feature that would mark him as such. The *ḥazzan* wore no special costume

95

93, 105, 92

335

334

when officiating; he had only to wear the long robe of a serious, studious man.

The function of the *ḥazzan* was precisely defined throughout most of the period we are considering and that of the rabbi was still close to what it had been in the Talmudic days—which is quite different from what it has become in modern times. Until at least the fourteenth century, the rabbi was not in the paid employment of the Jewish community. He was only expected to teach the Law, to answer questions having to do with ritual and legal matters, and to preach sometimes, especially before important holidays.

Therefore it is not surprising that the only images of rabbin are depictions of men of learning and especially of masters teaching. A rabbi seated in the magisterial chair with a book in his hand or on a desk was a frequent marginal illustration in the Passover ritual book (the *Haggada*) which portrayed the figures of famous rabbin, in fourteenth-century Spain,[115] in fifteenth-century Germany,[116] and in fifteenth-century Italy.[117] From these same three countries we have fourteenth- and fifteenth-century illustrations of rabbin teaching groups of disciples. Occasionally, disciples stood before the master,[118] but usually they were seated. One sign of customs derived from neighbouring Arab communities is that in early fourteenth-century Castile disciples still sometimes sat on a long cushion;[119] but generally the disciples used benches[120] and sometimes they had a long table in front of them.[121] A lamp from the ceiling only suggests to us the secluded interior of a fourteenth-century school room.[122] However, in an example from fifteenth-century Italy, the whole school room is spread before our eyes: floor, ceiling and walls with windows and doors giving onto the outside world.[123]

147

258

176

185

256  A mill in Germany, *c.* 1460–70: the master-miller beckons to his assistant, who is driving a donkey loaded with a sack of corn towards the mill.
Jerusalem, Israel Museum, Yahuda Haggada, folio 1 verso (upper register).

257  A Jewish baker, late fourteenth-century Italy: *mazzot* being made by hand on a table; they are arranged in rows on boards and brought to the oven and put into the oven with a long-handled scoop.
Jerusalem, Schocken Institute, Ms. 24085, folio 25 recto.

256

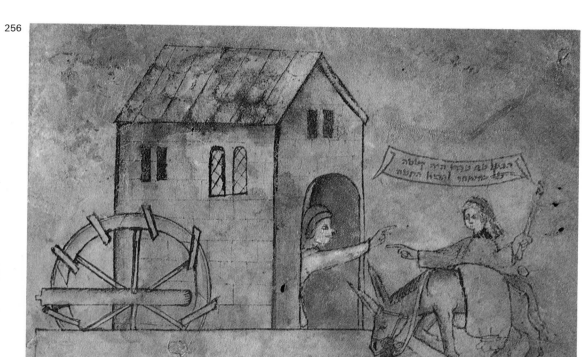

מִמִּצְרַיִם עֲלֵיהֶם מִיַּד
כִּי לֹא חָמֵץ כִּי גֹרְשׁוּ
מִמִּצְרַיִם וְלֹא יָכְלוּ
לְהִתְמַהְמֵהַּ וְגַם צֵדָה
לֹא עָשׂוּ לָהֶם׃

257

258

259

260

261

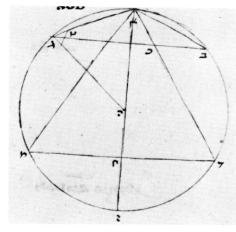

301 School teachers (*melammedim*) gave elementary instruction; the rabbi taught adolescents, who began to study the Talmud in depth at about the age of thirteen, and older, already independent students, who often came from afar to study under a famous master. Teaching was not solely magistral, for pupils could, and 260 were expected to, ask questions. If the questioner was already a master himself, the lesson might give rise to a debate, to which young students listened with fascination. [124]

The essential purpose of teaching was to deepen the understanding of the Law. In northern France and Germany the curriculum was dominated by Talmudic studies, whereas in Spain, southern France and Italy towards the late twelfth century, a period earlier than the one we are considering, Jewish schools (*yeshivot*) were opened to secular students also. Not only were Hebrew grammar and philology and the theory and practice of poetry added to the curriculum, but philosophy as related to revelation was also taught, as were Aristotelian logic as it was transmitted by Averroes, Euclidean geometry, arithmetic, medicine, natural science and metaphysics—in short, all the seven liberal arts. Of course every pupil did not tackle this vast programme, and the teaching of Greek philosophy gave rise to serious controversy in Provence and Spain in the thirteenth and early fourteenth centuries, but

262 A figure from a manuscript copied in 1480, which includes a number of works on mathematics, among them two books on the 'five bodies' by Hypsicles (a Greek mathematician who lived in the first half of the 2nd century B.C.E.; his books were copied by Jewish and Arabic translators after the thirteen books of Euclid as Books XIV and XV of the latter's opus). Illustrated here is the figure of the second demonstration of Proposition IV of Book I: that the area of the dodecahedron and the side of the cube are proportional to the area of the icosahedron and the side of the icosahedron. The figure is not in fact correct: the segments בא and אג, the sides of the pentagon of the dodecahedron, are clearly too short. Similarly, the triangle אדה inscribed in the circle centred on ה, which is the triangle of the icosahedron, is not equilateral, as it should be. The letter ב should mark the intersection of אד and of בג, and the segment גט should be equal to the third of בג.

When compared to the figure in the original Greek manuscript, this figure and the order of the Hebrew letters on it are inverted from left to right and are shown as if seen in a mirror. This trait, seen in all figures in Hebrew mathematical manuscripts, derives from the direction of the writing of Hebrew letters.

In spite of the care with which the copyist has, on the whole, drawn the figure, he did not ensure that it was copied correctly.
Munich, Bayerische Staatsbibliothek, Cod. Hebr. 36, folio 97 verso.

263 A figure from the same mathematical manuscript as that in Plate 262 for Proposition II of Book II of Hypsicles: drawing an octahedron in a regular triangular pyramid (regular tetrahedron). Six points of the octahedron הזחטיכ touch the centres of the six sides of the pyramid אבגד.
Munich, Bayerische Staatsbibliothek, Cod. Hebr. 36, folio 99 verso.

258 A Jewish teacher in Spain and his students, *c.* 1350–60: seated in his chair, he holds a rod, the symbol of authority of the *magister*, in his right hand; his pupils sit in rows on benches in front of him, each with a book in his hand, all teaching being based on a particular text.
Sarajevo, National Museum, Haggada, folio 25 recto of the text.

259 A teaching scene in a Jewish community in Italy, *c.* 1430: the teacher explains a text to his pupils; on the left are a number of bound volumes in a bookcase which is Gothic in style, even at this date; the books are stored on their sides, as was usual at this time.
London, British Library, MS. Add. 26968, folio 118 recto.

260 A disputation between two Jewish teachers in front of a group of students in mid fifteenth-century Germany: the teachers are seated, their books open on the desks placed in front of them; the students listen to the proceedings standing up.
Oxford, Bodleian Library, MS. Opp. 154, folio 23 verso.

261 Decoration typical of Ashkenazi manuscripts of the first half of the fourteenth century: the Hebrew letters of an initial in a monumental display script are set in the undulating richness of a stylized floral decoration and fantastic fauna of an imaginary world.
Oxford, Bodleian Library, MS. Mich. 619, folio 100 verso.

medicine and mathematics were judged necessary and continued 262-3 to be taught as a general rule. Medical treatises, and manuals of astronomy, arithmetic and geometry were copied in large numbers for school use. As these copies were purely utilitarian and usually made rapidly, little care was given to the figures. Some exceptions do survive, however: for instance, a compendium of 1480 from Constantinople, by the hand of a copyist who probably emigrated from Spain, of an entire mathematical library in one volume. [125]

These disciplines were only taught by the rabbin themselves. As we have already noted, there was no intellectual specialization other than by personal choice, one man being more interested in medicine, another in astronomy. Maimonides was master of the Talmud, philosopher, doctor of medicine and deeply versed in astronomy. The arithmetical notation used most generally in the schools was that of Abraham ibn Ezra (1089–1164), who was a biblical exegetist, grammarian, philosopher, poet, astronomer and mathematician. His method introduced decimal numeration using the nine first letters of the Hebrew alphabet for the digits 1 to 9, a special sign for zero and positional notation. Without being creative, many rabbin were entirely conversant with the scientific knowledge of their times.

264    A copyist in Italy, *c.* 1470, with an inkwell, quill pen and scraper on his writing desk.
Jerusalem, Israel Museum, Ms. Rothschild 24, folio 369 recto.

## Books and the Arts and Crafts of Book Production

Both sacred and profane study depended on books. The traditional texts were indispensable, and, as soon as a master's reputation spread, his writings were in demand too. A concern for precision entailed a constant reference to books. An Italian miniature of the 1430s depicts the books available to a master and his pupils in a two-tiered cabinet: the books are arranged on their sides in the upper part, which has a Gothic cornice; while the lower part has a projecting shelf on which books can lie open for easy consultation. [126] Italy preserved other illustrations from the second half of the fifteenth century which portray rabbin at their studies surrounded by books. [127]

Much was being written and had already been translated, especially from Arabic into Hebrew, in the twelfth and thirteenth centuries, and translations were still being made throughout the period we are studying. It is well known that Jewish translators played an outstanding role, from the twelfth

century onwards, in transmitting to the West not only classical and Muslim philosophy and science but also Jewish philosophy. Copying was even more widely practised, since every book was in manuscript. One can only imagine the amount of work that went up in flames in 1242 when twenty-four cartloads of volumes of the Talmud, *Mishna* and *Midrash* were burnt all at once in Paris at the Place de la Grève. Although other manuscripts escaped that conflagration, they were confiscated and burnt later.

Jewish iconography does not differentiate between writing, copying and translating. It is only through the context that we can distinguish the activity of a figure seated in a chair or at a desk in front of a sheet of parchment or a codex, with his inkhorn, pen and scraper. [128] It would have been interesting to see the Jewish copyist actually writing from right to left, but generally, this process completed, only the finished line or page is shown. [129] Unfortunately, the only copyists who are seen writing, write from left to right and from the left-hand to the right-hand page—probably indicating that the illuminator of Ms. Rothschild 24 was not Jewish. [130]

While books for study, commentaries of all kinds and scientific works were often copied very rapidly in a semi-cursive script, [131] more specialized copyists were employed for prized volumes. They wrote in a standardized semi-cursive style, Gothic in Ashkenazi countries, [132] and rounded in Spain. [133] Scribes still practised the square script, which required the most training, according to the traditions of the place where the scribe learned his skill: the Ashkenazi hand [134] had very contrasted horizontals and verticals; the Sephardi hand [135] was carefully balanced, while in Italy, in addition to these two there was also an almost round, very elegant script. [136] The square script was generally used for copies of the Pentateuch, the Bible in codex form, for psalters, books of ceremonies and prayer books. The scribes' work was not only indispensable for study but also for the religious services themselves. The *sofer setam*, the one man among the scribes who was particularly indispensable to the Jewish community, being trained in the immutable rules, codified since the Talmud, for copying the rolls of the *Tora, tefillin, mezuzot*, and divorce documents, is ignored in iconography.

Jewish iconography also ignores the whole process of making books: the preparation of parchment, folios, gatherings of the folio leaves, and all the activities of the binder. It is impossible to prove absolutely that the original bindings on certain Hebrew

265 Medieval Hebrew scripts: 1) Spanish cursive of the fifteenth century (Munich, Bayerische Staatsbibliothek, Cod. hebr. 249, folio 11 verso); 2) Standard Ashkenazi semi-cursive of 1295–6 with gothicizing tendencies (Budapest, Hungarian Academy of Sciences, MS. A 78/II, folio 55 recto); 3) fourteenth-century Sephardi semi-cursive from Spain (Paris, Bibliothèque Nationale, ms. hébr. 689, folio 29 recto); 4) a square German Ashkenazi script of the 1460s (London, British Library, MS. Add. 14762, folio 15 recto); 5) a square Sephardi script from Spain of 1299–1300 (Lisbon, Biblioteca Nacional, MS. Il. 72, folio 433 verso); 6) a round Italian hand of the second half of the fifteenth century (Jerusalem, Jewish National and University Library, Ms. Heb. 8° 1957, folio 42 recto) (details).

manuscripts from various places were made by Jewish craftsmen, although there are strong reasons to presume that this was the case. For instance, there is documentary evidence that in fourteenth-century Barcelona many bookbinders were Jewish, and they bound both Jewish and Christian books. Surviving archives and bindings attest the practice of bookbinding and leather tooling by German Jews in the last decades of the fifteenth century. Only Meir Jaffe is known by name, because he paid for a residence permit by binding a Pentateuch, among other books, for the city council of Nuremberg in 1468. At any rate, we do have illustrations in our manuscripts of bound books. In the fifteenth century, at least, they are pictured in their original bindings with metal fittings and locks intact, [137] and there are glimpses of rolls in liturgical scenes. [138]

From the thirteenth century, Jews in the West began to decorate and illustrate their books. However, the illuminator's craft was not the subject of a single illustration that could show us either his implements or workplace; only the work itself provides evidence of the art of Jewish illuminators. The illustrations included in this book only show one aspect of illuminating, for being concerned to illustrate Jewish life in the Middle Ages our choice of manuscripts has been limited to examples of historiated illumination—not the field in which the art of Jewish books shows any originality. Jewish historiated illumination was, on the contrary, manifestly dependent on contemporary illumination in all times and places. If Jewish illumination has some original characteristics, it was in pure decoration. The Ashkenazi manuscripts of the late thirteenth and first half of the fourteenth centuries have pages where the dynamism of form, the daring contrasts of colour, and the treatment of the initial word as a structural element in the decorative composition are unparalleled in contemporary Western illumination. [139] There is also one type of decoration which Jews alone cultivated in Western Europe: drawings, not done with lines but with microscopic writing, called micrography. Among the Ashkenazis, though the process is very different, the very aery compositions of this drawing share some of the features of painted decoration. But it was in Spain, particularly in the fifteenth century, that the development of these panels of micrographic interlace, whether floral or geometric, attained a complexity and refinement unequalled in the earlier period. [140] Under the pen of the Jewish decorator-copyist, a letter is not only a sign bearing a meaning, it also

189

creates form and rhythm and has a life all its own—these letters seem actually to 'look at us' with a most extraordinarily powerful expression.[141] Poor, incomplete and unequally represented from one country and one period to another, the picture of Jewish professional life in the Middle Ages presented here has still provided a glimpse of how medieval Jewish craftsmen, shopkeepers, financiers and scholars met the material and spiritual needs of their communities. At certain times and in specific places, the scope of their activities spread beyond the confines of their group: such people played an economic, social and intellectual role in Christian cities. But the direction forced on Jewish history by the Catholic Church, and supported for much less theological reasons by temporal sovereigns, tended to isolate Jewish communities within their Christian surroundings and to make Jews an exceptional people singled out for humiliation and servitude.

For the Catholic Church, the Jews had been condemned by the death of Christ to perpetual slavery. In the same way, throughout the thirteenth century, Western monarchs put Jews progressively into a category of *servi* (property of the crown). In England, France, Spain and Germany, Jews saw their rights of residence, their peace, prosperity and life become ever more dependent on the pleasure of Christian sovereigns, and on the narrowness or generosity of these men's Christian devoutness, humanity and political and financial interests. It was to their masters—kings and princes—that Jews had to appeal, often in 268, 277 vain, amidst the dangers that beset them.[142]

267

אליב שָׁרוֹט מָהֵים

בבת יהודה תַּאֲנִיָהוֹאֲנֵי

גרש יְבַקֵשׁ הַדֻּבֹּרָה

לֹא הֵבִיס שׁוֹרֵשִׁי

שׁ אָסְפוּ לִי הַכֹּהֲנִים

268

קַרְיִבוּ הַכֹּהֵן

הָרַג

יַיִן

לְל

אֵלִיְמִ

עוֹד בְּמִקְרֶה שׁ

269

םם וַיָּמָם הָאִשָּׁה וְסֻלַּם בָּאֵשׁ בַ

לֹל אֵלַיִךְ מִזְבְּחִ

בֹל בְּבָחֲרִי וְשֻׁפַּךְ

הֹר וּבְחֻמָּה

דֹרִ יְשָׁה

270

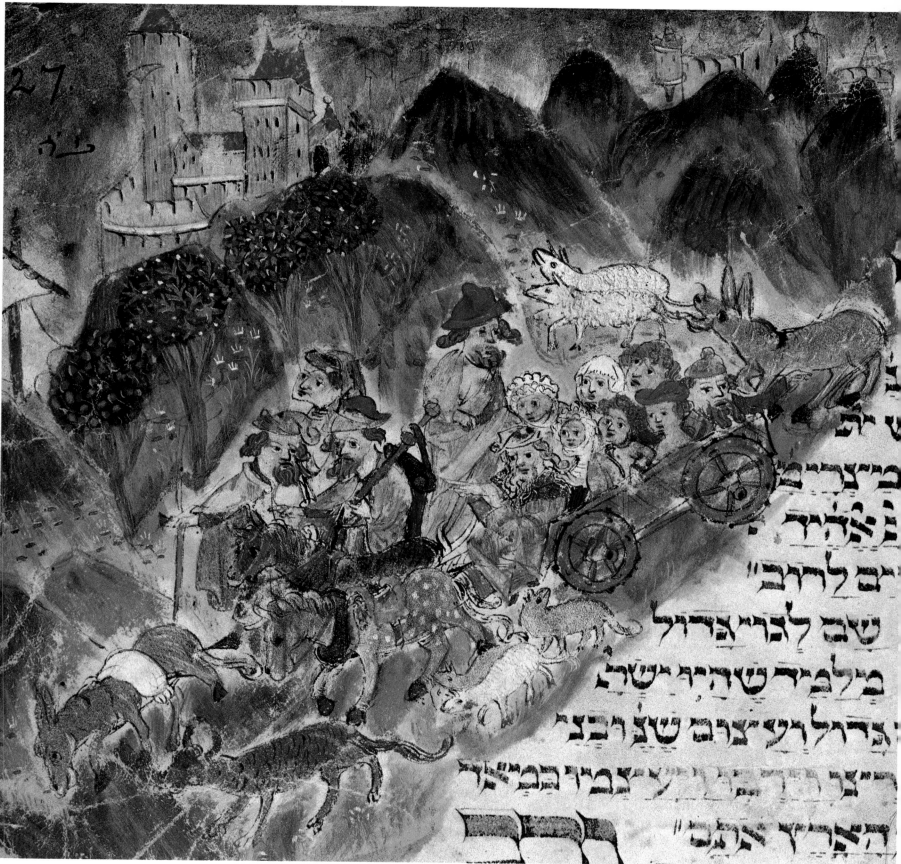

272

273

274

275   Spanish Sephardi decoration in micrography typical of the years 1470–80.
Parma, Biblioteca Palatina, Ms. Parm. 2809–De Rossi 187, folio 3 recto (detail).

276   A letter of a square Ashkenazi script, 1272, curiously brought to life by the insertion in the centre of an eye and eye brow.
Jerusalem, Jewish National and University Library, Worms Maḥzor/I, folio 127 recto (detail).

276

271   Jews driven from a city in Germany, *c.* 1427–8: they have managed to take with them a few animals and a carriage to spare the women, the infirm and the old the arduous journey on foot.
Hamburg, Staats- und Universitätsbibliothek, Cod. Hebr. 37, folio 27 recto.

272   Jews of Castile taking the road to exile, early fourteenth century: driven from the city where they lived, and deprived of all their goods, they can only take some clothing and a few meagre provisions in sacks thrown over their shoulders.
London, British Library, MS. Or. 2737, folio 83 verso (detail).

273   On the familiar road to exile in Germany, *c.* 1460–70: whereas some families are obliged to travel by foot, carrying their babies in cradles or in baskets (cf. Pl. 174), some groups of women might be conveyed in carriages.
Jerusalem, Schocken Institute, 2nd Nuremberg Haggada, folio 19 verso (detail).

274   Germany, *c.* 1470: Jews pursued with blows and assaults from even beyond the gates of the cities where they had been obliged to leave their places of worship, tombs, dwelling places, and all kinds of goods.
Jerusalem, Sassoon Collection, Ms. 511, p. 16 (detail).

275

It is true that the Middle Ages was a period of insecurity for everyone: famines, epidemics and wars struck people in towns and country—Jews and Christians—without pity. But many times Jews were held responsible for these common disasters —the Black Death of 1348, for example—and subjected to massacre or expulsion as a result. Although completely pacific, Jews were the only group of human beings whose possessions, freedom and physical and spiritual wellbeing were ceaselessly threatened. Jewish houses were ransacked; Jewish books, confiscated or burnt; Jewish goods pillaged. [143] They themselves were thrown into prison, [144] and only heavy ransoms freed them from their chains. [145]

278-9
280

Offered conversion at sword point or at the foot of the stake, Jews chose to have their throats cut, to be tortured or burnt [146] rather than abjure. The final centuries of the Middle Ages saw

267, 269-70

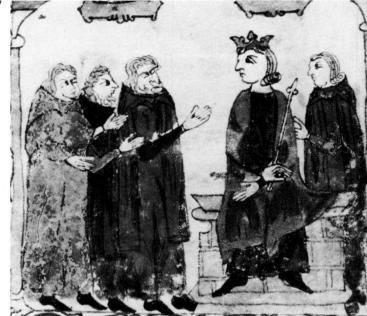

277

278

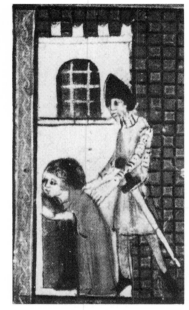

279

280

277 Castile, first quarter of the fourteenth century: the king's advisors urge him to expel the Jews from the kingdom.
London, British Library, MS. Or. 2737, folio 78 verso (detail).

278 A German Jew in about 1450 in front of his empty chests pillaged by a mob during an attack on the Jewish quarter.
Oxford, Bodleian Library, MS. Opp. 154, folio 12 verso.

279 A Spanish Jew thrown into prison in Aragon after 1350: imprisonment was often a means of forcing a community to pay large ransoms.
Sarajevo, National Museum, Haggada, folio 13 verso (upper register, left).

280 A Jewish prisoner, Spain, c. 1350: unkempt and unshaven, his hands freed from their shackles, he comes out of the opened door of his prison to a liberty which was either the result of unexpected clemency or the payment of a ransom.
Jerusalem, Israel Museum, Ms. Sassoon 514, folio 7 recto (detail).

the period of Jewish martyrdom painfully lengthened: after the massacre of the first crusade at Mainz in 1096 and that at Blois in 1171 came the massacre at Troyes in 1288, the crusade of the Pastoureaux in the south of France and the north of Spain in 1320, the bloody years of 1298 to 1348 in Germany, the destruction of the Spanish Jewish communities in 1391, and the incessant persecution of the German Jews during the fifteenth century. Finally, it became rare for a Jew to be born, live and die in the same city or country. The threat of expulsion weighed on every Jewish life, and it was always accompanied by violence. Taking with them no more than a few clothes and sustenance, [147] happy if they had been able to save their wives and children, [148] beaten and pursued, [149] the Jews had no choice but to take to the uncertain road of exile. They were 'without strength', lamented the poet Salomon da Piera in 1391, 'for wherever they turn, there is no peace'.

271-4

196

# VI Family Life

Behind the diversity of professional activities lay the web of family life. To what extent does medieval imagery enable us to uncover the strands of this web and lead us to an appreciation of the basic unit of the Jewish community? Does the historian gain any insight into how the family functioned, and how relations between families reflected the tone and harmony of life within Jewish society?

We have chosen to approach the problem by tracing the activities of one family throughout an ordinary day. Although the Jewish calendar placed the beginning of the day at nightfall, we shall observe our family going about its activities between daybreak and sunset. Whatever was indicated by the calendar, in the Middle Ages Jews regarded the day as falling between two periods of nocturnal sleep—periods of temporary death from which, at dawn, the pious Jew thanked his Creator for delivery. First of all, we shall follow the different members of the family: father, mother and then children. Then we shall examine those moments when they were together. Finally, adopting another perspective, we shall look at the family in its historical context and participate in the festivals and ceremonies that marked the various stages of life between the cradle and the grave.

## The Family's Daily Round

### A Father's Day

For medieval man, the day began at sunrise. For Jews it generally began even earlier, since their religion required that they say a morning prayer before embarking on any other labour. Though a Jew had to wait for sunrise to recite the main part of this prayer, the *shema yisra 'el* ('Hear, O Israel...'), the declaration of Jewish faith, he was allowed to recite the beginning of it before dawn and also to study the Law before praying—for craftsmen and tradesmen, this time before dawn was often the only opportunity for devotion to study.

Morning prayer was recited communally at the synagogue, and one of the duties of the *shammash* (the beadle of the Jewish community) was to summon the faithful there at daybreak. To do this, he went through the streets of the Jewish quarter knocking at doors and shutters. Early in the thirteenth century he was already referred to in Germanic countries, where he was known as the *Schulklopfer*, but there is no pictorial record of him.

Even before the formal morning prayer, a Jew already gave himself over to prayer, for every movement he made after waking was an occasion to praise, bless and give thanks to his Creator.

Apart from rather late Italian pictures from the years 1465 and 1470 no illustrations of this early prayer, its setting, or rituals survive. The liturgy varied little among the different rites throughout the Middle Ages: as soon as a Jew was roused by the crowing of the cock ('to whom God has given the wisdom to tell day from night', as the appropriate blessing puts it), he recited the blessings prescribed for the moment of waking, while stretching his limbs and opening his eyes for the first time. He is depicted just as he sits up in bed and, with his eyes fervently raised, recites the blessing that accompanies this movement. [1] The series of blessings continued as he proceeded to get up, placing his feet on the floor, standing upright and donning his clothes. Before leaving his bed and taking off his nightcap, the Italian Jew in our illustration had already put on his tunic *(cote)* while blessing 'him who clothes the naked'. Directly after leaving his bed, he had to wash his hands; then he could proceed, with the utmost care, to his toilette. A late fourteenth-century Italian miniature shows that Jews groomed their hair with the type of comb then common, with a double row of teeth, not unlike our fine-toothed modern combs. [2]

A mid-fourteenth-century scene from Spain [3] shows the same combs being used in the de-lousing process, but that operation could also be done by hand, as German illustrations of the second half of the fifteenth century attest. [4] In spite of their body hygiene and their baths—which from the thirteenth century onwards, they took more frequently than did their non-Jewish contemporaries—medieval Jews were no better able than Christians to avoid the universal plague of fleas and lice that infested clothing and hair. Anyone needing a mirror could make use of one of the round ones in circular frames that were available, in Italy or Germany, from the late fourteenth to the second half of the fifteenth century. [5]

Still before the communal morning prayer, the Jew had to retire to empty his bowels. This had to be done in isolation and according to the requirements of ritual cleanliness, as textual sources bear witness, made much stricter for the Jew than was customary among contemporary non-Jews. No illustration portrays this feature of Jewish habits.

Having completed his ablutions and fully dressed himself, a Jew proceeded again to wash his hands, to the accompaniment

of the appropriate blessing. He did not plunge his hands directly into the water for this rite, but held them over a basin under water poured from a hanging cistern[6] or ewer, he then dried them carefully on a towel hung beside the cistern.[7]

There exist very few illuminations of the daily communal prayer recited in the synagogue. Most scenes of Jews at prayer illustrate holiday services. The daily services differed from them only in that certain special rites associated with some of the feasts were omitted, and a few modifications or additions in the content of various parts of the prayer were made. The Italian miniature of about 1465,[8] showing Jews praying in a synagogue by the light of the candles placed on their desks, can be taken to convey the atmosphere of these morning prayer meetings, although, in fact, it illustrated a recitation of the prayers of supplication and penitence performed before dawn on the days preceding *rosh ha-shana* and between that holiday and *yom kipur*.

Two commandments specified that Jews engaging in morning prayer had to wear the *tallit* with its *ziziyyot* (prayer shawl with its ritual fringes) and *tefillin* (phylacteries). Textual sources reveal that respect for these two commandments was far from general among ordinary practising Jews in the twelfth and thirteenth centuries, even though the commandments are mentioned in the daily prayer, the *shema*, itself. Jewish illuminations show that the wearing of the *tallit* only became more regular in the fifteenth century, at least in Germany and Italy—the only countries to have left any illustrations from that period.[9] Only one illumination from Italy, dating from about 1470,[10] depicts a Jew putting on his *tallit* and pronouncing a blessing upon the *ziziyyot*.

Jewish illumination provides no examples of the little square-bottomed black leather boxes being worn on the forehead or arm of Jews in prayer. Generally cubic in shape but sometimes cylindrical, *tefillin* contained parchment copies of the four passages of the *Tora* commanding their use (Exodus XIII:1–10, 11–16; Deut. VI: 4–9, XI:13–21) and are depicted in a few ancient Christian Byzantine illuminations, in illustrations of the *Christian Topography* by Cosmas Indicopleustes[11] and the *Octateuch*,[12] dating from the ninth to the eleventh century. Here, the *tefilla shel rosh* which can clearly be identified, is worn on the forehead, but the strap holding it on is not represented. In the picture of Ezra on one of the first folios of the famous Codex Amiatinus,[13] an early eighth-century manuscript copied and illuminated in Northumberland, the shape of the box is strange: high and narrow with a base that becomes larger at the sides.

There is no known picture of the *tefilla shel yad*, which was worn just above the inside of the elbow on the left arm, with the strap wound round the arm.

But in Hebrew copies of the *Mishne Tora* of Maimonides, from the thirteenth to the fifteenth century, in the passage concerning *tefillin* (II:3; 3,1–6) and the way the texts in them are to be copied and arranged, there are diagrams of cross-sections of the *tefilla shel rosh* with its four compartments each one containing one of the four biblical passages. In the single compartment of the *tefilla shel yad*, these passages are copied on a single parchment.[14]

Once these initial religious duties had been carried out, it was time to take sustenance, unless it was a day of public or individual fasting, which only ended with nightfall.

Except in exceptional circumstances, public fasts were held on fixed days. An individual could fast on any day except the *shabat* or a holiday. Reasons for individual fasts varied: one might fast after a bad dream, for example. In that case, the day of fasting ended with a brief ceremony that was quite generalized but of which we only have Italian illustrations from 1470 and after 1480:[14a] the dreamer assembled three people to whom be told his dream; then he and his listeners said the appropriate invocations, expressing the wish that the dream's bad omens be converted into favourable ones.

To return to the first meal of the day: at this early hour, it was no more than a quick snack, after which the head of the family would devote himself to one of the professional activities described in the preceding chapter. The nature of this activity, be it manual, commercial or liberal, gave its particular colour to the father's day.

The status in the social hierarchy conferred by this activity, the material ease or even wealth it brought, or conversely the poverty it was inadequate to avert, also contributed to diversify the days of the members of a community. The social inequalities we have already seen affecting dwellings, their furnishings and comforts, or even clothing, also distinguished the daily style of life. Whereas Jews were normally obliged to go about their business on foot, in Spain the court Jew whose duties involved waiting upon the sovereign in his chancery or treasury, or the Jews attending him as physicians, had the privilege of travelling by mule, escorted by valets who took charge of the animal.[15] 281
Jews were also attended by servants in the exercise of certain Jewish community obligations, such as the charitable distribution of *mazza* (unleavened bread) and the ritual sweet *haroset* on the eve of the feast of *pesah*.[16] Among these numerous servants 318

figured slaves of both sexes, Moors or Tartars, conforming to the practice common to the Spanish aristocracy of the day. Only one Aragonese illustration from the years 1350 to 1360 [17] depicts this custom, well-attested in surviving texts: a woman with negroid features and dark skin is seated at the family table for the *seder* ceremony. Although the texts seem to indicate that it was quite common for the middle classes in Catalonia to own at least one or two slaves, humble artisans and small tradespeople certainly had to content themselves with the help of one or more apprentices and the members of their family, both in professional work and in the household. In a Jewish bakery in Castile from the first quarter of the fourteenth century young apprentices work alongside the master and his wife and daughters. [18] Towards the middle of the century, a Jewish baker in a German community was also represented being helped by his wife. [19]

Many Italian scenes of the fifteenth century provide glimpses of servants busy in the houses of well-to-do Jews. Young valets can be seen waiting at table. [20] Elsewhere, a page presents a precious casket to his master, no doubt a prosperous money-lender. [21]

## A Mother's Day

Medieval Jewish women were by no means exempt from social inequality. Without any independent resources, a Jewish woman—a widow perhaps in Navarre—might be obliged to take part in the roughest building work on royal palaces and fortresses, but such a dire situation was exceptional and is not shown in any of our illuminations. It was much less arduous to work as a servant and, indeed, this was the usual occupation of the poorest young women. They are depicted working in kitchens in Spain, [22] in Germany, [23] and in Italy. [24] As for the wives of shopkeepers or craftsmen, they usually worked alongside their husbands.

Whatever the constraints on the life of the poor, or the activities of a broad spectrum of women outside the home, women's duties were primarily concerned with the home itself. The domestic tasks had to be tackled alone or with the help of a domestic staff, the size of which depended on the household's standard of living.

Rising early like her husband, a Jewish woman also began her day with blessings and ritual ablutions. Since she was not obliged by the laws of her religion to wear the *ẓiẓiyyot* and *tefillin*, to pray at fixed times or to attend communal prayers, she was freer in her choice of when to recite her prayers, and the time she devoted to them depended entirely on her piety. There are no known representations of the daily private prayer by Jewish women. Indeed, there are even very few illustrations showing women tidying and cleaning their houses, seeing to the preparation and serving of meals or educating their children. Some idea of the daily tasks of sweeping and dusting is given us in the few known illustrations of the extensive spring-cleaning that preceded the feast of *pesaḥ*, [25] but there are no pictorial records of the other indispensable chores, such as laundering linen and cleaning clothes. The spinning of wool, linen or flax —the most typical occupation of all medieval women, whether queens or peasants, Jewesses or gentiles—was only illustrated in a few exceptional instances. Jewish illumination from Germany contains only one allusion to spinning, and it is an oblique one in a marginal drollery developed from a standard decorative subject: a woman is brandishing her distaff at a fox who is heedlessly making off with her cock. [26] In fourteenth-century Spain and fifteenth-century Italy, however, spinning was seen as the occupation of Eve, mother of mankind, after the expulsion from the Garden of Eden, [27] an attitude that is more in accordance with medieval norms. A woman's daily chore of spinning with distaff and spindle likewise did not appear in Italy [28] until the end of the fourteenth century or the beginning of the fifteenth.

282  A woman, early fifteenth-century Italy, spinning linen or hemp with a distaff and spindle.
Venice, Museo Ebraico, Bible, folio 11 recto (detail).

283  A pigeon, one of the birds of the air that was permitted food, from a manuscript illustrated in Castile, c. 1300.
Lisbon, Biblioteca Nacional, Ms. Il. 72, folio 328 verso (detail).

The mistress of the household, moreover, was never shown providing for the family table. We have already observed that there were no depictions of shops or markets in Jewish *134, 149* illumination. Mistress and servants are only shown in the kitchen, among spits of roasting meat, cauldrons, pots and pans with soups and stews, in illustrations from Spain, [29] Germany [30] and Italy. [31]

None of these pictures pays attention to the specifically Jewish manner of preparing food. None shows, for example, the special treatment of meat before cooking. Meat had to come from animals ritually slaughtered, with the forbidden fat and the sciatic nerve—for quadrupeds—removed; after this, the meat still needed to be drained of as much blood as possible. To this end, it was salted, soaked in water or singed. Nor do illuminations show the strict separation of meat and dairy foods: not only are these not to be mixed, but they also have to be prepared and eaten in different utensils or dishes that are washed and stored separately.

The tables appearing in most of the scenes where meals are illustrated were laid for the *seder*, and thus bear only the ritual foods of this symbolic repast: *mazza* (unleavened bread), *maror* (bitter herbs), *haroset* (sweetmeat) and the ceremonial cups of wine. Pictorial information on Jewish food in the Middle Ages is extremely poor when compared to the textual sources of the various periods for each region with Jewish communities. It is from these textual sources alone that we learn of the varieties of bread and pastry to which the Jews were partial, the fresh and dried fruits (local or exotic) and vegetables that they enjoyed, their favourite fish (eaten fresh, dried or salted), and the way they prepared meat and poultry.

No illumination provides any idea of a complete medieval Jewish menu. On a Spanish table from about 1300 [32] only bread, *125* a cup of wine and a chicken are visible. But bread was the basic source of nourishment and wine the usual drink for Jews, as for all their contemporaries in both southern and northern Europe. Roasted or boiled meat—the flesh of 'clean', ritually slaughtered animals such as beef or mutton [33]—was still the main dish at every meal, both at midday and in the evening, insofar as the household's means allowed. It obviously neither appeared frequently nor was abundant on the tables of the poor. Non-prohibited fowl, whether domesticated like chicken, [34] *299*

284　A German picture, dating from about 1300, showing a long scaly fish with fins, features which Jews considered 'pure': it was thus among the permitted foods.
Oxford, Bodleian Library, MS. Can. Or. 137, folio 220 verso (detail).

285–6　Pictures of two types of fish, Castile, *c.* 1300: one was long, the other short and wide. The carefully drawn scales and fins show that both fish were 'pure'.
Lisbon, Biblioteca Nacional, Ms. Il. 72, folio 428 verso and 256 recto (details).

285

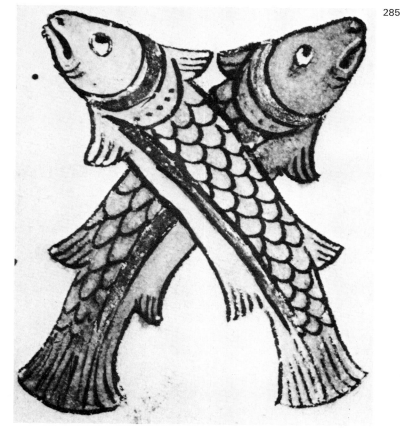

286

283, 296　ducks, geese and pigeons, [35] or wild like partridge, [36] was also eaten. In fact, as long as it had been ritually bled beforehand, poultry remained a basic food source. Indeed only the poorest of the poor could not keep a few chickens, even when generally precarious conditions, burdensome rectrictions or heavy taxes

284　restricted the *shehita* of cattle or drove the price of such meat too

285-6　high. Fresh fish, with their scales and fins, always well represented in our illuminations, [37] were the only kind authorized by the Law (Leviticus XI:9–12) and had been a favourite dish for *shabat* since Talmudic times. Of the vegetables

297　that accompanied meat or fish, only salads were shown. [38] Fruit

298　of the appropriate season that completed the meal was rarely depicted, although we do have examples of figs in Castile, [39] of

300, 367　pomegranates [40] or grapes [41] in Italy.

　　The lady of the house or her servants was responsible for feeding the household animals. (Pietists took moral refinement to the point of enjoining them to attend to such feeding before feeding themselves.) The animals consisted of a few laying hens

287-8　and chickens, [42] or a cat, essential for keeping down the number of rats and mice in every part of Europe, [43] though mouse-traps were also used, as first pictured in fifteenth-century Germany and Italy. [43a] Nor did the women of the house forget the family

368, 380　dog, who is often shown anxiously awaiting the meal's leftovers. [43b]

　　Care of the sick naturally fell to women also. This fact is well

242　illustrated in the Italian scenes from the first half of the fifteenth century [44] showing a woman at the bedside of a patient receiving the doctor's prescriptions.

　　The Law did not impose on women the multiple *mizwot* (precepts) that it did on men, but three were laid down as essential: *nidda* (monthly purification), *halla* (burning a portion of dough each time she baked a loaf of bread, as every Jewish baker had to do), *hadlaqat ha-nerot* (kindling the lights for the *shabat* and holidays). Only a nielloed casket made in the Ferrara region between 1460 and 1480 gives a complete picture of these three *mizwot*. Manuscript illumination provides a single

287

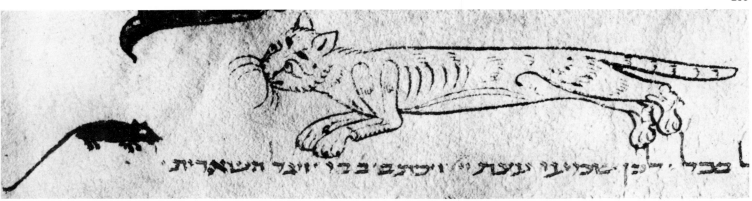

288

287-8 The inhabitants of both northern and southern Europe relied on cats to deal with mice and rats. In Italy there were instances where pawnbrokers, when establishing themselves in a new city, had to undertake to keep a cat to drive away mice that could damage clothes or books left as security for loans.
London, British Library, MS. Add. 11639, folio 236 recto.
Lisbon, Biblioteca Nacional, Ms. Il. 72, folio 433 verso.

106 representation of *nidda*, showing a woman in the ritual bath. [45] A woman is never shown separating or burning the *ḥalla*, nor lighting the lamp hung over the table or candles in their candlesticks.

Apart from fulfilling the role of companion and helpmeet to her husband, and acting as 'king-pin', of the home, the Jewish woman was also a mother. Judaism has always considered parenthood as the fulfilment of marriage—a concept embodied in the divine injunction of the book of Genesis: 'be fruitful and multiply' (I:28). Judaism has always exalted the institutions of marriage and family.

Illustrations of the phases of the Jewish woman's maternal life are rare. A German scene from the second half of the fifteenth century is an exception; it illustrates a pregnant woman with her arched silhouette and protruding belly. [46] Other illuminations of

291 the same period depict the mother-to-be tucked up in bed in labour, watched over by older women: her mother, an aged nurse, a relative, a neighbour or the midwife. [47] In Spain, from the fourteenth century onwards, there are illustrations of the

289 birth itself, showing the precise moment when the midwife takes hold of the child's head [48]—in this case, the heads of twins—or of a mother with a newborn child in her arms. [49] In late fifteenth-century Italy, we are shown a mother reclining in bed

290 while her newborn infant is being examined. [50] But there are only the barest allusions to suckling, the care of the newly born or the caresses and play characteristic of the mother's first relations with her child. Again, only a few isolated illuminations represent

318 a mother holding a babe in her arms. [51]

As already mentioned, belief in astrology was widespread in the Middle Ages, superstition and magical practices no less so. Contrary to the accepted notion in medieval Christian society that a Jew was someone liable to cast evil spells, if not a sorcerer in league with the devil, magic among the Jews, which was roundly condemned in the Bible, was restricted to the most innocent practices of divination and the use of charms and amulets. The prospect of a birth, with all the attendant hopes and fears and the dangers threatening the newborn child, drove Jews to reinforce the efficacy of prayer with magic. Yet no medieval illustration survives of the amulets that were used at that time as a protection against Lilith, the murderess of women in childbirth and newborn babes, or against the evil eye. We could perhaps interpret a pair of German miniatures of about 1460 [52] as showing a scene of bibliomancy: worried about the outcome 291 of a painful pregnancy, a woman is listening to the omen a sage has derived from the first word or verse that caught his eye as he opened the Bible.

## A Child's Day

### The Very Young

Just as there are very few pictures with any hint about the relations between a mother and her baby, there are also hardly any that illustrate the life of a young child, his cares, games,

pleasures, pains or illnesses. A few German pictures from the second half of the fifteenth century [53] are rather late exceptions: they suggest that the Jewish mother, in order to prevent her child's suffocation, a frequent accident in the Middle Ages, would not let it sleep beside her, but laid it in a cradle. No child is shown being weaned, nor, with a single exception, [54] taking its first steps once out of swaddling-clothes, nor its first toys, rattle, 292 doll or ball. Virtually the only portrayal of a baby's silhouette and gestures is in an Italian Hebrew manuscript from about 1470, [55] which is evidently influenced by the fashion for decorative *putti*, though in a style less stereotyped than usual. 293

## Girls

A young girl stayed at home and was educated by her mother. The mother's example and precepts trained her in her religious duties, moral responsibilities and domestic tasks. Young girls appear only incidentally in certain illuminations, particularly Spanish or Italian ones [56] either at the mother's side or in a 163 situation revealing no particular autonomy. Older girls were depicted more often, distinguishable among elder women by their bare heads. These adolescents shared in housework or such artisanal tasks as baking, for their own families or as servants [57] 178 or at social gatherings (to which we shall return) like dances. [58] 322-3 However, they are never depicted in private.

## Boys

We can get more information from our illustrations about the daily life of young boys. They enjoyed greater freedom than girls and engaged in more active and noisy games, such as playing at horses: a German illumination from the fifteenth century shows

292　A child, Germany, 1450, takes his first steps, guided by his mother and grandfather.
Munich, Bayerische Staatsbibliothek, Cod. Hebr. 107, folio 79 verso.

293　A Jewish boy, Italy, *c.* 1470, with curly hair, chubby cheeks, and comfortable shoes and clothes.
Jerusalem, Israel Museum, Ms. Rothschild 24, folio 246 recto (detail).

292

293

a jester mounted on the *Steckenpferd* (the curved stick that served 304 boys as a horse for their games). [59] Boys were allowed out on the streets of the Jewish quarter, where they could sometimes enjoy 305 themselves watching a trained dog performing tricks, or a dancing bear, or listen to street musicians. [60]

Like their sisters, boys acquired the essentials of moral and religious training up to the age of five from their mothers, but no trace of this remains in illuminations. Boys had already learned to repeat the blessings recited by their parents, and went with their fathers to the synagogue, at least on the *shabat* and holidays. In some fourteenth-century Spanish illustrations, boys are shown sitting or standing beside their fathers in the synagogue; [61] they followed the service, absorbed the rhythms and tunes of the psalms, hymns and prayers, and, with suitable 88, 95 gravity, carried their fathers' prayers books. [62]

By the age of five—and earlier in Sephardi countries—play time was much reduced for any normal, health boy, and his day became as long and busy as his parents': rising well before dawn, at least in winter, he divided his time between school and the synagogue. Here the master took his pupils for the prayers that punctuated the day. In Ashkenazi countries the child's entry into

294　The first actions of an Italian Jew on awakening, from a miniature of *c.* 1465: as he opens his eyes and sits up in bed he utters the first blessings of the day; once he has washed and dressed himself, he performs the ritual ablution of his hands, the *neṭilat yadayim*, with water pouring from a fountain into a basin; behind him hangs the towel he will use to dry himself; finally, he recites the morning prayer standing with a book in his hand.
Jerusalem, Jewish National and University Library, Ms. Heb. 8° 4450, folio 2 recto (detail).

295　Spain, after 1350: a woman spinning with distaff and spindle.
Sarajevo, National Museum, Haggada, folio 3 verso (lower register, detail).

296　A partridge from Spain in 1300; this wild bird could be eaten only if taken alive and its throat cut so that it bled according to the *sheḥita* rules applicable to poultry.
Lisbon, Biblioteca Nacional, Ms. Il. 72, folio 248 verso (detail).

297　A lettuce with large leaves from Italy, 1456: although it was only shown ▷ on a page of a book of prayers illustrating the text of the Passover Haggada, because it was among the prescribed items on the *seder* table—as a substitute for the *maror* or bitter herb—this vegetable must also have been eaten on less formal occasions.
Cambridge, University Library, MS. Add. 437, folio 158 recto.

298　A basket of fruit from Spain, 1300: apart from figs and locally grown fruit, ▷ there are fruits from the land of Israel (Deuteronomy VIII:8) which were eaten with blessings and special thanks that expressed the nostalgia and longing for return to the land of their fathers.
Lisbon, Biblioteca Nacional, Ms. Il. 72, folio 112 verso (detail).

294

295

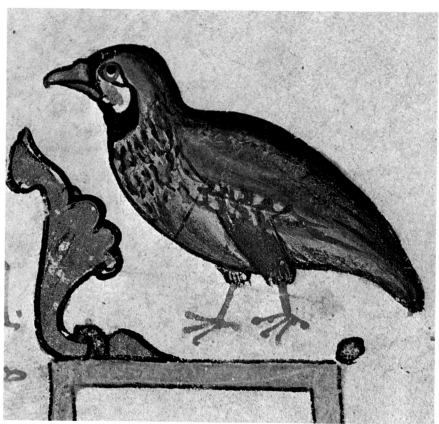

296

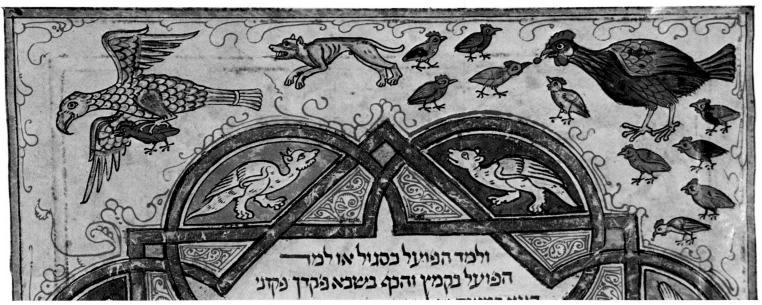

ולמד הפועל כסגול או למד
הפועל בקמץ והקף בשבא נקדן עקני

301

302

303

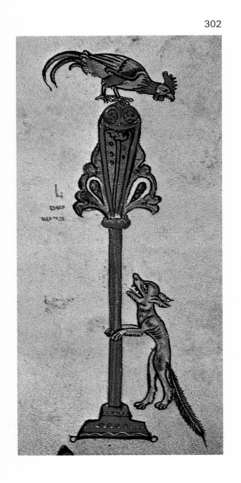

ספר במדבר סני

school was marked by a veritable initiation ceremony. Since this was also the boy's first introduction to the study of the *Tora*, some communities made it coincide with *shavu'ot* (Pentecost), which commemorated the revelation on Sinai. On the eve of the holiday, three boiled eggs, three honey cakes, apples and other fruit were prepared for the child, and the letters of the alphabet were written on a slate. On the morning of the holiday itself, the boy, washed and wearing new clothes, was carried in the arms of a rabbi or a learned friend of the family to the synagogue and the school. In the synagogue, the boy was set at a desk in front of the *Tora* scroll, from which the Ten Commandments were read. At school, after the letters of the alphabet had been read to him, his slate was smeared with honey, and he was made to lick it. Then, he ate the cakes and fruit. This initiation—obviously a symbolic incentive to study and a kind of token Pavlovian conditioning—was described in the late eleventh century in the *Maḥzor* Vitry from northern France, and again in an early thirteenth-century manuscript from the Rhineland. However, it 306 was not illustrated until some time in the first quarter of the fourteenth century, in a community near the upper region of the Rhine. [63] After this initiation, the mother took her son to school each day and fetched him home. [64]

◁◁ 299 A hen surrounded by her chicks in a farm-yard, Spain, 1300; in spite of the efforts of a guard dog, a buzzard or hawk has managed to bear off a chick as his prey.
Lisbon, Biblioteca Nacional, Ms. Il. 72, folio 442 verso (detail).

◁ 300 A Jew under his vine-arbour, Italy, 1470s: before eating the first grape from the bunch, he pronounces the same blessing as for figs, grapes also being a fruit from the land of Israel; once he has eaten the bunch, he will recite the same blessings. The same would be the case for pomegranates, olives and dates.
Jerusalem, Israel Museum, Ms. Rothschild 24, folio 125 verso.

301 A scene of elementary education, Germany, late fourteenth century: the time of the lesson is measured by an hour-glass; the master holds a whip, a symbol of scholastic authority whose role was primarily that of a deterrent—a master who used it too violently and frequently lost his job; the child, seated on a small chair in front of a low desk, follows the letters with a short stick. The illuminator has chosen to show the text of the Golden Rule of Hillel the Elder as a means of expressing the underlying message of Jewish teaching.
London, British Library, MS. Add. 19776, folio 72 verso (detail).

302 From Spain in 1300: a story very popular in all circles, that of the fox who persuaded a cock to come down from his perch by flattery and cunning.
Lisbon, Biblioteca Nacional, Ms. Il. 72, folio 29 verso (detail).

303 Early fifteenth-century Italy: the cock, a favorite hero in stories and fables; the picture shows him steering a sailing boat.
Venice, Museo Ebraico, Bible, folio 20 verso (detail).

After a rapid apprenticeship in reading and writing, the boy was set to read and translate the *Tora*, into the vernacular, both from the original Hebrew and from the Aramaic version. At about the age of ten, he began Talmudic studies, starting with the *Mishna*, following it at about thirteen with the most important extracts for religious practice from the *Gemara* tractates: those on blessings and holidays. Thus while the boys were learning to read, write and reason they were also learning the rites and moral precepts of their religion. This triple aspect

306 Jewish children in the Rhineland being initiated into their studies, *c.* 1310–30: in the centre, a learned man holds the child wrapped up in his cloak —and not in his *ṭallit*, as is sometimes indicated in the texts—to protect him from the evil eye as he carries him towards the school room. On the left, the children present themselves to their teacher, holding the boiled eggs and cakes with honey prepared specially for them; the teacher takes each child in turn onto his lap and gives him a slate (shown here by the rectangular object covered in burnished gold which he holds between his hands) on which are written the letters of the Hebrew alphabet. The illuminator has not illustrated the moment when the child, once the letter and appropriate verses inscribed on the eggs and cakes have been read to him, licks the honey covering the slate and eats the eggs and cakes. On the right, the teacher leads the children, still carrying the eggs and cakes, to the edge of an expanse of water filled with fish. Textual sources give the symbolical explanation of this rite: the river represents the *Tora*, a source of the soul's satisfaction, and as the river expands from its source, so is the child invited to expand continually his understanding of the Law. The fish recall that the *Tora* is as indispensable to spiritual life as water to fish.
Leipzig, Universitätsbibliothek, Ms. V 1102/I, folio 131 recto.

—linguistic, ethical and religious—of medieval Jewish education is perfectly illustrated in a picture from the late fourteenth century: [65] an hour-glass hangs on the wall to measure the time of the lessons; the boy is guided in his reading by a master armed with a whip, an instrument the latter used with a light hand, 'without leaving a mark', when the child's memory of the initiatory honey proved insufficient. The text before the child is none other than the fundamental moral principle of Jewish ethics (Leviticus XIX:18), the golden rule, as formulated by Hillel the Elder (Babylonian *Talmud*, *Shabat*, 31a): 'Do not do unto others what you would not have done to yourself: that is the whole of *Tora*, the rest is merely commentary.'

Study was not always so austere. At school and more especially at home it might take the form of reading fables with didactic or moral lessons, tales from the *Talmud*, animal stories from the *Mashal ha-qadmoni* (Fables of Antiquity), written by the Spaniard Isaac ibn Sahula in 1281, or the *Mishley shua'lim* (Fables of Foxes) by the Frenchman Berekhia ben Natronai (late twelfth- to early thirteenth century). Among other things, the latter writer translated the *Ysopet* by Marie de France and made a Latin translation of Aesop's *Romulus*, which was later lost. In such fables and stories, and the pictures illustrating them, children met the lion, king of the beasts, [66] the wolf and the lamb, [67] the fox and the cock. [68] The fantasy of the fairy stories introduced them into a world where roles were reversed: a hare who is served by a dog [69] or returns triumphantly from a successful dog hunt. [70] It was also a world in which animals behave like people: a cock sails a boat, [71] a monkey fishes. [72] Here the ancient tradition of 'animal musicians' is still very much alive. There are pictures of a hare playing the bagpipes; [73] a wolf, a rebeck; a monkey, a trumpet; a goat, a horn. [74]

The overriding aim of this education, whether achieved directly or indirectly by means of fables and tales, was to strengthen a boy in his fidelity to his religion and people, and to develop in him the essential human virtues of justice, truthfulness, loyalty, honesty, kindness and modesty. He was taught to abhor denunciation and calumny, [75] which disturbed the peace of the Jewish community and might even endanger it if exploited by the gentiles in the outer world. Stress was laid on the practice of *ẓedaqa*, that all-embracing and essential virtue based equally on a sense of justice and love of one's neighbour.

307  An animal story from the *Mashal ha-qadmoni* of Isaac ibn Sahula: the lion, king of the animals, has convoked his vassals.
Munich, Bayerische Staatsbibliothek, Cod. Hebr. 107, folio 9 verso.

308  In the 'upside down world' of fables, where the weak become powerful and the persecuted are honoured, a humble and submissive dog is shown as the cup-bearer of a hare (Spain, after 1350).
London, British Library, MS. Add. 14761, folio 30 verso (detail).

309  Another picture of the 'upside down world': a hare, with a sword at his side, comes back from hunting a dog, which he carries proudly hung by its legs from his staff (northern France, late thirteenth century).
London, British Library, MS. Add. 11639, folio 327 verso.

310  In the make-believe world of stories, a hare plays the bagpipes (Castile, 1300).
Lisbon, Biblioteca Nacional, Ms. Il. 72, folio 347 recto.

308

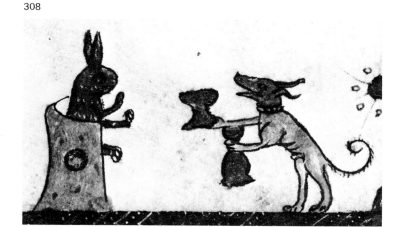

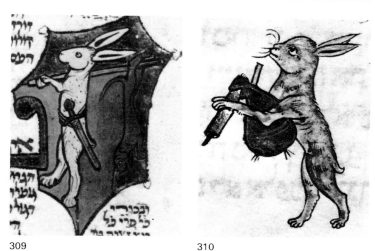

309                                          310

On that virtue rested all the institutions of mutual aid in the Jewish community, only a few aspects of which have been recorded in medieval Jewish illumination: the giving of gifts, 318, 121 food,[76] clothing[77] or alms[78] to the neediest, especially on the 313 *shabat* and holidays.

These basic tendencies of Jewish education are confirmed in a document in a curiously indirect way. When Jews succumbed to the temptation to penetrate the secrets of the future by having their horoscope drawn or their hand read, the questions uppermost in their minds were revealed. For example, in the 324 chiromantic hand found in a thirteenth-century manuscript,[79] beside legitimate concerns about health reflecting an obsession of that period (there is even a sign for leprosy) and the universal desire for a long and happy life, was the wish to know whether or not the questioner would commit the sin of denunciation, whether he would be true to his faith and capable, if necessary, of bearing witness by martyrdom. All Jewish education sought to prepare a boy to live up to this very special ideal of life.

When a child entered into the thirteenth year of his life he became *bar-miẓwa*, that is, he had to follow all the commandments; he came of age religiously and legally and was considered responsible for his actions. Despite its importance, however, in the Middle Ages this occasion did not give rise to the festivities that it does today, and there is no trace of a *bar-miẓwa* in our illuminations.

From the age of thirteen then, especially if a boy had not shown particular aptitude for study, he could start his professional life as an apprentice to his father or in another house. Other children continued their studies. After an intense course in grammar that allowed them mastery of the language,

311 Slanderers, 'workers of iniquity', 'who whet their tongues like swords' (Psalms LXIV:3–4) (Italy, late thirteenth century).
Parma, Biblioteca Palatina, Ms. Parm. 1870–De Rossi 510, folio 85 verso (details).

312 Denunciation, condemned in Leviticus (XIX:16), was liable to disturb the peace of the Jewish community and put it in danger when Christian authorities took cognizance of it: on the left, the denouncer breathes his accusations into the ear of a malevolent onlooker; on the right, the victim (Italy, c. 1400).
Jerusalem, Jewish National and University Library, Ms. Heb. 4° 1193, folio 18 verso (detail).

311

312

313

313 Mindful of his duty towards his neighbour (Leviticus XIX:18), whether he be a stranger (Deuteronomy X:19) or a brother (Deuteronomy XV:7), the upright man obeys the precept which enjoins him to open wide his hand to the poor and to the needy, and to give food and clothing to those left naked and unfed by misfortune, injustice, hate and persecution (Germany, c. 1460).
London, British Library, MS. Add. 14762, folio 12 verso.

314 Animals acting as humans, late fourteenth-century Italy: a monkey, easily represented imitating human activities, sits fishing with a rod. Medieval Christians were liable to regard monkeys as the distant descendants of fallen angels who had become devils, while they were seen in Jewish legend as the descendants of men corrupted by original sin and idolatry at the time of Enoch and the construction of the tower of Babel.
Oxford, Bodleian Library, MS. Can. Or. 81, folio 2 recto (detail).

315–17 Spain, 1300, the animal world made human: the wolf is shown playing the rebeck, the monkey a straight trumpet and the goat a horn, compare a row of animal musicians of Sumer, as seen on a royal harp of Ur.
Lisbon, Biblioteca Nacional, Ms. Il. 72, folio 440 verso (details).

318 Spain, 1320–30: tales illustrating *zedaqa*, that fundamental virtue governed ▷ by a sense of justice and love of others. A rich notable on the eve of Passover orders his servants to distribute *mazzot* and *haroset*, both essential for the celebration of the *seder*; a mother with her child is among the recipients, the children are also given *mazzot* and pieces of *haroset* for their families.
London, British Library, MS. Add. 27210, folio 15 recto (upper register, left).

319 Relaxing after a day's work on a winter's evening, northern Italy, towards ▷▷ the end of the fourteenth century: seated near the hearth where a cauldron boils away, a man warms his hands and feet.
Jerusalem, Schocken Institute, Ms. 24085, folio 33 verso (detail).

320 Hunting in Spain, about 1300: the taking of a hare. ▷▷
Lisbon, Biblioteca Nacional, Ms. Il. 72, folio 305 recto.

321 Although essentially not a Jewish pastime, hunting—either with dogs ▷▷ or with falcons—was a sport indulged in by the Jews who frequented Spanish courts even as late as the second half of the fourteenth century. For other Jews, hunting was no more than an occasional spectacle.
Paris, Bibliothèque Nationale, ms. hébr. 1203, folio 45 verso.

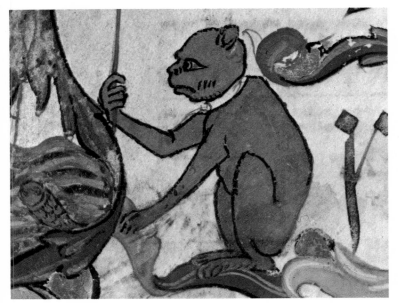

מעולי
מעולה למד קמ
תהפך ההא נגיול
כל הא נקבה ש

316

317

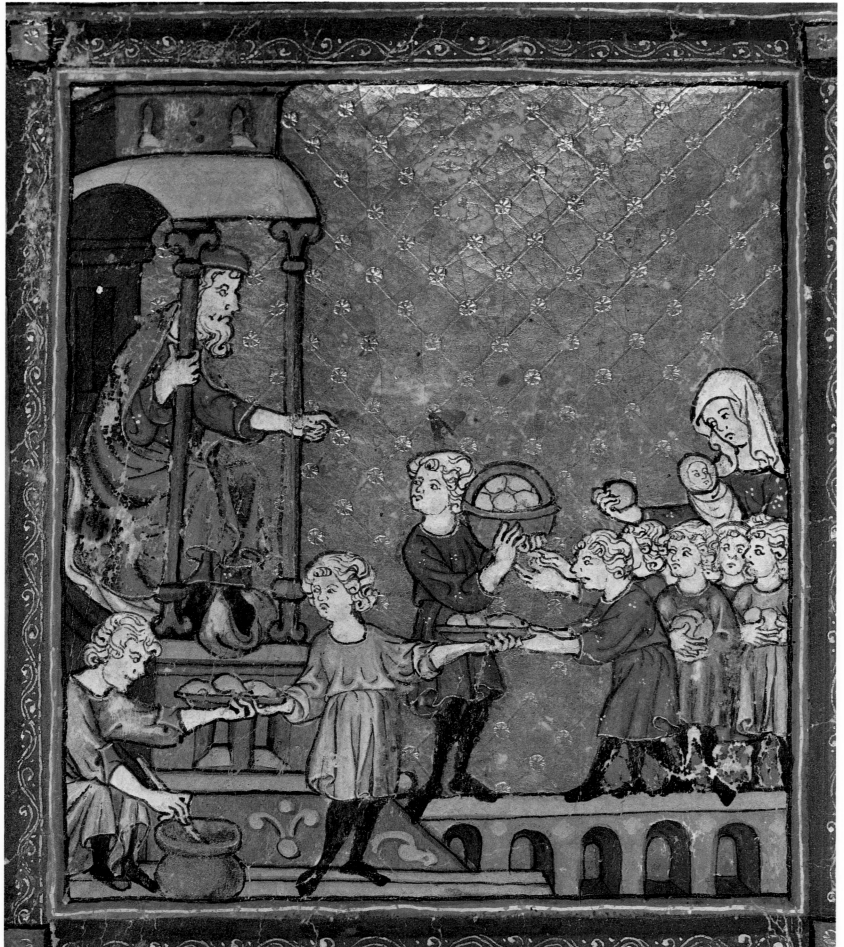

318

319

320

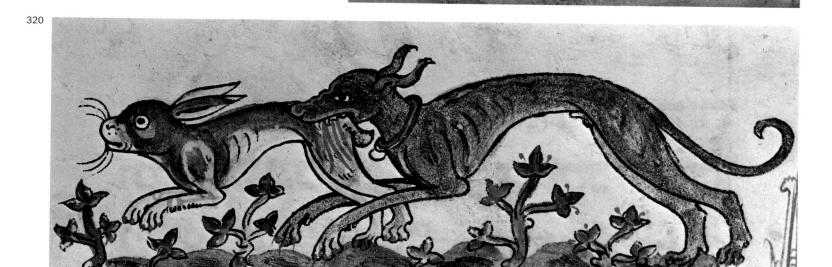

321

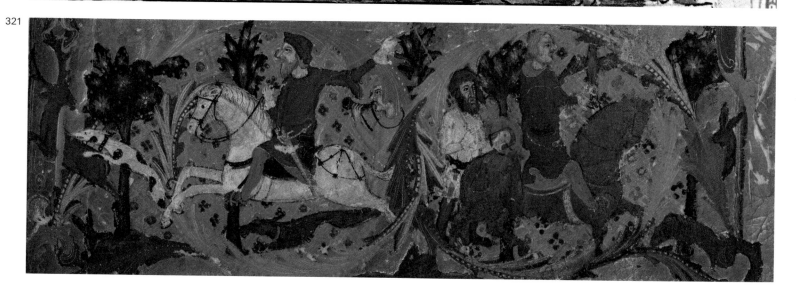

322

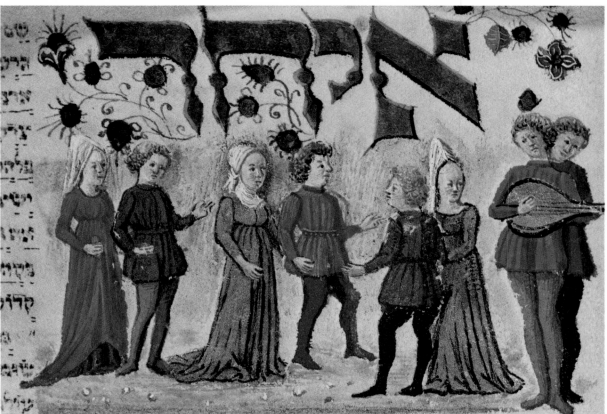

323

322 Jewish girls from Aragon dancing, *c.* 1350–60: holding hands in a line, they improvise steps and figures to the rhythm of a small drum.
Sarajevo, National Museum, Haggada, folio 28 recto (lower register).

323 Italy, about 1470: couples dance solemnly to the sound of the lute. The women's hair is covered—one even wears a veil draped as a wimple— indicating that the couples are married. Apart from married couples and close relations, rabbin forbade members of the opposite sex to dance with each other at balls.
Jerusalem, Israel Museum, Ms. Rothschild 24, folio 246 verso.

324 A palmist's hand drawn in northern France, last decades of the thirteenth century: the right hand is shown, from which a man's character and fate could be read (a woman's fortune was read from the left hand). The significance read into the lines and marks on the hand reveal familiar preoccupations, whether life will be long (wrist and base of the thumb) or short (top of the palm), happiness (base of the thumb), serious or incurable illness (first finger or thumb), as well as peculiarly medieval obsessions such as fear of leprosy (the middle of the palm), desire for male offspring (little finger), or the outcome of a sea crossing (the middle of the palm), which probably signified a pilgrimage to Jerusalem or exile to a remote country. There are also references to moral, spiritual and religious qualities: vulgarity, debauchery, chastity, conciliation and hatred (the two latter qualities being signified by signs on the palm), as well as to slander and denunciation (wrist), wisdom (the ring finger), fidelity and return to the fold (first finger). Many marks and lines on the palm reveal the tragic side of medieval Jewish life: torture (base of the thumb), corporal punishment and martyrdom (palm).
London, British Library, MS. Add. 11639, folio 115 recto.

324

they finally began serious study of the *Talmud* and the *halakha*, the latter being the law codified in the former. There are many illuminations portraying the rapt attention of students listening to the teaching and discussions of their masters. [80]

Some children and young people received their instruction at home from private tutors, especially in Spain but also in Italy where it was particularly in vogue in the fifteenth century. This did not mean that their life was any less studious than that of the children who went to school. Their studies at home followed the same programme, for Ashkenazi, Sephardi and Italian educational specialists were essentially in agreement about how studies should progress, the order in which to use the books and the questions that were to be discussed.

In addition to their biblical studies, children also acquired a minimum of secular knowledge on subjects such as arithmetic. Students who had completed Talmudic studies could go on to learn about geometry, optics, astronomy, natural sciences and medicine. However, there are no pictures portraying the activities involved in this specialized teaching.

258-60

## A Family Meal

So far only the nucleus of the medieval Jewish family—the father, mother and children—has been introduced; however, in most cases this family also included grandparents, other relatives and the spouses of married children and their offspring, who gathered around the family table for meals. Jewish miniatures only represent holiday meals, nevertheless they offer valid evidence of ordinary meals as well. [81] Though less elaborate and less richly served than meals on the *shabat* and holidays, ordinary meals were invested with the same religious significance. Since the destruction of the sacrificial altar, the function of purifying and sanctifying had in part been passed on to the family table. No one sat down before washing his hands, *neṭilat yadayim*. [82] This was followed by *ha-moẓi* (blessing of the bread), which dispenses with the blessings for the other food, except the wine. The master of the house pronounced it as he held up a loaf of bread, [83] and immediately after he ate a morsel

## Leisure and Entertainment

before distributing it to each person present who did the same. Between courses, passages from the *Tora* or the psalms were recited, so that the religious character of the meal was never forgotten, and any manifestation of gluttony or lax behaviour was prevented. The meal's ritual significance was stressed again by the prayer with which it ended. Preceded by another washing of the hands, [84] this long grace (*birkhat ha-mazon*) was recited aloud, and with even greater solemnity if there were three or more pious adults at the same table. [85]

For most people, the afternoon differed little from the morning. Adults returned to their work, girls to their apprenticeship or domestic tasks, boys to school and the youngest children to their play. The faithful assembled once more in the synagogue for the afternoon prayer (*minha*), which was generally recited at the end of the afternoon, so that it could be followed by the evening prayer (*arvit*). The family would then gather together again for the evening meal. After the evening meal the father usually studied and the children did their homework. Only the last stage of the evening, the prayer before going to bed, which was essentially an examination of conscience and a recitation of the *shema*, [86] has been illustrated. 131

Such a day of work or study, punctuated with ritual obligations of which only a few have been described, did of course provide moments of rest and leisure; the length and nature of these varied with standard of living, social situation, profession, opportunity and age. For the humble, leisure took the form of rest after a hard day's work, in the cold season, the only comfort being sitting near the warmth of the hearth. [87] But the leisure time of the well-to-do and the rich was filled with greater refinements. Seated in a carved chair, a wealthy Jew could enjoy the company of his household pets—falcon, monkey and dog —and lose himself in the contemplation of a flowering rose bush. [88] 319 325

Leisure hours spent in company rather than alone were often a time for games. Like their Christian contemporaries, medieval Jews were devoted to games: tactical games like chess, games of chance and, from the fifteenth century, card games. Playing for money was severely condemned by rabbinical authorities, who held that the loser ruined his own home, while the winner ruined someone else's; and furthermore, a player, a prey to this passion, neglected his work and study. In order to combat the evil effects of gaming on personal and community life, rabbin in Germany, Spain and Italy disapproved of games in general and imposed various restrictions and sanctions on playing for money. These were only lifted, in part, on half-holidays, working holidays, such as *hanuka, purim*, neomenia, and the intermediary holidays

of *pesaḥ* and *sukot*. Even on these occasions, playing for money was usually only allowed if the winnings were destined for charity. Medieval Jewish illuminations only rarely showed games being played, and there are none that illustrate either chess or card games. There is an isolated instance of dice being played in a German manuscript of the early fourteenth century;[89] a sketch, a bit later, of a hopscotch board with the three dice used for the oldest form of that game,[89a] while a late fourteenth-century Italian *siddur* shows dice being played during *purim* holiday.[90]

Sports likewise rarely appear in Jewish illuminations, despite the enthusiasm of Jews for such activities, mentioned in textual sources. There are no foot races, no tennis, only a wrestling match from early fifteenth-century Italy.[91] Hunting, on the other hand, was only indulged in by certain rich Jews who adopted some of the customs of their gentile acquaintances: such scenes come from Spain from as late as the fourteenth century[92] and from fifteenth-century Italy, where a few rich Jews retired in summer to their country villas and adopted the same pastimes as their patrician friends.

The most widespread entertainment among medieval Jews was certainly dancing. Dancing in costume and disguises was especially popular during *purim* holiday, as we see in an Italian miniature from about 1450.[93] There was also dancing at weddings, as well as on the *shabat* and holidays. Men and women were traditionally separated in lines or circles for dancing and followed figures that were generally improvised.[94] Despite rabbinical disapproval, the custom of mixing the two sexes during dances developed,[95] and couples even danced together who were neither married nor closely related, like brother and sister, mother and son, for example. These might have been officially tolerated.

Textual sources indicate that Jews were partial to all games of the intellect, such as *gemaṭriot* in which one played on the numerical value of letters, riddles and puzzles, but such pastimes did not lend themselves easily to illustration.

## Family Relations

The members of the family we have seen pursuing their daily occupations separately were nonetheless bound together by deep mutual feeling. We have already noticed how rarely the

330 Brotherly love: an elder brother takes his younger brother in his arms and embraces him (Spain, c. 1320–30).
London, British Library, MS. Add. 27210, folio 7 recto (lower register, left, detail).

in men's lives (Proverbs V:4) [99]—the dominant attitude towards women was one of affectionate respect. This is magnificently expressed in the poem *eshet ḥayil* ('the woman of valour') (Proverbs XXXI:10–31). Although the poem can be interpreted allegorically as a glorification of the Law or the *shabat*, or in cabalistic circles as the divine presence *(shekhina)*, nothing detracts from the direct homage it renders to woman: 'strength and honour are her clothing' *(ibid.*, 25), 'she opens her mouth with wisdom, and in her tongue is the law of kindness' *(ibid.*, 26); 'her children rise up and call her blessed, her husband also, and he praises her' *(ibid.*, 28). [100]

338

affection of a mother for her baby was illustrated. Perhaps the image of maternity, too evocative of the Madonna with child, was placed under a kind of taboo. But pictures of paternity are, it must be admitted, no less rare. [96] Allusions to any other close ties of affection, such as those between brothers, [97] were not at all common either. Such subjects are only evoked under the guise of biblical archetypes: the affection of Jacob for Benjamin, Rachel's last-born child, and the brotherly attachment of Joseph and Benjamin or Moses and Aaron.

330–1

It would be wrong to conclude that family relations were not warm. Ethical preoccupations certainly imposed limits on expansive demonstrations of affection: embracing and kissing cannot have been common sights. The strength of parents' attachment to their children is evidenced by the constant solicitude with which they surrounded them, guiding them along the moral and religious path of their faith and making sure that from their tenderest years they were involved in all religious activities of the synagogue and home. Parents' affection was expressed fully on the eve of every *shabat* and holiday when, on returning from the synagogue, they blessed their children, [98] with the wish that their sons emulate Ephraim and Manasseh, and their daughters, the mothers of Israel: Sarah, Rebecca, Rachel and Leah. As for the children, they responded with affection and respect divided equally between their parents, as was required by the fifth commandment. The juridical inferiority of women in medieval Jewish society found no echo in family life, for at home a Jewish woman was her husband's equal. In spite of a certain satirical vein that was above all literary and rich in misogynistic sentiments derived from non-Jews, and despite some traditional jokes inspired by the cynical reflections of the author of Proverbs on women—as bitter as wormwood

88

337

## Family Ceremonies

In Jewish society every important event in the private life of the family was marked by a religious ceremony. Jewish illustration could only capture the intensity of joy and sadness experienced by individuals by portraying the rituals, liturgical chants and formulae associated with such emotion, but it was through this communal participation that individual indulgence, egotism or withdrawal were avoided and at the same time joy was enhanced and sorrow eased.

331 An expression of fraternal affection, Spain, first quarter of the fourteenth century: two brothers meet each other after a long period of separation and embrace.
London, British Library, MS. Or. 2737, folio 68 recto.

332 Circumcision in Emilia, c. 1455-65: the *sandaq*, seated on a bench, holds the ▷ infant on his knees, while the *mohel* carries out the operation; the child is half naked, wearing only a blue striped nappy around his body.
Parma, Biblioteca Palatina, Ms. Parm. 3596, folio 267 recto.

333 Circumcision in Naples, third quarter of the fifteenth century: on the left ▷ sits the *sandaq*, the godfather, with the baby on his knees; the *mohel*, with his special knife in his right hand, prepares to carry out the operation; on the right he is shown after the operation with a cup in his hand pronouncing the blessings associated with the ceremony. The person on the right is wearing what seems to be a long scarf thrown over his shoulder—this may be the *ṭallit*, which would be worn as a matter of course for the ceremony, though the style in which it is draped is rather casual.
Nîmes, Bibliothèque Municipale, ms. 13, folio 181 verso.

331

332

333

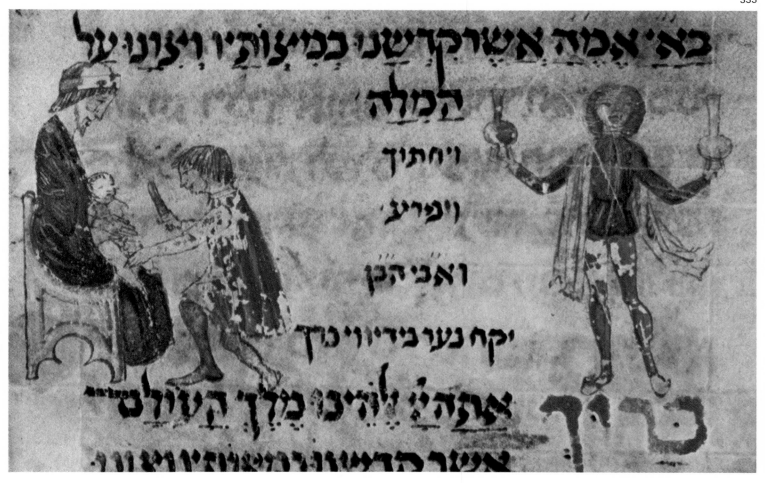

בָּא אִמָּה אֲשֶׁר קִדְּשָׁנוּ כְּמִצְוֹתָיו וְצִוָּנוּ עַל

הַמִּילָה

וַיַּחְתּוֹךְ

וַיִּפְרַע

וְאָבִי הַבֵּן

יִקַּח נַעַר בַּדְּיוֹ וַיִּמַּךְ

אַתָּ אֱלֹ...נוּ מֶלֶךְ הָעוֹלָם

אֲשֶׁר הָ...ו...צוֹתָיו וַיְצַ...

יהודה ' כבקר זה יוסנו יוכל
תבן זה עטטו ' סמך למיטות

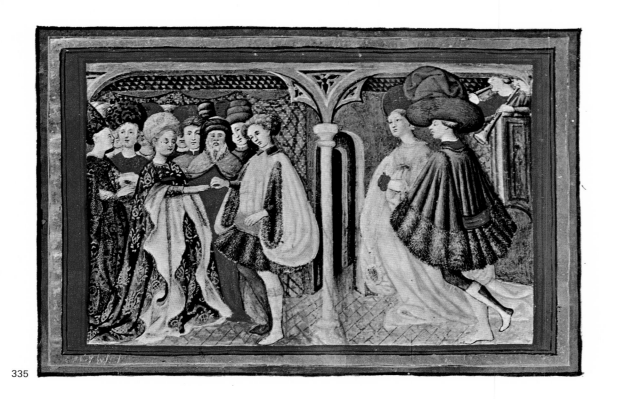

335

336

337 *Maror* being eaten during the *seder*, the ritual meal at Passover. For Ashkenazi Jews in Italy and Germany, *maror*, the bitter herbs—the symbol of the bitterness of slavery in Egypt—became associated with a joke directed against woman, i.e. woman like honey became 'bitter as wormwood' (Proverbs V:4). The husband, with the *maror* in his hand, cries *maror ze* ('this is the *maror*') and touches his wife's forehead with his other hand. The wife seems to accept the joke with complete submission.
Jerusalem, Israel Museum, Ms. Rothschild 24, folio 160 recto.

338 Wife and mother, the Jewish woman was queen of her household, surrounded by the affection and respect of her husband and children. The illuminator has shown her here sitting enthroned on a tall gilt chair.
Jerusalem, Israel Museum, Ms. Rothschild 24, folio 78 verso.

337

338

## Circumcision

The first duty of a father towards his son was to have him circumcised so that he entered into the covenant of Abraham. If the child's health was no obstacle, *mila* (circumcision) took place on the eighth day after birth, in conformity with the biblical commandment (Genesis XVII:10–14). In the Middle Ages, the ceremony generally took place in the synagogue and was carried out by a specially trained *mohel*. From one country to another only the details of the rite differed.

◁ 334 The pronouncing of the seven blessings at a marriage feast, Italy, about 1470: these blessings, the *sheva berakhot*, were recited by the person presiding over the meal, cup in hand, after it had come to an end with the *birkhat ha-mazon*, the prayer of grace. The newly wedded husband is bare-headed, but his wife wears a veil draped over her head and neck so that her hair is completely covered.
Jerusalem, Israel Museum, Ms. Rothschild 24, folio 121 verso.

335 A Jewish marriage, Italy, *c.* 1435: the couple, surrounded by numerous spectators, is splendidly dressed in the latest fashion. The bride wears a high *houppelande* and a *balzo*; the groom, a fur-lined *giornea* with wide bag-shaped sleeves and parti-coloured *chausses*. On the left-hand side of the miniature, the groom puts a ring on the finger of the bride's right hand while pronouncing the words 'Behold you are consecrated unto me with this ring according to the law of Moses and of Israel'. Strictly speaking it is thus no more than a betrothal, the first phase of the ceremony. Although we cannot see the hands of the officiant between the couple, the way in which his cloak opens and is raised on either side seems to show that he is holding the bride and groom by the arm, as he does in other Italian pictures of the fifteenth century (for example: Parma, Biblioteca Palatina, Ms. Parm. 3596, folio 275 recto; Jerusalem, Israel Museum, Ms. Rothschild 24, folio 120 verso; Budapest, Hungarian Academy of Sciences, Ms. A 380/II, folio 230 recto). The two men seen on the right and left of the officiant are probably the two witnesses necessary for the ceremony. On the right, to the music of the small wind orchestra known as the *capella alta*, seen on the tribune, the married couple open the ball. The groom, bare-headed for the ceremony, now wears an enormous *mazzochio a ciambella*.
Vatican, Biblioteca Apostolica, Ms. Rossian. 555, folio 220 recto.

336 A Jewish marriage, Germany, about 1272: the second phase of the ceremony is illustrated, the *nissu in*, or marriage itself. The couple are brought together under the *hupa*, the symbolical tent made by the *tallit* thrown over their heads; the officiant, with the cup of wine in his hand, recites the *sheva berakhot* or seven marriage blessings. The groom, like the officiant, wears the Jewish hat. The representation of the bride is particularly interesting: she is covered from head to toe in a loose fur-lined cloak which barely opens to reveal a featureless face; all we can see are the ends of her black shoes and a suggestion of her hands keeping the cloak closed. More than one figure in this manuscript has had its face rubbed out and drawn in again, and the groom's face is one of these; but the bride may well have had a veil over her face, as was the custom. The loose fur-lined cloak was worn as a sign of mourning for Jerusalem, its destroyed Temple, and the exile—painful thoughts which Jews always remembered at times of celebration.
Jerusalem, Jewish National and University Library, Worms Maḥzor/I, folio 72 verso (details).

339 An illuminator, in Germany, *c.* 1300, not content with showing the circumcision alone (on the left), illustrates the beginning of the ceremony when the godmother, surrounded by the women of the family, brings the child to the synagogue.
Jerusalem, Israel Museum, Regensburg Bible, folio 18 verso (detail).

340 A circumcision, Germany, first half of the fifteenth century: sitting on a chair with his feet on a stool, the *sandaq*, godfather, wrapped in the *ṭallit*, holds the child firmly on his knees and spreads his legs apart so that the *mohel* can operate more easily.
Budapest, Hungarian Academy of Sciences, Ms. A 383, folio 40 recto.

The only country from which there is no illustration of circumcision is Spain, apart from the biblical one of Sephora, the wife of Moses, circumcising her last-born (Exodus IV:25). [101] Germany and Italy, on the other hand, offer a choice of illuminations, ranging in date from 1300 to the late fifteenth century.

Some illustrations depict the *mohel* alone, operating on the child laid across his laps. [102] Usually the illustrations were more complete and closer to the reality of the medieval ceremony. For instance, the *sandaq* (the godfather) was represented seated with the child on his knees while the *mohel*, standing or kneeling in front of him, operated with his special knife. [103] Sometimes a scene from the first or last phase of the ceremony was illustrated in addition to the main scene: either the godmother bringing in the child, [104] or the *mohel*, after the operation, cup in hand, reciting the blessing over the wine, the special blessing for this ceremony, and the prayer during which the name given to the child was announced. [105] There is no illustration, however, of that moment when the *mohel* makes the child drink a few drops of wine from the cup, although this was traditionally part of the ceremony. Iconography concentrated on the essential ritual gestures; therefore, we are not shown the rest of the operation: the suction of the wound by the *mohel* and the bandaging of it with healing herbs. Nor are there illustrations of the banquets offered by the godfather and the father of the child on this happy occasion.

## The Redemption of the First-Born

The second duty of a father towards his first-born son was *pidyon ha-ben* ('redemption of the first-born son'). Since according to the Bible (Exodus XIII:2; XXII:29 and Numbers III:12–13) every first-born son belonged to God, that son had to be redeemed on the thirty-first day after his birth. Only the first-born sons of the descendants of Levi, *lewiyyim* and *kohanim* (Levites and Priests), consecrated to the service of God, were exempt from this ritual. The father had to present his son to a *kohen* (a descendant of Aaron); the latter asked him with an Aramaic formula whether he wished to redeem his son or deliver him up. The father expressed the wish to keep the child and handed to the priest the sum considered equivalent to the five silver shekels mentioned in the Bible (Numbers XVIII:16); then the father and the priest recited the appropriate blessings. Of the three pictures of this ceremony we have been able to trace— one in a fifteenth-century German manuscript, [106] the other two in Italian manuscripts of the last decades of the same century [107]—it is strange to see that only the first depicted the redemption being carried out by the father. In the Italian

332, 340

339

333

341

illuminations it is the mother who presents her child to the priest. Although in Italy, as in other countries, the father redeemed his son, the priest asked the mother (whose presence was therefore necessary) whether the boy was indeed her first-born, for the redemption concerned the woman's first-born son, not the man's. This is probably what the Italian illuminators wished to emphasize by depicting only the mother.

## Engagement and Marriage

The day that all Jewish parents waited for, with as much hope as the peace or turmoil of the times allowed, was the day when their sons and daughters reached that crucial moment in their lives, their wedding. Marriage not only enabled man and woman to obey the precept to procreate but also to attain fulfilment through each other, since 'any man who has no wife is no proper man' (Babylonian *Talmud, Yevamot*, 63a): he 'lives without joy, without blessing, without goodness... without *Tora*, without protection... or peace' (*ibid*., 62b).

The legal and liturgical structure of marriage ceremonies, as established by the *halakha*, was remarkably consistent through-

out the ages in all the regions where Jewish communities were settled. Only in minor customs and in the festivities that accompanied the ceremony can a few differences be noticed at various periods and in different regions.

Negotiations *(shiddukhim)* were entered into, leading to an agreement between the parties, or those acting on their behalf, to contract a marriage and a settlement of the given date, the amount of the dowry and the financial and other necessary arrangements. As far as we know, this preliminary stage leading to marriage was illustrated in only one miniature of 1480 from Italy.[108]

From that time on, the couple exchanged gifts on festive occasions and received gifts from their friends and family, especially on the wedding day. But there is no illumination depicting this exchange of gifts or the ceremonial surrounding it. Hardly any medieval objects that were deemed worthy to be given as wedding gifts have come down to us. The most remarkable strictly Jewish present is certainly the casket in the Israel Museum mentioned previously (see n. 45 above). It is made of silver, partly gilded and nielloed, and was produced in northern Italy (probably at Ferrara) between 1460 and 1480 for a bride who was surely Ashkenazi, for the casket reflects a German custom: on the *shabat*, the mistress of the house did not wear the keys to her chests or cupboards; she only wore the small ornately crafted key to her key casket. The cover had numbered dials, labelled in Italian using Hebrew letters, to help the housewife keep track of the linen available and the linen in the wash.

The marriage ceremony itself consisted of two phases, originally with an interval of varying length between them. In our period, however, one followed directly on the other as part of a single celebration. In the first phase, the betrothal (*kiddushin* or *erusin*), the officiant recited the blessing known as *birkhat ha-erusin*, and in the presence of two witnesses the groom placed a ring on his fiancée's finger—usually the index finger—as a sign of acquisition and consecretion 'according to the law of Moses and of Israel'. Then, again before two witnesses, came the delivery of the *ketuba* (the marriage contract that established the rights and duties of the future husband) to the bride. The only illuminated *ketuba* from the West to have survived, copied at Krems in Austria in 1391 or 1392,[109] illustrates the moment the groom is about to give the ring to his bride. This was also the scene most often portrayed in Italy in the second half of the fifteenth century.[110] There is only one known illumination, 342

187, 335

342   *Ketuba* (marriage contract), late fourteenth century. This is the only illustrated *ketuba* to have survived from the medieval West, and shows the bride and groom in its ornamental border. The former wears a high crown, the latter the Jewish hat. The bride stretches out her arm towards the groom who is holding a ring: in contrast to rings shown in other marriage scenes, this one clearly has a stone set in it. So this cannot be the marriage ring itself, which was quite plain and not decorated with any stone or incrustation. What we are shown must be one of the rings used only for the ceremony—a fairly large number of these are known, but they date mostly from the sixteenth, seventeenth and eighteenth centuries, and only a few from the medieval period. They are richly decorated, and might have a very elaborate setting in the shape of a building: some see this as a reference to the temple or the synagogue; others, as the new home set up by the couple. Other such rings bear the traditional inscription *mazal ṭov* ('good luck'), and some have the names of their owners inscribed on them: this seems to show that they belonged to individuals. In some cases, these rings belonged to the community and were lent to couples who could not afford them themselves. Some rings of this kind are so big and have such protrusions around the ring that they were obviously designed to be used symbolically rather than actually worn.
Vienna, Österreichische Nationalbibliothek, Cod. Hebr. 218 (details).

again from fifteenth-century Italy, showing the *ketuba* being handed over to the bride in the presence of two witnesses. [111] The marriage was not actually completed until the second phase of the ceremony (called *nissu'in*) marked by the recitation of the *sheva berakhot* (the seven marriage blessings); these were recited by the officiant as he held a cup of wine in his hand. Afterwards the groom and his bride drank from the cup. During this second phase of the ceremony, the bride and groom met in a symbolic tent representing the nuptial chamber (the *ḥupa*), made either by throwing a prayer shawl (the *ṭallit*) over their heads—as was depicted from as early as the late thirteenth century in Germany [112] and in fifteenth-century Italy [113]—or by placing the long tippet of the groom's *chaperon* on the bride's head, as illustrated in a fifteenth-century German illumination. [114]

336, 183
344

A single illustration from Italy dated about 1470 [115] (the only depiction of the marriage banquet, which united the many guests around the newly married couple and their families) represents the seven blessings that were repeated after the grace that ended the meal at the wedding feast and at every meal of the

334

343   A marriage procession, Italy, 1465: the Jewish bride, mounted on a white horse, is escorted by young friends from her own family and others, both mounted and on foot, as she goes towards the city where she is to be married; a similar procession of members of the groom's family came to meet her (folio 28 recto of the same manuscript).
London, British Library, MS. Harley 5686, folio 27 verso.

344   A Jewish marriage, Germany, 1470s. This picture portrays none of the ▷ symbols of mourning which were usually displayed amid the gaiety of the celebrations. The bride wears only a cloak over her shoulders, which is open wide enough to reveal that she is not wearing the *sargenes*, or linen shroud, over her dress. Her hair is freely flowing and held in place by a light diadem. Her head and face are uncovered, although ancient tradition demanded that she be led towards the bridegroom with a veil hiding her face, just as Rebecca covered her face with a veil when she met Isaac (Genesis XXIV:65). The groom wears a *chaperon* draped around his head and not pulled down over his shoulders as was the custom for both Jews and Christians when in mourning. In addition, the symbolical *ḥupa*, under which the couple is united, is not represented by the *ṭallit* but—according to a strictly German tradition—by the long liripipe, or *cornette*, of the groom's *chaperon*, the end of which is stretched out and placed over the bride's head.
Near the bride stands her mother, and we can see the officiant standing near the groom. The groom is on the point of putting the engagement ring on the bride's finger, while the officiant, cup in hand, gets ready to recite the blessings, not only those of the betrothal but also the seven marriage blessings, symbolized by the uniting of the couple under the *ḥupa*. The illuminator thus wanted to show, in an abbreviated fashion, the two phases of the ceremony. The inclusion of the lute player is intended to convey the atmosphere of celebration in which the whole ceremony took place.
Jerusalem, Schocken Institute, 2nd Nuremberg Haggada, folio 12 verso.

345   The *ḥaliza* ceremony, Germany, early fifteenth century: the brother of the ▷ dead husband who refuses to contract a levirate marriage has his foot placed on a stool; the widow is undoing his shoe to remove it, a symbolical gesture that freed the brother-in-law from his obligation and left both parties free to marry as they pleased.
Parma, Biblioteca Palatina, Ms. Parm. 2823–De Rossi 893, folio 324 verso.

228

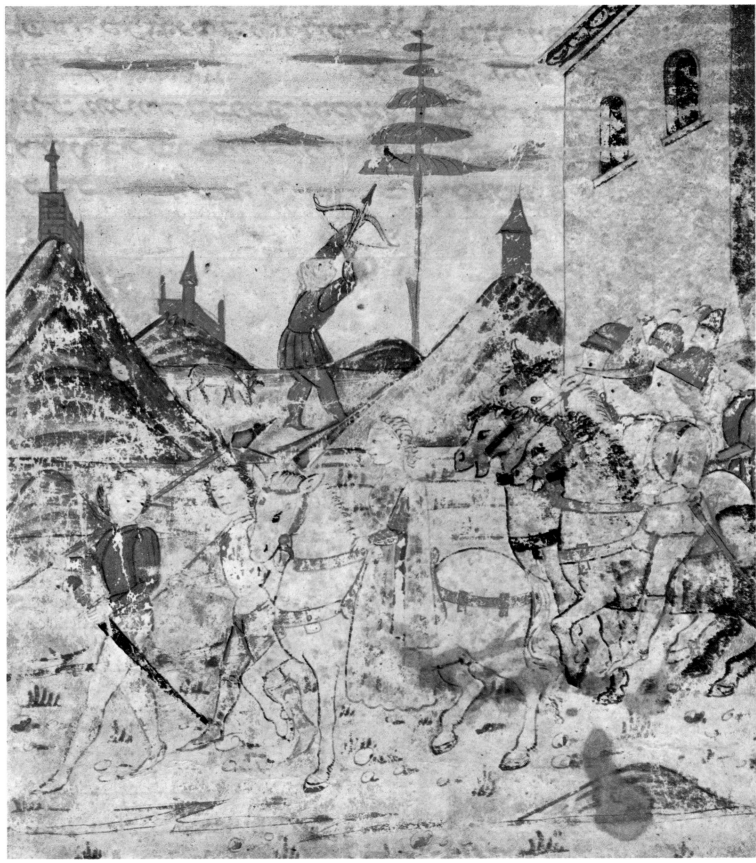

343

344

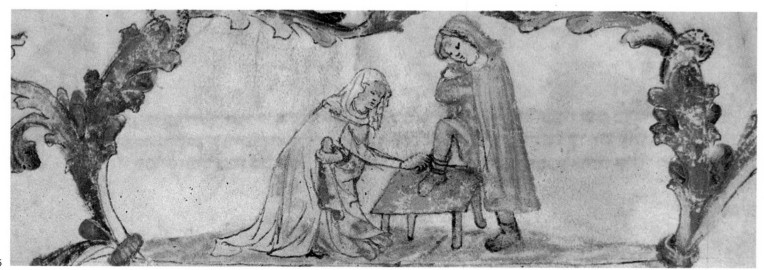

345

346

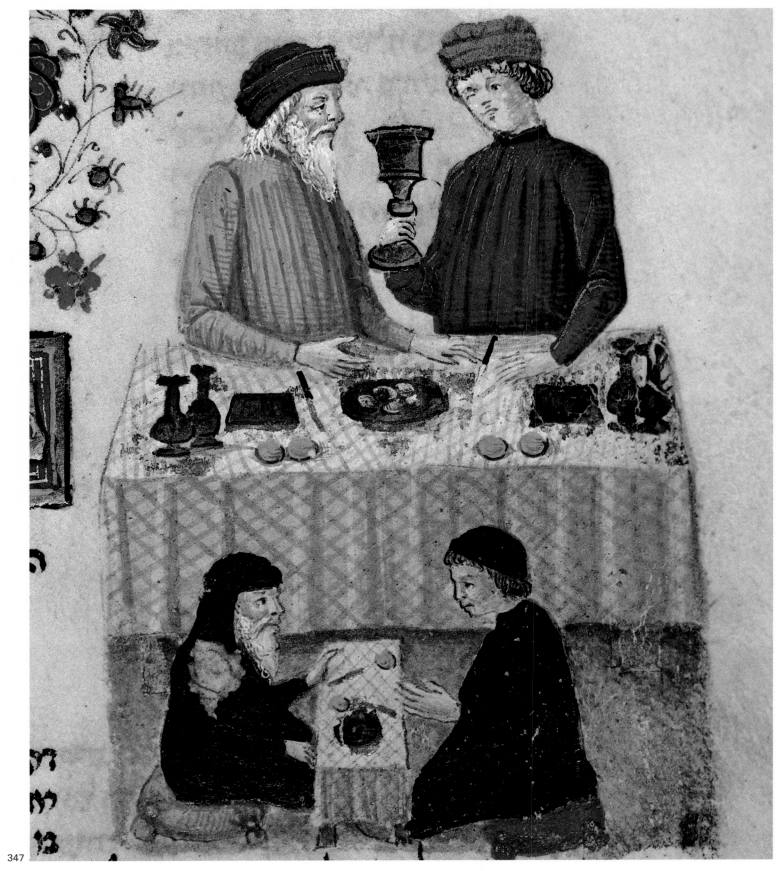

347

seven following days, at which a new guest was present. After each blessing, the newly married couple drank from the cup after the officiant.

The illuminations showing the different stages of the marriage ceremony, together with a few others, enable us to discern certain regional traditions. For instance, in late thirteenth-century Germany the bride was wrapped in a great fur coat covering her head and almost completely hiding her face;[116] according to textual sources, this custom was still practised in the fifteenth century. On the other hand, in the late fourteenth and fifteenth centuries, the bride was shown wearing a crown over her long loose hair: in the first example it is a tall crown of gold[117] and a plain light diadem in the second.[118] German illuminations from about 1460[119] combined in a single scene the giving of the ring and the *hupa* with the recitation of the seven blessings. In only one case[119a] does the closed scroll held by the reciter of the blessings also hint at the presentation of the *ketuba*. The presence of musicians—lutists, flutists and pipers—evokes the entertainments that accompanied the ceremony.[119b]

More details of these festivities can be found in Italian illustrations. Dancing and music are depicted in the first half of the fifteenth century,[120] a cavalcade in about 1465,[121] a procession of boys and girls carrying lighted torches in 1480.[122]

◁ 346  Mourning in Italy, *c.* 1470: the coffin, on trestles, is covered with a black drapery of figured velvet. The lamenting couple, who are saying the prayer that precedes burial, are dressed in black: robes and cloak for both and a *cappucio a foggia* for the man; the only white garment is the woman's veil. The geometric shape of the drapery over the deceased seems to indicate that his remains were laid to rest in a coffin. Our pictures show that this was not always the case, and we know from the differing opinions of a number of rabbin that some buried their dead in coffins while others did not. Sometimes the coffin was only used to transport the body to the cemetery. Use of the coffin seems to have been more general with Ashkenazi than with Sephardi Jews.
Jerusalem, Israel Museum, Ms. Rothschild 24, folio 121 verso.

347  The *se'uddat havra'a* or meal of consolation, Italy, *c.* 1470. This was the first meal of the members of the bereaved family after the burial: those in mourning, an old and a young man, are seated on cushions on the ground for the occasion; the meal—prepared by friends or neighbours, since the bereaved were not allowed to eat 'their own bread'—was served for them on a low table; two guests, whose brightly coloured clothes contrasting with the black of those bereaved show that they were not in mourning, take part in the meal but have it served on the main table; one of them raises the cup to say grace; indeed, just as the bereaved were exempted from saying any prayer until the burial, so they were relieved from doing any more than following the *birkhat ha-mazon* at this meal, which was recited for them.
Jerusalem, Israel Museum, Ms. Rothschild 24, folio 122 verso.

In Italy, too, the wedding canopy appeared, but not for the marriage ceremony itself: it was held over the bride at the moment when her party met that of the groom.[123]

Textual sources from both Italy and Germany[124] state that it was customary for the groom to smash a glass goblet as a sign of mourning for the destruction of the Temple, but this is not represented in any miniature.

## Levirate Marriage, Ḥaliza *and Divorce*

Illness, accident or a pogrom could throw a wife into widowhood even before she had become a mother. Basing itself on Deuteronomy XXV:5–6, the law obliged a brother of the deceased to take upon himself a levirate marriage, if he was in a position to do so without contravening another commandment: he had to marry the widow after the three months of obligatory mourning. If he refused to marry her, the widow was not allowed to remarry. Nor could the brother-in-law take another wife before the widow freed him from his obligation by the ceremony of *haliza* (Deuteronomy XXV:7–9). Because this ceremony was designed to humiliate the brother of the deceased for refusing to give the latter a progeny, the active role was taken by the widow. Once the brother-in-law had repeated his refusal in front of a tribunal, the widow took off her shoe, threw it on the ground, and spat in front of him. Medieval rabbin from Spain gave levirate marriage priority over *haliza*, whereas Ashkenazi rabbin opted for the priority of *haliza*, which explains why the only illumination of this ceremony comes from a German Bible of the early fifteenth century.[125]

Divorce was never taken as a subject for Jewish illumination.

## Death, Mourning and Funeral Rites

When death struck a member of the family, a series of rites had to be observed. Medieval illumination, however, illustrated only a few of them, and not always the most characteristic ones.

Spain has not provided any illustrations of happy ceremonies, such as circumcision, redemption of the first-born or marriage, but has left a number of illuminations depicting the different stages of funerals. Spanning the fourteenth century are

348 The *qina*, early fourteenth-century Castile: the deceased lies on the bed, on his back with his eyes closed. Two weeping mourners are shown making the symbolical gestures signifying grief; one embraces the deceased, the other raises her hands in a gesture of despair. Such mourners also clapped their hands to punctuate the lamentations they sang.
London, British Library, MS. Or. 2737, folio 82 verso (detail).

349 A Jewish funeral procession, early fourteenth-century Castile: the coffin with its high lid lies directly on the shoulders of the men carrying it; those following the coffin raise their arms as a sign of lamentation; their clothes are of the bright colours usual on such occasions.
London, British Library, MS. Or. 2737, folio 84 recto (detail).

shown wearing cloaks of dark brown or dark blue. [133] There are unfortunately no illustrations of the ritual purification of the body *(ṭahara)* or the *shiva* rites for the seven days that followed the burial.

Pictures of death and mourning are even rarer in German and Italian manuscripts. Among the former are a few pictures of bodies, either completely enveloped in shrouds *(sargenes)* as in a thirteenth-century illumination, [134] or with face and feet left uncovered. [135] There are no more than two Italian manuscripts, from the 1470s and 1480s, with miniatures having death as their subject. The longer series appears in the second manuscript: a dying man is shown giving final instructions to his sons, breathing his last, his mortal remains being carried on a bier with no coffin, and being lamented at the open grave before being laid to rest in it. [136] But the most interesting illustration comes from the first manuscript. After a *qina* and prayer scene around the 346 coffin, [137] the only known representation of an important rite of *shiva* is the *se'uddat havra'a* (the first meal of the bereaved after the 347 funeral), a meal of consolation prepared by friends or relatives. [138] The two people in mourning do not partake of the meal at the usual table, but are seated on cushions at a low table. These two illuminations provide evidence for the adoption of black for mourning clothes and pall, whereas in the pictures from 1480, only the bereaved were dressed in black.

348 illustrations, first, of *qina* (lamentation), beside the deathbed on which the corpse lies, eyes closed, arms stretched out under the sheets beside the body, [126] or wrapped in a shroud but with the 349 face left bare. [127] Then came the transport of the body, in a 350, 116 coffin, [127a] perhaps covered by drapery, [128] or simply on a bier; [129] finally came the burial, laying the corpse to rest in its grave of 115 earth. [130] But before interment, the *qina* was taken up again around the coffin placed on the ground. [131] Members of the afflicted family walked with their heads lowered and covered, their hands hidden under their robes; [132] they are sometimes

Although large sections of the historical and geographical decor of Jewish life in the Middle Ages remain unknown, and vast areas of the spectrum of Jewish professional activities in this period remain closed to investigation, what can be said about the way in which our illuminations influence our view of family life? Glimpses of intimate gestures, personal cares, the humblest domestic activities in pursuit of health and physical well being and the spontaneous gestures of affection are exceedingly rare and merely provide hints rather than direct evidence. In this, Jewish illumination provided a faithful reflection, if not of life as it was, at least of life as they wished to live it. The miniatures we have examined, so chary of what was anecdotal and individual in everyday family life, certainly do not risk exhibitionism, but they do illustrate and explain to us, most eloquently, all those gestures and activities which, bound by ritual norms, are thus removed from the realm of the accidental.

What Jewish illumination does show us in this way, undoubtedly in the particular idiom of the period, is the timeless and exalted structure given to daily life by a religion with immutable precepts that govern all its manifestations.

# VII    Religious Life

We have seen how frequently religious rites punctuated the daily round of medieval Jewish life and marked its every phase. Indeed, because of the absence of suitable illuminations we have not mentioned a number of occasions on which the Jews sought to glorify their Creator. It may then seem quite arbitrary to have separated our description of Jewish religious life from family and social life; yet we thought our study would gain a certain clarity if we presented these aspects of Jewish life as two panels of a diptych. Though, in fact, daily life was dominated by religion and ritual, we restricted its perspective to the human dimension: we have shown mortal man within the confines of the material needs of his organic life and its relationships, dominated by emotional and intellectual needs and by moral dictates. Religious life, on the other hand, while transcending these limitations, offers us the opportunity to see the Jew in his relationship with God. This relationship is given a framework by daily prayer, weekly celebration of the *shabat* and the annual celebration of a number of holidays, and it is defined by the rites and religious content that distinguish them.

## Prayer and Its Characteristics

Jewish prayer has the same fundamental character whether it is private or collective. It is a profession of faith in the one and true God—not only is it performed daily, but it structures the Jewish day by a triple repetition of the *shema yisra'el*—and a glorification of the Creator by the created, expressed in the ensemble of psalms, hymns and blessings that make up its setting. The glorification of the Lord of the universe is also the aim of the blessings repeated by every Jew throughout the day.

Illustrations can obviously show no more of the prayer than its outward forms, the gestures and poses of those praying or at most, attempt to suggest its more inward features by depicting symbolic gestures. A Spanish illuminator attempting to express the intensity and fervour of the supplication of a persecuted 351 people portrayed a Jew kneeling in prayer, his arms outstretched and hands raised to heaven;[1] a fourteenth-century German *mahzor* shows an officiant on his knees on the night of *yom kipur*;[2] and again an Italian illustration from about 1470 shows a Jew kneeling in prayer on the day of *shabat shuva* (the *shabat* of repentance),[3] which falls between *rosh ha-shana* and *yom kipur*.

In fact, Jews did not kneel to pray. Prayers were said standing, 294, 92 as we have already observed in scenes of private prayer or public

services in the synagogue.[4] The officiant who conducted the public prayers always stood.[5] The congregation, on the other 93, 96 hand, usually sat down during the less solemn moments of the service.[6] Certainly, deep bowing from the waist punctuated the prayer as it went on,[7] but one prostrated oneself completely only at the most solemn moments of *rosh ha-shana* and *yom kipur*.[8]

However, prayer might also be a believer's self-examination of his imperfections, repentance for his failure to keep the Law, or expression of contrition and supplication for forgiveness. Clearly those prayers involving benediction or glorification were spoken while standing, whereas those of self-examination recited during evening prayers[9] or the *selihot*—the prayers of 131 entreaty on the days of repentance held before *rosh ha-shana* and 96 *yom kipur*—were spoken while sitting, holding one's head.[10] This pose, symbolic of grief and sorrow, was accentuated further in the evening and morning services of the fast of *tisha be'av*, on the ninth day of the month of *av*, which commemorated the destruction of the Temple; on that day, like those afflicted, the congregation sat on the floor to pray, except 381 during the most important blessings and the recitation of the *qinot*, the hymns of lamentation.[11] To catch the spirit of these services, an illuminator from the Rhineland shows one of the faithful making a gesture of despair: his arms raised to heaven. 352 This gesture, while never 'institutionalized' by official sanction, was certainly made, at least occasionally, in real life.[12]

Another notable aspect of Jewish prayer was that it was not spoken but chanted. This was the case for all blessings and invocations, as well as for the poetic texts, the psalms and hymns incorporated in prayer with their traditional modes of psalmody or melody, and the readings from the Bible, whose motifs and phrases were the result of complex and precise secular elaborations determined by the cluster of Masoretic accents. Not many illuminators attempted to depict this auditory aspect of prayer; however, there are some rare exceptions. The most simple and direct method—showing figures with their mouths open as they chanted—was used in the late thirteenth century[13] and again in the second half of the fifteenth.[14] Much more explicit, but rarely used and abandoned early on because of its unrealistic 'naïveté', was the introduction into the picture of a fragment of music with notes and words placed near the chanting figure. There are two such pictures from the late thirteenth century[15] giving us a particularly precious and rare documentation of melodic fragments for psalms chanted in synagogue services: one for Psalm 98 sung at the beginning of the *shabat* on Friday

351 'We cried unto the Eternal, the God of our fathers' (*haggada* for Passover). The artist of this Spanish vignette of around 1350 is not attempting to give an accurate picture of a Jew in prayer but simply to express as eloquently as possible the intensity of the entreaty by depicting a kneeling pose with the hands stretched towards Heaven. Jewish prayer was spoken standing. London, British Library, MS. Or. 2884, folio 41 verso.

352 A group of Jews in Germany, *c.* 1427–8, reciting prayers of lamentation: they are seated barefoot with heads bowed or with arms raised in entreaty. Hamburg, Staats- und Universitätsbibliothek, Cod. Hebr. 37, folio 161 verso.

365 evening, the other for Psalm 86 sung before bringing out the *Tora* scroll from the ark in the morning. A late fourteenth- or early fifteenth-century illustration in a Bible from Spain or north Italy [15a] contains the melody of the first verses of the Song of Songs that was chanted particularly in the Passover morning service.

## Rest on the Seventh Day, *Shabat*

*Shabat* is one of the fundamental institutions of Judaism, symbolic in Jewish thought of man's recognition of the creative omnipotence of the one God; its observance is a sign of God's covenant with the people of Israel. The essential character of its

353 The setting up of an *eruv*, Italy, *c.* 1374: the Jew seen digging is making a ditch to form a precinct called *eruv*, within which it would be allowable on *shabat* and holidays to carry things from the private to the public domain and vice versa. The precinct could also be represented by a slope, though a fence was more usual.
London, British Library, MS. Or. 5024, folio 40 verso.

observance—which gave it its name, The Rest—was pronounced in the Fourth Commandment (Exodus XX:8–11 and XXXI:12–18; Deuteronomy V:12–15). On this day, the Jew abstains from all voluntary interference with the state of matter, transformations of energy or any activity involving the modification or creation of an object. Thus for this one day of the week he gives back to his Creator that complete domination of the world in which his activity during the six working days makes him a participant.

Since expressing the fullness of this idea pictorially was certainly not easy, it is not surprising that it was only occasionally attempted. We know of only two instances; in both, the illuminator interprets the idea of rest literally. One is Spanish and dates from the years 1350–1360,[16] the other is German, from the second half of the fifteenth century.[17] Both show a Jew alone, resting according to the Fourth Commandment: both are in a sitting position, one with his hands on his knees, the other with his arms crossed.

Though he may retreat into this holy period of *shabat*, this instant of eternity and foretaste of the world to come, the exigencies of maintaining life and even properly honouring the *shabat* itself prevent him from freeing himself entirely from all material activities (that will have to wait until the appointed time when every day will be *shabat*). Thus some rites were destined to make lawful the most indispensable of these activities while still respecting the general prohibition.

## Shabat *and Space: the* Eruvim

To ensure scrupulous respect for the *shabat* without making it impossibly constricting, the rabbin of the Talmud made many decisions which provided the basis for certain rites. Medieval Jewish iconography contains very few pictures of these rites, although they were universally and rigorously observed throughout the Jewish communities. Essentially, they are concerned with necessary activities such as travelling or transport. Performance of these rites made certain activities permissible on the *shabat* which a literal interpretation of the law would have prohibited; hence, their name, *eruv*: the act of blending.

There are no illustrations of the *eruv tehumim*, the rite allowing one to extend the permissible limits of displacement from one's place of residence. However, a picture from Italy of the 1470s[18]

illustrates the *eruv ḥazerot*, by which several dwellings giving onto the same courtyard were made into one private domain, thus allowing things to be carried from one house to another. A woman and a young man can be seen holding a *mazza* instead of bread since here the rite is being performed just before the feast of *pesah*. The rite consists of accepting a loaf of bread, provided by one of the members of the group, with the traditional gesture: one of the participants takes it into his hand in the name of all. This symbolic act, accompanied by the appropriate benediction and invocation, ensured that the various family meals became a common meal; the various families, a single family; their separate dwellings, a single dwelling.

Another picture dating from almost a century earlier, 353 *c.* 1375,[19] illustrates the *eruv* authorizing things to be carried in public places. A symbolic barrier was established, usually by means of stakes and transversal poles, though, as in our picture, a ditch or bank could serve the same purpose.

## *The* Eruv Tavshilin

The last *eruv* to be mentioned relates not to the restriction of movement on the *shabat* but to another essential activity, the preparation of meals. Lighting a fire and cooking are strictly forbidden on the *shabat*, so that on the Friday before, all the food for the three meals of the *shabat* is prepared in advance. In every community, in the East or West, North or South, it became the custom to prepare dishes which could continue to cook in a

354 Two Jews in Italy, about 1470, establish an *eruv tavshilin*: this rite, carried out before the beginning of a holiday preceding a *shabat*, authorized the preparation on the day of the holiday itself of food for meals on the *shabat*. The two Jews, an older and a younger man, each hold in both hands the two foods required by the rite, bread—here *mazza* because it is the feast of *pesah*—and the cooked foodstuff most usually used—an egg—and pronounce the blessing and the prescribed phrases.
Jerusalem, Israel Museum, Ms. Rothschild 24, folio 123 recto.

## The Rites of Friday Evening, Eve of the Shabat

It is surprising that there should be so few illustrations of the preparations for the *shabat* that have always given Friday a rhythm and colour distinct from the other working days of the week; it is even more surprising that the celebration of the *shabat* itself is only incidentally represented, since the activities involved are religious rather than secular. There are no pictures of women lighting the ritual *shabat* lamps before sunset. Nor are there any representing the *qiddush*, the sanctification of the day of *shabat* and the blessing over the cup of wine, pronounced before the evening meal by the master of the house on his return from worship, and repeated on the next day before the midday meal. Two very modest illustrations, from Italian prayer books, one of the late fourteenth century,[22] the other of the second half of the fifteenth century,[23] show in the margin of the *qiddush* text of the *shabat* a hand holding a glass of wine. So our notion of this ceremony has to rely on illustrations of the *qiddush* of those holidays where an identical ritual gesture was usual, notably the feast of *pesah*. This is the most frequently illustrated, sometimes in Sephardi but mainly in Ashkenazi and Italian manuscripts, either by a single figure or by a scene with several figures, with the central figure holding the cup.[24] The only illustration to be found of the *qiddush* of the holidays of *rosh ha-shana*[25] and *sukot*[26] are Italian, and they are quite rare in medieval Italian illumination. 136 132, 152 367-8, 372

There is only one surviving picture of a Friday evening service, in an Italian synagogue of about 1465 in Emilia.[27] It is accompanied by an allegorical representation of the ceremony of *qabalat shabat*, which signified the start of the *shabat* itself: the Jewish people welcome the *shabat* in the same way that the bride of the Italian picture surrounded by her entourage is welcomed 343 by the entourage of her betrothed, who comes to meet her with the nuptial canopy.[28] The iconography of the welcome of *shabat* is especially interesting in that it is clearly inspired by the mystic symbolism identifying the bride and the *shabat* as one, and making the *shabat* a nuptial feast, and therefore provides a much earlier figurative rendering than the splendid poetic expression given the ceremony in the following century, after 1535, by Solomon Alkabez of Safed, whose hymn has been chanted every Friday evening in every synagogue since the late sixteenth century: '*lekha dodi liqrat kalla*' ('come, my beloved, to meet the bride').

warm oven throughout Friday night and on until the mealtime the next day without being spoiled.

On occasions when a holiday preceded the *shabat*, meals could not be prepared in advance in this way. A less rigorous prohibition allows certain cooking operations on such days, but only for consumption on that day; this led to the introduction of the *eruv tavshilin*, of which we have some illustrations dating from the last decades of the fifteenth century. Two figures hold a flat, wafer-like cake—here again a *mazza*, since the ceremony is being 354 performed before the *pesah* feast—on which is placed, in one case, an egg,[20] in the other two cases what looks like a piece of cooked meat.[21] As they stand, they recite the blessing and ritual formula. With two dishes cooked before the holiday and set aside for the *shabat*, the rite is intended to authorize the 'mixture' of the permitted preparation of meals for the holiday with the forbidden preparation of the *shabat* meals. The father of the family performs the *eruv*. By associating another person in the rite, as he does in our pictures, either one of his grown-up children or someone outside the family, he exempts any member of the community who had forgotten to perform it.

355 The officiant at prayer in a German synagogue, 1462–70: standing at his lectern in front of the holy ark, he follows the service in the prayer book. He wears the *ṭallit*, the prayer shawl, over head and shoulders, with its trimming of *ẓiẓiyyot*, the tassels hanging from the four corners. He recites the *nishmat*, 'The soul of every living being', the prayer invoking grace which came before the *shema* in the morning prayer of the *shabat* and holidays.
Jerusalem, Sassoon Collection, Ms. 511, p. 28.

356 The opening of the ark of the covenant in a German synagogue, 1462–70: the reading of the Law, the most solemn moment of the *shabat* and holiday services, was preceded by the ceremonial bringing out of the scroll from the ark where it was kept, and followed, symmetrically, by its return there. Psalms and chants accompanied the ritual of the opening and shutting of the ark, and of the conveyance of the scroll.
Jerusalem, Sassoon Collection, Ms. 511, p. 23.

There is no illustration for the *shabat* of the blessing of children by their father which we have already mentioned in connection with family life. Since this blessing, pronounced on the eve of and at the end of the morning services of every *shabat* and holiday, is always accompanied by the identical ritual gesture—placing of hands on the child's head—whenever it is performed, we can easily infer what the Friday evening ceremony was like from a Spanish picture, from between 1350 and 1360, which portrays it on the eve of the *pesah* feast. [29]

## Morning Service

We have no series of pictures to record the progress of the *shabat* morning service, though it can be reconstructed from scenes of the congregation assembled at the synagogue on other occasions, [30] and those we have already mentioned of officiants at their desks. [31] The high point of the *shabat* morning service is the reading, taken from the *Tora* scroll, of the weekly pericope. Here again we can recreate this moment with the help of various dispersed illuminations of different dates and provenances. Some show us the open ark with its scrolls, [32] others illustrate the chanting that accompanied the bringing out of the scroll, [33] while yet others show the officiant carrying the scroll to the desk. [34] Finally, we see the officiant reading the pericope from the opened scroll to the attentive congregation, [35] after which the faithful are shown chanting as they escort the scroll, now closed and adorned with its ornaments, back to the ark where it is housed. [36]

## *The* Havdala

Pictures of the final ceremony of the *shabat*, the *havdala*, which symbolized the separation between the *shabat* and the following day, are no more abundant. There is no known illustration of this rite in its most usual and complete form, as carried out at the end of a *shabat* that is followed by a working day. It then consists of four blessings: one is recited over the cup of wine, the second over the aromatic spices, the third over the flames of the fire and the fourth, the *havdala* blessing itself, signifying the separation of the sacred from the profane. The second blessing is characteristic of this complete *havdala*. The fragrance of the spices symbolizes the *neshama yetera*, the additional soul which,

355

356

according to tradition, each Jew receives on the *shabat* and loses at its conclusion. By inhaling the fragrance, he expresses his regret at its passing and his desire to restrain it momentarily. This blessing over the fragrant spices has never been illustrated, leaving us no representation of the receptacles used for *besamim*, the fragrant spices.

Only the first blessing of the *havdala* of the *shabat* was called to mind, a single time, in a Sephardi manuscript of the second half of the fifteenth century, by a hand sketched holding a glass of wine. [36a]

The only *havdala* we find habitually illustrated in the few miniatures at our disposal is that recited at the end of a *shabat* preceding a holiday. Coming after the blessing over the cup of wine, the *qiddush*, it does not include the first blessing, nor the second over the aromatic spices; the third is spoken over a light

already kindled, and the fourth evokes the separation of the holiness of the *shabat* from the lesser sanctity of the holiday. A late fourteenth-century Ashkenazi picture shows the third
357 blessing, over the flame of a candle. [37] In a Spanish Haggada from about 1350 to 1360, the illustrations are more informative: according to custom the head of the family holds the *qiddush* cup in his hand while saying the blessing over the flame of a plaited
366 candle that a child is holding in front of him. [38] Ashkenazi pictures of this rite, both German and Italian, show that the blessing of light was—at least in the fifteenth century—done over the flames of a star-shaped lamp hung over the table. [39] Some Ashkenazi pictures show only a Jew standing without a lamp, sometimes with the cup in his hand, as he makes the ritual gesture to accompany the blessing of the light: his hands raised, fingers bent, and eyes fixed on his nails or on the lines of his palms. [40]

## The Calendar

The regular weekly celebration of the *shabat* is entirely independent of the Jewish month and lunar year, unlike the holidays, so closely connected with the passage of the year and seasons. The dates of their celebration, the *zemanim*, were established by means of a calendar. Because it played such a central role in Jewish religious life (this role motivated, as we have seen, the research that regulated and perfected it), the calendar appears quite often in prayer books, and was occasionally copied into biblical manuscripts where, in Spain at least, it might be richly decorated. What medieval Jewish manuscripts give us in such cases is not a picture of a calendar but the calendar itself, as used by generations of Jews.

Being neither yearly nor monthly, these calendars did not provide the same propitious field for illumination as the

Christian calendars in psalters and books of hours with their signs of the Zodiac and labours of the months. Jewish calendars are cyclical, serving only to determine the character of each year so that the details of its liturgical sequence can be calculated. The two Jewish calendars most remarkable for their execution and decoration were made by the same decorator-copyist in Castile in *c.* 1300. [41]

358 They begin with thirteen [42] and fifteen [43] lunar cycles, respectively, in an arrangement of columns, one a year for each cycle, under various types of arcade with nineteen lines to each column. On each of the nineteen lines is to be found the year's numerical position in the cycle; [44] the year according to the small computation (since the letter representing thousands in the date given at the beginning is not repeated); then the indication of the 'fixing' *(qevi'a)* of the the year by means of three Hebrew letters, which identify the three basic elements of the Jewish liturgical year, namely, the day of the week on which the first day of *tishri* falls (the first day of the year), the type of year (regular, complete or defective), and lastly the day of the week on which the feast of *pesah* falls. Two other details then follow: the position of the year in the twenty-eight-year solar cycle, and its position in the nineteen-year lunar cycle. These are indicated not by letter-numerals, but, in the case of the former, by the twenty-eight words of a phrase about the variations of the years in the unfolding of the thirteen lunar cycles, and, of the latter, by the nineteen words of a verse from Isaiah (XL:26).

359 The two 'words' corresponding to each year correspond to a reading on a circular disc. [45] This disc is movable, which makes it easy to consult the seasonal indications without moving the book: in the central circle, divided into nineteen sectors, it gave the day of the Jewish month, the hour of the *tequfa*, and the beginning of each of the four seasons of the nineteen-year cycle; in the outer ring were the day and the hour of the beginnings of the seasons of the Jewish year in sequence during the twenty-eight years of a Julian solar cycle. Besides its function for checking and reference, this cycle, which at the end of its phase brought the *tequfot* back to the same day of the week and the same hour, served to establish the date of a ceremony of secondary importance, the blessing of the sun. Unfortunately, this ceremony has left no trace in surviving illuminations. It took place every twenty-eight years on the first day of the cycle, at the *tequfa* of *nisan*, that is to say at the beginning of spring.

Beyond this, the 'word' which gave the year its position in the lunar cycle also showed whether it was an ordinary year of

359 A circular mobile table accompanying a calendar copied in Castile, about 1300. It is read in a counter-clockwise direction, and gives the day of the month and the hour of the *tequfot* of the four seasons of the nineteen-year lunar cycle, indicated in the inner ring which is divided into nineteen sectors; in the outer ring, divided into twenty-eight sectors, are given the day of the week and the hour of the *tequfot* during each of the twenty-eight years of the *mahzor gadol*, the great cycle which is a solar Julian cycle.

The cycle of the nineteen lunar years determines the sequence of the common years and the seven embolismic years. The cycle of twenty-eight solar years corresponds to the period after which the *tequfot* recur on the same day of the week and the same hour.

Copied around the inner ring is a verse from Isaiah (XL:26) concerning the creation of the stars. The words of this verse, distributed round the nineteen sectors and also copied on the lists of the calendar previously mentioned, serve as the references for this table. The references for the twenty-eight sectors of the outer ring are also provided by the words of the short text copied round the edge of the mobile disc. It relates to a third cycle, the cycle of thirteen lunar cycles, i.e., 247 years, or cycle of *nahshon* (ninth century) which has an almost exact number of weeks so that at the end of it, the first day of the Jewish year, the first of *tishri*, again falls on the same day of the week. The spandrels of the panels are decorated with stylized plant motifs, a lion and a griffin.

Paris, Bibliothèque Nationale, ms. hébr. 21, folio 3 verso.

twelve months, or one of the seven embolismic years of thirteen months which fell in the third, sixth, eighth, eleventh, fourteenth, seventeenth and nineteenth places. The seven extra months thus added to the nineteen lunar years make them coincide with the nineteen Julian solar years and thus correct the displacement of the seasons.

Two more mobile circular discs, one for embolismic, the other for ordinary years, [46] provide the number of weekly Bible 360 readings for each year, according to the particular 'fixing' of that year among the seven possible ones. Consequently, it also

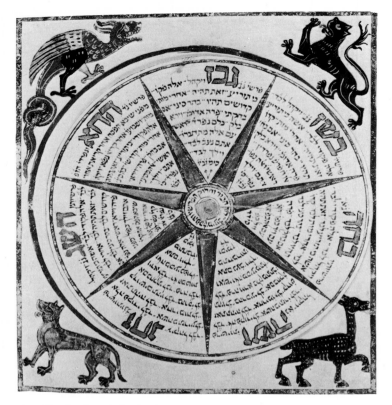

360 Circular liturgical calendar with a mobile parchment disk, copied and decorated in Castile, 1300–1. The rays of a star divide the disc into seven sectors —read clockwise, surprisingly enough—with each corresponding to one of the seven types of embolismic year; that is to say, with thirteen months, of the *maḥzor qaṭan*, the little cycle of nineteen lunar years. The character of each type of year is marked by the three large letters in the first line of each sector: the first indicates on which of the four 'permitted' days falls the feast of *rosh ha-shana*, i.e., the first day of the year; the second, whether the year is regular, complete or defective, i.e., whether it contains 384, 385 or 383 days; the third, on which day of the week the *pesaḥ* holiday falls. Each sector then indicates the number of biblical readings corresponding to the number of weeks in each type of year and the variants, combined or separate pericopes, which result so that the annual cycle of the reading of the *Tora* can be appropriately completed. An analogous disc gives the characteristics of the seven possible types of common year, that is to say those of twelve months (this disc is in the same manuscript, folio 2 recto). The animals painted in the angles of the panel—dragon, lion, giraffe and wolf —are purely decorative.
Paris, Bibliothèque Nationale, ms. hébr. 20, folio 7 verso.

indicated the number of weeks it contained and which of the traditionally coupled pericopes were to be read together or separately.

Finally, two more mobile discs gave the dates of the holidays, fasts and neomenia (new moons) for each year, again in accordance with its length and 'fixing'. [47]

The day we referred to earlier which served as the basis for calculating the *molad*—the conjunction of moon, sun and *tequfa*—began at six in the evening, its twenty-four 'equinoxial' hours all equal and divided into 1,080 *ḥalaqim* (parts). But the day mentioned later in connection with the beginning and end of the *shabat* and holidays was the day which began at sunset and consisted of twelve hours of day-time and twelve of night, 'temporary' hours varying in length according to the season.

## Cyclic Reading of the *Tora*

The cyclic reading of the entire text of the *Tora* was already an established custom in the Talmudic period. There were two cycles, the Palestinian which was triennial and the Babylonian which was annual, and it was the latter that became the norm in the medieval West. We have indirect evidence of this, as early as the thirteenth century (and it is of especial value to those interested in book illustration), in the codex of the Bible (used for private weekly readings, the scroll alone being acceptable for liturgical use) which shows the beginning pericopes of the annual cycle, in Italy and in Ashkenazi countries by an initial word, sometimes decorated, and in Sephardi countries by the decoration of the indicator which might go so far as to illustrate the text—we have used several of these illustrations in this book.    298, 375

This annual reading of the Law, being linked to the succession of *shabatot* and not following the monthly cycle, was only marginally affected by the calendar; the order was left unchanged, but the variable number of weeks in the year led to some contraction or expansion of the rhythm of the reading. *Shabatot* were so closely linked with their pericopes that they took their names: the first of the cycle was *shabat bereshit* (*shabat* of the creation), the second *shabat noaḥ* (*shabat* of the generations of Noah), and so on. In this way, events were very often dated by pericopes rather than by months: for example, 'the third day of the week when *mishpatim* is read', *mishpatim* being the pericope of the 'ordinances'.

Thus the history of their ancestors served as the back-cloth of the lives of Jews in the Middle Ages, its colours perpetually revived by ever-repeated readings, complemented by the cycle of prophetic pericopes, the psalter and other poetic books introduced into the liturgy.

## Holidays

According to the commandment given in Exodus XII:2, *nisan* was the first month of the year, and the months were therefore counted beginning with *nisan* in spring. To comply with this commandment, many *maḥzorim* in the Middle Ages adopted an order of holidays that began with the feast of *nisan*, that of *pesaḥ*. Yet this did not alter the fact that the year began in autumn, on the first of *tishri*, and the feast marking this day and

the following, which had been the *rosh ha-shana*, the feast of the New Year, since the time of the *mishna*, was celebrated as such throughout the Middle Ages. So we will begin the description of the medieval liturgical year with the autumn holidays.

## Rosh ha-shana

### The Rites

This holiday is mentioned in the Pentateuch as 'a day when the horn is sounded' (Numbers XXIX:1) and 'a sacred occasion commemorated with loud blasts' (Leviticus XXIII:24). The sounding of the *shofar* remained its characteristic rite.

It was the day when the Lord of the universe passed judgement on his creation, and preparation was made for it by a month of penitence during which the officiant sounded the *shofar* night and morning. An Italian picture of *c.* 1465, [48] though it does not illustrate the actual blowing of the horn, gives us a picture of one of these services in the month of *elul* when the faithful gathered before dawn—indicated by the candles burning on their desks—to recite *selihot*, their prayers of supplication.

More often illustrated are the solemnities on the day itself when the horns were sounded with long blasts, thirty times repeated, first before, and then during the service of *musaf*, alternately expressing invocation, alarm and peace.

Some illustrations from Ashkenazi countries offer very few characteristic details of the horn, [49] while in others the instrument itself and the pose of the *shofar* blower are reproduced very precisely.

362, 364  At the beginning and during the first half of the fourteenth
361  century, and again in the fifteenth, the ram's horn in most pictures is of the shape that was to become standard—extending out straight from the mouthpiece along most of its length and bending almost at a right angle near the wide end. [50] In some illustrations, it is clear that the *shofar* blower was cloaked in the *tallit*. [51] The illuminators also recorded the position taken up by the *shofar* blower, with one foot, usually the right, raised above the other on a pair of steps or a stool, often three-legged. [52] The intention was apotropaic: to thwart the demon whose influence was thought to be transmitted through the ground —a three-legged stool was reputed to be particularly

efficacious. The devil, the accuser of Israel, tried on that day to disturb the souls of repentant Jews and especially the soul of the *shofar* blower who expressed publicly the repentance and hope of the community; the devil's influence was neutralized, as the fervent sounding of the horn put him to flight. [53]

One of our pictures introduces a further element of the ceremony and shows the precise moment it took place, after the reading of the Law: a pious Jew facing the *shofar* blower sits wrapped in his *tallit* as he holds the *Tora* scroll in his arms; the scroll does not go back into the ark until after the first series of blasts. [54]

Spanish illumination has left us no picture of the *rosh ha-shana* holiday, [54a] though we can see many examples of the *shofar* among the representations of cult objects of the sanctuary, ranging from the thirteenth to the fifteenth century. Although

the shape is usually too stylized to provide reliable evidence, we sometimes see a very straight *shofar* similar to northern ones. [55]

From Italy there are only a few pictures of the celebration of the holiday, also dating from the fourteenth and fifteenth centuries. Some show horn blowers bereft of characteristic detail; [56] others, towards the end of the fifteenth century, show blowers using horns that were very different from the Ashkenazi *shofar*, unstraightened and with undulating curves. [57] Some more detailed pictures illustrate the sounding of the horn in a wider human and architectural context, showing the congregation and the synagogue. [58]

None of these illustrations preserves a trace of the well-attested custom in Italy of wearing white on holidays, any more than Ashkenazi pictures show the wearing of the *sargenes*, the white garment intended for use as a shroud.

Of the domestic ritual of the feast, only the *qiddush* of the second day showed any extraordinary feature, and this is represented in a single Italian picture of the 1470s: [59] the master of the house is shown cup in hand after the sanctification of the holiday pronouncing, as the rite required, the blessing on the enjoyment of new things. In this case he is shown blessing fruit from the recent harvest, pomegranates and white grapes, placed on the table.

## The Meaning of the Holiday

Illustrations can tell us more of the significance of the holiday than the mere form of the ritual gestures they record. During these two days, hymns and prayers exalt with passion and grandeur the universal sovereignty of the one and only God, king of justice, peace and mercy. Owing to this theme of royalty that dominated the holiday, the image of crowns above the word *melekh* (king) recurs like a leitmotiv in the chants and prayers of the services. [60]

The sound of the *shofar*, however, must have inspired alarm and despair in the soul confronted by the supreme judge 'who plumbs the hearts of humble and great alike'. On this day all creatures await the weighing of their merits and faults, for 'the Lord holds in his hand the scales of justice', and having decided the fate of each for the year to come, inscribes it or not as the case may be 'in the book of eternal life'. These two themes, the weighing of souls and inscription in the book of life, inspired Ashkenazi illuminators in 1300–1310 and the decades following. The earliest picture shows us two winged creatures with lion heads, and the two archangels who stand closest to the divine judge, Gabriel and Michael, the former holding the scales, the latter acting as the great celestial scribe inscribing the verdict. [61]

On another illumination, a supernatural arm appearing from a cloud holds the divine scales, while Satan, the accuser of Israel, is trying to load his side of the scales with his own weight, since it is not sufficiently full, in his view, of faults and transgressions. [62] In a third manuscript, we again have a picture of the scales weighing virtues against vices, [63] and in addition, seconding the efforts of the *shofar* blower, the figure of the archangel Michael in his role of intercessor for the children of Israel. [64] The archangel holding the scales and the devil trying to add his weight to the sins are motifs that reappear in the first half of the fifteenth century. [65]

Consciousness of sins committed and humiliation at personal indignity might have devastated the soul were it not that confidence in God's mercy towards his chosen people, and trust in divine intercession because of the merits of the patriarchs Abraham and Isaac, those exemplary figures of submission to divine will, triumphed over all else. The repeated reference in hymns and prayers to the sacrifice consented to by father and son, the story in the Bible reading for the second day (Genesis XXII:1–19), the symbolic reminder in the sound of the ram's horn, the animal substituted for Isaac, all contributed from

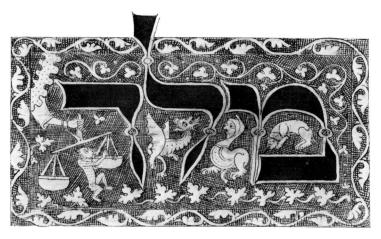

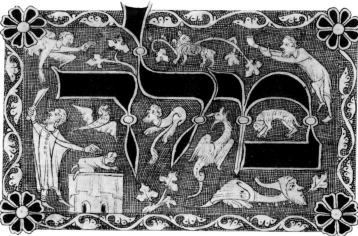

indeed, evoke the voluntary sacrifice, the martyrdom that some had already faced and which every individual should be ready to face. It also expresses both unshakable confidence in the midst of the most inhuman suffering and the ardent hope that, as with the trial of Abraham and Isaac, an end would be made to the trial of the persecuted people and that the hour of redemption was at hand.

## Yom Kipur, *the Day of the Great Pardon*

The celebration of *yom kipur* on the tenth of *tishri* is closely linked with that of *rosh ha-shana*, for divine judgement is only definitively sealed after the days of atonement separating the two holidays and at the end of the great fast of *yom kipur*.

The holiday itself was preceded by the performance of several rites that medieval illustration has almost completely ignored, the traditional ritual immersion, the self-flagellation carried out by the most pious and *kapara*, the rite of substitutive immolation, which remained popular despite the open disapproval of the rabbinical authorities. Though long practised in Germany, immolation does not seem to have been represented there before the sixteenth century; on the other hand, it was abandoned in Italy from the sixteenth century onwards. It does appear in an Italian miniature of the 1480s, where we see a young man immolating an expiatory cock which he has previously circled over his head three times.[69] In Spain the *hazzan* performed this rite on behalf on the community, but we have no illustrations as evidence.

No special ritual object is associated with *yom kipur*, except for the sounding of the *shofar* at its close. Neither is any special rite associated with it other than the total fasting during the day spent in the synagogue. The iconography of the fast is therefore unaffected by its ritual.

The services themselves inspired only a few pictures. There are no illustrations of the moving scene of the congregation assembled for repentance dressed in white and without shoes. The officiant alone makes a few appearances; he is shown, for example, at the initial ceremony of the evening service, *kol nidrey*, the solemn annulment of all vows, symbolically kneeling before his lectern;[70] in a more realistic pose he is bowed but standing, robed in his *tallit* and without shoes.[71] We also see the opening of the holy ark at morning service, at the moment when

1300 onwards to the frequent choice by illuminators of the scene
364 of Isaac's sacrifice, or at least the motif of the ram, in Ashkenazi *mahzorim*.[66] The commemorative character of this rite could be stressed by bringing together the images of the *shofar* blower and the ram,[67] while another picture might unite in a single composition—the restraints of time being eliminated—the intercessory sacrifice of Isaac and the annual judgement of the children of Israel.[68]

While the image of the sacrifice of Isaac was certainly invoked as an exemplary act performed in the distant past but continuing to function in favour of the Jewish people, it seems to have acquired a different meaning during the persecutions of the late thirteenth and first half of the fourteenth century. It does,

90

98 supplication is made to '*ha poteaḥ lanu sha'arey raḥamim*', He who opens the gates of mercy to us. [72]

The commemorative aspect of the holiday has also left little mark on its iconography. It is not a special biblical event that is being remembered but the liturgy of the holiday in the Temple. The only remaining representation of the function of the high priest during the *musaf* service is in a single fifteenth-century picture showing the hurling forth of the scapegoat, laden with the sins of Israel, into a gorge in the desert where the demon Azazel dwelt (Leviticus XVI:21–22). [73]

We owe to the reading, during the afternoon service, of the Book of Jonah, centred on the theme of the efficacy of repentance, the single picture of that prophet's adventures preserved in a fifteenth-century *maḥzor*. [74]

The subject most frequently treated in pictures is that which provides the dominant theme of all the prayers and hymns of the fast: the mercy of the Creator, as limitless as his omnipotence, in response to the confession and repentance of his people. The notion of sovereignty was sometimes associated with mercy by the motif of *ḥayyot*, the supernatural creatures that support the chariot of the throne of divine majesty, and also by the motif of the throne itself. [75] But the most insistent theme is that of mercy. To begin with, it suggested certain secondary motifs and scenes. Thus the elect status of Israel conferred by divine love distinguishes it as the rose in the valley, and this idea inspired the illuminators of the Ashkenazi *maḥzorim* to use the motif of a 394 rose, decoratively stylized in the thirteenth and early fourteenth centuries, evolving in the fifteenth into botanical realism. [76] Expressing the hope that divine election would ensure them salvation, repentant Jews appealed to the merits of Abraham, disdainer of idols. Just as God once saved him from the furnace, [77] his descendants, faithful to that one true God, hoped that he in his turn would ensure their salvation.

Mercy itself is expressed in the symbol of gates, a symbol taken directly from the text of the prayer. The gates of inexhaustible divine mercy, which opened as the day of fast and repentance began, display their monumental portals on page after page of our manuscripts from the thirteenth to the fifteenth century. [78] They were still open as the day fell, during the entreaties of *ne'ila*, the closing service, [79] but as the *shofar* 393 sounded its final blast, [80] the gates we had seen wide open [81] were inexorably shut, and the archangel sealed the sentence of the judgement. [82] The moving drama played on that day at the gates of heaven between mercy and repentance did not appeal to the imagination of the illuminators of Italian *maḥzorim*, in whose works we have come across only one modest echo, in a vignette showing the gates of heaven closed at the end of the day. [83]

## Rosh ḥodesh, the Beginning of the Month, and Birkhat ha-levana, the Blessing of the Moon

At the end of the fast of *yom kipur*, the blessing of the new moon was pronounced, it being the custom in the month of *tishri* not to say it earlier. After the beginning of any month had been celebrated by introducing into the day's service the special blessings and psalms, and once the moon was visible and bright enough, at some time between the third day and the middle of the month, the Jews glorified God, guardian of Israel, and pronounced the blessing for the moon. The only exception to this was in the month of *av*, when the ceremony could take place only after the fast of the ninth day. The moon, with its alternate waxing and waning, had become a symbol of the survival of the Jewish people from every persecution. This ceremony is recalled, especially in fifteenth-century Italian prayer books, by

365 Liturgical chant for a synagogue service in Italy, probably in Emilia, late thirteenth century: a group of worshippers under the direction of a choir-master is intoning '*ein kamokha ba-elokim*' (Psalm LXXXVI:8. 'There is none like unto you among the gods, O Lord'), the beginning of one of the verses to be sung before the scroll of the Law is taken out of the ark. The Hebrew text and notes of the melody are written from right to left in the book shown lying open in front of the group of figures. On the four or five line staves, the musical notation conforms completely to the square notation usual at this period.
Parma, Biblioteca Palatina, Ms. Parm. 1870–De Rossi 510, folio 213 verso.

366 A picture from Spain, *c.* 1350–60 showing the *havdala*, the ceremony separating the *shabat* from the weekday, here a holiday since there is no blessing over the spices. The father is seated and, still holding the cup of wine over which he has already pronounced the benediction while reciting the *qiddush*, stretches out his fingers, as the rite prescribes, to the flames of the plaited candle held solemnly by the child standing before him.
London, British Library, MS. Add. 14761, folio 26 recto (detail).

365

366

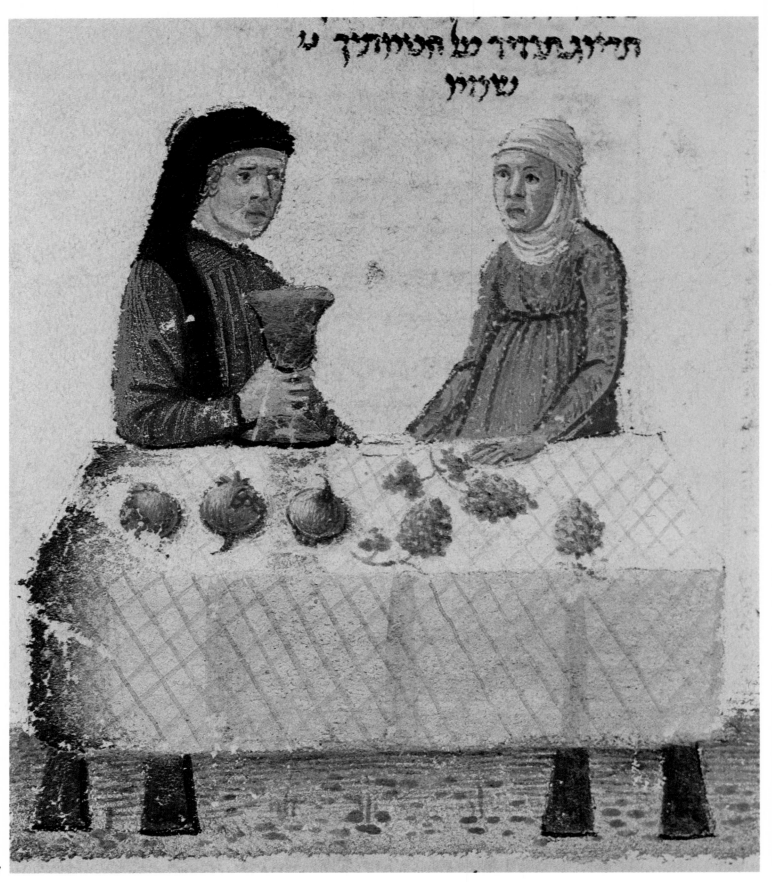

תרדגתדיר מט הטמודיך י
שנית

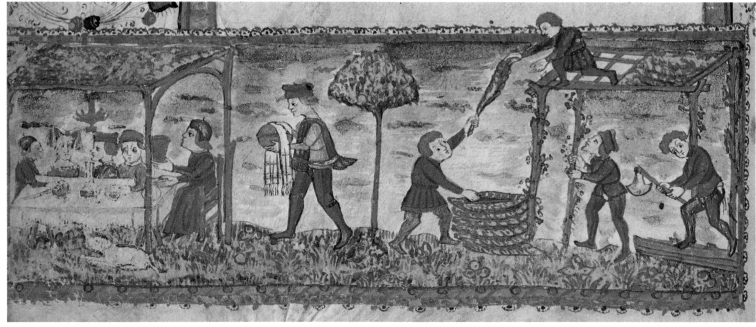

368

369

370

השומרת על פני המים · יען כל היוצא מן העץ יין עושין
ממנה קטולה להדליק כו זאת הער חוץ מן הפשוט שעֿשֿף

371

372

◁ 367  The *qiddush*, the glorification of God and the benediction over the cup of wine, on the evening of the second day of *rosh ha-shana*. It is pronounced by a man, while a woman listens; on the table are the pomegranates and bunches of grapes of the new harvest over which is recited the *sheheḥeyanu*, the blessing appropriate to the enjoyment of new things (Italy, *c.* 1470).
Jerusalem, Israel Museum, Ms. Rothschild 24, folio 131 recto.

◁ 368  A scene from the province of Emilia, northern Italy, *c.* 1465–70: the building of the *suka* and a meal in it. On the right, a group of young men are building the *suka*. The roof lattice has already been raised on four forked posts. One of the young men is still making battens with an axe, while another is steadying one of the roof posts upon which a third has climbed to arrange the *sekhakh*, the covering of ritual leafy branches—these are handed to him from a heap on the ground by a fourth person. On the left is shown the eve of the holiday, with the family seated round the table under the star-shaped oil lamp listening to the *qiddush* being recited by the master of the house, cup in hand. A young servant is already bringing a covered dish for the meal. Note that the illuminator, in order to display the scene, has not shown the walls of the hut: it should in fact be closed on at least three sides.
Jerusalem, George Weill Collection, Maḥzor, p. 505 (detail).

◁ 369  A *suka*, Italy, 1374: a ritual booth built for the length of the Feast of Tabernacles, with walls and roof made of intertwined branches of fresh leaves; the opening shows only a bench inside. A table could also be installed, since the hut was used for study and for meals. The very pious also brought in a couch for sleeping, at night.
London, British Library, MS. Or. 5024, folio 70 verso.

◁ 370  A Jew in late fourteenth-century Italy carrying out the *miẓwa* of the *arba‘a minim*, the precept of the 'four species', palm, myrtle, willow and citron. The illuminator has not shown clearly the boughs of myrtle and willow knotted at the base of the palm; furthermore, his figure is holding the citron in his right hand and the *lulav*, the palm, in his left, whereas the reverse is required by the rite, pre-eminence being given to the *lulav*, over which the blessing is recited.
Jerusalem, Schocken Institute, Ms. 24085, folio 27 recto.

371  For *ḥanuka*, 1374, an Italian Jew is lighting the ritual lamp of eight cups. This lamp is of yellow metal, probably brass, and of a mural type. The cups have spouts for holding the wicks, and are arranged on a horizontal metal plaque, the back of which is in the form of a crenellated wall. Judging by the traces of red on the opening of each spout, the cloaked figure has already lit seven of the wicks, and is about to light the last. Unless the illuminator painted all the flames ahead without thinking, which is quite possible, the act conforms to the rite: the lights are counted progressively, each evening, starting from the right, but they are lit beginning with the last, thus starting from the left.
London, British Library, MS. Or. 5024, folio 19 recto.

372  Entitled *zemannim* ('Time') in Book III (on the *shabat* and holidays) of the *Mishne Tora* of Maimonides, two holidays, Italy, *c.* 1450: a) on the left, the *qiddush* of *sukot*, at table in the *suka*, the booth roofed with branches; b) on the right, a ball at *purim*, the feast of *purim* is the only Jewish holiday to admit festivities of a profane type along with its religious rites, and it was characterized by balls, buffoonery, parodies, theatrical performances, and even, in fifteenth-century Italy, masquerades. In this picture, a figure disguised as a buffoon dressed entirely in yellow is leaping around the hall, in which two couples are standing in a line, elegantly and richly dressed, going through the steps of one of the fashionable dances of the period.
Vatican, Biblioteca Apostolica, Cod. Rossian. 498, folio 85 verso.

the motif of the crescent, usually executed in burnished silver. [84] A single picture of the 1470s shows a Jew performing the rite, standing beneath a sky in which the silver crescent of the moon shines among golden stars. [85]

# Sukot, *the Feast of Tabernacles*

The nine days of *sukot*, from the fifteenth to the twenty-third of *tishri*, marked the last of the autumn holidays. They were celebrated in a less austere atmosphere, though also less exalted, than the 'awesome days' of *rosh ha-shana* and *yom kipur*.

*Sukot* was agricultural in origin, the festival of harvest and petition for winter rains to ensure the earth's fertility. Unlike the ritual accessories for other holidays, those for *sukot* which were all taken from the plant world, introduced an unusually rustic decor into the synagogue and home.

Medieval illuminators were interested above all in the ritual aspect of this holiday, since it was so picturesque. Of the three rites, *suka, lulav* and *hoshanot*, the former two are the easiest to reconstruct with the help of German and Italian illustrations dating from about 1300 to the last decades of the fifteenth century.

## *Suka*, the Ritual Hut or Booth

The *suka* is a light hut or booth with a roof of twisted leafy branches known as *sekhakh*. It is shown very schematically as a branch of willow placed across two others in an Ashkenazi *maḥzor* of *c.* 1300. [86] Only Italian pictures from the last decades of the fourteenth century give us a more realistic representation.

The biblical commandment (Leviticus XXIII:42) orders that this fragile dwelling be lived in for seven days. Jews built them in courtyards near their houses which, in the West, they abandoned for as many hours as the cold and rain of autumn weather allowed. Fourteenth-century pictures show us the structure of stakes and poles, with the filling of entwined branches for the walls and roof. We can also see the furnishings: 369 a bench to sit on for study, a table set up for meals. [87] A group of Jews at table in a *suka*, too open for ritual purposes but with a leafy roof of branches, can be seen in a picture of *c.* 1450. [88] 372 Then in the second half of the fifteenth century, in addition to

exterior views of huts, solidly held up by a structure of stakes and light beams which support branches of varying degrees of leafiness,[89] there appear others opened wide to show the family meal being inaugurated by the *qiddush* of the holiday.[90] Lastly, we are shown the building of the *suka*, a task customarily begun as soon as *kipur* was over in order to ensure that it was finished by the fifteenth of *tishri*, on the evening of which the holiday began.[91]

368, 372

### Arba 'a minim, the Four Species

The fulfilment of the precept of the four species (Leviticus XXIII:40)—*lulav* or palm, *hadas* or myrtle, *arava* or willow, *etrog* or citron—is the rite that inspired the most pictures from the thirteenth to the fifteenth century in Ashkenazi countries, in Italy from the late fourteenth to the late fifteenth century, but in Spain only exceptionally, in *c.* 1350. The required blessing was made every morning of the holiday, as soon as possible after sunrise; myrtles and willows were held in the same hand as the palm, the citron in the other, squeezed against the bottom of the three branches; the palm was then waved in each of the cardinal directions. During the morning service, the ceremony of waving the *lulav* (the word signifying collectively the three kinds of foliage) was repeated several times as the psalms of the *hallel* (Psalms CXIII-CXVIII) were recited—this being the first time in the year that they were chanted (Leviticus XIII:42).

370

Medieval illuminators could not depict the happiness of the congregation at the rustling of the palms during the glorious chanting of the *hallel*. All we are shown is the moment when the *lulav* and *etrog* were individually blessed. However, most illuminators were evidently aware of the gravity and fervent enthusiasm that held sway during the accomplishment of the rite. The more unusual of the four species, the palm and citron, appealed particularly to the medieval imagination, no doubt on account of their exotic nature: in all periods and even in the roughest representations, their form is shown with a precision that contrasts with the usual lack of stylistic differentiation in the treatment of plants. Not only is the oblong shape of the *etrog* emphasized, but also its point, and the silhouette of the newly opened palm leaf, its fronds scarcely unfolded or still tucked against its stalk.[92]

A single Italian picture of the 1480s apparently gives evidence of the custom cited by Leon of Modena, taking not only a citron

but a whole branch of the tree with its fruit,[93] though this detail may perhaps be a result of the ignorance of a non-Jewish painter. We should note too the difficulty of attributing the presence or absence of the *tallit* on the shoulders of the worshippers holding the *lulav* and *etrog* either to difference in customs, to actual observation or to forgetfulness on the part of the illuminator. It does, however, seem to be worn more frequently in the fifteenth century.

Lastly, an Italian picture of 1460–1465,[94] in which the father is blessing the *lulav* in the presence of his wife and children, together with the picture near it showing a meal in the *suka* with a little boy sitting beside his mother, reminds us that these rites, especially the temporary lodging in the hut or booth with its roof of leaves, made *sukot* one of the holidays most attractive and directly accessible to the child's experience.

### The Hoshanot

Derived from the liturgy of the Temple, the rite of *hoshanot* (willow branches) owed its name to the special prayers of the holiday given the name of *hoshana raba*, the great supplication. It inspired very few illustrations, despite the great solemnity of the day. Two Italian manuscripts alone record it, one towards the end of the fourteenth century showing a long series of figures holding the *hoshanot*,[95] the other of the late fifteenth century showing a single figure.[96] Neither illustrates the rite itself, with the waving of the boughs and the stripping of their leaves during the recitation of the prayers of supplication.

373

### The Ninth Day of the Feast, Simḥat tora, Rejoicing of the Tora

This day, when the annual reading of the Pentateuch was finished, was marked by intense spiritual joy. According to a custom prevalent since the twelfth century emphasizing the fact that Jewish life never for an instant departed from the Law, immediately after the reading of the last pericope—the blessing of Moses and of his death (Deuteronomy XXXIII:1–XXXIV:12)—they anticipated the *shabat bereshit* by reading the beginning of the first pericope (Genesis I:1–XII:3) from another scroll. It became the custom to honour those called upon to read these two pericopes with the titles of

373 The day of *hoshana raba*, the seventh day of the *sukot* festival, the '*mizwa* of the *hoshanot*', the *almemor*, to which all the *Tora* scrolls had been brought, was encircled seven times by a procession carrying *lulavim* (palms), to the recitation of prayers of supplication or *hoshanot*, after which the commandment was adhered to: a bunch of five willow branches, called *hoshanot* after the special prayers for the holiday, was taken in hand and defoliated by beating it on the ground at the end of the prayer '*kol mevasser mevasser we' omer*' ('hark, the heralding of good tidings'), whose every word vibrates with messianic hopes. The rite was originally connected with invocations for rain, echoed particularly in the *piyyut* chanted at the moment when the branches of willow are taken up. Rain and water had now become solely symbols of salvation (Italian illustration, end of the 14th century).
London, British Library, MS. Add. 26968, folio 303 verso.

*ḥatan tora*, bridegroom of the Law, and *ḥatan bereshit*, bridegroom of the beginning. A feeble echo of the exaltation of this solemn reading is rendered by a few Ashkenazi pictures of the late fourteenth and early fifteenth centuries: the carrying of the scrolls to the lectern, the opening of the scroll, [97] and after the reading, during the chanting of '*Tora*, tree of life, life for all', one of the 'bridegrooms', holding the scroll in his arms, closed but not yet covered with its precious 'mantle'. [98]

94

## The Significance of *Sukot* in the Middle Ages

The tenuous link which talmudic interpretation of a verse of Leviticus (XXIII:43) had done its best to establish between the rite of the *suka* and the sojourn of the Hebrews in the desert, was the only means of justifying the holiday as a biblical commemoration, a theme that was developed by a number of hymns. It found no expression in Jewish iconography until the seventeenth century.

On the other hand, the rite of the 'four species' was quite consciously felt to be a commemoration of the ritual of the celebration in the Temple, a connection supported by liturgical texts. Although the picturesque nature of the rite helps account for the fact that it was frequently illustrated, the major influence was undoubtedly the poignant nostalgia felt about the destruction of the sanctuary and the loss of the ancestral homeland, as well as the expectation of the messianic restoration and salvation.

The connotations of redemption identified with the feast had multiplied, and were developed in the hymns. The *suka* recalled the messianic *suka* at the banquet of the Just, and the imagery suggested to the artist the previous combat of *behemot* and Leviathan, [99] the latter's skin being needed to cover the *suka* of the Just.

The initial meaning of the *hoshanot* ritual and the fervent petition for rain were also charged with this same expectation of salvation. The sought-for water from heaven is the mercy of divine salvation, solicited in the name of the long line of worthy, intercessory ancestors, of heroes prefiguring the Messiah, and of David his ancestor. This also accounts for our pictures of Samson and the psalmist-king. [100]

That the illuminators chose to portray the signs of the Zodiac from among the various themes intertwined in the variations of the great *piyyut* of the petition for rain was certainly more an

evocation of the cosmic frame in which the divine omnipotence and grace operated than a simple record of the seasonal character of the holiday. [101]

## The Half-Holidays: Ḥanuka, the Feast of Lights, and Purim, the Holiday of Lots

In the long period separating the great holidays of autumn from Passover, the Jews celebrated two half-holidays; that is, holidays on which working was not prohibited. These were joyous holidays commemorating historic deliverances of the Jewish people from oppression and threats to their faith and existence.

### Ḥanuka

As its name implies, ḥanuka signifies dedication: the holiday commemorates the purified Temple, after the victory of Judas Maccabaeus over the troops of Antiochus IV Epiphaneus (in 165 B.C.E.). According to tradition, the event was marked by a miracle: the only phial of oil found unpolluted in the Temple enabled the lampstand to be lit for the eight days of the inauguration. The holiday was thus given the name of 'feast of lights', and during its eight days of celebration, from the twenty-fifth of kislew, there were to be no fasts or penances. The hallel was chanted every morning, and at nightfall, both in the synagogue and in every home, the lights were lit to the accompaniment of blessings and songs. Despite the extreme popularity of this holiday throughout the Middle Ages, the illustrations never show us the family gatherings where young and old rejoiced together in the light of the lamp. We see only 371 the illuminated lamps, [102] the ritual of the lighting itself, [103] and on occasion the lighting up in the synagogue in the presence of the congregation. [104]

There are a few early fifteenth-century German pictures recalling the oppression that weighed on the Jewish people before their deliverance, which is the subject of this celebration: the subjects involved are the martyrdom of Eleazar, and that of the seven sons of Hannah, the exemplary mother. [105] Traditionally, there was held to be a parallel between deliverance from that oppression and the deliverance wrought by Judith. The story of

the heroine of Bethulia was recalled in the hymns of the holiday and found its way into our illuminations. [106] The lighting of the lampstand in the restored Temple could not fail to recall the inauguration of the tabernacle and the lighting of the first lampstand by Aaron. [107]

The memory of these deliverances and the miracles that went with them gave consolation and grounds for hope to the persecuted Jews.

### Purim

On the fourteenth of adar, towards the end of winter, the commemoration of the miraculous deliverance of the Jews of Persia, as related in the book of Esther, was celebrated. The holiday is known as that of 'lots' (purim), because the persecutor Haman drew lots to decide on the day for the massacre. Celebrations were even more joyous than those for ḥanuka, because the Jews had been freed from an even greater danger: not only had they been oppressed but threatened with extinction.

The central rite of the holiday was the public reading of the story of Esther in the synagogue, both night and morning, from a scroll written according to the same stringent rules as the scroll of the Tora, and similarly devoid of decoration. The few existing pictures of this reading give little idea of what it was like. Both in Italy and Germany, they show no more than the figure of the 374 person reading from the scroll which, according to the rite, has been unrolled in advance. [108]

Textual sources tell us of the noisy, colourful rejoicings in which adults participated as eagerly as children. Compared to this, the evidence of the visual record is very poor indeed: all we are shown is a table where men play dice while drinking, [109] a 372 dance, and the antics of a figure disguised as a buffoon. [110] There is no trace of the banquet that marked the only day in the year when drinking with little restraint was allowed. What struck the Jewish imagination, however, apart from the few allusions to some historical episodes, [111] was the theme of the punishment of the persecutor, made to suffer through his sons, who were hanged with him, because he tried to wipe out a whole people. [112]

It seems that this motif was popular not because it represented a desire for vengeance, but because the persecuted community saw in it blinding proof that they had divine protection, and that however powerful their oppressors or the threat of danger, this protection would never fail them.

## *Special* Shabatot

During the five or six weeks preceding the month of *nisan*—the number varied according to the year's calendar—four *shabatot* stood out from the rest. Besides the pericope for the day, an additional pericope was read from another scroll, and gave its name to the *shabat*: *shabat sheqalim*, from the pericope of the shekels (Exodus XXX:11–16), *shabat zakhor*, from the pericope 'remember' (Deuteronomy XXV:17–19), *shabat para*, from the pericope of the *para aduma*, the red heifer (Numbers XIX), and *shabat ha-ḥodesh*, from the pericope of the month (Exodus XII:1–20).

These pericopes made each *shabat* a special commemoration. The first and the third, however, were included in the commemorations of the cult of the Temple. The pericope for *shabat sheqalim* not only alluded to the biblical story of the shekels but also to the personal tax of half a silver shekel collected by the priests for the service of the Temple. The iconography gives it prominent representation through the motif of a money-changer weighing coins [113] or a pair of scales. [114]

In addition to textual sources, two of these illustrations attest that in the Middle Ages the expiatory significance attached from the beginning to this tax, which was allocated specifically for sacrifices, had become dominant. The scales are no longer those of the money-changer but of the judgement of Israel; the witnesses of his daily and nightly sins, the sun and moon, are also present, summoned by Satan, the accusor, who is possibly represented by the furious lion rushing in from the right. Yet divine mercy keeps guard, with its high portals open, [115] its presence announced by the four *ḥayyot* of the chariot of Ezekiel's vision. [116]

The *shabat para* in its turn recalled the purifications required before entering the enclosure of the sanctuary for the celebration of holidays, purifications which were themselves abolished with the cult when the sanctuary was destroyed. Its symbol, preserved in iconography from the mid-thirteenth to the fifteenth century, is the striking image of the pure red heifer which was to be immolated on the Mount of Olives in front of the open doors of the Temple, and its ashes mixed with the lustral water. [117]

The *zakhor* pericope was also to be read on the *shabat* before the feast of *purim*. Haman, the persecutor of the exiled Persian Jews, was thought to be a descendant of Amalek, whose attack and subsequent defeat were remembered on this *shabat*.

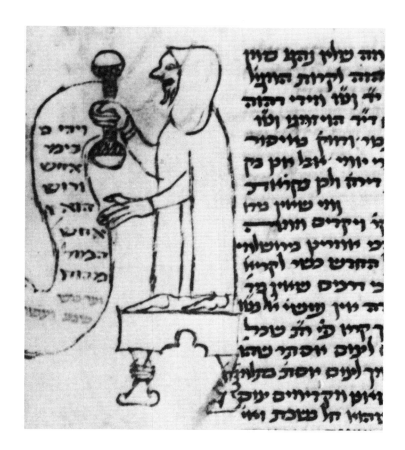

Illustration of this is rare and wholly anecdotal; [118] it never goes beyond the letter of the text to stress the implication of the incessant fight which is incumbent upon Israel to combat absolute evil, symbolized by Amalek.

The *ha-ḥodesh* pericope, read on the last *shabat* before the first of *nisan*, recalled the institution of regarding *nisan*, the month of the Exodus from Egypt, as the first month. Its symbol was that of the beginning of the month, the crescent of the new moon; either alone, [119] with a star between its horns; [120] or, most frequently, opposed to the sun depicted as a large star or radiating disk. [121] The crescent occasionally enclosed the obscure face of the moon in which legendary tradition saw the face of Jacob, father of the twelve tribes—for the moon was held to be the emblem of Israel, opposed to the sun which was the emblem of Edom. [122]

376

375

377

375 The pericope of *para aduma* (Numbers XIX: 1–22), the red heifer whose ashes were necessary for the preparation of the lustral water at the time of the Wilderness Sanctuary and of the Temple. This supplementary pericope, for the second of the four special *shabatot* preceding *pesah*, is illustrated in a few Ashkenazi and Sephardi Bibles—among them the Spanish Bible dated 1300 from which the above picture was taken—by the image of a cow, reddish-brown or red in colour if it is painted. This image of the red heifer appears more frequently at the head of the ritual of this special *shabat*, called *shabat para*, in German and Italian *mahzorim*.
Lisbon, Biblioteca Nacional, Ms. Il. 72, folio 88 recto.

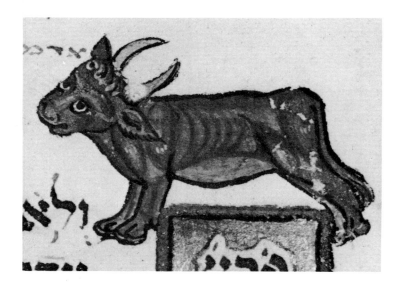

reciprocal fidelity, wipes out the transgressions of its people. It is this love of God for his people, the ultimate hope of medieval Jewish communities in the dark periods of their history, that the illuminators chose to express in the image of the *hatan* and *kalla*, the betrothed Jewish couple. [123] This image was suggested by the allegory of conjugal love, an allegory used to exalt the love of God in a *piyyut* of the day, nourished by the prophetic imagery of Hosea, Jeremiah, Ezekiel and Isaiah, and the lyricism of the Song of Songs.

336

### *Pesah*, Passover

Of all Jewish holidays, Passover inspired the most varied and lively medieval miniatures. They describe every aspect of this holiday: the preparation, liturgy and significance. [124] In fact, the iconography of the *pesah* holiday is so abundant that we can do no more than select a few references. (For an almost exhaustive study, see Mendel Metzger, *La* Haggada *Enluminée* [Leiden, 1973].)

## *The* Shabat ha-gadol, *the Great* Shabat, *and* Pesah, *Passover*

### *Shabat ha-gadol*

This was the last *shabat* before *pesah* and was celebrated in anticipation of that holiday. It was, next to *shabat shuva* preceding *yom kipur*, the most important *shabat* of the year. It was only on these two *shabatot* that medieval rabbin were accustomed to deliver a sermon to their communities. On the eve of *yom kipur* they exhorted their congregations to penitence; before *pesah*, they expounded the ritual requirements of the holiday, especially the dietary prescriptions; the *hazzan* also read part of the *haggada*, the ritual of the *seder*.

Some Ashkenazi pictures of the late thirteenth and first half of the fourteenth century set out to emphasize another dimension of this *shabat*. According to tradition, the final deliverance of the Jewish people, to be effected by the Messiah, was to take place in the same month as the Exodus from Egypt, so that on this *shabat* the prophecy of Malachi announcing 'the awesome and fearful day of the Lord' (Malachi III:23) was read. Trust in this deliverance was founded on faith in the covenant, in divine election, the source of love which, though demanding a

### *The Preparations*

Unlike other holidays which needed only moral and spiritual preparation—meditation, resolutions to reform personal conduct, and acts of *zedaqa*—the dietary prescriptions relating to *pesah* required long and detailed preparation. The biblical prohibition from eating *hamez*, yeast, during the eight days of the holiday (Deuteronomy XVI:3–4) meant that enough unleavened bread had to be made during the preceding weeks to last throughout the holiday. Illustrations from the late thirteenth to the end of the fifteenth century show animated scenes of this bread being made under the very strict regulations fixed by the Talmud. Rabbin oversaw the whole process—from the cutting of the wheat, the milling, sifting and kneading, to the baking—throughout which there was to be no fermentation. [125]

This prohibition was so important that the first requirement of *zedaqa* was for members of a community to provide the poor with the flour needed for the *mazzot*, unleavened bread, or with the bread itself. Some fourteenth-century pictures from Castile or Aragon show notables or rich householders distributing *mazzot* prior to the holiday. [126]

142, 318

The manufacture of *mazzot*, which could only be undertaken
by Jews, was usually done at the communal oven. Another series
of preparations also connected with the prohibition of *hamez* was
likewise done in communal establishments: once the metal
cooking utensils had been thoroughly cleaned, they were made
kasher, pure, by plunging them into the boiling water in an
enormous cauldron in the communal kitchen. This can be seen
in pictures from both Spain [127] and Germany [128] from the first
quarter of the fourteenth century. In a Spanish scene of the same
period we see the other kind of purification, by water, for glass
and new objects, in the *miqwe*, the ritual bath. [129]

Another requirement of the prohibition was the complete
cleaning of one's home, and we can see Spanish [130] and
German [131] families carrying this operation out with zeal and
solemnity.

In addition to the cooking needed for other meals of the first
two days of the holiday, [132] our illustrations record the prepara-
tions for the *seder*, the ritual meal of the first two evenings.
Walnuts, almonds, apples, figs and dates are ground in a mortar;
mixed with wine, they are used to make the sweet paste called
*haroset*. [133] Sufficient wine had also to be drawn for the ritual
cups. [134]

*Preparatory Rites*

There are numerous detailed pictures of the rite completing the
cleaning of the house, the *bediqat-hamez*, in which any last traces
of yeast were sought out by candlelight on the evening between
the thirteenth and fourteenth of *nisan*. The most notable
illustrations are those of the Ashkenazi rite, in which a goose or
chicken wing was used to brush the last crumbs from corners. [135]
This alone among the rites of *pesah* was considered separate from
the celebration of the *seder*.

Seder, *the Symbolic Meal of Passover Eve*

Immediately following the evening service of the night that
marked the beginning of the fifteenth of *nisan*, Jews came
together to celebrate the *seder*. For all those who for one reason
or another could not celebrate it at home, there was a *seder* in the
communal hall, [136] but every father of a family endeavoured to
celebrate it, and, in answer to the appeal of the *haggada* 'let all

who hunger come and eat [bread]' to receive as many guests as
his means allowed.

The table would be set before nightfall, covered with the best
cloth, and laid with the ritual foods. The most detailed pictures
show the *mazza*, bread of slavery which had become the symbol
of liberty (in Ashkenazi countries it is shown in a metal basin, [137]
in Spain in a basket, [138] in Italy in either [139]), together with the
green leaves of the *maror*, the bitter herb symbolizing the
bitterness of slavery, and sometimes the plate of *haroset*, the paste
recalling the mortar that the children of Israel had to make
during their enslavement in Egypt. These pictures do not show
the roasted bone substituted for the paschal lamb, which was not
eaten since the destruction of the Temple. The *karpas*, a
vegetable soaked in salt water, only appears at the moment it is
to be served, right at the beginning of the *seder*. [140]

The order of ceremonial gestures and of the consumption of
ritual foods was read aloud from the *haggada*. This ritual book,
peculiar to Passover, announces the rites, indicates the blessings
that are to accompany them and explains them in relation to the
captivity and the deliverance from Egypt.

Owing to the illustrations in a number of copies of this ritual
book that have come down to us, we are able to reconstruct the
medieval context of the holiday. In the illuminations, the *haggada*
appears on the table or in the hands of the participants, [141] but we
see no more than a few hastily written words on the open pages,
and nothing to suggest the rich decoration that so often
embellished them.

After the *qiddush*, [142] the washing of hands, and eating of the
*karpas*, [143] soaked in salt water, the celebrant of the *seder* broke
one of the three *mazzot* placed on the dish or in the basket, [144]
putting one half, the *afiqoman*, aside for the end of the meal. [145]
He then raised the dish or basket [146] while pronouncing the first
words of the *ha lahma*, which at once establish the *mazza* as the
central symbol of the feast. Jews in the north and in Italy had the
custom, shown in several pictures, of joining with the celebrant
to raise the dish or basket. Sephardi Jews passed it over the head
of each person as a reminder of how in their haste the Israelites
had had to take their unleavened dough with them.

Then came a rite that was only spoken, the *ma-nishtana* ('Why
is this different...?') or four questions relating to the meaning of
the feast and its rites. The questions were put by the youngest of
the participants, thus making the child a privileged actor in the
celebration. In spite of its importance, this rite, which fulfils the
commandment to refer to the story of the Exodus from Egypt

113, 257
114, 108
111
143
118
134, 139
137-8

127, 129, 132
144, 378
193, 379
378
189, 193, 379
378

(Exodus XIII:8), was virtually ignored by illustrators [147] in favour of the especially popular figuration of the four types of questioners. [148]

190, 180    The other significant ritual gestures punctuating the unfolding of the narration are the designation or the raising of the ritual foods: the *mazza* [149] and the *maror* [150] before they were
150, 177    eaten, and the cup full of wine, [151] which was repeated several times, as during the *qiddush*.

133    The contents of the cup was drunk four times during the *seder*. [152] Similarly, *mazza* and *maror* were eaten first separately and then together before the banquet which was part of the celebration of the *seder*. [153] After the meal, the *afiqoman*, which had been wrapped in a napkin or hidden under the tablecloth, was uncovered and shared among the participants. [154]

153    The ritual ablution of the hands was performed three times: before tasting the *karpas*, before eating the *mazza* and again before saying grace. [155]

   Fifteenth-century German and Italian Ashkenazi pictures depict a last ritual, that of opening the door of the house. This took place after saying grace, at that moment when the fourth cup was raised to pronounce the *shefokh* invoking divine succour
380    against persecutors. [156]

   Illustrations remind us too that throughout the *seder*, according to ritual requirements, the celebrant maintained his position leaning on one elbow, sometimes supported on a
133    cushion [157] and the participants adopted the same position as they drank. [158]

## The Significance and Meaning of the Seder Rites

The last rite mentioned symbolized liberty regained, for this was the position, stretched out on a bed and leaning on one elbow, that free men of the Graeco-Roman world assumed as they ate —it was in this context that the rite was born. The ritual foods, *mazza* and *maror*, are also symbols of liberty and bondage respectively. And the cup of wine raised each time God's succour was recalled symbolized the joy of deliverance.

   The ritual meal of the *seder* commemorated the first Passover, celebrated while the Jews were still in Egypt on the night of the tenth plague. On this night, in each of their houses, the Israelites who were ready to depart, consumed a meal consisting of the flesh of a lamb with unleavened bread and bitter herbs (Exodus XII:8–11). [159] Superimposed on this biblical commemoration is the nostalgic memory of Passover as it was celebrated at the time of the Temple, when the paschal lamb was sacrificed. [160] It is to this latter commemoration that is due the modification introduced into the series of ritual foods, paschal lamb, *mazza* and *maror*, and the very unequal place given them in Jewish imagery. Whereas the latter two are illustrated quite frequently, [161] and were actually eaten, the former is very rarely shown. [162] A memento, in the form of a burnt bone, was substituted for it on the table, and in its stead the *afiqoman*, the half-*mazza*, was eaten symbolically at the end of the ceremony.

376    The traditional illustration of the service on the first of the four special *shabatot* preceding *pesah*, *shabat sheqalim*, in an Italian *mahzor*, 1441: since the supplementary pericope (Exodus XXX:11-17) of this *shabat* refers to the tax of half a shekel that adult men of the children of Israel had to pay yearly for the upkeep of the Tabernacle, it shows the scales of the money-changer who provided the faithful with the correct coins corresponding to a silver half-shekel, in exchange for any other money. Already in the biblical text, the tax signifies 'a ransom for his soul', 'atonement money of the children of Israel' (Exodus XXX:12 and 16); the scales thus became identified with the scales of the Last Judgement and a symbol of redemption.
Jerusalem, Schocken Institute, Ms. 13873, folio 67 verso.

377    The service of the fourth special *shabat*, when the supplementary pericope *ha-hodesh* (Exodus XII:1-20) is read, is illustrated in German and Italian *mahzorim* by a crescent moon, often accompanied by a star. In this pericope 'of the month', Moses not only receives the commandment to count the month of *nisan*, (the month of the Exodus from Egypt), as the first of the year, but is taught, according to midrashic tradition, to recognize by observation the exact moment of the *molad*, the conjunction and the appearance of the new moon marking the beginning of the month. The crescent depicted in this Italian vignette of 1441 with its horns turned to the right, in fact, corresponds not to the first but to the last phase of the moon. The illuminator of this manuscript was not alone in making this mistake.
Jerusalem, Schocken Institute, Ms. 13873, folio 76 verso.

378    The ritual *seder* meal on *pesah* eve, the Passover holiday, Spain, 1350–60. ▷
A Jewish family, the father presiding over the ceremony, a male guest facing him, the mother with two boys on her right and a girl on her left, are all sitting round the *seder* table; this is covered with a damask cloth embroidered or woven with decorative stripes, on which is laid a carafe and a cup for the wine (the rite required one for each person), and three open books, or *haggadot*, containing the rituals of the *seder* and thus allowing participants to follow the ceremony. The rite illustrated is that which in Spain accompanied the words 'ha lahma anya' ('This is the bread of affliction'), the first words of the Passover *haggada*: the master of the house has placed the cloth-covered basket containing the *mazzot*, the unleavened bread, and the *maror*, the bitter herbs, on the head of the child seated on his left; it was then placed successively on the heads of each person at the table as a symbolic reminder of the Exodus from Egypt when, in their haste to leave, the Israelites had to carry on their backs their kneading troughs filled with dough not yet leavened (Exodus XII:34 and 39).
London, British Library, MS. Add. 14761, folio 28 verso (detail).

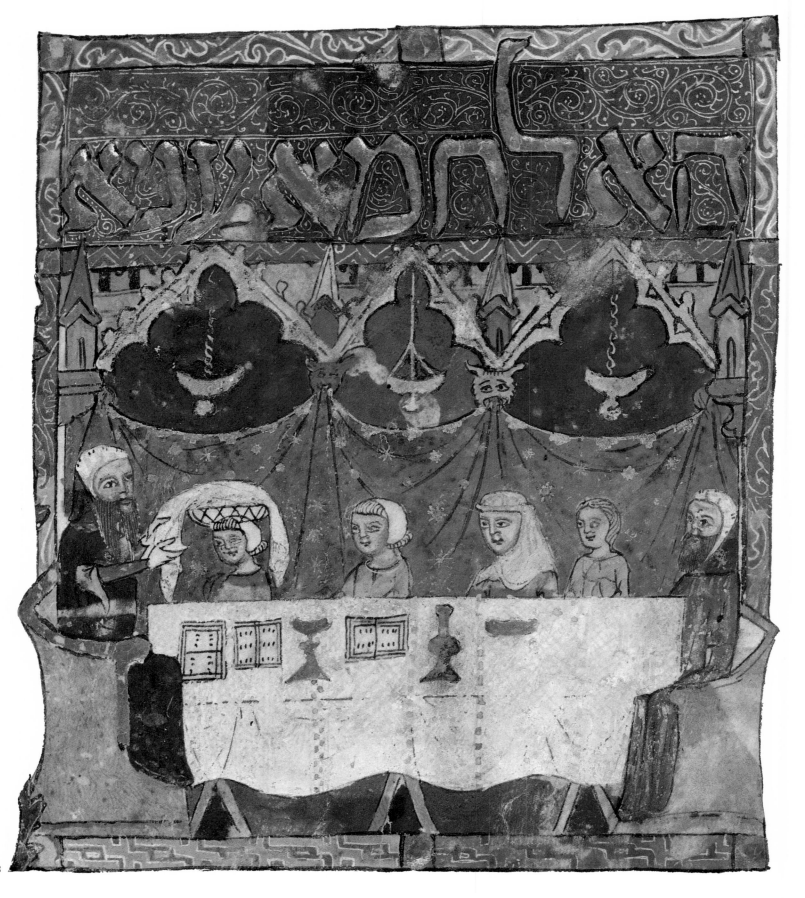

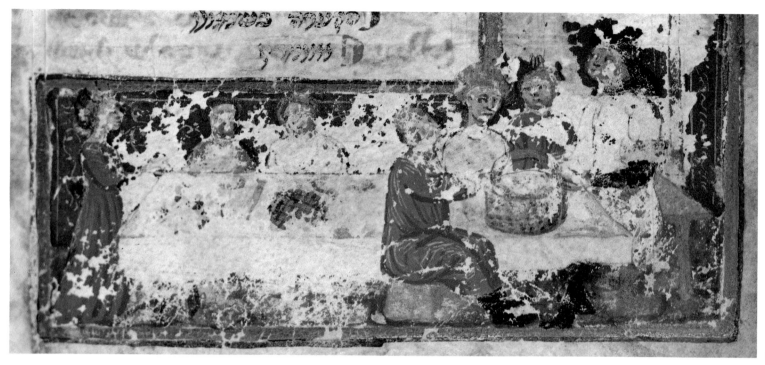

379

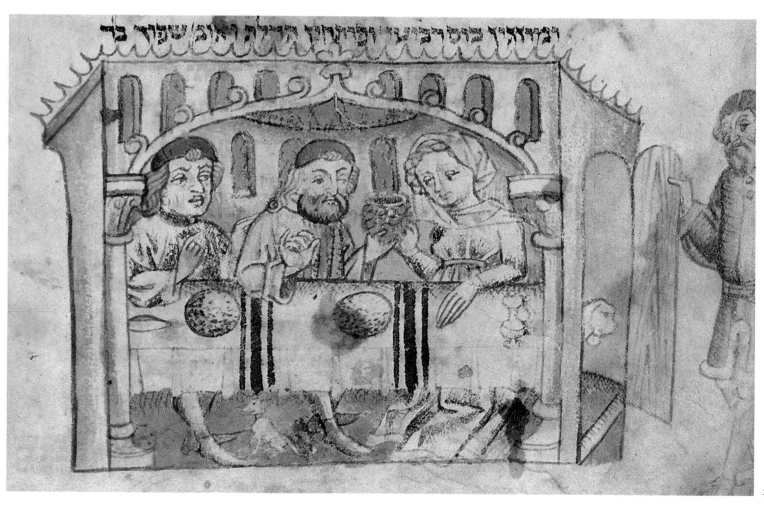

380

381

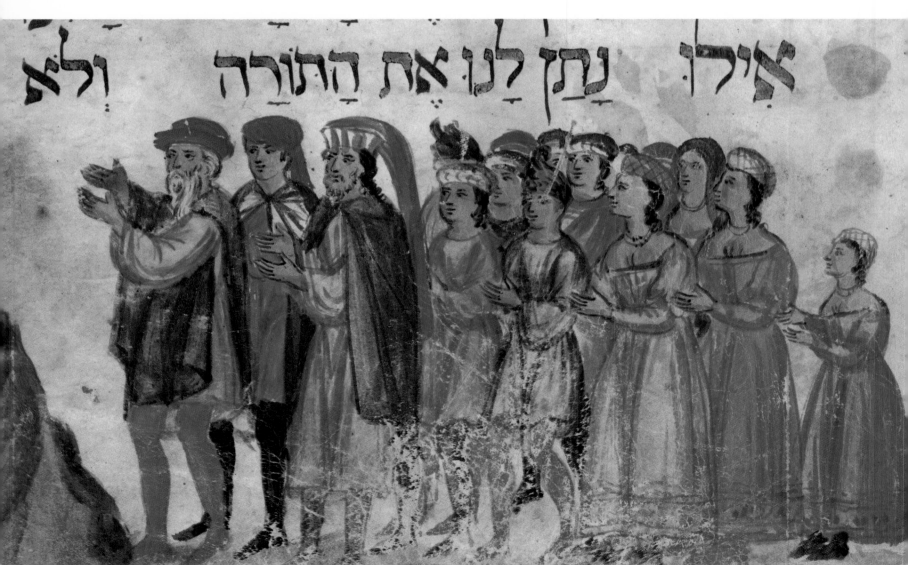

אילו נתן לנו את התורה ולא

382

However, the dominant sentiment of this night was not the melancholy evoked by the abolished cult but joy expressed by the chanting of the *hallel* and the hymns associated with the feast, which glorified God for having performed the miracle of the liberation of the children of Israel. The miraculous character of the Exodus from Egypt, so often illustrated in *Haggadot*, [163] is a theme particularly stressed in the narration from the *Haggada*.

This night was not only commemorative. More than any other feast, it was experienced as a living and confident anticipation of the final deliverance. 'Next year in Jerusalem'

was the wish spoken as the *seder* drew to its close in Ashkenazi and Sephardi rites, expressing the hope not only of return to the restored Jerusalem of the Messianic era, but of entry into the celestial Jerusalem. [164] The rite of opening the door, an invitation to the Messiah to hasten his coming, was more than once made explicit by illustrators, who showed Elijah announcing and guiding the Messiah mounted on his ass. [165] Other illustrators transpose this anticipation to a fairy-tale world in which the whole Jewish people enters into the end of time, riding behind the Messiah on the miraculously long tail of the ass; [166] in a more grandiose perspective, we are shown the dead brought to life on the arrival of the Messiah, a portent of the day of judgement. [167]

## The Celebration of the Holiday in the Synagogue

Only two moments in the Passover's morning service, moments shared in common with other holidays, are revived for us in a few pictures: the recitation of the *hallel*, during which, in Spain, the officiant stands on the *bima* holding the *Tora* scroll in his arms as he faces the congregation [168] and, in an Italian synagogue, the bringing out of the scroll of the Law from the holy ark accompanied by traditional chants. [169]

Accompanying the text of prayers and hymns are more pictures illustrating the event commemorated by the holiday: the hasty departure, the pursuit by Pharaoh's army and the crossing of the sea. [170]

From the first morning of the holiday, the prayer for rain was replaced by one for dew. The *piyyuṭ* following it, composed, like the prayer for rain, by the great liturgical poet Eleazar Kalir, inspired the same series of illustrations of the signs of the Zodiac. [171]

These pictures are sometimes paralleled by pictures of the corresponding labours of the month, [172] and relate the holiday to its position in the natural cycle of the year. Jews must have interpreted them in the light of the moral and religious significance found in the text. On occasion, the picture has made this explicit itself, as when the scales, the sign of the month of *tishri*, are replaced by the scales of judgement and the dispute between the interceding archangel and the accusing devil for the souls of the children of Israel. [173]

The Song of Songs was read at *pesaḥ*. It was considered a mystical allegory of the relationship between God and his

◁ 379   The rite of *ha laḥma*, Italy, first half of the fifteenth century. The *mazzot* and *maror* are in a basket, as in Spain; instead of raising it, as the rite suggests, when the words '*ha laḥma*' are pronounced, the master of the house and one of the participants beside him place their hands on the handle. There are, however, many Italian pictures showing the basket being raised.
London, British Library, MS. Add. 26968, folio 110 verso (detail).

◁ 380   The *shefokh* rite during a *seder*, Germany, mid-fifteenth century: while the cup of wine, the symbol of deliverance, is raised for the fourth time, and before pronouncing the blessing and drinking from it, one of the participants goes to open the door of the house. This gesture of complete confidence in divine protection, in a particularly hostile world at this period of violent and incessant persecution, expressed with added fervour the anticipation of the coming of Elijah, the herald of the Messiah, inviting him to accomplish the final redemption of Israel on this night which commemorated the deliverance from slavery in Egypt.
Parma, Biblioteca Palatina, Ms. Parm. 2895–De Rossi 653, p. 254.

381   The fast of *tisha be'av*, on the ninth of *av*, Italy, towards the end of the fifteenth century. After the evening service, which begins the day of fasting on the anniversary of the destruction of the Temple, a Jew sits on the ground, his shoes off as the rite demanded, and reads, by the light of a single lamp, the Lamentations of Jeremiah and various *qinot*, hymns of mourning composed specially for this day.
New York, Jewish Theological Seminary of America, MS. Acc. No. 03225, called MS. Rothschild II, folio 200 verso.

382   The celebration of the Feast of Weeks, *shavu'ot*, which in the first centuries of the common era became '*zeman mattan toratenu*' (the time of the giving of our *Tora*), brought together medieval Jews to commemorate the revelation on Sinai. This miniature was executed in a Jewish community on a Greek island, Candia or perhaps Corfu, in the last quarter of the sixteenth century. The illuminator has given the appearance and costume of his own contemporaries to the Israelites assembled at the foot of Sinai, a practice followed in all other medieval Jewish pictures of biblical scenes. But the apparent identification of the witnesses of the revelation with their remote ancestors in the Middle Ages is peculiarly apposite to the evocation of *shavu'ot* as it was lived in the medieval period, since it was not solely a commemoration of the revelation and the covenant, but also a solemn renewal of the latter in the present time.
Paris, Bibliothèque Nationale, ms. hébr. 1388, folio 14 recto (detail).

people, and was thus particularly appropriate to the holiday commemorating, in the deliverance from slavery in Egypt, the resounding confirmation of the election of the tribes of Israel promised in the revelation at Sinai. It is rarely illustrated in the Jewish Bible, and then only by allusive motifs such as a musical instrument [174] or musicians [175] or by the symbolic image of the hunted stag. [176] The appearance of the Song of Songs in the *mahzor* did no more to inspire illuminators. There is a single picture of Solomon—to whom the book was attributed—seated on his magic throne with the sword of justice in his hand and pointing to the *Tora* scroll, the source and guide for the wisdom of his judgements, which alone is able to express the Jewish people's nostalgic memory of the glorious past. [177]

## Shavu'ot, *Feast of Weeks*

The holidays of *pesah* and *shavu'ot* had been linked together on different planes. As agricultural holidays, the former corresponded to the barley harvest, the latter to the wheat harvest. The sacrificial rites marking their liturgy in the Temple period were only known in the Middle Ages from biblical and liturgical texts, and were rarely recorded in pictures; in an exceptional example, we see a figure bringing the sheaf of the first fruits of the new barley of the *omer* on the second day of *pesah* (Leviticus XXIII:10) [178] and in another, on the day of *shavu'ot*, the baking of the two raised loaves made from the flour of the new wheat (Leviticus XXIII:17). [179]

The season of *shavu'ot*, the wheat harvest, was recalled by a reading from the Book of Ruth on the second day of the holiday, and by the rare but lovely pictures that bring to life its pastoral scenes. [180]

With the Temple destroyed and the rites abolished, the holiday, celebrated on the sixth and seventh of *siwan* had long been no more than a biblical commemoration, but one of capital importance since the event it celebrated, the revelation at Sinai and the promulgation of the Law, had been a decisive historical moment for the people of Israel (Exodus XIX–XX). Moreover, this commemoration was experienced personally by each Jew, who on that day renewed his allegiance to the God of his fathers and to his Law. Thus the seven weeks separating the two holidays, whose days were counted by the *sefirat-ha-'omer* (Leviticus XXIII:15), or the count of the first fruits (the period having been given the name of the offering that marked its first

day), had become a time of spiritual preparation between *pesah*, the feast of physical liberation, and *shavu'ot*, the feast of spiritual liberation by divine revelation, the gift and the acceptance of the Law that determined the destiny of Israel. There were special readings of *pirqey avot*, a treatise of the *Mishna* on the theme of *Tora*, its transmission since Sinai, its teaching and glorification.

The gift of the Law is represented in some Bibles from the thirteenth to the fifteenth century, sometimes in a summary or fragmentary form or sometimes as a whole scene [181] (for example, in the *Mishne Tora* of Maimonides, [182] in *Haggadot*, [183] in prayer books illustrating a *piyyut* or the biblical pericope for *simhattora*, [184] or again the *pirqey avot* [185] or a *piyyut* of the *shabat* before *shavu'ot* [186]). It is natural enough that the representation of the gift of the Law should have figured so prominently in the *mahzor*, since the pericope of the first day of the holiday (Exodus XIX–XX), the solemn reading of the Decalogue and the glorification of the *Tora*, sung in hymns, enhanced the character of the drama that was played on Sinai. [187]

Some of these pictures attest the continuing popularity of the legends of the *Midrash* which had enriched the biblical story: after first refusing the Law, the children of Israel were brought to accept it under threat of being crushed under Sinai, [188] which by a miracle had been torn up from its roots [189] and raised to the foot of the divine throne.

In striking contrast to *pesah*, there were no special rites peculiar to *shavu'ot*. As on other holidays for which pictures have recorded the same moments in the liturgy, the *hallel* was chanted and the *Tora* brought out for reading. And as in other feasts and on the *shabat* as well, the descendants of Aaron blessed the people with the *birkhat kohanim*, the priestly blessing, on the people. Very few pictures of this rite survive, and they give only an approximate idea of the position of the hands as the blessing was recited, [190] whereas this position is shown with some precision on the shields bearing the coats of arms of Italian *kohanim*. [191] On Levite coats of arms, we see Levites carrying the ewer, the basin and sometimes the towel, [192] these objects were used by the Levites to wash the hands of the *kohanim*; the latter pronounced the blessing.

## The Fast of *Tisha be'av*

The *shavu'ot* holiday marked the spiritual peak of the Jewish year. It was the last holiday before the autumn: there only

383 The transmission of the Law, commemorated by *shavu'ot*, in a German *mahzor*, first half of the fourteenth century: to the sound of trumpets sounded by crowned and haloed angels (a detail borrowed from Christian iconography), with flames encircling Sinai and curling up its flanks, the divine hand emerges from the cloud of fire floating beneath the heavens and the firmament where the stars are fixed; it holds out to Moses the two tablets of the Law, fitted in a frame with a handle; on the right, Moses hands the tablets to the kneeling figure of Aaron, while at the bottom of the picture (not reproduced) the people of Israel, with arms raised, wait in turn, to receive the Law.

Moses, who is receiving the tablets of the Law on behalf of the people of Israel, is represented as young, blond, shaven, and crowned with roses like someone betrothed. This nuptial symbolism reminds us that the revelation at Sinai was regarded as the celebration of a mystic marriage between Israel and the *Tora*.

Note that the illuminator, in his concern not to portray the human face, has not drawn in Aaron's features and has hidden the eyes of the angels and of Moses by bringing down the gold crowns of the former and the flower crown of the latter over their lowered eyelids.

Dresden, Sächsische Landesbibliothek, Ms. A 46ª, folio 202 verso (upper register).

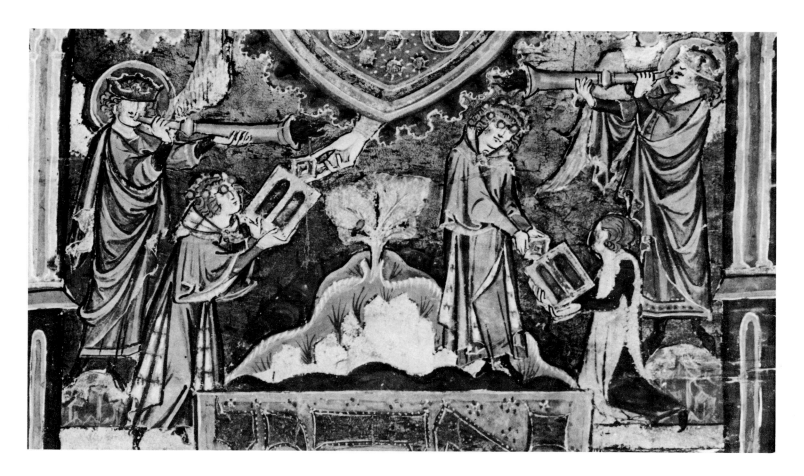

remained the darkest anniversary in the history of the people of Israel, the destruction of the first and second Temples and the national catastrophe.

From the beginning of the month of *av*, a period of renunciation of all joy and comfort prepared for the observance of this anniversary, celebrated on *tisha be'av*, the ninth of the month of *av*, in deepest mourning and with rigorous fasting. Mourning began even before nightfall at the last meal, the *se'udda mafseqet*, which was of the utmost frugality, taken seated on the ground in silence and solitude, a veritable meal of affliction. [193] At nightfall, both at home and in the synagogue, only the barest minimum of lighting was allowed, from a single-wick lamp. [194] Shoes were not worn, and one could only sit on the floor or on low stools. [194a] Even the study of the *Tora* was forbidden, since it provided spiritual joy, except for the most melancholy books, Job, Jeremiah and Lamentations.

The reading of Lamentations formed part of the liturgy of the evening service; [194b] it was followed by the *qinot*. A few pictures in thirteenth- or fifteenth-century Bibles or ritual books show Jews plunged in affliction, seated on stools or on the ground, head in hand, listening to or reading the mournful account of the destruction of the holy city. [195]

## Some Religious Beliefs and Concepts

The practice of illustrating with pictures works containing the liturgy for the day, week or year varied in popularity according

384 The *birkhat kohanim*, priestly blessing, Italy, *c.* 1400. The painter of this illumination, who was not a Jew, has put the *kohen* in a veritable ambo of a kind that did not exist in Italian synagogues; furthermore, though he has noted the position of the hands correctly, raised with the palms turned down, the fingers are not portrayed as they ought to be since they are shown equally separated with the index fingers touching. The rite in fact requires that the hands, raised to shoulder level, should touch only by the thumbs separated from the index fingers, and that the fingers be grouped in pairs.
Jerusalem, Jewish National and University Library, Ms. Heb. 4° 1193, folio 40 verso.

## The Law, Pivot of Religious Life

By daily study of the Law and no less regular fulfilment of God's commandments and by prayer, the medieval Jew forged and tested his own fidelity to the ancestral covenant. Perpetually deepening his knowledge of this Law by making it a continual object of study and reflection and embracing it with ever-increasing fervour, he submitted to it every detail of his behaviour. The centrality of the Law in Jewish life, shaping its every aspect, could not be better expressed than by the age-old symbol of the tree of life that had early been attached to it. This attachment, however, is illustrated far more in texts and the liturgy than in painted images,[197] or sculptures,[198] which are 390 rare.

## Pietistic and Mystical Trends

Notwithstanding the strong unity created in medieval Judaism by its unbreakable attachment to the Law, there were forces at work generating tensions within the heart of religious thought. They can be seen in the controversy that continued with alternating violence and moderation from the late twelfth to the fifteenth century around the work of Maimonides, between the strict upholders of faith and tradition and the followers of reason and philosophy. Apart from this, a desire for a more intimate relationship with God, though always within the world of the Law, lay at the source of various pietistic movements in Spain, France and Germany in which moral asceticism was combined with a mystical spirituality. At the same time, there was a resurgence of the ancient Jewish gnosticism, in Provence, where it came into contact with the neo-platonism that held sway in rabbinical circles: thus was born the Kabbala which was propagated in Spain and branched into different trends identified by the greater or lesser importance given to theosophical speculation or to mystical illumination.

Our survey of Jewish medieval religion would be seriously distorted without at least a rapid and schematic description of the diversity and richness of these trends and the spiritual experience they imply.

This, however, brings us to an area in which our pictures do little to guide us. Even though the language of one of these trends, that of theosophical thought, is prodigal in its use of mythical images and symbols, neither it nor the others inspired

to the period and to the geographical and cultural area. But wherever it is evidenced, it contributes, as we have shown, to make manifest and emphasize not only the ritual acts themselves but also the outstanding events and individuals who initiated them in the earliest history—that enshrined in the Bible—of the Jewish people, and thereby some of the themes and symbols of its faith and of its religious and mystical thought.

386 From *rosh ha-shana* to *shavu'ot*, from the promise made to Abraham[196] and the first covenant, sealed in his flesh, to the consecration of the election of his descendants at Sinai and the renewal of the covenant by the gift and acceptance of the *Tora*, from the exemplary obedience of the first patriarch, 'the friend of God', to the devotion of Moses, 'the faithful shepherd', in the service of God and his people, the medieval Jew relived the dramatic vicissitudes of the exacting dialogue established between God and his creation.

parallels in representational art. Medieval cabalistic manuscripts offer nothing but pen diagrams to illustrate their speculations on the structure and process of creation, and in particular the hierarchy and interactions of the *sefirot*, the progressive manifestations of the interior life of God and of the diverse names of God as creator. They are bereft of any artistic pretensions and probably were not intended to be 'images' in the proper sense: deprived of their caption and isolated from the text they elucidate, they would have no meaning. An exception can be made for pages where, for example, the simple 'tree' *(ilan)*, a diagrammatic structure of the *sefirot*, is replaced by a fine painting of the seven-branched lampstand which was considered by the cabalists as another symbol of the structure of the *sefirot*, flanked by two 'trees', also painted, one with divine names and the other with lights. [199]

Likewise, since they were forbidden to represent the divinity, who is never seen, illuminators only ventured to transpose visually the most external symbols of the vision of the chariot and throne of divine glory, namely the creatures *(ḥayyot)* 387-8 supporting the chariot's wheels [200] (Cf. Chapter I, n. 1 and nn. 236–239) and very occasionally the throne [201] or the rings of the seven heavens which the soul must cross to reach supreme

ecstacy. [202] We have already seen the signs used to symbolize the 4-5 creative act: rays or a hand [203] (Cf. Chapter I, nn. 2–3). Similarly a hand, used as a symbol of action, served to express the direct intervention of God in worldly events, such as the crossing of the Red Sea [204] or the moment on Sinai. [205] 383

## The Supernatural and Eschatology

What our illuminations have transmitted to us of the supernatural world and eschatological beliefs in the Middle Ages is therefore at a much humbler level, that of the pious Jew who knew no more of mystical speculations and experience than what was conveyed in the most current *Midrashim* and in liturgical chants.

### Angels

While the only God, infinitely distant and hidden but revealed in his *Tora*, remains invisible, Jewish imagery allows more presence to angels, the worshippers of his glory or executors and messengers of His will. Both in mystical thought and in popular belief angels intervened in the lives of individuals and in the life of the community as a whole, as they had done among their biblical ancestors. Such intervention is never portrayed directly, however. Only illustrations of their missions to the patriarchs and their families or to Moses, offer us a clue as to how they appeared to the medieval Jewish imagination. These celestial messengers are sometimes represented by no more than an arm or a wing [206] or a wing in a cluster of rays. [207] They may be represented unequivocally as bodies which, combining the opposing elements of fire and water, are winged but nevertheless human in form [208] or as strange creatures without heads, thus dissimulating partially their human form. [209] Again they may appear without any trace of their celestial origin, in a simple human form without wings. [210] Usually shown as adolescents, these agents of divine will, whether winged or not, are occasionally given a beard as a sign of maturity, or even of old age. [211]

Every man was believed to have his guardian angel to guide him away from evil—as the angels had guided Lot and his daughters away from the cursed cities [212]—while at the same time an angel of destruction also followed his every step to incite him to evil.

386　Abraham, the founder of monotheism and ancestor of the people of Israel: during the night of anguish following the divine promise of innumerable descendants (Genesis XV : 5), a vision showed him the future of this progeny, its sojourn in the promised land as reward for its fidelity, its dispersion and exile as punishment for its transgressions, divine pardon always prompt for the repentant, and the final coming of the Messiah (picture from the Rhineland, *c.* 1427–8).
Hamburg, Staats- und Universitätsbibliothek, Cod. Hebr. 37, folio 26 recto.

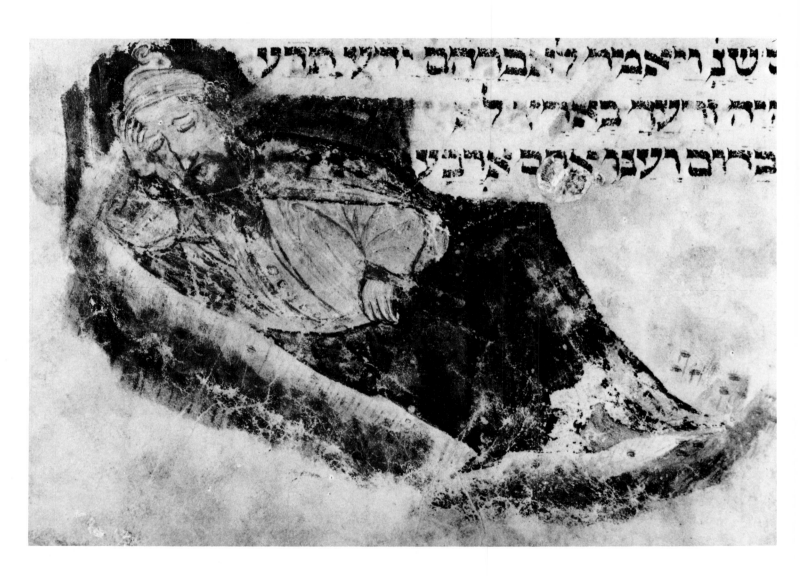

We have already seen the great angels Michael and Gabriel in their role during the annual judgement of Israel.[213] Pictures of angels performing their ministry in the realm of the beyond are in fact rare. Apart from the archangels of the judgement and, in a single instance, the very mysterious taurine angel of the abyss who rules the rain,[214] we only get a glimpse of the angel of peace who receives the souls of the just at the gates of paradise—a narrow gate which will, however, open wide in response to prayer and penitence—and a few members of the angelic choir who are joined by human souls as they themselves become angels and sing hymns to the glory of God.[215] Jewish illuminators made no attempt to compete with the grandiose liturgical and mystical descriptions of the celestial hierarchies created solely to stand around the divine throne and proclaim the royalty and sanctity of the lord of the world, which was itself recalled each day in prayer.

389

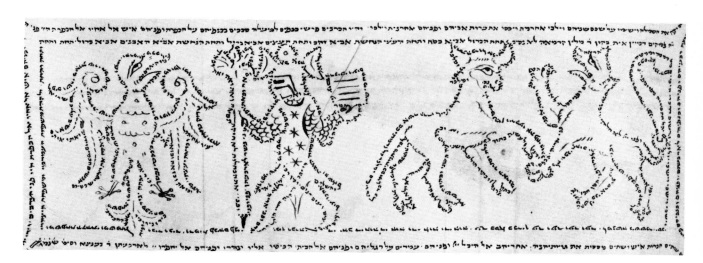

## Death and the World Beyond

Pictures are of no great help to us in reconstituting a continuous frieze of the *olam ha-ba*, the beyond, or of the events marking the end of time. A few glimpses are all that we are given.

Opinions differed on where souls dwelt after death. Did they await the last judgement in the tomb? Were the souls of the just set aside in a 'treasury'? Was there an immediate personal judgement which gave the joys of paradise to the just without delay and sent the unjust to expiate their sins in Gehenna? What were the places of delight and torment like? Subjects of debate for each generation of theologians and a source of hope and anguish for the body of the faithful, these questions found an abundance of answers with a wealth of imaginative elaborations in midrashic tradition and in legend. In this respect medieval Jewish iconography differs from Christian iconography in that it leaves us with no idea about the torments of the damned and gives us no more than a glimpse of the infinite joy of the just.

Paradise, expressly created as a dwelling for the righteous, was seen as the most important creation of the third day. But there were various traditions about its nature and location. For some, it was situated in the third heaven and was distinct from the celestial Eden which was even more blessed and to be found in the seventh heaven or even higher. For others, the celestial Eden was also in the third heaven, next to paradise or combined with it, both divided into sections reserved for different categories of the just, for example proselytes, martyrs, penitents, those with perfect faith, patriarchs, the kings of Israel, Elijah, and the Messiah. A picture from around 1300 sketches two of these divisions of the celestial Eden awaiting the souls of the just. [216]

The celestial Eden was therefore different from the garden planted on the confines of the earth and sky, where Adam dwelt before the Fall and which a man's soul had to cross before arriving at its celestial home. Yet though always situated in the heavens, paradise still has all the characteristics of the garden of Eden: not only the freshness of its breezes, its incomparable perfumes, its running streams, its vegetation, but above all the tree of life planted at its centre. This protects the whole completely with its gigantic leaves, while from its roots spurt the four miraculous rivers, of milk, honey, oil and wine. The three separate trees seen in a miniature of the second quarter of the thirteenth century [217] are no more than an evocation of Paradise allowing us to imagine it as we will, but a fifteenth-century Italian illuminator has left us his own explicit vision: a stream, shady glades, inoffensive animals and a cruel monster lying down together as they did before the Fall. [218]

Paradise was also confused with the celestial Jerusalem. Established in the fourth heaven, it was built entirely of pearls and gems irradiated by the light of the divine presence; in the temple, the archetype of the terrestrial Temple, which rose in its centre, the souls of the just were daily offered up in sacrifice.

271

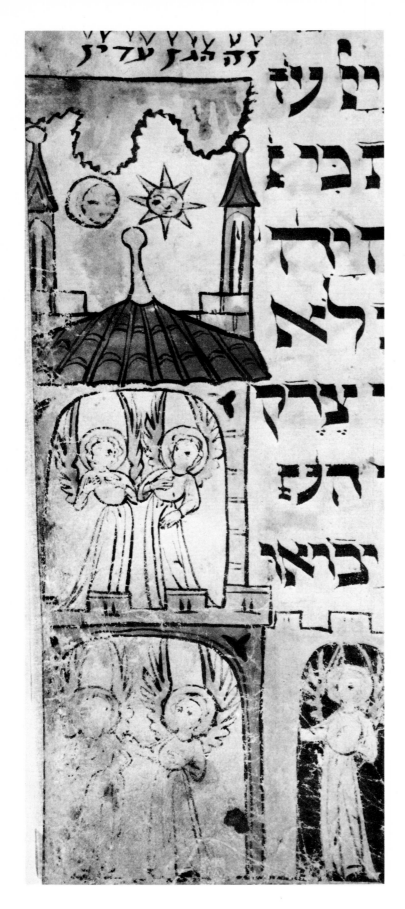

389 The entry of the just into paradise, as seen by a Jewish illuminator of the Rhineland, *c.* 1300. The just, three men wearing Jewish hats (not pictured), approach the 'gate of the Lord' (Psalms CXVIII:20), which takes the form of a crenellated porch with superimposed bays under a tiled pinnacled roof. On the threshold of the 'narrow gate' into paradise the just are awaited, not by the mortal flame of the cherub's fiery sword, but by a welcoming angel. Other angels, each with a halo like that of the angel guarding the gate—an evident borrowing from Christian iconography—seem to be waiting for the just as they extol divine glory. Like the terrestrial world, paradise, situated in the third heaven, is lit by the sun and the moon which themselves dwell in the fourth heaven.
Jerusalem, Israel Museum, Bird's Head Haggada, folio 33 recto (detail).

However, illuminators were rarely tempted to record in pictures of the ideal city even a few reflections of this vision of splendour.[219] Yet it is surely from this dream of the celestial Jerusalem that the vision emerged of heaven as an ideal city enclosed within its ramparts, overtopped by towers, roofs and gables, and pierced by monumental gates, which, as we have seen, when open symbolized divine mercy.[220] 391 393

However imagined, the fate of the soul after death was not definitive, for at the end of time the dead had to be resurrected for the day of judgement. Then would the just be confirmed in their bliss and the sinners, apart from those guilty of inexpiable crimes, pardoned and admitted to paradise.

Resurrection and the Messianic Age

Despite the problems it raised for philosophers, the resurrection of the dead, with the body and soul united in responsibility for their actions, was an article of faith for the medieval Jew who daily, on awakening, gave thanks to 'the Eternal who gives back his soul to the dead'. Resurrection was inevitably linked to the other great hope of Jews, the coming of the Messiah to restore and redeem Israel, and it was counted among the miracles that

390 The tree of life, symbol of the *Tora*, illustrated at the beginning of an Italian Hebrew Bible copied in Rome in 1287. The tree rises to the stars, guarded by two facing lions 'passant', and with birds perched on each of its branches. After the reading of the Law in the synagogue service the congregation chanted, 'She is a tree of life to those who grasp her' (Proverbs III:18).
Vatican, Biblioteca Apostolica, Cod. Vat. ebr. 9, folio 102 verso.

391 The messianic Jerusalem, seen by a fourteenth-century Italian illuminator, at the beginning of the Book of Isaiah, as an echo of his prophecy. The elegant architecture of the arcaded pavilions with their conical roofs or ribbed domes standing inside their ramparts are given an air of ethereal and radiant splendour befitting the vision, by means of delicate colouring and the very fine tracery of gilded decoration covering the whole.
London, British Library, MS. Add. 11657, folio 171 verso (detail).

392 'Blessed be He who spoke and the world came into being' *(barukh ▷ she'amar...)*. These words of the morning prayer inspired, in an Italian manuscript of the 1470s, a depiction of the garden of Eden: we are shown a field of flowers watered by a stream where deer, hare, peacock, swans and a fantastic bird rest, graze, peck, drink, swim and leap. Among the tree trunks and in the shadow of their boughs, a dragon glides without alarming the peaceful denizens of the garden. The composition, a precious and fragile vision, is sketched in delicate colours on a purple ground, as if on coloured glass, and seems to float in its sombre vividness.
Jerusalem, Israel Museum, Ms. Rothschild 24, folio 84 recto.

390

391

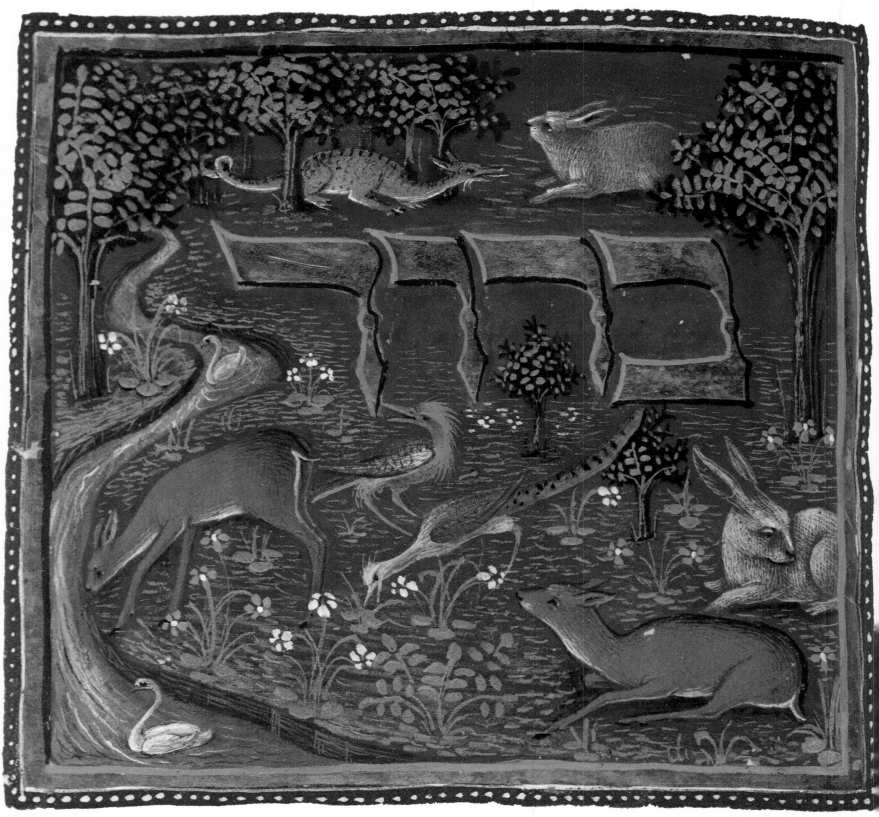

392

393

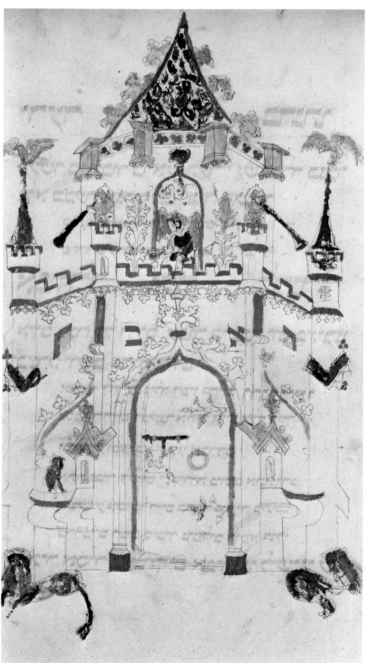

394

395

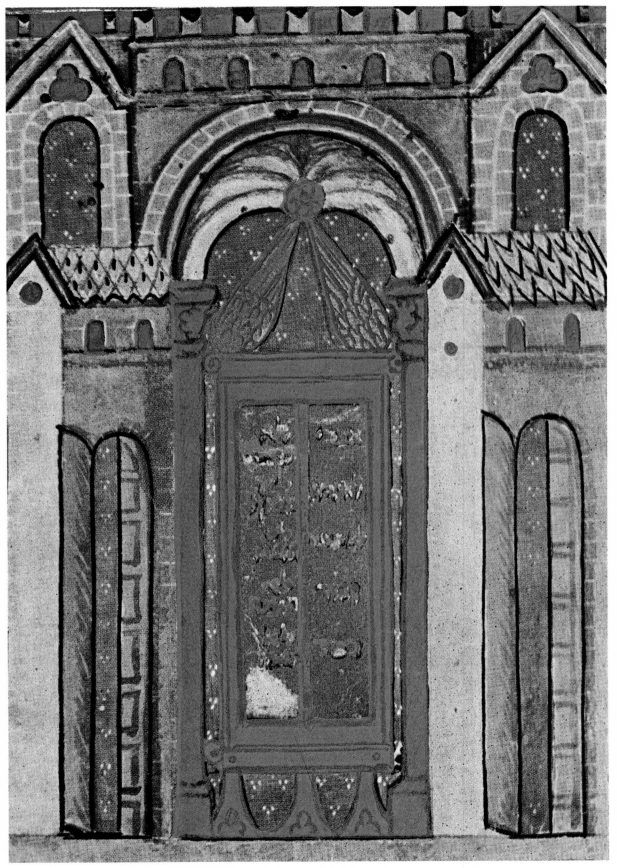

396

would mark that exceptional time. Some held that only the generation witnessing his coming would live through the blessed age of the Messiah, [221] whereas resurrection would only happen at the last judgement. Others thought that the resurrection would inaugurate the messianic age, when at the call of the *shofar* of Elijah, the herald of the king who 'comes... just and having salvation, lowly, and riding upon an ass'

(Zechariah IX:9), the dead would rise from their tombs; [222] in this picture the Messiah himself sounds the rally for the scattered and awakens the dead, while Elijah only leads him. In this case, the Everlasting will 'have brought... again from the people' (Ezekiel XXXIX:27) all the generations of Israel, the scattered and persecuted of all ages, to Jerusalem, the holy city now restored, to share the joys of those days of peace and glory. For God's people, pardoned because of their fidelity to the Law throughout the worst trials of exile, would know at last, as a rose  394 disentangled from the thorn thicket or the deer escaped from the chase, [223] the unmingled joys of divine election.

Why should it be that the day of terror, so suited to inspire an artist's imagination (as it did in Christian art), the day of judgement, become a taboo subject for our medieval illuminators? At least we are drawn to this conclusion from our illustrated manuscripts, and that despite all the rich development of this theme in Jewish tradition and legend. Was it to make quite clear their distance from the great Christian eschatological vision with its glorification of the deified Messiah appointed supreme judge? That is not impossible. But it is certain too that the day of judgement had not the exceptional character in Jewish religious and moral life that it had for the Christians. It was no more than a final manifestation, as history came to an end, of divine justice and mercy which was operating continuously in this world with individuals as with nations, and in a more formal manner with Israel each year from *rosh ha-shana* to *yom kipur*. Insofar as the illuminators of Jewish manuscripts did not shrink entirely from depicting the end of time, their imagination took them beyond the judgement to dwell on the bliss of the just in paradise. It is expressed symbolically in a thirteenth-century German miniature [224] by the image of the banquet provided for all the just as they enter paradise. Seated under trees, wearing golden crowns, they partake of the flesh of the mythical monsters, that is to say the *ziz*, Leviathan and *behemot*, who represent the three great animal orders created and reserved, according to talmudic legend, specifically for this last repast before a wholly spiritual beatitude.

◁ 393  The gates of Heaven: a German vision of the first half of the fifteenth century. At the end of *yom kipur*, the Feast of Forgiveness, judgement is pronounced and 'the gates of mercy' *(sha'arey raḥamim)* close, having been open all day. The medieval artist imagined the gates of Heaven as the gates of a fortified town, with buttresses, crenellated walls and turrets, pinnacles and belfries, bays, a pierced gallery, a gable and carved decoration in the flamboyant Gothic style. Lions guard the entrance, and birds perch on the towers. Through the lateral windows, angels sound loud trumpets. Over the closed doorway, through the great window of the central building, sky and stars can be seen, and an angel who holds the sealed decree.
Budapest, Hungarian Academy of Sciences, Ms. A 387, folio 417 recto.

◁ 394  Two images symbolic of the dramatic destiny of Israel among the nations: as the chosen people beloved of God, it is the rose of the valley (Song of Songs II:2, recalled at the beginning of the *piyyuṭ* of the *musaf* of *kipur*, *shoshan emeq*), and the faithful hart or hind; but as the rose is surrounded by thorns and the exhausted hart 'gone without strength before the pursuer' (Lamentations I:6), so is Israel ceaselessly a prey to persecution (Germany, *c.* 1325).
Oxford, Bodleian Library, MS. Mich. 619, folio 201 recto.

◁ 395  The Temple and its cult, in a Spanish picture of 1366–82. Transposed into a visionary realm by the unearthly brilliance of the gold ground, the objects portrayed evoke the vanished Temple whose restoration was awaited. A broad portico with angle pavilions represents the building itself; the musical instruments, trumpets and biblical *shofarot*, on the one hand, the contemporary psalterion, portable organ, viols and lutes, on the other, represent the solemn performance of the cult to the sound of the chants and instruments of the Levites; the enormous jar of manna and the long flowering rod that dominate the picture, also set aside with the ark until the advent of the messianic age, are made symbols of hope for the restoration.
Jerusalem, Sassoon Collection, Farḥi Bible, p. 186.

396  The messianic Temple, in a Spanish *Haggada*, 1350–60. Symbol of the awaited deliverance, anticipation of which was made more intense by each wave of persecutions, the Temple is given its most direct expression in this unique picture. Behind the details of its architecture, which are Spanish in style (battlements, lobed openings, double-pitch tiled roofs, round-headed doors, ribbed vault), we find the general structure of the building described in biblical texts, Ezekiel, the Book of Kings, and Chronicles: the high central hall with its flat roof and long windows, flanked by storeyed chambers, and its monumental porch with two tall pillars of bronze. The inner sanctuary is open right to the back, to the Holy of Holies, to disclose the open ark, and within it, beneath the wings of the cherubim sloping to meet each other, the two tablets of the Law. It is the importance given to the tablets in the ark that gives the picture its eschatological meaning: they disappeared during the destruction of the first Temple, and were to reappear in the restored Temple of the messianic age.
Sarajevo, National Museum, Haggada, folio 32 recto.

## The Restoration of the Temple

The most ardent eschatological hope, however, and the most peculiarly Jewish, was the return of the *shekhina*, the divine presence, to the dwelling it had chosen, the Temple of

397 The seven-branched lampstand and the two olive trees of Zechariah's vision: 'those seven ... are the eyes of the Lord, ranging over the whole earth' (Zechariah IV:10).
Budapest, Hungarian Academy of Sciences, Ms. A 77/III, sketch taken from folio 3 verso.

Jerusalem, miraculously rebuilt so that all the nations should come to acknowledge the sovereignty of the One God.

In Italy, from the thirteenth to the fifteenth century, expression of this expectation was confined to a symbolic image of a monumental seven-branched lampstand. [225]

Pictures of the lampstand alone are also found in Ashkenazi manuscripts during the thirteenth and the first half of the fourteenth century, [226] but there is more than one allusion to the re-establishment of the cult in the form of a picture of Aaron beside the lampstand tending the flames of the lamps, a ritual gesture which began and ended the ritual of the cult each day. [227]

397 A single picture in a late thirteenth-century *Mishne Tora* probably from the Rhineland, [228] has a more obvious eschatological symbol to offer. We are shown the cult lampstand with its characteristic details, but the two leafy trees growing from the side legs of the base make it the lampstand of the vision of Zechariah which appeared between two olive trees. Its seven lights are an image of the spirit of God watching over the world (Zechariah IV). [229]

In Spain, more complex and impressive images were used between the thirteenth and the fifteenth century to symbolize this tenacious hope. They seem to have been conceived of originally as a visual memento of the cult furnishings of the Wilderness Tabernacle, but they were subsequently enriched by signs to reveal their new function. An inscription bearing the text of the daily entreaty for the rebuilding of the Temple at first appeared sufficient. [230] Then came motifs giving clearer reference to the Temple: the golden vine of its vestibule, [231] the
395 musical instruments of the Levites, [232] the *yakhin* and *boaz* bronze pillars of its porch. [233] The most frequently used motif, however, was the Mount of Olives; a neighbour of the mount of the Temple, and itself the site where certain essential rites such as the immolation of the red heifer were performed, it left no doubt as to the identity of the sanctuary to which thought should be directed. [234]

This motif was at first so small and placed in such a secondary position in any composition that it seems difficult to allow that it served any effective symbolical role for the eschatalogical hopes of manifestation of divine power, the appearance of the Messiah and the resurrection of the dead which prophetic texts and the *midrash* situate on the Mount of Olives. This became possible when it became more prominent and when it was accompanied by a biblical quotation (Zechariah XIV:4) which itself is charged with these same hopes. [235]

Expectation of the rebuilding of the Temple is unequivocally expressed in a few motifs combined in isolated illustrations [236] or included in traditional images. [237] They evoke the building itself, associated with the Ark of the Covenant and the Tables of the 396 Law, or with the flowering rod and jar of manna which were all 395 objects preserved in the Holy of Holies and intimately linked with the existence of the Temple. They were to reappear only in the messianic Temple, having been providentially hidden when the Temple of Solomon was destroyed.

While waiting for the day of bliss, with a daily prayer that it might arrive 'soon and in [their] time', the most pious of the Jews were driven by their yearning to face the myriad difficulties of the pilgrimage to Zion, to weep over the ruins of the sanctuary. By land and by sea, 'placing their joy', like the great poet and thinker Judah Ha-Levi (before 1075–1141), 'in the burning desire of their hearts', they hastened to 'Canaan, to the most precious of mountains' to 'embrace the stones of Zion' and 'mingle [their] tears with its dust... sweeter to the tongue than honey'. It was a coveted fate to end one's days in the land of promise and to be buried among those who would be the first, on the day of resurrection, to see the miraculously restored Temple.

278

# Conclusion

If this investigation appeared to us as legitimate and worthwhile, has it been justified by the results? We think that it has, especially when the scarcity of our sources is taken into consideration.

We do not wish, however, to conceal either from ourselves or our readers the disproportion that remains between our booty and the profusion of information on material civilization, domestic, social, professional and religious life, which is lavished on the historian by occidental illumination of the same period.

We can, of course, be tempted to attribute the gaps in our information to the destruction of documents and to reflect that if they had come down to us intact, Jewish illumination would likewise satisfy our curiosity in all these fields.

However, some aspects of what has been left for us of Jewish illumination makes us think, rather, that seen in its totality, it would not differ fundamentally from what we do know of it. Chance destruction does not seem to be responsible for the small number of images in secular or rather semi-secular books, since neither history, law nor science were then dissociated from religion. Far from considering decoration and image as a desecration of their liturgical books, rituals and even Bibles, the Jews of the Middle Ages seem, on the contrary, to have added them as a mark of reverence and to have taken pains to embellish in this way books whose contents made them their most precious possessions.

It was apparently by deliberate choice that medieval Jews did not seek more occasions to leave some figurated allusion to his own history, the events of his own time and the leading personalities of social and religious life, or to portray the relations of his community with civil and ecclesiastical authorities. Beyond the 'accidents' of contemporary history, one story alone appeared worthy to be told in pictures, that of the patriarchs, timeless and exemplary, which prefigured all history. Deliberate choice again lies behind the rejection of the anecdotal and ephemeral side of daily life as a subject for images: the medieval Jew restricted himself to portraying only the gesture associated with a rite and reduced the accessories to a minimum.

Not without some misgivings, we have more or less forced our images to provide us with information that they were not designed to give, to supply us with evidence on what they wanted to ignore. Quite apart from the fruits of our quest and their own intrinsic interest, we feel that our 'in depth' inquiry has produced a valuable testimony on some hitherto unappreciated aspects of the Jewish mentality in the Middle Ages. Far from revealing a group isolated in an unshakeable singularity (which would explain why the larger encompassing society rejected it), these pictures, seen from the point of view of everyday life, present us with a community of men who, as far as material civilization and material culture were concerned, appear totally integrated into the environment in which it was implanted, distinguishing itself only by its religious thought and practices.

This impression is further reinforced by the medieval Jew's portrayal of himself in the figures of his Hebrew and Israelite ancestors, or the contemporary figures of the faithful carrying out religious ceremonies. Nothing distinguished Jew from gentile in physical type. The medieval Jew did not see himself as different from his non-Jewish neighbors and did not seek to be different. It is remarkable that the humiliating condition imposed upon him did not lead to a desire to gain revenge by portraying in caricature his persecutors, Pharaoh and his counsellors or Haman, both figures symbolic of all oppressors. He was not tempted to vilify, even his cruelest enemies, the creature made in the image of his Creator.

Our inquiry has already been sufficiently justified if we have been successful in confronting with the serene mirror of Jewish art, the biased and partial picture, humiliating and hateful, given of the medieval Jew, his person, life and religion, by the distorting mirror of Christian art [1] in the last centuries of the Middle Ages.

---

[1] Cf. B. Blumenkranz, *Le Juif médiéval au miroir de l'art chrétien*, Paris, 1966.

# Notes

Names of libraries are given in abbreviated form. Complete names will be found in the catalogue of the manuscripts.

When a note contains references to different manuscripts, whether they are of different geographic origin or all from the same place, they are generally listed in chronological order.

When a single note contains several references to manuscripts of the same origin, they are grouped by geographical area, and within each area the references appear in chronological order, the first group generally containing the earliest documents.

Exceptions to these rules occur only when the text itself imposes a different sequence.

## CHAPTER I

1 The two themes, Creation and the appearance of the divine glory, are expressly associated at the beginning of Book III of Maimonides' *More Nevukhim, The Guide of the Perplexed*, and inspired a fine illustration placed at the beginning of the book in a copy made in an Ashkenazi country in the 14th century. This full-page illustration brings together the celestial vault and the stars, the four elements, the animals of the Garden of Eden, the Fall and the four creatures of the vision, which are seen supporting the divine chariot. Unfortunately it is not known in which collection this manuscript is now to be found. We have only photographs of it, too poor in quality for reproduction. We are mentioning this illustration because of its importance, and in the hope that some alert and well-informed reader may be able to help us to locate it.

2 Sarajevo, Nat. Mus., Haggada, fol. 1v and 2r.

3 Parma, Bibl. Pal., Ms. Parm. 2151–De Rossi 3, fol. 1r; London, Brit. Libr., MS. Harl. 5710, fol. 1r.

4 Sarajevo, Nat. Mus., Haggada, fol. 1v and 2r; Venice, Mus. Ebr., Bible, fol. 23r.

5 London, Brit. Libr., MS. Add. 11639, fol. 517r; Milan, Bibl. Ambr., Ms. B. 32. Inf., fol. 135v; Jerusalem, Isr. Mus., Ms. 180/52, known as the Regensburg Bible, fol. 154v; Jerusalem, Schocken Inst., Ms. 14940, known as the Schocken Bible, fol. 1v; Hamburg, St.- u. Univ.-Bibl., Cod. hebr. 37, fol. 1r; Sarajevo, Nat. Mus., Haggada, fol. 2r; Imola, Bibl. Com., Bible, fol. 13v.

6 London, Brit. Libr., MS. Add. 11639, fol. 517r; Milan, Bibl. Ambr., Ms. B. 32. Inf., fol. 135v; Budapest, Ac. Sc., Ms. A 77/III, fol. 81r; Dresden, Sächs. Land.-Bibl., Ms. A 46ᵃ, fol. 202v; Sarajevo, Nat. Mus., Haggada, fol. 2r; Jerusalem, Schocken Inst., Ms. 24087, known as 2nd Nuremberg Haggada or Nuremberg Haggada II, fol. 35r (Genesis XXXII: 32).

7 Sarajevo, Nat. Mus., Haggada, fol. 2r.

8 Lisbon, Bibl. Nac., Ms. Il. 72, fol. 239v; Jerusalem, Coll. Sassoon, Ms. 82, known as *Shem tov* Bible, p. 244; and, for example, Oxford, Bodl. Libr., MS. Mich. 617, fol. 26r; Jerusalem, Jew. Nat. Univ. Libr., Ms. Heb. 49781/I, known as Worms Maḥzor/I, fol. 64v; Oxford, Bodl. Libr., MS. Laud. Or. 321, fol. 57v; Leipzig, Univ.-Bibl., Ms. V 1102/I, fol. 59r; Jerusalem, Schocken Inst., Ms. 13873, fol. 76v; Parma, Bibl. Pal.,

Ms. Parm. 1756–De Rossi 236, fol. 93r; Jerusalem, Jew. Nat. Univ. Libr., Ms. Heb. 8° 5572, fol. 60r.

9 Oxford, Bodl. Libr., MS. Mich. 617, fol. 49v, 50v; Jerusalem, Jew. Nat. Univ. Libr., Worms Maḥzor/I, fol. 96r and v; London, Brit. Libr., MS. Add. 22413, fol. 139r; Budapest, Ac. Sc., Ms. A 384, fol. 143r.

10 Oxford, Bodl. Libr., MS. Laud. Or. 321, fol. 89v, 90r, 325r and v; Dresden, Sächs. Land.-Bibl., Ms. A 46ᵃ, fol. 132v. In the Oxford manuscript, the facial features may have been scratched out.

11 Dresden, Sächs. Land.-Bibl., Ms. A 46ᵃ, fol. 132v.

12 Wrocław, Univ. Lib., Or. Ms. I, 1, fol. 264v.

13 London, Brit. Libr., MS. Add. 26896, fol. 153v.

14 Jerusalem, Jew. Nat. Univ. Libr., Worms Maḥzor/I, fol. 97v.

15 Dresden, Sächs. Land.-Bibl., Ms. A 46ᵃ, fol. 134r.

16 London, Brit. Libr., MS. Add. 22413, fol. 141v; Budapest, Ac. Sc., Ms. A 384, fol. 145r; Wrocław, Univ. Libr., Or. Ms. I, 1, fol. 266r.

17 Oxford, Bodl. Libr., MS. Mich. 617, fol. 51r; Oxford, Bodl. Libr., MS. Laud. Or. 321, fol. 91r, 326r; Oxford, Bodl. Libr., MS. Opp. 161, fol. 64r; Leipzig, Univ.-Bibl., Ms. V 1102/I, fol. 87r; London, Brit. Libr., MS. Add. 26896, fol. 155v.

18 London, Brit. Libr., MS. Add. 22413, fol. 139v; Budapest, Ac. Sc., Ms. A 384, fol. 143r.

19 Oxford, Bodl. Libr., MS. Opp. 161, fol. 63r.

20 London, Brit. Libr., MS. Add. 22413, fol. 142r.

21 Oxford, Bodl. Libr., MS. Laud. Or. 321, fol. 91r, 326r.

22 Dresden, Sächs. Land.-Bibl., Ms. A 46ᵃ, fol. 134r.

23 Jerusalem, Jew. Nat. Univ. Libr., Worms Maḥzor/I, fol. 97r.

24 Oxford, Bodl. Libr., MS. Opp. 161, fol. 34r, 64r.

25 Oxford, Bodl. Libr., MS. Mich. 617, fol. 50v.

26 *Ibid.*, fol. 51r; Jerusalem, Jew. Nat. Univ. Libr., Worms Maḥzor/I, fol. 97v; London, Brit. Libr., MS. Add. 22413, fol. 142r; Budapest, Ac. Sc., Ms. A 384, fol. 145r; Leipzig, Univ.-Bibl., Ms. V 1102/I, fol. 87r and Ms. B.H. 3, fol. 9v; Wrocław, Univ. Libr., Or. Ms. I, 1, fol. 266v; Dresden, Sächs. Land.-Bibl., Ms. A 46ᵃ, fol. 134v; Oxford, Bodl. Libr., MS. Opp. 161, fol. 64v.

27 Oxford, Bodl. Libr., MS. Laud. Or. 321, fol. 91r, 326r.

28 Oxford, Bodl. Libr., MS. Mich. 617, fol. 51r;

Jerusalem, Jew. Nat. Univ. Libr., Worms Maḥzor/I, fol. 97v; Budapest, Ac. Sc., Ms. A 384, fol. 145r; Leipzig, Univ.-Bibl., Ms. V 1102/I, fol. 87r; Dresden, Sächs. Land.-Bibl., Ms. A 46ᵃ, fol. 134v.

A slightly older Zodiac, from the second quarter of the 13th century, and obviously of northern French origin (Amsterdam, Jew. Hist. Mus., Ms. Inv. no. 1, fol. 45r to 47r), lacks the unusual deformed faces and animal heads, but presents the same typical motif of the well (though dissociated in this case from the goat) and an equal ignorance to the crab and scorpion.

29 Oxford, Bodl. Libr., MS. Opp. 161, fol. 84r.

30 Jerusalem, Jew. Nat. Univ. Libr., Worms Maḥzor/I, fol. 95v–97v; Budapest, Ac. Sc., Ms. A 384, fol. 142v–145v.

31 Munich, Bayer. St.-Bibl., Cod. hebr. 3/II, fol. 280v–288r.

32 *Ibid.*, fol. 282v.

33 *Ibid.*, fol. 287r.

34 *Ibid.*, fol. 285v.

35 Paris, Bibl. Nat., ms. hébr. 1181, fol. 264v.

36 Bologna, Bibl. Univ., Ms. 2197, fol. 6v–7r.

37 *Ibid.*, fol. 7r.

38 Jerusalem, Jew. Nat. Univ. Libr., Worms Maḥzor/I, fol. 97r; Budapest, Ac. Sc., Ms. A 384, fol. 145r.

39 New York, Jew. Theol. Sem. Amer., MS. Acc. No. 03225, known as Rothschild MS. II, fol. 5r.

40 Sarajevo, Nat. Mus., Haggada, fol. 5v; New York, Jew. Theol. Sem. Amer., MS. Acc. No. 02922, fol. 84r.

41 New York, Jew. Theol. Sem. Amer., MS. Acc. No. 02922, fol. 84v.

42 Oxford, Bodl. Libr., MS. Opp. 14, fol. 9v; Paris, Bibl. Nat., ms. hébr. 642, fol. 41r; Cambridge, Univ. Libr., MS. Add. 468, fol. 6r; Cambridge, Univ. Libr., MS. Add. 437, fol. 94v.

43 London, Brit. Libr., MS. Add. 22413, fol. 3r; Sarajevo, Nat. Mus., Haggada, fol. 30r; Jerusalem, Jew. Nat. Univ. Libr., Ms. Heb. 8° 4450, fol. 203v; New York, Jew. Theol. Sem. Amer., MS. Rothschild II, fol. 139r.

44 E.g.: London, Brit. Libr., MS. Or. 2737, fol. 76v; London, Brit. Libr., MS. Add. 27210, fol. 13r; Manchester, J. Ryl. Univ. Libr., MS. Ryl. Hebr. 6, fol. 17r; Sarajevo, Nat. Mus., Haggada, fol. 25v; Budapest, Ac. Sc., Ms. A 422, fol. 5v; London, Brit. Libr., MS. Harl. 5686, fol. 60r; Cincinnati, Hebr. Un. College, Haggada, fol. 23v.

45 Oxford, Bodl. Libr., MS. Opp. 154, fol. 46v.

46 Jerusalem, Isr. Mus., Ms. 180/51, known as Ms. Rothschild 24, fol. 382r.

47 Dublin, Trinity College Libr., MS. 16, fol. 76v.

48 Paris, Bibl. Nat., ms. hébr. 20, fol. 13r; London, Brit. Libr., MS. Add. 27210, fol. 2v; London, Brit. Libr., MS. Or. 2884, fol. 2v; New York, Jew. Theol. Sem. Amer., MS. Acc. No. 02922, fol. 84v.

49 London, Brit. Libr., MS. Add. 27210, fol. 2v; London, Brit. Libr., MS. Or. 2884, fol. 1v.

50 E.g.: Dublin, Trinity College Libr., MS. 16, fol. 68v; London, Brit. Libr., MS. Or. 2737, fol. 71v, 79v; London, Brit. Libr., MS. Add. 27210, fol. 12v, 13r; London, Brit. Libr., MS. Or. 2884, fol. 14r, 15v; Sarajevo, Nat. Mus., Haggada, fol. 23v, 25v.

51 Sarajevo, Nat. Mus., Haggada, fol. 3r of the text; Jerusalem, Isr. Mus., Ms. Rothschild 24, fol. 220r, 228v; Jerusalem, Isr. Mus., Ms. 180/55, fol. 4v, 134v.

52 Paris, Bibl. Nat., ms. hébr. 15, fol. 374v.

53 Oxford, Bodl. Libr., MS. Can. Or. 79, fol. 2v.

54 Jerusalem, Schocken Inst., 2nd Nuremberg Haggada, fol. 39r; Jerusalem, Isr. Mus., Ms. 180/50, known as Yahuda Haggada, fol. 38r.

55 Berlin, St.-Bibl., Preuss. Kulturbes., Orientabt., Ms. Ham. 81, fol. 410v.

56 Sarajevo, Nat. Mus., Haggada, fol. 23v.

57 Bologna, Bibl. Univ., Ms. 2197, fol. 78r; New York, Jew. Theol. Sem. Amer., MS. Rothschild II, fol. 5r.

58 Lisbon, Bibl. Nac., Ms. Il. 72, fol. 442v.

59 E.g.: Lisbon, Bibl. Nac., Ms. Il. 72, fol. 29v, 439r; Parma, Bibl. Pal., Ms. Parm. 1870–De Rossi 510, fol. 214v; Budapest, Ac. Sc., Ms. A 77/IV, fol. 70r; Jerusalem, Jew. Nat. Univ. Libr., Ms. Heb. 8° 4450, fol. 2r.

60 Lisbon, Bibl. Nac., Ms. Il. 72, fol. 442v.

61 London, Brit. Libr., MS. Add. 11639, fol. 332v.

62 Darmstadt, Hess. Land.- u. Hochschulbibl., Cod. or. 8, fol. 25v, 51v; Vatican, Bibl. Apost., Cod. Rossian. 498, fol. 13v; Paris, Sém. Isr., ms. 1, fol. 352r.

63 London, Brit. Libr., MS. Or. 2091, fol. 338r.

64 Lisbon, Bibl. Nac., Ms. Il. 72, fol. 437r.

65 Jerusalem, Schocken Inst., 2nd Nuremberg Haggada, fol. 3r; Jerusalem, Isr. Mus., Yahuda Haggada, fol. 2v.

66 Lisbon, Bibl. Nac., Ms. Il. 72, fol. 328v.

67 Berlin, St.-Bibl., Preuss. Kulturbes., Orientabt., Ms. or. fol. 1212, fol. 96v; Parma, Bibl. Pal., Ms. Parm. 1870–De Rossi 510, fol. 76r; Oxford, Bodl. Libr., MS. Can. Or. 79, fol. 2v.

68 Parma, Bibl. Pal., Ms. Parm. 1870–De Rossi 510, fol. 126r; Lisbon, Bibl. Nac., Ms. Il. 72, fol. 437v.

69 Paris, Bibl. Nat., ms. hébr. 20, fol. 2r; Rome, Bibl. Casan., Ms. 3010, fol. 187v.

70 Imola, Bibl. Com., Bible, fol. 78v.

71 Paris, Bibl. Nat., ms. hébr. 42, fol. 193v; Jerusalem, Isr. Mus., Ms. Rothschild 24, fol. 213v, 214v, 231r.

72 Jerusalem, Isr. Mus., Ms. Rothschild 24, fol. 65r.

73 Oxford, Bodl. Libr., MS. Can. Or. 137, fol. 220v; Vatican, Bibl. Apost., Cod. Urbin. ebr. 1, fol. 268v.

74 Lisbon, Bibl. Nac., Ms. Il. 72, fol. 31v, 147r, 441v; Oxford, Bodl. Libr., MS. Opp. 154, fol. 42v, 47v; Jerusalem, Isr. Mus., Ms. Rothschild 24, fol. 352v, 357v.

75 Lisbon, Bibl. Nac., Ms. Il. 72, fol. 248v, 437r.

76 Lisbon, Bibl. Nac., Ms. Il. 72, fol. 445r; Paris, Bibl. Nat., ms. hébr. 1203, fol. 45v.

77 Parma, Bibl. Pal., Ms. Parm. 1870–De Rossi 510, fol. 96r; Lisbon, Bibl. Nac., Ms. Il. 72, fol. 438v; Jerusalem, Isr. Mus., Ms. Rothschild 24, fol. 163v.

78 Jerusalem, Isr. Mus., Ms. Rothschild 24, fol. 164r.

79 Parma, Bibl. Pal., Ms. Parm. 1870–De Rossi 510, fol. 13r.

80 London, Brit. Libr., MS. Add. 11639, fol. 352v; Rome, Bibl. Casan., Ms. 2898, fol. 111v; Budapest, Ac. Sc., Ms. A 422, fol. 19v, 37v; Budapest, Ac. Sc., Ms. A 278, fol. 1r; Bologna, Bibl. Univ., Ms. 2197, fol. 2r; London, Brit. Libr., MS. Add. 27167, fol. 419v.

81 Paris, Bibl. Nat., ms. esp. 30.

82 Parma, Bibl. Pal., Ms. Parm. 1870–De Rossi 510, fol. 68r.

83 Paris, Bibl. Nat., ms. hébr. 29, fol. 15v; Imola, Bibl. Com., Bible, fol. 166v; London, Brit. Libr., MS. Add. 27167, fol. 148v.

84 Leipzig, Univ.-Bibl., Ms. V 1102/II, fol. 184v.

85 Lisbon, Bibl. Nac., Ms. Il. 72, fol. 436v; Rome, Bibl. Casan., Ms. 2898, fol. 61r; London, Brit. Libr., MS. Add. 11639, fol. 292v; Paris, Bibl. Nat., ms. hébr. 4, fol. 5v; Wrocław, Ossolinski Libr.–Coll. Pawlikowski, Ms. 141, p. 379; Budapest, Ac. Sc., Ms. A 422, fol. 26r; London, Brit. Libr., MS. Add. 14761, fol. 17v; Oxford, Bodl. Libr., MS. Can. Or. 79, fol. 8v; Paris, Bibl. Nat., ms. hébr. 42, fol. 47r; Aberdeen, Univ. Libr., MS. 23, fol. 1v.

86 E.g.: London, Brit. Libr., MS. Or. 2737, fol. 70v; Sarajevo, Nat. Mus., Haggada, fol. 22r; Jerusalem, Schocken Inst., 2nd Nuremberg Haggada, fol. 15v.

87 Oxford, Bodl. Libr., MS. Opp. 14, fol. 73v.

88 E.g.: London, Brit. Libr., MS. Add. 27210, fol. 2v; Sarajevo, Nat. Mus., Haggada, fol. 3v; Jerusalem, Schocken Inst., 2nd Nuremberg Haggada, fol. 30v.

89 London, Brit. Libr., MS. Add. 11639, fol. 306v; Parma, Bibl. Pal., Ms. Parm. 1870–De Rossi 510, fol. 142v; Bologna, Bibl. Univ., Ms. 2197, fol. 78r.

90 Paris, Bibl. Nat., ms. hébr. 1314, fol. 17v; Parma, Bibl. Pal., Ms. Parm. 2809–De Rossi 187, fol. 6r.

91 London, Brit. Libr., MS. Add. 11639, fol. 227r; London, Brit. Libr., MS. Add. 26968, fol. 323r; Budapest, Ac. Sc., Ms. A 278, fol. 1r.

92 Dublin, Trinity College Libr., MS. 16, fol. 129v.

93 London, Brit. Libr., MS. Add. 11639, fol. 243r; Budapest, Ac. Sc., Ms. A 422, fol. 15v; Venice, Mus. Ebr., Bible, fol. 8v.

94 Venice, Mus. Ebr., Bible, fol. 7v; Bologna, Bibl. Univ., Ms. 2197, fol. 41r.

95 London, Brit. Libr., MS. Add. 11639, fol. 162r.

96 London, Brit. Libr., MS. Add. 11639, fol. 521r; Leipzig, Univ. Bibl., Ms. V 1102/I, fol. 131r; Munich, Bayer. St.-Bibl., Cod. hebr. 107, fol. 60v; London, Brit. Libr., MS. Or. 2737, fol. 69v; Oxford, Bodl. Libr., MS. Can. Or. 81, fol. 2r; Jerusalem, Isr. Mus., Ms. Rothschild 24, fol. 346v.

97 London, Brit. Libr., MS. Add. 11639, fol. 339r; Oxford, Bodl. Libr., MS. Can. Or. 137, fol. 220v; Wrocław, Ossolinski Libr.–Coll. Pawlikowski, Ms. 141, p. 794; Lisbon, Bibl. Nac., Ms. Il. 72, fol. 256r.

98 Lisbon, Bibl. Nac., Ms. Il. 72, fol. 428v.

99 London, Brit. Libr., MS. Add. 26968, fol. 322v; Jerusalem, Isr. Mus., Ms. Rothschild 24, fol. 243v.

100 Budapest, Ac. Sc., Ms. A 278, fol. 1r.

101 London, Brit. Libr., MS. Add. 11639, fol. 236r; Lisbon, Bibl. Nac., Ms. Il. 72, fol. 433v; Budapest, Ac. Sc., Ms. A 77/III, fol. 57r; New York, Priv. coll., form. Frankfurt/M., St.-Bibl., Ms. Ausst. 5, fol. 493v.

102 Oxford, Bodl. Libr., MS. Opp. 154, fol. 21v, 27v; Jerusalem, Isr. Mus., Ms. Rothschild 24, fol. 334r, 336r.

103 London, Brit. Libr., MS. Add. 11639, fol. 227r; Venice, Mus. Ebr., Bible, fol. 7v; Paris, Bibl. Nat., ms. hébr. 418, fol. 198r.

104 Vatican, Bibl. Apost., Cod. Urbin. ebr. 1, fol. 504r; Lisbon, Bibl. Nac., Ms. Il. 72, fol. 410v; Jerusalem, Isr. Mus., Ms. Rothschild 24, fol. 103r.

105 Paris, Bibl. Nat., ms. hébr. 20, fol. 2r.

106 Oxford, Bodl. Libr., Ms. Can. Or. 137, fol. 70v; London, Brit. Libr., MS. Add. 14761, fol. 20v; Oxford, Bodl. Libr., MS. Can. Or. 81, fol. 2r.

107 Lisbon, Bibl. Nac., Ms. Il. 72, fol. 305r.

108 London, Brit. Libr., MS. Add. 11639, fol. 281r.

109 London, Brit. Libr., MS. Add. 11639, fol. 338v.

110 London, Brit. Libr., MS. Add. 11639, fol. 166r; Paris, Bibl. Nat., ms. hébr. 4, fol. 5v; Jerusalem, Schocken Inst., Ms. 14940, fol. 128v; Jerusalem, Sassoon Coll., Ms. 506, known as De Castro Pentateuch, p. 665; Oxford, Bodl. Libr., MS. Mich. 619, fol. 201r; Hamburg, St.- u. Univ.-Bibl., Cod. Levy 19, fol. 97r; Paris, Bibl. Nat., ms. hébr. 1203, fol. 45v.

111 Vatican, Bibl. Apost., Cod. Urbin. ebr. 1, fol. 146r.

112 Rome, Bibl. Casan., Ms. 2898, fol. 55r.

113 Budapest, Ac. Sc., Ms. A 77/I, fol. 46v; Oxford, Bodl. Libr., MS. Kenn. 1, fol. 7v.

114 Vatican, Bibl. Apost., Cod. Vat. ebr. 9, fol. 3r; Lisbon, Bibl. Nac., Ms. Il. 72, fol. 180v; Paris, Bibl. Nat., ms. hébr. 20, fol. 7v; London, Brit. Libr., MS. Add. 27210, fol. 12v.

115 Lisbon, Bibl. Nac., Ms. Il. 72, fol. 27v, 318v; Paris, Bibl. Nat., ms. hébr. 20, fol. 7r, 70r.

116 Vatican, Bibl. Apost., Cod. Urbin. ebr. 1, fol. 504r; Darmstadt, Hess. Land.- u. Hochschulbibl., Cod. or. 8, fol. 25v; Parma, Bibl. Pal., Ms. Parm. 1682–De Rossi 293, fol. 216r.

117 London, Brit. Libr., MS. Add. 27210, fol. 10v; Sarajevo, Nat. Mus., Haggada, fol. 21v; Budapest, Ac. Sc., Ms. A 422, fol. 59v.

118 London, Brit. Libr., MS. Add. 26968, fol. 238r; Jerusalem, Isr. Mus., Ms. Rothschild 24, fol. 65r.

119 Bologna, Bibl. Univ., Ms. 2197, fol. 7r.

120 London, Brit. Libr., MS. Add. 27210, fol. 2v.

121 Vatican, Bibl. Apost., Cod. Vat. ebr. 14, fol. 217r.

122 Vatican, Bibl. Apost., Cod. Vat. ebr. 14, fol. 59v.

123 Darmstadt, Hess. Land.- u. Hochschulbibl., Cod. or. 13, fol. 202v; Sarajevo, Nat. Mus., Haggada, fol. 16r; Oxford, Bodl. Libr., MS. Opp. 154, fol. 12r, 24r; Venice, Mus. Ebr., Bible, fol. 19v; Jerusalem, Schocken Inst., 2nd Nuremberg Haggada, fol. 20r; Jerusalem, Isr. Mus., Yahuda Haggada, fol 1v.

124 London, Brit. Libr., MS. Or. 2737, fol. 67v, 92r and v.

125 London, Brit. Libr., MS. Or. 2884, fol. 10v; Jerusalem, Schocken Inst., 2nd Nuremberg Haggada, fol. 19v.

126 Paris, Bibl. Nat., ms. hébr. 19, fol. 1r; Leipzig, Univ.-Bibl., Ms. V 1102/I, fol. 52r; London, Brit. Libr., Ms. Or. 2884, fol. 8r; London, Brit. Libr., MS. Harl. 5686, fol. 27v.;

127 Budapest, Ac. Sc., Ms. A 77/I, fol. 16v; Budapest, Ac. Sc., Ms. A 384, fol. 103v; Paris, Bibl. Nat., ms. hébr. 4, fol. 249v; Sarajevo, Nat. Mus., Haggada, fol. 27v; Jerusalem, Jew. Nat. Univ. Libr., Ms. Heb. 8° 4450, fol. 115v.

128 Vatican, Bibl. Apost., Cod. Urbin. ebr. 1, fol. 504r; Darmstadt, Hess. Land.- u. Hochschulbibl., Cod. or. 8, fol. 25v; Parma, Bibl. Pal., Ms. Parm. 2895–De Rossi 653, p. 255; Munich, Bayer St.-Bibl., Cod. or. 3/II, fol. 268r.

129 Vatican, Bibl. Apost., Cod. Vat. ebr. 9, fol. 31r; Parma, Bibl. Pal., Ms. Parm. 1870–De Rossi 510, fol. 13r, 17v; Milan, Bibl. Ambr., Ms. G.3. Sup., fol. 106v; Washington, D.C., Libr. of Congress, Haggada, fol. 15v.

130 London, Brit. Libr., MS. Add. 14761, fol. 20v; Oxford, Bodl. Libr., MS. Kenn. 1, fol. 6r.

131 Hamburg, St.- u. Univ.-Bibl., Cod. Levy 19, fol. 625r.

132 Jerusalem, Isr. Mus., Ms. Rothschild 24, fol. 103r.

133 Lisbon, Bibl. Nac., Ms. Il. 72, fol. 438v, 440v.

134 Oxford, Bodl. Libr., MS. Opp. 14, fol. 270v.

135 Vienna, Öst. Nat.-Bibl., Cod. Hebr. 16, fol. 226r; Paris, Bibl. Nat., ms. hébr. 5, fol. 119r; ms. hébr. 6, fol. 72v; Lisbon, Bibl. Nac., Ms. Il. 72, fol. 5v, 448v; Paris, Bibl. Nat., ms. hébr. 20, fol. 7v; Vatican, Bibl. Apost., Cod. Vat. ebr. 9, fol. 53v, 63r, 102v.

136 Wrocław, Ossolinski Libr.–Pawlikowski Coll., Ms. 141, p. 379.

137 Parma, Bibl. Pal., Ms. Parm. 1870–De Rossi 510, fol. 11v; Milan, Bibl. Ambr., Ms. G.3. Sup., fol. 106v; Parma, Bibl. Pal., Ms. Parm. 2032–De Rossi 613, fol. 80r; Budapest, Ac. Sc., Ms. A 278, fol. 3v; Lisbon, Bibl. Nac., Ms. Il. 72, fol. 6r, 118v; London, Brit. Libr., MS. Add. 14761, fol. 26r.

138 Wrocław, Ossolinski Libr.–Pawlikowski Coll., Ms. 141, p. 794.

139 Darmstadt, Hess. Land.- u. Hochschulbibl., Cod. or. 8, fol. 25v.

140 Vatican, Bibl. Apost., Cod. Vat. ebr. 9, fol. 98r; Lisbon, Bibl. Nac., Ms. Il. 72, fol. 443r.

141 Vatican, Bibl. Apost., Cod. Vat. ebr. 9, fol. 8r; Parma, Bibl. Pal., Ms. Parm. 2032–De Rossi 613, fol. 111v; Jerusalem, Isr. Mus., Ms. Rothschild 24, fol. 87r, 303v, 306r.

142 Jerusalem, Isr. Mus., Ms. Rothschild 24, fol. 235r.

143 Jerusalem, Isr. Mus., Ms. Rothschild 24, fol. 87r, 236r.

144 London, Brit. Libr., MS. Add. 11639, fol. 448r.

144a London, Brit. Libr., MS. Add. 21160, fol. 194r.

144b Darmstadt, Hess. Land.- u. Hochschulbibl., Cod. or. 13, fol. 236v.

145 Lisbon, Bibl. Nac., Ms. Il. 72, fol. 436v.

146 *Ibid.*, fol. 258v, 326r.

147 Jerusalem, Isr. Mus., Ms. Rothschild 24, fol. 358v.

148 Milan, Bibl. Ambr., Ms. B.31. Inf., fol. 30v; Ms. B.32. Inf., fol. 3r.

149 Vatican, Bibl. Apost., Cod. Vat. ebr. 14, fol. 24v, 216v.

149a London, Brit. Libr., MS. Add. 21160, fol. 148r.

149b Jerusalem, Schocken Inst., Bible, fol. 1v.

150 Jerusalem, Schocken Inst., Ms. 24100, known as Nuremberg Maḥzor, fol. 120r.

151 London, Brit. Libr., MS. Add. 27210, fol. 6v; Sarajevo, Nat. Mus., Haggada, fol. 8r.

152 London, Brit. Libr., MS. Or. 2884, fol. 7r; Sarajevo, Nat. Mus., Haggada, fol. 12r.

153 Paris, Bibl. Nat., ms. esp. 30.

154 Jerusalem, Schocken Inst., 2nd Nuremberg Haggada, fol. 31v.

155 Parma, Bibl. Pal., Ms. Parm. 2823–De Rossi 893, fol. 53v.

156 Jerusalem, Isr. Mus., Ms. Rothschild 24, fol. 65r.

157 Wrocław, Ossolinski Libr.–Pawlikowski Coll., Ms. 141, p. 801.

157a However, the white vermiculations decorating the pink body of the giraffe of Ms. Pawlikowski 141 may have been an attempt to indicate these marks.

158 Lisbon, Bibl. Nac., Ms. Il. 72, fol. 436v; Dublin, Trinity College Libr., MS. 16, fol. 76v.

159 Paris, Bibl. Nat., ms. hébr. 20, fol. 7v.

160 London, Brit. Libr., MS. Add. 15282, fol. 238r; Vatican, Bibl. Apost., Cod. Urbin. ebr. 1, fol. 268v.

161 Jerusalem, Schocken Inst., Nuremberg Maḥzor, fol. 1v; Dresden, Sächs. Land.-Bibl., Ms. A 46ᵃ, fol. 116v; Darmstadt, Hess. Land.- u. Hochschulbibl., Cod. or. 13, fol. 73v.

162 Jerusalem, Isr. Mus., Yahuda Haggada, fol. 26v.

163 Lisbon, Bibl. Nac., Ms. Il. 72, fol. 112v.

164 Paris, Bibl. Nat., ms. esp. 30.

165 London, Brit. Libr., MS. Add. 11639, fol. 235v.

166 London, Brit. Libr., MS. Add. 15282, fol. 238r; Vatican, Bibl. Apost., Cod. Urbin. ebr. 1, fol. 268v.

167 Lisbon, Bibl. Nac., Ms. Il. 72, fol. 112v.

168 Paris, Bibl. Nat., ms. esp. 30.

169 Vatican, Bibl. Apost., Cod. Urbin. ebr. 1, fol. 504r.

170 Hamburg, St.- u. Univ.-Bibl., Cod. Levy 19, fol. 97r.

171 *Ibid.*

172 Vatican, Bibl. Apost., Cod. Urbin. ebr. 1, fol. 743r, 829r; Paris, Bibl. Nat., ms. hébr. 6, fol. 72v; London, Brit. Libr., MS. Or. 2091, fol. 268r (bottom margin); Hamburg, St.- u. Univ.-Bibl., Cod. Levy 19, fol. 97r; Dresden, Hess. Land.-Bibl., Ms. A 46ᵃ, fol. 132r.

173 Oxford, Bodl. Libr., MS. Opp. 154, fol. 48v.

174 Jerusalem, Schocken Inst., 2nd Nuremberg Haggada, fol. 30r; Jerusalem, Isr. Mus., Yahuda Haggada, fol. 27r.

175 Lisbon, Bibl. Nac., Ms. Il. 72, fol. 441r.

176 *Ibid.*, fol. 399r.

177 Rome, Bibl. Casan., Ms. 2898, fol. 76r.

178 Hamburg, St.- u. Univ.-Bibl., Cod. hebr. 155, fol. 19v.

179 Venice, Mus. Ebr., Bible, fol. 21r.

180 Jerusalem, Isr. Mus., Ms. Rothschild 24, fol. 358v.

181 Oxford, Bodl. Libr., MS. Can. Or. 62, fol. 1r.

182 London, Brit. Libr., MS. Add. 11639, fol. 306v.

183 *Ibid.*, fol. 319v.

184 London, Brit. Libr., MS. Add. 11639, fol. 325r.

185 Parma, Bibl. Pal., Ms. Parm. 1870–De Rossi 510, fol. 38r; Lisbon, Bibl. Nac., Ms. Il. 72, fol. 399v;

Paris, Bibl. Nat., ms. hébr. 21, fol. 3v; Vatican, Bibl. Apost., Cod. Urbin. ebr. 1, fol. 240r, 829v; Paris, Bibl. Nat., ms. hébr. 4, fol. 5v; Oxford, Bodl. Libr., MS. Can. Or. 137, fol. 70v; London, Brit. Libr., MS. Or. 2091, fol. 268r; Wrocław, Ossolinski Libr.–Pawlikowski Coll., Ms. 141, p. 379; Dresden, Sächs. Land.-Bibl., Ms. A 46ᵃ, fol. 82r; Berlin, Deut. St.-Bibl., Ms. or. fol. 1210, fol. 1v.

186 Rome, Bibl. Casan., Ms. 2898, fol. 66v.

187 *Ibid.*, fol. 65r.

188 London, Brit. Libr., MS. Add. 11639, fol. 295v.

189 Hamburg, St.- u. Univ.-Bibl., Cod. Levy 19, fol. 273r.

190 Berlin, Deut. St.-Bibl., Ms. or. fol. 1211, fol. 175v.

191 London, Brit. Libr., MS. Or. 2091, fol. 251r.

192 Paris, Bibl. Nat., ms. hébr. 6, fol. 18r.

193 Berlin, Deut. St.-Bibl., Ms. or. fol. 1211, fol. 462v.

194 Oxford, Bodl. Libr., MS. Reggio 2, fol. 1v.

195 *Ibid.*, MS. Reggio 1, fol. 159v.

196 E.g.: Parma, Bibl. Pal., Ms. Parm. 1870–De Rossi 510, fol. 35r, 57v; Berlin, St.-Bibl. Preuss. Kulturbes., Orientabt., Ms. or. qu. 371, fol. 115v, 210v; Hamburg, St.- u. Univ.-Bibl., Cod. hebr. 155, fol. 2r; Florence, Bibl. Laur., Ms. Plut. 2.1, fol. 19v, 24v, 672v.

197 E.g.: Paris, Bibl. Nat., ms. hébr. 20, fol. 7r and v; Paris, Bibl. Nat., ms. hébr. 21, fol. 3v; Lisbon, Bibl. Nac., Ms. Il. 72, fol. 37v; London, Brit. Libr., MS. Add. 14761, fol. 24v, 28v, 31v and *passim.*

198 E.g.: Paris, Bibl. Nat., ms. hébr. 6, fol. 235r; Paris, Bibl. Nat., ms. hébr. 4, fol. 43v; Vatican, Bibl. Apost., Cod. Urbin. ebr. 1, fol. 268v, 504r; Berlin, St.-Bibl., Preuss. Kulturbes., Orientabt., Ms. or. fol. 1212, fol. 1r, 273v; Oxford, Bodl. Libr., MS. Can. Or. 137, fol. 220v; Oxford, Bodl. Libr., MS. Reggio 1, fol. 159v, 207v; Dresden, Sächs. Land.-Bibl., Ms. A 46ᵃ, fol. 132r.

199 Paris, Bibl. Nat., ms. hébr. 20, fol. 8r, 69r.

200 London, Brit. Libr., MS. Add. 14761, fol. 24v, 31v, 39r; Paris, Bibl. Nat., ms. hébr. 20, fol. 8r.

201 London, Brit. Libr., MS. Add. 11639, fol. 306v.

202 Lisbon, Bibl. Nac., Ms. Il. 72, fol. 232v; Copenhagen, Roy. Libr., Cod. Hebr. II, fol. 8r; Paris, Bibl. Nat., ms. hébr. 6, fol. 1r, 117r; Wrocław, Bibl. Univ., Ms. Or. I, 1, fol. 89v; London, Brit. Libr., MS. Add. 15282, fol. 1v; Paris, Bibl. Nat., ms. hébr. 4, fol. 43v; Paris, Bibl. Nat., ms. hébr. 48, fol. 231r; Berlin, Deut. St.-Bibl., Ms. or. fol. 1210, fol. 1v.

203 Karlsruhe, Bad. Land.-Bibl., Ms. Reuchlin 1, fol. 77r; Hamburg, St.- u. Univ.-Bibl., Cod. Levy 19, fol. 242v, 536v; Oxford, Bodl. Libr., MS. Mich. 619, fol. 100v; London, Brit. Libr., MS. Add. 14761, fol. 31v, 33v, 39r and v, 43v, 47v, 48v.

204 Lisbon, Bibl. Nac., Ms. Il. 72, fol. 386v; Berlin, Deut. St.-Bibl., Ms. or. fol. 1210, fol. 3v.

205 Hamburg, St.- u. Univ.-Bibl., Cod. Levy 19, fol. 549r; Jerusalem, Schocken Inst., Nuremberg Maḥzor, fol. 78v.

206 Berlin, Deut. St.-Bibl., Ms. or. fol. 1210, fol. 129r.

207 Paris, Bibl. Nat., ms. hébr. 6, fol. 18r; Vatican, Bibl. Apost., Cod. Urbin. ebr. 1, fol. 268v.

208 Parma, Bibl. Pal., Ms. Parm. 1870–De Rossi 510,

fol. 8v, 54v, 201v; Paris, Bibl. Nat., ms. hébr. 6, fol. 1r; London, Brit. Libr., MS. Add. 14761, fol. 34r, 36r, 39r, 42v, 46r.

209 Oxford, Bodl. Libr., MS. Mich. 619, fol. 100v.

210 Vatican, Bibl. Apost., Cod. Urbin. ebr. 1, fol. 268v; Paris, Bibl. Nat., ms. hébr. 6, fol. 118r; Hamburg, St.- u. Univ.-Bibl., Cod. Levy 19, fol. 97r, 242v, 402v, 479r, 549r; Oxford, Bodl. Libr., MS. Reggio 2, fol. 1v; Lisbon, Bibl. Nac., Ms. Il. 72, fol. 441r; Copenhagen, Roy. Libr., Cod. Hebr. II, fol. 6r; London, Brit. Libr., MS. Add. 14761, fol. 26r and v, 35r; Florence, Bibl. Laur., Ms. Plut. 2.1, fol. 21v, 22v.

211 E.g.: Oxford, Bodl. Libr., MS. Mich. 619, fol. 100v.

212 Paris, Bibl. Nat., ms. hébr. 6, fol. 282v.

213 Vatican, Bibl. Apost., Cod. Urbin. ebr. 1, fol. 62r, 743r.

214 Lisbon, Bibl. Nac., Ms. Il. 72, fol. 442v.

215 Wrocław, Ossolinski Libr.-Pawlikowski Coll., Ms. 141, p. 794.

216 Paris, Bibl. Nat., ms. hébr. 1203, fol. 14r; Hamburg, St.- u. Univ.-Bibl., Cod. Levy 19, fol. 549r.

217 Munich, Bayer. St.-Bibl., Cod. hebr. 3/I, fol. 48r.

218 Lisbon, Bibl. Nac., Ms. Il. 72, fol. 443r; Hamburg, St.- u. Univ.-Bibl., Cod. Levy 19, fol. 549r.

219 E.g.: Milan, Bibl. Ambr., Ms. B. 30–31–32. Inf., *passim*; Jerusalem, Jew. Nat. Univ. Libr., Worms Maḥzor, *passim*; Jerusalem, Isr. Mus., Ms. 180/57, known as Bird's Head Haggada, *passim*; London, Brit. Libr., MS. Add. 22413, fol. 71r; Leipzig, Univ.-Bibl., Ms. V 1102, *passim*; Dresden, Sächs. Land.-Bibl., Ms. A 46ª, fol. 82r; Wrocław, Univ. Libr., Ms. Or. I, 1, fol. 46v.

220 London, Brit. Libr., MS. Add. 11639.

221 Wrocław, Ossolinski Libr.- Pawlikowski Coll., Ms. 141.

222 Lisbon, Bibl. Nac., Ms. Il. 72.

223 Venice, Mus. Ebr., Bible.

224 Venice, Mus. Ebr., Bible, fol. 11v; Jerusalem, Schocken Inst., 2nd Nuremberg Haggada, fol. 39r.

225 Vatican, Bibl. Apost., Cod. Vat. ebr. 14, fol. 216v, 217r; Paris, Bibl. Nat., ms. hébr. 20, fol. 114v, 115r; Oxford, Bodl. Libr., MS. Opp. 14, fol. 132v.

226 London, Brit. Libr., MS. Add. 15282, fol. 179v; Berlin, Deut. St.-Bibl., Ms. or. fol. 1210, fol. 273v.

227 Paris, Bibl. Nat., ms. hébr. 20, fol. 170r.

228 Paris, Bibl. Nat., ms. hébr. 20, fol. 254r.

229 Budapest, Ac. Sc., Ms. A 384, fol. 183v.

230 London, Brit. Libr., MS. Add. 15282, fol. 179v; Berlin, Deut. St.-Bibl., Ms. or. fol. 1210, fol. 273v.

231 Milan, Bibl. Ambr., Ms. B. 30. Inf., fol. 135v.

232 Complete series: Berlin, Deut. St.-Bibl., Ms. or. fol. 1210, fol. 273v; for the emblems of the four 'leading tribes': London, Brit. Libr., MS. Add. 15282, fol. 179v; for the banner of Judah: Milan, Bibl. Ambr., Ms. B. 30. Inf., fol. 135v.

233 Vatican, Bibl. Apost., Cod. Rossian. 555, fol. 12v; Oxford, Bodl. Libr., MS. Mich. 127, fol. 16v.

234 E.g.: Jerusalem, Jew. Nat. Univ. Libr., Worms Maḥzor/I, fol. 170v; Jerusalem, Isr. Mus., form. Coll. Sassoon, Ms. 506, p. 665; London, Brit.

Libr., MS. Add. 22413, fol. 49r; Oxford, Bodl. Libr., MS. Mich. 619, fol. 201r.

235 E.g.: Vienna, Öst. Nat.-Bibl., Cod. Hebr. 16, fol. 226r; Ms. form. Jerusalem, Coll. Sassoon, Ms. 1047, p. 312.

236 Milan, Bibl. Ambr., Ms. B. 32. Inf., fol. 135v.

237 Florence, Bibl. Laur., Ms. Plut. 3.8, fol. 287v.

238 Copenhagen, Roy. Libr., Cod. Hebr. XXXVII, fol. 202r.

239 Milan, Bibl. Ambr., Ms. B. 32. Inf., fol. 135v; London, Brit. Libr., MS. Add. 11639, fol. 354v; London, Brit. Libr., MS. Add. 21160, fol. 285r; London, Brit. Libr., MS. Or. 2091, fol. 203r; Oxford, Bodl. Libr., Bodl. MS. Or. 802, fol. 96v; Leipzig, Univ.-Bibl., Ms. V 1102/I, fol. 31v; Wrocław, Univ. Libr., Ms. Or. I, 1, fol. 89v.

240 E.g.: London, Brit. Libr., MS. Add. 11639, fol. 520v; Budapest, Ac. Sc., Ms. A 77/IV, fol. 70r; Jerusalem, Schocken Inst., Bible, fol. 1v; Jerusalem, Schocken Inst., 1st Nuremberg Haggada, fol. 25v; Oxford, Bodl. Libr., MS. Can. Or. 79, fol. 8v; Oxford, Bodl. Libr., MS. Can. Or. 62, fol. 1r; London, Brit. Libr., MS. Harl. 5717, fol. 5v; Imola, Bibl. Com., Bible, fol. 13v.

241 E.g.: Cambridge, Univ. Libr., MS. Add. 652, fol. 2v; London, Brit. Libr., MS. Add. 27210, fol. 2v; London, Brit. Libr., MS. Or. 2884, fol. 2r; Sarajevo, Nat. Mus., Haggada, fol. 3v; Paris, Bibl. Nat., ms. hébr. 1314, fol. 17v; Parma, Bibl. Pal., Ms. Parm. 2809–De Rossi 187, fol. 6r; Jerusalem, Coll. Sassoon, Ms. 506, p. 2; Oxford, Bodl. Libr., MS. Opp. 14, fol. 3v; Jerusalem, Schocken Inst., 2nd Nuremberg Haggada, fol. 30v; Parma, Bibl. Pal., Ms. Parm. 2821–De Rossi 661, fol. 1v; London, Brit. Libr., MS. Harl. 7621, fol. 1r.

242 Vatican, Bibl. Apost., Cod. Vat. ebr. 14, fol. 8v; London, Brit. Libr., MS. Add. 11639, fol. 521r; New York, Jew. Theol. Sem. Amer., Ms. Acc. No. 02922, fol. 84v; Parma, Bibl. Pal., Ms. Parm. 2018–De Rossi 535, fol. 16v.

243 Munich, Bayer. St.-Bibl., Cod. hebr. 5/I, fol. 6r; Vatican, Bibl. Apost., Cod. Vat. ebr. 14, fol. 7r; London, Brit. Libr., MS. Add. 11639, fol. 521r; Paris, Bibl. Nat., ms. hébr. 4, fol. 9r; Jerusalem, Schocken Inst., Bible, fol. 1v; Paris, Bibl. Nat., ms. hébr. 20, fol. 14r; Sarajevo, Nat. Mus., Haggada, fol. 5v; New York, Jew. Theol. Sem. Amer., MS. Acc. No. 02922, fol. 84v; Parma, Bibl. Pal., Ms. Parm. 2018–De Rossi 535, fol. 16v.

244 Jerusalem, Schocken Inst., Bible, fol. 1v; Jerusalem, Jew. Nat. Univ. Libr., Ms. Heb. 8° 1401, fol. 81r; Budapest, Ac. Sc., Ms. A 1, p. 380; Jerusalem, Schocken Inst., 1st Nuremberg Haggada or Nuremberg Haggada I, fol. 25v.

245 Cambridge, Univ. Libr., MS. Add. 652, fol. 315v; Washington, D.C., Libr. of Congress, Haggada, fol. 30r; Jerusalem, Isr. Mus., Ms. Rothschild 24, fol. 164v.

246 E.g.: Parma, Bibl. Pal., Ms. Parm. 2152–De Rossi 3, fol. 276v; New York, Publ. Libr., Spencer Coll., Bible in 2 vols., vol. II, fol. 189v; London, Brit. Libr., MS. Add. 21160, fol. 292r; Hamburg, St.- u. Univ.-Bibl., Cod. Levy 19, fol. 469r; Jerusalem, Schocken Inst., 1st Nuremberg Haggada, fol. 25v; Budapest, Ac. Sc., Ms. A 387, fol. 377v; Jerusalem, Schocken Inst., 2nd

Nuremberg Haggada, fol. 41r; Jerusalem, Isr. Mus., Yahuda Haggada, fol. 40r; Lisbon, Bibl. Nac., Ms. Il. 72, fol. 304r; Oxford, Bodl. Libr., MS. Kenn. 1, fol. 305r; Berlin, St.-Bibl., Preuss. Kulturbes., Orientabt., Ms. Ham. 81, fol. 312v.

247 E.g.: London, Brit. Libr., MS. Add. 11639, fol. 520r; Budapest, Ac. Sc., Ms. A 77/II, fol. 90r; Budapest, Ac. Sc., Ms. A 78/I, fol. 8v; Hamburg, St.- u. Univ.-Bibl., Cod. Levy 19, fol. 402v; Hamburg, St.- u. Univ.-Bibl., Cod. hebr. 5, p. 32; Leipzig, Univ.-Bibl., Ms. V 1102/I, fol. 19r; Budapest, Ac. Sc., Ms. A 383, fol. 189v; Jerusalem, Schocken Inst., 2nd Nuremberg Haggada, fol. 39r; Jerusalem, Isr. Mus., Yahuda Haggada, fol. 38r; London, Brit. Libr., MS. Or. 2737, fol. 35v; Paris, Bibl. Nat., ms. hébr. 1203, fol. 1r; London, Brit. Libr., MS. Add. 26968, fol. 340r.

248 E.g.: London, Brit. Libr., MS. Or. 2737, fol. 93v; London, Brit. Libr., MS. Add. 27210, fol. 4v; Sarajevo, Nat. Mus., Haggada, fol. 8r.

249 Munich, Bayer. St.-Bibl., Cod. hebr. 5/I, fol. 18v; Milan, Bibl. Ambr., Ms. B. 30. Inf., fol. 102r; London, Brit. Libr., MS. Add. 11639, fol. 521v; Budapest, Ac. Sc., Ms. A 77/III, fol. 81r; Oxford, Bodl. Libr., MS. Laud. 321, fol. 184r; Oxford, Bodl. Libr., MS. Can. Or. 140, fol. 35v; New York, Jew. Theol. Sem. Amer., MS. Acc. No. 0017, fol. 121r; Jerusalem, Isr. Mus., Regensburg Bible, fol. 18v; Jerusalem, Isr. Mus., Bird's Head Haggada, fol. 15v; Jerusalem, Schocken Inst., Bible, fol. 1v; Paris, Bibl. Nat., ms. hébr. 36, fol. 283v; Oxford, Bodl. Libr., MS. Reggio 1, fol. 159v; Hamburg, St.- u. Univ.-Bibl., Cod. Levy 19, fol. 34v; Leipzig, Univ.-Bibl., Ms. V 1102/II, fol. 66r; Wrocław, Bibl. Univ., Ms. Or. I, 1, fol. 46v; Oxford, Bodl. Libr., MS. Opp. 14, fol. 2v, 120r; Darmstadt, Hess. Land.- u. Hochschulbibl., Cod. or. 13, fol. 202v; Hamburg, St.- u. Univ.-Bibl., Cod. hebr. 37, fol. 1r; Jerusalem, Schocken Inst., 2nd Nuremberg Haggada, fol. 31r; Jerusalem, Isr. Mus., Yahuda Haggada, fol. 30r.

250 Berlin, St.-Bibl., Preuss. Kulturbes., Orientabt., Ms. or. quart. 9, fol. 14v; London, Brit. Libr., MS. Add. 15282, fol. 28r; Leipzig, Univ.-Bibl., Ms. V 1102/II, fol. 26v; Oxford, Bodl. Libr., MS. Mich., 619, fol. 5v; Budapest, Ac. Sc., Ms. A 387, fol. 101r, 315v; Darmstadt, Hess. Land.- u. Hochschulbibl., Cod. or. 28, fol. 5r.

251 Florence, Bibl. Laur., Ms. Plut. 3.8, fol. 20v.

251a Cambridge, Univ. Libr., MS. Add. 652, fol. 13v.

252 London, Brit. Libr., MS. Add. 11639, fol. 517v. In MS. Add. 21160 (London, Brit. Libr.), fol. 269r, the bird resembles several others on neighbouring pages and appears close to the *masora magna* at the bottom of the page. The bird is not referred to as the *ḥol*, but this same word happens to appear, in a completely different sense, in a note of the *masora parva* close by.

253 Milan, Bibl. Ambr., Ms. B. 32. Inf., fol. 136r.

254 Milan, Bibl. Ambr., Ms. B. 32. Inf., fol. 136r; London, Brit. Libr., MS. Add. 11639, fol. 518v, 519r; London, Brit. Libr., MS. Add. 21160, fol. 182r, 183v; New York, Jew. Theol. Sem. Amer., MS. Acc. No. 0017, fol. 2v; Hamburg, St.- u. Univ.-Bibl., Cod. hebr. 7, p. 89; Leipzig, Univ.-Bibl., Ms. V 1102/II, fol. 181v.

255 London, Brit. Libr., MS. Add. 11639, fol. 352v;

Oxford, Bodl. Libr., MS. Mich. 619, fol. 100v.

256 London, Brit. Libr., MS. Add. 22413, fol. 49r, 131r; Oxford, Bodl. Libr., MS. Mich. 619, fol. 100v; Dresden, Sächs. Land.-Bibl., Ms. A 46ᵃ, fol. 82r.

257 London, Brit. Libr., MS. Add. 11639, fol. 332v.

258 Oxford, Bodl. Libr., MS. Laud. Or. 321, fol. 312v.

259 London, Brit. Libr., MS. Add. 11639, fol. 273v; Jerusalem, Schocken Inst., Bible, fol. 128v; Budapest, Ac. Sc., Ms. A 384, fol. 85v.

260 Budapest, Ac. Sc., Ms. A 384, fol. 73r; Oxford, Bodl. Libr., MS. Mich. 619, fol. 201r; London, Brit. Libr., MS. Add. 22413, fol. 71r.

261 London, Brit. Libr., MS. Add. 22413, fol. 71r.

262 Lisbon, Bibl. Nac., Ms. Il. 72, fol. 134v, 316v.

263 Sarajevo, Nat. Mus., Haggada, fol. 31r of the text.

264 Lisbon, Bibl. Nac., Ms. Il. 72, fol. 112v; Dublin, Trinity College Libr., MS. 16, fol. 68v; Sarajevo, Nat. Mus., Haggada, fol. 47r of the text.

265 Paris, Bibl. Nat., ms. hébr. 7, fol. 100v.

266 Sarajevo, Nat. Mus., Haggada, fol. 29v.

267 Parma, Bibl. Pal., Ms. Parm. 1870–De Rossi 510, fol. 198r.

268 Hamburg, St.- u. Univ.-Bibl., Cod. hebr. 37, fol. 27r; Jerusalem, Isr. Mus., Siddur Ruzhin, fol. 162v, 163r.

269 Jerusalem, Isr. Mus., Ms. Rothschild 24, fol. 45v, 65r, 80r; Jerusalem, Isr. Mus. Ms. 180/55, fol. 4v; London, Brit. Libr., MS. Harl. 5686, fol. 27v; Rovigo, Bibl. Ac. Concordi, Ms. 220, fol. 1r, 9r, 31v.

270 Vatican, Bibl. Apost., Ms. Rossian. 498, fol. 13v.

270a New York, Jew. Theol. Sem. Amer., MS. Rothschild II, fol. 274v.

271 Jerusalem, Isr. Mus., Ms. Rothschild 24, fol. 125v.

272 Ibid., fol. 131r.

272a Sarajevo, Mus. Nat., Haggada, fol. 29v.

273 Berlin, St.-Bibl., Preuss. Kulturbes., Orientabt., Ms. Ham. 81, fol. 375r, 378v.

274 Parma, Bibl. Pal., Ms. Parm. 1994–De Rossi 346, fol. 74v.

275 London, Brit. Libr., MS. Add. 14762, fol. 6r.

276 Jerusalem, Isr. Mus., Ms. Rothschild 24, fol. 37r, 164v, 132v, 166v.

277 Paris, Bibl. Nat., ms. hébr. 1199.

278 E.g.: Jerusalem, Schocken Inst., Ms. 24085, fol. 27r; London, Brit. Libr., MS. Or. 5024, fol. 70v; Budapest, Ac. Sc., Ms. A 380/II, fol. 175v.

279 E.g.: Parma, Bibl. Pal., Ms. Parm. 1934–De Rossi 863, fol. 10v; Jerusalem, Jew. Nat. Univ. Libr., Ms. 8° 4450, fol. 120v; Cambridge, Univ. Libr., MS. Add. 437, fol. 158r.

280 Paris, Bibl. Nat., ms. hébr. 7, fol. 100v.

281 E.g.: Parma, Bibl. Pal., Ms. Parm. 2810–De Rossi 518, fol. 8r; London, Brit. Libr., MS. Kings 1, fol. 3v; Jerusalem, Coll. Sassoon, Ms. 468, known as Farḥi Bible, p. 187; Jerusalem, Coll. Sassoon, Ms. 16, known as Rashba Bible, p. 7; Paris, Bibl. Nat., ms. hébr. 31, 1314, fol. 1v.

282 Lisbon, Bibl. Nac., Ms. Il. 72, fol. 316v.

282a London, Brit. Libr., MS. Add. 11639, fol. 122r.

283 Paris, Bibl. Nat., ms. hébr. 4, fol. 5v; Berlin, St.-Bibl., Preuss. Kulturbes., Orientabt., Ms. or. 1211, fol. 1r.

283a Cf. references for the serpent given in notes 240 and 241 of this chapter, except for the following

four references: Cambridge, Univ. Libr., MS. Add. 652, fol. 2v; Paris, Bibl. Nat., ms. hébr. 1314, fol. 17v; Parma, Bibl. Pal., Ms. Parm. 2809–De Rossi 187, fol. 6r; Oxford, Bodl. Libr., MS. Opp. 14, fol. 3v. In the last-mentioned manuscript, however, cf. fol. 3r.

284 New York, Priv. coll., form. Frankfurt/M., St.-Bibl., Ms. Ausst. 4, fol. 25r.

285 E.g.: Jerusalem, Isr. Mus., Bird's Head Haggada, fol. 23r; Leipzig, Univ.-Bibl., Ms. V 1102/I, fol. 73r.

286 E.g.: London, Brit. Libr., MS. Add. 11639, fol. 120r; Jerusalem, Schocken Inst., Bible, fol. 1v; Sarajevo, Nat. Mus., Haggada, fol. 27v.

287 E.g.: Lisbon, Bibl. Nac., Ms. Il. 72, fol. 304r.;

288 E.g.: Leipzig, Univ.-Bibl., Ms. V 1102/I, fol. 130v; Sarajevo, Nat. Mus., Haggada, fol. 30r.

289 Paris, Bibl. Nat., ms. esp. 30.

290 Sarajevo, Nat. Mus., Haggada, fol. 12r and 31v of the text.

291 Bologna, Bibl. Univ., Ms. 2197, fol. 2r, 210r.

292 Jerusalem, Isr. Mus., Ms. Rothschild 24, fol. 65r.

293 Ibid.

294 Bologna, Bibl. Univ., Ms. 2197, fol. 2r, 210r.

295 Ibid.

296 Ibid., fol. 2r.

297 E.g.: Vatican, Bibl. Apost., Cod. Urbin. ebr. 1, fol. 268v, 504r; London, Brit. Libr., MS. Add. 15282, fol. 1v, 137r.

298 E.g.: Lisbon, Bibl. Nac., Ms. Il. 72, fol. 3r, 7v, 39r, 178v, 448v; Oxford, Bodl. Libr., MS. Kenn. 2, fol. 15r, 81v; Paris, Bibl. Nat., ms. hébr. 21, fol. 263v.

299 E.g.: London, Brit. Libr., MS. Or. 2884, fol. 27v; Sarajevo, Nat. Mus., Haggada, fol. 3r of the text.

300 Nîmes, Bibl. Mun., ms. 13, fol. 112r.

301 New York, Hisp. Soc., MS. B. 241, fol. 288v.

302 Budapest, Ac. Sc., Ms. A 422, fol. 39r, 48r.

303 Copenhagen, Roy. Libr., Cod. Hebr. XXXVII, fol. 4r; Ms. form. Jerusalem, Coll. Sassoon, Ms. 1047, pp. 2, 8, 9, 312.

304 Parma, Bibl. Pal., Ms. Parm. 3183–De Rossi 196, fol. 324r.

305 E.g.: Vienna, Öst. Nat.-Bibl., Cod. Hebr. 16, fol. 226r; Paris, Bibl. Nat., ms. hébr. 5, fol. 119r; London, Brit. Libr., MS. Add. 15282, fol. 1v, 137r.

306 Sarajevo, Nat. Mus., Haggada, fol. 3r, 19v of the text.

307 Lisbon, Bibl. Nac., Ms. Il. 72, fol. 3r, 178r, 7v, 445v.

308 London, Brit. Libr., MS. Add. 14761, fol. 61r.

309 London, Brit. Libr., MS. Add. 11639, fol. 333v, 341v.

310 Milan, Bibl. Ambr., Ms. Fragm. S.P. II. 252.

311 London, Brit. Libr., MS. Add. 26968, fol. 340v; London, Brit. Libr., MS. Or. 2736, fol. 3v; Oxford, Bodl. Libr., MS. Can. Or. 81, fol. 1v; Venice, Mus. Ebr., Bible, fol. 22v.

312 New York, Jew. Theol. Sem. Amer., MS. Rothschild II, fol. 2v, 4r.

313 Oxford, Bodl. Libr., MS. Can. Or. 79, fol. 2v; Bologna, Bibl. Univ., Ms. 2197, fol. 2r.

314 London, Brit. Libr., MS. Or. 2737, fol. 86v.

315 Ibid., fol. 735 and v; Lisbon, Bibl. Nac., Ms. Il. 72, fol. 444v, 445r.

316 E.g.: Paris, Bibl. Nat., ms. hébr. 7, fol. 2v, 5v; Copenhagen, Roy. Libr., Cod. Hebr. II, fol. 4r;

London, Brit. Libr., MS. Add. 15250, fol. 1v, 2r.

317 Jerusalem, Isr. Mus., Ms. 181/41, known as Sassoon Ms. 514, fol. 42v.

318 Ibid., fol. 70r.

319 Sarajevo, Nat. Mus., Haggada, fol. 26r, 34r.

320 Budapest, Ac. Sc., Ms. A 422, fol. 4r, 6r, 59v, 60r.

321 E.g.: Jerusalem, Jew. Nat. Univ. Libr., Worms Maḥzor/II, fol. 73r and ibid./I, fol. 39v.

322 London, Brit. Libr., MS. Add. 15282, fol. 1v, 238r.

323 Jerusalem, Jew. Nat. Univ. Libr., Ms. Heb. 8° 5214, fol. 83r.

324 Darmstadt, Hess. Land.- u. Hochschulbibl., Cod. or. 8, fol. 37v, 48v; Hamburg, St.- u. Univ.-Bibl., Cod. hebr. 37, fol. 173r.

325 Manchester, J. Ryl. Univ. Libr., MS. Ryl. Hebr. 7, fol. 5v.

326 Jerusalem, Coll. Sassoon, Ms. 511, p. 16.

327 Jerusalem, Schocken Inst., 2nd Nuremberg Haggada, fol. 11r.

328 Hamburg, St.- u. Univ.-Bibl., Cod. hebr. 37, fol. 154r; Manchester, J. Ryl. Univ. Libr., MS. Ryl. Hebr. 7, fol. 33r; Jerusalem, Isr. Mus., Siddur Ruzhin, fol. 163r.

329 Parma, Bibl. Pal., Ms. Parm. 1870–De Rossi 510, fol. 119v; Parma, Bibl. Pal., Ms. Parm. 2153–De Rossi 3, fol. 145r.

330 E.g.: Florence, Bibl. Laur., Ms. Plut. 3.10, fol. 176r; Jerusalem, Isr. Mus., Ms. Rothschild 24, fol. 65r, 165r.

331 Chantilly, Mus. Condé, ms. 732, fol. 13v; Paris, Bibl. Nat., ms. hébr. 1388, fol. 7v, 8r.

CHAPTER II

1 Sarajevo, Nat. Mus., Haggada, fol. 34r.

2 Jerusalem, Isr. Mus., Ms. 181/41, known as Sassoon Ms. 514, fol. 32v.

3 Oxford, Bodl. Libr., MS. Opp. Add. 8° 14, fol. 242r.

4 London, Brit. Libr., MS. Or. 2884, fol. 17v.

5 London, Brit. Libr., MS. Add. 19776, fol. 72v.

6 Jerusalem, Jew. Nat. Univ. Libr., Ms. Heb. 4° 1193, fol. 38r.

7 Jerusalem, Isr. Mus., Ms. 180/51, known as Ms. Rothschild 24, fol. 137v, 143r.

8 Vatican, Bibl. Apost., Cod. Rossian. 555, fol. 12v.

9 London, Brit. Libr., MS. Or. 2884, fol. 17v; London, Brit. Libr., MS. Add. 14761, fol. 65v; Budapest, Ac. Sc., Ms. A 422, fol. 42r.

10 Budapest, Ac. Sc., Ms. A 422, fol. 42r.

11 London, Brit. Libr., MS. Harl. 5686, fol. 28r; Jerusalem, Coll. G. Weill, Maḥzor, p. 1; Vatican, Bibl. Apost., Cod. Rossian. 555, fol. 12v.

12 Parma, Bibl. Pal., Ms. Parm. 3006–De Rossi 654, fol. 99v.

13 Milan, Bibl. Ambr., Ms. Fragm. S.P. II.252.

14 Munich, Bayer. St.-Bibl., Cod. hebr. 3/I, fol. 48r.

15 Jerusalem, Coll. Sassoon, Ms. 511.

16 Ibid., p. 28.

17 Ibid., p. 23.

18 Sarajevo, Nat. Mus., Haggada, fol. 34r.

19 Parma, Bibl. Pal., Ms. Parm. 1711–De Rossi 234, fol. 90r.

20 Jerusalem, Jew. Nat. Univ. Libr., Ms. Heb. 4° 1193, fol. 33v.

21 Vatican, Bibl. Apost., Cod. Rossian. 555, fol. 12v.

22 London, Brit. Libr., MS. Harl. 5686, fol. 28r.

23 Jerusalem, Coll. G. Weill, Maḥzor, pp. 1, 173.

24 Jerusalem, Isr. Mus., Ms. Rothschild 24, fol. 105v.

25 Princeton, Univ. Libr., MS. Garrett 26, fol. 29v, 37v, 38v.

26 Munich, Bayer. St.-Bibl., Cod. hebr. 3/I, fol. 48r.

27 Jerusalem, Coll. Sassoon, Ms. 511, p. 28.

28 Jerusalem, Isr. Mus., Ms. Rothschild 24, fol. 105v.

29 Vatican, Bibl. Apost., Cod. Vat. ebr. 324, fol. 80v; London, Brit. Libr., MS. Add. 19776, fol. 96r; Hamburg, St.- u. Univ.-Bibl., Cod. hebr. 37, fol. 114r; Budapest, Ac. Sc., Ms. A 383, fol. 178r.

30 Jerusalem, Jew. Nat. Univ. Libr., Ms. Heb. 4° 1193, fol. 32r.

31 Budapest, Ac. Sc., Ms. A 384, fol. 183v.

32 Vatican, Bibl. Apost., Cod. Vat. ebr. 324, fol. 80v.

33 London, Brit. Libr., MS. Add. 14761, fol. 65v; Budapest, Ac. Sc., Ms. A 422, fol. 42r.

34 Sarajevo, Nat. Mus., Haggada, fol. 34r.

35 Munich, Bayer. St.-Bibl., Cod. hebr. 3/I, fol. 48r; Jerusalem, Coll. Sassoon, Ms. 541, p. 23.

36 Jerusalem, Jew. Nat. Univ. Libr., Ms. Heb. 4° 1193, fol. 32r.

37 Vatican, Bibl. Apost., Cod. Rossian. 555, fol. 12v.

38 Jerusalem, Isr. Mus., Ms. Rothschild 24, fol. 105v.

39 New York, Jew. Theol. Sem. Amer., MS. Acc. No. 03225, known as MS. Rothschild II, fol. 125v.

40 Milan, Bibl. Ambr., Ms. Fragm. S.P.II.252.

40a Jerusalem, Isr. Mus., Sassoon Ms. 514, fol. 32v.

41 Sarajevo, Nat. Mus., Haggada, fol. 34r.

42 London, Brit. Libr., MS. Or. 2884, fol. 17v; London, Brit. Libr., MS. Add. 14761, fol. 65v; Budapest, Ac. Sc., Ms. A 422, fol. 42r.

43 Jerusalem, Jew. Nat. Univ. Libr., Ms. Heb. 4° 1193, fol. 33v.

44 London, Brit. Libr., MS. Add. 26968, fol. 139v; Jerusalem, Isr. Mus., Ms. Rothschild 24, fol. 132v, 139r.

45 Jerusalem, Coll. G. Weill, Maḥzor, p. 1.

45a Ibid., p. 1.

46 Jerusalem, Isr. Mus., Ms. Rothschild 24, fol. 83v.

47 Vatican, Bibl. Apost., Cod. Rossian. 498, fol. 117v.

48 London, Brit. Libr., MS. Or. 2884, fol. 17v; Sarajevo, Nat. Mus., Haggada, fol. 34r; Budapest, Ac. Sc., Ms. A 422, fol. 42r.

49 London, Brit. Libr., MS. Or. 2884, fol. 17v; London, Brit. Libr., MS. Add. 14761, fol. 65v.

50 Oxford, Bodl. Libr., MS. Opp. Add. 8° 14, fol. 242r.

51 Milan, Bibl. Ambr., Ms. Fragm. S.P.II.252.

52 Vatican, Bibl. Apost., Cod. Rossian. 555, fol. 12v.

53 London, Brit. Libr., MS. Harl. 5686, fol. 28r.

54 Jerusalem, Coll. G. Weill, Maḥzor, p. 173.

55 Ibid., p. 1.

56 Ibid., p. 1.

57 Parma, Bibl. Pal., Ms. Parm. 3006–De Rossi 654, fol. 99v; Milan, Bibl. Ambr., Ms. Fragm. S.P.II.252.

58 Hamburg, St.- u. Univ.-Bibl., Cod. hebr. 37, fol. 144r.

59 Jerusalem, Isr. Mus., Ms. Rothschild 24, fol. 132v, 139r for example.

60 London, Brit. Libr., MS. Add. 14761, fol. 65v; Budapest, Ac. Sc., Ms. A 422, fol. 42r.

61 London, Brit. Libr., MS. Or. 2884, fol. 17v; Oxford, Bodl. Libr., MS. Opp. Add. 8° 14, fol. 242r.

62 Jerusalem, Coll. G. Weill, Maḥzor, pp. 1, 173; London, Brit. Libr., MS. Harl. 5686, fol. 28r.

63 Vatican, Apost. Bibl., Cod. Rossian. 555, fol. 12v.

64 Sarajevo, Nat. Mus., Haggada, fol. 34r.

65 Jerusalem, Coll. G. Weill, Maḥzor, pp. 1, 173; London, Brit. Libr., MS. Harl. 5686, fol. 28r.

66 London, Brit. Libr., MS. Add. 26986, fol. 101r.

67 Jerusalem, Isr. Mus., Ms. Rothschild 24, fol. 113v.

67 Jerusalem, Isr. Mus., Ms. Rothschild 24, fol. 113v.

68 Milan, Bibl. Ambr., Ms. Fragm. S.P.II.252.

69 Jerusalem, Coll. Sassoon, Ms. 511, p. 28.

70 Jerusalem, Isr. Mus., Ms. Rothschild 24, fol. 79v.

71 Vatican, Bibl. Apost., Cod. Rossian. 555, fol. 12v.

72 Hamburg, St.- u. Univ.-Bibl., Cod. hebr. 37, fol. 79v.

73 London, Brit. Libr., MS. Or. 2737, fol. 90r.

74 Darmstadt, Hess. Land.- u. Hochschulbibl., Cod. or. 8, fol. 58r.

75 Jerusalem, Schocken Inst., Ms. 24085, fol. 1v; Darmstadt, Hess. Land.- u. Hochschulbibl., Cod. or. 28, fol. 2r; Budapest, Ac. Sc., Ms. A 387, fol. 500v; Jerusalem, Schocken Inst., Ms. 24087, known as 2nd Nuremberg Haggada, fol. 22r.

76 Jerusalem, Isr. Mus., Ms. 180/50, known as Yahuda Haggada, fol. 1v; Jerusalem, Schocken Inst., 2nd Nuremberg Haggada, fol. 2r.

77 London, Brit. Libr., MS. Add. 27210, fol. 15r; London, Brit. Libr., MS. Or. 1404, fol. 8r.

78 Vatican, Bibl. Apost., Cod. Rossian. 555, fol. 127ᵃ v; Rome, Bibl. Casan., Ms. 3096, fol. 1r.

79 Jerusalem, Jew. Nat. Univ. Libr., Ms. Heb. 4° 781/I, known as Worms Maḥzor/I, fol. 169r.

80 Jerusalem, Isr. Mus., Ms. 180/57, known as Bird's Head Haggada, fol. 26r; Oxford, Bodl. Libr., MS. Laud. Or. 321, fol. 127v.

81 Jerusalem, Schocken Inst., 2nd Nuremberg Haggada, fol. 2v.

82 London, Brit. Libr., MS. Or. 2737, fol. 88r.

83 Sarajevo, Nat. mus., Haggada, fol. 22r; Bologna, Bibl. Univ., Ms. 2559, fol. 3r.

84 Jerusalem, Schocken Inst., Ms. 24085, fol. 25r.;

85 Jerusalem, Isr. Mus., Ms. Rothschild 24, fol. 155v.

86 Leipzig, Univ.-Bibl., Ms. V 1102/I, fol. 68v.

87 London, Brit. Libr., MS. Or. 2737, fol. 87r.

88 London, Brit. Libr., MS. Add. 27210, fol. 15r.

89 London, Brit. Libr., MS. Or. 1404, fol. 8r.

89a Darmstadt, Hess. Land.- u. Hochschulbibl., Cod. or. 8, fol. 37v, 48v.

89b In fact, in an illustration from the first half of the 15th century (Hamburg, St.- u. Univ.-Bibl., Cod. hebr. 37, fol. 35v), the only sign of the resurrection of the dead depicting them as arising from the grave is seen in the frames of coffins protruding through the grassy ground.

90 London, Brit. Libr., MS. Add. 27210, fol. 8v; London, Brit. Libr., MS. Or. 2884, fol. 11v.

91 Budapest, Ac. Sc., Ms. A 422, fol. 1v.

92 Princeton, Univ. Libr., MS. Garrett 26, fol. 57r.

93 Ibid., fol. 60r.

94 Vatican, Bibl. Apost., Cod. Vat. ebr. 14, fol. 16v, 75v.

95 London, Brit. Libr., MS. Add. 11639, fol. 118r and v, for example.

96 Munich, Bayer. St.-Bibl., Cod. hebr. 5, copied in 1233.

97 Milan, Bibl. Ambr., Ms. B. 30–31–32. Inf., dating from 1236–1238.

98 Wrocław, Univ. Libr., Ms. M 1106, copied in 1237–1238.

99 Munich, Bayer. St.-Bibl., Cod. hebr. 5/I, fol. 44v.

100 Hamburg, St.- u. Univ.-Bibl., Cod. hebr. 37, fol. 27v.

101 Jerusalem, Schocken Inst., 2nd Nuremberg Haggada, fol. 17v, 32v; Jerusalem, Isr. Mus., Yahuda Haggada, fol. 16v, 17r.

102 Jerusalem, Schocken Inst., 2nd Nuremberg Haggada, fol. 3r.

103 Darmstadt, Hess. Land.- u. Hochschulbibl., Cod. or. 8, fol. 37v, 48v.

104 London, Brit. Libr., MS. Add. 27210, fol. 4v, 5r.

105 London, Brit. Libr., MS. Or. 1404, fol. 6v.

106 Sarajevo, Nat. Mus., Haggada, fol. 13v, 20r, 26r.

107 Ibid., fol. 26r.

108 Budapest, Ac. Sc., Ms. A 422, fol. 6r, 43r.

109 Ibid., fol. 7v, 10r.

110 London, Brit. Libr., MS. Add. 27210, fol. 6v.

111 Manchester, J. Ryl. Univ. Libr., MS. Ryl. Hebr. 6, fol. 19v; London, Brit. Libr., MS. Add. 27210, fol. 15r.

112 Budapest, Ac. Sc., Ms. A 422, fol. 4r.

113 Parma, Bibl. Pal., Ms. Parm. 1870–De Rossi 510, fol. 79v.

114 London, Brit. Libr., MS. Harl. 5686, fol. 60r; Parma, Bibl. Pal., Ms. Parm. 3143–De Rossi 958, fol. 17v; New York, Priv. coll., form. Frankfurt/M., St.-Bibl., Ms. Ausst. 6, fol. 170v, 195v.

115 Parma, Bibl. Pal., Ms. Parm. 3273–De Rossi 134, fol. 1v.

116 Jerusalem, Isr. Mus., Ms. Rothschild 24, fol. 126v.

117 Ibid., fol. 64v.

118 Ibid., fol. 165v, 418v.

119 Ibid., fol. 44v.

120 Parma, Bibl. Pal., Ms. Parm. 3143–De Rossi 958, fol. 2r.

## CHAPTER III

1 New York, Priv. coll., form. Frankfurt/M., St.-Bibl., Ms. Ausst. 6, fol. 195v.

2 Jerusalem, Isr. Mus., Ms. 180/51, known as Ms. Rothschild 24, fol. 126v.

3 London, Brit. Libr., MS. Add. 11639, fol. 121r.

4 Munich, Bayer. St.-Bibl., Cod. hebr. 5/I, fol. 37r.

5 Hamburg, St.- u. Univ.-Bibl., Cod. hebr. 37, fol. 79v.

6 Jerusalem, Schocken Inst., Ms. 24087, known as 2nd Nuremberg Haggada, fol. 33r.

7 Jerusalem, Isr. Mus., Ms. 180/50, known as Yahuda Haggada, fol. 32r.

8 Jerusalem, Coll. Sassoon, Ms. 511, p. 33.

9 London, Brit. Libr., MS. Or. 2737, fol. 64r, 82v.

10 London, Brit. Libr., MS. Add. 27210, fol. 5r, 6v, 7r, 8v.

11 Sarajevo, Nat. Mus., Haggada, fol. 9v, 11v, 13v, 14r.

12 *Ibid.*, fol. 13v.

13 *Ibid.*, fol. 13v, 14r.

14 Budapest, Ac. Sc., Ms. A 422, fol. 1v, 4r.

15 *Ibid.*, fol. 4r.

16 Jerusalem, Jew. Nat. Univ. Libr., Ms. Heb. 4° 1193, fol. 32r.

17 Bologna, Bibl. Univ., Ms. 2197, fol. 402r.

18 *Ibid.*, fol. 402r.

19 Jerusalem, Jew. Nat. Univ. Libr., Ms. Heb. 8° 4450, fol. 2r.

20 Hamburg, St.- u. Univ.-Bibl, Cod. hebr. 37, fol. 27v; Jerusalem, Isr. Mus., Ms. 180/5, known as Siddur Ruzhin, fol. 163v; Paris, Bibl. Nat., ms. hébr. 1333, fol. 12v; Jerusalem, Schocken Inst., 2nd Nuremberg Haggada, fol. 14r; Jerusalem, Isr. Mus., Yahuda Haggada, fol. 13r.

21 London, Brit. Libr., MS. Add. 11639, fol. 118r, 205r.

22 *Ibid.*, fol. 205r.

23 *Ibid.*, fol. 116r, 117v, 118r, 205r, 260v, 524r.

24 Lisbon, Bibl. Nac., Ms. Il. 72, fol. 322v.

25 London, Brit. Libr., MS. Or. 1404, fol. 8r; London, Brit. Libr., MS. Add. 27210, fol. 3r.

26 London, Brit. Libr., MS. Add. 27210, fol. 5r, 7r.

27 *Ibid.*, fol. 6v.

28 Manchester, J. Ryl. Univ. Libr., MS. Ryl. Hebr. 6, fol. 19v.

29 London, Brit. Libr., MS. Add. 27210, fol. 13r.

30 Sarajevo, Nat. Mus., Haggada, fol. 16r, 31v of the text; London, Brit. Libr., MS. Add. 14761, fol. 19v, 20v.

31 London, Brit. Libr., MS. Or. 1404, fol. 8r.

32 London, Brit. Libr., MS. Or. 2884, fol. 3v, 18r; London, Brit. Libr., MS. Add. 14761, fol. 19v, 28v.

33 London, Brit. Libr., MS. Add. 14761, fol. 28v.

34 London, Brit. Libr., MS. Or. 2737, fol. 91r.

35 Sarajevo, Nat. Mus., Haggada, fol. 16r.

36 London, Brit. Libr., MS. Add. 14761, fol. 19v.

37 London, Brit. Libr., MS. Or. 2884, fol. 27v; London, Brit. Libr., MS. Add. 14761, fol. 26r, 61r.

38 Budapest, Ac. Sc., Ms. A 422, fol. 2r, 6r, 9r.

39 Wrocław, Univ. Libr., Ms. M 1106, fol. 278v; Milan, Bibl. Ambr., Ms. B.32.Inf., fol. 136r.

40 Milan, Bibl. Ambr., Ms. B.32.Inf., fol. 78r.

41 Jerusalem, Jew. Nat. Univ. Libr., Ms. Heb. 4° 781/I, known as Worms Maḥzor/I, fol. 86r.

42 Jerusalem, Isr. Mus., Ms. 180/57, known as Bird's Head Haggada, fol. 7r.

43 *Ibid.*, fol. 6v.

44 Parma, Bibl. Pal., Ms. Parm. 3286–De Rossi 440, fol. 96r.

45 Darmstadt, Hess. Land.- u. Hochschulbibl., Cod. or. 8, fol. 37v, 48v.

46 *Ibid.*, fol. 37v.

47 Manchester, J. Ryl. Univ. Libr., MS. Ryl. Hebr. 7, fol. 5r.

48 Oxford, Bodl. Libr., MS. Opp. 154, fol. 29r, 39v; Parma, Bibl. Pal., Ms. Parm. 2895–De Rossi 653, pp. 236, 254, 255.

49 Parma, Bibl. Pal., Ms. Parm. 2895–De Rossi 653, p. 234.

50 Oxford, Bodl. Libr., MS. Opp. 154, fol. 39v.

51 Munich, Bayer. St.-Bibl., Cod. hebr. 107, fol. 23v.

52 *Ibid.*, fol. 23v; Oxford, Bodl. Libr., MS. Opp. 154, fol. 12v.

53 London, Brit. Libr., MS. Add. 14762, fol. 6r.

54 *Ibid.*, fol. 2v.

55 *Ibid.*, fol. 1v.

55a Cf. A. Berliner, *Aus dem Leben der deutschen Juden im Mittelalter*, Berlin, 1900, pp. 36-37; for an English translation, cf. I. Abrahams, *Jewish Life in the Middle Ages*, London, 1896, pp. 149-150.

56 Darmstadt, Hess. Land.- u. Hochschulbibl., Cod. or. 28, fol. 12r and v.

57 Jerusalem, Schocken Inst., 2nd Nuremberg Haggada, fol. 4r, 32v.

58 Jerusalem, Isr. Mus., Yahuda Haggada, fol. 4r, 22r.

59 Jerusalem, Schocken Inst., 2nd Nuremberg Haggada, fol. 18v.

60 Cincinnati, Hebr. Un. College, Haggada, fol. 2v.

61 *Ibid.*, fol. 1v.

62 Jerusalem, Schocken Inst., Ms. 24085, fol. 29r.

63 *Ibid.*, fol. 25r.

64 Nimes, Bibl. Mun., ms. 13, fol. 100r.

65 *Ibid.*, fol. 102v.

66 *Ibid.*, fol. 102v.

67 Vatican, Bibl. Apost., Ms. Rossian. 498, fol. 85v.

68 Jerusalem, Isr. Mus., Ms. Rothschild 24, fol. 121v, 131r, 156v, 464v.

69 London, Brit. Libr., MS. Harl. 5686, fol. 61v.

70 Parma, Bibl. Pal., Ms. Parm. 3143–De Rossi 958, fol. 4r, 11v, 12r and v.

71 Washington, D.C., Libr. of Congress, Haggada, fol. 4r.

72 Parma, Bibl. Pal., Ms. Parm. 2998–De Rossi 111, fol. 2r.

73 Parma, Bibl. Pal., Ms. Parm. 3143–De Rossi 958, fol. 2v.

74 London, Brit. Libr., MS. Add. 14762, fol. 22v.

75 Parma, Bibl. Pal., Ms. Parm. 2998–De Rossi 111, fol. 23v.

76 Parma, Bibl. Pal., Ms. Parm. 3143–De Rossi 958, fol. 12v.

77 Jerusalem, Isr. Mus., Ms. Rothschild 24, fol. 78v.

78 Parma, Bibl. Pal., Ms. Parm. 2998-De Rossi 111, fol. 3v.

79 London, Brit. Libr., MS. Add. 14762, fol. 22r.

80 Cologny-Geneva, Bibl. Bodmer., Cod. Bodmer 81, Haggada, fol. 1r.

81 Jerusalem, Isr. Mus., Ms. Rothschild 24, fol. 155v.

82 London, Brit. Libr., MS. Add. 14762, fol. 7v.

83 Jerusalem, Isr. Mus., Ms. Rothschild 24, fol. 369r, 418v, 467r.

84 *Ibid.*, fol. 44v.

85 *Ibid.*, fol. 464v.

86 *Ibid.*, fol. 174v.

87 Parma, Bibl. Pal., Ms. Parm. 3143–De Rossi 958, fol. 10r.

88 Parma, Bibl. Pal., Ms. Parm. 3596, fol. 3v.

89 London, Brit. Libr., MS. Add. 11639, fol. 207v.

90 Parma, Bibl. Pal., Ms. Parm. 3518, fol. 21r; Jerusalem, Isr. Mus., Bird's Head Haggada, fol. 23r.

91 Paris, Bibl. Nat., ms. hébr. 1333, fol. 19r.

92 *Ibid.*, fol. 17r.

93 Parma, Bibl. Pal., Ms. Parm. 2411–De Rossi 1107, fol. 27r.

94 London, Brit. Libr., MS. Or. 2737, fol. 91v.

95 *Ibid.*, fol. 90v.

96 London, Brit. Libr., MS. Or. 1404, fol. 7v, 8r.

97 Jerusalem, Isr. Mus., Ms. 181/41, known as Sassoon Ms. 514, fol. 55v.

98 Budapest, Ac. Sc., Ms. A 422, fol. 2r.

99 Jerusalem, Schocken Inst., Ms. 24085, fol. 32v.

100 Parma, Bibl. Pal., Ms. Parm. 3143–De Rossi 958, fol. 10v.

101 *Ibid.*, fol. 11v.

102 New Haven, Yale Univ. Libr., Haggada, fol. 18v; Washington, D.C., Libr. of Congress, Haggada, fol. 14v.

103 London, Brit. Libr., MS. Or. 2737, fol. 89r, 90v; Jerusalem, Schocken Inst., 2nd Nuremberg Haggada, fol. 18r; Jerusalem, Schocken Inst., Ms. 24085, fol. 32v; Parma, Bibl. Pal., Ms. Parm. 3143–De Rossi 958, fol. 10v.

104 London, Brit. Libr., MS. Or. 2737, fol. 88v; Jerusalem, Isr. Mus., Yahuda Haggada, fol. 3v; Jerusalem, Schocken Inst., Ms. 24085, fol. 27v.

105 Leipzig, Univ.-Bibl., Ms. V 1102/I, fol. 68v.

106 Lisbon, Bibl. Nac., Ms. Il. 72, fol. 112v; London, Brit. Libr., MS. Or. 2737, fol. 89v; London, Brit. Libr., MS. Add. 27210, fol. 15r.

107 London, Brit. Libr., MS. Add. 14762, fol. 15r; London, Brit. Libr., MS. Add. 26957, fol. 39r.

108 Jerusalem, Isr. Mus., Yahuda Haggada, fol. 1v; Jerusalem, Schocken Inst., 2nd Nuremberg Haggada, fol. 2r.

109 London, Brit. Libr., MS. Add. 27210, fol. 15r.

110 London, Brit. Libr., MS. Or. 2884, fol. 17r.

111 Jerusalem, Schocken Inst., 2nd Nuremberg Haggada, fol. 3r; Jerusalem, Isr. Mus., Yahuda Haggada, fol. 2v.

112 E.g.: London, Brit. Libr., MS. Add. 14762, fol. 1v; Jerusalem, Schocken Inst., 2nd Nuremberg Haggada, fol. 3r; Jerusalem, Isr. Mus., Ms. Rothschild 24, fol. 155v.

113 Jerusalem, Schocken Inst., 2nd Nuremberg Haggada, fol. 3r; Jerusalem, Isr. Mus., Yahuda Haggada, fol. 2v.

114 Paris, Bibl. Nat., ms. hébr. 1333, fol. 2v; Jerusalem, Schocken Inst., 2nd Nuremberg Haggada, fol. 4r; Jerusalem, Isr. Mus., Yahuda Haggada, fol. 3v.

115 Milan, Bibl. Ambr., Ms. B.32.Inf., fol. 136r; Wrocław, Univ. Libr., Ms. M 1106, fol. 278v; London, MS. Add. 11639, fol. 118r, 205r.

116 London, Brit. Libr., MS. Or. 2737, fol. 91r.

117 London, Brit. Libr., MS. Add. 27210, fol. 3r; Manchester, J. Ryl. Univ. Libr., MS. Ryl. Hebr. 6, fol. 19v.

118 London, Brit. Libr., MS. Or. 1404, fol. 8r.

119 Sarajevo, Nat. Mus., Haggada, fol. 16r, 31v of the text.

120 Budapest, Ac. Sc., Ms. A 422, fol. 2r.

121 Jerusalem, Schocken Inst., Ms. 24085, fol. 29r.

122 Bologna, Bibl. Univ., Ms. 2197, fol. 402r.

123 Jerusalem, Coll. G. Weill, Maḥzor, p. 505; Nimes, Bibl. Mun., ms. 13, fol. 100r.

124 Parma, Bibl. Pal., Ms. Parm. 3143–De Rossi 958, fol. 2v, 4r, 12r and v.

125 New York, Priv. coll., form. Frankfurt/M., St.-Bibl., Ms. 725/17, fol. 21r.

126 Jerusalem, Isr. Mus., Bird's Head Haggada, fol. 2r, 7v, 28r.

127 Parma, Bibl. Pal., Ms. Parm. 2895–De Rossi 653, pp. 233, 234, 236.

128 London, Brit. Libr., MS. Add. 14762, fol. 2v, 6v; Jerusalem, Schocken Inst., 2nd Nuremberg Haggada, fol. 4r and v, 12v, 18v, 22v; Jerusalem, Isr. Mus., Yahuda Haggada, fol. 22r.

129 Cambridge, Univ. Libr., MS. Add. 662, fol. 39r; Parma, Bibl. Pal., Ms. Parm. 2895–De Rossi 653, pp. 234, 236, 254; Jerusalem, Schocken Inst., 2nd Nuremberg Haggada, fol. 3r, 4r, 6v.

130 Darmstadt, Hess. Land.- u. Hochschulbibl., Cod. or. 28, fol. 3r.

131 London, Brit. Libr., MS. Or. 2737, fol. 91r; Budapest, Ac. Sc., Ms. A 422, fol. 2r.

132 London, Brit. Libr., MS. Or. 2884, fol. 27v.

133 Jerusalem, Schocken Inst., Ms. 24085, fol. 2v, 3r, 5r, 26v.

134 Darmstadt, Hess. Land.- u. Hochschulbibl., Cod. or. 8, fol. 5r; Cambridge, Univ. Libr., MS. Add. 662, fol. 39r.

135 London, Brit. Libr., MS. Add. 14762, fol. 2v.

135a London, Brit. Libr., MS. Add. 11639, fol. 119v; Wrocław, Univ. Libr., Ms Or. I, 1, fol. 46v.

136 Paris, Bibl. Nat., ms. hébr. 1333, fol. 17v; Jerusalem, Schocken Inst., 2nd Nuremberg Haggada, fol. 4v, 6r, 18v.

137 Jerusalem, Isr. Mus., Yahuda Haggada, fol. 25v.

138 Jerusalem, Schocken Inst., 2nd Nuremberg Haggada, fol. 26r.

139 E.g.: Paris, Bibl. Nat., ms. hébr. 1333, fol. 20v, 23r; Jerusalem, Schocken Inst., 2nd Nuremberg Haggada, fol. 4v, 6v, 22v; Jerusalem, Isr. Mus., Yahuda Haggada, fol. 22r.

140 London, Brit. Libr., MS. Add. 11639, fol. 205r.

141 Parma, Bibl. Pal., Ms. Parm. 2895–De Rossi 653, pp. 234, 236; Paris, Bibl. Nat., ms. hébr. 1333, fol. 19v; Cincinnati, Hebr. Un. College, Haggada, fol. 2v.

142 Parma, Bibl. Pal., Ms. Parm. 2998-De Rossi 111, fol. 2r; Parma, Bibl. Pal., Ms. Parm. 3143–De Rossi 958, fol. 11v.

143 London, Brit. Libr., MS. Add. 14761, fol. 19v.

144 Jerusalem, Isr. Mus., Ms. Rothschild 24, fol. 161v; Parma, Bibl. Pal., Ms. Parm. 3143-De Rossi 958, fol. 14r.

145 Jerusalem, Isr. Mus., Bird's Head Haggada, fol. 28r; Paris, Bibl. Nat., ms. hébr. 1333, fol. 5r; Jerusalem, Isr. Mus., Yahuda Haggada, fol. 26r.

146 London, Brit. Libr., MS. Add. 14761, fol. 27v, 28r.

147 Jerusalem, Isr. Mus., Bird's Head Haggada, fol. 2r, 6r, 29v.

148 Darmstadt, Hess. Land.- u. Hochschulbibl., Cod. or. 13, fol. 69r.

149 Manchester, J. Ryl. Univ. Libr., MS. Ryl. Hebr. 7, fol. 5r.

150 Jerusalem, Jew. Nat. Univ. Libr., Heb. Ms. 8° 4450, fol. 2r; Cologny-Geneva, Bibl. Bodmer., Haggada, fol. 5r.

151 Parma, Bibl. Pal., Ms. Parm. 3143-De Rossi 958, fol. 3v, 14v.

152 Budapest, Ac. Sc., Ms. A 422, fol. 2r.

153 Sarajevo, Nat. Mus., Haggada, fol. 33v.

154 Jerusalem, Coll. G. Weill, Maḥzor, p. 505.

155 Paris, Bibl. Nat., ms. hébr. 1333, fol. 17r.

156 Manchester, J. Ryl. Univ. Libr., MS. Ryl. Hebr. 6, fol. 19v; London, Brit. Libr., MS. Or. 1404, fol. 7v; Sarajevo, Nat. Mus., Haggada, fol. 31v of the text; Budapest, Ac. Sc., Ms. A 422, fol. 1v, 6r.

157 London, Brit. Libr., MS. Add. 14761, fol. 19v, 28v.

158 London, Brit. Libr., MS. Or. 2884, fol. 18r.

159 Sarajevo, Nat. Mus., Haggada, fol. 31v of the text.

160 Parma, Bibl. Pal., Ms. Parm. 3518, fol. 21r.

161 Jerusalem, Schocken Inst., 1st Nuremberg Haggada, fol. 14r.

162 London, Brit. Libr., MS. Add. 14762, fol. 6r; Jerusalem, Isr. Mus., Yahuda Haggada, fol. 4r and v, 6r; Paris, Bibl. Nat., ms. hébr. 1333, fol. 4v, 5v, 20v, 23r; Darmstadt, Hess. Land.- u. Hochschulbibl., Cod. or. 28, fol. 3r.

163 Jerusalem, Coll. Sassoon, Ms. 511, p. 33.

164 Parma, Bibl. Pal., Ms. Parm. 3143–De Rossi 958, fol. 10v.

165 Cologny-Geneva, Bibl. Bodmer., Haggada, fol. 5r; Jerusalem, Coll. G. Weill, Maḥzor, p. 505; Parma, Bibl. Pal., Ms. Parm. 2998–De Rossi 111, fol. 2r; Parma, Bibl. Pal., Ms. Parm. 3143–De Rossi 958, fol. 2v, 4r, 11v; New York, Priv. coll., form. Frankfurt/M., St.-Bibl., Ms. 725/17, fol. 21r.

166 Jerusalem, Isr. Mus., Ms. Rothschild 24, fol. 156v, 160r for example.

167 Paris, Bibl. Nat., ms. hébr. 1333, fol. 4v; Jerusalem, Schocken Inst., 2nd Nuremberg Haggada, fol. 5v; Jerusalem, Isr. Mus., Yahuda Haggada, fol. 5r; Parma, Bibl. Pal., Ms. Parm. 3143–De Rossi 958, fol. 3r.

168 E.g.: London, Brit. Libr., MS. Add. 27210, fol. 15r; Paris, Bibl. Nat., ms. hébr. 1333, fol. 1v; Jerusalem, Isr. Mus., Ms. Rothschild 24, fol. 155v; Parma, Bibl. Pal., Ms. Parm. 3143–De Rossi 958, fol. 2r.

169 London, Brit. Libr., MS. Add. 14761, fol. 24v.

170 Ibid., fol. 26r.

171 London, Brit. Libr., MS. Or. 5024, fol. 19r.

172 Vatican, Bibl. Apost., Cod. Vat. ebr. 173, fol. 108r.

173 Jerusalem, Coll. Sassoon, Ms. 1028, p. 296.

174 London, Brit. Libr., MS. Add. 14761, fol. 28v.

175 London, Brit. Libr., MS. Add. 27210, fol. 7r; Jerusalem, Isr. Mus., Ms. Rothschild 24, fol. 64v.

176 Sarajevo, Nat. Mus., Haggada, fol. 9v.

177 Parma, Bibl. Pal., Ms. Parm. 3596, fol. 156v.

178 Paris, Bibl. Nat., ms. hébr. 418, fol. 198r.

179 Jerusalem, Isr. Mus., Ms. Rothschild 24, fol. 122v.

180 Cologny-Geneva, Bibl. Bodmer., Haggada, fol. 5r.

181 Sarajevo, Nat. Mus., Haggada, fol. 31v of the text; Paris, Bibl. Nat., ms. hébr. 1333, fol. 5v; Darmstadt, Hess. Land.- u. Hochschulbibl., Cod. or. 28, fol. 3r.

182 Jerusalem, Isr. Mus., Ms. Rothschild 24, fol. 64v; New York, Jew. Theol. Sem. Amer., MS. Acc. No. 03225, known as MS. Rothschild II, fol. 200v.

183 Florence, Bibl. Laur., Ms. Plut. 3.10, fol. 178v; Oxford, Bodl. Libr., MS. Mich. 610, fol. 2r.

184 Jerusalem, Isr. Mus., Ms. Rothschild 24, fol. 64v.

185 Parma, Bibl. Pal., Ms. Parm. 3143–De Rossi 958, fol. 2v.

CHAPTER IV

1 London, Brit. Libr.

2 London, Brit. Libr., MS. Or. 2737, fol. 90v.

3 Ibid., fol. 82v, 84r.

4 Ibid., fol. 83v, 84r and v.

5 Ibid., fol. 90v.

6 Ibid., fol. 90v.

7 Ibid., fol. 62v, 88r.

8 Ibid., fol. 91v.

9 Ibid., fol. 89v, 90r.

10 Ibid., fol. 68r, 84r, 91r.

11 Ibid., fol. 20v, 78v.

12 Ibid., fol. 20v, 78v.

13 Ibid., fol. 68r.

14 Ibid., fol. 78v.

15 Ibid., fol. 86r, 87v, 88r.

16 Ibid., fol. 82v, 86r.

17 Ibid., fol. 87r, 88r.;

18 Ibid., fol. 86v.

19 London, Brit. Libr.

20 London, Brit. Libr., MS. Add. 27210, fol. 15r.

21 Ibid., fol. 15r.

22 Ibid., fol. 15r.

23 Ibid., fol. 13r.

24 Ibid., fol. 7r.

24 Ibid., fol. 7r.

25 Ibid., fol. 7r.

26 Ibid., fol. 5r.

27 Ibid., fol. 7r.

28 Ibid., fol. 7r.

29 Ibid., fol. 7r.

30 Ibid., fol. 8v.

31 Ibid., fol. 7r, 15r.

32 Ibid., fol. 11r.

33 Ibid., fol. 7r, 9r.

34 Ibid., fol. 7r.

35 Ibid., fol. 11r.

36 Ibid., fol. 7r.

37 Ibid., fol. 11r.

38 Ibid., fol. 5r.

39 Ibid., fol. 11r.

40 Ibid., fol. 13r.

41 Ibid., fol. 4v.

42 Ibid., fol. 6v, 15r.

43 Ibid., fol. 15r.

44 Ibid., fol. 15r.

45 Ibid., fol. 15r.

46 Ibid., fol. 8v.

47 Ibid., fol. 8v.

48 Ibid., fol. 15r.

49 Manchester, J. Ryl. Univ. Libr.

50 London, Brit. Libr.

51 Manchester, J. Ryl. Univ. Libr., MS. Ryl. Hebr. 6, fol. 18r, 19v; London, Brit. Libr., MS. Or. 1404, fol. 18r.

52 London, Brit. Libr., MS. Or. 1404, fol. 7v.

53 Ibid., fol. 8r, 18r.

54 Manchester, J. Ryl. Univ. Libr., MS. Ryl. Hebr. 6, fol. 19v.

55 Ibid., fol. 19v.

56 Ibid., fol. 19v.

57 London, Brit. Libr., MS. Or. 1404, fol. 7v.

58 Manchester, J. Ryl. Univ. Libr., MS. Ryl. Hebr. 6, fol. 19v.

59 London, Brit. Libr., MS. Or. 1404, fol. 7v.

60 Manchester, J. Ryl. Univ. Libr., MS. Ryl. Hebr. 6, fol. 19v.

61 London, Brit. Libr.

62 Sarajevo, Nat. Mus.

63 Bologna, Bibl. Univ.

64 Jerusalem, Isr. Mus., Ms. 181/41, known as Ms. Sassoon 514.

65 London, Brit. Libr.

66 Jerusalem, Isr. Mus., Ms. Sassoon 514, fol. 55r.

67 Bologna, Bibl. Univ., Ms. 2559, fol. 1r; London, Brit. Libr., MS. Or. 2884, fol. 10v, 11r.

68 London, Brit. Libr., MS. Or. 2884, fol. 10v.

69 Sarajevo, Nat. Mus., Haggada, fol. 17v, 29v.

70 Jerusalem, Isr. Mus., Ms. Sassoon 514, fol. 59r.

71 London, Brit. Libr., MS. Or. 2884, fol. 27v.

72 Bologna, Bibl. Univ., Ms. 2559, fol. 5r; Sarajevo, Nat. Mus., Haggada, fol. 19v, 25v, 31v of the text; London, Brit. Libr., MS. Add. 14761, fol. 51v, 61r.

73 Bologna, Bibl. Univ., Ms. 2559, fol. 5r; Sarajevo, Nat. Mus., Haggada, fol. 19v, 25v, 31v of the text; London, Brit. Libr., MS. Add. 14761, fol. 51v, 61r.

74 London, Brit. Libr., MS. Or. 2884, fol. 17v; London, Brit. Libr., MS. Add. 14761, fol. 65v; Sarajevo, Nat. Mus., Haggada, fol. 34r.

75 London, Brit. Libr., MS. Or. 2884, fol. 2v.

76 Sarajevo, Nat. Mus., Haggada, fol. 31v of the text.

77 London, Brit. Libr, MS. Or. 2884, fol. 10v.

77a Sarajevo, Nat. Mus., Haggada, fol. 11v.

78 London, Brit. Libr., MS. Or. 2884, fol. 17v.

79 Sarajevo, Nat. Mus., Haggada, fol. 34r.

79a *Ibid.*, fol. 3v.

79b *Ibid., passim.*

80 London, Brit. Libr., MS. Or. 2884, fol. 18r.

81 Sarajevo, Nat. Mus., Haggada, fol. 28r.

82 *Ibid.*, fol. 31v of the text.

83 *Ibid.*, fol. 20r, 28r.

84 London, Brit. Libr., MS. Or. 2884, fol. 17r, 18r; Sarajevo, Nat. Mus., Haggada, fol. 31v of the text.

85 London, Brit. Libr., MS. Or. 2884, fol. 16r; Sarajevo, Nat. Mus., Haggada, fol. 9v, 28r; London, Brit. Libr., MS. Add. 14761, fol. 28v.

86 Jerusalem, Isr. Mus., Ms. Sassoon 514, fol. 56v.

87 Sarajevo, Nat. Mus., Haggada, fol. 9v.

88 Jerusalem, Isr. Mus., Ms. Sassoon 514, fol. 56v.

89 London, Brit. Libr., MS. Add. 14761, fol. 28v.

90 Sarajevo, Nat. Mus., Haggada, fol. 15v.

91 Budapest, Ac. Sc., Ms. A 422.

92 *Ibid.*, fol. 2r, 3v, 41v.

93 *Ibid.*, fol. 42r.

94 *Ibid.*, fol. 5v, 6r.

95 *Ibid.*, fol. 2r, 3v, 6r.

95a *Ibid.*, fol. 4r.

95b *Ibid.*, fol. 4r.

96 *Ibid.*, fol. 42r, 57v.

97 *Ibid.*, fol. 10r, 42r.

98 *Ibid.*, fol. 57v.

99 *Ibid.*, fol. 3v.

100 *Ibid.*, fol. 60r.

101 *Ibid.*, fol. 3v, 60r.

102 *Ibid.*, fol. 57v.

103 Vatican, Bibl. Apost.

104 Vatican, Bibl. Apost., Cod. Vat. ebr. 14, fol. 9r, 24v.

105 London, Brit. Libr.

106 London, Brit. Libr., MS. Add. 11639, fol. 118v, 205r, 518r for example.

107 *Ibid.*, fol. 114r, 741r.

108 *Ibid.*, fol. 116r, 523r.

109 *Ibid.*, fol. 121r, 518r, 741r.

110 *Ibid.*, fol. 116r.

111 *Ibid.*, fol. 118r and v.

112 *Ibid.*, fol. 121r.

113 *Ibid.*, fol. 118v.

114 *Ibid.*, fol. 518r.

115 *Ibid.*, fol. 741r.

116 *Ibid.*, fol. 518r.

117 *Ibid.*, fol. 205v.

118 *Ibid.*, fol. 114r, 116r, 118r and v, 522v, 741r and v, 742v.

119 *Ibid.*, fol. 205r.

120 *Ibid.*, fol. 116r.

121 Warsaw, Jew. Hist. Inst., Ms. 242.

122 *Ibid.*, fol. 6r, 21v.

123 *Ibid.*, fol. 6r, 21r.

124 Munich, Bayer. St.-Bibl.

125 Milan, Bibl. Ambr.

126 Munich, Bayer. St.-Bibl., Cod. hebr. 5/I, fol. 44v.

127 *Ibid.*, Cod. hebr. 5/II, fol. 183r.

128 *Ibid.*, Cod. hebr. 5/I, fol. 44v, 63r.

129 Milan, Bibl. Ambr., Ms. B.30.Inf., fol. 102r.

130 *Ibid.*, fol. 56r.

131 *Ibid.*, fol. 102r.

132 *Ibid.*, fol. 182v.

133 *Ibid.*, Ms. B.32.Inf., fol. 136r.

134 *Ibid.*, Ms. B.30.Inf., fol. 102r, 182v.

135 Jerusalem, Jew. Nat. Univ. Libr., Ms. Heb. 4° 781/I, known as Worms Maḥzor/I, fol. 72v.

136 Jerusalem, Isr. Mus., Ms. 180/52, known as Regensburg Bible, fol. 18v.

137 London, Brit. Libr., MS. Add. 22413, fol. 148r; Leipzig, Univ.-Bibl., Ms. V 1102/I, fol. 131r.

138 Jerusalem, Schocken Inst., Ms. 14940, known as Schocken Bible, fol. 1v.

139 Jerusalem, Isr. Mus., Ms. 180/57, known as Bird's Head Haggada, fol. 33r and *passim.*

140 Budapest, Ac. Sc., Ms. A 77/IV, fol. 32r and Ms. A 77/II, fol. 48r; Budapest, Ac. Sc., Ms. A 78/I, fol. 8v.

141 London, Brit. Libr., MS. Add. 22413, fol. 3r.

142 Budapest, Ac. Sc., Ms. A 384, fol. 197r.

143 Jerusalem, Schocken Inst., Schocken Bible, fol. 1v.

144 *Ibid.*, fol. 1v.

145 London, Brit. Libr., MS. Add. 22413, fol. 71r; Budapest, Ac. Sc., Ms. A 384, fol. 228r.

146 Hamburg, St.- u. Univ.-Bibl., Cod. Levy 19.

147 Parma, Bibl. Pal., Ms. Parm. 3191–De Rossi 264, fol. 159r.

148 Hamburg, St.- u. Univ.-Bibl., Cod. Levy 19, fol. 34v.

149 *Ibid.*, fol. 274r.

150 *Ibid.*, fol. 403r, 625r.

151 Jerusalem, Isr. Mus., Bird's Head Haggada, fol. 7r.

152 *Ibid.*, fol. 26v.

153 *Ibid.*, fol. 25v.

154 Jerusalem, Isr. Mus., Regensburg Bible, fol. 18v.

155 Leipzig, Univ.-Bibl., Ms. V 1102/I, fol. 68v.

156 London, Brit. Libr., MS. Add. 22413, fol. 3r.

157 Oxford, Bodl. Libr., MS. Opp. 14, fol. 30r.

158 Darmstadt, Hess. Land.- u. Hochschulbibl., Cod. or. 13, fol. 73v.

159 Oxford, Bodl. Libr., MS. Opp. 14, fol. 270v.

160 *Ibid.*, fol. 30r, 33r, 120r.

161 *Ibid.*, fol. 30r, 33r, 120r.

162 Dresden, Sächs. Land.-Bibl., Ms. A 46ᵃ, fol. 202v.

163 *Ibid.*, fol. 202v.

164 London, Brit. Libr., MS. Add. 19776, fol. 72v.

165 Vatican, Bibl. Apost., Cod. Vat. ebr. 324, fol. 41v.

166 Darmstadt, Hess. Land.- u. Hochschulbibl., Cod. or. 8.

167 *Ibid.*, fol. 37v.

168 *Ibid.*, fol. 48v.

169 *Ibid.*, fol. 48v.

170 *Ibid.*, fol. 48v.

171 *Ibid.*, fol. 37v, 48v.

172 *Ibid.*, fol. 48v.

173 *Ibid.*, fol. 37v, 48v.

174 *Ibid.*, fol. 48v.

175 *Ibid.*, fol. 37v, 48v.

176 *Ibid.*, fol. 48v.

177 *Ibid.*, fol. 48v.

178 *Ibid.*, fol. 48v.

179 *Ibid.*, fol. 37v.

180 *Ibid.*, fol. 37v.

181 Jerusalem, Schocken Inst., Ms. 24086, known as 1st Nuremberg Haggada.

182 *Ibid.*, fol. 14r.

183 Budapest, Ac. Sc., Ms. A 371, fol. 21v, 29v.

184 Hamburg, St.- u. Univ.-Bibl.

185 Hamburg, St.- u. Univ.-Bibl., Cod. hebr. 37, fol. 27r, 79r.

186 *Ibid.*, fol. 26r, 27r, 154r.

187 *Ibid.*, fol. 167v.

188 *Ibid.*, fol. 27v.

189 *Ibid.*, fol. 24r, 154r.

190 *Ibid.*, fol. 27v.

191 Oxford, Bodl. Libr., MS. Opp. 154; Parma, Bibl. Pal., Ms. Parm. 2895-De Rossi 653; Munich, Bayer. St.-Bibl., Cod. hebr. 107.

192 Oxford, Bodl. Libr., MS. Opp. 154, fol. 36r.

193 *Ibid.*, fol. 12r.

194 *Ibid.*, fol. 12r.

195 *Ibid.*, fol. 29r.

196 *Ibid.*, fol. 12v.

197 *Ibid.*, fol. 23v.

198 Parma, Bibl. Pal., Ms. Parm. 2895–De Rossi 653, p. 254.

199 Oxford, Bodl. Libr., MS. Opp. 154, fol. 12r.

200 *Ibid.*, fol. 23v, 29r.

201 *Ibid.*, fol. 12r.

202 *Ibid.*, fol. 29r, 39v.

203 *Ibid.*, fol. 24r, 44v.

204 Munich, Bayer. St.-Bibl., Cod. hebr. 107, fol. 23v.

205 Oxford, Bodl. Libr., MS. Opp. 154, fol. 23v; Parma, Bibl. Pal., Ms. Parm. 2895–De Rossi 653, p. 254.

206 Oxford, Bodl. Libr., MS. Opp. 154, fol. 26r.

207 *Ibid.*, fol. 12r.

208 *Ibid.*, fol. 26r.

209 *Ibid.*, fol. 12r; Parma, Bibl. Pal., Ms. Parm. 2895–De Rossi 653, p. 254.

210 London, Brit. Libr.

211 London, Brit. Libr., MS. Add. 14762, fol. 1v, 7v.

212 *Ibid.*, fol. 2r, 6v.

213 *Ibid.*, fol. 7v.

214 *Ibid.*, fol. 6r.

215 *Ibid.*, fol. 2v, 6r.

216 *Ibid.*, fol. 1v, 2v, 6r, 7v.

217 *Ibid.*, fol. 7v.

218 *Ibid.*, fol. 7v.

219 Paris, Bibl. Nat.

220 Jerusalem, Schocken Inst., Ms. 24087, known as 2nd Nuremberg Haggada.

221 Jerusalem, Isr. Mus., Ms. 180/50, known as Yahuda Haggada.

222 Paris, Bibl. Nat., ms. hébr. 1333, fol. 1v; Jerusalem, Isr. Mus., 2nd Nuremberg Haggada, fol. 7v.

223 Jerusalem, Isr. Mus., Yahuda Haggada, fol. 1v; Jerusalem, Schocken Inst., 2nd Nuremberg Haggada, fol. 12v.

224 Paris, Bibl. Nat., ms. hébr. 1333, fol. 2v, 5r;

Jerusalem, Schocken Inst., 2nd Nuremberg Haggada, fol. 12v, 20r; Jerusalem, Isr. Mus., Yahuda Haggada, fol. 2v.

225 Paris, Bibl. Nat., ms. hébr. 1333, fol. 3v, 5r; Jerusalem, Schocken Inst., 2nd Nuremberg Haggada, fol. 12v.

226 Jerusalem, Schocken Inst., 2nd Nuremberg Haggada, fol. 12v, 20r.

227 Jerusalem, Schocken Inst., 2nd Nuremberg Haggada, fol. 3v; Jerusalem, Isr. Mus., Yahuda Haggada, fol. 3r.

228 Jerusalem, Schocken Inst., 2nd Nuremberg Haggada, fol. 20r.

229 *Ibid.*, fol. 20r.

230 *Ibid.*, fol. 4v, 22v, 32v; Jerusalem, Isr. Mus., Yahuda Haggada, fol. 1v, 4v.

231 Paris, Bibl. Nat., ms. hébr. 1333, fol. 5r.

232 Jerusalem, Schocken Inst., 2nd Nuremberg Haggada, fol. 20r, 32v.

233 *Ibid.*, fol. 2r.

234 *Ibid.*, fol. 20r.

235 *Ibid.*, fol. 12v, 20r.

236 *Ibid.*, fol. 2v, 12v, 20r, 32v; Jerusalem, Isr. Mus., Yahuda Haggada, fol. 22r.

236a London, Brit. Libr., MS. Add. 14762, fol. 12v; Jerusalem, Schocken Inst., 2nd Nuremberg Haggada, fol. 16r.

236b Paris, Bibl. Nat., ms. hébr. 1333, fol. 16v.

237 Jerusalem, Schocken Inst., 2nd Nuremberg Haggada, fol. 20r.

238 *Ibid.*, fol. 20r.

239 Cincinnati, Hebr. Un. College, Haggada, fol. 2v.

240 *Ibid.*, fol. 2r, 31v.

241 *Ibid.*, fol. 14v.

242 *Ibid.*, fol. 2r, 2v, 31v.

243 Munich, Bayer. St.-Bibl., Cod. hebr. 200, fol. 7v for example.

244 Parma, Bibl. Pal., Ms. Parm. 1870–De Rossi 510.

245 *Ibid.*, fol. 85v.

246 *Ibid.*, fol. 164v.

247 *Ibid.*, fol. 107v.

248 *Ibid.*, fol. 213v.

249 *Ibid.*, fol. 114v.

250 *Ibid.*, fol. 107v, 119v.

251 *Ibid.*, fol. 163r.

252 Jerusalem, Schocken Inst., Ms. 24085.

253 *Ibid.*, fol. 23v.

254 *Ibid.*, fol. 3r, 25r.

255 *Ibid.*, fol. 27r.

256 *Ibid.*, fol. 14r.

257 *Ibid.*, fol. 3r, 23v.

258 *Ibid.*, fol. 23v.

259 *Ibid.*, fol. 25r, 32r.

260 *Ibid.*, fol. 25r, 32r.

261 *Ibid.*, fol. 32r.

262 *Ibid.*, fol. 16r.

263 Vatican, Bibl. Apost., Cod. Rossian. 555.

264 Oxford, Bodl. Libr., MS. Can. Or. 79.

265 London, Brit. Libr., MS. Add. 26968.

266 Bologna, Bibl. Univ., Ms. 2197.

267 London, Brit. Libr., MS. Add. 26968, fol. 110v; Vatican, Bibl. Apost., Cod. Rossian. 555, fol. 127ᵃv.

268 Vatican, Bibl. Apost., Cod. Rossian. 555, fol. 220r.

269 *Ibid.*, fol. 220r.

270 Oxford, Bodl. Libr., MS. Can. Or. 79, fol. 2v.

271 Vatican, Bibl. Apost., Cod. Rossian. 555, fol. 127ᵃv, 220r; Oxford, Bodl. Libr., MS. Can.

Or. 79, fol. 2v; London, Brit. Libr., MS. Add. 26968, fol. 101r, 110v.

272 Vatican, Bibl. Apost., Cod. Rossian. 555, fol. 127ᵃv, 292ᵃv.

273 Oxford, Bodl. Libr., MS. Can Or. 79, fol. 2v, 135v; London, Brit. Libr., MS. Add. 26968, fol. 139v.

274 Vatican, Bibl. Apost., Cod. Rossian. 555, fol. 292ᵃv.

275 *Ibid.*, fol. 292ᵃv; Oxford, Bodl. Libr., MS. Can. Or. 79, fol. 135v.

276 Vatican, Bibl. Apost., Cod. Rossian. 555, fol. 292ᵃv.

277 *Ibid.*, fol. 292ᵃv, 220r.

278 *Ibid.*, fol. 292ᵃv; London, Brit. Libr., MS. Add. 26968, fol. 110v.

279 Vatican, Bibl. Apost., Cod. Rossian. 555, fol. 220r.

280 *Ibid.*, fol. 220r.

281 *Ibid.*, fol. 292ᵃv.

282 *Ibid.*, fol. 220r, 292ᵃv; London, Brit. Libr., MS. Add. 26968, fol. 118r.

283 Vatican, Bibl. Apost., Cod. Rossian. 555, fol. 292ᵃv.

284 *Ibid.*, fol. 292ᵃv, 220r, 127ᵃv.

285 *Ibid.*, fol. 220r; Oxford, Bodl. Libr., MS. Can. Or. 79, fol. 135v.

286 Bologna, Bibl. Univ., Ms. 2197.

287 *Ibid.*, fol. 402r.

288 *Ibid.*, fol. 7r.

289 *Ibid.*, fol. 210r, 492r.

290 *Ibid.*, fol. 492r.

291 *Ibid.*, fol. 7r, 78r, 210r, 402r.

292 *Ibid.*, fol. 7r, 402r.

293 New York, Priv. coll., form. Frankfurt/M., St.-Bibl., Ms. Ausst. 6; Vatican, Bibl. Apost., Cod. Rossian. 498.

294 London, Brit. Libr.

295 Jerusalem, Jew. Nat. Univ. Libr.

296 Jerusalem, Coll. G. Weill.

297 London, Brit. Libr.

298 Parma, Bibl. Pal.

299 E.g.: Vatican, Bibl. Apost., Cod. Rossian. 498, fol. 2v, 13v; Parma, Bibl. Pal., Ms. Parm. 3596, fol. 3v; Jerusalem, Coll. G. Weill, Maḥzor, p. 1.

300 London, Brit. Libr., MS. Add. 26957, fol. 45r.

301 London, Brit. Libr., MS. Add. 14762, fol. 15r; Jerusalem, Jew. Nat. Univ. Libr., Ms. Heb. 8° 4450, fol. 116r; Jerusalem, Coll. G. Weill, Maḥzor, p. 505.

302 Parma, Bibl. Pal., Ms. Parm. 3596, fol. 267r, 268v, 275r; London, Brit. Libr., MS. Harl. 5686, fol. 61v.

303 Jerusalem, Coll. G. Weill, Maḥzor, p. 505.

304 Parma, Bibl. Pal., Ms. Parm. 3596, fol. 156v.

305 *Ibid.*, fol. 156v; London, Brit. Libr., MS. Harl. 5686, fol. 61v; London, Brit. Libr., MS. Add. 14762, fol. 15r; London, Brit. Libr., MS. Add. 26957, fol. 45v.

306 London, Brit. Libr., MS. Add. 26957, fol. 45v.

307 E.g.: Parma, Bibl. Pal., Ms. Parm. 3596, fol. 156v; London, Brit. Libr., MS. Harl. 5686, fol. 61v; London, Brit. Libr., MS. Add. 14762, fol. 15r; London, Brit. Libr., MS. Add. 26957, fol. 45v.

308 Vatican, Bibl. Apost., Cod. Rossian. 498, fol. 85v; London, Brit. Libr., MS. Harl. 5686, fol. 27v; Jerusalem, Coll. G. Weill, Maḥzor, p. 505.

309 Vatican, Bibl. Apost., Cod. Rossian. 498, fol. 85v; Jerusalem, Coll. G. Weill, Maḥzor, p. 505.

310 London, Brit. Libr., MS. Add. 26957, fol. 45v.

311 London, Brit. Libr., MS. Harl. 5686, fol. 61v; Parma, Bibl. Pal., Ms. Parm. 3596, fol. 275r.

312 London, Brit. Libr., MS. Harl. 5686, fol. 27v, 28r; London, Brit. Libr., MS. Add. 26957, fol. 43v, 45v; London, Brit. Libr., MS. Add. 14762, fol. 15r.

313 Parma, Bibl. Pal., Ms. Parm. 3596, fol. 267r, 275r; Jerusalem, Jew. Nat. Univ. Libr., Ms. Heb. 8° 4450, fol. 2r.

314 Vatican, Bibl. Apost., Ms. Rossian. 498.

315 *Ibid.*, fol. 85v.

316 *Ibid.*, fol. 85v.

317 Jerusalem, Coll. G. Weill, Maḥzor, p. 505; London, Brit. Libr., MS. Add. 26957, fol. 39r, 45r.

318 Jerusalem, Coll. G. Weill, Maḥzor, p. 505; London, Brit. Libr., MS. Add. 26957, fol. 39r, 45r.

319 Parma, Bibl. Pal., Ms. Parm. 3596, fol. 275r; London, Brit. Libr., MS. Harl. 5686, fol. 27v, 28r.

320 Jerusalem, Jew. Nat. Univ. Libr., Ms. Heb. 8° 4450, fol. 203v; Jerusalem, Coll. G. Weill, Maḥzor, p. 505; London, Brit. Libr., MS. Add. 26957, fol. 39r.

321 London, Brit. Libr., MS. Add. 26957, fol. 45r.

322 London, Brit. Libr., MS. Harl. 5686, fol. 27v, 28r.

323 Parma, Bibl. Pal., Ms. Parm. 3596, fol. 275r.

324 London, Brit. Libr., MS. Add. 14762, fol. 15r; Jerusalem, Jew. Nat. Univ. Libr., Ms. Heb. 8° 4450, fol. 203v.

325 Parma, Bibl. Pal., Ms. Parm. 3596, fol. 267r; Stuttgart, Würt. Land.-Bibl., Cod. or. 4° 1, fol. 8r.

326 Washington, D.C., Libr. of Congress; New York, Jew. Theol. Sem. Amer., MS. Acc. No. 03225, known as MS. Rothschild II.

327 Jerusalem, Isr. Mus., Ms. 180/51, known as Ms. Rothschild 24.

328 *Ibid.*, fol. 64v, 78v, 123r.

329 *Ibid.*, fol. 246v.

330 *Ibid.*, fol. 137v.

331 *Ibid.*, fol. 78v, 121v, 131r.

332 *Ibid.*, fol. 78v.

333 *Ibid.*, fol. 64v.

334 *Ibid.*, fol. 64v, 246v.

335 *Ibid.*, fol. 64v, 246v.

336 *Ibid.*, fol. 246v.

337 Parma, Bibl. Pal., Ms. Parm. 3143–De Rossi 958.

338 *Ibid.*, fol. 3v, 12v.

339 *Ibid.*, fol. 17v.

340 *Ibid.*, fol. 5v.

341 *Ibid.*, fol. 2v.

342 *Ibid.*, fol. 5v, 10r, 12v.

343 *Ibid.*, fol. 12v.

344 *Ibid.*, fol. 5v.

345 *Ibid.*, fol. 2v, 12v.

346 *Ibid.*, fol. 2v, 12v.

347 *Ibid.*, fol. 12v.

347a Mr. Schwab (in 'Un manuscrit hébreu de la Bibliothèque Nationale à Paris', *Journal Asiatique*, 8th series, vol. XIX, 1892, p. 180) saw what he thought to be a wheel badge on the clothing of the figure painted in the outer margin of fol. 6r. But this greenish blue disc which overlaps the fastening of the clothing, near the neck, is not a wheel badge; it is an accidental stain, caused no doubt by a drop of water, which

made the color of the *mazzo* held by the figure in fol. 5v (outer margin) leave a circular stain on the figure in fol. 6r. The corresponding dark spot where the color has disappeared can be seen on the *mazzo*.

348 London, Brit. Libr., MS. Add. 14762, fol. 43r, 45r.

348a *Ibid.*, fol. 9r.

349 Hamburg, St.- u. Univ.-Bibl., Cod. Scrin. 132, fol. 75v.

349a In fact, in addition to the few drawings of the wheel badge, already cited, two others could be mentioned, but it is significant that these wheel badges, painted by a Jewish illuminator, the copyist-decorator of Cod. Levy 19 (Hamburg, St.- u. Univ.-Bibl.), both appear on humorous figures (fol. 14v), and thus in an atmosphere of smiling relaxation.

350 Cambridge, Univ. Libr., MS. Add. 662, fol. 53r.

351 Milan, Bibl. Ambr., Ms. Fragm. SP.II.252.

352 Parma, Bibl. Pal., Ms. Parm. 2823–De Rossi 893, fol. 147r.

353 Vatican, Bibl. Apost., Cod. Urbin. ebr. 1, fol. 776r.

354 Leipzig, Univ.-Bibl., Ms. V 1102/I, fol. 174r.

354a London, Brit. Libr., MS. Add. 27210, fol. 8v; London, Brit. Libr., MS. Or. 2881, fol. 11r.

354b Sarajevo, Nat. Mus., Haggada, fol. 19v.

355 Heidelberg, Univ.-Bibl., Cod. pal. 845.

355a Cf. B. Blumenkranz, *Le juif médiéval au miroir de l'art chrétien*, Paris, 1966, pp. 20, 23, 26, 36, 86, 87, 88, 98, 112.

356 Jerusalem, Jew. Nat. Univ. Libr., Ms. Heb. 4° 1193, fol. 27r.

357 London, Brit. Libr., MS. Or. 2884, fol. 17v; London, Brit. Libr., MS. Add. 14761, fol. 65v; Budapest, Ac. Sc., Ms. A 422, fol. 42r.

358 Parma, Bibl. Pal., Ms. Parm. 3006–De Rossi 654, fol. 99v; Leipzig, Univ.-Bibl., Ms. V 1102/I, fol. 27r.

359 Amsterdam, Jew. Hist. Mus., Inv. no. 1, Maḥzor, fol. 171v.

360 London, Brit. Libr., MS. Add. 19776, fol. 96r.

361 Hamburg, St.- u. Univ.-Bibl., Cod. hebr. 37, fol. 114r; Jerusalem, Coll. Sassoon, Ms. 511, p. 28.

362 Jerusalem, Coll. G. Weill, Maḥzor, p. 1.

363 London, Brit. Libr., MS. Add. 26968, fol. 139v.

364 New York, Jew. Theol. Sem. Amer., MS. Rothschild II, fol. 125v.

365 London, Brit. Libr., MS. Add. 11639, fol. 205r.

366 Jerusalem, Schocken Inst., Ms. 24085, fol. 29r.

367 Sarajevo, Nat. Mus., Haggada, fol. 31v of the text.

368 Jerusalem, Schocken Inst., 2nd Nuremberg Haggada, fol. 4v; Parma, Bibl. Pal., Ms. Parm. 3143–De Rossi 958, fol. 12v.

369 Vatican, Bibl. Apost., Cod. Rossian. 555, fol. 12v.

370 Sarajevo, Nat. Mus., Haggada, fol. 34r; Oxford, Bodl. Libr., MS. Opp. Add. 8° 14, fol. 242r.

371 Vatican, Bibl. Apost., Cod. Vat. ebr. 14, fol. 166r.

372 E.g.: Amsterdam, Jew. Hist. Mus., Inv. no. 1, Maḥzor, fol. 171v; Parma, Bibl. Pal., Ms. Parm. 3006–De Rossi 654, fol. 99v; Milan, Bibl. Ambr., Ms. Fragm. S.P.II.252; Jerusalem, Coll. Sassoon, Ms. 506, known as De Castro Pentateuch, p. 697.

373 Leipzig, Univ.-Bibl., Ms. V 1102/I, fol. 27r.

374 Jerusalem, Jew. Nat. Univ. Libr., Worms Maḥzor/I, fol. 72v.

374a Oxford, Bodl. Libr., MS. Can. Or. 79, fol. 2v; Princeton, Univ. Libr., MS. Garrett 26, fol. 17r.

375 London, Brit. Libr., MS. Or. 2884, fol. 17v; London, Brit. Libr., MS. Add. 14761, fol. 65v; Budapest, Ac. Sc., Ms. A 422, fol. 42r.

376 Parma, Bibl. Pal., Ms. Parm. 1870–De Rossi 510, fol. 163v.

377 Parma, Bibl. Pal., Ms. Parm. 1711–De Rossi 234, fol. 115v, 137v, 90r; Jerusalem, Jew. Nat. Univ. Libr., Ms. Heb. 4° 1193, fol. 32r, 33v.

378 Jerusalem, Jew. Nat. Univ. Libr., Ms. Heb. 4° 1193, fol. 40v.

379 Vatican, Bibl. Apost., Cod. Rossian. 555, fol. 12v.

380 Hamburg, St.- u. Univ.-Bibl., Cod. hebr. 37, fol. 114r.

381 London, Brit. Libr., MS. Add. 26968, fol. 139v; Jerusalem, Coll. G. Weill, Maḥzor, p. 1.

382 Jerusalem, Isr. Mus., Ms. Rothschild 24, fol. 105v, 274v.

382a E.g.: Paris, Bibl. All. Isr. Univ., ms. 24 H. fol. 79v, 84v; Cambridge, Univ. Libr., MS. Add. 662, fol. 65r; Jerusalem, Isr. Mus., Ms. Rothschild 24, fol. 137v.

383 Budapest, Ac. Sc., Ms. A 383, fol. 180v; Jerusalem, Coll. G. Weill, Maḥzor, p. 505; Vienna, Öst. Nat.-Bibl., Cod. Hebr. 75, fol. 66r.

384 Budapest, Ac. Sc., Ms. A 383, fol. 40r.

385 Amsterdam, Jew. Hist. Mus., Inv. no. 1, Maḥzor, fol. 171v.

386 Oxford, Bodl. Libr., MS. Opp. 776, fol. 20v.

387 Parma, Bibl. Pal., Ms. Parm. 3006–De Rossi 654, fol. 99v.

388 Jerusalem, Coll. G. Weill, Maḥzor, p. 505; New York, Jew. Theol. Sem. Amer., MS. Rothschild II, fol. 125v.

389 Leipzig, Univ.-Bibl., Ms. V 1102/I, fol. 27r; Budapest, Ac. Sc., Ms. A 383, fol. 180v.

390 Parma, Bibl. Pal., Ms. Parm. 1870–De Rossi 510, fol. 163v.

391 London, Brit. Libr., MS. Add. 14762, fol. 8v.

## CHAPTER V

1 London, Brit. Libr., MS. Add. 11639, fol. 273v.

2 Vatican, Bibl. Apost., Cod. Vat. ebr. 14.

3 *Ibid.*, fol. 59v.

4 *Ibid.*, fol. 36v, 155r, for example.

5 *Ibid.*, fol. 23r, 89v.

6 Lisbon, Bibl. Nac., Ms. Il. 72, fol. 112v, 316v; Paris, Bibl. Nat., ms. hébr. 7, fol. 100v; London, Brit. Libr., MS. Or. 2737, fol. 1r; Sarajevo, Nat. Mus., Haggada, fol. 31r of the text, fol. 47r of the text.

7 London, Brit. Libr., MS. Add. 27210, fol. 3r; London, Brit. Libr., MS. Or. 2884, fol. 3r.

8 Sarajevo, Nat. Mus., Haggada, fol. 3v.

9 London, Brit. Libr., MS. Or. 2737; London, Brit. Libr., MS. Add. 27210; London, Brit. Libr., MS. Or. 2884; London, Brit. Libr., MS. Add. 14761; Sarajevo, Nat. Mus., Haggada; Budapest, Ac. Sc., Ms. A 422.

10 London, Brit. Libr., MS. Add. 27210, fol. 11r; London, Brit. Libr., MS. Add. 14761, fol. 30v.

11 London, Brit. Libr., MS. Add. 14761, fol. 30v, 43r; London, Brit. Libr., MS. Or. 2737, fol. 62v; Budapest, Ac. Sc., Ms. A 422, fol. 59v.

12 London, Brit. Libr., MS. Add. 27210, fol. 11r.

13 London, Brit. Libr., MS. Add. 27210, fol. 11r; London, Brit. Libr., MS. Add. 14761, fol. 30v, 43r.

14 London, Brit. Libr., MS. Add. 14761, fol. 30v; Budapest, Ac. Sc., Ms. A 422, fol. 59v.

15 London, Brit. Libr., MS. Or. 2884, fol. 2v.

16 Sarajevo, Nat. Mus., Haggada, fol. 4r.

17 *Ibid.*, fol. 4r.

18 London, Brit. Libr., MS. Or. 2884, fol. 2v.

19 *Ibid.*, fol. 2v.

19a E.g. in the 11th century, in a Greek manuscript, Vatican, Bibl. Apost., Cod. Vat. gr. 747, fol. 46v, or in the 14th century, in Roussillon, in the St. Michael reredos of the cathedral of Elne, dated 1367–1369 and thus earlier than the Haggada of Sarajevo (cf. José Gudiol Ricart, 'Pintura gotica', in *Ars Hispaniae*, IX, Madrid, 1955, p. 80 and p. 82, fig. 55). In the former case, the woman giving birth is seated; in the second, she is standing.
Also worth noting are the pictures in a medieval Italian manuscript of the 14th century, Vienna, Öst. Nat.-Bibl., Series nova, Ms. 2641, fol. 40v–43.

20 London, Brit. Libr., MS. Or. 2737, fol. 64r.

21 Sarajevo, Nat. Mus., Haggada, fol. 9v.

22 Madrid, Casa de Alba, Alba Bible, fol. 28r.

23 London, Brit. Libr., MS. Or. 2737, fol. 82v; Budapest, Ac. Sc., Ms. A 422, fol. 1v.

24 London, Brit. Libr., MS. Add. 14761, fol. 61r, 28v.

25 Lisbon, Bibl. Nac., Ms. Il. 72, fol. 206r.

26 London, Brit. Libr., MS. Or. 2884, fol. 8v; Sarajevo, Nat. Mus., Haggada, fol. 16r, 15v.

27 Lisbon, Bibl. Nac., Ms. Il. 72, fol. 304r; Jerusalem, Coll. Sassoon, Ms. 82, known as *Shem ṭov* Bible, p. 481.

28 Madrid, Bibl. Nac., Cod. Vª 26/6, fol. 326v.

29 Paris, Bibl. Nat., ms. esp. 30.

30 Oxford, Bodl. Libr., MS. Kenn. 1, fol. 305r.

31 Paris, Bibl. Nat., ms. esp. 30.

32 Paris, Priv. coll., form. Jerusalem, Coll. Sassoon, Ms. 699.

33 Vienna, Öst. Nat.-Bibl., Cod. Hebr. 132; and the Ms. formerly Jerusalem, Coll. Sassoon, Ms. 823.

34 Oxford, Bodl. Libr., MS. Kenn. 1, fol. 90r.

35 Copenhagen, Roy. Libr., Cod. Hebr. XXXVII, fol. 114r.

36 London, Brit. Libr., MS. Add. 27210; London, Brit. Libr., MS. Or. 2884; Sarajevo, Nat. Mus., Haggada.

37 London, Brit. Libr., MS. Add. 22413, fol. 71r; Jerusalem, Jew. Nat. Univ. Libr., Ms. Heb. 4° 781/I, known as Worms Maḥzor/I, fol. 35r (drawing added in first half of 15th century).

38 Jerusalem, Jew. Nat. Univ. Libr., Worms Maḥzor/I, fol. 95v–97v; Budapest, Ac. Sc., Ms. A 384, fol. 142v–145v.

39 Parma, Bibl. Pal., Ms. Parm. 3286–De Rossi 440, fol. 123r.

40 Darmstadt, Hess. Land.- u. Hochschulbibl., Cod. or. 13, fol. 202v.

41 Parma, Bibl. Pal., Ms. Parm. 3289–De Rossi 265, fol. 95r.

42 Paris, Bibl. Nat., ms. hébr. 36, fol. 69v, 95v, 114r.

43 Hamburg, St.- u. Univ.-Bibl., Cod. hebr. 37, fol. 27v.

44 London, Brit. Libr., MS. Add. 14762, fol. 7r.

45 Paris, Bibl. Nat., ms. hébr. 19, fol. 1r; Leipzig, Univ.-Bibl., Ms. V 1102/I, fol. 52r.

46 Oxford, Bodl. Libr., MS. Opp. 154, fol. 24r.

47 Munich, Bayer. St.-Bibl., Cod. hebr. 107, fol. 60v; Jerusalem, Schocken Inst., Ms. 24087, known as 2nd Nuremberg Haggada, fol. 41r.

48 Leipzig, Univ.-Bibl., Ms. V 1102/I, fol. 31v.

49 Jerusalem, Jew. Nat. Univ. Libr., Worms Maḥzor/I, fol. 39v.

50 Dresden, Sächs. Land.-Bibl., Ms. A 46ᵃ, fol. 202v, lower section.

51 Budapest, Ac. Sc., Ms. A 371, fol. 29v.

52 London, Brit. Libr., MS. Add. 14762, fol. 1v.

53 Oxford, Bodl. Libr., MS. Opp. 154, fol. 39v; Munich, Bayer. St.-Bibl., Cod. hebr. 107, fol. 65r.

54 Budapest, Ac. Sc., Ms. A 384, fol. 183v.

55 Oxford, Bodl. Libr., MS. Opp. 14, fol. 270v.

56 Jerusalem, Schocken Inst., 2nd Nuremberg Haggada, fol. 12v; Jerusalem, Isr. Mus., Yahuda Haggada, fol. 11v.

57 Oxford, Bodl. Libr., MS. Opp. 776, fol. 79v.

57a London, Brit. Libr., MS. Or. 10878, fol. 17r.

58 Jerusalem, Coll. Sassoon, Ms. 1028, p. 323; Jerusalem, Schocken Inst., Ms. 13873, fol. 67v.

58a London, Brit. Libr., MS. Or. 5024, fol. 225v; London, Brit. Libr., MS. Add. 27137, fol. 14r.

59 London, Brit. Libr., MS. Or. 5024, fol. 184v.

60 Parma, Bibl. Pal., Ms. Parm. 3143–De Rossi 958, fol. 4v.

61 London, Brit. Libr., MS. Or. 5024, fol. 225v.

62 New York, Priv. coll., form. Frankfurt/M., St.-Bibl., Ms. Ausst. 6, fol. 195v.

63 Venice, Mus. Ebr., Bible, fol. 19v.

64 Parma, Bibl. Pal., Ms. Parm. 2998–De Rossi 111, fol. 2v; Stuttgart, Würt. Land.-Bibl., Cod. or. 4° 1, fol. 4r; London, Brit. Libr., MS. Add. 26957, fol. 39v.

65 Parma, Bibl. Pal., Ms. Parm. 1870–De Rossi 510, fol. 105r.

66 Vatican, Bibl. Apost., Cod. Rossian. 555, fol. 220r.

67 Vercelli, Sem. Vesc., loose folio of the *Arba'a ṭurim* by Jacob ben Asher, beginning of part III.

67a Oxford, Bodl. Libr., MS. Can. Or. 79, fol. 149r; Vatican, Bibl. Apost., Cod. Rossian. 498, fol. 13v; Jerusalem, Isr. Mus., Ms. 180/51, known as MS. Rothschild 24, fol. 353r, 354r.

68 Vatican, Bibl. Apost., Cod. Rossian. 498, fol. 13v.

69 Cambridge, Univ. Libr., MS. Dd. 10.68, fol. 2r; Bologna, Bibl. Univ., Ms. 2197, fol. 7r, 402r, 492r.

70 Bologna, Bibl. Univ., Ms. 2197, fol. 7r.

71 Cambridge, Univ. Libr., MS. Dd. 10.68, fol. 2r; Bologna, Bibl. Univ., Ms. 2197, fol. 7r.

72 Cambridge, Univ. Libr., MS. Dd. 10.68, fol. 7v.

73 Bologna, Bibl. Univ., Ms. 2197, fol. 402r.

74 *Ibid.*, fol. 402r.

75 *Ibid.*, fol. 402r, lower panel.

76 *Ibid.*, fol. 492r.

77 Cambridge, Univ. Libr., MS. Dd. 10.68, fol. 223r; Bologna, Bibl. Univ., Ms. 2197, fol. 2r, lower panel.

78 Bologna, Bibl. Univ., Ms. 2197, fol. 492r.

79 Cambridge, Univ. Libr., MS. Dd. 10.68, fol. 37v.

80 Paris, Bibl. Nat., ms. hébr. 1199.

81 *Ibid.*, fol. 45r.

82 *Ibid.*, fol. 58r.

83 *Ibid.*, fol. 65v.

84 Cambridge, Univ. Libr., MS. Dd. 10.68, fol. 211r.

85 Bologna, Bibl. Univ., Ms. 2197, fol. 492r, lower scenes.

86 *Ibid.*, fol. 492r, lower scenes.

87 *Ibid.*, fol. 492r, lateral scenes.

88 *Ibid.*, fol. 2r, 7r, 402r, 492r. Our heartiest thanks to Dr. Samuel Kottek (Jerusalem), who helped us to identify the medical acts illustrated in Ms. 2197 of Bologna and acquainted us with the properties of the plants of ms. hébr. 1199 of Paris.

89 Bologna, Bibl. Univ., Ms. 2297, fol. 4r.

90 Paris, Bibl. Nat., ms. hébr. 1181, fol. 264v.

91 Bologna, Bibl. Univ., Ms. 2197, fol. 41r.

92 Manchester, J. Ryl. Univ. Libr., MS. Ryl. Hebr. 6, fol. 19v; London, Brit. Libr., MS. Or. 1404, fol. 7v; London, Brit. Libr., MS. Add. 27210, fol. 15r.

93 Jerusalem, Isr. Mus., Ms. 180/57, known as Bird's Head Haggada, fol. 21r.

94 Vatican, Bibl. Apost., Cod.. Rossian. 555, fol. 127ᵃv.

95 Chantilly, Mus. Condé, ms. 732, fol. 20v; Paris, Bibl. Nat., ms. hébr. 1388, fol. 15r.

96 Jerusalem, Schocken Inst.;, 2nd Nuremberg Haggada, fol. 17v.

97 Jerusalem, Isr. Mus., Ms. 180/50, known as Yahuda Haggada, fol. 16v.

98 Hamburg, St.- u. Univ.-Bibl., Cod. Scrin. 132, fol. 6r.

98a London, Brit. Libr., MS. Add. 27210, fol. 15r.

99 Vatican, Bibl. Apost., Cod. Rossian. 555, fol. 127ᵃv.

100 Rome, Bibl. Casan., Ms. 3096, fol. 1r.

101 E.g.: London, Brit. Libr., MS. Or. 2737, fol. 87v, 88r; Jerusalem, Schocken Inst., Ms. 24085, fol. 25r.

102 Jerusalem, Isr. Mus., Yahuda Haggada, fol. 1v.

103 Jerusalem, Isr. Mus., Bird's Head Haggada, fol. 25v, 26r; Jerusalem, Isr. Mus., Yahuda Haggada, fol. 2r; Jerusalem, Schocken Inst., 2nd Nuremberg Haggada, fol. 2v; Jerusalem, Isr. Mus., Ms. Rothschild 24, fol. 155v.

104 London, Brit. Libr., MS. Or. 5024, fol. 64v.

105 Jerusalem, Jew. Nat. Univ. Libr., Ms. Heb. 4° 1193, fol. 22v.

105a London, Brit. Libr., MS. Add. 27137, fol. 14r.

106 Jerusalem, Jew. Nat. Univ. Libr., Ms. Heb. 4° 1193, fol. 18v.

107 London, Brit. Libr., MS. Add. 27137, fol. 14r; New York, Priv. coll., form. Frankfurt/M., St.-Bibl., Ms. Ausst. 6, fol. 170v.

108 London, Brit. Libr., MS. Or. 5024, fol. 241r.

108a London, Brit. Libr., MS. Add. 27137, fol. 14r.

109 Oxford, Bodl. Libr., MS. Can. Or. 79, fol. 135v; New York, Priv. coll., form. Frankfurt/M., St.-Bibl., Ms. Ausst. 6, fol. 298r.

110 Vatican, Bibl. Apost., Cod. Rossian. 555, fol. 292ᵃv.

111 E.g.: London, Brit. Libr., MS. Add. 14761, fol. 65v; Budapest, Ac. Sc., Ms. A 422, fol. 42r; Leipzig, Univ.-Bibl., Ms. V 1102/I, fol. 27r; Vatican, Bibl. Apost., Cod. Rossian. 555, fol. 12v.

112 Vatican, Bibl. Apost., Cod. Vat. ebr. 324, fol. 80v; Hamburg, St.- u. Univ.-Bibl., Cod. hebr. 37, fol. 114r.

113 Vatican, Bibl. Apost., Cod. Rossian. 555, fol. 220r.

114 Jerusalem, Isr. Mus., Ms. Rothschild 24, fol. 120v, 121r.

115 E.g.: London, Brit. Libr., MS. Or. 1404, fol. 9v, 10r, 17r; Manchester, J. Ryl. Univ. Libr., MS. Ryl. Hebr. 6, fol. 22v, 28r and v, 30v; London, Brit. Libr., MS. Or. 2884, fol. 34v; London, Brit. Libr., MS Add. 14761, fol. 53r, 54r.

116 Paris, Bibl. Nat., ms. hébr. 1333, fol. 7v; Munich, Bayer. St.-Bibl., Cod. hebr. 200, fol. 18r and v; Cincinnati, Hebr. Un. College, Haggada, fol. 9r.

117 New Haven, Yale Univ. Libr., MS. 143, Haggada, fol. 3v, 4r, 15r; Parma, Bibl. Pal., Ms. Parm. 3143–De Rossi 958, fol. 10r.

118 London, Brit. Libr., MS. Or. 2737, fol. 20v; Jerusalem, Schocken Inst., Ms. 24085, fol. 23v; Oxford, Bodl. Libr., MS. Opp. 154, fol. 8v, 30v.

119 Parma, Bibl. Pal., Ms. Parm. 2411-De Rossi 1107, fol. 26v.

120 Sarajevo, Nat. Mus., Haggada, fol. 25r of the text; London, Brit. Libr., MS. Add. 14761, fol. 51v; Budapest, Ac. Sc., Ms. A 422, fol. 33v; London, Brit. Libr., MS. Add. 26968, fol. 118r.

121 London, Brit. Libr., MS. Add. 14761, fol. 59v; New York, Jew. Theol. Sem. Amer., MS. Acc. No. 02922, fol. 27v.

122 Berlin, St.-Bibl., Preuss. Kulturbes., Orientabt., Ms. Ham. 288, fol. 10v; London, Brit. Libr., MS. Or. 2737, fol. 22v; Jerusalem, Schocken Inst., Ms. 24085, fol. 23v.

123 Vatican, Bibl. Apost., Cod. Rossian. 498, fol. 2v.

124 Oxford, Bodl. Libr., MS. Opp. 154; fol. 23v.

125 Munich, Bayer. St.-Bibl., Cod. hebr. 36, for example fol. 97v, 99v. We should like to thank Mr Charles Wencker (Strasbourg) for having helped us to master the two demonstrations by Hypsicles.

126 London, Brit. Libr., MS. Add. 26968, fol. 118r.

127 Parma, Bibl. Pal., Ms. Parm. 3596, fol. 3v; Jerusalem, Isr. Mus., Ms. Rothschild 24, fol. 44v; Parma, Bibl. Pal., Ms. Parm. 3143–De Rossi 958, fol. 10r.

128 Jerusalem, Isr. Mus., Ms. Rothschild 24, fol. 369r.

129 Bible, now lost, form. Cairo, Mosseri Coll., beginning of Proverbs; Jerusalem, Isr. Mus., Ms. Rothschild 24, fol. 369r.

130 Jerusalem, Isr. Mus., Ms. Rothschild 24, fol. 174v, 464v, 467r.

131 Munich, Bayer. St.-Bibl., Cod. hebr. 249, fol. 11v.

132 Budapest, Ac. Sc., Ms. A 78/II, fol. 55r.

133 Paris, Bibl. Nat., ms. hébr. 689, fol. 29r.

134 London, Brit. Libr., MS. Add. 14762, fol. 15r.

135 Lisbon, Bibl. Nac., Ms. Il. 72, fol. 433v.

136 Jerusalem, Jew. Nat. Univ. Libr., Ms. Heb. 8° 1957, fol. 42r.

137 London, Brit. Libr., MS. Add. 14762, fol. 7v; London, Brit. Libr., MS. Add. 26968, fol. 118r; Jerusalem, Isr. Mus., Ms. Rothschild 24, fol. 44v.

138 E.g.: London, Brit. Libr., MS. Add. 19776, fol. 96r; Hamburg, St.- u. Univ.-Bibl., Cod. hebr. 37, fol. 114r.

139 E.g.: Oxford, Bodl. Libr., MS. Mich. 619, fol. 100v.

140 E.g.: Parma, Bibl. Pal., Ms. Parm. 2809–De Rossi 187, fol. 3r.

141 Jerusalem, Jew. Nat. Univ. Libr., Worms Maḥzor/I, fol. 127r.

142 London, Brit. Libr., MS. Or. 2737, fol. 78v; Paris, Bibl. Nat., ms. hébr. 1333, fol. 11r.

143 Oxford, Bodl. Libr., MS. Opp. 154, fol. 12v.

144 Sarajevo, Nat. Mus., Haggada, fol. 13v.

145 Jerusalem, Isr. Mus., Ms. 181/41, known as Ms. Sassoon 514, fol. 7r.

146 Hamburg, St.- u. Univ.-Bibl., Cod. hebr. 37, fol. 168v, 79r.

147 London, Brit. Libr., MS. Or. 2737, fol. 83v.

148 Hamburg, St.- u. Univ.-Bibl., Cod. hebr. 37, fol. 27r; London, Brit. Libr., MS. Add. 14762, fol. 15r; Jerusalem, Schocken Inst., 2nd Nuremberg Haggada, fol. 19v, 20r.;

149 Jerusalem, Coll. Sassoon, Ms. 511, p. 16.

## CHAPTER VI

1 Jerusalem, Jew. Nat. Univ. Libr., Ms. Heb. 8° 4450, fol. 2r (the cock which has awakened him is shown in the margin, to the left of the panel, and does not appear in our reproduction).

2 Jerusalem, Schocken Inst., Ms. 24085, fol. 26r.;

3 London, Brit. Libr., MS. Or. 2884, fol. 14r.

4 Jerusalem, Schocken Inst., Ms. 24087, known as 2nd Nuremberg Haggada, fol. 15v; Jerusalem, Isr. Mus., Ms. 180/50, known as Yahuda Haggada, fol.; 14v.

5 Jerusalem, Schocken Inst., Ms. 24085, fol. 26r; Oxford, Bodl. Libr., MS. Opp. 154, fol. 29r; Jerusalem, Coll. Sassoon, Ms. 511, p. 17.

6 Jerusalem, Jew. Nat. Univ. Libr., Ms. Heb. 8° 4450, fol. 2r.

7 Ibid.

8 Jerusalem, Coll. G. Weill, Maḥzor, p. 1.

9 E.g.: Hamburg, St.- u. Univ.-Bibl., Cod. hebr. 37, fol. 114r, and Vatican, Bibl. Apost., Cod. Rossian. 555, fol. 12v.

10 Jerusalem, Isr. Mus., Ms. 180/51, known as Ms. Rothschild 24, fol. 83v.

11 Vatican, Bibl. Apost., Cod. Vat. gr. 699, fol. 48r.;

12 Vatican, Bibl. Apost., Cod. Vat. gr. 746, fol. 241v, 242r.

13 Florence, Bibl. Laur., Ms. Amiatinus 1, fol. 5r.

14 E.g.: Budapest, Ac. Sc., Ms. A 77/I, fol. 60v, and the Ms. form. Jerusalem, Coll. Sassoon, Ms. 417, p. 83.

14a Jerusalem, Isr. Mus., Ms. Rothschild 24, fol. 118r.

15 London, Brit. Libr., MS. Or. 2737, fol. 92v.

16 London, Brit. Libr., MS. Add. 27210, fol. 15r.

17 Sarajevo, Nat. Mus., Haggada, fol. 31v of the text.

18 London, Brit. Libr., MS. Or. 2737, fol. 87v, 88r.

19 Darmstadt, Hess. Land.- u. Hochschulbibl., Cod. or. 13, fol. 73v.

20 E.g.: Jerusalem, Coll. G. Weill, Maḥzor, p. 505; Parma, Bibl. Pal., Ms. Parm. 3143–De Rossi 958, fol. 12v.

21 Parma, Bibl. Pal., Ms. Parm. 3596, fol. 156v.

22 E.g.: Budapest, Ac. Sc., Ms. A 422, fol. 2r.

23 E.g.: Jerusalem, Schocken Inst., 2nd Nuremberg Haggada, fol. 18r.

24 Parma, Bibl. Pal., Ms. Parm. 3143–De Rossi 958, fol. 10v.

25 E.g.: London, Brit. Libr., MS. Add. 27210, fol. 15r, and Jerusalem, Schocken Inst., 2nd Nuremberg Haggada, fol. 3r.

26 Budapest, Ac. Sc., Ms. A 77/I, fol. 46v.

27 Sarajevo, Nat. Mus., Haggada, fol. 3v; Paris, Séminaire Israélite, ms. 1, fol. 1r.

28 London, Brit. Libr., MS. Or. 5024, fol. 5v; Venice, Mus. Ebr., Bible, fol. 11r.

29 E.g.: Budapest, Ac. Sc., Ms. A 422, fol. 2r.

30 E.g.: Paris, Bibl. Nat., ms. hébr. 1333, fol. 17r; Jerusalem, Schocken Inst., 2nd Nuremberg Haggada, fol. 18r; Washington, D.C., Libr. of Congress, Haggada, fol. 14v.

31 E.g.: Parma, Bibl. Pal., Ms. Parm. 3143–De Rossi 958, fol. 10v.

32 Lisbon, Bibl. Nac., Ms. Il. 72, fol. 322v.

33 London, Brit. Libr., MS. Add. 27210, fol. 15r; Vatican, Bibl. Apost., Cod. Rossian. 555, fol. 127ᵃv; Rome, Bibl. Casan., Ms. 3096, fol. 1r.

34 Lisbon, Bibl. Nac., Ms. Il. 72, fol. 442v.

35 Ibid., fol. 328v.

36 Ibid., fol. 248v.

37 E.g.: Oxford, Bodl. Libr., MS. Can. Or. 137, fol. 220v, and Lisbon, Bibl. Nac., Ms. Il. 72, fol. 428v, 256r.

38 E.g.: Cambridge, Univ. Libr., MS. Add. 437, fol. 158r.

39 Lisbon, Bibl. Nac., Ms. Il. 72, fol. 112v.

40 Jerusalem, Isr. Mus., Ms. Rothschild 24, fol. 131r.

41 Ibid., fol. 131r, 125v.

42 Lisbon, Bibl. Nac., Ms. Il. 72, fol. 442v.

43 London, Brit. Libr., MS. Add. 11639, fol. 236r; New York, Priv. coll., form. Frankfurt/M., St.-Bibl., Ms. Ausst. 5, fol. 493v; Budapest, Ac. Sc., Ms. A 77/III, fol. 57r; Lisbon, Bibl. Nac., Ms. Il. 72, fol. 433v.

43a Oxford, Bodl. Libr., MS. Opp. 154, fol. 21v, 27v; Munich, Bayer. St.-Bibl., Cod. hebr. 107, fol. 46r, 48r; Jerusalem, Isr. Mus., Ms. Rothschild 24, fol. 334r, 336r.

43b E.g.: Jerusalem, Schocken Inst., Ms. 24086, known as 1st Nuremberg Haggada, fol. 14r; Parma, Bibl. Pal., Ms. Parm. 2895–De Rossi 653, p. 254; Jerusalem, Coll. G. Weill, Maḥzor, p. 505.

44 Bologna, Bibl. Univ., Ms. 2197, fol. 402r.

45 Hamburg, St.- u. Univ.-Bibl., Cod. hebr. 37, fol. 9v.

46 Jerusalem, Schocken Inst., 2nd Nuremberg Haggada, fol. 32v; Jerusalem, Isr. Mus., Yahuda Haggada, fol. 31v.

47 Jerusalem, Schocken Inst., 2nd Nuremberg Haggada, fol. 33r; Jerusalem, Isr. Mus., Yahuda Haggada, fol. 32r.

48 Sarajevo, Nat. Mus., Haggada, fol. 9v.

49 London, Brit. Libr., MS. Or. 2737, fol. 64r.

50 Princeton, Univ. Libr., MS. Garrett 26, fol. 1v.

51 E.g.: London, Brit. Libr., MS. Add. 27210, fol. 15r; Budapest, Ac. Sc., Ms. A 422, fol. 10r.

52 Jerusalem, Schocken Inst., 2nd Nuremberg Haggada, fol. 32v; Jerusalem, Isr. Mus., Yahuda Haggada, fol. 31v.

53 Jerusalem, Schocken Inst., 2nd Nuremberg Haggada, fol. 20r; Jerusalem, Isr. Mus., Yahuda Haggada, fol. 19r.

54 Munich, Bayer. St.-Bibl., Cod. hebr. 107, fol. 79v.

55 Jerusalem, Isr. Mus., Ms. Rothschild 24, fol. 246r, for example.

56 E.g.: Budapest, Ac. Sc., Ms. A 422, fol. 57v, 58r; Jerusalem, Jew. Nat. Univ. Libr., Ms. Heb. 4° 4450, fol. 203v; Washington, D.C., Libr. of Congress, Haggada, fol. 19v.

57 E.g.: London, Brit. Libr., MS. Or. 2737, fol. 87v, 88r; Budapest, Ac. Sc., Ms. A 422, fol. 2r; Jerusalem, Schocken Inst., Ms. 24085, fol. 25r; Paris, Bibl. Nat., ms. hébr. 1333, fol. 17r.

58 E.g.: Sarajevo, Nat. Mus., Haggada, fol. 28r; Budapest, Ac. Sc., Ms. A 422, fol. 3v, 60r; Jerusalem, Schocken Inst., Ms. 24085, fol. 32r.

59 Parma, Bibl. Pal., Ms. Parm. 2998–De Rossi 111, fol. 4r.

60 Oxford, Bodl. Libr., MS. Opp. 14, fol. 270v.

61 London, Brit. Libr., MS. Add. 14761, fol. 65v; Budapest, Ac. Sc., Ms. A 422, fol. 42r.

62 Sarajevo, Mus. Nat., Haggada, fol. 34r, and London, Brit. Libr., MS. Add. 14761, fol. 65v.

63 Leipzig, Univ.-Bibl., Ms. V 1102/I, fol. 131r.

64 Jerusalem, Schocken Inst., 2nd Nuremberg Haggada, fol. 33r; Jerusalem, Isr. Mus., Yahuda Haggada, fol. 32r.

65 London, Brit. Libr., MS. Add. 19776, fol. 72v.

66 E.g.: Munich, Bayer. St.-Bibl., Cod. hebr. 107, fol. 9v.

67 Venice, Mus. Ebr., Bible, fol. 17r.

68 Budapest, Ac. Sc., Ms. A 77/IV, fol. 70r; Lisbon, Bibl. Nac., Ms. Il. 72, fol. 29v.

69 London, Brit. Libr., MS. Add. 14761, fol. 30v.

70 London, Brit. Libr., MS. Add. 11639, fol. 327v.

71 Venice, Mus. Ebr., Bible, fol. 20v.

72 Oxford, Bodl. Libr., MS. Can. Or. 81, fol. 2r.

73 Lisbon, Bibl. Nac., Ms. Il. 72, fol. 347r.

74 Ibid., fol. 440v.

75 Parma, Bibl. Pal., Ms. Parm. 1870–De Rossi 510, fol. 85v; Jerusalem, Jew. Nat. Univ. Libr., MS. Heb. 4° 1193, fol. 18v.

76 London, Brit. Libr., MS. Add. 27210, fol. 15r; London, Brit. Libr., MS. Or. 2884, fol. 17r; Sarajevo, Nat. Mus., Haggada, fol. 33v; Parma, Bibl. Pal., Ms. Parm. 3273–De Rossi 134, fol. 1v.

77 London, Brit. Libr., MS. Add. 14762, fol. 12v.

78 Princeton, Univ. Libr., MS. Garrett 26, fol. 47v.

79 London, Brit. Libr., MS. Add. 11639, fol. 115r. Our sincere thanks to Dr. Moshé Catane (Jerusalem), who deciphered the inscriptions in this hand for us.

80 E.g.: London, Brit. Libr., MS. Or. 2737, fol. 20v; Sarajevo, Nat. Mus., Haggada, fol. 25r of the text; Vatican, Bibl. Apost., Cod. Rossian. 498, fol. 2v.

81 E.g.: Sarajevo, Nat. Mus., Haggada, fol. 31v of the text; Budapest, Ac. Sc., Ms. A 422, fol. 2r; New York, Priv. coll. form. Frankfurt/M., St.-Bibl., Ms. 725/17, fol. 21r.

82 E.g.: Jerusalem, Isr. Mus., Ms. 180/57, known as Bird's Head Haggada, fol. 28r; Jerusalem, Schocken Inst., 2nd Nuremberg Haggada, fol. 25v; London, Brit. Libr., MS. Add. 14761, fol. 19v; Paris, Bibl. Nat., ms. hébr. 1333, fol. 5r; Darmstadt, Hess. Land.- u. Hochschulbibl., Cod. or. 28, fol. 12r; Parma, Bibl. Pal., Ms. Parm. 3143–De Rossi 958, fol. 3v.

83 E.g.: Jerusalem, Isr. Mus., Bird's Head Haggada, fol. 28r; Jerusalem, Schocken Inst., 2nd Nuremberg Haggada, fol. 25v; Darmstadt, Hess. Land.- u. Hochschulbibl., Cod. or. 28, fol. 12r.

84 E.g.: Paris, Bibl. Nat., ms. hébr. 1333, fol. 23r; Parma, Bibl. Pal., Ms. Parm. 3143–De Rossi 958, fol. 14v.

85 E.g.: Paris, Bibl. Nat., ms. hébr. 1333, fol. 23r.

86 Jerusalem, Jew. Nat. Univ. Libr., Ms. Heb. 4° 1193, fol. 32r.

87 Jerusalem, Schocken Inst., Ms. 24085, fol. 33v.

88 Hamburg, St.- u. Univ.-Bibl., Cod. Levy 19, fol. 625r.

89 Paris, Bibl. Nat., ms. hébr. 10, fol. 56v–57r.

89a Berlin, St.-Bibl., Preuss. Kulturbes., Orient-abt., Ms. or. qu. 1, fol. 36v.

90 London, Brit. Libr., MS. Add. 26968, fol. 209v.

91 Venice, Mus. Ebr., Bible, fol. 15r.

92 Lisbon, Bibl. Nac., Ms. Il. 72, fol. 153r, 305r; Paris, Bibl. Nat., ms. hébr. 1203, fol. 45v.

93 Vatican, Bibl. Apost., Cod. Rossian. 498, fol. 85v.

94 E.g.: London, Brit. Libr., MS. Or. 2737, fol. 86v; Sarajevo, Nat. Mus., Haggada, fol. 28r; Budapest, Ac. Sc., Ms. A 422, fol. 3v; Jerusalem, Schocken Inst., 2nd Nuremberg Haggada, fol. 22r.

95 E.g.: Budapest, Ac. Sc., Ms. A 422, fol. 60r; Jerusalem, Isr. Mus., Ms. Rothschild 24, fol. 246v

96 E.g.: London, Brit. Libr., MS. Or. 2884, fol. 9r; Jerusalem, Schocken Inst., 2nd Nuremberg Haggada, fol. 35v; Vienna, Öst. Nat.-Bibl., Cod. Hebr. 88, fol. 1v.

97 London, Brit. Libr., MS. Or. 2737, fol. 68r; London, Brit. Libr., MS. Add. 27210, fol. 7r; London, Brit. Libr., MS. Or. 2884, fol. 9v, 10v; Sarajevo, Nat. Mus., Haggada, fol. 17v; Jerusalem, Schocken Inst., 2nd Nuremberg Haggada, fol. 13v.

98 Sarajevo, Nat. Mus., Haggada, fol. 34r of the text.

99 E.g.: Darmstadt, Hess. Land.- u. Hochschul-bibl., Cod. or. 28, fol. 12r; Paris, Bibl. Nat., ms. hébr. 1333, fol. 19v; Jerusalem, Isr. Mus., Ms. Rothschild 24, fol. 160r.

100 Wrocław, Ossolinski Libr.–Pawlikowski Coll., Ms. 141, p. 890; Jerusalem, Isr. Mus., Ms. Rothschild 24, fol. 78v.

101 Manchester, J. Ryl. Univ. Libr., MS. Ryl. Hebr. 6, fol. 14r; London, Brit. Libr., MS. Or. 1404, fol. 2r.

102 Cambridge, Univ. Libr., MS. Add. 662, fol. 35v.

103 E.g.: Budapest, Ac. Sc., Ms. A 383, fol. 40r; Parma, Bibl. Pal., Ms. Parm. 3596, fol. 267r, 268v; Jerusalem, Isr. Mus., Ms. Rothschild 24, fol. 118v; Budapest, Ac. Sc., Ms. A 380/II, fol. 227v.

104 Jerusalem, Isr. Mus., Ms. 180/52, known as Regensburg Bible, fol. 18v.

105 Nîmes, Bibl. Mun., ms. 13, fol. 181v; Princeton, Univ. Libr., MS. Garrett 26, fol. 3r.

106 Oxford, Bodl. Libr., MS. Opp. 53, fol. 237r.

107 Budapest, Ac. Sc., Ms. A 380/II, fol. 228v; Princeton, Univ. Libr., Ms. Garrett 26, fol. 8r.

108 Princeton, Univ. Libr., MS. Garrett 26, fol. 13r.

109 Vienna, Öst. Nat.-Bibl., Cod. Hebr. 218.

110 E.g.: Vatican, Bibl. Apost., Cod. Rossian. 555, fol. 220r; London, Jews' College, Montefiore Libr., MS. 249, fol. 10v; Parma, Bibl. Pal., Ms. Parm. 3596, fol. 275r; Jerusalem, Isr. Mus., MS. Rothschild 24, fol. 120v; Hamburg, St.- u. Univ.-Bibl., Cod. Scrin. 132, fol. 75v; Budapest, Ac. Sc., Ms. A 380/II, fol. 230r.

111 Budapest, Ac. Sc., Ms. A 380/II, fol. 231v.

112 Jerusalem, Jew. Nat. Univ. Libr., Ms. Heb. 4° 781/I, known as Worms Maḥzor/I, fol. 72v.

113 Oxford, Bodl. Libr., MS. Can. Or. 79, fol. 2v; Princeton, Univ. Libr., MS. Garrett 26, fol. 17r.

114 Jerusalem, Schocken Inst., 2nd Nuremberg Haggada, fol. 12v; Jerusalem, Isr. Mus., Yahuda Haggada, fol. 11v.

115 Jerusalem, Isr. Mus., MS. Rothschild 24, fol. 121v.

116 Jerusalem, Jew. Nat. Univ. Libr., Worms Maḥ-zor/I, fol. 72v.

117 Vienna, Öst. Nat.-Bibl., Cod. Hebr. 218.

118 Jerusalem, Schocken Inst., 2nd Nuremberg Haggada, fol. 12v.

119 Ibid., fol. 12v; Jerusalem, Isr. Mus., Yahuda Haggada, fol. 11v.

119a Jerusalem, Isr. Mus., Yahuda Haggada, fol. 11v.

119b Ibid., fol. 11v; Jerusalem, Schocken Inst., 2nd Nuremberg Haggada, fol. 12v.

120 Vatican, Bibl. Apost., Cod. Rossian. 555, fol. 220r.

121 London, Brit. Libr., MS. Harl. 5686, fol. 27v, 28r.

122 Princeton, Univ. Libr., MS. Garrett 26, fol. 14r, 15v, 20v.

123 London, Brit. Libr., MS. Harl. 5686, fol. 28r.

124 E.g., in Ms. A 380/II at Budapest, fol. 231v, on the very page where we find the illustration of the conferring of the *ketuba*.

125 Parma, Bibl. Pal., Ms. Parm. 2823–De Rossi 893, fol. 324v.

126 London, Brit. Libr., MS. Or. 2737, fol. 82v.

127 Budapest, Ac. Sc., Ms. A 422, fol. 1v.

127a London, Brit. Libr., MS. Or. 2737, fol. 84r.

128 London, Brit. Libr., MS. Add. 27210, fol. 14v; Sarajevo, Nat. Mus., Haggada, fol. 19v.

129 Budapest, Ac. Sc., Ms. A 422, fol. 1v.

130 Ibid.;

131 London, Brit. Libr., MS. Add. 27210, fol. 8v; London, Brit. Libr., MS. Or. 2884, fol. 11v.

132 Sarajevo, Nat. Mus., Haggada, fol. 19v.

133 London, Brit. Libr., MS. Add. 27210, fol. 8v, 14v; London, Brit. Libr., MS. Or. 2884, fol. 11v.

134 Milan, Bibl. Ambr., Ms. B.30.Inf., fol. 56r.

135 Oxford, Bodl. Libr., MS. Opp. 53, fol. 248v.

136 Princeton, Univ. Libr., MS. Garrett 26, fol. 55r, 56r, 57r, 60r.

137 Jerusalem, Isr. Mus., MS. Rothschild 24, fol. 121v.

138 Ibid., fol. 122v.

## CHAPTER VII

1 London, Brit. Libr., MS. Or. 2884, fol. 41v.

2 Berlin, St.-Bibl., Preuss. Kulturbes., Orientabt., Ms. or. fol. 388, fol. 69r.

3 Jerusalem, Isr. Mus., Ms. 180/51, known as Ms. Rothschild 24, fol. 233r.

4 E.g.: London, Brit. Libr., MS. Add. 14761, fol. 65v; Hamburg, St.- u. Univ.-Bibl., Cod. hebr. 37, fol. 114r; London, Brit. Libr., MS. Add. 26968, fol. 139v; Vatican, Bibl. Apost., Cod. Rossian. 555, fol. 12v; Jerusalem, Jew. Nat. Univ. Libr., MS. Heb. 8° 4450, fol. 2r.

5 E.g.: Milan, Bibl. Ambr., Ms. Fragm. S.P.II.252; Parma, Bibl. Pal., Ms. Parm. 3006–De Rossi 654, fol. 99v; Leipzig, Univ.-Bibl., Ms. V 1102/I, fol. 27r; London, Brit. Libr., MS. Harl. 5686, fol. 28r; Jerusalem, Coll. G. Weill, Maḥzor, p. 1; Jerusalem, Coll. Sassoon, Ms. 511, p. 28.

6 E.g.: London, Brit. Libr., MS. Harl. 5686, fol. 28r; Jerusalem, Isr. Mus., MS. Rothschild 24, fol. 103r.

7 London, Brit. Libr., MS. Add. 26968, fol. 290r.

8 Jerusalem, Isr. Mus., MS. Rothschild 24, fol. 139r.

9 Jerusalem, Jew. Nat. Univ. Libr., Ms. Heb. 4° 1193, fol. 32r.

10 Jerusalem, Coll. G. Weill, Maḥzor, p. 1.

11 New York, Jew. Theol. Sem. Amer., MS. Acc. No. 03225, known as MS. Rothschild II, fol. 200v.

12 Hamburg, St.- u. Univ.-Bibl., Cod. hebr. 37, fol. 161v.

13 Parma, Bibl. Pal., Ms. Parm. 1870–De Rossi 510, fol. 41v, 126r, 188r.

14 Jerusalem, Isr. Mus., Ms. Rothschild 24, fol. 274v.

15 Parma, Bibl. Pal., Ms. Parm. 1870–De Rossi 510, fol. 139r, 213v.

15a Cairo, later Paris, Mosseri Coll., Bible lost during Second World War.

16 Sarajevo, Nat. Mus., Haggada, fol. 2r.

17 Darmstadt, Land.- u. Hochschulbibl., Cod. or. 28, fol. 9r.

18 Jerusalem, Isr. Mus., Ms. Rothschild 24, fol. 123v.

19 London, Brit. Libr., MS. Or. 5024, fol. 40v.

20 Jerusalem, Isr. Mus., Ms. Rothschild 24, fol. 123r.

21 London, Brit. Libr., MS. Add. 14762, fol. 2r; Cincinnati, Hebr. Un. College, Haggada, fol. 2r.

22 Jerusalem, Coll. Sassoon, Ms. 1028, p. 157.

23 New York, Jew. Theol. Sem. Amer., MS. Mic. 8204, fol. 62v.

24 E.g.: For Spain: London, Brit. Libr., MS. Or. 2884, fol. 27v; London, Brit. Libr., MS. Add. 14761, fol. 21v. For Ashkenazi countries: Jerusalem, Isr. Mus., Ms. 180/57, known as Bird's Head Haggada, fol. 2r; Darmstadt, Hess. Land.- u. Hochschulbibl., Cod. or. 8, fol. 5r, 6r, 7r; Parma, Bibl. Pal., Ms. Parm. 2895–De Rossi 653, p. 232; London, Brit. Libr., MS. Add. 14762, fol. 2v; Cincinnati, Hebr. Un. College, Haggada, fol. 2v; Jerusalem, Schocken Inst., Ms. 24087, known as 2nd Nuremberg Haggada, fol. 4v; Paris, Bibl. Nat., ms. hébr. 1333, fol. 2r, 3v, 4r; Darmstadt, Hess. Land.- u. Hochschul-bibl., Cod. or. 28, fol. 2v. For Italy: Parma, Bibl. Pal., Ms. Parm. 2998–De Rossi 111, fol. 1r; Stuttgart, Württ. Land.-Bibl., Cod. or. 4° 1, fol. 2r; Jerusalem, Isr. Mus., Ms. Rothschild 24, fol. 156r; Parma, Bibl. Pal., Ms. Parm. 3143–De Rossi 958, fol. 2v.

25 Jerusalem, Isr. Mus., Ms. Rothschild 24, fol. 131r.

26 Jerusalem, Coll. G. Weill, Maḥzor, p. 505.

27 London, Brit. Libr., MS. Harl. 5686, fol. 28r.

28 Ibid., fol. 27v, 28r.

29 Sarajevo, Nat. Mus., Haggada, fol. 34r.

30 E.g.: London, Brit. Libr., MS. Harl. 5686, fol. 28r.

31 E.g.: Parma, Bibl. Pal., Ms. Parm. 3006–de Rossi 654, fol. 99v; Milan, Bibl. Ambr., Ms. Fragm. S.P.II.252; Jerusalem, Coll. Sassoon, Ms. 511, p. 28.

32 E.g.: Jerusalem, Coll. Sassoon, Ms. 511, p. 23.

33 Parma, Bibl. Pal., Ms. Parm. 1870–De Rossi 510, fol. 213v.

34 E.g.: Jerusalem, Isr. Mus., Ms. Rothschild 24, fol. 105v.

35 London, Brit. Libr., MS. Add. 19776, fol. 96r; Hamburg, St.- u. Univ.-Bibl., Cod. hebr. 37, fol. 114r.

36 Vatican, Bibl. Apost., Cod. Rossian. 555, fol. 12v.

36a Cambridge, Univ. Libr., MS. Add. 1204, fol. 81r.

37 Vatican, Bibl. Apost., Cod. Vat. ebr. 324, fol. 41v.

38 London, Brit. Libr., MS. Add. 14761, fol. 24v, 26r.

39 E.g.: Jerusalem, Schocken Inst., 2nd Nuremberg Haggada, fol. 5v; Jerusalem, Isr. Mus., Ms. 180/50, known as Yahuda Haggada, fol. 5r; Paris, Bibl. Nat., ms. hébr. 1333, fol. 4v; Darmstadt, Hess. Land.- u. Hochschulbibl., Cod. or. 28, fol. 2v; Parma, Bibl. Pal., Ms. Parm. 3143–de Rossi 958, fol. 3r.

40 E.g.: Jerusalem, Isr. Mus., Bird's Head Haggada, fol. 5v; London, Brit. Libr., MS. Add. 14762, fol. 4r; Munich, Bayer. St.-Bibl., Cod. hebr. 200, fol. 8v.

41 Paris, Bibl. Nat., ms. hébr. 20, fol. 2r–8v; Paris, Bibl. Nat., ms. hébr. 21, fol. 2r–4v (now incomplete).

42 Paris, Bibl. Nat., ms. hébr. 20, fol. 3v–6v.

43 Paris, Bibl. Nat., ms. hébr. 21, fol. 2r–3r, with major gap.

44 Paris, Bibl. Nat., ms. hébr. 20 only.

45 Paris, Bibl. Nat., ms. hébr. 20, fol. 7r; Paris, Bibl. Nat., ms. hébr. 21, fol. 3v.

46 Paris, Bibl. Nat., ms. hébr. 20, fol. 7v, 2r.

47 Paris, Bibl. Nat., ms. hébr. 20, fol. 8r and v; Paris, Bibl. Nat., ms. hébr. 21, fol. 4r and v.

48 Jerusalem, Coll. G. Weill, Maḥzor, p. 1.

49 E.g.: Leipzig, Univ.-Bibl., Ms. V 1102/II, fol. 26v.

50 E.g.: Paris, Bibl. All. Isr. Un., ms. 24H, fol. 42r, 74v, 79v, 84v; Oxford, Bodl. Libr., MS. Reggio 1, fol. 159v; Vienna, Öst. Nat.-Bibl., Cod. Hebr. 174, fol. 37r; Budapest, Ac. Sc., Ms. A 388/II, fol. 12v, 163v; Darmstadt, Hess. Land.- u. Hochschulbibl., Cod. or. 13, fol. 187v; Cambridge, Univ. Libr., MS. Add. 662, fol. 65r.

51 E.g.: Paris, All. Isr. Un., Ms. 24H, fol. 79v and 84v; Vienna, Öst. Nat.-Bibl., Cod. Hebr. 174, fol. 20v; Cambridge, Univ. Libr., MS. Add. 662, fol. 65r.

52 E.g.: Paris, Bibl. All. Isr. Un., ms. 24H, fol. 42r, 74v, 79v, 84v; Oxford, Bodl. Libr., MS. Reggio 1, fol. 159v: the foot is raised, but the support is missing; Vienna, Öst. Nat.-Bibl., Cod. Hebr. 174, fol. 20v; Budapest, Ac. Sc., Ms. A 388/II, fol. 12v, 163v; Darmstadt, Hess. Land.- u. Hochschulbibl., Cod. or. 13, fol. 187v; Cambridge, Univ. Libr., MS. Add. 662, fol. 65r.

53 Paris, Bibl. All. Isr. Un., ms. 24H, fol. 84v; Budapest, Ac. Sc., Ms. A 388/II, fol. 12v.

54 Paris, Bibl. All. Isr. Un., ms. 24H, fol. 42r.

54a At most, we find a small pen drawing of a *shofar* player in Paris, Bibl. Nat., ms. hébr. 7, fol. 293v.

55 London, Brit. Libr., MS. Kings 1, fol. 4r.

56 E.g.: London, Brit. Libr., MS. Or. 5024, fol. 78r; London, Brit. Libr., MS. Add. 26968, fol. 244r, 248r 251v; Parma, Bibl. Pal., Ms. Parm. 1756-De Rossi 236, fol. 172v; New York, Jew. Theol. Sem. Amer., MS. Rothschild II, fol. 247r.

57 Budapest, Ac. Sc., Ms. A 380/II, fol. 38r, 41r, 42v, 44r.

58 Jerusalem, Isr. Mus., Ms. Rothschild 24, fol. 137v; Jerusalem, Coll. G. Weill, Maḥzor, p. 173 (two pictures).

59 Jerusalem, Isr. Mus., Ms. Rothschild 24, fol. 131r.

60 E.g.: Leipzig, Univ.-Bibl., Ms. V 1102/II, fol. 26v, 54r; Budapest, Ac. Sc., Ms. A 380/II, fol. 33v.

61 Oxford, Bodl. Libr., MS. Laud. Or. 321, fol. 165v.

62 Oxford, Bodl. Libr., MS. Reggio 1, fol. 207v.

63 Vienna, Öst. Nat.-Bibl., Cod. Hebr. 174, fol. 1v.

64 *Ibid.*, fol. 20v.

65 Hamburg, St.- u. Univ.-Bibl., Cod. hebr. 37, fol. 1r.

66 E.g.: Parma, Bibl. Pal., Ms. Parm. 3518, fol. 25v; Oxford, Bodl. Libr., MS. Laud. Or. 321, fol. 184r; Oxford, Bodl. Libr., MS. Can. Or. 140, fol. 35v; Oxford, Bodl. Libr., MS. Reggio 1, fol. 159v; Leipzig, Univ.-Bibl., Ms. V 1102/II, fol. 26v, 66r; Oxford, Bodl. Libr., MS. Mich. 619, fol. 5v; Wrocław, Univ. Libr., Ms. Or. I, 1, fol. 46v; Darmstadt, Hess. Land.- u. Hochschulbibl., Cod. or. 13, fol. 202v; Hamburg, St.- u. Univ. Bibl., Cod. hebr. 37, fol. 1r.

67 E.g.: Oxford, Bodl. Libr., MS. Reggio 1, fol. 159v; Leipzig, Univ.-Bibl., Ms. V 1102/II, fol. 26v.

68 Hamburg, St.- u. Univ.-Bibl., Cod. hebr. 37, fol. 1r.

69 Budapest, Ac. Sc., Ms. A 380/II, fol. 27r.

70 Berlin, St.-Bibl., Preuss. Kulturbes., Orientabt., Ms. or. fol. 388, fol. 69r.

71 Budapest, Ac. Sc., Ms. A 388/II, fol. 54v.

72 Munich, Bayer. St.-Bibl., Cod. hebr. 3/I, fol. 48r.

73 Budapest, Ac. Sc., Ms. A 387, fol. 350v.

74 Budapest, Ac. Sc., Ms. A 387, fol. 377v, 379v.

75 Wrocław, Univ. Libr., Ms. Or. I, 1, fol. 89v.

76 E.g.: Jerusalem, Jew. Nat. Univ. Libr., Ms. Heb. 4° 781/II, known as Worms Maḥzor/II, fol. 199v; Oxford, Bodl. Libr., MS. Laud. Or. 321, fol. 248v; Leipzig, Univ.-Bibl., Ms. V 1102/II, fol. 129v; Oxford, Bodl. Libr., MS. Mich. 619, fol. 201r; Budapest, Ac. Sc., Ms. A 388/II, fol. 113r; Budapest, Ac. Sc., Ms A 387, fol. 316r.

77 Leipzig, Univ.-Bibl., Ms. V 1102/II, fol. 164v.

78 E.g.: Oxford, Bodl. Libr., MS. Mich. 627, fol. 59r; Jerusalem, Jew. Nat. Univ. Libr., Worms Maḥzor/II, fol. 73r; Oxford, Bodl. Libr., MS. Reggio 2, fol. 30v; Leipzig, Univ.-Bibl., Ms. V 1102/II, fol. 85r; Wrocław, Univ. Libr., MS Or. I, 1, fol. 89v; Budapest, Ac. Sc., Ms A 388/II, fol. 68v; Jerusalem, Jew. Nat. Univ. Libr., Ms. Heb. 8° 5214, fol. 83r.

79 E.g.: Leipzig, Univ.-Bibl., Ms. V 1102/II, fol. 174r, 176r; Wrocław, Univ. Libr., Ms. Or. I, 1, fol. 221v.

80 Leipzig, Univ.-Bibl., Ms. V 1102/II, fol. 176r; Budapest, Ac. Sc., Ms. A 387, fol. 417r.

81 Wrocław, Univ. Libr., MS. Or. I, 1, fol. 89v.

82 Budapest, Ac. Sc., Ms. A 387, fol. 417r.

83 London, Brit. Libr., MS. Add. 26968, fol. 287r.

84 E.g.: Oxford, Bodl. Libr., MS. Mich. 610, fol. 52v; Parma, Bibl. Pal., Ms. Parm. 1756–De Rossi 236, fol. 93r; Vatican, Bibl. Apost., Cod. Vat. ebr. 573, fol. 97r; Jerusalem, Jew. Nat. Univ. Libr., Ms. Heb. 8° 5572, fol. 60r; Jerusalem, Jew. Nat. Univ. Libr., Ms. Heb. 8° 5492, fol. 113r; Jerusalem, Coll. Sassoon, Ms. 23, p. 82.

85 Jerusalem, Isr. Mus., Ms. Rothschild 24, fol. 130v.

86 Oxford, Bodl. Libr., MS. Laud. Or. 321, fol. 312v.

87 London, Brit. Libr., MS. Or. 5024, fol. 70v; London, Brit. Libr., MS. Add. 26968, fol. 295r, 316v.

88 Vatican, Bibl. Apost., Cod. Rossian. 498, fol. 85v.

89 Vatican, Bibl. Apost., Cod. Vat. ebr. 573, fol. 248v; Jerusalem, Coll. Sassoon, Ms. 23, p. 759; Budapest, Ac. Sc., Ms. A 380/II, fol. 175r.

90 Parma, Bibl. Pal., Ms. Parm. 1756-De Rossi 236, fol. 220v; Jerusalem, Coll. G. Weill, Maḥzor, p. 505.

91 Jerusalem, Coll. G. Weill, Maḥzor, p. 505.

92 E.g.: in Ashkenazi countries: Oxford, Bodl. Libr., MS. Opp. 669, fol. 1r; Warsaw, Univ. Libr., Ms. 258, fol. 70v; Göttingen, Niedersächs. St.- u. Univ.-Bibl., Ms. hebr. 5 (orient. 9), fol. 313r; Oxford, Bodl. Libr., MS. Or. Laud. 321, fol. 320v; Parma, Bibl. Pal., Ms. Parm. 3518, fol. 24r; Leipzig, Univ.-Bibl., Ms. V 1102/II, fol. 181v; London, Brit. Libr., MS. Add. 22413, fol. 85r; Darmstadt, Hess. Land.- u. Hochschulbibl., Cod. or. 13, fol. 326v; Hamburg, St.- u. Univ.-Bibl., Cod. hebr. 37, fol. 9; Budapest, Ac. Sc., Ms. A 383, fol. 180v; Oxford, Bodl. Libr., MS. Lyell 99, fol. 89r; in Spain: Jerusalem, Isr. Mus., Ms. 181/41, form. Ms. Sassoon 514, fol. 74r; in Italy: Jerusalem, Schocken Inst., Ms. 24085, fol. 27r; London, Brit. Libr., MS. Or. 5024, fol. 70v; London, Brit. Libr., MS. Add. 26968, fol. 298v; Jerusalem, Coll. G. Weill, Maḥzor, p. 505; Jerusalem, Isr. Mus., Ms. Rothschild 24, fol. 147r; Vienna, Öst. Nat.-Bibl., Cod. Hebr. 75, fol. 66r.

93 Budapest, Ac. Sc., Ms. A 380/II, fol. 175v.

94 Jerusalem, Coll. G. Weill, Maḥzor, p. 505.

95 London, Brit. Libr., MS. Add. 26968, fol. 303v–308v.

96 Budapest, Ac. Sc., Ms. A 380/II, fol. 195r.

97 Vatican, Bibl. Apost., Cod. Vat. ebr. 324, fol. 80v.

98 Budapest, Ac. Sc., Ms. A 383, fol. 178v.

99 Leipzig, Univ.-Bibl., Ms. V 1102/II, fol. 181v.

100 Budapest, Ac. Sc., Ms. A 383, fol. 189v.

101 Oxford, Bodl. Libr., MS. Laud. Or. 321, fol. 325r, 326v; London, Brit. Libr., MS. Add. 22413, fol. 138r–142v; Wrocław, Univ. Libr., Ms. Or. I, 1, fol. 264r–266v; Darmstadt, Hess. Land.- u. Hochschulbibl., Cod. or. 13, fol. 346v–348v; Munich, Bayer. St.-Bibl., Cod. hebr. 3/II, fol. 280v–288r.

102 Jerusalem, Coll. Sassoon, Ms. 1028, p. 296; Vatican, Bibl. Apost., Cod. Vat. ebr. 573, fol. 108r.

103 London, Brit. Libr., MS. Or. 5024, fol. 19r; Jerusalem, Isr. Mus., Ms. Rothschild 24, fol. 113v.

104 London, Brit. Libr., MS. Add. 26968, fol. 101r.

105 Hamburg, St.- u. Univ.-Bibl., Cod. Hebr. 37, fol. 79r and v.

106 *Ibid.*, fol. 81r.

107 Darmstadt, Hess. Land.- u. Hochschulbibl., Cod. or. 13, fol. 33r.

108 London, Brit. Libr., MS. Or. 5024, fol. 79v; Vatican, Bibl. Apost., Cod. Vat. ebr. 324, fol. 180r.

109 London, Brit. Libr., MS. Add. 26968, fol. 209v.

110 Vatican, Bibl. Apost., Cod. Rossian. 498, fol. 85v.

111 In *mahzorim*: Oxford, Bodl. Libr., MS. Laud. Or. 321, fol. 48v; Leipzig, Univ.-Bibl., Ms. V 1102/I, fol. 51v, 52r. In Bibles: Wrocław, Univ. Libr., Ms. M 1106, fol. 278v; Milan, Bibl. Ambr., Ms. B.32.Inf., fol. 78r; London, Brit. Libr., MS. Add. 11639, fol. 524r, 527v; Parma, Bibl. Pal., Ms. Parm. 2823–De Rossi 893, fol. 343r; Paris, Bibl. Nat., ms. hébr. 1322, fol. 491r.

112 In *mahzorim*: Oxford, Bodl. Libr., MS. Mich. 617, fol. 16r; Jerusalem, Jew. Nat. Univ. Libr., Worms Mahzor/I, fol. 57r; Oxford, Bodl. Libr., MS. Laud. Or. 321, fol. 51r; Leipzig, Univ.-Bibl., Ms. V 1102/I, fol. 51v; Dresden, Sächs. Land.- Bibl., Ms. A 46ª, fol. 82r; Darmstadt, Hess. Land.- u. Hochschulbibl., Cod. or. 13, fol. 53v; Jerusalem, Isr. Mus., Ms. Rothschild 24, fol. 114r. In Bibles: Wrocław, Univ. Libr., Ms. M 1106, fol. 301v; Munich, Bayer. St.-Bibl., Cod. hebr. 2, fol. 261r; Jerusalem, Isr. Mus., Ms. 180/52, known as Regensburg Bible, fol.157v; Jerusalem, Isr. Mus., Ms. form. Coll. Sassoon, Ms. 506, known as De Castro Pentateuch, p. 721.

113 Jerusalem, Jew. Nat. Univ. Libr., Worms Mahzor/I, fol. 39v.

114 Leipzig, Univ.-Bibl., Ms. V 1102/I, fol. 31v; Jerusalem, Coll. Sassoon, Ms. 1028, p. 323; Jerusalem, Schocken Inst., Ms. 13873, fol. 67v.

115 Jerusalem, Jew. Nat. Univ. Libr., Worms Mahzor/I, fol. 39v.

116 Leipzig, Univ.-Bibl., Ms. V 1102/I, fol. 31v.

117 In *mahzorim*, in Germanic countries: Oxford, Bodl. Libr., MS. Mich. 617, fol. 21r; Jerusalem, Jew. Nat. Univ. Libr., Worms Mahzor/I, fol. 59r; Oxford, Bodl. Libr., MS Laud. Or. 321, fol. 51v; Leipzig, Univ.-Bibl., Ms. V 1102/I, fol. 53v; Budapest, Ac. Sc., Ms. A 384, fol. 73r; Darmstadt, Hess. Land.- u. Hochschulbibl., Cod. or. 13, fol. 55r; in Italy: Jerusalem, Coll. Sassoon, Ms. 1028, p. 354; Jerusalem, Schocken Inst., Ms. 13873, fol. 76r; Oxford, Bodl. Libr., MS. Mich. 610, fol. 82r. In Bibles, in Ashkenazi countries: Vatican, Bibl. Apost., Cod. Vat. ebr. 14, fol. 170r; Parma, Bibl. Pal., Ms. Parm. 3289–De Rossi 265, fol. 216r; Paris, Bibl. Nat., ms. hébr. 1, fol. 104v; in Spain: Lisbon, Bibl. Nac., Ms. Il. 72, fol. 88r; Oxford, Bodl. Libr., MS. Kenn. 1, fol. 88v; in Italy: Budapest, Ac. Sc., Ms. A 1, p. 371.

118 Oxford, Bodl. Libr., MS. Laud. Or. 321, fol. 43v: Moses writing the story of the struggle, and Joshua as victor; Darmstadt, Hess. Land.- u. Hochschulbibl., Cod. or. 13, fol. 44r: Amalek enraged; Jerusalem, Coll. Sassoon, Ms. 1028, p. 326: two hands admonishing, 'remember!'

119 Parma, Bibl. Pal., Ms. Parm. 3515, fol. 98r.

120 Dresden, Sächs. Land.-Bibl., Ms. A 46ª, fol. 94v.

121 Oxford, Bodl. Libr., MS. Mich. 617, fol. 26r; Jerusalem, Jew. Nat. Univ. Libr., Worms Mahzor/I, fol. 64v; Oxford, Bodl. Libr., MS. Laud. Or. 321, fol. 57v; Budapest, Ac. Sc., Ms. A 388/I, fol. 90r; Leipzig, Univ.-Bibl., Ms. V 1102/I, fol. 59r; Budapest, Ac. Sc., Ms. A 384, fol. 85v; Darmstadt, Hess. Land.- u. Hochschulbibl., Cod. or. 13, fol. 60r.

122 Budapest, Ac. Sc., Ms A 388/I, fol. 90r; Leipzig, Univ.-Bibl., Ms. V 1102/I, fol. 59r; Budapest, Ac. Sc., Ms. A 384, fol. 85v.

123 Jerusalem, Jew. Nat. Univ. Libr., Worms Mahzor/I, fol. 72v; Oxford, Bodl. Libr., MS. Laud. Or. 321, fol. 61r; Leipzig, Univ.-Bibl., Ms. V 1102/I, fol. 64v; Hamburg, St.- u. Univ.-Bibl., Cod. Levy 37, fol. 169v; Darmstadt, Hess. Land.- u. Hochschulbibl., Cod. or. 13, fol. 65v.

124 *Pesah* has inspired much too vast an iconography for us to be able to offer, in these notes, anything more than a selection of references. For a nearly exhaustive study, see Mendel Metzger, *La Haggada enluminée* (Leiden, 1973).

125 E.g., in Germanic countries: Jerusalem, Isr. Mus., Bird's Head Haggada, fol. 25v, 26r; Leipzig, Univ.-Bibl., Ms. V 1102/I, fol. 70v; Jerusalem, Schocken Inst., 2nd Nuremberg Haggada, fol. 2r and v; Darmstadt, Hess. Land.- u. Hochschulbibl., Cod. or. 13, fol. 73v. In Spain: London, Brit. Libr., MS. Or. 2737, fol. 87v, 88r. In Italy, but in an Ashkenazi milieu: Jerusalem, Isr. Mus., Ms. Rothschild 24, fol. 155v.

126 London, Brit. Libr., MS. Or. 2737, fol. 89v; London, Brit. Libr., MS. Add. 27210, fol. 15r; London, Brit. Libr., MS. Or. 2884, fol. 17r; Sarajevo, Nat. Mus., Haggada, fol. 33v.

127 London, Brit. Libr., MS. Or. 2737, fol. 87r; London, Brit. Libr., MS. Add. 27210, fol. 15r.

128 Leipzig, Univ.-Bibl., Ms. V 1102/I, fol. 68v.

129 London, Brit. Libr., MS. Or. 2737, fol. 90r.

130 London, Brit. Libr., MS. Add. 27210, fol. 15r; London, Brit. Libr., MS. Or. 2884, fol. 17r.

131 E.g.: Jerusalem, Schocken Inst., 2nd Nuremberg Haggada, fol. 3r.

132 E.g.: London, Brit. Libr., MS. Or. 2737, fol. 90v; Budapest, Ac. Sc., Ms. A 422, fol. 2r; Paris, Bibl. Nat., ms. hébr. 1333, fol. 17r; Parma, Bibl. Pal., Ms. Parm. 3143–De Rossi 958, fol. 10v.

133 E.g.: London, Brit. Libr., MS. Or. 2737, fol. 88v; Jerusalem, Schocken Inst., 2nd Nuremberg Haggada, fol. 4r.

134 E.g.: Paris, Bibl. Nat., ms. hébr. 1333, fol. 2v; Jerusalem, Isr. Mus., Yahuda Haggada, fol. 3v.

135 E.g.: Paris, Bibl. Nat., ms. hébr. 1333, fol. 1v; London, Brit. Libr., MS. Add. 14762, fol. 1v; Cincinnati, Hebr. Un. College, Haggada, fol. 1v; Parma, Bibl. Pal., Ms. Parm. 3143–De Rossi 958, fol. 2r.

136 E.g.: London, Brit. Libr., MS. Or. 1404, fol. 8r.

137 E.g.: London, Brit. Libr., MS. Add. 11639, fol. 205r; Parma, Bibl. Pal., Ms. Parm. 2895–De Rossi 653, p. 236; London, Brit. Libr., MS. Add. 14762, fol. 6r.

138 E.g.: London, Brit. Libr., MS. Or. 2737, fol. 91r; London, Brit. Libr., MS. Add. 14761, fol. 17v.

139 E.g.: London, Brit. Libr., MS. Add. 26968, fol. 110v; Cologny-Geneva, Bibl. Bodmer, Cod. Bodmer 81, fol. 5r; Jerusalem, Jew. Nat. Univ. Libr., MS. Heb. 8° 4450, fol. 115v; London, Brit. Libr., MS. Add. 26957, fol. 39r.

140 E.g.: Hamburg, St.- u. Univ.-Bibl., Cod. hebr. 155, fol. 9v; Parma, Bibl. Pal., Ms. Parm. 3143–De Rossi 958, fol. 3v.

141 E.g.: London, Brit. Libr., MS. Or. 2737, fol. 91r; London, Brit. Libr., MS. Or. 2884, fol. 18r; London, Brit. Libr., MS. Add. 14761,

fol. 28v; Jerusalem, Isr. Mus., Bird's Head Haggada, fol. 7r; Jerusalem, Schocken Inst., Ms. 24086, known as 1st Nuremberg Haggada, fol. 14r; Parma, Bibl. Pal., Ms. Parm. 2895–De Rossi 653, p. 235; London, Brit. Libr., MS. Add. 14762, fol. 6r; Paris, Bibl. Nat., ms. hébr. 1333, fol. 20v; Parma, Bibl. Pal., Ms. Parm. 3143–De Rossi 958, fol. 12v.

142 See n. 24.

143 See n. 140.

144 E.g.: London, Brit. Libr., MS. Add. 14761, fol. 20v; Jerusalem, Schocken Inst., 2nd Nuremberg Haggada, fol. 6v; Jerusalem, Isr. Mus., Yahuda Haggada, fol. 6r; Jerusalem, Isr. Mus., Ms. Rothschild 24, fol. 156v.

145 Jerusalem, Isr. Mus., Bird's Head Haggada, fol. 6v; London, Brit. Libr., MS. Add. 14761, fol. 20v.

146 E.g.: Nîmes, Bibl. Mun., ms. 13, fol. 102v; London, Brit. Libr., MS. Add. 26968, fol. 110v; London, Brit. Libr., MS. Harl. 5686, fol. 61v; Jerusalem, Jew. Nat. Univ. Libr., Ms. Heb. 8° 4450, fol. 115v; London, Brit. Libr., MS. Add. 26957, fol. 39r; Paris, Bibl. Nat., ms. hébr. 1333, fol. 5v; Jerusalem, Schocken Inst., 2nd Nuremberg Haggada, fol. 6v.

147 E.g.: Jerusalem, Schocken Inst., 2nd Nuremberg Haggada, fol. 7r.

148 E.g.: London, Brit. Libr., MS. Add. 14761, fol. 34r and v, 35r and v; Darmstadt, Hess. Land.- u. Hochschulbibl., Cod. or. 28, fol. 4r and v; London, Brit. Libr., MS. Add. 14762, fol. 8v, 9r and v.

149 E.g.: London, Brit. Libr., MS. Or. 1404, fol. 17v; London, Brit. Libr., MS. Or. 2884, fol. 51v; Warsaw, Jew. Hist. Inst., Ms. 242, fol. 21v; Parma, Bibl. Pal., Ms. Parm. 2895–De Rossi 653, p. 250; Jerusalem, Schocken Inst., 2nd Nuremberg Haggada, fol. 21r; London, Brit. Libr., MS. Add. 14762, fol. 22v; Parma, Bibl. Pal., Ms. Parm. 3143–De Rossi 958, fol. 11v.

150 E.g.: London, Brit. Libr., MS. Or. 2884, fol. 52r; London, Brit. Libr., MS. Or. 1404, fol. 18r; Warsaw, Jew. Hist. Inst., Ms. 242, fol. 22r; Nîmes, Bibl. Mun., ms. 13, fol. 112v; Jerusalem, Schocken Inst., 2nd Nuremberg Haggada, fol. 21v; London, Brit. Libr., MS. Add. 14762, fol. 22v; Parma, Bibl. Pal., Ms. Parm. 3143–De Rossi 958, fol. 12r.

151 E.g.: London, Brit. Libr., MS. Add. 14761, fol. 64v, 67v; Budapest, Ac. Sc., Ms. A 422, fol. 41v, 44r; Warsaw, Jew. Hist. Inst., Ms. 242, fol. 23r, 24r; Jerusalem, Isr. Mus., Bird's Head Haggada, fol. 26v, 28r, 30r; Jerusalem, Schocken Inst., 1st Nuremberg Haggada, fol. 14r; Paris, Bibl. Nat., ms. hébr. 1333, fol. 20v; Jerusalem, Schocken Inst., 2nd Nuremberg Haggada, fol. 22v, 24v, 26v, 27r and v, 28r and v; Jerusalem, Isr. Mus., Ms. Rothschild 24, fol. 160v, 162v, 166r; Parma, Bibl. Pal., Ms. Parm. 3143–De Rossi 958, fol. 12v, 13v, 17v.

152 E.g.: Sarajevo, Nat. Mus., Haggada, fol. 31v of the text; Jerusalem, Schocken Inst., 2nd Nuremberg Haggada, fol. 25r, 29r.

153 E.g.: Jerusalem, Isr. Mus., Bird's Head Haggada, fol. 28r and v, 29r; Paris, Bibl. Nat., ms. hébr. 1333, fol. 22v; Jerusalem, Schocken Inst., 2nd Nuremberg Haggada, fol. 25v, 26r; Parma, Bibl. Pal., Ms. Parm. 3143–De Rossi 958, fol. 14r and v.

154 E.g.: London, Brit. Libr., MS. Add. 14761, fol. 28r; Jerusalem, Isr. Mus., Bird's Head Haggada, fol. 29v; Paris, Bibl. Nat., ms. hébr. 1333, fol. 23r; Jerusalem, Schocken Inst., 2nd Nuremberg Haggada, fol. 26r; Parma, Bibl. Pal., Ms. Parm. 3143–De Rossi 958, fol. 14v.

155 E.g.: London, Brit. Libr., MS. Add. 14761, fol. 19v, 27v, 28r; Jerusalem, Isr. Mus., Bird's Head Haggada, fol. 6r, 28r, 29v; Paris, Bibl. Nat., ms. hébr. 1333, fol. 5r, 22v; Jerusalem, Schocken Inst., 2nd Nuremberg Haggada, fol. 6r, 25v, 26r; Jerusalem, Isr. Mus., Ms. Rothschild 24, fol. 161v; Parma, Bibl. Pal., Ms. Parm. 3143–De Rossi 958, fol. 3v, 14r and v.

156 New York, Jew. Theol. Sem. Amer., MS. Acc. No. 75048, fol. 14v; Parma, Bibl. Pal., Ms. Parm. 2895–De Rossi 653, p. 254; Jerusalem, Schocken Inst., 2nd Nuremberg Haggada, fol. 29v; Darmstadt, Hess. Land.- u. Hochschulbibl., Cod. or. 28, fol. 13r; Jerusalem, Coll. Sassoon, Ms. 511, p. 20; Munich, Bayer. St.-Bibl., Cod. hebr. 200, fol. 24v; Washington, D.C., Libr. of Congress, Haggada, fol. 19v; Parma, Bibl. Pal., Ms. Parm. 3143–De Rossi 958, fol. 17v.

157 E.g.: Jerusalem, Isr. Mus., Bird's Head Haggada, fol. 8r; Sarajevo, Nat. Mus., Haggada, fol. 31r of the text; Parma, Bibl. Pal., Ms. Parm. 3143–De Rossi 958, fol. 4r.

158 London, Brit. Libr., MS. Add. 14761, fol. 19v.

159 Parma, Bibl. Pal., Ms. Parm. 2895–De Rossi 653, p. 255.

160 Hamburg, St.- u. Univ.-Bibl., Cod. hebr. 37, fol. 31r.

161 E.g.: Modena, Bibl. Est., Cod. a.K.I.22 (Or. 92), fol. 6v, 7v; Hamburg, St.- u. Univ.-Bibl., Cod. hebr. 37, fol. 31v; Hamburg, St.- u. Univ.-Bibl., Cod. hebr. 155, fol. 39r, 40r; Jerusalem, Schocken Inst., Ms. 24085, fol. 24v, 25v; Jerusalem, Schocken Inst., Ms. 13873, fol. 85r and v.

162 E.g.: Jerusalem, Isr. Mus., Ms. 181/41, form. Ms. Sassoon 514, fol. 55v; Hamburg, St.- u. Univ.-Bibl., Cod. hebr. 155, fol. 39v; Jerusalem, Schocken Inst., Ms. 13873, fol. 85r.

163 E.g.: Parma, Bibl. Pal., Ms. Parm. 2411–De Rossi 1107, fol. 6r; London, Brit. Libr., MS. Add. 27210, fol. 14v; Bologna, Bibl. Univ., Ms. 2559, fol. 6v; Jerusalem, Jew. Nat. Univ. Libr., Ms. 8° 4450, fol. 115v, 116r; Jerusalem, Coll. Sassoon, Ms. 511, pp. 16, 18, 19.

164 Jerusalem, Isr. Mus., Bird's Head Haggada, fol. 47r.

165 E.g.: Darmstadt, Hess. Land.- u. Hochschulbibl., Cod. or. 28, fol. 12v, 13r; Parma, Bibl. Pal., Ms. Parm. 3143–De Rossi 958, fol. 17v.

166 E.g.: Manchester, J. Ryl. Univ. Libr., MS. Ryl. Hebr. 7, fol. 33r; Jerusalem, Schocken Inst., 2nd Nuremberg Haggada, fol. 41v; Washington, D.C., Libr. of Congress, Haggada, fol. 19v.

167 Hamburg, St.- u. Univ.-Bibl., Cod. hebr. 37, fol. 35v.

168 London, Brit. Libr., MS. Add. 14761, fol. 65v; Budapest, Ac. Sc., Ms. A 422, fol. 42r.

169 London, Brit. Libr., MS. Add. 26968, fol. 139v.

170 E.g.: Oxford, Bodl. Libr., MS. Laud. Or. 321, fol. 108r; Leipzig, Univ.-Bibl., Ms. V 1102/I, fol. 72v, 73r; Budapest, Ac. Sc., Ms. A 384, fol. 197r, 228r; London, Brit. Libr., MS. Harl. 5686, fol. 60v, 61r.

171 E.g.: Amsterdam, Jew. Hist. Mus., Ms. Inv. No. 1, fol. 45r–47r; Oxford, Bodl. Libr., MS.

Mich. 617, fol. 49r–51v; Jerusalem, Jew. Nat. Univ. Libr., Worms Maḥzor/I, fol. 95v–97v; Oxford, Bodl. Libr., MS. Laud. Or. 321, fol. 89r–91r; Leipzig, Univ.-Bibl., Ms. V 1102/I, fol. 85r–87r; Ms. B.H.3, fol. 7v–9v (the medallions have been removed: only the 4th, 9th and 11th signs remain, fol. 8v, 9v); Budapest, Ac. Sc., Ms. A 384, fol. 142v–145v; Dresden, Sächs. Land.-Bibl., Ms. A 46ª, fol. 132r–134v; Oxford, Bodl. Libr., MS. Opp. 161, fol. 62v–64v; Darmstadt, Hess. Land.- u. Hochschulbibl., Cod. or. 13, fol. 83r–85r.

172 Jerusalem, Jew. Nat. Univ. Libr., Worms Maḥzor/I, fol. 95v–97v; Budapest, Ac. Sc., Ms. A 384, fol. 142v–145v.

173 Dresden, Sächs. Land.-Bibl., Ms. A 46ª, fol. 133v.

174 Vatican, Bibl. Apost., Cod. Vat. ebr. 14, fol. 242v.

175 Parma, Bibl. Pal., Ms. Parm. 2823–De Rossi 893, fol. 320r.

176 Jerusalem, Isr. Mus., form. Coll. Sassoon, Ms. 506, p. 665.

177 Budapest, Ac. Sc., Ms. A 384, fol. 183v.

178 Leipzig, Univ.-Bibl., Ms. V 1102/I, fol. 90r.

179 Oxford, Bodl. Libr., MS. Laud. Or. 321, fol. 127v.

180 London, Brit. Libr., MS. Add. 22413, fol. 71r; Jerusalem, Jew. Nat. Univ. Libr., Worms Maḥzor/I, fol. 35r (picture added in 15th century).

181 E.g.: Vatican, Bibl. Apost., Cod. Vat. ebr. 14, fol. 100v; Milan, Bibl. Ambr., Ms. B. 30. Inf., fol. 182v; Wrocław, Univ. Libr., Ms. M 1106, fol. 169v; Jerusalem, Schocken Inst., Ms. 14940, known as Schocken Bible, fol. 1v; Jerusalem, Isr. Mus., Regensburg Bible, fol. 154v.

182 Budapest, Ac. Sc., Ms. A 77/IV, fol. 32r.

183 E.g.: Jerusalem, Isr. Mus., Bird's Head Haggada, fol. 23r; Sarajevo, Nat. Mus., Haggada, fol. 30r; Jerusalem, Schocken Inst., 2nd Nuremberg Haggada, fol. 37v; Jerusalem, Isr. Mus., Yahuda Haggada, fol. 36v; Darmstadt, Hess. Land.- u. Hochschulbibl., Cod. or. 28, fol. 9v; Paris, Bibl. Nat., ms. hébr. 1388, fol. 14r; Chantilly, Mus. Condé, ms. 732, fol. 19v.

184 Budapest, Ac. Sc., Ms. A 383, fol. 177r; London, Brit. Libr., MS. Add. 19945, fol. 164r.

185 E.g.: Cambridge, Univ. Libr., MS. Add. 662, fol. 53v; Budapest, Ac. Sc., Ms. A 383, fol. 69r; Parma, Bibl. Pal., Ms. Parm. 2895–De Rossi 653, p. 271; New York, Jew Theol. Sem. Amer., MS. Rothschild II, fol. 139r.

186 Jerusalem, Coll. Sassoon, Ms. 23, p. 333.

187 E.g.: Jerusalem, Jew. Nat. Univ. Libr., Worms, Maḥzor/I, fol. 151r; Oxford, Bodl. Libr., MS. Laud. Or. 321, fol. 127v; Leipzig, Univ.-Bibl., Ms. V 1102/I, fol. 130v; London, Brit. Libr., MS. Add. 22413, fol. 31r; Dresden, Sächs. Land.-Bibl., Ms. A 46ª, fol. 202v; Darmstadt, Hess. Land.-u. Hochschulbibl., Cod. or. 13, fol. 126r.

188 Budapest, Ac. Sc., Ms. A 77/IV, fol. 32r (the illuminator had adorned Moses with the horns associated with his Christian model, but they have been scratched out). Contrary to what has been affirmed, neither the drawing in the Regensburg Bible nor that in the Leipzig Maḥzor shows any cavity in the mountain wall where the Israelites might have been shut up; they are found at the foot of the mountain.

189 Parma, Bibl. Pal., Ms. Parm. 1756–De Rossi 236, fol. 152v.

190 E.g.: Jerusalem, Jew. Nat. Univ. Libr., Ms. Heb. 4° 1193, fol. 40v; Budapest, Ac. Sc., Ms. A 387, fol. 363v.

191 E.g.: London, Mocatta Libr., Italian Maḥzor, fol. 1r; Paris, Sém. Isr., ms. 1, fol. 104v.

192 E.g.: Oxford, Bodl. Libr., MS. Can. Or. 15, fol. 1r.

193 London, Brit. Libr., MS. Add. 26968, fol. 325v.

194 New York, Jew. Theol. Sem. Amer., MS. Rothschild II, fol. 200v.

194a Ibid.; London, Brit. Libr., MS. Add. 9405, fol. 12r.

194b Jerusalem, Isr. Mus., form. Ms. Sassoon 506, p. 697.

195 E.g.: Wrocław, Ossolinski Libr.–Pawlikowski Coll., Ms. 141, p. 909; Florence, Bibl. Laur., Ms. Plut. 3.8, fol. 471r; Parma, Bibl. Pal., Ms. Parm. 2153–De Rossi 3, fol. 145r; London, Brit. Libr., MS. Add. 9405, fol. 12r; Parma, Bibl. Pal., Ms. Parm. 2823–De Rossi 893, fol. 338r; New York, Jew. Theol. Sem. Amer., MS. Rothschild II, fol. 200v; Paris, Bibl. Nat., ms. hébr. 1322, fol. 484v (picture defaced).

196 Hamburg, St.- u. Univ.-Bibl., Cod. hebr. 37, fol. 26r.

197 E.g.: Vatican, Bibl. Apost., Cod. Vat. ebr. 9, fol. Iv, 48r, 63r, 101v, 102v, 296r, 327v; London, Brit. Libr., MS. Add. 11639, fol. 122r; Paris, Bibl. Nat., ms. hébr. 4, fol. 5v; Rome, Bibl. Casan., Ms. 3010, fol. 383r; Berlin, St.-Bibl., Preuss. Kulturbes., Orientabt., Ms. or., fol. 1212, fol. 1r; lost Ms., form. Breslau (Wrocław), Jüd.-Theol. Sem., Cod. 12, fol. 5v.

198 Prague, 'Altneuschul', tympanums of south portal and of the Ark of the Covenant.

199 Paris, Bibl. Nat., ms. hébr. 819, initial recto fol. (not numbered).

200 Cf. Chap. 1, n. 1 and n. 236–239.

201 Wrocław, Univ. Libr., Ms. Or. I, 1, fol. 89v.

202 Milan, Bibl. Ambr., Ms. B. 32. Inf., fol. 135v.

203 Cf. Chap. 1, n. 2–3.

204 London, Brit. Libr., MS. Add. 14762, fol. 15r.

205 Jerusalem, Schocken Inst., Bible fol. 1v; Jerusalem, Isr. Mus., Bird's Head Haggada, fol. 23r; Jerusalem, Isr. Mus., Regensburg Bible, fol. 154v; Dresden, Sächs. Land.-Bibl., Ms. A 46ª, fol. 202v.

206 London, Brit. Libr., MS. Or. 2737, fol. 67r, 93v.

207 Sarajevo, Nat. Mus., Haggada, fol. 21v.

208 E.g.: Jerusalem, Schocken Inst., Bible, fol. 1v; London, Brit. Libr., MS. Or. 2884, fol. 4v, 5v; Dresden, Sächs. Land.-Bibl., Ms. A 46ª, fol. 202v.

209 Sarajevo, Nat. Mus., Haggada, fol. 10r.

210 London, Brit. Libr., MS. Add. 11639, fol. 118r and v.

211 London, Brit. Libr., MS. Add. 11639, fol. 118r; Oxford, Bodl. Libr., MS. Opp. 14, fol. 22v, 120r.

212 London, Brit. Libr., MS. Add. 11639, fol. 119v.

213 Oxford, Bodl. Libr., MS. Laud. 321, fol. 165v; Vienna, Öst. Nat.-Bibl., Cod. Hebr. 174, fol. 20v; Hamburg, St.- u. Univ.-Bibl., Cod. hebr. 37, fol. 1r.

214 Oxford, Bodl. Libr., MS. Laud. 321, fol. 321r.

215 Jerusalem, Isr. Mus., Bird's Head Haggada, fol. 33r.

216 Ibid.

217 Milan, Bibl. Ambr., Ms. B. 32. Inf., fol. 136r.

218 Jerusalem, Isr. Mus., Ms. Rothschild 24, fol. 84r.

219 E.g.: Jerusalem, Isr. Mus., Bird's Head Haggada, fol. 47r; London, Brit. Libr., MS. Add. 11657, fol. 171v.

220 Cf. above, p. 248 and n. 78, 79.

221 Cf. above, p. 265 and n. 166.

222 Hamburg, St.- u. Univ.-Bibl., Cod. hebr. 37, fol. 35v; this illumination shows the Messiah Himself sounding the reunion of the dispersed and awakening the dead, while Elijah merely accompagnies them.

223 Oxford, Bodl. Libr., MS. Mich. 619, fol. 201r.

224 Milan, Bibl. Ambr., Ms. B. 32. Inf's, fol. 136r.

225 E.g.: London, Brit. Libr., MS. Harl. 5710, fol. 136r; Parma, Bibl. Pal., Ms. Parm. 2160–De Rossi 683, fol. 1v; Oxford, Bodl. Libr., MS. Can. Or. 81, fol. 132v; Jerusalem, Schocken Inst., Ms. 13873, fol. 18v; Budapest, Ac. Sc., Ms. A 1, p. 218. The series of motifs decorating the sanctuary can be explained by the influence of Spanish models (Florence, Bibl. Laur., Ms. Plut. 2.1, fol. 92r, 105v, 106r, 107r, 111v) or by the nature of the text being illustrated, e.g. *Rashi* (Florence, Bibl. Laur., Ms. Plut. 3.10, fol. 92r–93r, 95r).

226 E.g.: Munich, Bayer. St.-Bibl., Cod. hebr. 5/I, fol. 65r; New York, Priv. coll., form. Frankfurt/M., St.-Bibl., Ms. Ausst. 5, fol. 226v; Budapest, Ac. Sc., Ms. A 78/I, fol. 308v.

227 London, Brit. Libr., MS. Add. 11639, fol. 114r, 522v; Paris, Bibl. Nat., ms. hébr. 5, fol. 117v–118r; Paris, Bibl. Nat., ms. hébr. 36, fol. 283v; Jerusalem, Isr. Mus., Regensburg Bible, fol. 155v, 156r; Darmstadt, Hess. Land.- u. Hochschulbibl., Cod. or. 13, fol. 33r.

228 Budapest, Ac. Sc., Ms. A 77/III, fol. 3v.

229 In the 12th-century *Hortus deliciarum* by Herrade de Landsberg, we find a Christian precedent for this unusual motif, conceived in fact to illustrate the vision of Zachariah. We cannot say how—through what wandering, influence or derivation from a common source—the illuminator of the *Mishne Tora*, more than a century later, rediscovered the inspiration of the abbess of Mont-Saint-Odile.

230 E.g.: Paris, Bibl. Nat., ms. hébr. 7, fol. 13r.

231 New York, Priv. coll., form. Frankfurt/M., St.-Bibl., Ms. Ausst. 4, fol. 25r.

232 E.g.: Rome, Com. Isr., Ms. cat. No. 19, fol. 215r.

233 London, Brit. Libr., MS. Kings 1, fol. 4r.

234 E.g.: London, Brit. Libr., MS. Harl. 1528, fol. 8r; Milan, Bibl. Ambr., Ms. C.105 Sup., fol. 2r; Parma, Bibl. Pal., Ms. Parm. 2810–De Rossi 518, fol. 8r; Paris, Bibl. Saint-Sulpice, ms. 1933, fol. 6r.

235 Paris, Bibl. Nat., ms. hébr. 31, fol. 4v.

236 Sarajevo, Nat. Mus., Haggada, fol. 32r.

237 Jerusalem, Coll. Sassoon, Ms. 16, known as Rashba Bible, p. 6; Jerusalem, Coll. Sassoon, Ms. 368, known as Farḥi Bible, p. 186.

# Illustrations

At the end of the entries for the 113 manuscripts from which we have taken pictures appear the numbers, in italics, of the illustrations in which they are reproduced in this book.

Although we have almost never reproduced the whole of the decoration of a page, we have only indicated it as a 'detail' when one or several elements from a particular scene or from a decorative ensemble have been selected for reproduction.

A small number of the motifs or scenes have had to be reduced for reproduction, but the great majority of our illustrations have in fact been enlarged to bring out the details that interest us or to emphasize the expressiveness of certain faces and gestures.

# Catalogue of Hebrew Manuscripts Containing Illustrations Used as the Basis for this Book

The entries in this catalogue describe the 259 Hebrew manuscripts which we have had reason to mention in this book, some of them several times, others more rarely, and a certain number only once.

A star (✳) distinguishes those manuscripts, 113 in all, containing a picture, page or detail of a page that has been reproduced and described in the text and in the captions to the illustrations.

Lack of space has obliged us to limit ourselves in the entries to the most basic information about the manuscripts and to reduce to a minimum remarks on text and illumination.

Thus we refer to the most important texts contained in the codex, the number of folios (those not originally part of the codex are omitted, except when added early in its history and consequently of some interest), the dimensions of the folios (followed, in brackets, by the dimensions of the written space), the number of lines and of columns.

The script, either square, rabbinical or cursive, is not described in detail, but its type, Sephardi, Ashkenazi or Italian, is always mentioned. Regions of Sephardi and Ashkenazi culture always produced texts in Sephardi and Ashkenazi scripts only, but this was not the case for Italy, where immigration of Jews led to three types of script: Italian (itself divided into several types), Ashkenazi and Sephardi, being used concurrently.

It has not been possible to give evidence for the dating and geographical attribution of manuscripts lacking colophons. Other than for manuscripts now in the United States, we have based our conclusions on codicological information (character of the parchment, the kind of gatherings, ruling), mostly collected by ourselves. *

We have intentionally avoided any comment of an aesthetic nature on the decoration. A distinction was made between decoration (any motif or group of motifs that embellish a page, including on occasion figures and scenes) and illustration (a simple motif or a complex image that relates directly to the accompanying text, or at least represents a figure or scene, from the Bible for instance, which is easily identifiable).

Details of the technique used (drawing in outline or in micrography, ink or paint) follow. When gold, albeit frequently used in initial letters, does not appear in any way in the decoration or illustrations, we have not mentioned it, in order to avoid repetition.

It has not been possible to give a reference to each illustration in every manuscript. However, aware of how misleading a reference to 'illustrations' can be when so many Hebrew manuscripts contain no more than one or two motifs related to the text in 400 to 600 folios, we have given these references only in cases where there were no more than two or three.

When text and decoration are contemporary, or nearly so, and executed in the same locality or region, we have not repeated the date and place attributed to the text when this is dated and localized or datable and localizable. If, on the other hand, the style or some particularity of the decoration serves as a *terminus ante quem* to date the whole and to give a means of localizing at least the decoration, the date accompanies the reference to the latter.

Very few decorated Hebrew manuscripts from the West have been noticed by historians of illumination in the different countries where they were produced. A large number of them remain totally unpublished or virtually ignored. In more than one case, historians of Jewish art have not had at their disposal sufficient comparative material, not only contemporary Christian manuscripts but also Hebrew manuscripts, to make their judgements on dating and localization definitive. This makes us regret all the more that we have been unable to provide, for each manuscript, either the bibliographical references (when they exist), references to comparative material or any observations that might support our statements when they differ from those already published, even from those that we have ourselves published in the past.

---

\* We would like especially to thank the keepers of manuscripts and specialists who examined and made the necessary verification on manuscripts or who saw that this was done for us.

Some manuscripts have been known ever since they were first published by names such as the Sarajevo Haggada, the Haggada of the Birds, Nuremberg Haggada II, Worms Maḥzor. When such manuscripts are first mentioned, their precise references are cited; thereafter we refer to the best known by name, in order not to confuse the reader. We have not adopted those used profusely in a recent publication (B. Narkiss, *Hebrew Illuminated Manuscripts*) such as 'the Golden Haggada', 'Brother to the Rylands Spanish Haggada', 'Dragon Haggada', 'Bibliothèque Nationale Pentateuch', 'Parma Bible', since they are too arbitrary or too vague to designate specifically or usefully the manuscripts they purport to describe.

The reader will not find any reference in this book to the illustrations in a well-known and already published Ashkenazi manuscript of the Haggada, the Erna Michael Haggada (Jerusalem, Israel Museum, Ms. 180/58). The text of this manuscript is authentic, but the illuminations were either painted or heavily repainted in the nineteenth century in a medieval style which is rather vague where architecture, figures and costume are concerned.

Whereas the rarity of some Jewish illustrations has allowed us to give, in the preceding notes, all the references to a motif or particular scene that we are aware of, for others we have only adduced a few examples, if they were of significance, preferably those least well known. Therefore, the list that might be made from our references would not be exhaustive.

The same is true of this catalogue. The subject of this book, oriented towards certain kinds of illustration, has led us to ignore some illustrated manuscripts, above all a large number of manuscripts that were only decorated. This catalogue thus contains no more than a selection from the illuminated Hebrew manuscripts that are available today.

Entries are arranged in alphabetical order by the names of the cities where the collections are to be found. When there are several collections in one city, these are also arranged alphabetically, by the names of the collections. Where several manuscripts from a single collection are cited, the order adopted is alphabetical by the letters in the manuscript reference, thereafter in numerical sequence by manuscript reference number.

1 **Aberdeen,** University Library, MS. 23: Bible with *masora*; 390 (⟨1⟩+389) fol. (2 fol. missing between fol. 61 and 62); 325/329×232/241 (197×155) mm, 32 l., 2 col.; Sephardi script; probably written in Naples itself, completed in 1494 (fol. 388r); micrographic decoration, painted decoration done in Naples, binding done in one of the binderies associated with the royal library.

2 **Amsterdam,** Jewish Historical Museum, Ms. Inv. no. 1, Maḥzor: *maḥzor* of Ashkenazi rite (northern France); 331 (1–79, ⟨5⟩, 80–326) fol.; 462/466×333 (345×223) mm, 27 l.; Ashkenazi script; probably written in northern France, perhaps in Normandy, in Rouen, in the second quarter of the 13th century; decoration and a few illustrations (ink, gold and some colours).

3 **Berlin,** Deutsche Staatsbibliothek, Ms. or. fol. 1210–1211: Bible with *targum* and *masora*; 1133 (1, 3–585+549) fol.; 605×445 (398×302) mm; 30 l., 3 col.; Ashkenazi script; written in Germany, punctuation and *masora* completed in 1343 (II, fol. 547r); micrographic decoration, and decoration with sepia ink.

4 **Berlin,** Staatsbibliothek Preussischer Kulturbesitz, Orientabteilung, Ms. Hamilton 81: Bible with *masora* and Antiochus *megilla*; 448 (⟨1⟩, 1–447) fol.; 211/212×160/165 (141×109) mm, 32 l., 2 col.; Sephardi script; written in a Sephardi hand, probably in Spain in the first half of the 15th century; micrographic decoration contemporary with the text; decoration and illustrations painted in a Franco-Flemish style, added in 1470–1480 in a French-speaking region (fol. 378v), perhaps Burgundy.

5 **Berlin,** Staatsbibliothek Preussischer Kulturbesitz, Orientabteilung, Ms. Hamilton 288: *haggada* included in a *maḥzor* (damaged) for the three pilgrimage feasts (*pesaḥ, shavu'ot, sukot*), of Sephardi rite; 106 fol.; 206/209×157/161 (153×103) mm, 11 l. *(haggada)*, 26 l., 2 col. (prayers); Sephardi script; written in Spain, probably in Castile, in the first quarter of the 14th century; painted decoration and illustrations.

6 **Berlin,** Staatsbibliothek Preussischer Kulturbesitz, Orientabteilung, Ms. or. fol. 1212: Bible with *targum* intercalated (for the Pentateuch) and *masora*; 588 fol.; 550×385 (420×235) mm, 33 l., 3 col.; Ashkenazi script; written in Germany *c.* 1300; micrographic decoration.

7 **Berlin,** Staatsbibliothek Preussischer Kulturbesitz, Orientabteilung, Ms. or. qu. 1: Pentateuch with *targum* and Rashi, *hafṭarot* with Rashi, *megillot* with *targum* and Dream of Mordecai; 1110 fol.; 233×163 (120×97) mm, 23 l. (biblical text); Ashkenazi script; written by a French scribe (fol. 847r) in Germany in the first quarter of the 14th century; pen decoration (coloured inks) done in the first decades of the 14th century.

8 **Berlin,** Staatsbibliothek Preussischer Kulturbesitz, Orientabteilung, Ms. or. qu. 9: Pentateuch, *megillot*, Job, *hafṭarot* (those of the feasts with *targum* intercalated), *masora*; 196 (3–198) fol.; 134/135×118 (88×77) mm, 29 l., 3 col.; Ashkenazi script; written in North West France, in Normandy (Rouen) in 1233 (fol. 197r); decoration in micrography and drawn (sepia ink) (cf. cat. no. 242 *, Vatican, Bibl. Apost., Cod. Vat. ebr. 14).

9 **Berlin,** Staatsbibliothek Preussischer Kulturbesitz, Orientabteilung, Ms. or. qu. 371: Bible with *masora*; 392 (4–101, 103–281, 283–397) fol.; 205×150 (132/133×86) mm, 2 col., 35 l.; Italian script; written in Italy; pen (red and blue ink) and painted decoration, perhaps done in or around Rome, in the last decades of the 13th century.

10 **Berlin,** Staatsbibliothek Preussischer Kulturbesitz, Orientabteilung, Ms. or. fol. 388: *maḥzor* for *rosh ha-shana, kipur* and *sukot*, of Ashkenazi rite; 283 (2–284, 285–287 added in the 15th century and 288–293 added in the 17th century) fol.; 345/347×264 (235/242×155) mm, 19 to 24 l. (prayers), 36 to 38 l. (biblical texts), 1 and 3 col.; Ashkenazi script; written in Germany; decoration and 1 illustration (fol. 69r) painted in the second half of the 14th century.

✱11 **Bologna,** Biblioteca Universitaria, Ms. 2197: the Canon of Avicenna (980–1037); 531 fol.; 404×260 (271×166) mm, 56 l., 2 col.; Italian script; written in northern Italy in the second quarter of the 15th century, decoration, by several hands and incomplete, and illustrations, painted in 1438–1440 in northern Italy, in Lombardy or

---

* The indication 'cat. no.' refers to the numbers in the present catalogue.

perhaps in the Veneto (cf. cat. no. 152, Oxford, Bodl. Libr., MS. Can. Or. 79). *Cf. Pls. 53, 66, 238, 242, 243, 247-249.*

**✳12 Bologna,** Biblioteca Universitaria, Ms. 2297: Book I of the Canon of Avicenna (980–1037); 133 fol.; 322 × 241 (215 × 159) mm, 33 l., 2 col.; Sephardi script; written in Spain or Italy towards the end of the 14th century; 1 painted illustration (fol. 4r) of the early 15th century, done in Italy. *Cf. Pl. 250.*

**✳13 Bologna,** Biblioteca Universitaria, Ms. 2559: fragment of a *haggada* of Sephardi rite (cat. no. 128, Modena, Bibl. Est., Cod. α. K. I. 22 = Or. 92, contains another fragment from this *haggada*) included in a *mahzor* which is also fragmentary; 205 fol.; 244/247 × 174/177 (170 × 120) mm, 9 and 17 l.; Sephardi script; written in Spain, probably in Aragon; pen decoration (coloured inks) and illustrations painted 1350–1360. *Cf. Pl. 166.*

**14 Breslau (Wrocław),** Jüdisch-Theologisches Seminar (no longer in existence *), Cod. 12 (lost or destroyed): Pentateuch and Song of Songs; 314 fol.; 144 × 93 mm, 19 l.; Sephardi script; written in Italy in the late 14th century; painted decoration and illustrations.

**15 Budapest,** Hungarian Academy of Sciences, Ms. A 1: Pentateuch (damaged at the beginning); 530 p.; 151/155 × 118 (81 × 57) mm, 18 l.; Italian script; written in Italy; decoration and 3 illustrations (p. 218, 305, 371) of the first half of the 15th century (red and violet ink, gold and touches of colour).

**✳16 Budapest,** Hungarian Academy of Sciences, Ms. A 77/I–II–III–IV: *Mishne Tora* of Maimonides (1135–1204) with glosses and *teshuvot*; 624 (=159+169+153+143; 144–169 added in the 15th century) fol.; 495 × 363 (304/310 × 226/227) mm, 39 l., 3 col.; Ashkenazi script; text completed in an Ashkenazi country, in 1296 (IV: fol. 143r); glosses and *teshuvot* added in Cologne in 1413 (IV: fol. 169v); pen (red and blue ink) decoration and diagrams, perhaps in the hand of the copyist; painted decoration and illustrations, done under the influence of Franco-Flemish illumination in the two decades after the text was completed, more probably in the Rhineland than in the neighbouring territories of the Empire to the North East of the kingdom of France. *Cf. Pl. 397.*

**✳17 Budapest,** Hungarian Academy of Sciences, Ms. A 78/I–II: *Mishne Tora* of Maimonides (1135-1204), with fragmentary *Haggahot Maïmuniyyot* (I: before fol. 1, gap of 1 diploma) 253–259 (gap filled); 628 (354 (⟨2⟩ + 1–252, 259–358) + 274) fol.; 545/547 × 365 (319 × 215) mm, 42 l., 3 col.; Ashkenazi script; text completed in Germany in 1310 (II, fol. 274v); diagrams, decoration painted and pen (blue and red ink), 3 painted illustrations (I: 8v, 308v). *Cf. Pl. 265.*

**18 Budapest,** Hungarian Academy of Sciences, Ms. A 278: *Malmad ha-talmidim* (a goad to scholars) by Jacob Anatoli (13th century); 106 fol.; 392/395 × 280 (260 × 182/183) mm, 48 l., 2 col.; Italian script; text completed in Italy, in Rimini (fol. 106r), in 1377 at the latest (cf. Paris, Bibl. Nat., ms. hébr. 401; fol. 142v, where the same scribe states that he completed at Rimini in this year the *Malmad ha-talmidim* and the *More nevukhim*, Parma, Bibl. Pal., Ms. Parm. 3208–De Rossi 1064; cf. also cat. no. 117, London, Brit. Libr., MS. Or. 5024, written in 1374 by the same scribe); painted decoration contemporary with the text.

**✳19 Budapest,** Hungarian Academy of Sciences, Ms. A 371: fragment of a *siddur* of Ashkenazi rite, with commentary (parts missing), (cat. no. 21, Budapest, Hungarian Academy of Sciences, Ms. A 383, makes up the other part); 63 fol.; 201 × 146 (62/90 × 42/70) mm, 12 to 16 l. (prayers), 44 l. at the most (commentary); Ashkenazi script; written in Germany in the first half of the 15th century; painted and pen decoration. *Cf. Pl. 171.*

**20 Budapest,** Hungarian Academy of Sciences, Ms. A 380/I–II: *mahzor* of Italian rite; 475 (228+247 (1–246, ⟨1⟩)) fol.; 162/167 × 114/118 (102 × 70) mm, 31 l.; Italian script; text completed in central Italy, in Pesaro, in 1481 (II, fol. 243v); painted decoration and illustrations.

**✳21 Budapest,** Hungarian Academy of Sciences, Ms. A 383: fragment of a *siddur* of Ashkenazi rite, with commentary (cat. no. 19, Budapest, Hungarian Academy of Sciences, Ms A 371, is the beginning of this manuscript, with lacunae); 227 fol.; 205 × 150 (varying written space: 105 × 70 maximum) mm, 12 to 20 l. (prayers), 42 l. at the most

---

* This institute was closed by the Nazis in 1938, before the town, then called Breslau, became Wrocław again, and has not been revived since.

(commentary); written in Germany in the first half of the 15th century; painted decoration, pen and painted illustrations. *Cf. Pl. 340.*

**22 Budapest,** Hungarian Academy of Sciences, Ms. A 384: part of a *mahzor* of Ashkenazi rite, with commentary (other parts: cat. no. 99, London, Brit. Libr., MS. Add. 22413, and cat. no. 164, Oxford, Bodl. Libr., MS. Mich. 619); 236 (17–212, ⟨1⟩, 213–251; 1–16 added) fol.; 320 × 220 (198/200 × 90/105) mm, 26 l. (prayers); Ashkenazi script; written in the first quarter of the 14th century; illustrations and decoration painted c. 1320–1325 in southern Germany, probably in Swabia.

**✳23 Budapest,** Hungarian Academy of Sciences, Ms. A 387: *mahzor* for *rosh ha-shana, kipur* and *sukot,* of Ashkenazi rite; 568 (1–361, ⟨1⟩, 362–567) fol.; 330 × 227 (210 × 150) mm, 14 l. usually; Ashkenazi scripts; written in Germany, perhaps in the Rhineland, by several hands in the first half of the 15th century; pen and painted decoration and illustrations, also executed in several hands. *Cf. Pl. 393.*

**✳24 Budapest,** Hungarian Academy of Sciences, Ms. A 388 I–II: *mahzor* of Ashkenazi rite; 405 (200 + 205) fol.; 485/490 × 340 (320 × 200) mm, 28 l.; Ashkenazi script; written in Germany in the early 14th century; pen and painted decoration and illustrations. *Cf. Pl. 362.*

**✳25 Budapest,** Hungarian Academy of Sciences, Ms. A 422, known as the Kaufmann Haggada: *haggada* of Sephardi rite; 60 fol.; 195/223 × 167/185 (150 × 110) mm, 9 l.; Sephardi script; written in Spain, probably in Aragon, in the last quarter of the 14th century; pen (red and violet ink) and painted decoration, painted illustrations (partially repainted at a recent date). *Cf. Pls. 116, 134, 163.*

**26 Cairo,** later Paris, Mosseri Collection (disappeared during World War II): Bible (extensively damaged at the beginning and end); not foliated; 260 × 220 mm; 25 l.; 2 col.; Sephardi script; written in Spain or in northern Italy; decoration and illustrations (of which 45 remain: this is the only cycle known to us in a Hebrew Bible from the Mediterranean) done c. 1400 in Catalonia or in northern Italy.

**✳27 Cambridge,** University Library, MS. Add. 437: *siddur* of Italian rite; 330 (1–17, 20–332) fol.; 127 × 93 (83 × 55) mm, 17 l.; Italo-Sephardi script; written in northern Italy (Ferrara) in 1456 (fol. 332 r); pen (coloured inks) decoration and 4 illustrations. *Cf. Pl. 297.*

**28 Cambridge,** University Library, MS. Add. 468: first part of a Bible (Pentateuch and earlier Prophets) with the *More nevukhim* (second part: Cincinnati, Hebr. Un. College, MS. 13); 270 fol. (numbering up to 288, taking account of missing folios); 173/176 × 122 (107 × 67/68) mm, 32 l., 2 col.; Sephardi script; written in Spain in the 15th century; decoration and a few illustrations (very damaged) painted in the second half of the 15th century.

**29 Cambridge,** University Library, MS. Add. 652: Pentateuch and Hagiographa; 327 (1–240, 249–335; 241–248=fol. made good) fol.; 263/265 × 214/215 (172/177 × 141) mm, 28 and 26 l., 2 col.; Sephardi script; written in Spain in the 14th century; decoration and 4 illustrations in micrography, pen decoration (coloured inks, sepia and red) and gold, added.

**✳30 Cambridge,** University Library, MS. Add. 662: *siddur* of Ashkenazi rite (with gaps); 210 fol. (numbering up to 238, of which 28 fol. are replacements); 343 × 262 (225/250 × 165) mm, 22 l.; Ashkenazi script; written in Germany in the early 15th century; pen (coloured inks) and painted decoration and illustrations, done in the first quarter of the 15th century. *Cf. Pls. 201, 361.*

**31 Cambridge,** University Library, MS. Add. 1204: *siddur* of Ashkenazi rite (damaged); 99 (1–64, 69–89, 91–104) fol.; 148/150 × 104/108 (97 × 60) mm, 16 l.; Sephardi script; written in Spain, in the second half of the 15th century; pen (violet and sepia ink) decoration with traces of red and green paint, and 1 illustration (fol. 81r).

**32 Cambridge,** University Library, MS. Dd. 10.68: Collection of medical Treatises; 259 (1–150, 153–261) fol.; 267/270 × 217 (200 × 156) mm, 35 l., 2 col.; Italian script; written in Italy; decoration and illustrations painted in the 1st third of the 15th century.

**33 Carlsruhe,** Badische Landesbibliothek, Ms. Reuchlin 1: Bible with *targum* intercalated (in the Pentateuch) and *masora*; 686 (1–317, 320–688) fol.; 510 × 379 (308/310 × 237/238) mm, 31 l., 3 col.; Ashkenazi scripts; written by two hands: (1) fol. 1-342; (2) fol. 343–688, in Germany, in the first decades of the 14th century; pen (sepia ink) and micrographic decoration.

**34  Chantilly,** Musée Condé, ms. 732: *haggada* of Greek rite; 43 (2–44; 1 and 45 added) fol.; 282 × 222 (165 × 125) mm, 12 l.; Sephardi script; written in Crete or Corfu, *c.* 1500; painted decoration and illustrations, contemporary with the text; illustrations partly repainted, completed or added, probably in the 17th century. *Cf. Pl. 83.*

**35  Cincinnati,** Hebrew Union College—Jewish Institute of Religion, Haggada: *haggada* of Ashkenazi rite; 69 fol.; 340 × 251 (221 × 129/130) mm, 9 l.; Ashkenazi script; written in southern Germany, perhaps in the Ulm region, in 1480–1490; painted decoration and illustrations; painted borders around the pages added, not before the late 16th century.

**36  Cologny-Geneva,** Biblioteca Bodmeriana–Martin Bodmer Foundation, Cod. Bodmer 81: *haggada* of Ashkenazi rite; 34 fol.; 279 × 194 (160 × 100) mm, 15–16 l.; 29 l.; Ashkenazi script; written in Italy between 1450 and 1460; painted and pen decoration and illustrations done in northern Italy, 1450–1460.

**37  Copenhagen,** Royal Library, Cod. Hebr. II: Bible with *masora*; 523 fol.; 319 × 242 (215 × 160) mm, 28 l., 2 col., Sephardi script; probably written in Roussillon, then part of the kingdom of Majorca, in 1301 (fol. 521r); micrographic pen (red and violet ink) and painted decoration; 2 pages of painted illustrations (fol. 11v and 12r). For the motifs of the micrographic decoration and the programme of the illustrations, cf. cat. no. 179, Paris, Bibl. Nat., ms. hébr. 7.

**\*38  Copenhagen,** Royal Library, Cod. Hebr. XXXVII: *More nevukhim* of Maimonides (1135–1204); 352 fol.; 196 × 133/136 (125 × 76/77) mm, 26 l.; Sephardi script; text completed in Spain, in Barcelona, 1347–1348 (fol. 316r); pen (red and violet ink) decoration contemporary with the text; painted decoration and 3 illustrations (fol. 3v, 114r, 202r), in the style of the St. Mark master, done in the 2nd half of the 14th century. *Cf. Pl. 217.*

**\*39  Darmstadt,** Hessische Landes- und Hochschulbibliothek, Cod. or. 8, known as the Darmstadt Haggada I: *haggada* of Ashkenazi rite; 58 fol.; 352/354 × 256 (201/210 × 145 and 240 × 180 (text in margin) mm, 13 l. *(haggada)* and 42 l. (text in margin); Ashkenazi script; written in Germany, in the Rhineland, in the first quarter of the 15th century; painted decoration and illustrations. *Cf. Pls. 169, 170.*

**\*40  Darmstadt,** Hessische Landes- und Hochschulbibliothek, Cod. or. 13: *mahzor* of Ashkenazi rite; 358 (5–362; 1–4 added) fol.; 300 × 230 (variable written space) mm, varying number of lines; Ashkenazi script; text completed in Germany, in Hammelburg (Lower Franconia) in 1348 (fol. 359v); painted decoration and illustrations. *Cf. Pl. 220.*

**41  Darmstadt,** Hessische Landes- und Hochschulbibliothek, Cod. or. 28: *haggada* of Ashkenazi rite; 20 fol.; 230/259 × 170/178 (140/148 × 100) mm, 16 and 17 l.; Ashkenazi script; written in Germany in the last quarter of the 15th century; illustrations painted in the last two decades of the 15th century.

**\*42  Dresden,** Sächsische Landesbibliothek, Ms. A 46ᵃ: 1st part of a *mahzor* of Ashkenazi rite (cat. no. 258, Wrocław, Bibl. Univ., Ms. Or. I, 1 makes up the 2nd part); 293 fol.; 522/528 × 380 (332 × 240 (fol. 1–44), 324 × 241/242 (fol. 45–293)) mm, 30 l. (fol. 1–44), 25 l. (fol. 45–293); Ashkenazi script; written in Germany in the first decades of the 14th century; pen decoration (black and red ink); decoration and illustrations painted *c.* 1340. *Cf. Pls. 3, 383.*

**43  Dublin,** Trinity College Library, MS. 16: Prophets and Hagiographa, with *masora* (probably a Bible without the Pentateuch); 186 fol.; 284 × 232 (209/214 × 157/159) mm, 35 l., 2 col.; Sephardi script; written in Spain, probably in Soria (Old Castile), *c.* 1300; micrographic decoration (same repertory as cat. no. 183, Paris, Bibl. Nat., ms. hébr. 20; cat. no. 88, Lisbon, Bibl. Nac., Ms. Il. 72; cat. no. 158, Oxford, Bodl. Libr., MS. Kenn. 2 and MS. Opp. Add. 4° 75–76; Parma, Bibl. Pal., Ms. Parm. 2938–De Rossi 341) and painted decoration with 3 illustrations (fol. 68v, 76v, 91r).

**44  Florence,** Biblioteca Medicea Laurenziana, Ms. Plut. 2. 1: Bible with *masora* and commentaries (Rashi, Abraham ibn Ezra, David Qimḥi, Levi ben Gerson, Benjamin of Rome); 946 (2–947) fol.; 410 × 305 (biblical text: 178 × 109) mm, 22 l. (biblical text); Sephardi script; written in northern Italy, Ferrara, in 1396/1397 (fol. 942v–944r); micrographic and pen decoration (probably in the hand of the scribe); painted decoration in several hands and a few painted illustrations.

**45  Florence,** Biblioteca Medicea Laurenziana, Ms. Plut. 3. 8: Commentary of Rashi (1040–1105) and others on the Bible (Chronicles are omitted); 495 fol.; 323 × 220 (218/223 × 150/152) mm, 40 l., 2 col.; Italian script; written in Italy towards the end of the 13th century, pen (red and blue ink) and painted decoration, painted illustrations.

**\*46  Florence,** Biblioteca Medicea Laurenziana, Ms. Plut. 3. 10: Pentateuch with *targum* and Rashi, *megillot* and *haftarot* with Rashi, *masora*; 296 fol.; 262/264 × 188/190 (142/146 × 88/89; text of the Pentateuch), 32 l. (Pentateuch); Ashkenazi and Italian script; written in northern Italy, perhaps in the late 14th century and certainly by *c.* 1400; micrographic decoration, drawn with pen and painted at various dates during the first half of the 15th century; a few pen and painted illustrations, also in different hands and styles and of different dates, done during the same period. *Cf. Pls. 82, 154.*

**47  Göttingen,** Niedersächsische Staats- und Universitätsbibliothek, Ms. hebr. 5 (orient. 9): *mahzor* of Ashkenazi rite (with gaps); 320 (1–264, 269–324) fol.; 305/310 × 232 (202 × 160) mm, 22 l.; Ashkenazi script; apparently written in the first decade of the 14th century (fol. 233r) by a French speaking scribe (fol. 164r) in a province of northern or eastern France, or in the Empire, e.g. Lorraine; decorated letters (sepia ink) and 1 illustration (fol. 313r) done by pen.

**48  Hamburg,** Staats- und Universitätsbibliothek, Cod. hebr. 5–6–7: Prophets and Hagiographa with *masora* (remains of a damaged Bible; Cod. hebr. 4 (Pentateuch), which is associated with them, is an odd volume); 616 (188 + 201 + 227) p. (= 308 fol.); 358 × 258 (188/194 × 262/268) mm, 34 l., 3 col.; Ashkenazi scripts; text completed in Germany in 1309 (III, p. 155); pen decoration (sepia ink with a few touches of colour).

**\*49  Hamburg,** Staats- und Universitätsbibliothek, Cod. hebr. 37: *siddur* of Ashkenazi rite, followed by *qinot* and *minhagim*; 205 fol.; 301/330 × 224 (190/193 × 135) mm, 22 l.; Ashkenazi script; written in Germany, probably in the Rhineland and perhaps in Mainz, *c.* 1427–1428 (fol. 122r); painted decoration and illustrations (partly incomplete). *Cf. Pls. 78, 84, 105, 106, 117, 199, 267, 269–271, 352, 386.*

**50  Hamburg,** Staats- und Universitätsbibliothek, Cod. hebr. 155: *haggada* with prayers for *pesaḥ* (incomplete: missing the beginning and the end), of Italian rite; 116 fol.; 181/188 × 133/136 (108 × 80) mm, 7 l. *(haggada)*, 10 l. (prayers); Italian script; written in Italy, 1310–1330; painted decoration and illustrations.

**\*51  Hamburg,** Staats- und Universitätsbibliothek, Cod. Levy 19: Pentateuch with *masora, haftarot, megillot* (and Dream of Mordecai), Job, with *targum* intercalated and Rashi; 626 fol.; 208 × 162 (121 × 92; biblical text) mm, 27 and 28 l. (biblical text); Ashkenazi script; text completed in Brabant, Brussels, in 1310 (fol. 624v–625r); pen (red, blue and sepia ink) and painted decoration and illustrations, all done by the scribe himself at the same date (fol. 625r). *Cf. Pls. 34, 49, 325.*

**52  Hamburg,** Staats- und Universitätsbibliothek, Cod. Levy 37: daily prayers and *piyyuṭim* for special *shabatot*, of Ashkenazi rite; 228 (6–19, 27–240; fol. 1–5, 20–26 added) fol.; 272 × 207 (170 × 115) mm, 19 l.; Ashkenazi script; written in Germany, in the first half of the 14th century; painted decoration, 1 painted illustration (fol. 169v).

**\*53  Hamburg,** Staats- und Universitätsbibliothek, Cod. Scrin. 132 (= hebr. 337): *Sha'arey dura* (Laws of forbidden food) and *Hilkhot nidda* (Laws of menstrual women) of Isaac ben Meïr of Düren (2nd half of the 13th century) and *Birkhot MaHaRaM* (the blessings of Meïr of Rothenburg, *c.* 1215–1293, and their epitome); 122 fol.; 153 × 117 (100/110 × 67) mm, 18 l. (text), 36 l. (glosses); Ashkenazi scripts; written in northern Italy: fol. 1–118 in Padua in 1476 (fol. 118v); fol. 119r–121r, in 1492; decoration and illustrations painted in 2 series, one by an artist from Padua, the other in a style common in Hebrew manuscripts from northern Italy after 1460. *Cf. Pl. 199.*

**54  Imola,** Biblioteca Comunale, Hebrew Bible: Bible with *masora* and *megilla* of Antiochus; 355 (⟨1⟩, 353, ⟨1⟩) fol.; 237/238 × 160 (157 × 105) mm; 38 l., 2 col.; Sephardi script; written in Spain in the 2nd half of the 15th century; decoration done at two periods: (1) micrographic decoration, painted and in ink, in the body of the original vol.; (2) painted decoration fol. 93v, 166v, and 2 illustrations fol. 337v and 338r, added in Italy, probably in Naples (deeds of purchase and sale in this city in 1493 and 1494, fol. 351r and 1r).

*55 **Jerusalem**, G. Weill Collection, Maḥzor: 2nd part of a *maḥzor* of Italian rite (the 1st part is cat. no. 68, Jerusalem, Jewish National and University Library, Ms. Heb. 8° 4450); 642 pp. (=321 fol.); 255/256×184/188 (152/159×101/102) mm; 20 and 21 l.; Italian script; written in northern Italy, probably in Emilia; pen (red ink) and painted decoration, illustrations painted at two periods in two different studios, between 1465 and 1470–1475. *Cf. Pls. 96, 368.*

*56 **Jerusalem**, Israel Museum, Ms. 180/50, known as the Yahuda Haggada: *haggada* of Ashkenazi rite; 40 fol.; 232×175 (132/134×86) mm, 13 and 19 l.; Ashkenazi script; written in Germany; decoration and illustrations painted in 1460–1470. *Cf. Pls. 148, 256.*

*57 **Jerusalem**, Israel Museum, Ms. 180/51, known as Rothschild Ms. 24: Miscellany (biblical, liturgical—including a *siddur* of Ashkenazi rite—*halakhiques* (on religious laws), philosophical and historical/legendary texts, etc.); 473 fol.; 211×157 (main text: 118×65/67; marginal text: 162×106/112) mm, 27 to 28 and 35 to 36 l. (main text), 64 l. at the most (marginal text); Ashkenazi script; written in northern Italy; decoration and illustrations painted *c.* 1470 in Ferrara or nearby. *Cf. Pls. 62, 87, 97, 100, 122, 138, 157, 194, 254, 264, 266, 293, 300, 323, 334, 337, 338, 346, 347, 354, 367, 392.*

*58 **Jerusalem**, Israel Museum, Ms. 180/52, known as the Regensburg Bible: Pentateuch with *megillot, hafṭarot* and *masora*, Job and Jeremiah II: 29–VIII: 12, IX: 24–X, 16; 246 fol.; 242×190 (172/173×103/109 and 173×120/124; 168/169×115) mm. 30 l.; Ashkenazi scripts; biblical text, and *masora*, written in two different hands (1: 1–167; 2: 168–245), in southern Germany, perhaps in Bavaria, *c.* 1300; painted decoration and illustrations. *Cf. Pl. 339.*

*59 **Jerusalem**, Israel Museum, Ms. 180/53, known as the Ruzhin Siddur: *siddur* of Ashkenazi rite; 331 (3–333; 1–2 and 334–335 added) fol.; 185×143 (80/90×50/63) mm, 15 l.; written in Germany, *c.* 1460; Ashkenazi script; painted decoration and illustrations, done in the 1460s.

*60 **Jerusalem**, Israel Museum, Ms. 180/55: Psalms, Job, Proverbs; 230 fol.; 95×64 (47×30) mm, 16 l.; Italian script; written in Italy in the 2nd half of the 15th century; pen (red and and blue ink) and 3 painted illustrations with decorated margins, probably done in Florence in the last third of the 15th century.

*61 **Jerusalem**, Israel Museum, Ms. 180/57, known as the Haggada of the Birds: *haggada* of Ashkenazi rite; 47 fol.; 271×185 (175/181×106/107) mm, 12 and 13 l.; Ashkenazi script; written in Germany, probably in the Rhineland, *c.* 1300; painted decoration and illlustrations. *Cf. Pl. 389.*

*62 **Jerusalem**, Israel Museum, Ms. 180/41, known as Ms. Sassoon 514: *haggada* with commentary (biblical pericopes) and *piyyuṭim* for *pesaḥ* and *shavu'ot*, of Sephardi rite; 168 fol.; 205×164 (137×90) mm, 8 l. *(haggada)*, 18 and 19 l.; written in Spain, perhaps in Aragon; decoration and illustrations painted *c.* 1350. *Cf. Pls. 72, 75, 89, 280.*

*63 **Jerusalem**, Israel Museum, formerly Rabbi S.D. Sassoon Collection, Ms. 506, known as the De Castro Pentateuch; Pentateuch with *targum* and Rashi, *megillot* and *hafṭarot* with Rashi and *masora*; 840 p. (=420 fol.); 467×327 (303×215/216) mm, 43 l., 3 col.; Ashkenazi script; text completed in Germany in 1344 (p. 839); pen and painted decoration and a few illustrations.

*64 **Jerusalem**, Jewish National and University Library, Ms. Heb. 4° 781/I–II, known as the Worms Maḥzor: *maḥzor* of Ashkenazi rite; made up of 2 odd volumes; I: 226 fol.; 391/393×307/310 (300/303×208/211) mm, 26 and 27 l.; II: 219 fol.; 445×310 (270×190) mm, 25 l.; Ashkenazi scripts; written in Germany; vol. I completed in 1272, vol. II perhaps a little later; decoration of both volumes and illustrations of vol. I done in the Rhineland in the last decades of the 13th century. *Cf. Pls. 73, 76, 219, 276, 336.*

*65 **Jerusalem**, Jewish National and University Library, Ms. Heb. 4° 1193: *Mishne Tora* of Maimonides (1135–1204); 462 fol. (fol. 463 added); 447/449×298 (313×180) mm, 49 l., 2 col.; Sephardi script; probably written in Spain, before 1351 (fol. 462v: deed of purchase); decoration and illustrations (fol. 1–40 only) painted in central Italy, probably in Perugia, *c.* 1400, in the studio of Matteo di Ser Cambio. *Cf. Pls. 99, 131, 203, 312, 384.*

66 **Jerusalem**, Jewish National and University Library, Ms. Heb. 8°

1401: Bible with *Sefer ha-shorashim* (Book of the roots) of David Qimḥi (1160?–1235?): Bible: vol. I and II, Qimḥi, upper and lower margins of vol. I and II and vol. III (gaps in the Bible); 405 (199 [204 numbered of which 5 were added] +206) = Bible +53 = end of Qimḥi) fol.; Bible: 210/213×151/157 (138/141×98/102) mm, 31 l., 2 col.; Sephardi script; text completed in Spain, in Saragossa (Aragon), in 1341 (II, fol. 206v); pen (coloured inks) and painted decoration and 2 illustrations (I, fol. 23r and 81r).

*67 **Jerusalem**, Jewish National and University Library, Ms. Heb. 8° 1957: liturgical book (Psalms, *haggada* of Italian rite); 71 fol.; 121×86 (73×56) mm; 16 l.; Italian script; written in Italy in the 2nd half of the 15th century; not decorated. *Cf. Pl. 265.*

68 **Jerusalem**, Jewish National and University Library, Ms. Heb. 8° 4450: 1st part of a *maḥzor* of Italian rite (the 2nd part is cat. no. 55, Jerusalem, G. Weill Coll., Maḥzor); 319 fol.; 255/257×186/187 (152/159×101/102) mm; 20 and 21 l.; Italian script; written in northern Italy, probably Emilia, by the copyist of MS. Harley 5686 (=cat. no. 107), who noted his name on fol. 197v.; pen (red ink) and painted decoration, painted illustrations in two series, done in two different studios, between 1465 and 1470–1475. *Cf. Pl. 294.*

69 **Jerusalem**, Jewish National and University Library, Ms. Heb. 8° 5214: *maḥzor* of Ashkenazi rite; 648 (649 numbered + 1, but the numbering skips from 79 to 81 and from 88 to 90) fol.; 227/229×144/148 (118×76) mm; 12–14 l.; Ashkenazi script; written in Germany in the 2nd quarter of the 14th century; pen (coloured inks) decoration and 1 painted illustration (fol. 83r) done *c.* 1350.

70 **Jerusalem**, Jewish National and University Library, Ms. Heb. 8° 5492: *siddur* of Italian rite; 363 (1–260, ⟨1⟩, 261–362) fol.; 96/98×70 (67×45) mm; 14 l.; Sephardi scripts; mostly written in northern Italy, in Mantua, in 1480 or in 1485 (fol. 313v); painted decoration and 2 illustrations.

71 **Jerusalem**, Jewish National and University Library, Ms. Heb. 8° 5572: *siddur* of Italian rite; 304 fol.; 96×74 (60×37) mm, 17 and 18 l.; Italian script; written in Italy in the 1470s; painted decoration and 3 illustrations.

72 **Jerusalem**, Rabbi S.D. Sassoon Collection,* Ms. 16, formerly known as the Rashba Bible: Bible with *masora*; 952 p. (=476 fol.); 292×222 (216×136) mm, 33 l., 2 col.; Sephardi script; writing, by the same scribe as cat. no. 186, Paris, Bibl. Nat., ms. hébr. 31, completed in Spain, in Cervera (Catalonia), in 1383 (p. 951); micrographic and painted decoration, 2 painted illustrations (pp. 6 and 7).

73 **Jerusalem**, Rabbi S.D. Sassoon Collection, Ms. 23: *maḥzor* of Italian rite; 850 p. (=425 fol.); 177/180×129 (113×83) mm; 30 l.; Italian script; written in central Italy, in Pesaro, in 1480 (pp. 842–843); painted decoration and a few painted illustrations.

74 **Jerusalem**, Rabbi S.D. Sassoon Collection, Ms. 82, known as the *Shem ṭov* Bible: Bible with *masora* (the beginning and central portion are damaged—Ruth and the beginning of the Psalms are missing); 768 p. (=384 fol.); 343/344×254/259 (220×121) mm, 31 l., 2 col.; Sephardi script; text completed in Spain, in Soria (Old Castile), in 1312 (p. 753); pen (coloured inks) and painted decoration; 1 illustration (p. 481); Italianate decoration added on pp. 503–505. For the painted decoration, cf. cat. no. 88, Lisbon, Bibl. Nac., Ms. Il. 72.

*75 **Jerusalem**, Rabbi S.D. Sassoon Collection, Ms. 368, known as the Farḥi Bible: Bible with *masora*, preceded by numerous Masoretic and grammatical texts; 1056 p. (=528 fol.); 259×211 (152×144) mm;

* This collection was made by Rabbi S.D. Sassoon, who gathered together 1,220 Hebrew and Samaritan manuscripts during the first three decades of this century. The collection was kept in England, in London and later in Letchworth, until the departure of Rabbi S.D. Sassoon for Jerusalem some ten years ago. It is now being dispersed (1st sale in 1975, 2nd in 1978, 3rd in 1981). In the case of manuscripts already sold, we have usually been able to refer to the new owner only where this is a public institution or an institution open to the public. For each manuscript, we give the reference in the Sassoon collection which alone allows its description to be traced in the monumental catalogue to the collection, *Ohel Dawid, Descriptive Catalogue of the Hebrew and Samaritan Manuscripts in the Sassoon Library,* by S.D. Sassoon, Oxford–London, 1932.

17–43 l. (pp. 1–192), 31 l., 2 col. (Bible); Sephardi script; written in Spain between 1366 and 1382 (pp. 1–2), in the kingdom of Aragon (Catalonia? Majorca?); micrographic, pen and painted (Bible) decoration; many decorated pages and painted illustrations in the initial texts. *Cf. Pl. 395.*

**\*76 Jerusalem,** Rabbi S.D. Sassoon Collection, Ms. 511 (not now in the collection); *haggada* of Ashkenazi rite; 36 p; (= 18 fol.); 265 × 185 (160 × 105) mm, 18 l.; Ashkenazi script; written in Germany, probably in 14[6]2; numerous painted illustrations. *Cf. Pls. 123, 274, 355, 356.*

**77 Jerusalem,** Rabbi S.D. Sassoon Collection, Ms. 823 (not now in the collection): astronomical tables of Jacob ben David ben Yom Ṭov Fu'al (14th century), compiled *c.* 1361, with a catalogue of the fixed stars, 3 astronomical treatises and 1 philosophical treaty (with gaps); 228 p. (= 114 fol.); 277 × 209 (195/200 × 136) mm, 37 l., 2 col.; Sephardi scripts; written in Spain, in several hands, the latest of the 14th century; illustrations painted *c.* 1400.

**78 Jerusalem,** Rabbi S.D. Sassoon, Ms. 1028: *maḥzor* of Italian rite; 840 p. (= 420 fol.); 159 × 122 (110 × 67) mm, 21 l.; Sephardi script; written in central Italy (Pisa) in 1397 (p. 840); decoration and many illustrations (coloured inks and a few colours).

**79 Jerusalem,** Rabbi S.D. Sassoon, Ms. 1047 (not now in the collection): *More nevukhim (Guide of the Perplexed)* of Maimonides (1135–1204), damaged (gaps: between pp. 176 and 177 = 1 illuminated page, between pp. 304 and 305 and at the end = text); 496 p. (= 248 fol.); 293 × 215 (192 × 138) mm, 23 l., 2 col.; Sephardi script; written in Spain, probably in Catalonia, in the second half of the 14th century; painted decoration showing the influence of the style of the Master of St. Mark.

**\*80 Jerusalem,** Schocken Institute for Jewish Studies of the Jewish Theological Seminary of America, Ms. 13873: *maḥzor* of Italian rite, followed by ritual prescriptions and juridical formulae, etc. (from fol. 358r); 466 fol.; 387/394 × 274/282 (227 × 157) mm, 36 and 71 l.; Italian script; text completed in central Italy in 1441 (fol. 465v); pen decoration (coloured ink and paint) and 7 painted illustrations. *Cf. Pls. 376, 377.*

**81 Jerusalem,** Schocken Institute for Jewish Studies of the Jewish Theological Seminary of America, Ms. 14940, known as the Schocken Bible: Bible with *masora*; 128 fol.; 222 × 157 (167 × 113/114) mm, 69 l., 3 col.; Ashkenazi script; written in Germany; micrographic decoration, painted decoration, and 47 painted illustrations (fol. 1v [46] and 93r [1]), done *c.* 1300 in southern Germany, probably in Swabia.

**\*82 Jerusalem,** Schocken Institute for Jewish Studies of the Jewish Theological Seminary of America, Ms 24085: *haggada* of Ashkenazi rite, fragmentary (gaps between fol. 32v and 33r), with a *piyyuṭ* of Sephardi rite added later (on fol. 40r and v); 40 fol.; 256/258 × 197/199 (145 × 85/90) mm, 12 l.; Ashkenazi script; probably written in northern Italy; pen decoration (coloured inks) and illustrations painted in northern Italy towards the end of the 14th century, probably by two hands. *Cf. Pls. 151, 176-178, 257, 319, 370.*

**83 Jerusalem,** Schocken Institute for Jewish Studies of the Jewish Theological Seminary of America, Ms. 24086, known as the Nuremberg Haggada I: *haggada* of Ashkenazi rite; 30 fol.; 272/282 × 194/199 (217/225 × 140/145) mm, 17 and 18 l.; Ashkenazi script; written in Germany; decoration and illustrations in ink and a few colours, done by 1425–1430 at the latest.

**\*84 Jerusalem,** Schocken Institute for Jewish Studies of the Jewish Theological Seminary of America, Ms. 24087, known as the Nuremberg Haggada II: *haggada* of Ashkenazi rite; 42 fol.; 252/254 × 179/182 (135 × 90) mm, 12, 17 and 19 l.; Ashkenazi script; written in Germany; decoration and illustrations painted 1460–1470. *Cf. Pls. 86, 107, 110, 118, 129, 130, 152, 174, 228, 273, 291, 344.*

**85 Jerusalem,** Schocken Institute for Jewish Studies of the Jewish Theological Seminary of America, Ms. 24100, known as the Nuremberg Maḥzor: *maḥzor* of Ashkenazi rite (damaged); 521 (517+4 loose) fol.; 492/500 × 372/375 (315/327 × 205/228) mm, 30 l.; Ashkenazi script; text completed in 1331 (fol. 517v); pen and painted decoration, perhaps done in the Rhineland.

**86 Leipzig,** Universitätsbibliothek, Ms. B. H. 3: *maḥzor* of Ashkenazi rite (with gaps); 354 (3–249, 260–366; numbering goes directly from 249 to 260) fol.; 425 × 325 (280 × 207) mm, 24 l.; Ashkenazi script; written in Germany in the second quarter of the 14th century; decoration and a few illustrations in ink, with a few colours, damaged (only three signs of the Zodiac survive, fol. 8v and 9v).

**\*87 Leipzig,** Universitätsbibliothek, Ms. V 1102/I–II; *maḥzor* of Ashkenazi rite (a few gaps, and folios out of place); 404 (179 + 225) fol.; 491 × 363 and 485 × 358 (315/327 × 217/227) mm, 26 l. (prayers and *piyyuṭim*); Ashkenazi scripts; written by several hands in the first quarter of the 14th century; decoration and illustrations painted in 1310–1330, in South-West Germany. *Cf. Pls. 108, 226, 306.*

**\*88 Lisbon,** Biblioteca Nacional, Ms. Il. 72: Bible with *masora* and the *Sefer mikhlol* of David Qimḥi (1160?–1235?); 449 fol.; 279/283 × 220/222 (179/184 × 141/151) mm, 31 l., 2 col.; Sephardi script; text completed in Spain, in Cervera (Catalonia), in 1300; micrographic, pen (coloured inks) and painted decoration; a few painted illustrations probably done at about the same date in Castile, in the Soria workshop. Cf. for the micrographic decoration: cat. no. 43 = Dublin, Trin. College Libr., MS. 16; cat. no. 158 = Oxford, Bodl. Libr., MS. Kenn. 2; cat. no. 183 = Paris, Bibl. Nat., ms. hébr. 20; Oxford, Bodl. Libr., MS. Opp. Add. 4° 75–76; Parma, Bibl. Palat., Ms. Parm. 2938–De Rossi 341; and, for the painted decoration, cf. cat. no. 74 = Jerusalem, Rabbi S.D. Sassoon Collection, Ms. 82. *Cf. Pls. 1, 6, 20–23, 29, 31, 33, 35, 37, 46–48, 61, 63, 64, 125, 211, 215, 216, 265, 283, 285, 286, 288, 296, 298, 299, 302, 310, 315–317, 320, 329, 375.*

**89 London,** British Library, MSS. Add. 9405–9406: 2 fragments of a volume (from which the Pentateuch and the *hafṭarot* are missing) containing the *megillot* (except Esther), Job; Jeremiah I: 1–XXIII: 6; Isaiah XXXIV–XXXV; 46 (14+32) fol.; 250 × 193 (164 × 123) and 250 × 196 (160 × 123) mm, 28 and 27 l., 3 col.; Ashkenazi script; text completed in Germany, in 1309 (II, fol. 32v); 2 pen work illustrations (I, fol. 11v and 12r).

**\*90 London,** British Library, MS. Add. 11639: Miscellany (biblical, liturgical, ritual, juridical and grammatical texts); 749 (746+3; but 1–4, 739ᵃ, 744–746 added in Italy in the 15th century) fol.; 161 × 122 (main text: 72/78 × 52/58) mm, 21 l., 2 col.; Ashkenazi script; written in northern France between 1278 and 1286; painted decoration and illustrations, by several hands in a number of successive series, done in the last decades of the 13th and the beginning of the 14th century. *Cf. Pls. 2, 12, 13, 15–17, 25–27, 32, 40, 42, 44, 54–58, 132, 167, 287, 309, 324.*

**\*91 London,** British Library, MS. Add. 11657: ancient and modern prophets, damaged at the end; 333 fol.; 374 × 250 (233 × 133) mm, 25 l.; Italian script; written in Italy in the 14th century; painted decoration by two different hands, done in the second half of the 14th century in central Italy. *Cf. Pl. 391.*

**\*92 London,** British Library, MS. Add. 14761: *haggada* with prayers and *piyyuṭim* for *pesaḥ*, of Sephardi rite; 161 fol.; *haggada* (fol. 17v–88r): 253 × 185 (135/140 × 95) mm, 21 l.; Sephardi script; text completed in 1350–1360; painted decoration (partly incomplete) and illustrations, done in the same period, in the kingdom of Aragon, probably in Catalonia. *Cf. Pls. 36, 70, 95, 206, 208, 209, 308, 366, 378.*

**\*93 London,** British Library, MS. Add. 14762: *haggada* with marginal commentary, of Ashkenazi rite; 49 fol.; 369/377 × 274/277 (215 × 138) mm, 12 l.; Ashkenazi script; text completed in southern Germany, *c.* 1460; painted decoration and illustrations done in part in Germany (Ulm or Augsburg), also *c.* 1460, by three different hands, and in part in 1460–1470 by a fourth hand trained in northern Italy and following models common in that region. *Cf. Pls. 136, 137, 175, 186, 195, 198, 221, 265, 313.*

**94 London,** British Library, MS. Add. 15250: Bible with *masora*; 437 fol.; 355 × 289 (234 × 186) mm, 31 l., 3 col.; Sephardi script; text completed in Spain (in Barcelona?), 1320–1335; micrographic decoration and 2 p. of painted illustrations (fol. 3v and 4r).

**\*95 London,** British Library, MS. Add. 15282: Pentateuch with *targum* intercalated, *megillot, hafṭarot* and *masora*; 360 fol.; 230 × 164 (145 × 99) mm, 30 l., 3 col.; Ashkenazi script; text completed in Germany, in the first quarter of the 14th century; decoration and some illustrations, in micrography but mostly painted, done in southern Germany, probably in Swabia. *Cf. Pls. 74, 77.*

**★96  London,** British Library, MS. Add. 19776: Pentateuch with *megillot, haftarot* and various Masoretic treatises; 252 fol.; 292 × 220 (183 × 139) mm, 32 l., 2 col.; Ashkenazi scripts; written by one hand, punctuated by two others, completed in Germany (Coburg), in late 1395 (fol. 252r); painted decoration and illustrations. *Cf. Pls. 91, 301.*

**97  London,** British Library, MSS. Add. 19944– 19945: *mahzor* of Italian rite; 374 (197 + 177) fol.; 337 × 240 (215 × 135) mm, 37 l.; Italian script; text completed in Italy (Florence), in 1441 (II, fol. 169v); painted decoration and 1 illustration (II, fol. 164r).

**98  London,** British Library, MS. Add. 21160: Pentateuch (acephalous) with *targum* intercalated, a few *haftarot, megillot,* and Job (incomplete), with *masora*; 329 fol.; 387 × 285 (235 × 165) mm, 30 l., 3 col.; Ashkenazi script; written in Germany in the second half of the 13th century; decoration and illustrations in micrography.

**★99  London,** British Library, MS. Add. 22413: part of a *mahzor* of Ashkenazi rite, with commentary (other parts are cat. no. 22, Budapest, Hungarian Acad. of Sciences, Ms. A 384, and cat. no. 164, Oxford, Bodl. Libr., MS. Mich. 619); 167 fol.; 320 × 223 (main text: 203 × 95) mm, 26 l. (prayers); Ashkenazi script; written in the first third of the 14th century; decoration and illustrations painted *c.* 1320–1325 in South-West Germany, in Swabia. *Cf. Pls. 168, 218.*

**100  London,** British Library, MS. Add. 26896: first part of a *mahzor* (acephalous) of Ashkenazi rite; 404 fol.; 302 × 227 (185/195 × 140) mm, 22 l.; Ashkenazi script; written in Germany in the first half of the 14th century; decorations and a few illustrations, painted.

**★101  London,** British Library, MS. Add. 26957: *siddur* of Italian rite; 113 fol.; 139 × 98 (86 × 57) mm, 20 l.; Ashkenazi script; text completed in northern Italy in 1[4]69 (fol. 112r); pen decoration and illustrations (sepia and violet inks). *Cf. Pls. 179–182, 189, 190.*

**★102  London,** British Library, MS. Add. 26968: *siddur* of Italian rite; 345 (343 + 2 fol. bis) fol.; 138/141 × 107 (75/80 × 50) mm, 18 and 19 l.; Italian script; text completed in Italy, in Forli, Romagna, in 1383 (fol. 323v); painted decorations and illustrations, done in part *c.* 1383 and in part 1430–1440. *Cf. Pls. 11, 14, 28, 68, 259, 327, 373, 379, 385.*

**103  London,** British Library, MS. Add. 27137: *Arba'a turim* of Jacob ben Asher (1270?–1340), Book IV; 320 fol.; 194 × 148 (125 × 86) mm, 32 l., 2 col.; Ashkenazi script; text completed in [14]60 (fol. 320v) by a scribe trained in Germany; pen decoration (coloured inks) and 1 painted illustration (fol. 14r) done in northern Italy.

**104  London,** British Library, MS. Add. 27167: Pentateuch with *haftarot, megillot* and *masora*; 462 (1–8, 11-464) fol.; 169 × 115/119 (106/108 × 66/67) mm, 19 and 20 l.; Sephardi scripts; written by two different hands in Portugal, probably in Lisbon, in 1480–1485; pen (coloured ink) and painted decoration.

**★105  London,** British Library, MS. Add. 27210: *haggada* with readings from the Bible, and *piyyutim* for *pesah,* of Sephardi rite; 100 (2–101) fol.; 245 × 195 (165 × 126) mm, 10 and 26 l.; Sephardi script; written in Spain; decoration and illustrations painted in Catalonia *c.* 1320–1330. *Cf. Pls. 112, 143, 161, 318, 330.*

**106  London,** British Library, MS. Harley 1528: Bible with *masora*; 420 (1–4, 7-422; fol. 5–6 and 423–424 = additions) fol.; 350 × 265 (239 × 175) mm, 22 l., 3 col.; Sephardi script; written in Spain (Barcelona?) in the first quarter of the 14th century; painted and micrographic decoration, and 2 pages of painted illustrations (fol. 7v–8r).

**★107  London,** British Library, MS. Harley 5686: *mahzor* of Italian rite, with *dinim* (ritual prescriptions); 378 (8–384, ⟨1⟩ arbitrarily bound with 385–418, copied in 1427 and 419–449 added in the 15th century); fol.; 262 × 193 (155/157 × 105/110) mm, 26 to 29 l. (main text), 59 and more (marginal text); Italian script; text completed in Italy, in Reggio, Emilia, in 1465 (fol. 377v); pen painted decoration, and painted illustrations done in two successive phases between 1465 and 1470–1475. *Cf. Pls. 7, 193, 343.*

**108  London,** British Library, MSS. Harley 5710–5711: Bible with *masora*; 560 (258 + 302) fol.; 390 × 264 (227/228 × 153) mm; 29 l.; 2 col.; Italian script; written in Italy, probably in the region around Rome, in the late 13th or early 14th century; decoration and 2 illustrations (I, fol. 1r and 136r).

**109  London,** British Library, MSS. Harley 5716–5717: the *Arba'a turim* of Jacob ben Asher (1270?–1340); 535 (270 + 265 (2–266)) fol.; 366 × 264 (238 × 168) mm, 37 l., 2 col.; Italian script; text completed in Italy, *c.* 1475 (II, fol. 265v); pen (coloured inks) and painted decoration; 1 painted illustration (II, fol. 5v) of *c.* 1475–1480.

**110  London,** British Library, MS. Harley 7621; Pentateuch with *targum* and Rashi, *haftarot, megillot* with commentaries; 439 fol.; 225 × 174 (biblical text: 105 × 56) mm, 20 l.; Italian script; written in northern Italy; decoration and 1 illustration (fol. 1r) painted 1460–1470.

**111  London,** British Library, MS. Kings 1: Bible with *masora*; 429 (2–429, ⟨1⟩) fol.; 330 × 255 (204/210 × 165/170) mm, 32 l., 2 col.; Sephardi script; written in Spain, in Solsona, (Catalonia), in 1385 (fol. 427r); pen and painted decoration and illustrations contemporary with the text (fol. 2v–4v); decoration (at the beginning of each book) and illustrations (fol. 2r and 7v) added in the 17th century.

**★112  London,** British Library, MS. Or. 1404: *haggada* (with a commentary and biblical pericopes in the margin) and *piyyutim* for *pesah,* of Sephardi rite; 51 (1–50, ⟨1⟩) fol.; 269/273 × 224/229 (174/187 × 145) mm, 14 and 15 l. *(haggada),* 28 l. *(piyyutim);* Sephardi script; written in Spain, *c.* 1330; painted decoration and illustrations, perhaps done in the region of Valencia (then in the kingdom of Aragon). *Cf. Pl. 101.*

**★113  London,** British Library, MS. Or. 2091: Prophets and Hagiographa with *masora* (originally part of a complete Bible); 424 fol.; 442 × 321 (255/263 × 210/213) mm, 27 l., 3 col.; Ashkenazi script; written in Germany in the late 13th century; pen and micrographic decoration; 3 illustrations in micrography (fol. 203r). *Cf. Pls. 8, 9, 43, 45, 387, 388.*

**114  London,** British Library, MS. Or. 2736: *siddur* of Italian rite, with biblical texts (the poetical books, *megillot* and *haftarot*) in the margin; 484 (⟨2⟩, 1–2; ⟨1⟩, 3–479, ⟨2⟩) fol.; 139 × 97 (70 × 42/45) mm, 15 l. (main text), 22 l. (marginal text); Italian script; text completed in central Italy (Bertinoro) in 1390 (fol. 479r); pen decoration (coloured inks).

**★115  London,** British Library, MS. Or. 2737: *haggada* with biblical pericopes and *piyyutim* for *pesah,* of Sephardi rite; 94 (1–3, ⟨1⟩, 4–93) fol.; 162 × 122 (91/97 × 60) mm, 13 l.; Sephardi script; written in Spain; decoration and illustrations probably painted in Castile in the first quarter of the 14th century. *Cf. Pls. 71, 111, 113, 114, 139–142, 144, 159, 160, 214, 253, 272, 277, 281, 290, 331, 348, 349.*

**★116  London,** British Library, MS. Or. 2884: *haggada* preceded by *piyyutim* and prayers for *pesah,* of Sephardi rite; 64 fol.; 228 × 189 (148 × 112) mm, 9 to 10 l. *(haggada),* 14 l. *(piyyutim),* 19 l. (prayers); Sephardi script; written in Spain, *c.* 1350; decoration and illustrations painted in Aragon. *Cf. Pls. 65, 103, 115, 156, 162, 207, 351.*

**★117  London,** British Library, MS. Or. 5024: *pisqey* (decisions) of Isaiah by Trani the younger (?–*c.* 1280); 296 (3–298) fol.; 404 × 280 (272 × 185) mm, 52 l., 2 col.; Italian script; text completed in Italy, probably in Rimini, in 1374 (fol. 298v); painted decoration and illustrations; cf. cat. no. 18, Budapest, Hungarian Acad. of Sciences, Ms. A 278. *Cf. Pls. 235, 239, 353, 369, 371.*

**118  London,** British Library, MS. Or. 10878: collection of short treatises on astronomy, arithmetic, music, astrology; 17 fol.; 215 × 150 (160 × 100) mm, number of lines varies (fol. 4r: 62 l.); written around the end of the 14th century or in the first half of the 15th; diagrams; 2 illustrations (ink and colours), fol. 17r and v, with inscriptions and captions done by one hand, German, different from that of the text; German illumination from the first half of the 15th century.

**119  London,** Jews' College, Montefiore Library, MS. 249: ritual for circumcision, marriage, mourning, etc., and the *Qa'arat kesef* (the silver plate) of Joseph Ezobi (13th century); 60 (1–10, 12–61) fol.; 133 × 97 (72 × 50) mm, 10 l.; Italian script; written in Italy, *c.* 1450; pen and painted decoration, 1 painted illustration probably done in Emilia, *c.* 1455.

**120  London,** University College, Mocatta Library: *mahzor* of Italian rite; 392 fol.; 162 × 118/120 (92 × 65) mm, 20 l.; Sephardi script; written

in central Italy in the last decades of the 15th century; painted decoration and a few illustrations.

**121  Madrid,** Biblioteca Nacional, Cod. V$^a$ 26/6: Bible; 478 fol.; 315 × 225 (213/218 × 153) mm, 30 and 31 l.; Sephardi script; text completed in Spain (Castile) in the second quarter of the 14th century; painted decoration and 1 illustration (fol. 326v).

**∗122  Manchester,** John Rylands University Library, MS. Ryl. Hebr. 6: *haggada* with prayers and *piyyuṭim* for *pesaḥ*, of Sephardi rite; 57 fol.; 275 × 230 (175 × 130 and 172 × 140) mm, 14 l. and 30 l.; Sephardi script; *haggada* completed in Spain, *c.* 1330; painted decoration and illustrations done in Aragon. *Cf. Pl. 165.*

**∗123  Manchester,** John Rylands University Library, MS. Ryl. Hebr. 7: *haggada* of Ashkenazi rite; 50 fol.; 201 × 146 (75 × 57) mm, 9–13 l.; Ashkenazi script; text completed in Germany; painted decoration and illustrations, done *c.* 1430. *Cf. Pls. 79, 85, 135.*

**124  Milan,** Biblioteca Ambrosiana, Ms. B. 30–31–32 Inf.: Bible with *targum* intercalated (for the Pentateuch) and *masora*; 566 (222+208+136) fol.; 450 × 345 (305 × 227), 445 × 345 (303 × 227), 441 × 340 (305 × 227) mm, 34 l., 3 col.; Ashkenazi scripts; writing of vol. I completed in Germany, the text in 1236 (fol. 222v), the punctuation and *masora* in 1237–1238 (fol. 222v); vols. II and III written at about the same date by the same hand for the text, by another hand for the *masora*, from vol. II, fol. 32v; painted decoration and illustrations, done at the same period by different hands.

**125  Milan,** Biblioteca Ambrosiana, Ms. C. 105 Sup.: incomplete Bible (Pentateuch, Joshua I: 1–18, with *masora*); 135 (I–II, 1–133) fol.; 335 × 253 (213 × 150) mm, 28 l., 2 col.; Sephardi script; text completed in Spain in the second half of the 14th century; Italianate painted decoration added *c.* 1380 in Catalonia; painted illustrations on fols. I and II also added in Catalonia at about the same date.

**∗126  Milan,** Biblioteca Ambrosiana, Ms. Fragm. S.P. II. 252: leaf from a *maḥzor* of Ashkenazi rite; 340 × 225 mm, Ashkenazi script; written in Germany, *c.* 1300; decoration and illustrations done at the same date as the text. *Cf. Pls. 90, 202.*

**127  Milan,** Biblioteca Ambrosiana, Ms. G. 3. Sup.: miscellanies of mysticism and theology; 343 fol.; 143 × 107 (105 × 63) mm; 20 and 23 l.; Italian script; text completed in Italy, probably in or near Rome, in 1319 (fol. 129v); painted decoration and diagrams in ink contemporary with the text; later paintings added in northern Italy.

**128  Modena,** Biblioteca Estense, Cod. α. K. I. 22 (= Or. 92): *haggada* (fragment) of Sephardi rite (cat. no. 13, Bologna, Bibl. Univ., Ms. 2559, contains a second fragment from this *haggada*); 15 fol.; 245 × 178 (168 × 118) mm, 9 l.; Sephardi script; text completed in Spain (Aragon), 1350–1360; painted decoration and 2 illustrations (fol. 6v, 7v).

**129  Munich,** Bayerische Staatsbibliothek, Cod. hebr. 2: Pentateuch with *targum* intercalated, *masora, megillot, hafṭarot,* Job, Jeremiah I: 1–XXIII: 6, Isaiah XXXIV–XXXV; 331 fol.; 390 × 310 (286 × 216) mm, 30 l., 3 col.; Ashkenazi script; text completed in Germany in the second half of the 13th century; decoration and 1 illustration (fol. 261r) in micrography.

**∗130  Munich,** Bayerische Staatsbibliothek, Cod. hebr. 3/I–II: *maḥzor* for *kipur* and *sukot,* of Ashkenazi rite (in 2 vols.); 852 (484+368 (incorrect foliation: 489+371)) fol.; 372 × 255 (229 × 135) mm, 18 l.; Ashkenazi scripts; 1 scribe for each vol.: vol. I completed in Bavaria, in Ulm, in 1459 (fol. 487v); vol. II completed 1459–1460 (fol. 370v); painted decoration in each volume by a different hand, done at about the same date as the text. *Cf. Pl. 98.*

**∗131  Munich,** Bayerische Staatsbiliothek, Cod. hebr. 5/I–II: Commentary on the Bible by Rashi (1040–1105), with variants and additions, and by Joseph Qara (1060/70–1140); incomplete (the beginning is damaged and Proverbs are missing); 480 (218 (2–217+2 fol. *bis*)+262 (256+6 fol. *bis*)) fol.; 380 × 285 (270 × 190) mm, 43 and 44 l., 3 col.; Ashkenazi scripts; written by two scribes in Germany, completed in 1233 (fol. 254r–255r, 256v); painted decoration and illustrations contemporary with the text, done in the Wurtzburg region; pen decoration added in the mid-16th century (I, fol. 1r and II, fol. 1r). *Cf. Pl. 200.*

**∗132  Munich,** Bayerische Staatsbibliothek, Cod. hebr. 36: the Elements of Euclid and Books of Hypsicles in mathematical

miscellanies of 270 (⟨1⟩, 269) fol.; 92 (9–100) fol.; 330/332 × 240/245 (232 × 150) mm, 43 l.; Sephardi script; text completed in Turkey (Constantinople), in 1480 (fol. 173v); geometric figures in ink. *Cf. Pls. 262, 263.*

**∗133  Munich,** Bayerische Staatsbibliothek, Cod. hebr. 107: *Mashal ha-qadmoni* of Isaac ibn Sahula (1244–?) in a volume of miscellanies of 204 fol.; 94 (1–94) fol.; 278 × 207 (177 × 112) mm, 32–36 l., 1 and 2 col.; Ashkenazi script; text completed in Germany, *c.* 1450; ink and wash-drawing illustrations. *Cf. Pls. 128, 227, 229, 292, 307.*

**134  Munich,** Bayerische Staatsbiliothek, Cod. hebr. 200: *haggada* of Ashkenazi rite; 30 fol. (7–36); 285 × 234 (192/224 × 145/153) mm, 13 and 14 l.; Ashkenazi script; text completed in Germany, 1470–1480; painted decoration and illustrations.

**∗135  Munich,** Bayerische Staatsbiliothek, Cod. hebr. 249: astronomical miscellanies; 206 fol.; 206 × 150 (135/142 × 60/83) mm, varying number of lines; Sephardi scripts; written in Spain (?) in the late 15th century. *Cf. Pl. 265.*

**136  New Haven,** Yale University Library, Beinecke Rare Book and Manuscript Library, MS.+143 ∗: *haggada* of Ashkenazi rite; text completed in northern Italy; painted decoration and illustrations, done 1460–1470.

**137  New York,** Hispanic Society of America, MS. B. 241: Bible with *masora*; 585 fol.; 280 × 220 (176 × 145) mm, 26 l., 2 col.; Sephardi script; text probably completed in Spain, before 1480; painted and pen decoration, some contemporary with the text, some done in Lisbon, *c.* 1480–1485.

**138  New York,** Jewish Theological Seminary of America, MS. Acc. No. 0017: Collection of *piyyuṭim* of Ashkenazi rite; 201 fol.; 119 × 89 (72 × 50) mm, 19 l.; Ashkenazi script; written in Germany, *c.* 1300; painted decoration and illustrations.

**139  New York,** Jewish Theological Seminary of America, MS. Acc. No. 02922: *haggada* of Sephardi rite; 61 (1–53; 54–77 added in the 15th century; 78–85) fol.; 210 × 150 (119 × 82) mm, 9 l.; Sephardi script; text completed 1350–1360; decoration and illustrations, mostly incomplete.

**∗140  New York,** Jewish Theological Seminary of America, MS. Acc. No. 03225, known as Rothschild II: *maḥzor* of Italian rite; 477 fol; 287 × 205 (165 × 118) mm, 29 l.; Italian script; written in Italy, in Florence, in 1492 (fol. 469v and 477v); painted decoration and illustrations (some following models dating from 1465–1470), done by different hands. *Cf. Pls. 197, 381.*

**141  New York,** Jewish Theological Seminary of America, MS. Acc. No. 75048, known as JTS Haggada I: *haggada* of Ashkenazi rite; 23 fol.; 333 × 238 (216/222 × 155/158) mm, 23 l.; Ashkenazi script; written in Germany, *c.* 1450; decoration and illustrations.

**142  New York,** Jewish Theological Seminary of America, MS. Mic. 8224: *siddur* of Italian rite; 348 fol.; 142 × 102 (78/80 × 55) mm, 19 l.; Sephardi script; written in Italy, *c.* 1460; painted decoration.

**143  New York,** New York Public Library, Spencer Collection, Hebrew Bible/I–II: Bible (with a few gaps) with *masora*; 455 (253+202) fol.; 397 × 293 mm, 35 l., 3 col.; Ashkenazi script; text completed in Germany, probably in the Rhineland, in 1294 (I, fol. 253v); pen (coloured inks) decoration, with a few colours.

**144  New York,** Private Collection, formerly Frankfurt am Main, Stadtbibliothek, MS. Ausst. 4: Bible with *masora*; 500 fol.; 370 × 279 mm, 2 col., 30 l.; written in Spain (Catalonia) in the first quarter of the 14th century; painted decoration and illustrations (fol. 24v–26r).

**145  New York,** Private Collection, formerly Frankfurt am Main, Stadtbiliothek, Ms. Ausst. 5: Pentateuch with *targum*, Rashi and *masora*; 584 fol.; 274 × 214 mm, 22 l. (biblical text); Ashkenazi script; text

completed in Germany in 1296 (fol. 583r); painted decoration and 1 illustration (fol. 226v), done in the late 13th or early 14th century in the Rhineland; 1 illustration (fol. 478r) added in northern Italy, *c.* 1470.

**∗146  New York,** Private Collection, formerly Frankfurt am Main, Stadtbibliothek, MS. Ausst. 6: *Mishne Tora* of Maimonides (1135–1204), Books VII–XIV, damaged, missing the beginnings of Books VII and XIII (Books I–V = cat. no. 238, Vatican, Bibl. Apost., Ms. Rossian. 498); 347 fol.; 220 × 176 mm, 46 l.; Ashkenazi script; written in northern Italy around the middle of the 15th century; painted decoration and illustrations done in northern Italy (Lombardy), *c.* 1450; many marginal illustrations, binding damaged. *Cf. Pls. 240, 255.*

**147  New York,** Private Collection, formerly Frankfurt am Main, Stadtbibliothek, Ms. 725/17 (Ausst. 9): *haggada* of Italian rite; 39 fol.; 284/287 × 197/202 mm, 15 l.; Sephardi script; text completed in the early 16th century; painted decoration and illustrations, done in northern Italy (the Veneto?).

**∗148  Nîmes,** Bibliothèque Municipale, ms. 13: *siddur* of Spanish rite; 203 (⟨1⟩, 2–203) fol.; 129 × 111 (85 × 65) mm, 13 l.; Sephardi script; text probably completed in the region of Naples, in the third quarter of the 15th century; painted illustrations contemporary with the text. *Cf. Pl. 33.*

**149  Oxford,** Bodleian Library, MSS. Bodl. Or. 802–803–804: Bible, damaged (missing Jeremiah and Ezechiel, with gaps in vol. III), with *targum* intercalated and *masora*; 352 (1–97+98–202+1–150) fol.; 545 × 390, 546 × 395, 567 × 370 (362/363 × 263) mm, 34 and 35 l., 2, 3, 4 col.; Ashkenazi script; text completed in Germany in the early 14th century; decoration and 1 illustration in micrography.

**150  Oxford,** Bodleian Library, MS. Can. Or. 15: *Arba'a turim* of Jacob ben Asher (1270?–1340), Book II; 224 (1–9, ⟨1⟩, 10–223) fol.; 188 × 138 (115 × 82) mm, 31 l., 2 col.; Ashkenazi script; text completed in northern Italy (Piacenza), in 1479 (fol. 222v); decoration (ink and a few colours).

**∗151  Oxford,** Bodleian Library, MSS. Can. Or. 62: Pentateuch with *targum* and Rashi, *megillot* with commentaries, *haftarot*; 275 fol.; 305 × 220 (biblical text: 161 × 106) mm, 24 l., 1 col. (biblical text); Italian script; writing of the Pentateuch completed in northern Italy in 1472 (fol. 190r); painted decoration and 1 illustration (Emilia or Ferrara). *Cf. Pl. 39.*

**∗152  Oxford,** Bodleian Library, MS. Can. Or. 79: *Arba'a ṭurim* of Jacob ben Asher (1270?–1340), Books III and IV; 453 fol.; 305 × 244 (202 × 153) mm, 30 l., 2 col.; Italian script; text completed in northern Italy in 1438 (fol. 453v); painted decoration and illustrations (Lombardy? the Veneto?). *Cf. Pls. 69, 183.*

**∗153  Oxford,** Bodleian Library, MS. Can. Or. 81: Rashi's (1040–1105) Commentary on the Pentateuch; 191 fol.; 304 × 232 (188 × 139) mm, 32 l.; 2 col.; Sephardi script; text completed in Italy (Pisa), in 1396 (fol. 191r); painted decoration and illustrations. *Cf. Pl. 314.*

**154  Oxford,** Bodleian Library, MS. Can. Or. 91: Pentateuch with *targum* intercalated, *megillot, haftarot* and *masora*; 306 (2–307) fol.; 341 × 260 (230 × 170) mm, 31 l., 3 col.; Ashkenazi script; text completed in Germany in 1304 (fol. 307r) and punctuation in 1305 (fol. 307r); drawn and micrographic decoration.

**∗155  Oxford,** Bodleian Library, MS. Can. Or. 137: Pentateuch with *targum* intercalated, *haftarot* and *masora*; 309 fol.; 422 × 320 (303 × 226) mm, 29 l., 3 col.; Ashkenazi script; text completed in Germany, *c.* 1300; micrographic decoration. *Cf. Pls. 10, 284.*

**156  Oxford,** Bodleian Library, MS. Can. Or. 140: 2nd volume of a *maḥzor* of Ashkenazi rite (Oxford, Bodl. Libr., MS. Can. Or. 139 = vol. 1); 201 fol.; 444 × 330 (300 × 220) mm, 24 l.; Ashkenazi script; text completed in the first quarter of the 14th century; decoration and 1 illustration (fol. 35v), both by pen.

**∗157  Oxford,** Bodleian Library, MS. Kenn. 1: Bible with *masora* and the *sefer mikhlol* of David Qimḥi (*c.* 1160–1235); 454 (⟨1⟩, 1–453) fol.; 295 × 232 (176 × 143) mm, 30 l., 2 col.; Sephardi script; text completed in Spain (Corunna), in 1476 (fol. 438r); painted decoration and illustrations. *Cf. Pl. 210.*

**∗158  Oxford,** Bodleian Library, MS. Kenn. 2: Bible with *masora*; 427 fol.; 304 × 240 (195 × 145) mm, 35 l., 2 col.; Sephardi script; text

completed in Spain, probably in Soria (Castile), in the early 14th century; painted and micrographic decoration; plan of the temple (fol. 1v–2r), damaged, completed in Soria in 1306. For the micrographic decoration, cf. cat. no. 43, Dublin, Trin. College Libr., MS. 16; cat. no. 88, Lisbon, Bibl. Nac., Ms. Il. 72; cat. no. 183, Paris, Bibl. Nat. ms. hébr. 20; Oxford, Bodl. Libr., MSS. Opp. Add. 4° 75–76; Parma, Bibl. Pal., Ms. Parm. 2938–De Rossi 341. *Cf. Pl. 67.*

**159  Oxford,** Bodleian Library, MS. Laud. Or. 321: *maḥzor* of Ashkenazi rite; 362 fol.; 431 × 330/344 (original text: 314 × 217) mm, 30 l.; Ashkenazi scripts; written in Germany, *c.* 1300, and completed by various hands in the 14th and 15th centuries; painted decoration and illustrations contemporary with the hand of the original text.

**160  Oxford,** Bodleian Library, MS. Lyell 99: *siddur* of Ashkenazi rite; 264 fol.; 77 × 57 (44 × 32) mm, 13 l.; Ashkenazi script; text completed in northern Italy, 1460–1470; painted decoration and illustrations done at the same period, probably in northern Italy but following a German model and by a German hand.

**161  Oxford,** Bodleian Library, MS. Mich. 127: *Arba'a ṭurim* of Jacob ben Asher (1270?–1340), Book I; 260 fol.; 194 × 146 (125 × 85) mm, 31 l., 2 col.; Ashkenazi script; text completed in Germany in the first half of the 15th century; decoration contemporary with the text (fol. 16v), added in northern Italy (initials).

**∗162  Oxford,** Bodleian Library, MSS. Mich. 610–611: *maḥzor* of Italian rite, in 2 vols.; 412 (207 + 205) fol.; 340 × 250 (205 × 147) mm, 33 l.; Italian script; text completed in Italy, *c.* 1460; decoration and illustrations (ink, and red and blue colours) done in northern Italy. *Cf. Pl. 158.*

**163  Oxford,** Bodleian Library, MS. Mich. 617: 1st part of a *maḥzor* of Ashkenazi rite, damaged at the beginning (the 2nd part is cat. no. 165, Oxford, Bodl. Libr., MS. Mich. 627); 132 fol.; 404 × 295 (300 × 190/200) mm, 24 l.; Ashkenazi script; text completed in Germany in 1258 (cf. MS. Mich. 627, fol. 174r); painted decoration and illustrations.

**∗164  Oxford,** Bodleian Library, MS. Mich. 619: part of a *maḥzor* of Ashkenazi rite, with commentary (other parts: cat. no. 22, Budapest, Ac. Sc. Ms. A 384 and cat. no. 99, London, Brit. Libr., MS. Add. 22413); 281 (2–282) fol.; 344 × 244 (main text: 204 × 91/105) mm, 26 l. (prayers); Ashkenazi script; text completed *c.* 1320–1325; decoration painted in the first third of the 14th century. *Cf. Pls. 261, 394.*

**165  Oxford,** Bodleian Library, MS. Mich. 627: 2nd part of a *maḥzor* of Ashkenazi rite (the first part is cat. no. 163, Oxford, Bodl. Libr., MS. Mich. 617); 174 fol.; 402 × 294 (300 × 190/200) mm, 24 l.; Ashkenazi script; text completed in Germany in 1258 (fol. 174r); painted decoration.

**∗166  Oxford,** Bodleian Library, MS. Opp. 14: Pentateuch with *targum*, Rashi and *masora*, *megillot* with Rashi, *haftarot* with *masora*; 352 fol.; 317 × 258 (biblical text: 216 × 87, 216 × 128, 217 × 129) mm, 28 l., 1 and 2 col. (biblical text); Ashkenazi script; text completed in Germany in 1340 (fol. 352r); decoration and numerous illustrations both by pen. *Cf. Pl. 305.*

**167  Oxford,** Bodleian Library, MS. Opp. 53: *Arba'a ṭurim* of Jacob ben Asher (1270?–1340), Books I and II; 262 (1–2, ⟨1⟩, 3–261) fol.; 324 × 248 (216 × 196) mm, 40 l., 2 col.; Ashkenazi script; text completed in Germany, *c.* 1460–1465; painted decoration and 2 drawn illustrations.

**∗168  Oxford,** Bodleian Library, MS. Opp. 154: *Mashal ha-qadmoni* of Isaac ibn Sahula (1244–?) (a few gaps); 59 fol.; 273 × 178 (220 × 128) mm, 36 and 34 l.; Ashkenazi script; text completed in Germany in 1450 (fol. 59v); painted illustrations. *Cf. Pls. 172, 173, 222, 230, 260, 278.*

**169  Oxford,** Bodleian Library, MS. Opp. 161: *maḥzor* of Ashkenazi rite for special *shabatot, pesaḥ* and *shavu'ot* (damaged at the beginning; 1 gap); 145 fol.; 318 × 250 (220 × 163) mm, 25 l.; Ashkenazi script; text completed in Germany in 1342 (fol. 145r); decoration and illustrations (ink and red and blue colours).

**170  Oxford,** Bodleian Library, MSS. Opp. 670–669: *maḥzor* of Ashkenazi rite (northern France), in 2 volumes; 213 (135 + 78) fol.; 175 × 129 (116 × 75) mm, 19 to 23 l.; Ashkenazi script; text completed in northern France in the late 13th century; decoration and illustrations (ink and ochre).

**∗171  Oxford,** Bodleian Library, MS. Opp. 776: *siddur* of Ashkenazi

rite; 90 fol.; 94×84 (70×48) mm, 21 l.; Ashkenazi script; text completed in Germany in 1471 (fol. 90r); painted decoration and illustrations. *Cf. Pls. 196, 231.*

**✲172 Oxford,** Bodleian Library, MS. Opp. Add. 8° 14: *siddur* of Sephardi rite; 378 (⟨1⟩, 377) fol.; 118×91 (81×49) mm, 17 l.; Sephardi script; text completed in Spain in the third quarter of the 14th century; painted decoration and illustrations, in part contemporary with the text, in part added in Italy in the 15th century; *Cf. Pl. 104.*

**✲173 Oxford,** Bodleian Library, MSS. Reggio 1 and 2: *maḥzor* of Ashkenazi rite, in two odd volumes, written by three Ashkenazi hands (I and II in the 14th century, III in the 15th century); 536 (277+259) fol.; 320×238 and 335×238 (227/228×135/136) mm, 22 and 20 l.; only the text written by the second hand (I, fol. 158–269+II, fol. 1–257) (215×132 mm) is decorated: writing, decoration and illustrations (red and sepia inks) completed in Germany in the early 14th century. *Cf. Pls. 363, 364.*

**174 Paris,** Alliance Israélite Universelle Library, ms. 24 H: *maḥzor* of Ashkenazi rite for *rosh ha-shana* and *kipur* (damaged at the beginning and at the end); 438 (14–244, 244*bis*–450; 1–13 added) fol.; 312/319×239/241 (200/208×122/145) mm, 17 and 27 l., 1 and 2 col.; Ashkenazi script; written in Germany in the early 14th century; painted decoration and 4 illustrations, done by two hands.

**175 Paris,** Bibliothèque de la Compagnie de Saint-Sulpice, ms. 1933: Bible with *masora*; 344 (1–326, 328–345) fol.; 338/349×264/269 (234/235×183) mm, 35 l., 3 col.; Sephardi script; written in Spain (Catalonia) probably in 1355–1360; micrographic decoration contemporary with the text; painted panels and illustrations (fol. 1r–8r), of about the same date as the text; painted decoration, in a number of series, in the body of the volume, of a later date.

**176 Paris,** Bibliothèque Nationale, ms. hébr. 1–2–3: Bible with *masora* (damaged, gaps filled: I, fol. 136–139); 562 (139 (2–135, 140–144)+231+192) fol.; 386/391×320/330 (258/266×215/218) mm, 28 l., 3 col.; Ashkenazi script; text probably completed in Germany, in 1286 (III, fol. 192r); decoration and 3 illustrations in micrography (I, fol. 37v, 40r, 104v).

**177 Paris,** Bibliothèque Nationale, ms. hébr. 4: Bible with *masora* (gaps filled, fol. 77 and 301); 616 (5–76, 78–300, 302–622; fol. 1–4 added) fol.; 471/475×335/338 (284/287×208/211) mm, 28 l., 3 col.; Ashkenazi script; text completed in 1286 (fol. 446r); painted decoration, done by at least two hands and revealing in its motifs some French influence and a very marked Italian influence. It is none the less difficult to localize precisely beyond an attribution to an Ashkenazi country, of the late 13th century.

**178 Paris,** Bibliothèque Nationale, ms. hébr. 5–6: Bible with *masora* and *targum* intercalated for the Pentateuch; 666 (306 (⟨1⟩, 3–8, ⟨1⟩, 9–231, 233–307)+360 (1–267, 269–361)) fol.; 532/539×373/379 (328/342×232/239) mm, 32 l., 3 col.; Ashkenazi script; text completed in Germany, in [12]94–[12]95 (II, fol. 234v); decoration and 3 illustrations (I, fol. 117v, 118r and v), in micrography.

**179 Paris,** Bibliothèque Nationale, ms. hébr. 7: Bible with *masora*; 516 (2–517) fol.; 320/322×236/238 (209/211×147/150) mm, 30 l., 2 col.; Sephardi script; text completed in Roussillon, part of Aragon then in the kingdom of Majorca, in Perpignan, 1299 (fol. 512v); painted, pen and micrographic decoration, 2 pages of painted and a few pen illustrations (fol. 12v–13r).

**✲180 Paris,** Bibliothèque Nationale, ms. hébr. 8–9–10: Bible with *targum* (for the Pentateuch) and *masora*, damaged at the beginning; 563 (229+249+85) fol.; 445/448×318/325 (278/292×211/218) mm, 34 l., 3 col.; Ashkenazi script; writing of the *masora* completed in Germany in 1304 (III, fol. 85v); decoration in micrography. *Cf. Pl. 326.*

**181 Paris,** Bibliothèque Nationale, ms. hébr. 15: Bible with *masora* and the *Diqduqey ha-te'amim* of Aaron ben Asher (10th century); 525 (1–309, 309 *bis*–360, 362–439, 439*bis*–443, 443*bis*–496, 498–524) fol.; 318/320×240/245 (181/187×150/153) mm, 28 l., 2 col.; Sephardi script; written in Portugal, probably in Lisbon, *c.* 1480; micrographic decoration; painted decoration done in part in Lisbon (fol. 9v and 374v), in part in Italy, (Florence), in the late 15th century.

**✲182 Paris,** Bibliothèque Nationale, ms. hébr. 19: Bible with *masora*; 561 fol.; 452/455×332/335 (295/298×206/208) mm, 29 l., 3 col.;

Ashkenazi script; written in Germany in the 2nd half of the 13th century; micrographic decoration and 1 pen drawing added *c.* 1300 (fol. 1r). *Cf. Pl. 225.*

**43✲183 Paris,** Bibliothèque Nationale, ms. hébr. 20: Bible with *masora*; 470 (1–227, ⟨1⟩, 228–455, ⟨1⟩, 456–468; fol. 469 added in the 15th century) fol.; 275/279×216/221 (181/183×137/139) mm, 30 l., 2 col.; Sephardi and Italian scripts (one of which [end of the 15th century] was done by the copyist of the deed of purchase, fol. 466v, and the *megilla* of Antiochus, fol. 467v–468r, among others); *masora* written in Spain, in Toledo (Navarre) in 1300–1301 (fol. 45r, 58v, 69r); painted and micrographic decoration following models from Soria (Castile); 23 motifs (ink, gold, colour and micrography) illustrate the text. For the micrographic decoration cf. cat. no. 43, Dublin, Trin. College Libr., MS. 16; cat. no. 88, Lisbon, Bibl. Nac., Ms. Il. 72; cat. no. 158, Oxford, Bodl. Libr., MS. Kenn. 2; Oxford, Bodl. Libr., MSS. Opp. Add. 4° 75–76; Parma, Bibl. Pal., Ms. Parm. 2938–De Rossi 341. *Cf. Pl. 360.*

**✲184 Paris,** Bibliothèque Nationale, ms. hébr. 21; Bible with *masora*; 372 fol.; 280×227 (192/196×160/162) mm, 34 l., 3 col.; Sephardi script; written in Spain, probably in Castile, in the early 14th century; calendar decorated (fol. 1v–4v) by the hand of the scribe-artist responsible for cat. no. 183, Paris, Bibl. Nat., ms. hébr. 20, and for a plan of the Temple (cat. no. 158, Oxford, Bodl. Libr., MS. Kenn. 2); painted decoration by another hand, done at a later date. *Cf. Pls. 358, 359.*

**185 Paris,** Bibliothèque Nationale, ms. hébr. 29: Bible with *masora*; 410 (1–13, 15, 17–163, ⟨1⟩, 164–201, ⟨1⟩, 202–410) fol.; 225/226×182/183 (143×116/117) mm, 30 l., 3 and 2 col.; Sephardi script; written in Spain, in the 3rd quarter of the 15th century, decorated at two separate periods: 1) Masoretic decoration—margins and panels (ink and colours); 2) painted decoration done 1470–1480.

**186 Paris,** Bibliothèque Nationale, ms. hébr. 31: Bible with *masora*; 400 fol.; 229/230×164/170 (154/157×104/106) mm, 35 l., 2 col.; Sephardi script; written in Spain, by the same scribe as cat. no. 72, Jerusalem, Sassoon Coll., Ms. 16, in Saragossa (Aragon) in 1404 (fol. 395v); pen (red and violet ink) decoration and 4 painted illustrations (fol. 1v, 2v, 3r, 4v).

**187 Paris,** Bibliothèque Nationale, ms. hébr. 36: Pentateuch with *targum, megillot, hafṭarot* for *pesaḥ* and *shavu'ot*, Job and *masora*; 364 fol.; 508/514×350/357 (323/330×223/226) mm, 32 l. (33 to 35 l. at the beginning), 2 and 3 col.; Ashkenazi scripts; written in the county of Burgundy, part of the Empire, in Poligny or Foulenay, in 1300 (fol. 364v); punctuation and *masora* of the same date (cf. cat. no. 223, Parma, Bibl. Pal., Ms. Parm. 3191–De Rossi 264, cat. no. 225, Ms. Parm. 3286–3287–De Rossi 440, and cat. no. 226, Ms. Parm. 3289–De Rossi 265); pen (red, violet and blue ink), painted and micrographic decoration; 3 painted illustrations (fol. 283v).

**188 Paris,** Bibliothèque Nationale, ms. hébr. 42: Pentateuch with *targum* and Rashi, *hafṭarot*, Psalms, Proverbs, *megillot* with commentaries (beginning damaged); 456 fol.; 270×197/201 (variable justification); main text: 11 to 21 l., marginal text: 42 to 55 l.; Italian script; written in northern Italy in 14[4]3 or 14[7]3 (fol. 83v); decoration incomplete (in ink and painted) and 1 painted illustration (fol. 193v), done in 1470-1475.

**189 Paris,** Bibliothèque Nationale, ms. hébr. 48–49: Pentateuch with *targum*, Rashi, *hafṭarot* (intercalated with the Pentateuch) and *megillot* (damaged at the beginning); 967 (499 (4–76,⟨1⟩, 77–238, 238*bis*–287, ⟨1⟩, 288–351,⟨1⟩, 352–498; fol. 2–3 and 499 added in the 15th century)+468 (1–99,⟨1⟩, 100–413,⟨1⟩, 414–442,⟨1⟩, 443–465; fol. 466 added) fol.; 250×195/203 (132/133×115) mm, 20 l.; Ashkenazi script; written in Germany in the early 14th century; pen, painted and micrographic decoration, and 1 micrographic illustration (fol. 125r); painted decoration added in the first half of the 15th century, in Germany (I, fol. 3v, 231; II, fol. 130v, 288v).

**190 Paris,** Bibliothèque Nationale, ms. hébr. 418: *Sefer ha-asheri* (the Book of Asher) of Asher ben Yeḥiel (*c.* 1250–1327); 377 fol.; 330×250 (204/207×160/163) mm, 41 l., 2 col.; Ashkenazi script; written in northern Italy; decoration and 2 illustrations, fol. 1r and 198r (coloured inks and paint), done 1455–1465.

**191 Paris,** Bibliothèque Nationale, ms. hébr. 642: *siddur* of Ashkenazi

rite; 252 fol.; 168/171 × 119/122 (117 × 84) mm, 32 l., 2 col.; Ashkenazi script; probably written in northern Italy in the first quarter of the 15th century; painted decoration and illustrations.

★ **192** **Paris,** Bibliothèque Nationale, ms. hébr. 689: *More nevukhim* of Maimonides (1135–1204), text incomplete at the beginning; 149 (⟨1⟩, 1–148) fol.; 283/285 × 211 (180 × 115) mm; 30 l.; Sephardi script; written in Spain in the first half of the 14th century; pen decoration (red and violet ink). *Cf. Pl. 265.*

**193** **Paris,** Bibliothèque Nationale, ms. hébr. 819: *Sefer sha'arey ora* (Book of the Gates of Light) of Joseph Gikatila (1248–1325?); 148 (⟨1⟩, 1–120, 122–148) fol.; 265 × 193 (174/175 × 116/118) mm, 24 l.; Sephardi script; written in Italy in the 15th century; 1 illustration (ink and 3 colours) on the recto of the initial unnumbered folio.

★ **194** **Paris,** Bibliothèque Nationale, ms. hébr. 1181: Collection of works on medicine; 269 fol.; 360/364 × 250 (240 × 155) mm, 37 l., 2 col.; Sephardi script; written in Italy, towards the end of the 14th century; 2 painted illustrations with captions and explanatory notes in Italian script (fol. 263v and 264r). *Cf. Pl. 251.*

★ **195** **Paris,** Bibliothèque Nationale, ms. hébr. 1199: Medical herbal; 74 fol.; 201 × 149 mm; Italian scripts; text confined to captions for the illustrations (fol. 1r–65v) and to a few supplementary notes (fol. 67r–74v); pictures of 130 plants, both drawn by pen and painted, done in Italy in the second half of the 15th century. *Cf. Pls. 244–246.*

★ **196** **Paris,** Bibliothèque Nationale, ms. hébr. 1203: Medical treatises (Galen abridged by Maimonides, and Hippocrates with commentary by Galen, in Arabic but in Hebrew script) with gaps, 255 fol.; 246/250 × 164 (166 × 102) mm, 22 l.; Sephardi script; written in Spain; decoration and 2 pictures (fol. 1r and 45v) painted after 1350; the decoration reveals the influence of the Master of Saint Mark. *Cf. Pl. 321.*

**197** **Paris,** Bibliothèque Nationale, ms. hébr. 1314–1315: Bible with *masora*; 442 (222+220) fol.; 290 × 227 (178/182 × 152/155) mm, 30 l., 3 col.; Sephardi script; written in Spain in the 15th century, possibly as early as *c.* 1420 or alternatively *c.* 1450–1460; micrographic decoration and 1 illustration (fol. 17v), contemporary with the text; 2 painted illustrations (fol. 1v and 2r), not part of the original manuscript, done in the first half of the 15th century.

**198** **Paris,** Bibliothèque Nationale, ms. hébr. 1322: Pentateuch with *haftarot, megillot* and *masora*; 504 fol.; 66 × 45 (59 × 32) mm, 22 l.; Ashkenazi script; probably written in northern Italy *c.* 1470 or later; decoration and 2 illustrations (fol. 484v and 491v) done with pen, with a few colours, in a style common in northern Italy from 1465–1470 onwards.

★ **199** **Paris,** Bibliothèque Nationale, ms. hébr. 1333: *haggada* of Ashkenazi rite; 40 fol.; 235/238 × 172/175 (140 × 100) mm, 12 and 24 l.; Ashkenazi script; written in Germany; painted decoration and illustrations done *c.* 1460–1470. *Cf. Pls. 153, 268.*

★ **200** **Paris,** Bibliothèque Nationale, ms. hébr. 1388: *haggada* of Greek rite; 40 fol.; 276/285 × 221/224 (70 × 125/130) mm, 13 and 19 l.; Sephardi script; perhaps written in Crete (in Candia) or in Corfu, in 1583 (fol. 40r); painted decoration and illustrations, a faithful copy of much earlier models (cf. cat. no. 34, Chantilly, Musée Condé, ms. 732). *Cf. Pl. 382.*

**201** **Paris,** Private Collection, formerly Sassoon Collection, ms. 699: Ptolemy's Almagest; 146 pages (gap between pp. 16–17); 246 × 179 (170 × 114) mm, 27 l.; Sephardi script; written in Spain in the 14th or 15th century; figures drawn in pen, painted decoration of 1470–1480.

**202** **Paris,** Séminaire Israélite, ms. 1: Pentateuch with *targum, haftarot, megillot, masora* and commentaries (gap of 6 fol. between fol. 1 and 2); 505 (faulty numbering: 502+3 fol. *bis*, 8*bis*, 191*bis*, 353*bis*) fol.; 272/274 × 196/201 (135/140 × 60/65 for the biblical text) mm, 15–23 l. (biblical text); Ashkenazi script; text completed in northern Italy in 1447 (fol. 502v); pen (red and sepia ink and painted decoration, 3 painted illustrations (fol. 1); the style, technique and motifs of the decoration, of which this is the earliest dated specimen, was particularly popular in Hebrew manuscripts from northern Italy during the second half of the 15th century.

**203** **Parma,** Biblioteca Palatina, Ms. Parm. 1682–De Rossi 293: Pentateuch (1 gap: the initial fol. of Exodus); 265 fol.; 123 × 100

(72/76 × 62/63) mm, 20 l., 2 col.; Italian script; written in Italy; pen decoration and painted panels of the first half of the 15th century.

**204** **Parma,** Biblioteca Palatina, Ms. Parm. 1711–De Rossi 234: Psalms; 180 (9–188) fol.; 106 × 76 (55/58 × 41) mm, 12 l.; Italian script; text completed in central Italy, in Perugia, in 1391 (fol. 187v); pen (coloured inks) and painted decoration, painted illustrations.

**205** **Parma,** Biblioteca Palatina, Ms. Parm. 1756–De Rossi 236: *mahzor* of Italian rite; 286 fol.; 77 × 56 (37 × 28) mm, 14 l.; Italian script; written in northern Italy, 1450–1460; painted decoration and illustrations.

★ **206** **Parma,** Biblioteca Palatina, Ms. Parm. 1870–De Rossi 510: Psalms, with the commentary of Abraham ibn Ezra; 218 fol. (219–226 added in the 15th century); 132 × 100 (62 × 38) mm, 12 l. (biblical text); written in Italy, in the last quarter of the 13th century; Italian script; painted decoration and numerous illustrations, probably done in Emilia. *Cf. Pls. 80, 204, 234, 311, 365.*

**207** **Parma,** Biblioteca Palatina, Ms. Parm. 1934–De Rossi 863; *haggada* of Italian rite (damaged at the beginning); 24 fol.; 143/146 × 96/99 (75/78 × 55/57) mm, 17 l.; Italo-Sephardi script; written in central Italy after 1450; pen (red and blue ink) decoration and 3 painted illustrations (fol. 9v, 10r, 10v) done *c.* 1460.

**208** **Parma,** Biblioteca Palatina, Ms. Parm. 1994–1995–De Rossi 346: Bible with *masora*; 394 (200+194) fol.; 177 × 125 (114 × 78) mm, 35 l., 2 col.; Sephardi script; written in Spain 1470–1480; micrographic decoration, painted decoration done by two different hands; 1 painted illustration (II, fol. 88r).

**209** **Parma,** Biblioteca Palatina, Ms. Parm. 2018–De Rossi 535: Pentateuch with *haftarot, megillot, masora* and *megilla* of Antiochus; 208 (1–7, 9–209) fol.; 196 × 147 (116 × 88) mm, 28 l., 2 col.; Sephardi script; text completed in Spain, in 1484 (fol. 208v); micrographic decoration, and painted decoration done by two different hands; a few illustrations, 2 painted (fol. 16v), the others in micrography.

**210** **Parma,** Biblioteca Palatina, Ms. Parm. 2032–De Rossi 613: Hagiographa (without Chronicles); 240 fol.; 165/170 × 120 (100/104 × 68) mm, 20 l.; Italian script; written in Italy in the late 14th or early 15th century (fol. 240v: deed of sale of 1409); painted decoration, probably done in central Italy.

**211** **Parma,** Biblioteca Palatina, Ms. Parm. 2160–2161–De Rossi 683: Bible, incomplete (gap in Genesis, the Prophets and the end of Chronicles missing), with *masora*; 535 (253+282) fol.; 188/190 × 125/128 (100 × 65/66) mm, 22 l., 2 col.; written in Italy in the early 14th century; 2 initial words in gold (I, fol. 2v and II, fol. 99v) and 1 illustration (I, 1v), added at about the same date as the text.

★ **212** **Parma,** Biblioteca Palatina, Ms. Parm. 2151–2152–2153–De Rossi 3: Bible with *masora*; 657 (172+296+189) fol.; 197 × 134, 198 × 143, 199 × 139 (127/128 × 85/87) mm, 26 l., 2 col.; Italian script; text completed in Italy (Rome) in 1304 (III, fol. 188r); painted decoration and 1 illustration (III, fol. 145r). *Cf. Pl. 81.*

**213** **Parma,** Biblioteca Palatina, Ms. Parm. 2411–De Rossi 1107: *haggada* of Sephardi rite, with biblical pericopes for *pesah*; 56 fol.; 195/199 × 171/174 (125/130 × 110/116) mm, 9 and 18 l.; Sephardi script; written in Spain in the early 14th century; painted decoration and illustrations.

★ **214** **Parma,** Biblioteca Palatina, Ms. Parm. 2809–De Rossi 187: Bible with *masora*; 368 fol.; 259 × 208/214 (160 × 138) mm, 32 l.; 3 col.; Sephardi script; text completed in Spain, perhaps in the Seville region, in 1473 (fol. 368v); decoration and 1 illustration (fol. 6r) in micrography. *Cf. Pl. 275.*

**215** **Parma,** Biblioteca Palatina, Ms. Parm. 2810–2811–De Rossi 518: Bible with *masora*; 608 (376+232) fol.; 265 × 214 and 262 × 214 (192/195 × 127/128) mm, 27 l., 2 col.; Sephardi script; written in Spain in the early 14th century; painted decoration and 2 pages of illustrations (fol. 7v and 8r).

**216** **Parma,** Biblioteca Palatina, Ms. Parm. 2821–De Rossi 661: Pentateuch; 136 fol.; 250 × 198 (193 × 142) mm, 30 and 27 l., 2 col.; Germanic script; written in northern Italy; decoration and 1 illustration (fol. 1v) in violet ink with touches of colour, done in the 1460s.

★ **217** **Parma,** Biblioteca Palatina, Ms. Parm. 2823–De Rossi 893: Pentateuch with *haftarot, megillot*, Rashi; 353 fol.; 248 × 190 (biblical text: 140 × 73/75) mm, 22 l. (biblical text); Ashkenazi script; written in

Germany; painted decoration and illustrations, done in the early 15th century. *Cf. Pl. 345.*

★**218 Parma,** Biblioteca Palatina, Ms. Parm. 2895–De Rossi 653: *siddur* of Ashkenazi rite; 470 pages (=235 fol.); 260×200 (175/185×110/112) mm, 20 l.; Ashkenazi script; written in Germany, in Ulm, 1450 (p. 366) and in part in northern Italy, in Tarvisio or Treviso, 1453 (p. 466); decoration and illustrations (ink and a few colours), done in Germany before 1453. *Cf. Pls. 127, 145, 380.*

★**219 Parma,** Biblioteca Palatina, Ms. Parm. 2998–De Rossi 111: *haggada* of Ashkenazi rite; 24 fol.; 272/277×208/212 (170×120) mm, 16 l.; Ashkenazi script; written in northern Italy; pen decoration (violet ink) and painted illustrations, done 1460–1470. *Cf. Pls. 233, 304.*

★**220 Parma,** Biblioteca Palatina, Ms. Parm. 3006–3007–De Rossi 654: *maḥzor* for *rosh ha-shana* and *kipur*, of Ashkenazi rite, with commentary; 410 (253 fol. and 313 p.=157 fol.) fol.; 294×201 and 298×208 (190×123/125) mm, 28 l.; Ashkenazi script; completed in Tallard (Hautes-Alpes) or in Tillières (Normandy) (II, p. 313), in 1304 (I, fol. 253r, II, p. 313); pen decoration and a few illustrations. *Cf. Pl. 93.*

★**221 Parma,** Biblioteca Palatina, Ms. Parm. 3143–De Rossi 958: *haggada* of Ashkenazi rite; 26 fol.; 283/296×226 (175/190×130) mm, 15 to 17 l.; Ashkenazi script; written in northern Italy; painted illustrations, perhaps done in the Veneto towards the end of the 15th century. *Cf. Pls. 147, 149, 150, 155, 192, 232.*

**222 Parma,** Biblioteca Palatina, Ms. Parm. 3183–De Rossi 196: Bible (missing the end of Chronicles and Ezra-Nehemiah); 326 fol.; 397×312 (279×229) mm, 34 l., 3 col.; Sephardi script; written in Spain, perhaps in Huesca (Aragon), in the last quarter of the 13th century; pen, painted and micrographic decoration.

★**223 Parma,** Biblioteca Palatina, Ms. Parm. 3191–De Rossi 264: Pentateuch with *targum* intercalated, *megillot, haftarot* and *masora*, damaged but repaired; 430 (8–64, 72–443, 447) fol.; 405×320 (292/297×200/205) mm, 28 l., 3 col.; Ashkenazi scripts; probably written by a scribe and certainly by a *naqdan*, both active in the county of Burgundy, part of the Empire, *c.* 1300 (cf. cat. no. 187, Paris, Bibl. Nat., ms. hébr. 36, and cat. no. 225, Parma, Bibl. Pal., Ms. Parm. 3286–3287–De Rossi 440, and cat. no. 226, Ms. Parm. 3289–De Rossi 265); micrographic decoration. *Cf. Pl. 164.*

★**224 Parma,** Biblioteca Palatina, Ms. Parm. 3273–De Rossi 134; *Sefer ha-halakhot* (Book of Laws) of Isaac Alfasi ben Jacob (1013–1103), with commentaries and *Sha'arey shevu'ot* (The Gates of Oaths) of David ben Saadia (11th century), translated from the Arabic into Hebrew by David ben Ruben (1043?–?); 372 fol.; 370×278 (256×177) mm, 51 l. (main text), 66 to 82 l. (commentaries); Italian script; written *c.* 1460; pen (coloured inks) and painted decoration, and 1 painted illustration (fol. 1v), done in northern Italy 1460–1465. *Cf. Pl. 121.*

★**225 Parma,** Biblioteca Palatina, Ms. Parm. 3286–3287–De Rossi 440: Bible with *masora* (damaged at the beginning and end, and with gaps); 460 (258+202) fol.; 496/500×365/367 (318/319×215/217) mm, 26 l., 3 col.; Ashkenazi scripts; written by a scribe (fol. 161v) and by a *naqdan* (fol. 158r–161v) active *c.* 1300 in the county of Burgundy (cf. cat. no. 187, Paris, Bibl. Nat., ms. hébr. 36; cat. no. 223, Parma, Bibl. Pal., Ms. Parm. 3191–De Rossi 264; cat. no. 226, Ms. Parm. 3289–De Rossi 265); painted and micrographic decoration. *Cf. Pls. 126, 223.*

★**226 Parma,** Biblioteca Palatina, Ms. Parm. 3289–De Rossi 265: Pentateuch with *targum, megillot, haftarot* and *masora* (damaged at the beginning and end); 372 fol.; 527×368 (336/338×230/234) mm, 29 l., 3 col.; Ashkenazi scripts; probably written by a scribe and certainly by a *naqdan* (fol. 358r–372v) active in the county of Burgundy *c.* 1300 (cf. cat. no. 187, Paris, Bibl. Nat., ms. hébr. 36; cat. no. 223, Parma, Bibl. Pal., Ms. Parm. 3191–De Rossi 264; cat. no. 225, Ms. Parm. 3286–3287–De Rossi 440); decoration and illustrations in micrography. *Cf. Pl. 224.*

**227 Parma,** Biblioteca Palatina, Ms. Parm. 3515: *maḥzor* of Italian rite, with the Bible written in the margins; 534 fol.; 309×236 (171/176×122 and 250×180 with marginal text) mm, 30 and 15 l., 49 l. (marginal text); Sephardi script; written in central Italy in the first half of the 15th century; 1 diagram (fol. 207r); 1 sketched illustration (fol. 115r); pen and painted decoration.

**228 Parma,** Biblioteca Palatina, Ms. Parm. 3518: *siddur* of Ashkenazi

rite (northern France); 39 fol.; 303×209/214 (193/195×148/150) mm, 45 l., 3 col.; Ashkenazi script; written *c.* 1300, in northern France; decoration and illustrations (red and black ink).

★**229 Parma,** Biblioteca Palatina, Ms. Parm. 3596: Psalms, Job, Proverbs; 282 (3–284) fol. (fol. 285–286 added in the 18th century); 118×92 (85×49) mm, 13 l.; Italian script; written in northern Italy, in Emilia or Romagna, after 1450; painted decoration and illustrations, done 1455–1465. *Cf. Pls. 146, 187, 188, 332.*

★**230 Princeton,** University Library, MS. Garrett 26: Ritual for birth, marriage, death, etc.; 150 fol.; 110×80 (70×42) mm, 15 l.; Italian script; written in Italy towards the end of the 15th century; painted decoration and 27 illustrations, done in the Rimini region, 1480–1500. *Cf. Pls. 109, 341.*

★**231 Rome,** Biblioteca Casanatense, Ms. 2898: Hagiographa (damaged at the beginning: missing Chronicles and the beginning of Psalms, gaps; bound with a fragment of a Pentateuch with *haftarot* by another scribe and of a different date); 98 (55–152) fol.; 277/278×215 (195×147) mm, 24 l., 2 col.; Italian script; written in central Italy, towards the end of the 13th century; pen (red ink) and painted decoration. *Cf. Pls. 18, 24, 41.*

**232 Rome,** Biblioteca Casanatense, Ms. 3010: Pentateuch (beginning damaged) with *targum* intercalated, *megillot* (incomplete), *haftarot* (very damaged), Rashi and *masora*; 589 (2–584, 612–617, 620; fol. added to fill the gap) fol.; 360×268 (212×110) mm, 23 l.; Ashkenazi script; written in Germany by two hands in the first half of the 14th century; pen decoration and a few illustrations, both with a few touches of colour.

**233 Rome,** Biblioteca Casanatense, Ms. 3096: *Arba'a ṭurim* of Jacob ben Asher (1270?–1340), Book II; 170 fol.; 194×145 (123/124×85) mm, 32 l., 2 col.; Ashkenazi script; written either in Germany or in northern Italy; decoration and 2 illustrations (fol. 1r) done in northern Italy towards the middle of the 15th century.

**234 Rome,** Comunita Israelitica, Mostra permanente, cat. no. 19: Pentateuch with *masora*; 214 (2–215) fol.; 351×282 (260×200) mm, 21 l., 2 col.; Sephardi script; text completed in Spain, in Barcelona, 1325 (fol. 211r); decoration and 2 pages of illustrations (fol. 213v, 215r) in micrography.

**235 Rovigo,** Biblioteca dell'Accademia dei Concordi, Ms. 220: *Sefer iqqarim* (Book of Principles) of Joseph Albo (late 14th–15th century); 178 fol.; 360×250 (215×127) mm, 37 l.; Italian script; written in Italy; pen (coloured inks) and painted decoration, done 1460–1470 in central Italy, perhaps in Florence—in the decoration can be found the motifs and style of the Master of the '*girari bianchi*'.

★**236 Sarajevo,** National Museum, Haggada: *haggada* followed by *piyyuṭim*, prayers and biblical pericopes for *pesaḥ*, of Sephardi rite; 138 (1–34, 1–104) fol.; 221/225×162/164 (126/128×95/97), 10 l. (*haggada*), 17 l.; Sephardi script; written in Spain, probably in Aragon; pen (red and violet ink) and painted decoration; painted illustrations (by two main hands: (1) fol. 1–34: full page illumination; (2) fol. 25r and 31v of the text), done 1350–1360; in several places, the eyes, and, less frequently, the faces and other details, have been painted over in black ink at a late date. *Cf. Pls. 4, 5, 50, 51, 88, 119–120, 124, 133, 212, 213, 258, 279, 289, 295, 322, 350, 396.*

★**237 Stuttgart,** Württembergische Landesbibliothek, Cod. or. 4° 1: *haggada* of Ashkenazi rite; 22 fol.; 212×150 (150/153×95/100) mm, 15 and 24 l.; Ashkenazi script; written in Germany or in northern Italy in the second half of the 15th century; illustrations in pen and in part painted (a few colours only), done in northern Italy, 1460–1470. *Cf. Pls. 191, 241.*

★**238 Vatican City,** Biblioteca Apostolica Vaticana, Cod. Rossian. 498: first part of the *Mishne Tora* of Maimonides (1135–1204), Books I–V, with gaps (end of Book III, beginning of Book IV and all of Book VI) (the second part is cat. no. 146, New York, Private Coll., formerly Frankfurt am Main, St.-Bibl., Ms. Ausst. 6); 273 fol.; 225/229×180/185 (192×135) mm, generally 46 l.; Ashkenazi script; written in northern Italy, towards the middle of the 15th century; painted decoration and illustrations, done in northern Italy (Lombardy), *c.* 1450; numerous marginal illustrations, cropped on binding. *Cf. Pls. 52, 102, 185, 237, 372.*

★**239 Vatican City,** Biblioteca Apostolica Vaticana, Cod. Rossian.

555: *Arba'a ṭurim* of Jacob ben Asher (1270?–1340); 443 (1–127, ⟨1⟩, 128–292, ⟨1⟩, 293–441) fol.; 331 × 237 (226/227 × 153) mm, 52 l., 2 col.; Italian script; text completed in northern Italy (Mantua), in 1435 (fol. 440r); pen (sepia, red and blue ink) and painted decoration, 4 painted illustrations. *Cf. Pls. 92, 184, 252, 335.*

**✶240 Vatican City,** Biblioteca Apostolica Vaticana, Cod. Urbin., ebr. 1: Bible with *targum* intercalated, Rashi (for the Pentateuch) and *masora*; 979 fol.; 545 × 398 (322 × 230/247) mm, 35 l., 3 col.; Ashkenazi scripts; text written by a single scribe, the *masora* by two scribes, of which the second completed his work in 1294 (fol. 979v); micrographic decoration. *Cf. Pls. 19, 30, 60.*

**✶241 Vatican City,** Biblioteca Apostolica Vaticana, Cod. Vat. ebr. 9: Bible; 414 (I, 1–154, 156–395, 397, 397*bis*–414) fol.; 319 × 240 (185 × 156) mm, 26 l., 2 col.; Italian script; text completed in central Italy (Rome), in 1287 (fol. 410r); pen (blue and red ink) and painted decoration and a few illustrations; for the decorative motifs, cf. cat. no. 231, Rome, Bibl. Casan., Ms. 2898. *Cf. Pl. 390.*

**✶242 Vatican City,** Biblioteca Apostolica Vaticana, Cod. Vat. ebr. 14: Pentateuch (with *targum* intercalated), *megillot, hafṭarot,* with *masora*; 280 fol. (292, of which 1–3 are added, 19 numbers missing, and 10 fol. *bis*); 282 × 220 (178 × 160) mm, 30 l., 3 col.; Ashkenazi script; text completed in northern France (Normandy), probably in Rouen, in 1239 (fol. 292r) (by the same scribe as cat. no. 8, Berlin, St.-Bibl. Preuss. Kulturbes., Orientabt., Ms. or. qu. 9); micrographic and pen (sepia ink) decoration and illustrations, with a few colours. *Cf. Pl. 205.*

**✶243 Vatican City,** Biblioteca Apostolica Vaticana, Cod. Vat. ebr. 324: *siddur* of Ashkenazi rite; 398 fol.; 219/224 × 156/162 (130 × 100) mm, 34 l., 2 col.; Ashkenazi scripts; written in Germany by two scribes, of which the first completed his work between 1395 (fol. 82r) and 1398 (fol. 264r); pen (with a few touches of colour) decoration and illustrations. *Cf. Pls. 94, 357, 374.*

**244 Vatican City,** Biblioteca Apostolica Vaticana, Cod. Vat. ebr. 573: *siddur* of Italian rite; 339 (1–338, ⟨1⟩) fol.; 84 × 57 (44 × 30) mm, 15 l.; Italian script; written in northern Italy; painted decoration and a few illustrations, done 1460–1470.

**✶245 Venice,** Museo Ebraico, Bible, no. 85: Pentateuch with *masora, keter malkhut* (margins, fol. 1 to 20) of Solomon ibn Gabirol (1020–1058?) and *yigdal* (fol. 233–234); unfoliated: [234] fol.; 219 × 156/157 (biblical text: 132 × 82) mm, 26 l., 2 col.; Sephardi script; written in central Italy (Pisa and Perugia), between 1398 and 1405 (fol. 232v); painted decoration. *Cf. Pls. 38, 236, 282, 303, 328.*

**246 Vercelli,** Seminario Vescovile: Initial leaf of Book III of *Arba'a ṭurim* of Jacob ben Asher (1270?–1340), bound in a volume of miscellanies of talmudic commentaries, as fol. 13; 1 fol.; 337 × 249 mm; Italian script; written in Italy; decoration of the border, of purely Florentine inspiration, of 1465–1485 but done with the illustration in northern Italy, in the Ferrara (?) region.

**247 Vienna,** Österreichische Nationalbibliothek, Cod. Hebr. 16: Prophets and Hagiographa with *masora*; 368 (1–368; 369 added at a later date) fol.; 330 × 245 (210/213 × 163/165; 235 × 185) mm, 29 and 30 l., 2 and 3 col.; Ashkenazi scripts; written in Germany towards the end of the 13th century by several scribes, one of whom wrote the *masora* in 1299; micrographic, pen and painted decoration, done by several hands; a few illustrations (ink and 3 colours).

**248 Vienna,** Österreichische Nationalbibliothek, Cod. Hebr. 75: *siddur* of Ashkenazi rite followed by the *Sefer miẓwot qaṭan* (Small book of commandments of Isaac of Corbeil (13th century)); 274 fol.; 189/191 × 142 (125 × 80) mm, 30 l.; Ashkenazi script; written in Germany in the early 14th century; painted decoration contemporary with the text; pen (violet ink) and painted decoration, and pen illustrations added in northern Italy in the 1470s.

**249 Vienna,** Österreichische Nationalbibliothek, Cod. Hebr. 88: *Qa'arat kesef* (The Silver Plate) of Joseph Ezobi (13th century), followed by the *Seder birkhat ḥatanim* (marriage blessings); 16 fol.; 99 × 69 (55 × 67) mm, 16 l.; Italo-Sephardi script (fol. 1r–11r), Italian script (fol. 11v–16r); written in Italy towards the middle of the 15th century; painted decoration and 1 illustration (fol. 1v).

**250 Vienna,** Österreichische Nationalbibliothek, Cod. Hebr. 132: Catalogue of fixed stars included in a collection of works by Abraham ibn Ezra (1089–1164) and astronomical tables, of which 68 fol. survive; 5 (64–68) fol.; 277 × 195 (202/204 × 139/141) mm, number of lines varies between 30 and 37, 2 col.; Sephardi script; written in Spain, in Catalonia, in the late 14th century; 13 painted illustrations.

**251 Vienna,** Österreichische Nationalbibliothek, Cod. Hebr. 174: *maḥzor* of Ashkenazi rite for *rosh ha-shana, kipur, sukot* and special *shabatot*; 260 (266 numbered but 6 (87–92) added later) fol.; 270 × 198 (180 × 130) mm, generally 18 l.; Ashkenazi script; written in Germany in the first half of the 14th century; decoration and a few illustrations.

**✶252 Vienna,** Österreichische Nationalbibliothek, Cod. Hebr. 218; *ketuba* (marriage contract) in 4 fragments, with a gap on the horizontal tear; 1 fol.; the 2 upper fragments:283/284 × 210 (234/243 × 151)mm, the 2 lower fragments: 300/301 × 219/220 (300/301 × 163/164)mm; Ashkenazi script; written in Austria (Krems), 1391–1392; painted decoration and illustrations. *Cf. Pl. 342.*

**253 Warsaw,** Jewish Historical Institute, Ms. 242, known as the Wolf Haggada: *haggada* of Sephardi rite with additions that conform to the rite of northern France: fol. 2r–4r and 25v–27r *passim*, 33r and 27r (the continuation of the *shefokh* by the hand of another scribe); 36 fol.; 215/217 × 157/160 (147 × 99/102) mm, 10, 18, 19 and 20 l. *(haggada)*; Sephardi scripts; probably written in southern France (in Avignon?) for a Jew originally from northern France, Jacob ben Salomon Ẓarfati, doctor and philosopher, in the last quarter of the 14th century; pen (red and blue ink) decoration and illustrations (ink and touches of colour).

**254 Warsaw,** University Library, Ms. 258: *siddur* of Ashkenazi rite, followed by *piyyuṭim* and prayers (fol. 85v–125v) and by ritual prescriptions, etc. (fol. 125r onwards); 342 (4–345) fol.; 310 × 220 (205 × 132) mm, 29 l. (prayers); Ashkenazi script; written in Germany in the late 13th or early 14th century (fol. 224v: calendar for the years 1295/1296–1503/1504; fol. 228v: *tequfot* for the year 1302/1303); pen and painted decoration; 3 illustrations (ink and a few colours), fol. 37v, 70v, 74r.

**255 Washington, D.C.,** Library of Congress, MS. hebr. 1: *haggada* of Ashkenazi rite; 38 fol.; 230 × 154/160 (144/145 × 90/92) mm, 13 l.; Ashkenazi script; text completed perhaps in Germany or more probably in northern Italy, in 1478 (fol. 34v); pen and painted decoration, painted illustrations, done in northern Italy.

**256 Wrocław,** Ossolinski Library, Pawlikowski Collection, Ms. 141: Pentateuch with *targum* (in margins), *hafṭarot,* Job, Proverbs, *megillot* and *masora*; 960 pages (=480 fol.); 244 × 203/204 (biblical text and *targum*: 154 × 120; biblical text on its own: 151/155 × 105/107) mm, 21 l. (biblical text); 39 at most *(targum)*; Ashkenazi script; written after 1260 and before 1300 in an Ashkenazi region; pen and micrographic decoration, but most decoration and illustrations painted and evidence of Franco-Flemish influence of the last decades of the 13th century, done in a region neighbouring the North-East of the kingdom of France.

**257 Wrocław,** University Library, Ms. M 1106: Pentateuch with *targum* intercalated, *hafṭarot, megillot* (and Dream of Mordecai), the rest of the Hagiographa with *targum*, and *masora* (gaps between fol. 394 and 395); 456 fol.; 488 × 360 (315 × 230) mm, 35 l., 3 col.; Ashkenazi script; text completed by the scribe and the *naqdan* in '*erez ashkenaẓ*', in this particular case a 'Germanic country', in 1237–1238 (fol. 456r); painted and micrographic decoration, painted illustrations.

**✶258 Wrocław,** University Library, Ms. Or. I, 1: second part of a *maḥzor* of Ashkenazi rite (cat. no. 42, Dresden, Sächs. Land.-Bibl., Ms. A 46ᵃ, is the first part); 299 fol.; 533/538 × 383 (325/328 × 242) mm, 25 l.; Ashkenazi script; written in Germany, in the first decades of the 14th century; pen (red and black ink) and painted decoration; illustrations painted *c.* 1340. *Cf. Pl. 3.*

**259 Private and Unknown Collection,** formerly the Rabbi S. D. Sassoon Collection*, Ms. 417: *Mishne Tora* of Maimonides (1135–1204); 780 pages (=390 fol.); 362/366 × 265 (255 × 170) mm; 44 l., 2 col.; Sephardi script; probably written in Italy in the 15th century; initial words of books, chapters and paragraphs only partly written in, in sepia, red, gold and silver; with some gilt fringe and scroll ornamentation (ex.: p. 63, p. 79); *tefillin* sketched in (p. 8).

---

* Concerning this collection see footnote to no. 72 of this catalogue.

# Bibliography

The conception and dimensions of this work did not allow the inclusion of notes giving the relevant bibliographical references for each point. However, the reader will find in the brief bibliography that follows details of the sources and studies we found most useful in establishing the framework of our description of Jewish life in the Middle Ages and in formulating the specific questions we had to put to our illustrations.

On all topics covered in this book relating to the history and geography of Jewish life—economic, social, family, community and religious—and to customs, ceremonies and rites, professional and intellectual activities, sciences and philosophy, or to spiritual and mystical life, general articles or those devoted to specific details in the four principal Jewish encyclopedias may be consulted:

*The Jewish Encyclopedia*, New York, 1901–1906 (5th edition, 1925), 12 vols.
*Jüdisches Lexikon*, Berlin, 1927–1930, 4 vols.
*Encyclopaedia Judaica*, Berlin, 1928–1934, 10 vols. (published only as far as the letter *L = Lyra*, at the end of vol. 10).
*Encyclopaedia Judaica*, Jerusalem, 1971–1972, 16 vols.

To these works must be added the individual studies mentioned under the following rubrics.

Our description of the different aspects of Jewish life is to be seen in the context of the history of the Jews and of their juridical, social, economic and cultural conditions in the different countries of western Europe[1] during the last centuries of the Middle Ages, from the second quarter of the 13th century to the beginning of the 16th century. We should also note that we have limited ourselves in the bibliography to studies on countries from which illuminated Jewish manuscripts have come down to us.

For a general picture of the communities in western Europe, cf.:

Baron, S.W., *A Social and Religious History of the Jews*, New York and London – Philadelphia, 2nd edition: 1952–1976, vols. IX–XII.

For France:

The many articles that have appeared in the *Revue des études juives* from 1880 to the present on the Jews of different regions and localities of France.
Catane, M., *Des Croisades à nos jours*, Paris, 1956.
Schwarzfuchs, S. *Brève histoire des Juifs de France*, Paris, 1956.
Blumenkranz, B., *Les origines et le moyen age*, in *Histoire des Juifs en France* (under the direction of B. Blumenkranz), Toulouse 1972, pp. 13–65.
Chazan, R., *Medieval Jewry in Northern France: A Political and Social History*, Baltimore and London, 1973.

For German countries:

Caro, G. M., *Sozial- und Wirtschaftsgeschichte der Juden im Mittelalter und der Neuzeit*, Frankfurt am Main, 1908 and 1920, 2 vols.
Kisch, G., *Jews in Medieval Germany: A Study of Their Legal and Social Status*, Chicago, 1949.

For Spain and Portugal:

Kayserling, M., *Geschichte der Juden in Spanien und Portugal*, Berlin, 1861 and 1867, 2 vols.; Vol. II: *Die Juden in Portugal*.
Kriegel, M., *Les Juifs à la fin du Moyen Age dans l'Europe méditerranéenne*, Paris, 1979 (also covers the south of France).

For Italy:

Roth, C., *The History of the Jews of Italy*, Philadelphia, 1946; chapters III–VI.
Roth, C., *The Jews in the Renaissance*, Philadelphia, 1959.
Milano, A., *Storia degli ebrei in Italia*, Turin, 1963.
Shulvass, M. A., *The Jews in the World of the Renaissance*, Leiden, 1973.

The subjects discussed in each of our seven chapters are covered in a very uneven fashion in works published hitherto.

### Chapter I  The Medieval Jew and the Universe

The question has never been approached as a whole. The bibliography thus relates only to particular points:

On the creation:
see the Book of Genesis, I–III, and the Book of Psalms, *passim*.[2]

On the medieval Jewish cosmology, which conforms in essentials to that of Ptolemy, see the following:

Solomon Ibn Gabirol, *Keter malkhut*; translated into English by Lewis, B., *The Kingly Crown*, London, 1961.
Moses Maimonides, *More nevukhim*; translated into French by S. Munk, *Le Guide des Egarés*, Paris, 1863.

On the animal world and its symbolism inherited from the *Midrash*:

Ginzberg, *The Legends of the Jews*, Philadelphia, 1913 (7th impression: 1968), 6 vols., with an index by B. Cohen as Vol. 7.

On the Christian Bestiary, sometimes used as a source by our Jewish illuminators:

McCulloch, F., *Medieval Latin and French Bestiaries*, Chapel Hill, N.C., 1960.

On Majorcan cartography and the atlas of Abraham Cresques:

Libman Lebeson, A., 'Jewish Cartographers: A Forgotten Chapter of Jewish History', in *Historia Judaica*, X, 1948, pp. 155–174.
*El atlas catalan de Cresques Abraham*, Barcelona, 1975.

On medieval Jewish heraldry, there is little available other than studies relating to seals: cf. the bibliography in articles on the subject in the encyclopedias mentioned above.

Roth, C. "Stemmi di famiglie ebraiche italiane", in *Scritti in memoria di Leone Carpi* (Ed. by D. Carpi). Milan and Jerusalem, 1967, pp. 165–84, discusses essentially coats of arms after the Middle Ages.

### Chapter II  The Jewish Quarter

On its position within the town, its organization and its communal installations:

---

[1] We have only retained studies on the countries that have given us illuminated Jewish documents.

[2] All our biblical references (books, chapters, verses) are taken from the Hebrew Bible [translation: *Torah, Prophets, Writings*. 3 Vols. Philadelphia: Jewish Publication Society, 1962, 1978, 1982].

cf. the articles on each town where Jews lived in the Middle Ages in the encyclopedias cited above.

On the synagogues and the ritual baths, which have been the subject of the most detailed studies, cf.:

Krautheimer, R., *Mittelalterliche Synagogen*, Berlin, 1927.

Wischnitzer, R., *The Architecture of the European Synagogue*, Philadelphia, 1964.

Kashtan, A., 'Synagogue Architecture of the Medieval and Pre-Emancipation Periods', in *Jewish Art: An Illustrated History* (edited by C. Roth), London, 1961, cols. 253–308, figs. 102–137. [Editions in Hebrew and in German.]

For Spain:

Cantera Burgos, F., *Sinagogas españolas*, Madrid, 1955.

For the Holy Empire and neighbouring lands:

Böcher, O., *Die Alte Synagoge zu Worms*, in *Festschrift zur Wiedereinweihung der Alten Synagoge zu Worms* (edited by E. Roth), Frankfurt am Main, 1961, pp. 11–154, 78 plates (not paginated).

Münzer, Z., *Die Altneusynagoge in Prag*, in *Jahrbuch der Gesellschaft für Geschichte der Juden in der čechoslovakischen Republik*, VI, 1932, pp. 63–105, 11 figs., 10 plates.

### Chapter III  The House

Our sources are limited to a few references in medieval texts on the house itself and its furniture, which can be found in:

Abrahams, I., *Jewish Life in the Middle Ages*, London, 1896.

Rabinowitz, L., *The Social Life of the Jews of Northern France in the XII–XIV Centuries, as Reflected in the Rabbinical Literature of the Period*, London, 1938.

To study our medieval pictures, we have used the following indispensable work:

Viollet-le-Duc, E. E., *Dictionnaire raisonné du mobilier français de l'époque carolingienne à la Renaissance*, Paris, 1872, Vol. I.

### Chapter IV  Costume

This has mostly been studied from the point of view of the discrimination imposed by the ecclesiastical and civil authorities. The stress has been put on distinctive marks, the wheel-shaped badge, the Jewish hat, with its special colour and shape, clothes of a particular cut and colour, all of which were mentioned in papal bulls and royal edicts, and moreover we have had recourse to essentially non-Jewish documents, for example:

Robert, U. "Sur la roue des Juifs depuis le XIIIᵉ siècle", in *Revue des études juives* VI, 1882, pp. 81–95 and VII, 1883, pp. 94–102, fig.

Singermann, F. *Die Kennzeichnung der Juden im Mittelalter: Ein Beitrag zur sozialen Geschichte des Judentums*, Berlin, 1915.

Kisch, G. "The Yellow Badge in History", in *Historia Judaica* XIX, 1957, pp. 89–146.

Blumenkranz, B. *Le juif médiéval au miroir de l'art chrétien*, Paris, 1966, *passim*.

Rubens, A. *A History of Jewish Costume*, London, 1973 (1st edition: 1967), which adds references to some Jewish illustrations on pp. 81–96 and in Appendix 2, on pp. 184-5.

Having decided to describe the usual clothing of Jews as represented in exclusively Jewish illumination, we have had to make use of works on costume in the various countries where they lived during the Middle Ages.

For the whole of medieval Europe:

Weiss, H. *Kostümkunde: Geschichte der Tracht und des Geräthes vom 14ᵗᵉⁿ Jahrhundert bis auf die Gegenwart*, Stuttgart, 1872, Vol. III.

For France:

Viollet-le-Duc, E.-E. *op. cit.*, Vols. III and IV.

Houston, M.G. *Medieval Costume in England and France: The 13th, 14th and 15th Centuries*, London, 1950 (1st edition: 1939).

For the Germanic lands:

Hottenroth, F. *Handbuch der Deutschen Tracht*, Stuttgart, 1896.

For Spain:

Bernis Madrazo, C. *Indumentaria medieval Española*, Madrid, 1956.

For 15th-century Italy:

Cappi Bentivegna, F., *Abbigliamento e costume nella Pittura italiana*, Vol. I: *Rinascimento*, Rome, 1962.

### Chapter V  The Professional Life of the Jewish Community and its Place in the Medieval City

Apart from the works referred to under our first rubric, and especially:

S. W. Baron, *op. cit.*, Vol. XII,

the following works on the trades and professions in which Jews were engaged may be consulted:

Berliner, A., *Aus dem Leben der deutschen Juden im Mittelalter zugleich als Beitrag für deutsche Culturgeschichte: Nach gedruckten und ungedruckten Quellen*, Berlin 1900.

Abrahams, I., *Jewish Life in the Middle Ages*, London, 1896 (2nd edition, enlarged: London, 1932).

Wischnitzer, M., *A History of Jewish Crafts and Guilds*, New York, 1965.

Roth, C., *The Jews in the Renaissance, op. cit., passim* (for the 15th century, which the study takes as its starting point).

If the participation of Jews in scientific and technical development is mentioned, where relevant, in the general histories of science and technology, it is usually minimized. The articles in Jewish encyclopedias, especially those on mathematics, astronomy and medecine, in spite of their varying value, make it easier to perceive the present state of our knowledge.

### Chapter VI  Family Life

The picture of the Jewish family's everyday life has been sketched, in its essentials, in some of the works already mentioned, for example: Berliner, *op. cit.*; Abrahams, *op. cit.*

For the problem of Jewish education, dealt with in the general works already cited, the following may be consulted:

Güdemann, M., *Das jüdische Unterrichtswesen während der spanisch-arabischen Periode*, Vienna, 1873.

Güdemann, M. *Geschichte des Erziehungswesens und der Cultur der abendländischen Juden während des Mittelalters und der neueren Zeit*, Vienna, 1880-8, 3 Vols.:

Vol. I: *Geschichte... der Juden in Frankreich und Deutschland... (X.-XIV. Jahrhundert)*, Vienna, 1880.

Vol. II: *Geschichte... der Juden in Italien während des Mittelalters*, Vienna, 1884.

Vol. III: *Geschichte ... der Juden in Deutschland während des XIV. und XV. Jahrhunderts*, Vienna, 1888.

Marcus, J. R., *The Jew in the Medieval World: A Source Book, 315–1791*, Cincinnati, 1938.

On the religious ceremonies that marked the great moments of family life—birth, marriage, death—as they were performed in the Middle Ages, see the works mentioned above, by Berliner, Abrahams, and, for 15th-century Italy:

Roth, *The Jews in the Renaissance, op. cit.*

Studies of domestic Jewish cult objects, and of marriage contracts also, do not deal very much with the medieval period, given the extreme rarity of medieval specimens which have been preserved. However, for the few ḥanuka lamps that antedate the 16th century, and for a marriage casket of the 15th century, the following may be consulted:

Narkiss, M., *La lampe de ḥanuka* (in Hebrew), Jerusalem, 1939.

Narkiss, M., 'An Italian Niello Casket of the Fifteenth Century', in *Journal of the Warburg and Courtauld Institutes*, XXI, 1958, pp. 288–295, pl. 33.

Chapter VII Religious Life

The basic text is, obviously, the Pentateuch, followed by the elaboration of the *halakha* in the *Talmud* and the later rabbinical writings as well as their medieval codifications; see:

Moshe ben Maymon (Maimonides) (1135–1204), *Mishne Tora* (Repetition of the Law).
Jacob ben Asher (1270?–1340), *Arba'a ṭurim* (the Four Rows).

Also useful, although post medieval in date, is the definitive code of the *halakha* drawn up by:

Joseph Caro (1488–1575) in the *Shulḥan arukh* (the prepared table).

For the content of prayer and liturgical hymns, as well as for the ritual of holidays, the *siddur* and the *maḥzor* of the different rites in their medieval form should be consulted, and also, for example:

Zunz, L., *Literaturgeschichte der synagogalen Poesie*, Berlin, 1865 (2nd edition with an index by A. Gestetner, Berlin, 1889; reprint: Hildesheim, 1966).
Berliner, A., *Randbemerkungen zum täglichen Gebetbuche (Siddur)*, Berlin, 1909.

On the medieval Jewish cult as a whole, cf.:

Zunz, L., *Die Ritus des synagogalen Gottesdienstes, geschichtlich entwickelt*, Berlin, 1859 (reprint: Hildesheim, 1967).
Elbogen, I., *Der jüdische Gottesdienst in seiner geschichtlichen Entwicklung*, Berlin, 1913 (2nd and 3rd editions: Berlin, 1924 and 1931; reprint: Hildesheim, 1962).

On Jewish spirituality and the Kabbalah in the Middle Ages, cf.:

Scholem, G., *Les grands courants de la mystique juive*; translated by M. M. Davy, Paris, 1950 (2nd edition: 1968).
Scholem, G., *La Kabbale et sa symbolique*; translated from the German by J. Boesse, Paris, 1966.
Scholem, G., *Kabbalah*, Jerusalem, 1974.

Representation of certain rites and certain themes of Jewish religious hope has been the object of a few iconographic studies, for example: the rites associated with Passover:

Metzger, M., *La Haggada enluminée*, Leiden, 1973, (Illustrated with 481 figs).

The cycle of holidays in:

Katz, E., and Narkiss, B., *Machsor Lipsiae*, Leipzig, 1964, 2 vols., of which Vol. 1 is devoted to plates; text in German and English, and a list of the *piyyuṭim* in this *maḥzor* in Hebrew.
Metzger, M., *Un maḥzor enluminé du XVᵉ siècle*, in *Mitteilungen des kunsthistorischen Institutes in Florenz*, XX, 1976, pp. 159–196, 21 figs.

The ritual of daily life and family ceremonies:

Panofsky, E., 'Giotto and Maimonides in Avignon: The Story of an Illustrated Hebrew Manuscript', in *Journal of the Walters Art Gallery*, IV, 1941, pp. 27–44, 33 figs.
Panofsky, E., 'Giotto and Maimonides in Avignon: A Postscript', in *Journal of the Walters Art Gallery*, V, 1942, pp. 124–127, 1 fig.

The symbol of the tree of life:

Ameisenowa, Z., 'The Tree of Life in Jewish Iconography', in *Journal of the Warburg Institute*, II, 1938–1939, pp. 326–345, 11 figs.

The providential intervention of God in the history of Israel:

Metzger, M., 'Les illustrations bibliques d'un manuscrit hébreu du Nord de la France (1278–c. 1340)', in *Mélanges offerts à René Crozet*, Poitiers, 1966, pp. 1237–1253, 7 figs.

The theme of the Messiah:

Gutmann, J., 'The Messiah at the Seder: A Fifteenth-Century Motif in Jewish Art', in *Studies in Jewish History: Presented to Professor Raphael Mahler*, Merhavia, 1974, pp. 29–38, 6 figs.

Gutmann, J., 'When the Kingdom Comes: Messianic Themes in Medieval Jewish Art', in *Art Journal*, XXVII/2, 1967/1968, pp. 168–174, 14 figs.
Ameisenowa, Z., 'Das messianische Gastmahl der Gerechten in einer hebräischen Bibel aus dem XIII. Jahrhundert', in *Monatsschrift für Geschichte und Wissenschaft des Judentums*, LXXIX, 1935, pp. 404–422, 2 plates.

The image of the sanctuary and its symbolism:

Nordström, C.O., 'Some Miniatures in Hebrew Bibles' in *Synthronon*, Paris, 1968, pp. 89–105.
Metzger, T., 'Les objets du culte, le Sanctuaire du désert et le Temple de Jérusalem, dans les bibles hébraïques médiévales enluminées, en Orient et en Espagne', in *Bulletin of the John Rylands Library*, LII–LIII, 1970, separate reprint.
Gutmann, J., 'The Messianic Temple in Spanish Medieval Hebrew Manuscripts', in *The Temple of Solomon*, Missoula, 1976, pp. 125–145.

For the manuscripts mentioned in this book, the catalogues, where they exist, of the different libraries and collections may be consulted.

There is as yet no complete and detailed work on Hebrew illuminated manuscripts of the medieval West as a whole, though the following is useful in this respect:

Leveen, J., *The Hebrew Bible in Art*, London, 1944 (2nd edition: New York, 1974), chapter IV

as are two collections of plates with captions and general introduction:

Narkiss, B., *Hebrew Illuminated Manuscripts*, New York and Jerusalem, 1969; reprinted, Jerusalem, 1974.
Gutmann, J., *Hebrew Manuscript Painting*, London, 1979 (there are French and German translations of this work).

The only geographic group to have been studied systematically is from Portugal, and consists of the least fruitful manuscripts from our point of view since they almost all avoid illustration for decoration; cf.:

Sed-Rajna, G., *Manuscrits hébreux de Lisbonne*, Paris, 1970,
resumed in

Metzger, Th., *Les manuscrits hébreux copiés et décorés à Lisbonne dans les dernières décennies du XVᵉ siècle*, Paris, 1977.

Of other publications—facsimiles, monographs on various manuscripts, analyses of certain techniques of decoration, etc.—we restrict ourselves to mentioning only the first, facsimiles, whose plates complement the selection offered to the reader in this book, that is to say:

Sarajevo Haggada:

Müller, D.H. and Schlosser, J.v., *Die Haggadah von Sarajevo*, Vienna, 1898, 2 vols.
Roth, C., *The Sarajevo Haggadah*, London, 1963 (there are also French, Hebrew and Italian translations).

Darmstadt Haggada:

Italiener, B., Freimann, A., Mayer, A.L., and Schmidt, A., *Die Darmstädter Pessach-Haggadah*, Leipzig, 1927, 2 vols.
Gutmann, J., Knaus, H., Pieper, P. and Zimmermann, E., *Die Darmstädter Pessach-Haggadah*, Frankfurt am Main, Berlin, Vienna, 1972, 2 vols. (text in German and English).

Kaufmann Haggada:

Scheiber, A., *The Kaufmann Haggadah*, Budapest, 1957 (2nd edition: Budapest, 1959).

Haggada of the Birds:

Goldschmidt, E.D., Jaffé, H.L.C., Narkiss, B., Shapiro, M., and Spitzer, M., *The Bird's Head Haggadah*, Jerusalem, 1967, 2 vols.

Haggada, Add. MS. 27210 (London, British Library):

Narkiss, B., *The Golden Haggadah*, London, 1970.

# Photo Credits

The authors, who chose all the illuminations pictured in this book, and the publishers wish to thank the private collectors, curators and directors of the libraries and museums listed below for permission to reproduce documents in their possession. Ingrid de Kalbermatten was responsible for obtaining the majority of the photographs. The numbers refer to plate numbers.

Bologna, Biblioteca Universitaria   53, 66, 166, 238, 242-3, 247-50 (photos: Osvaldo Böhm, Venice)

Budapest, Hungarian Academy of Science   116, 134, 171, 265, 340, 362, 393 (photos: MTI, Budapest)

Cambridge, University Library   297

Chantilly, Musée Condé   83 (photo: Lauros-Giraudon, Paris)

Darmstadt, Hessische Landes- und Hochschul-bibliothek   169-70, 220

Dresden, Sächsische Landesbibliothek   3 (except the 7th sign of the Zodiac),   383 (photos: Deutsche Fotothek, Dresden)

Florence, Biblioteca Medicea Laurenziana   82, 154 (photos: Guido Sansoni, Florence)

Hamburg, Staats- und Universitätsbibliothek   34, 49, 78, 84, 105-6, 117, 267, 269-71, 325, 352, 386 (photos: Jochen Remmer, Hamburg)

Jerusalem, Israel Museum   62, 72, 75, 87, 89, 97, 100, 122, 138, 148, 157, 194, 256, 264, 266, 280, 293, 300, 323, 334, 337-9, 346-7, 354, 367, 389, 392 (photos: David Harris, Jerusalem)

– Jewish National and University Library   73, 76, 99, 131, 203, 219, 265, 276, 294, 312, 384 (photos: David Harris, Jerusalem)

– Schocken Institute   86, 107, 110, 118, 129-30, 151-2, 174, 176-8, 228, 257, 273, 291, 319, 344, 370, 376-7 (photos: David Harris, Jerusalem)

– G. Weill Collection   96, 368 (photos: David Harris, Jerusalem)

Leipzig, Universitätsbibliothek   108, 226, 306

Lisbon, Biblioteca Nacional   1, 6, 20-3, 29, 31, 33, 35, 37, 46-8, 61, 63-4, 125, 215-16, 265, 283, 285-6, 288, 296, 298-9, 302, 310, 315-17, 320, 329, 375 (photos: Estúdio Mário Novais, Lisbon)

London, British Library   2, 7-9, 11-17, 25-8, 32, 36, 40, 42-5, 54-8, 65, 68, 70-1, 74, 77, 91, 95, 101, 103, 111-15, 132, 136-7, 139-44, 156, 159-62, 167-8, 175, 179-82, 186, 189-90, 193, 195, 198, 206-9, 214, 218, 221, 235, 239, 253, 259, 265, 272, 277, 281, 287, 290, 301, 308-9, 313, 318, 324, 327, 330-1, 343, 348-9, 351, 353, 366, 369, 371, 373, 378-9, 385, 387-8, 391

Manchester, John Rylands University Library   79, 85, 135, 165

Milan, Biblioteca Ambrosiana   90, 202 (photos: Mario Carrieri, Milan)

Munich, Bayerische Staatsbibliothek   98, 128, 200, 227, 229, 262-3, 265, 292, 307

Nîmes, Bibliothèque Municipale   333

Oxford, Bodleian Library   10, 39, 67, 69, 104, 158, 172-3, 183, 196, 210, 222, 230-1, 260-1, 278, 284, 305, 314, 363-4, 394

Paris, Bibliothèque Nationale   59, 153, 225, 244-6, 251, 265, 268, 321, 326, 358-60, 382

Parma, Biblioteca Palatina   80-1, 93, 121, 126-7, 145-7, 149-50, 155, 164, 187-8, 192, 204, 223-4, 232, 234, 275, 304, 311, 332, 345, 365, 380

Princeton, University Library   109, 341

Rome, Biblioteca Casanatense   18, 24, 41 (photos: Dr. M. Vivarelli, Rome)

Stuttgart, Württembergische Landesbibliothek   191, 241

Vatican, Biblioteca Apostolica Vaticana   19, 30, 52, 60, 92, 94, 102, 184-5, 205, 237, 252, 335, 357, 372, 374, 390

Venice, Museo Ebraico   38, 236, 282, 303, 328 (photos: Osvaldo Böhm, Venice)

Vienna, Österreichische Nationalbibliothek   342

The following photographs and slides taken by the authors were graciously loaned to the publisher and have been reproduced with the permission of the libraries and collection concerned.

Copenhagen, Royal Library   217

Hamburg, Staats- und Universitätsbibliothek   199

Jerusalem, Israel Museum   254

– Jewish National and University Library   336

– Rabbi S.D. Sassoon Collection   123, 274, 355-6, 395

Lisbon, Biblioteca Nacional   211

Parma, Biblioteca Palatina   233

The authors had the photographs for the plates listed below made from microfilms or publications and graciously loaned them to the publisher. They are reproduced with the permission of the libraries and museums concerned.

Cambridge, University Library   201, 361

New York, private collection   240, 255 (after color 917-18, Encyclopaedia Judaica, Vol. 7, Berlin, 1931; R. Schilling and G. Swarzenski, Die illuminierten Handschriften und Einzelminiaturen... in Frankfurter Besitz, Frankfurt am Main, 1929, pl. LXXVIIIb)

Sarajevo, National Museum   4-5, 50-1, 88, 119-20, 124, 133, 212-13, 258, 279, 289, 295, 322, 350, 396 (after C. Roth, The Sarajevo Haggadah, London, 1963 [the pages of the facsimile are not numbered])

Wrocław, University Library   3 (the 7th sign of the Zodiac)

The Jewish Theological Seminary of America, New York, has generously authorized the reproduction of two slides it loaned to the authors: 197, 381

The sketches for 163 and 397 were drawn by Thérèse Metzger.

# Indexes

Since the table of contents is so detailed, it did not seem necessary to include a general index; however, the two indexes that follow may provide the reader with useful tools. In the first, the manuscripts are grouped according to the most important works they contain so as to give the reader an idea of the kinds of Hebrew texts that were decorated or illustrated. The second index, which classifies the manuscripts chronologically, by sure or probable date, provides an overview of the periods that have produced the most valuable testimony for our study.

## Index of the Works Contained in the Hebrew Manuscripts Mentioned in the Catalogue*

*Almagest* by Ptolemy  201

*Arba'a ṭurim* (The Four Rows) by Jacob ben Asher  103, 109, 150, 152, 161, 167, 233, *241, 246

astronomy  77, 118, *135, 250

Bible  1, 3, 4, 6, 7, 8, 9, 14, 15, 26, 28, 29, 33, 37, 43, 44, *46, 48, *51, 54, *57, *58, 60, *63, 66, *67, 72, 74, *75, 81, *88, 89, *90, *91, 94, *95, *96, 98, 104, 106, 108, 110, 111, *113, 114, 121, 124, 125, 129, 137, 143, 144, 145, 149, *151, 154, *155, *157, *158, *166, 175, 176, 177, 178, 179, *180, 181, *182, *183, *184, 185, 186, 187, 188, 189, 197, 198, 202, 203, 204, *206, 208, 209, 210, 211, *212, *214, 215, 216, *217, 222, *223, *225, *226, 227, *229, *231, 232, 234, *240, *241, *242, *245, 247, 256, 257

*Birkhot MaHaRaM* (The Blessings of Meir of Rothenburg)  *53

Canon of Avicenna  *11, *12

*dinim* (ritual prescriptions)  *107

*Diqduqey ha-te'amim* (treatise on accents and vowels) by Aaron ben Asher  181

Dream of Mordecai  7, *51

*Haggada* (ritual for Passover evening)  5, 13, *25, *34, 35, 36, *39, 41, 50, *56, *61, *62, *67, *76, *82, 83, *84, *92, *93, *105, *112, *115, *116, *122, *123, 128, 134, 136, 139, 141, 147, *199, *200, 207, 213, *219, *221, *236, *237, 253, 255

The following are references for the *maḥzorim* and *siddurim* that contain the text of the *haggada* in the services of the *Pesaḥ* holiday, but which are not singled out in our catalogue  2, 20, *27, *30, *49, *57, *59, 68, 70, 71, 73, 78, *80, *90, 97, *101, *102, *107, 114, 120, *140, *148, 160, *162, 170, *172, 191, 205, *218, 228, *243, 244, 248, 254

*Haggahot Maimuniyyot* (Notes on the *Mishne Tora* of Maimonides)  *17

*Hilkhot nidda* (Laws of menstrual women)  *53

*Keter malkhut* (The Kingly Crown) by Solomon ibn Gabirol  *245

*ketuba* (marriage contract)  *252

*Maḥzor* (prayers: cycle of holidays, either complete or partial)  2, 5, 10, *13, 20, 22, *23, *24, *40, *42, 47, 50, 52, *55, *62, *64, 68, 69, 73, 78, *80, 85, 86, *87, *92, 97, *99, 100, [*105], *107, *112, *115, 120, [*122], *126, *130, 138, *140, 156, 159, *162, 163, *164, 165, 169, 170, *173, 174, 205, *220, 227, 251, *258

*Malmad ha-talmidim* (A Goad to Scholars) by Jacob Anatoli  18

*Mashal ha-qadmoni* (Fables of Antiquity) by Isaac ibn Sahula  [*57], *133, *168

mathematics  118, *132

medicine  32, *194, *195, *196

*Megilla* of Antiochus (Scroll of Antiochus)  4, 54, 183, 209

*Minhagim* (customs)  *49

Miscellanea  *57, *90, 127

*Mishne Tora* (Repetition of the Law) by Maimonides  *16, *17, *65, *146, *238, 259

*More Nevukhim* (Guide of the Perplexed) by Maimonides  28, *38, 79, *192

music  118

*pisqey* (decisions)  *117

*piyyuṭim* (hymns)  *62, *92, *105, *112, *115, *122, 138

*Qa'arat kesef* (The Silver Plate) by Joseph Ezobi  119, 249

*qinot* (lamentations)  *49

Rashi = Rabbi Salomon ben Isaac (commentary on the Bible by)  7, 44, 45, *46, *51, *63, 110, *131, 145, *151, *153, *166, 188, 189, *217, 232, *240

ritual for ceremonies  119, *230

*Seder birkhat ḥatanim* (marriage blessings)  249

*Sefer ha-asheri* (The Book of Asher) by Asher ben Yeḥiel  190

*Sefer ha-halakhot* (Book of Laws) by Isaac Alfasi ben Jacob  *224

*Sefer ha-shorashim* (Book of the Roots) by David Qimḥi  66

*Sefer iqqarim* (Book of Principles) by Joseph Albo  235

*Sefer mikhlol* (a grammar) by David Qimḥi  *88, *157

*Sefer mizwot qaṭan* (Small Book of Commandments) by Isaac of Corbeil  248

*Sefer sha'arey ora* (Book of the Gates of Light) by Joseph Gikatila  193

*Sha'arey dura* (The Gates of Dura = Laws of forbidden food) by Isaac ben Meir of Duren  *53

*Sha'arey shevu'ot* (The Gates of Oaths) by David ben Saadia  224

*siddur* (prayers)  *19, *21, *27, *30, 31, *49, 52, *57, *59, 70, 71, *90, *101, *102, 114, 142, 148, 160, *171, *172, 191, *218, 228, *243, 244, 248, 254

*targum* (paraphrase in Aramaic)  3, 6, 7, 8, *46, *51, *63, 95, 98, 110, 124, 129, 145, 149, *151, 154, *155, *166, 178, *180, 187, 188, 189, 202, *223, 226, 232, *240, *242, 256, 257

*Teshuvot (Responsa)*  16

---

* The manuscripts are listed according to the number of their entry in our catalogue of manuscripts (p. 298), and a star * indicates those from which illustrations have been reproduced in this book.

# Chronological Index of the Hebrew Manuscripts Mentioned in the Catalogue

This book was set and printed in September, 1982 by Imprimeries Réunies S.A., Lausanne-Renens, who are also responsible for the photolithography.

Binding: Mayer+Soutter S.A., Renens

Design and Production: Claude Chevalley

This book was produced in Switzerland.